Profiles in Photography

Sponsored by
The Brooks Institute Alumni Association

ISBN 0-962-8858-0-0

Published by
Serbin Communications, Inc.
Santa Barbara, California

1940 FRANK BEANE

In founding Brooks Institute of Photography, Ernest H. Brooks Sr. established an educational foundation which formed the basis for thousands of careers in the world of visual communications. This book, which offers a glimpse into a few of those careers, is dedicated in his honor.

October 17, 1909 - June 21, 1990

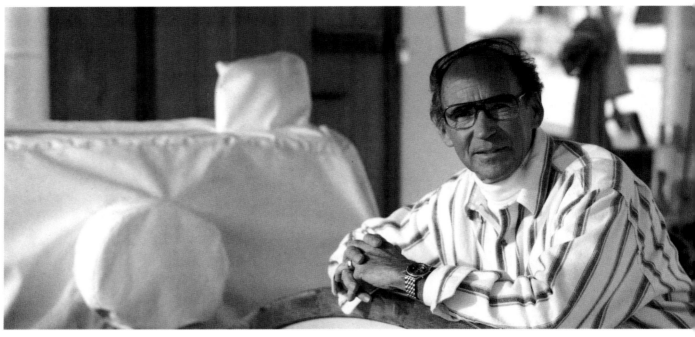

Ernest H. Brooks, II
President

Brooks Institute's worldwide reputation is maintained and enhanced everyday by a select group of people who earn their living through making images. Their work can be seen in magazines, newspapers, motion pictures and video productions in every corner of the globe. Each of these alumni has molded a career around individual dreams and aspirations, selecting a path and following it. Their goals are as diverse as the fields open to photographers. The common thread is their love of photography combined with unswerving dedication and commitment to excellence. Professional photography is one of the few occupations which allows its practitioners to live their dreams. For some it might be an avenue to creative fulfillment and financial reward; for others, a means to travel, to visit foreign countries and explore their cultures, or to delve into science and technology.

The outstanding and diversified work of the photographers featured here highlights the opportunities available in photography. It is work which entertains, informs, educates and contributes to understanding world events. And it is work which is as diverse as one can imagine: from images that celebrate Detroit's latest automotive products to those that celebrate a daughter's wedding; from images that portray captains of industry to those that portray captains of high school football teams; from images that document the passage of time to those that help predict the future.

These images, of various style and content, comprise the work of a group of men and women who received their photographic education at Brooks Institute. Through a small sampling of their work in the pages that follow, the Brooks Institute Alumni Association is proud to introduce some of its most successful members.

Profiles...

Cesar H. Alvarez

Cesar
7324 S. Pickering #A
Whittier, Calif. 90602
(213) 696-6409

Clients include: Casey Printing, Deaks International Foods, Sporty's Swimsuits, Lincoln Trust Fund, Classic Hair and Design, Amber Productions, Vismar Productions.

PAUL GONZALES 1984 OLYMPIC GOLD MEDALIST

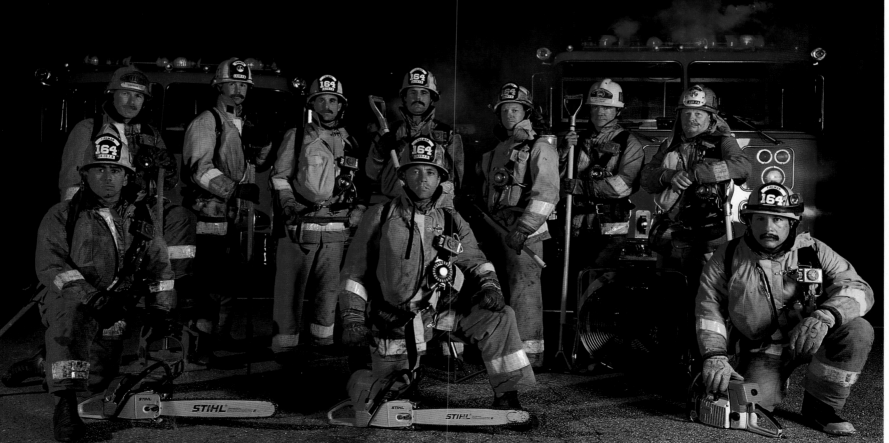

LOS ANGELES COUNTY FIRE DEPARTMENT

7

Alan Arellano

American Cyanamid Corporation
P.O. Box 2516
Danbury, CT 06813-2516
(203) 743-4451

Specialty: Corporate/Industrial/Medical
& Video Productions

Clients include: Jimmy Carter Foundation, Praxis Biologics, Lederle Laboratories, Storz Instruments, Bio Science Technologies (Finland), Ventura County Search & Rescue, Architectural Supplements, University of Chicago Medical Center (historic live liver transplant), Johns Hopkins Medical Center, UCLA Medical Center, Medical World News, American College of Surgeons, CNN News, Fox News, ABC's "Nightline." Represented by Custom Medical Stock House of Chicago, Ill.

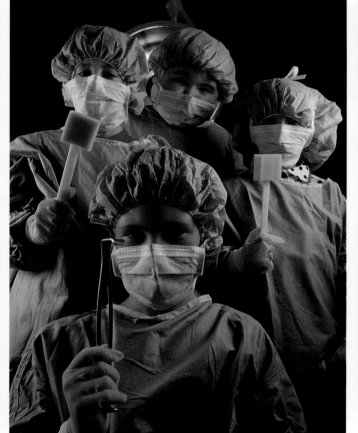

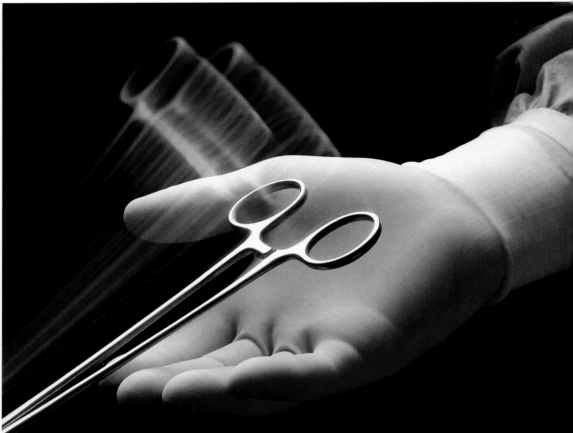

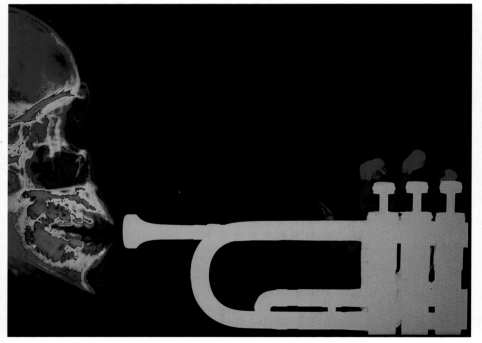

"SPECIALIST IN ILLUSIONARY IMAGERY"

Ken Arnone

Ken Arnone Photographic Design
3886 Ampudia Street
San Diego, CA 92110
(619) 298-3141

Specialty: Photographic Illustration

I got my BPA from Brooks in 1972, and opened Ken Arnone Photographic Design in October of that year in San Diego. I like diversity and challenge, and decided not to specialize. I have served such diverse clients as Ankony Angus Corporation, Atlas Hotels, Aeromexico, Sea World, General Motors, Sunset Magazine, Sail Magazine, California First Bank, Xscribe, etc. with over 10,000 images published. My studio handles everything from editorial to big production brochures and catalogs.

Bob Ashmun

Brass Shutter Studio
1143 E. Caro Road
Caro, MI 48723
(517) 673-3991

The Brass Shutter Studio has gained a reputation for our style of relaxed environmental portraiture by "discovering" and using unique locations and also by designing and building our own sets to control the look that we are in pursuit of. Our extensive use of the beaches and islands of the Great Lakes has provided additional avenues into portfolio and fashion work.

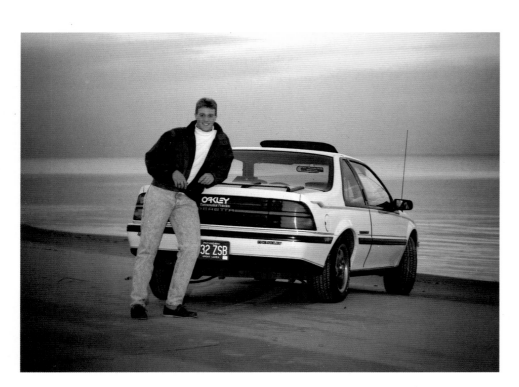

Claude S. Ayakawa

Claude S. Ayakawa, M. Photog., Cr.
94-889 Waipahu Street
Waipahu, Hawaii 96797
(808) 677-5943

Specialty: Portraits/Weddings/Commercial

Membership: Professional Photographers of America, Inc., Hawaii Professional Photographers, Inc., American Society of Photographers.
Honors: PP of A Photographic Craftsman Degree—1979, PP of A Master of Photography Degree—1985, PP of A / Hawaii PP National Award—1990.

Otto Baitz

Otto Baitz Photography of Architecture & Interior Design
130 Maple Avenue, Suite 9B-1
Red Bank, New Jersey 07701
(908) 530-8809

Specialty: Award-winning Photography of Architecture & Interior Design

Clients include: Gwathmey Siegel, Richard Rogers, Davis & Brody, Bohlin Powell Larkin Cywinski, Michael Graves, Skidmore Owings Merrill, Koetter Kim, Swanke Hayden Connell, RTKL, Venturi & Rauch, Architectural Record, Architecture, Progressive Architecture, A + U Japan, Interior Design, Interiors, House & Garden, House Beautiful, etc.

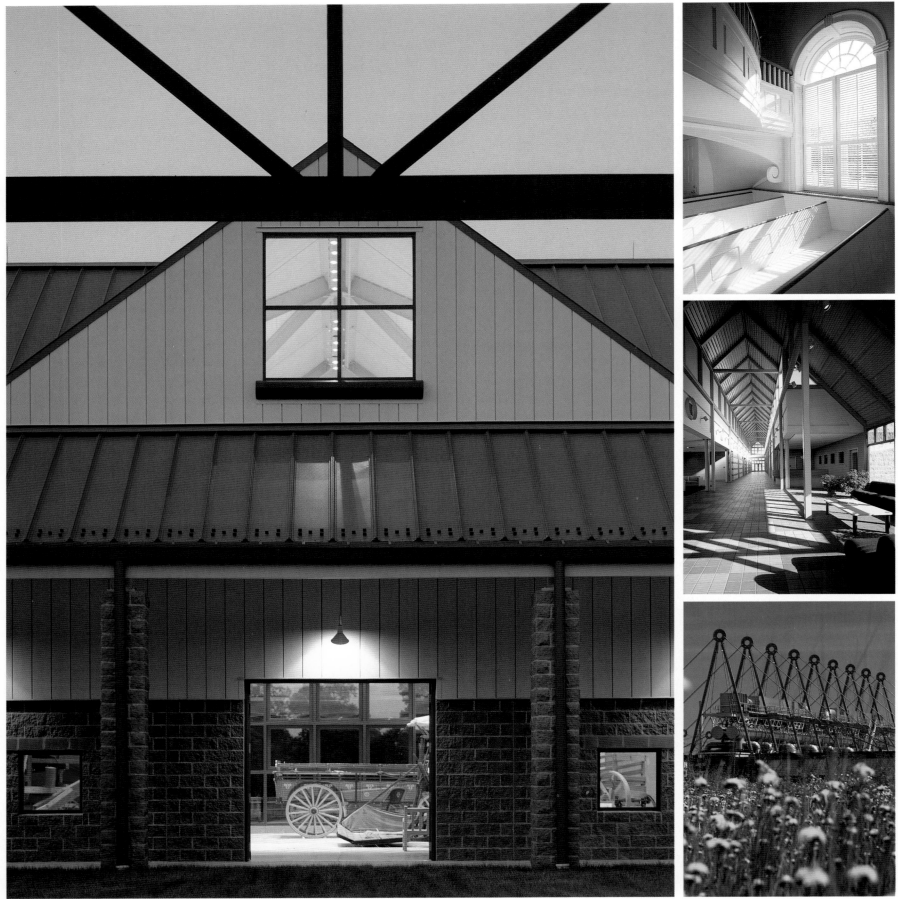

Frank Baker

Frank Baker Photography For Business
21462 La Capilla
Mission Viejo, CA 92691
(714) 472-1163

Specialty: ## Corporate/Editorial/Annual Reports

Located in the heart of Southern California. Assignments include travel worldwide. Work performed for these fine companies: Allergan Inc. Battaglia, Beckman, Bentley Labs, Coldwell Banker, California Avocado Commission, Carl's Jr., Fluor, General Mills, National Education Corporation, Pizza Hut, Pepsico, Shell Oil, Taco Bell, Teledyne, TRW, UPS, Unisys.

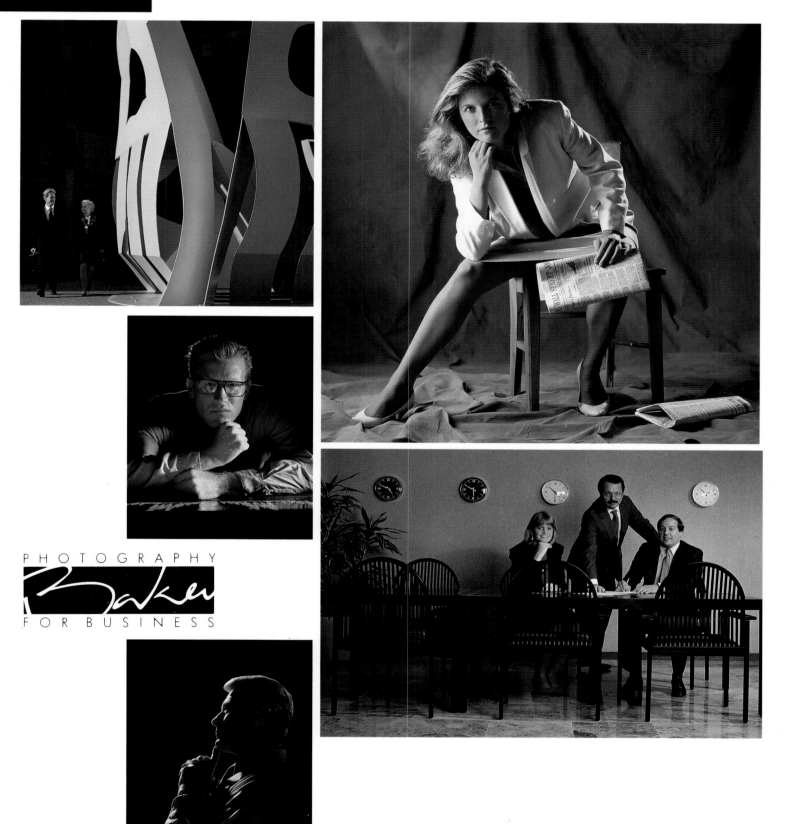

PHOTOGRAPHY
Baker
FOR BUSINESS

John R. Bare

John R. Bare & Associates
3001 Red Hill Avenue, Suite 4-102
Costa Mesa, CA 92626
(714) 979-8712 FAX (714) 979-1024

Specialty: Interior and Architectural Photography

In serving the marketing needs of the building industry, our clients include major residential developers and designers in California, as well as building industry publications and commercial developers and brokers. Additionally, we provide both studio and location photography for editorial and advertising uses, either on assignment or from our stock files.

THE LUSK COMPANIES

J.M. PETERS CO.

STANDARD PACIFIC CORP.

BUILDER MAGAZINE

PROFESSIONAL BUILDER

A.M. HOMES CO.

TRIZEC CORP.

THE BALDWIN CO.

SCHER-VOIT

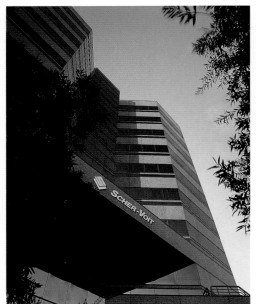

STOCK AND
ASSIGNMENT.
STUDIO AND
LOCATION.

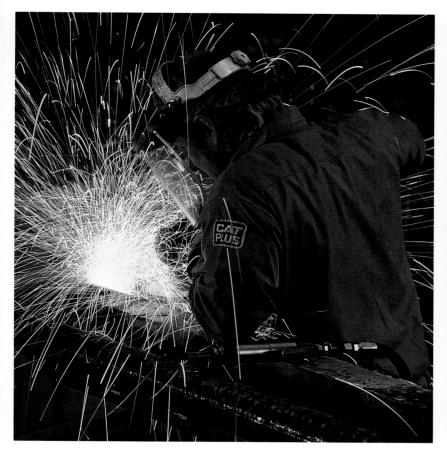

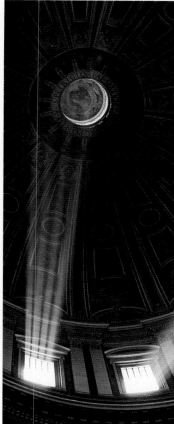

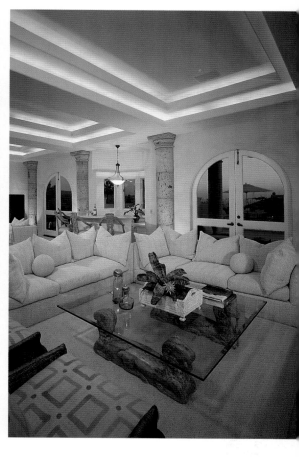

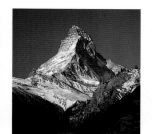

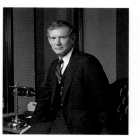

**JOHN R. BARE
AND ASSOCIATES**

3001 RED HILL AVE.

SUITE 4-102

COSTA MESA,

CALIFORNIA 92626

714 · 979 · 8712
FAX 714 · 979 · 1024

James Beckett

Brooks Institute Faculty
Beckett Photo-Graphics
P.O. Box 23923
Santa Barbara, CA 93121
(805) 966-2550

Specialty: ## Photo-Graphics for Corporate Publications

Jim is currently the Chairman of the Commercial Photography Department at Brooks Institute and is a full-time faculty member in the Industrial/Scientific Department. In addition, Jim maintains an active freelance business in Santa Barbara which serves clients from San Diego to San Francisco. Beckett Photo-Graphics specializes in Corporate Photography and Graphic Design.

16

Ernie Block

Ernie Block Studio, Inc.
18th and Wyandotte
Kansas City, Missouri 64108
(816) 472-4546

I was a good kid.

Sister Elizabeth Marietta recognized a potential for serious problems and considered it her sole purpose in life to provide me with three things . . . discipline, discipline, discipline.

Clients: American Italian Pasta Company, Andrews & McMeel Publishing, Armour Foods, Better Homes & Gardens, Farmland Industries, Hallmark Cards, Jason-Empire, Monsanto Corporation, Pasta LaBella, Rival Manufacturing, Toastmaster, Inc., United Cerebral Palsy, US Sprint, United Way, Williams Foods, Wolferman's English Muffins.

Represented by Linda Buchner

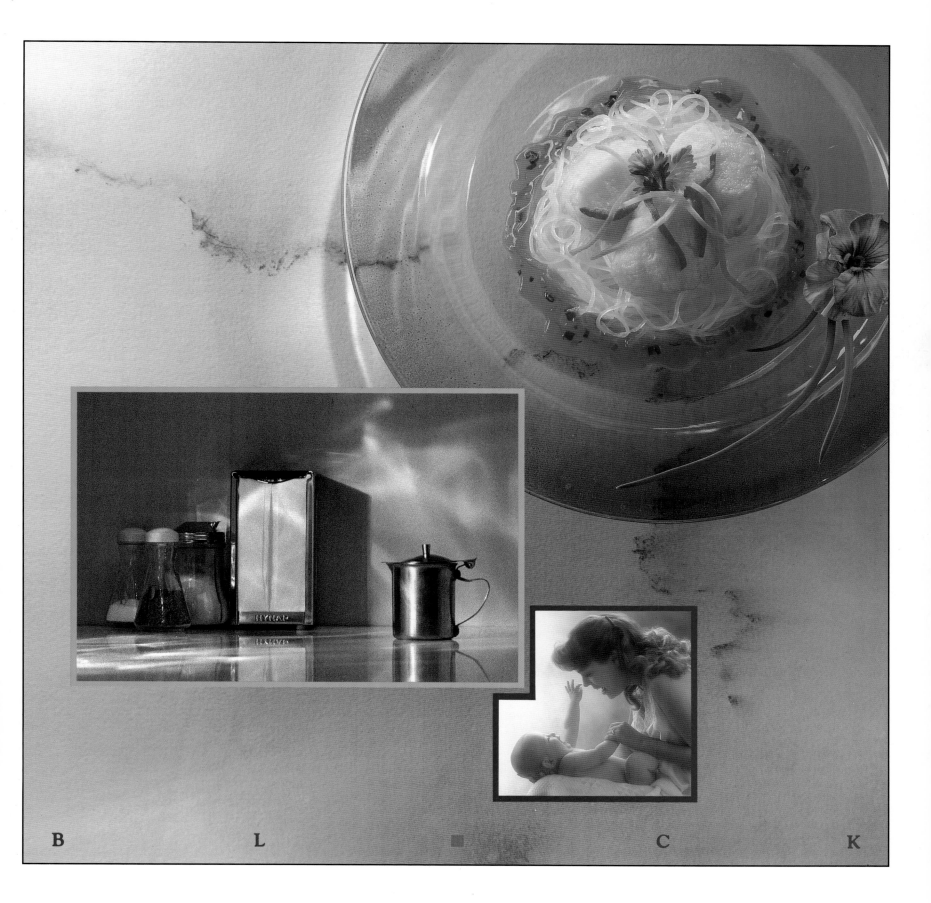

B L ■ C K

Bill Boxer

Bill Boxer Photography Inc.
11835 Canon Blvd., Suite C-104
Newport News, Virginia 23606
(804) 873-3686 FAX (804) 873-1597

Partial Client List: American Olean, BASF, Boy Scouts of America, Canon, CBN, Colonial Williamsburg Foundation, Designer Specifier Magazine, Ferguson Enterprises, Gammapar, General Dynamics, Mary Immaculate Hospital, Mercy Hospital, Mary Washington Hospital, Microbac, Newport News Shipbuilding, N-View Computer Products, Preciptech, Radisson Hotels, Riverside Medical Systems, Sheraton Hotels, Sequoia Computers, Southern Air Corporation, Tenneco, United Way, Vigyan Computer Products, The Virginia Tourist Bureau.

All multiple-image photographs are produced in-camera, and are unretouched.

BILL BOXER PHOTOGRAPHY

BILL BOXER PHOTOGRAPHY

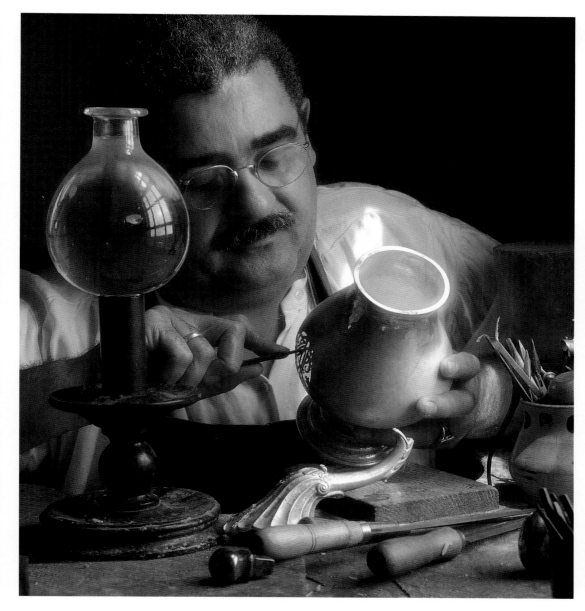

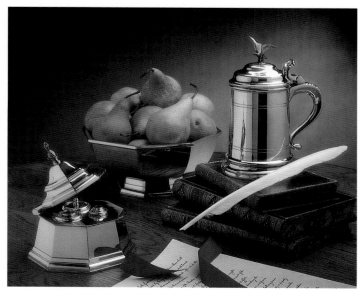

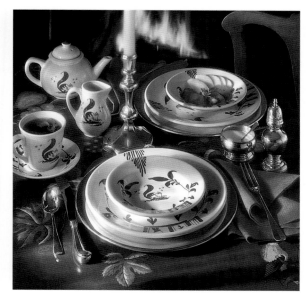

11835 CANON BOULEVARD SUITE C 104 NEWPORT NEWS, VIRGINIA 23606 (804) 873-FOTO FAX (804) 873-1597

BILL BOXER PHOTOGRAPHY

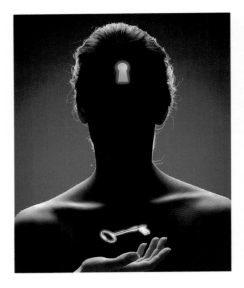

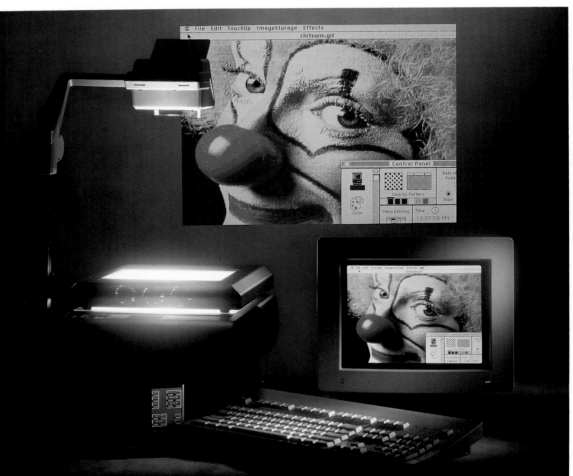

11835 CANON BOULEVARD SUITE C 104 NEWPORT NEWS, VIRGINIA 23606 (804) 873-FOTO FAX (804) 873-1597

BILL BOXER PHOTOGRAPHY

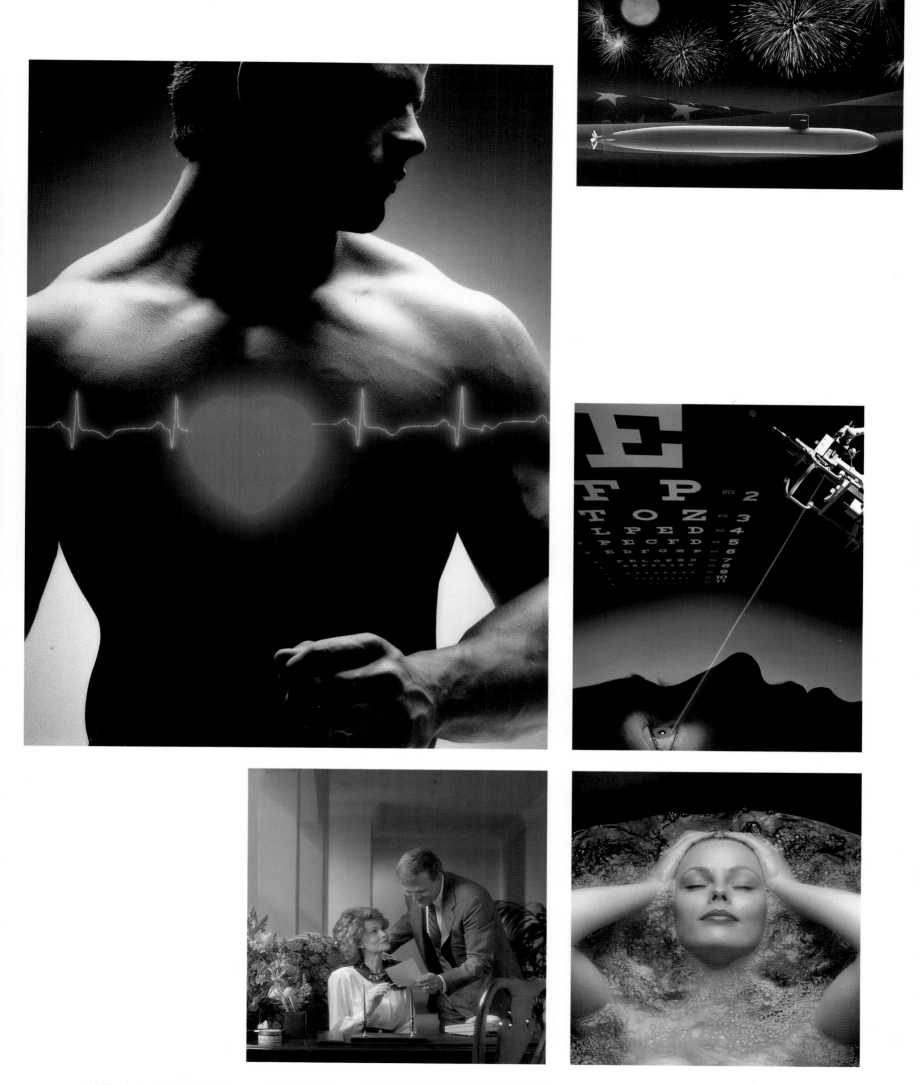

11835 CANON BOULEVARD SUITE C 104 NEWPORT NEWS, VIRGINIA 23606 (804) 873-FOTO FAX (804) 873-1597

Aidan Bradley

Aidan Bradley Photography
721 East Gutierrez
Santa Barbara, CA 93103
(805) 962-8466 FAX (805) 962-1132

Specialty: Photography for the Golf Industry

Born and educated in Ireland where there are more golf courses per capita than any other country in the world. Has operated an advertising studio for the past ten years in Santa Barbara, dealing with local, national, and international clients. Now specializing in images for the golf industry, both studio and location. Client list upon request.

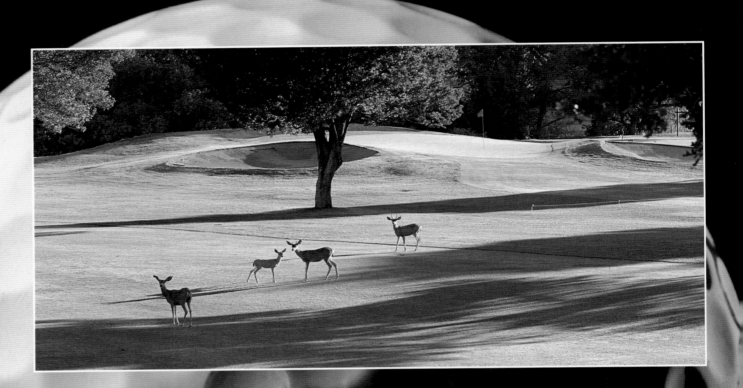

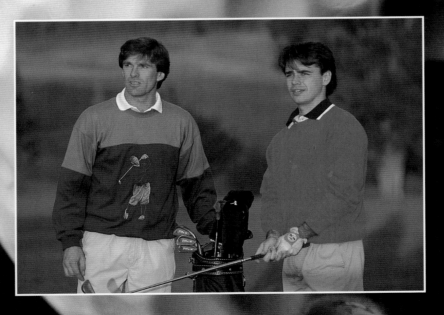

AIDAN
BRADLEY
PHOTOGRAPHY

721 East Gutierrez Street
Santa Barbara, California 93103
(805) 962-8466 • Fax (805) 962-1132

AIDAN
BRADLEY

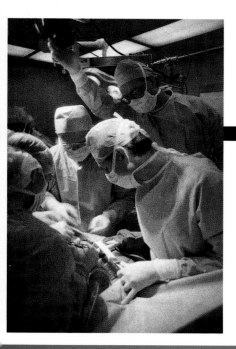

Terry L. Brian

MedaVision
1012 West Chestnut Street
Lompoc, California 93436
(805) 736-9959

Specialty: Medical Film/Video Producer

Specializing in filming on location, filmed in more than 110 major hospitals throughout the United States, Canada, Puerto Rico, England, Germany, Switzerland, and Finland. Produced over 400 films, many firsts in the field of surgery; for example: the first live liver donor transplant, performed by Dr. C. Broelsch. Interned under John Alonzo, Jr., who was the Director of Photography on "Chinatown," "Steel Magnolias," "Clifford," and many others. Clients: American College of Surgeons, ACOG, ACP&R, AORN, ABC, NBC, Fox, CNN, The Carter Center, the Veterans Administration which included President George Bush, Senator Pete Dominici, Senator Harrison Schmidt, and Congressman Manuel Lujan.

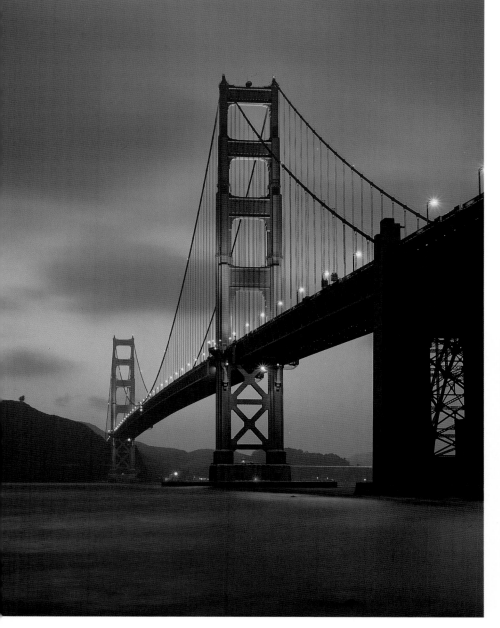

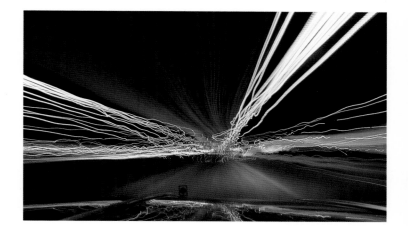

Ernest H. Brooks II

Backstreet Publications
P.O. Box 50626
Santa Barbara, CA 93150
(805) 966-3888

Photo credit: Robert Smith

Specialty: Ocean Related Subject Matter

President, Brooks Institute. Contributing photographer to numerous magazines and organizations including: Cousteau Society, California Highways, Trilogy, Ocean Realm, Monterey Bay Aquarium, Nature Conservancy, National Wildlife. Clients include: Eastman Kodak, Hasselblad, Tokina Optical, Bendix Marine, Furuno Marine, and Dillingham Corp. His work has been exhibited in the Metropolitan Museum of Art, Monterey Bay Aquarium Shark Exhibit, Yugoslavia—Man in the Sea, Our World Underwater.

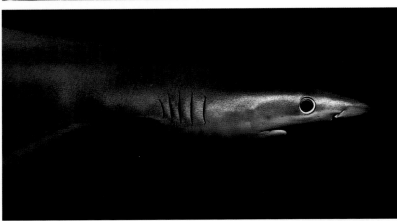

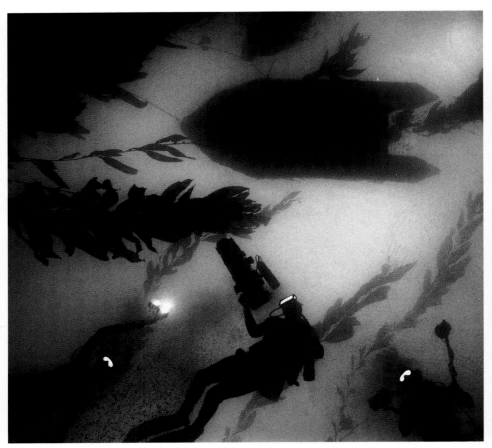

Edward Brown

P.O. Box 3838
South Pasadena, CA 91030
(818) 799-7827

Specialty: Commercial Illustration

A Brooks honor student, who worked as a studio manager at Brooks, and is now a free-lance commercial illustrator. My primary work is advertising, entertainment, business, product, and events.

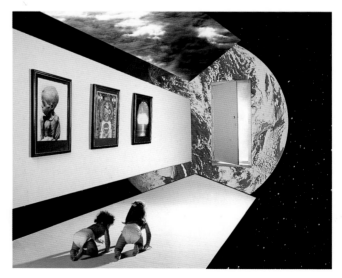

Julie Bubar

Julie Bubar Photography
545 Rimini Road
Del Mar, CA 92014
(619) 481-3831

Specialty: People & Products

Clients include: Del Mar Plaza, San Diego Magazine, ADC Stoorza, Scripps Hospital. Studio and location photography. Specializing in still life, people, corporate and public relations. Formats 35, 120, 4x5. BFA University of Southern California '76, BA Brooks Institute of Photography '84.

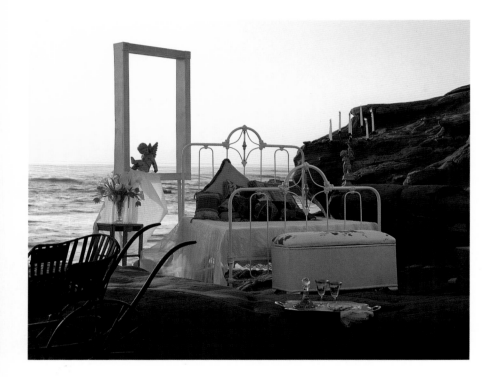

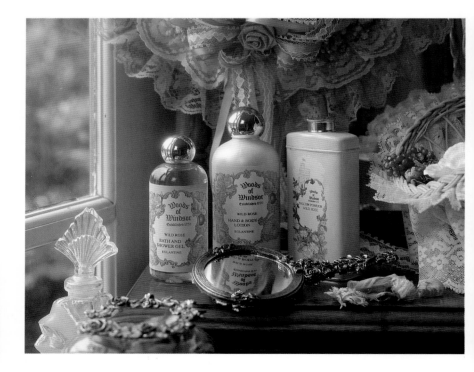

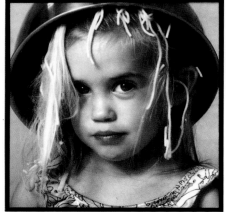

Thomas Carver

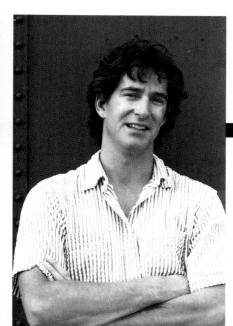

A Slice of Light
P.O. Box 93
Stonington, CT 06378
(203) 535-1129

Specialty: Transportation Industry/Night Lighting

My diverse library of stock images features advertising, editorial and corporate views from New England to Canada and the Pacific Northwest to California.
Clients include: PLM International, Union Pacific, Hyrail, Pentrex, PC Graphics, Kalmbach, Greene Plastics, Cross Sound Ferry Services and Resource Recovery Systems.

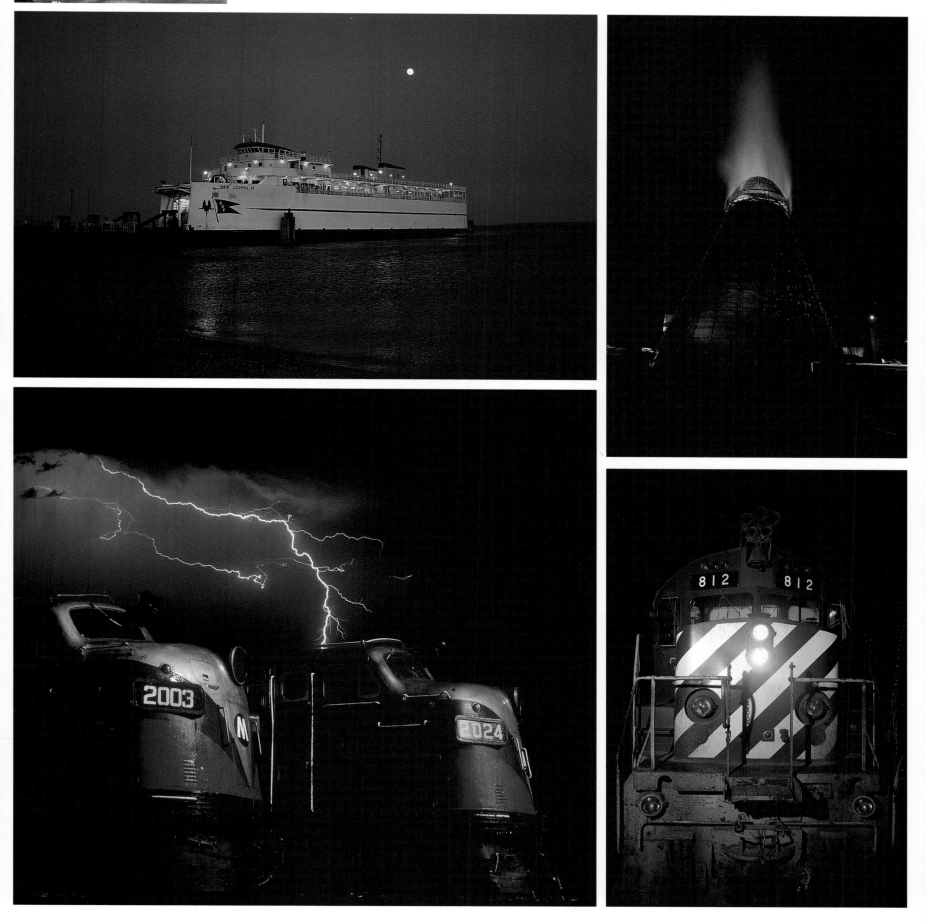

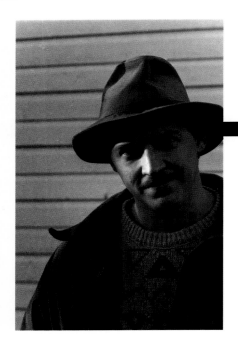

Jim Catena

Jim Catena Photography
P.O. Box 2128
Union, New Jersey 07083
(908) 851-2929

Specialty: Graphically Enhanced Photography

Clients include: The Prudential, Merrill Lynch, Paddock Publications, Asbury Park Press, North Jersey Newspapers, Chicago White Sox.
Other specialties include sports and nature.

All original photography, graphic enhancements and design work by Jim Catena. No airbrushing was used.

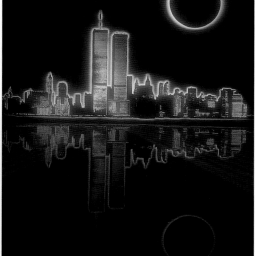

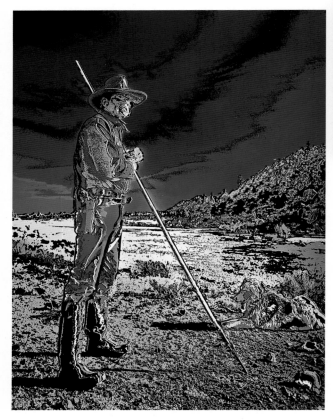

Dwight Gooden New York Mets

Carlton Fisk Chicago White Sox

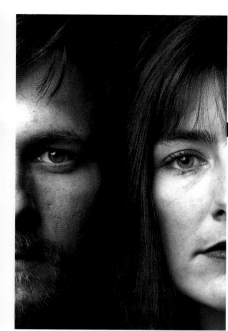

Cavanaugh Grimes Studio

Cavanaugh Grimes Studio
207 West Fourth Street
Austin, Texas 78701
(512) 478-0089 FAX (512) 472-1227

Specialty: People/Food—Still Life

Lizz Cavanaugh and David Grimes have the experience of four years in Los Angeles and New York working on national ad campaigns for the industry's leading agencies and publications. Their studio is now located in Austin, Texas, which brings their varied talents to the Southwest.

Cavanaugh Grimes Studio

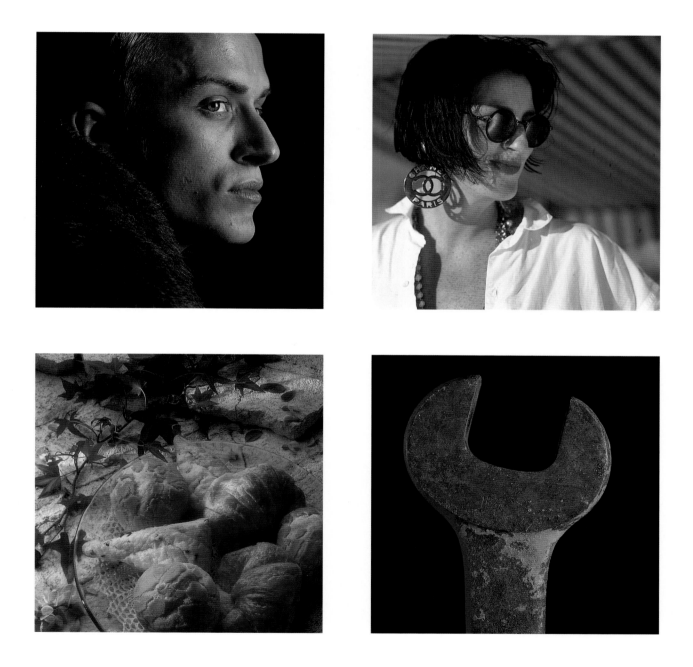

Represented by Arden Brands

713.464.2038

James Chen

James Chen Studios
1917 Anacapa Street
Santa Barbara, CA 93101
(805) 569-1849

Specialty: Corporate Communications, Marketing & Sales

JAMES CHEN is an internationally-active free-lance photographer based in Santa Barbara, CA, since 1966. His work has been featured in numerous publications, and is a recipient of awards for Outstanding Achievement and Photographic Excellence. Awards range from such noted organizations as the Art Directors Club of Los Angeles, San Francisco Society of Communication Arts, and International Hotel Sales Managers Association.

Jim Childress

Childress Photography
5048 50th Street
Lubbock, Texas 79414
(806) 795-8004

Specialty: Commercial/Illustrative/Portraiture

Degrees: B.A., B.P.A., CPP, Hon. Master of Science in Photography, Master of Photography, Photographic Craftsman.

Clients include: Texas Instruments, Meredith Corporation, Southwestern Bell Telephone, Feist Publications, IBM, NASA, U.S. Department of Agriculture, U.S. State Department, Presidents Ford and Bush, Dr. Henry Kissinger, congressmen, senators, Lubbock Independent School District, Furr's/Bishop Cafeterias, Albertson's Supermarkets, Pitney-Bowes, Conoco, Inc., TransAmerican Soil Blenders, Bush Hog Continental, Mack Trucks, U-Haul, ARA Food Services, and, additionally, warm West Texas neighbors.

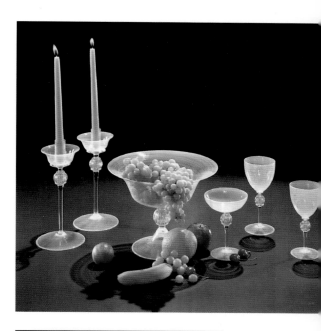

Gary R. Choppe

Creative Images Studios
25570 Rye Canyon Road, Unit A
Valencia, CA 91355
(805) 257-1699 or (805) 251-8957

Specialty: Advertising and Industrial Photography

I have worked out of the Santa Clarita Valley since 1983, and currently own two photography studios—one portrait and the other specializing in commercial work. I have taken pride in my community, with the organization of our recent cityhood and having the honor of being Santa Clarita Valley's Chamber President for 1990. Clients include: Carpeteria, Paramont Omni Speakers, Henery Mayo Hospital, Hampton Inn, Mastey Hair Products, Shotmaker, Six Flags Magic Mountain, Valencia Movie Studios, and Holiday Inn.

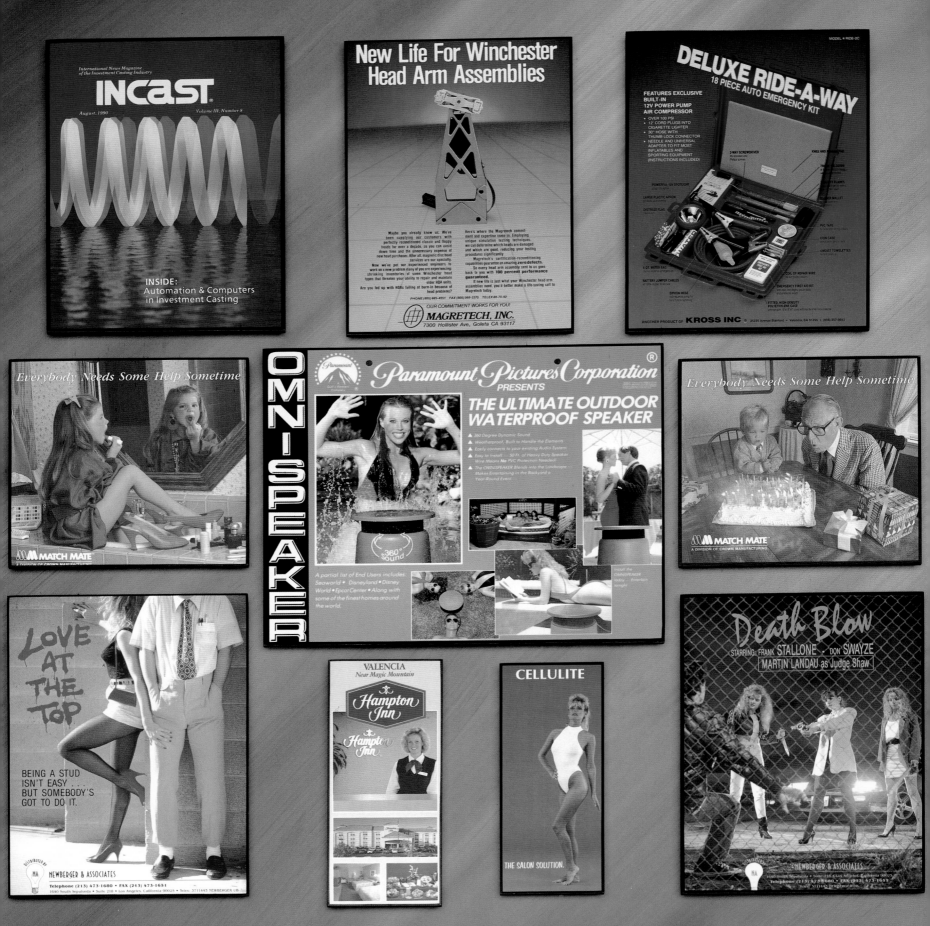

Ralph A. Clevenger

Brooks Institute Faculty
Wild Shots Co.
P.O. Box 30452
Santa Barbara, CA 93130
(805) 963-4069

Specialty: Wildlife and Underwater

With a background in marine zoology and multi-media, Ralph teaches audio-visual production, natural history photography, and stock photography at Brooks. Clients include: Audubon, Islands, California, Oceans, Sea, National Geographic Books, Smithsonian Books, Sierra Club Books, Reader's Digest Books, The National Park Service, The National Marine Sanctuary, Tokina Optical Corporation, and Patagonia Inc. Ralph's photography is represented worldwide by L.A.-based West Light Stock Agency.

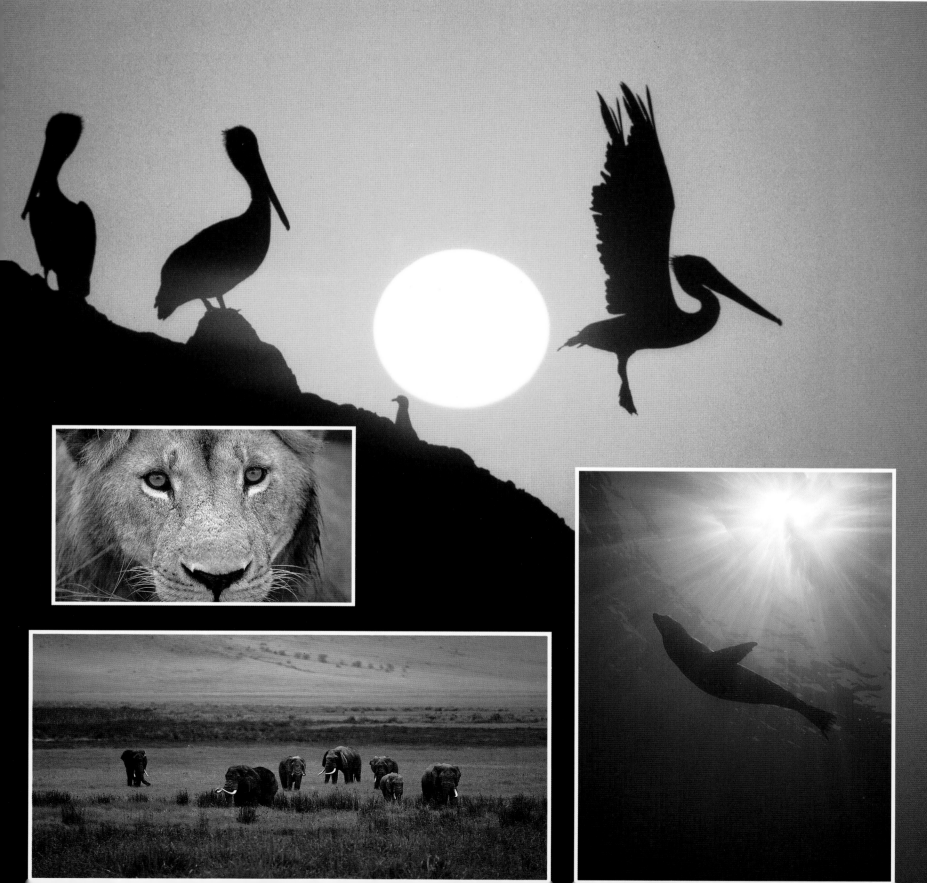

Robert W. Copeland

Copeland Photography
1239 Broad Street
Chattanooga, TN 37402
(615) 756-2681

Specialty: Glamourous Portraits and Weddings

Tony L. Corbell

Brooks Institute of Photography Administration/Faculty
801 Alston Road
Santa Barbara, CA 93108
(805) 966-3888

Specialty: Lighting Control, People Photography

Tony is currently the liaison between Brooks and the photographic industry. He guest lectures and teaches workshops on a regular basis on subjects such as outdoor lighting control and photographing people. Prior to joining Brooks, he directed and co-produced a series of educational tapes and publications for Finelight, a photographic research and development company. His photographic clients have included George Bush, John McEnroe, Tom Jones, Tony Dorsett, sixty officials in the Nigerian government, and others. Tony has also written The Ultimate Commercial Photographer's Handbook, Volumes I and II.

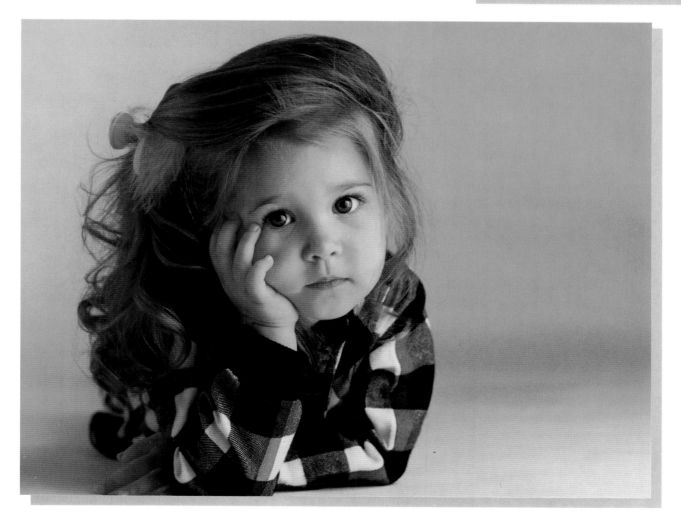

John L. Dark

Brooks Institute Faculty
John Dark Photography
11 Cortez Way
Santa Barbara, CA 93101
(805) 685-1744

Specialty: People Photography

A 1978 graduate of Brooks, John's clients include: 10,000 Oregonians, The State of Oregon, Figaro's Pizza, Intel Corp., Cookie Baron Bakery, A&W, Richcolor, Freres Lumber, Morgan Lumber, Guerdon's Industries. John's background working on fashion campaigns and people characterizations for advertising in New York and Los Angeles affords him the expertise necessary to teach applied courses which involve the photography of people in numerous situations. In addition to teaching at Brooks Institute, John enjoys lecturing to local and international groups on a variety of photographic topics both technical and motivational.

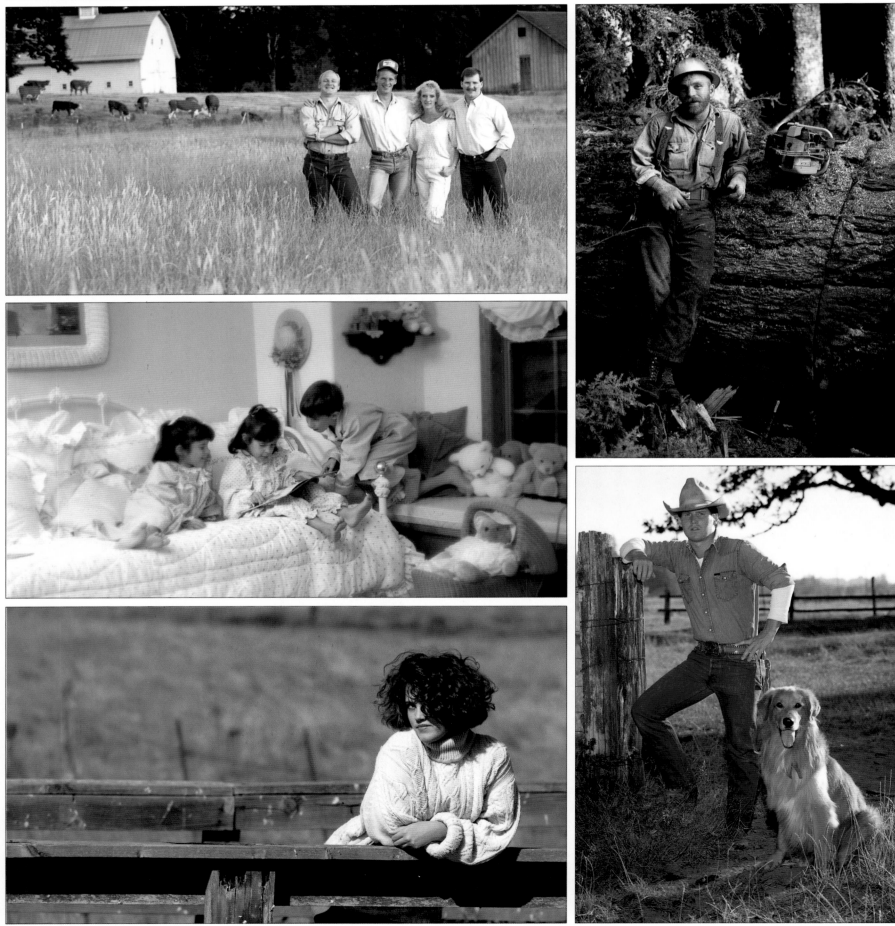

Nick Dekker

Brooks Institute of Photography Faculty
801 Alston Road
Santa Barbara, CA 93108
(805) 966-3888

Specialty: ## Black and White Fine Art

Nick has taught at Brooks for over fifteen years, served as Division Chairman and Faculty Board member, and is currently Campus Administrator. His classes include basic fundamental techniques in black and white and all aspects of the application of those techniques. Nick's clients include: General Motors, Motown Records, Ford Motor Company and many others.

John DeMello

John DeMello Photography
720 Iwilei Road, Suite 260
Honolulu, Hawaii 96817
(808) 521-3560

Specialty: Studio/Location

Clients include: Aloha Air Lines, Dole, Hawaiian Air, Hawaiian Tel, Hawaii Visitors Bureau, Hertz Rent-A-Car, Hilton Hotels, Hyatt Hotels International, Nike, The Ritz-Carlton Hotel Co. and Tasmania Bank.

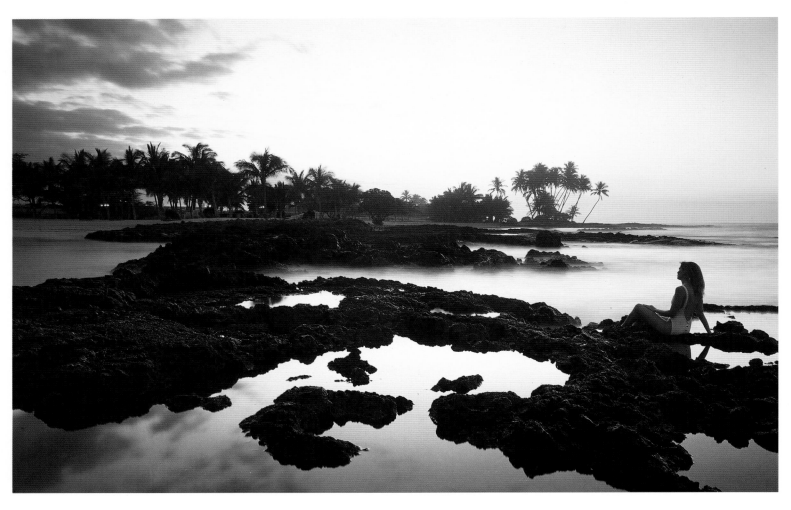

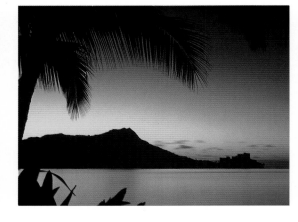

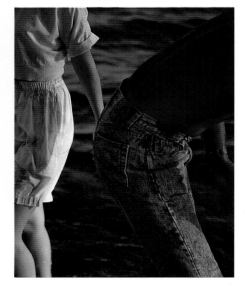

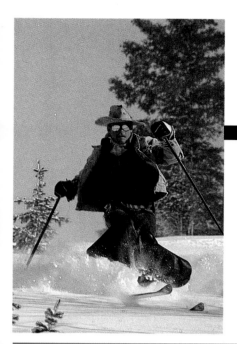

Charles E. Evans

Crystal River Photography Inc.
515 N. 8th Street
Carbondale, Colorado 81623
(303) 963-9532

Specialty: ## People and Products

Crystal River Photography Inc. is a Portrait and Commercial studio located in Carbondale, Colorado (24 mi. W. of Aspen).

Portrait: Business and Publicity work, Children, High School Seniors, Weddings, and Families.

Commercial Services: Brochures, Architectural Photography, Fashion, Small Products, Food, Ski and Specialty Sports, and Audio Visual Productions.

From the Ski Industry to Livestock, Interior Design to Small Products, the studio addresses the needs of a variety of markets.

Clients: Singapore Travel, Colo. General Construction, Architectural Furniture, Carbondale Council of the Arts and Humanities, University of Northern Colorado.

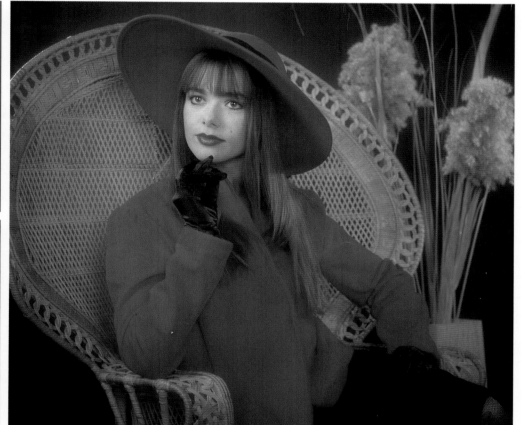

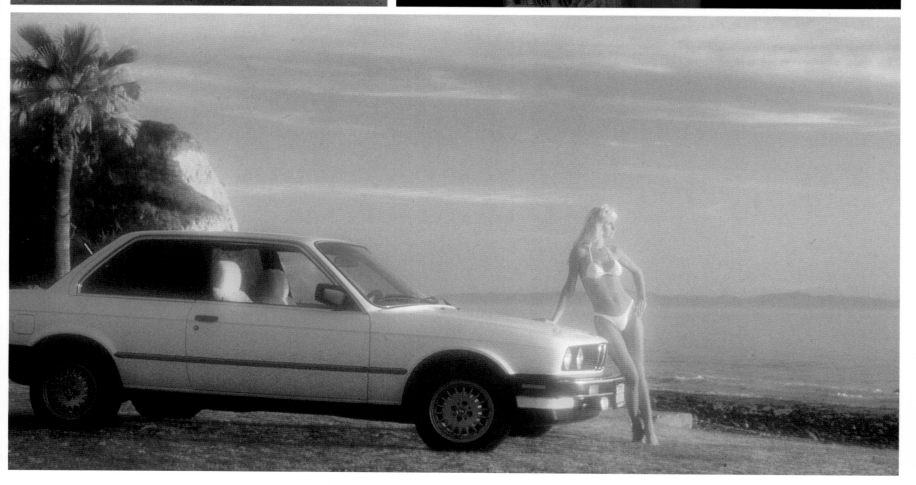

Russ Finley

Finley-Holiday Film Corporation
12607 E. Philadelphia Street
Whittier, CA 90601
(800) 345-6707 FAX (213) 693-4756

Specialty:

Stock Library, American Images

Unlike other photographers, Russ lives on the road year-round, allowing him to obtain exceptional coverage of his subjects. Specializing in national parks, he shoots stills on 4x5 and 6x7 format and motion-pictures on Betacam SP and 16mm. His subject list extends from coast to coast, featuring scenics, nature, mood shots, wildlife, historic sites, major cities and tourist areas.

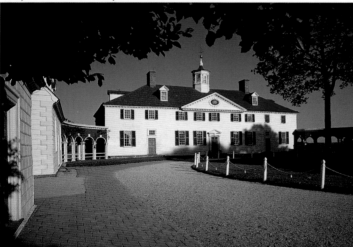
Navajo in Monument Valley

Russ Finley Stock Photograph and Motion-Picture Library

• 10,000 large format transparencies
• Thousands of hours of motion-pictures
• A full time staff to serve you

Featuring

- • National Parks
- • American Scenics
- • Nature & Wildlife
- • Historic Sites
- • Tourist Areas
- • Major Cities

Clients Include: Arizona Highways, National Geographic, Sierra Club Books, Impact Photo Graphics, KC Publications, Ackerman Advertising, Pali Arts Communications, Golden Turtle Press, Trailer Life Magazine, Stewart, Tabori & Chang, Thomasson-Grant, Landmark Calendars, Ervin Advertising and others.

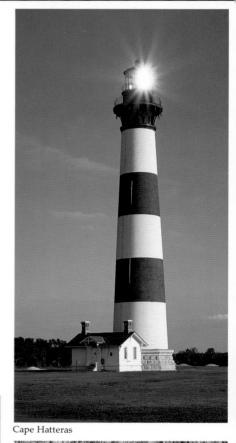
Cape Hatteras

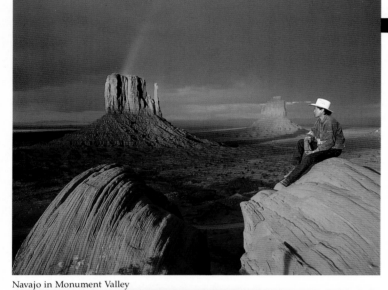
Mount Vernon, Home of George Washington

Surrender Room, Yorktown

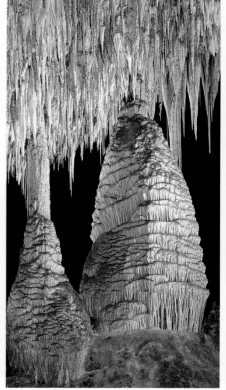
Carlsbad Caverns

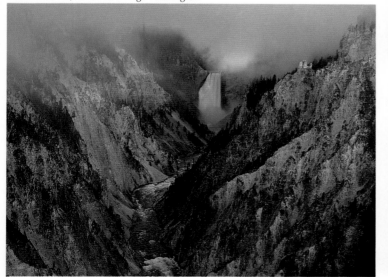
Grand Canyon of the Yellowstone

Bull Moose, Grand Teton

Steven Finson

Steven Finson Photography
265 Prado Road, Suite 4
San Luis Obispo, CA 93401
(805) 543-6907

Specialty: ## Photography for Corporate Communications

Clients include: Pacific Gas and Electric, California Business, Hind Inc., Martin Brothers Vineyards, Appoint, San Luis Obispo Council for the Performing Arts, T.J.'s Sportwide, Kornreich/Gleason Design.

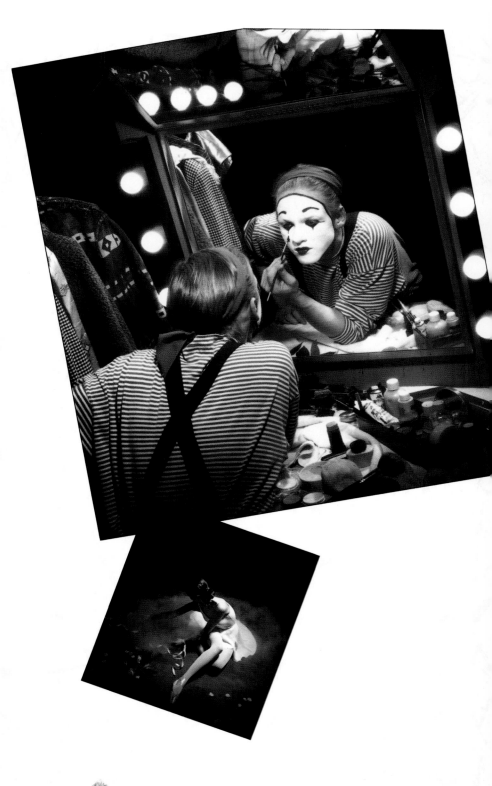

STEVEN FINSON PHOTOGRAPHY

265 Prado Road, Suite 4
San Luis Obispo, California 93401
805/543-6907

Kevin Flood

Kevin Flood Photography, Inc.
1329 Macklind Avenue
St. Louis, MO 63110
(314) 647-2485 FAX (314) 647-6467

Specialty: Advertising/Commercial

Studio still life and tabletop specializing in food, beverage and small product. Recent clients include Anheuser-Busch, AT&T, Con-Agra, DeKuyper Liqueurs, Emerson Electric, Hershey's, Jim Beam, Kellogg's, Mars Candies, McDonnell Douglas, Monsanto, Pet, Ralston Purina, Seven-Up, Southwestern Bell.

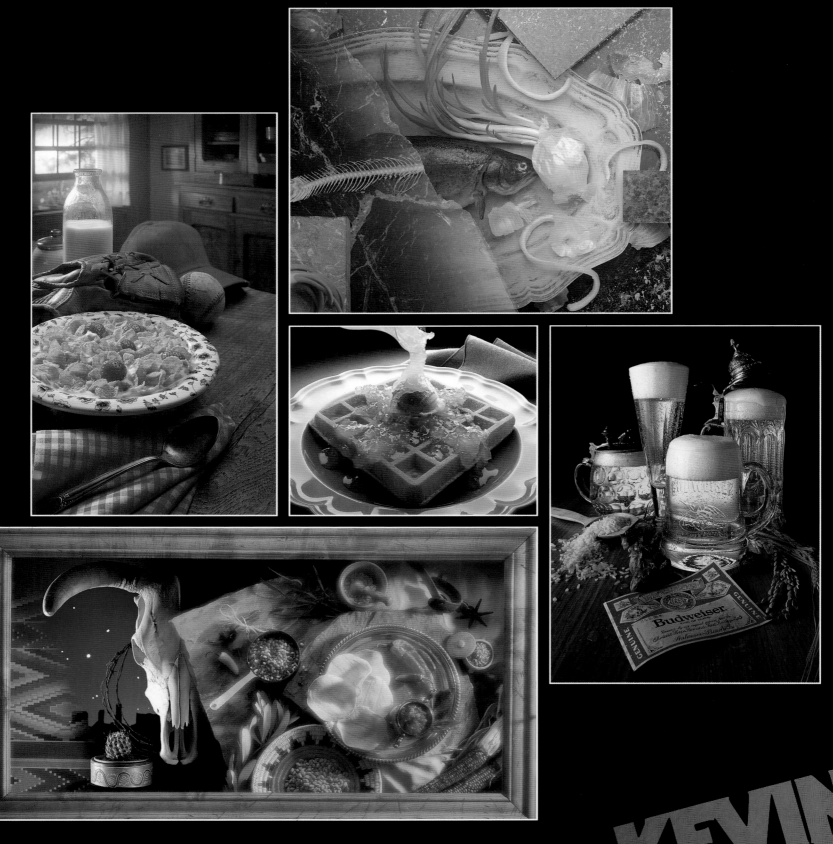

© 1991 KEVIN FLOOD

KEVIN FLOOD PHOTOGRAPHY, INC.
1329 MACKLIND AVE. ST. LOUIS, MO 63110
STUDIO 314-647-2485 FAX 314-647-6467

Kevin Flood

Kevin Flood Photography, Inc.
1329 Macklind Avenue
St. Louis, MO 63110
(314) 647-2485 FAX (314) 647-6467

Specialty: Travel/Scenic

Assignment and stock, landscape, travel and nature for advertising, editorial, design and fine art applications.

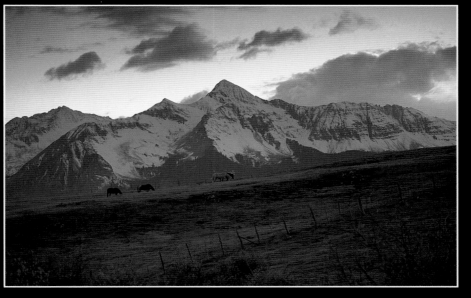

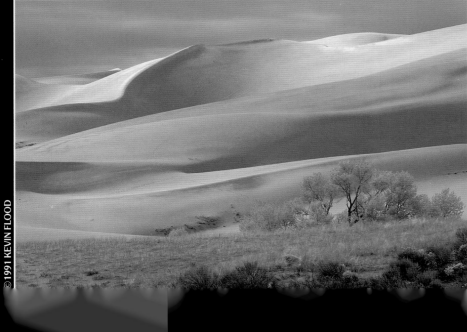

© 1991 KEVIN FLOOD

John McNally, Steve Fish

Photo Tek, Inc.
5285 Elam Young Parkway, Suite B-500
Hillsboro, OR 97124
(503) 640-8289

Specialty: Product illustration for high tech industries

Intel, Tektronix, Mentor Graphics, RadiSys, Forest Medical, Graphic Software Systems, Logic Automation, Wilbanks International, Sage, Whatman LabSales, Arco Alaska.

Clayton A. Fogle

Clayton A. Fogle Photography
P.O. Box 2354
Goleta, CA 93118-2354
(805) 968-4271

Specialty: Wildlife/Nature Photography

Fogle holds a B.A. Degree (Motion Picture Major) from Brooks Institute of Photography. Since 1978, as staff photographer for a prestigious research firm, he produced scientific/industrial movies, videotapes, and stills. He conducts workshops at the Santa Barbara Zoological Gardens and Natural History Museum. Fogle has captured wildlife from Alaska to Africa for these books and clients: *Hummingbirds; A Dazzle of Hummingbirds; Parrots, Macaws and Cockatoos;* Blake Publishing; Portland House, Publications International; Portal Publications; and Image Bank Book Publishers. Magazine credits include: *National Geographic, Bird Watcher's Digest, Birder's World, Wild Bird, Zoo Life, Peterson's Photographic Magazine,* and he contributes to the Allstock Agency.

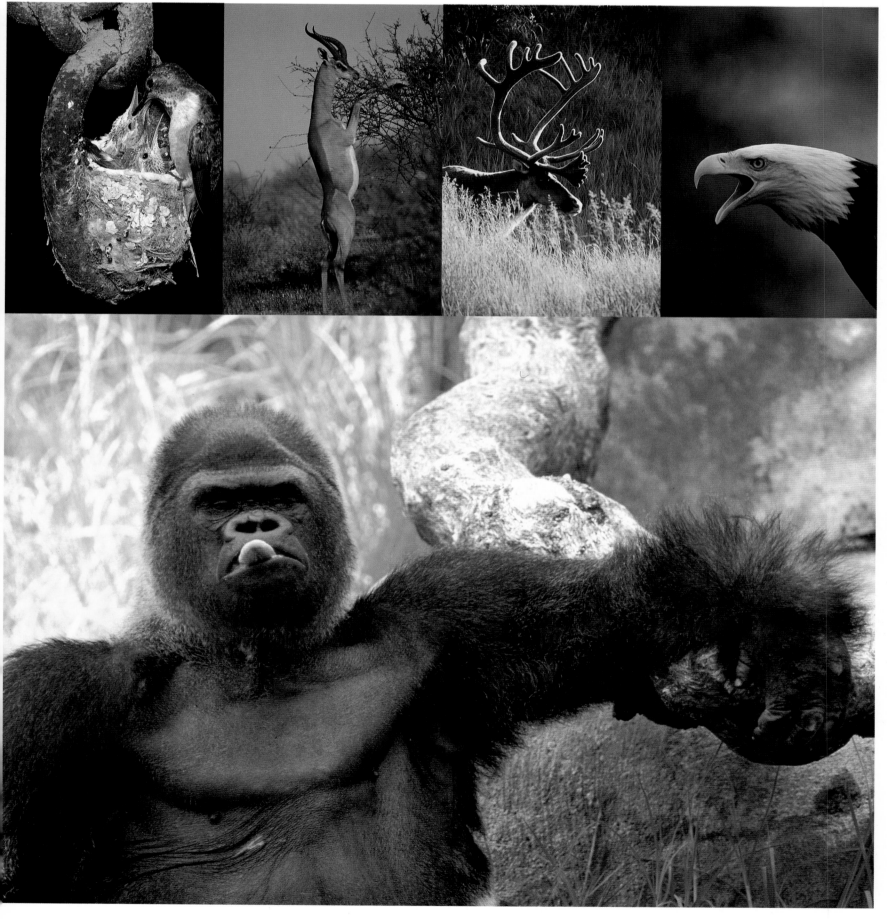

Douglas Foulke

Douglas Foulke Photography Inc.
140 West 22nd Street
New York, NY 10011
(212) 243-0822
Represented by Paula Krongard, (212) 683-1020.

Specialty: Fashion/Advertising

Client list: Adrian Avery, American Express, AT&T, Audi, Benson & Hedges, Brownstone Studio, Charmin, Chemical Bank, Crystal Cruises, Debeers Diamonds, DuPont, Equitable Life, GQ Magazine, Huggies, JC Penney, Jhirmack, Le Ritual, Mary Kay, MasterCard, Maxims Hotel, Mennen, New England Bell, Pall Mall, Pantene, Paul Stuart, Princess Cruises, Q Tips, Sally Hansen, Taster's Choice, Tylenol, Victoria Magazine, Wamsutta, Waterman Pens, Windsong, WNBC, Zotos.

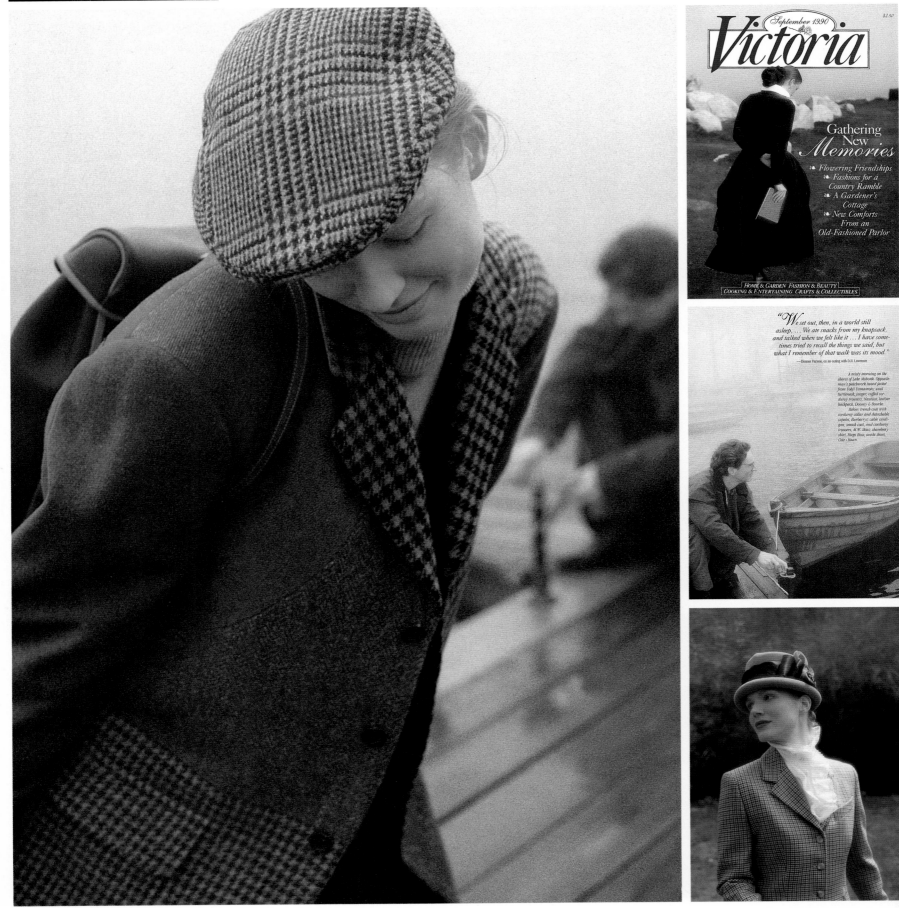

Randy Fugaté

Fugaté Studio
6754 Eton Avenue, Warner Center
Los Angeles, CA 91303
(818) 887-2003 FAX (818) 887-6950

Partial list of clients served in Southern California and nationally: American Multi Cinema, Ampex, Arby's, Bausch & Lomb, Bullock's, Cain-Sloan, Chevron, Chinon USA, Cinema Products, Coca-Cola, Days Inns of America, Designworks/USA, Drexel Heritage, Federal Express, Foley's, General Motors, Goldwater's, Gottschalk's, Gucci, J.W. Robinson's, J. Walter Thompson, JBL International, Kenworth Trucks, Lane Furniture, Liggett & Meyers, Litton, Marantz, Marriott Hotels, Milliken Carpets, Munford Inc., Pacific Video, Playboy, Price Pfister, Quarterdeck Systems, Rachel Perry Cosmetics, Redken, Sears, Sheraton Hotels, Southern Bell, Teleflora, The Southern Company, The Tinder Box, Thermador, Vector Research, Video Tape Products, Woodward & Lothrop.

UGATÉ PHOTOGRAPHY * 818-887-2003 * Member American Society of Magazine Photographers ©

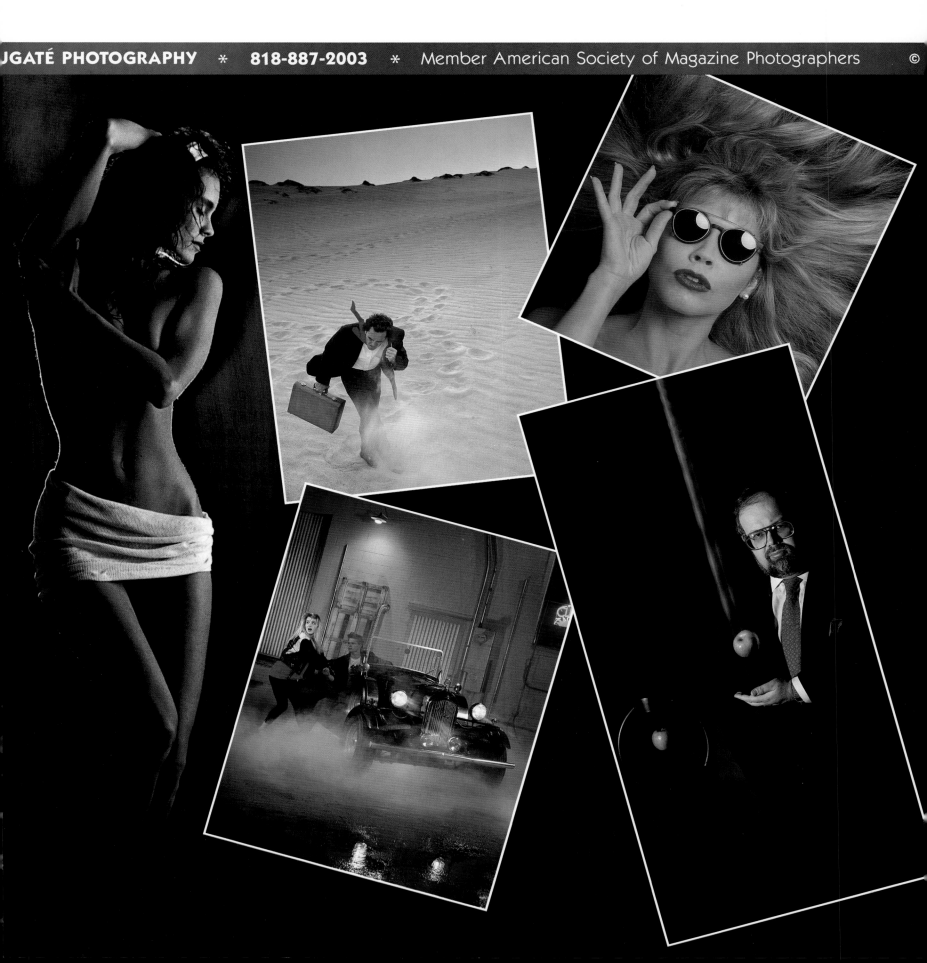

Larry Gatz

5250 Gulfton, 3B
Houston, Texas 77081
(713) 666-5203 FAX (713) 666-6601

Specialty: Production Magic

Enjoying 15 years experience, working around the world, photographing people, locations and products. A partial client list includes: American, Continental, Piedmont and Southwest Airlines; Hewlett-Packard and Compaq Computer; Philip Morris, Miller Brewing Company and Coca-Cola Foods.
Stock available through The Image Bank.

Luis Carlos P. Gavilan

Estudio Gavilan
2a Cda Popocatepetl 55-I
Mexico, D.F. 03330
(905) 604-6056 604-6532 FAX 604-6139

Specialty: Still Lifes, People, Studio

Ten years ago, Luis Carlos established his Studio in México City where he works for some of the most prestigious clients, including:

AFK Publicidad, Avon Cosmetics, Banamex, Bancomer, Berol, Bimex, Danone de México, De la Torre Publicidad, Domeq, Ericsson, Hermes Industrias, Industrias Conrad, Eriksson, J.W. Thompson, Kentucky Fried Chicken, Kimberly Clark, Kraft/ General Foods, Lebrija Rubio, Montenegro-Saatchi & Saatchi, Multibanco Mercantil, Nestle, Panamericana O&M, Pena Publicidad, Procter & Gamble, Richardson Vicks, Somex, Top Design, Walter Landor, Wearever, Young & Rubicam.

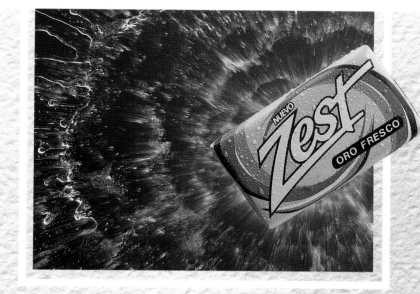

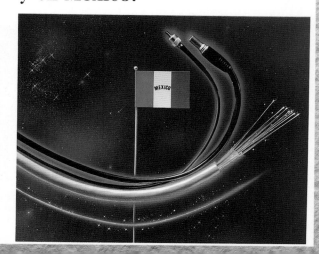

Gavilán
E·S·T·U·D·I·O

Ericsson, líder en el mundo… y en México.

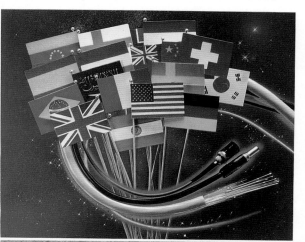

Stacy H. Geiken

Stacy H. Geiken Photography
268 Carlton Avenue
Los Gatos, CA 95032-2630
(408) 358-3087

Specialty: Corporate/Editorial On Location

Clients include: Hewlett Packard, Microsoft Corporation, Reebok International, Ltd., Mobil Oil Corporation, Stanford University, California Magazine, Forbes, and Runner's World.

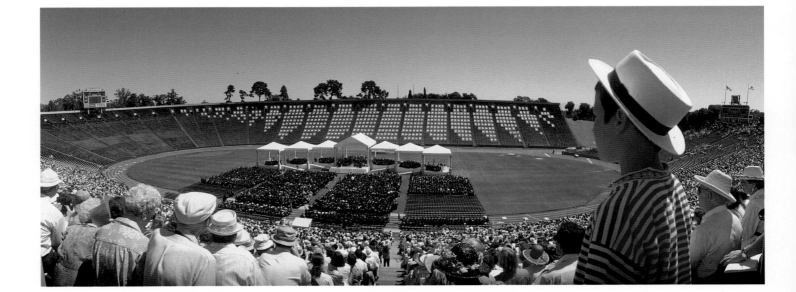

John G. Gilroy

John Gilroy Photography
2407 West Main Street
Kalamazoo, MI 49007
(616) 349-6805 (616) 381-8764

Specialty: Location & People for Corporate & Advertising

The search for visual interest and the use of light to illustrate are the photographic challenges that John seeks. His versatility in dealing with the demands of people/location photography make him equally well suited to photography in the board-room, factory or studio. His 20 years in corporate/advertising photography were preceded by his work as Still Photography and Motion Picture Director for DASPO, the elite Department of the Army Photographic Unit.

His graphic style leads him to work in annual reports, advertising photography and audio visual. His most recent clients are The Upjohn Company, First of America Corporation, James River Corporation and Consumers Power Company.

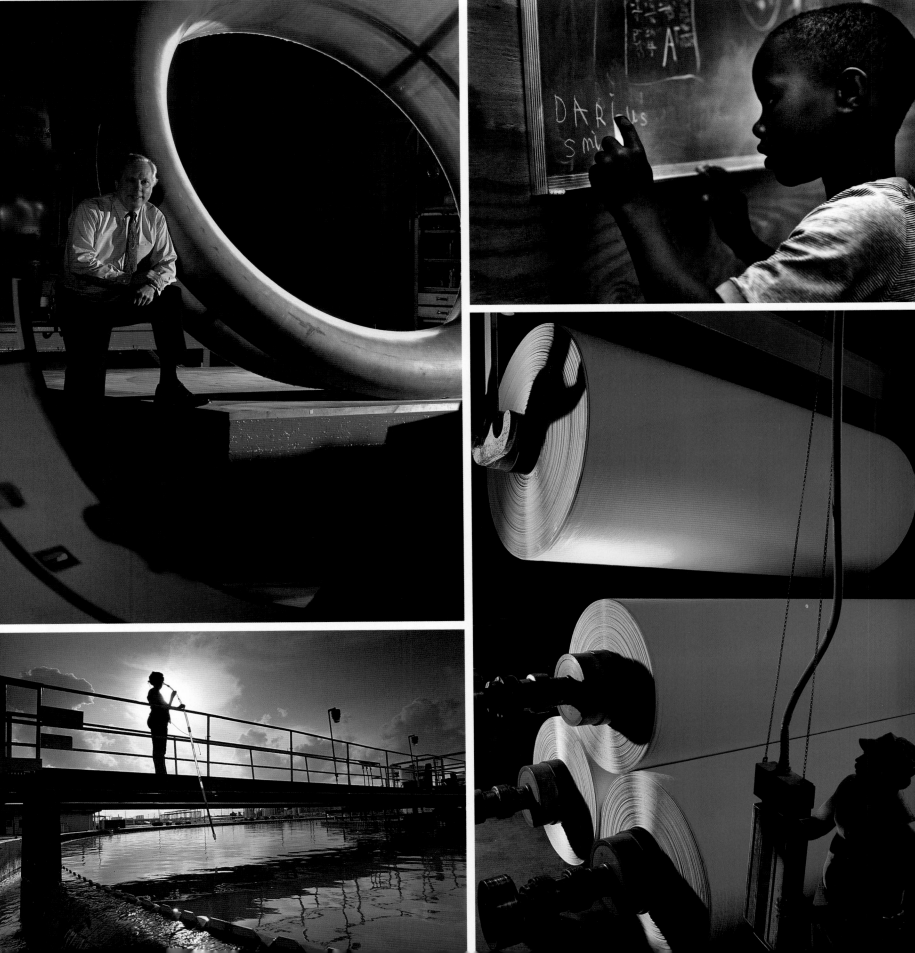

Thomas G. Grassi

Image-Tec
143 Essex Street
Haverhill, MA 01832
(508) 372-9598

Specialty: Product Illustration/In-house custom lab

Client list: Gare Inc. Eastpak, Knight Tool Co., Camelot Systems Inc., Pope Machinery Corp., State Line Tack Shop, Towle Silversmiths, Falcone Piano Co., DMS Treasures, Snell Acoustics, Wallace International, Royale Limousine Manufacturers, Wilfab Systems, Nefor Eng. & Mfg., AT&T.

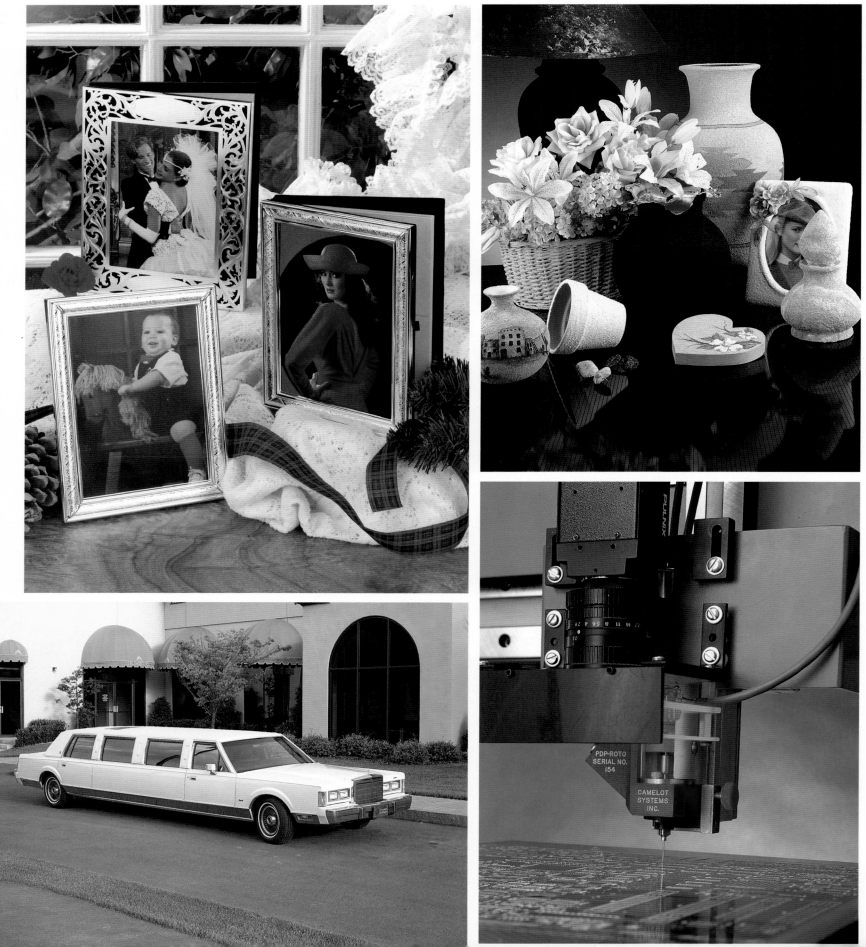

Ronald Haaland

Haaland Productions
1350 Camino Cristobal
Thousand Oaks, California 91360
(805) 499-0688

Specialty: People/Product/Still Life

Graduated Brooks Institute of Photography October 1989. Clients include: Los Angeles County Transportation Commission, Potomac Investments Associates, Doleware, and Haaland & Associates.

Kevin Halle

Kevin Halle / Photographic, Inc.
8615 Commerce Avenue
San Diego, California 92121
(619) 549-8881

From the real to the not so real, creating special images of products for advertising, corporate, industrial and editorial. Working within a studio of creative specialists. Studio or location.
Concepts—Yours, mine, ours!
Client list available upon request.

PHOTOGRAPHIC•INC

Represented by Laura Salome, 619.549.8881

Steve Hathaway

Steve Hathaway Photography
400 Treat Avenue, Suite F
San Francisco, CA 94110
(415) 255-2100 FAX (415) 255-5960

Specialty: People/Still Life

Studio: 4,000 square feet with 25-foot ceilings, drive in access, cyclorama, kitchen, conference room.

Awards: Advertising Photographers of America Awards Book 1991, Graphis Photo Annual 1991, Graphis Photo Annual 1989, Communication Arts Photography Annual 1988.

Professional associations: Advertising Photographers of America, Board Member San Francisco

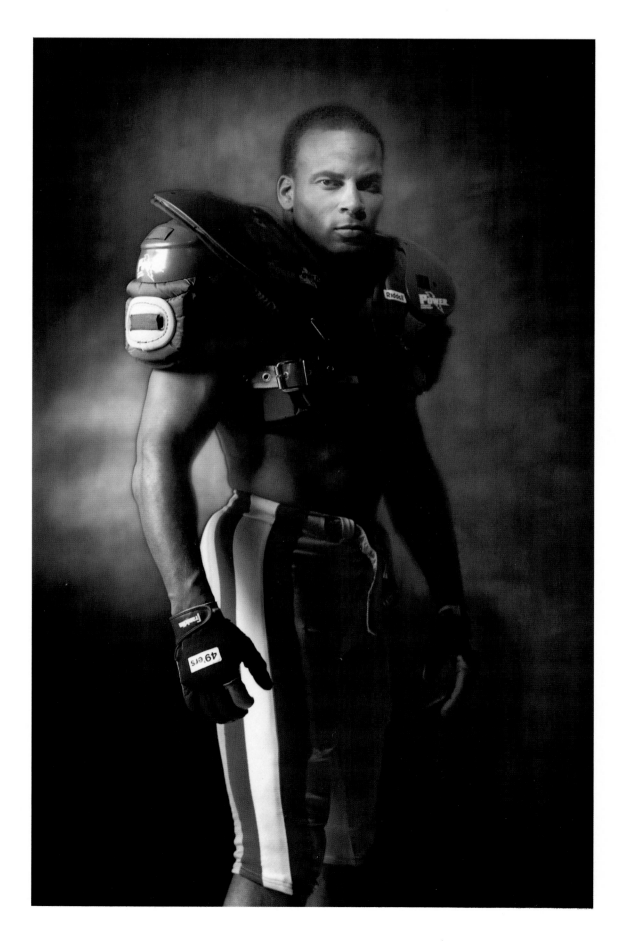

Peter Dyckman Hawkins

Photography by Dyckman
HCR 73 Box 249
Walker, MN 56484
(218) 547-2255

Specialty: Location, Commercial

After graduating from Brooks Institute in 1984, Peter Hawkins worked in Minneapolis for two years and then moved to Walker, Minnesota to open Photography by Dyckman. Brochures, postcards, and stills for television are among the products offered to clients.

Clients include: First National Bank of Walker, Omni Travel, Voyager Press, New Frontier Resort, Transamerica Realty, Leech Lake Area Chamber of Commerce, Hackensack Chamber of Commerce, The Brainerd Daily Dispatch, Nodak Lodge, The Gow School, Lunde Manufacturing.

Along with Minnesota nature images, Photography by Dyckman offers extensive stock file of travel photographs. Stock lists available upon request.

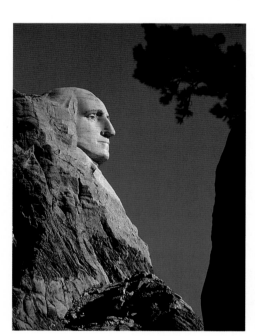

Photography by Dyckman

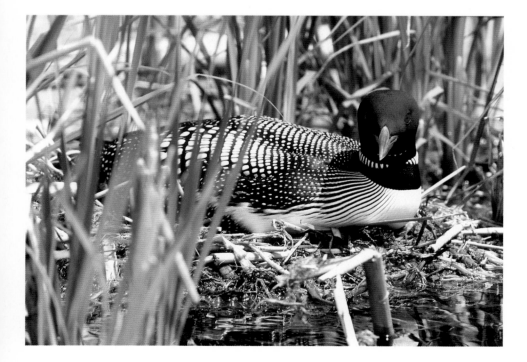

J. Greg Henry

J. Greg Henry Photography
438 N. Sycamore
Los Angeles, CA 90036
(213) 934-8025

Specialty: Advertising, Entertainment & Publicity

Partial client list: Artistic Brass, Asia Pacific Museum, Deanna Hamro Jewelry Design for *British Vogue*, Dustin Softwear Inc., *Entrepreneur Magazine*, Haworth Office Interiors, [ixi:z] Men's Wear, Kaiser, McEuen Inc., *Orange Coast Magazine*, Southern California Bank, United Cerebral Palsy, Zenith.

J. GREG HENRY
213.934.8025

David Hessemer

David Hessemer / Hot Shots Inc.
1231 N.W. Hoyt Street #304
Portland, Oregon 97209
(503) 243-1911 FAX (503) 243-1982

It is a rare thing when you can live where you want and have a job you love. Well that's the case here. Through the years I have been blessed with a loving, supportive wife, four great kids, a fun studio, and some super clients.

Hot Shots Inc. specializes in just about everything, from people, products, photo composites to special effects. We are willing and reasonable. We have a great crew that is fun to work with. Our clients include Nike, General Foods, Jantzen, Multnomah Press, Christian Parenting magazine, and many others.

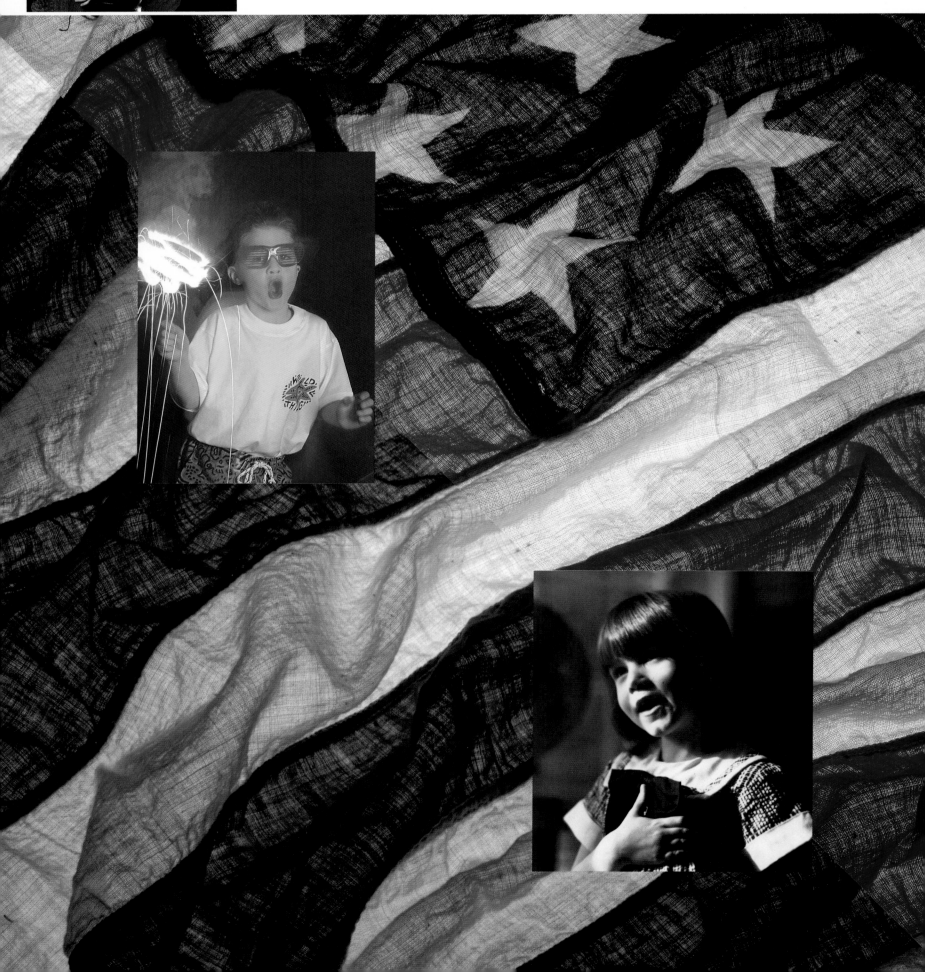

Peter A. Hogg

Peter A. Hogg Photography
1221 South La Brea Avenue
Los Angeles, CA 90019
(213) 937-0642 FAX (213) 936-2560
Represented by Linda Rose, (213) 458-0024.

Specialty: Advertising/food, people, product

Peter started his career in photography in his home town of Honolulu, Hawaii. Working with advertising agencies, he was able to work with such clients as Hilton, Hyatt, Continental and Western Airlines. In 1978, he reestablished his studio in Los Angeles and continued his work in advertising with agencies such as Foote Cone & Belding, Ogilvy & Mather, Dailey & Associates, and others. Clients include: Mattel, Las Vegas Hilton, Porsche, Carnation, StarKist, Yamaha, Nintendo, Kahlua, and Citizen Watches. With his diversity and experience he is able to understand the needs of his clients and make ideas work. People, food or special effects, he loves to shoot.

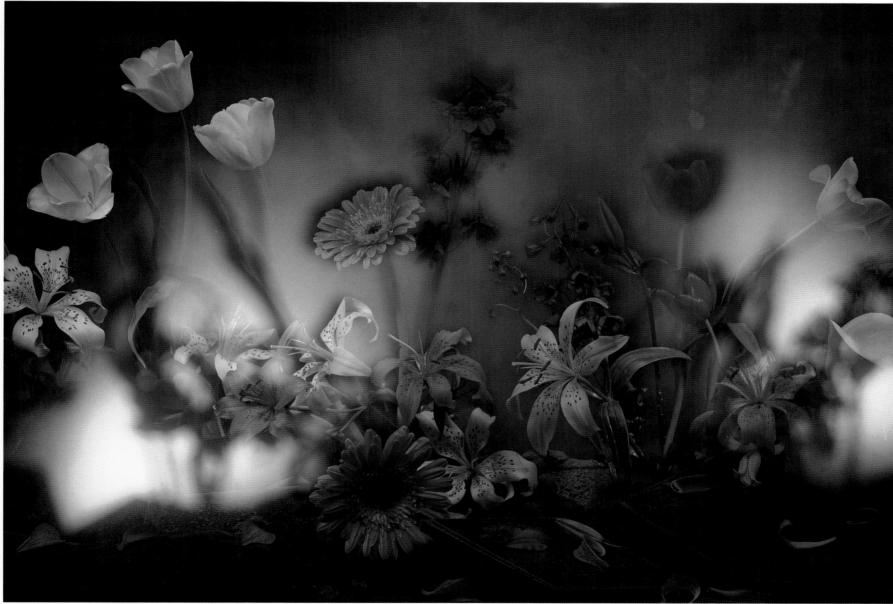

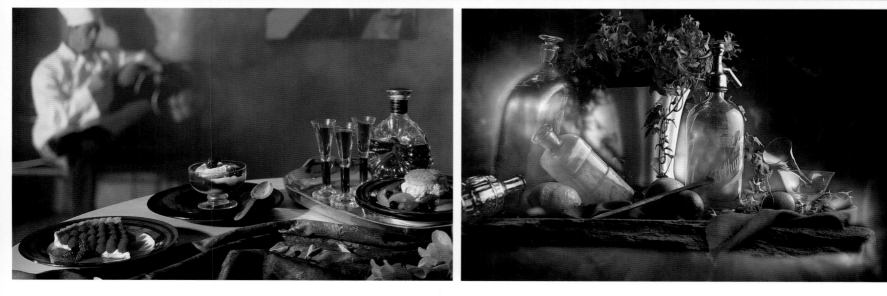

Ameen Howrani

Ameen Howrani Photography
2820 E. Grand Blvd.
Detroit, MI 48211
(313) 875-3123

Specialty: "Bringing personality into focus"

After 23 years in the business, Ameen Howrani has earned a reputation as one of the leading "people photographers" in the Midwest. He has photographed many celebrities in his loft studios in the heart of Motown—Candice Bergen, "Magic" Johnson, Aretha Franklin, Bobby Knight, Jeff Daniels and Isiah Thomas, to name a few. Ameen also shoots advertising and a wide variety of other print communications for some of the world's largest ad agencies and corporations. His award-winning work has taken him from coast to coast. But he's still waiting to realize the "impossible dream": "Someday," says Ameen, "I would really like to go on one long, good-paying, piece-of-cake assignment to Santa Barbara."

Neil Isgett

Neil Isgett Photography
4303-D South Blvd.
Charlotte, NC 28209
(704) 376-7172

Specialty: Advertising/Corporate/Industrial

My job is to turn advertising concepts and industrial problems into creative solutions. I am comfortable on location or in my 4000 sq. ft. studio. Additional work can be seen in American Showcase #13.

© Neil Isgett 1991

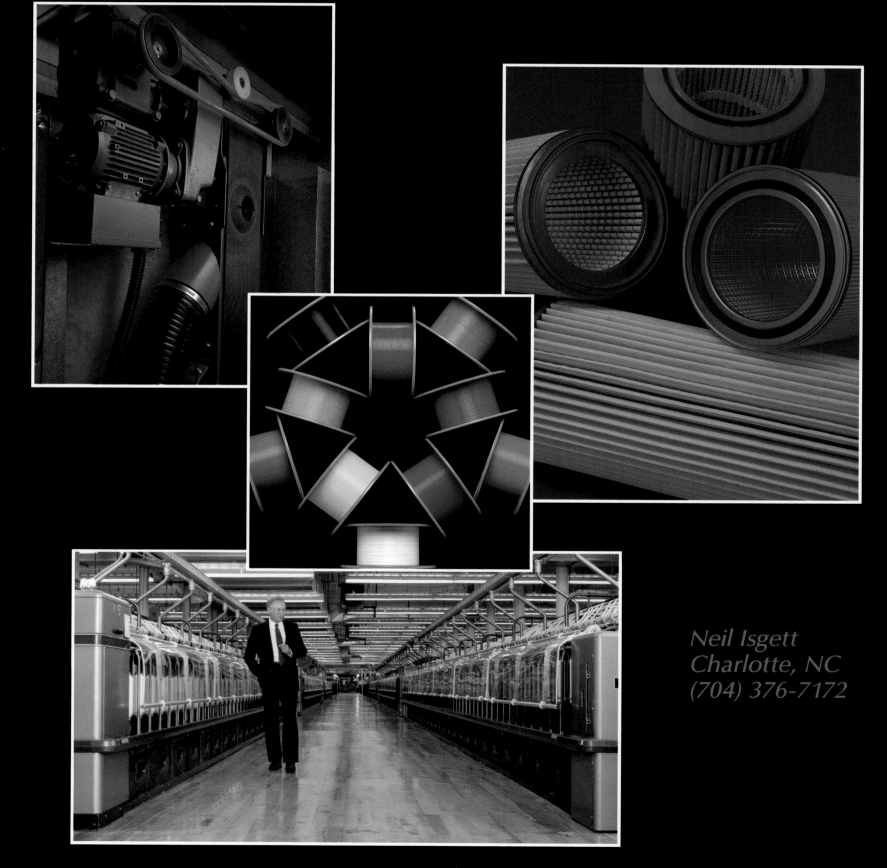

Neil Isgett
Charlotte, NC
(704) 376-7172

Michael Jarrett

Michael Jarrett Studio
16812 Redhill Avenue
Irvine, CA 92714
(714) 250-3377

Michael Jarrett has brought images to life for major corporations and advertising agencies in Southern California for the past 12 years.

Being known as a lighting specialist, one who's tireless, easy to work with, knows how to communicate a concept, put it to film and always manages to work within a budget, has given him the reputation he has today.

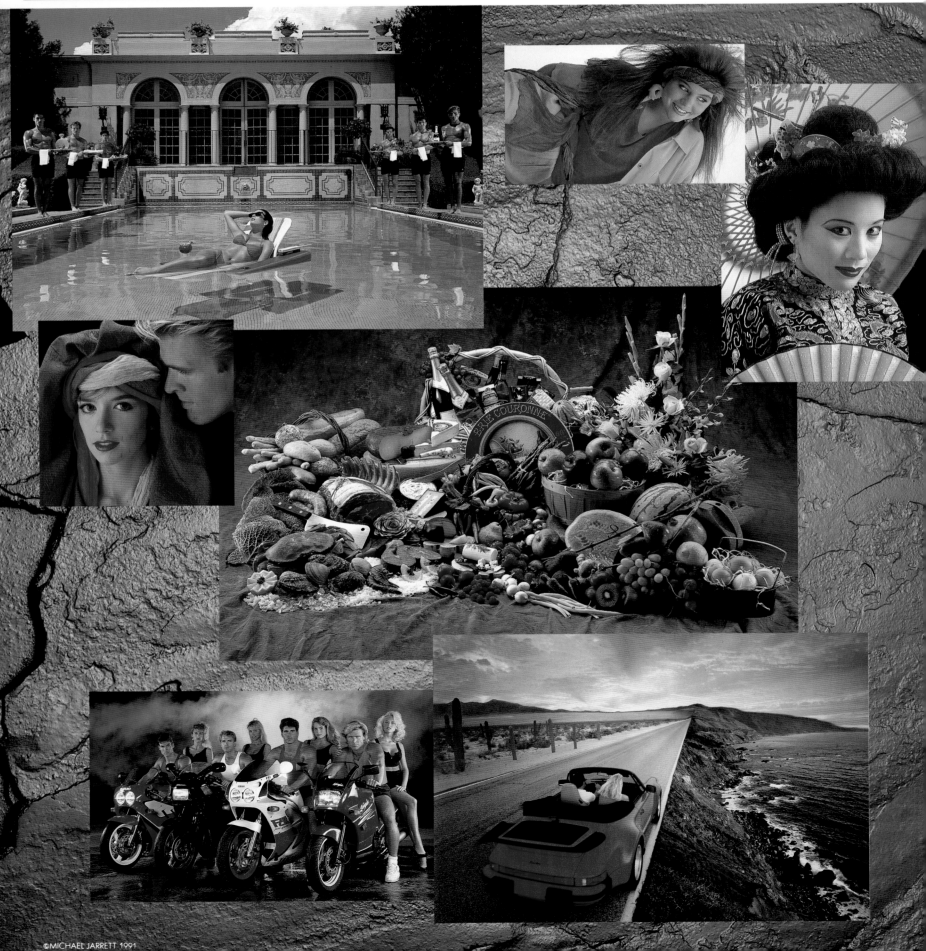

Ken Justice

Ken Justice Photography
1642 North Wilcox
Hollywood, CA 90028
(213) 462-2454

Deep in the heart of Hollywood lies a spacious 2700 square foot studio that Ken Justice calls home. Ken's unique blend of fine art photography and leading edge technology is quickly establishing him as a visionary photographer for the 90's. You are just as likely to find Ken shooting high fashion in the studio as you are of tracking him and crew to a shoot on location in the Mojave Desert.

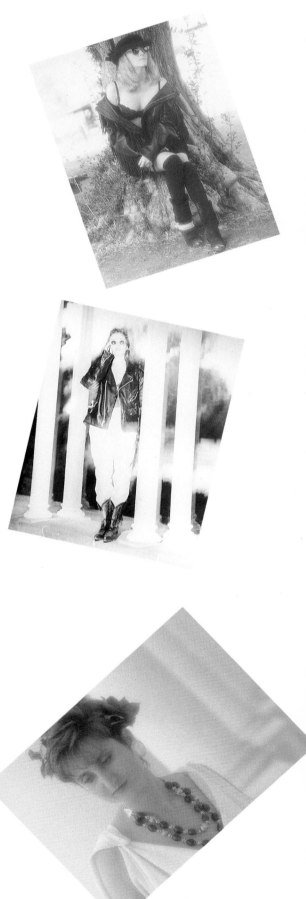

Jim Keen

Keen Communications
5341 Glen Haven Road
Soquel, CA 95073
(408) 476-2333 FAX (408) 475-2333

Specialty: ## Multi-media and Video Production

Extensive overseas experience with an emphasis on Pacific Rim countries. Video production awards include: honorable mention in the Columbus International Film Festival and a finalist in the International Film & TV Festival of New York. Large stock file of still images of people in "everyday life" activities and sports.

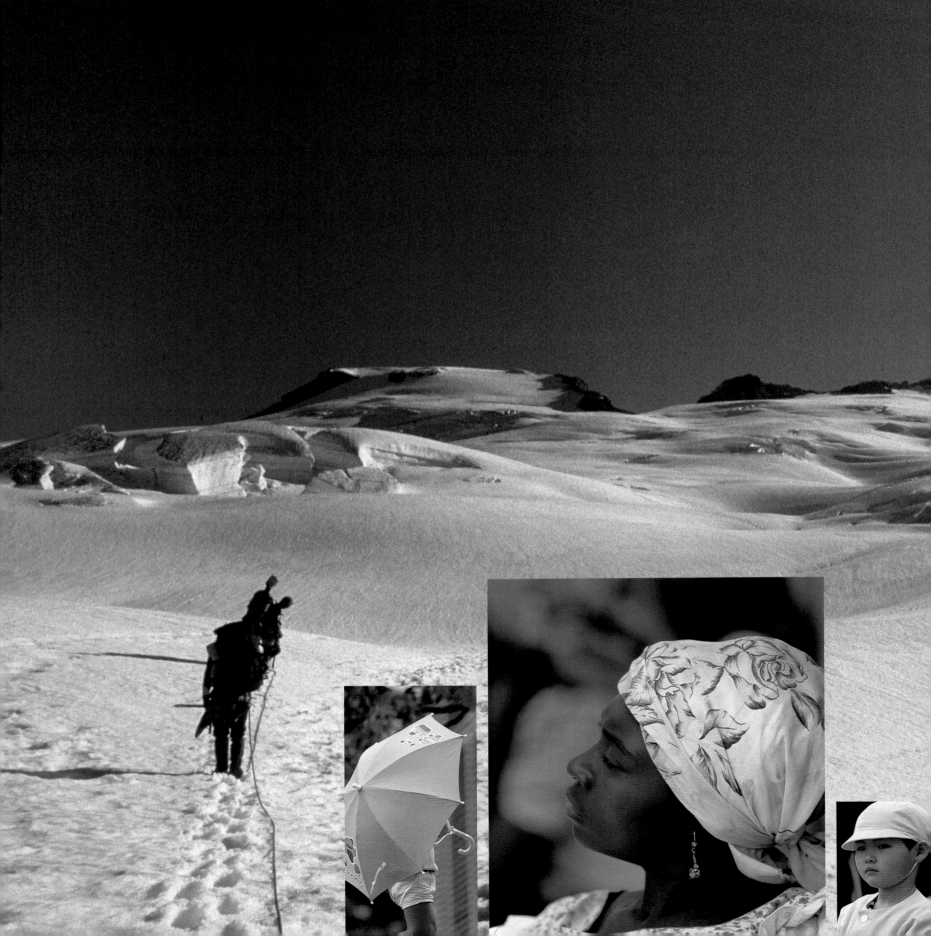

Keen
COMMUNICATIONS

Clients: International and Domestic

Bank of America, Bogard Construction, Computerland, CBFMS, Ifland Engineers, LAC Avionics, Lausanne II, Pacific Bell, Partners International, Reachout Expeditions, SPA Fitness Centers, The Athletic Congress, The California Strawberry Advisory Board, and The Wharf to Wharf Race, just to name a few.

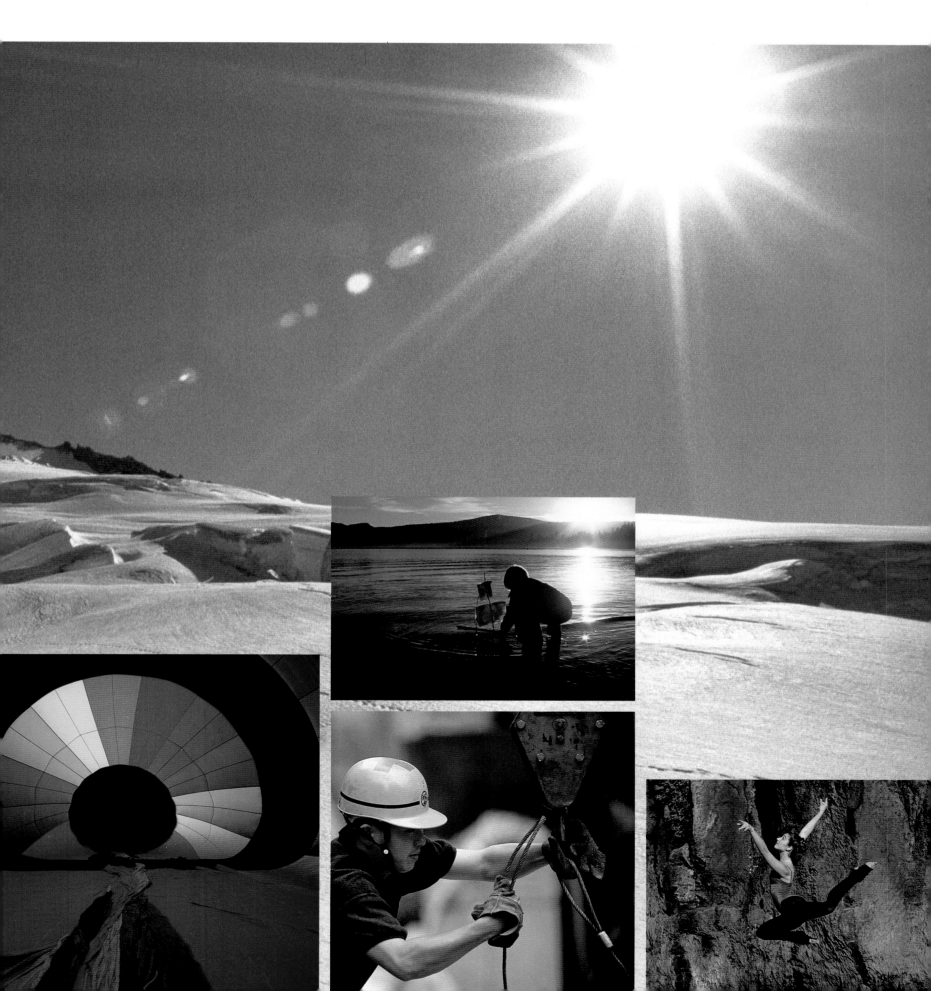

Greg Keller

Herrington-Olson Inc.
769 22nd St., Oakland, CA 94612
(415) 452-0501
San Francisco (415) 543-3827

Specialty: Oakland & San Francisco

Location: Have plane will travel.
Clients: Boyd Lighting, Cetus, Clorox, Dreyer's Grand Ice Cream, Fantasy Records, Ingersoll-Rand, Kelloggs, Ketchum Advertising, Reebok, Otis Spunkmeyer Cookies, U.C. California, Hunt Weber Clark Design, Vanderbyl Design.

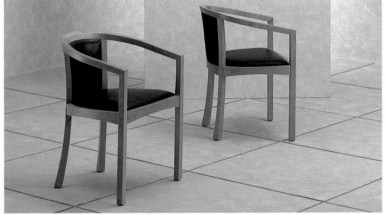

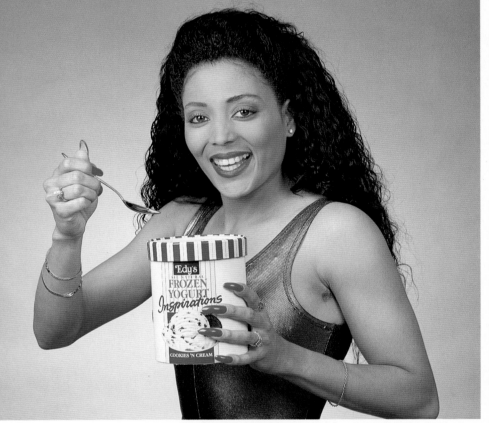

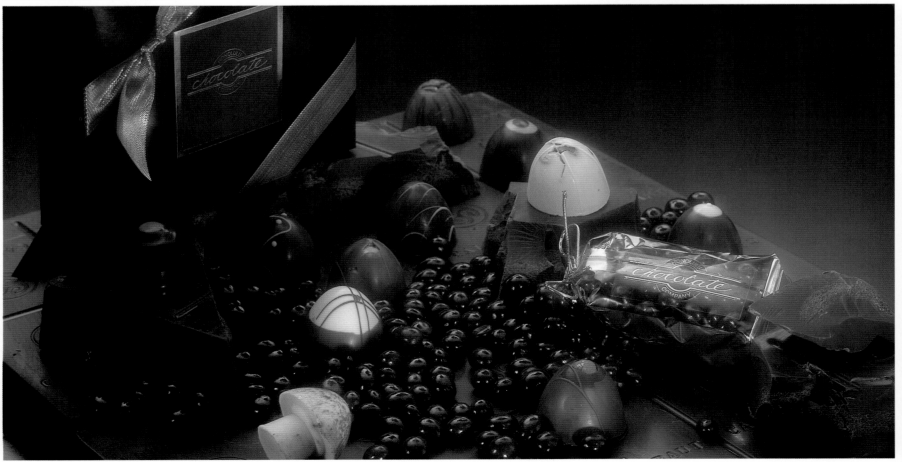

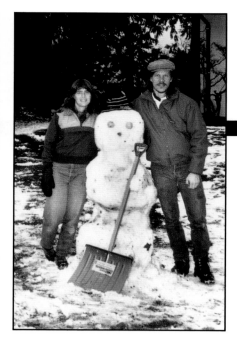

Tom Kirkendall/Vicky Spring

Kirdendall/Spring Photographers
18819 Olympic View Drive
Edmonds, Washington 98020
(206) 776-4685

Specialty: Location Advertising/Sports/Landscape

If it happens outdoors we put it on film. Our focus is outdoor action and landscape from around the world. Clients include: Mountaineers Books, Rodale Press, World Book, Children Press, Hallmark, Giant Bicycle, Cascade Ideal Pump, Recreational Equipment Inc. From our travels we have gathered a stock file of a quarter million images available through West Stock or directly from us.

Donald S. Kish

Display Photo-Graphic (1974) Ltd.
448 Hargrave Street
Winnipeg, Manitoba, Canada R3A 0X5

Specialty: Commercial, Industrial & Advertising Photography

Operating two studios consisting of over 6,000 sq. ft. in the Winnipeg area.

Our focus has been on creative excellence in the retail industry.

Clients include: Macleods/Stedmans, Safeway, S-Marque/Basicnet, Athletes Wear, Telemedia West, Clinique.

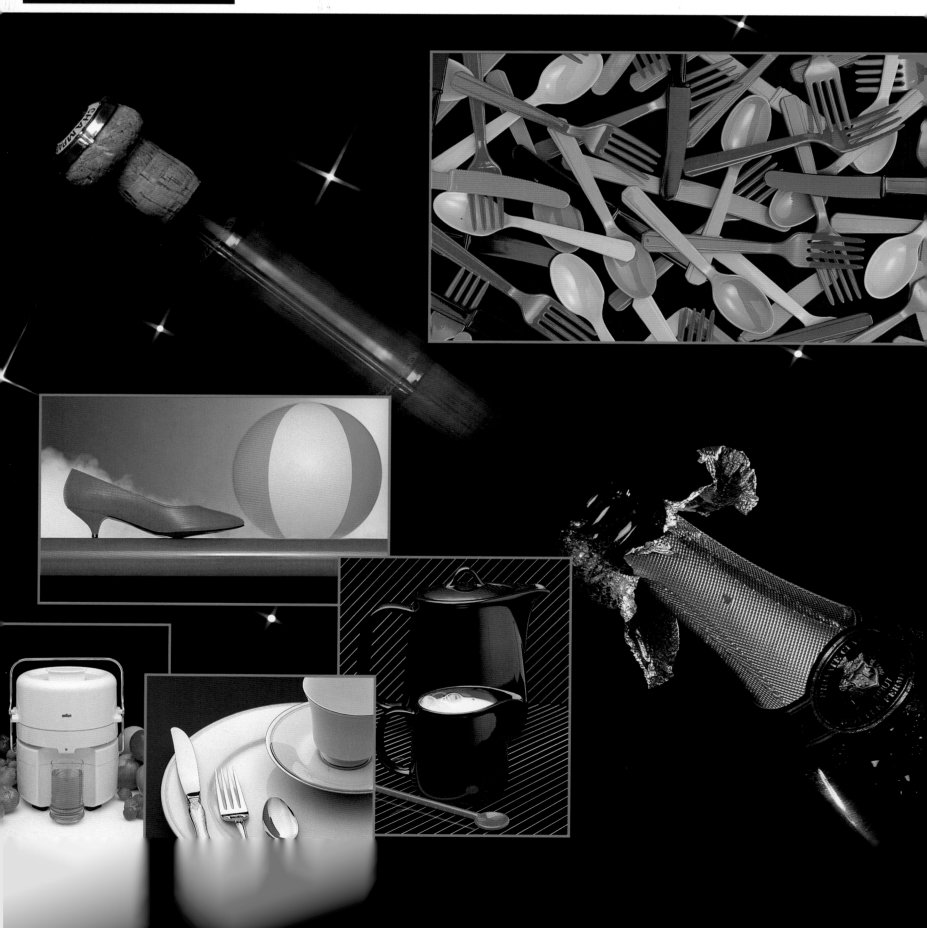

MOSCOW 29 SEPT. 90

Richard Kozak

Insight
3600 New York Avenue, N.E.
Washington, D.C. 20002
(202) 636-8800

Specialty: Photojournalism

Stock photography available. Contact: Leslie Current (202) 636-8800.

P. J. O'Rourke, photographed for Insight by Kozak

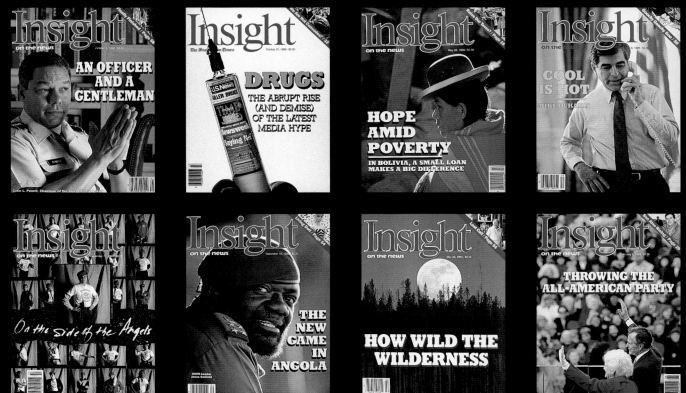

Paul Kranzler

Paul Kranzler Studio
1553 Platte Street, #207
Denver, CO 80202-1167
(303) 480-1060

Specialty: Studio Photography

Partial client list: American Express, Australian Outback, Citibank, Honeywell Test Instruments, Pentax Corporation, Pizza Hut, U S West.
Editorial Assignments: Autosound & Communications, The Confectioner, New York Magazine, Petersen's Photographic, Self Magazine.

PAUL KRANZLER STUDIO

303.480.1060

Steven Lama

Steven Lama Photography
742 Coeur Dalene Circle
El Paso, TX 79922
(915) 584-8872

Specialty: Commercial/Corporate/Industrial/Architecture

Clients include: Tony Lama Boot Co. Inc., Tony Lama Leather Products, Creations By Lama, Larry Mahan Boot Co., New Hyer Boot Co., El Paso Leather Components, Milano Hat Co., Blue Ribbon Nut Packaging Co., Hass Publications, Childrens World Learning Center.

Education: B.A. Communications, U.T. El Paso
M.S. Photography, Brooks Institute of Photography

Mark Langford

Mark Langford Photography
7349 Reindeer Trail
San Antonio, TX 78238
(512) 684-7015

Specialty: Annual Reports, Product Illustration, Stock and Architectural

Partial client list: Builders Square, Embassy Suites Hotels, Kaspar Wire Works Inc., Sani-Fresh International, La Quinta, Ray Cook Company, Lancer Corp., Coca-Cola International, Qualex Inc., USAA and Friedrich Air Conditioning.

Gordon Lazzarone

Gordon Lazzarone Photography
3460 Second Avenue
Sacramento, CA 95817
(916) 454-3301

Specialty: Photographic Illustration

Clients include: California Division of Recycling, California Grocer Magazine, California Housing Finance Agency, Foundation Health Plan, Grass Valley Group, PacTel Cellular, Office Club, Spare Time Inc., S.J. Foster Fine Linens, The Money Store.

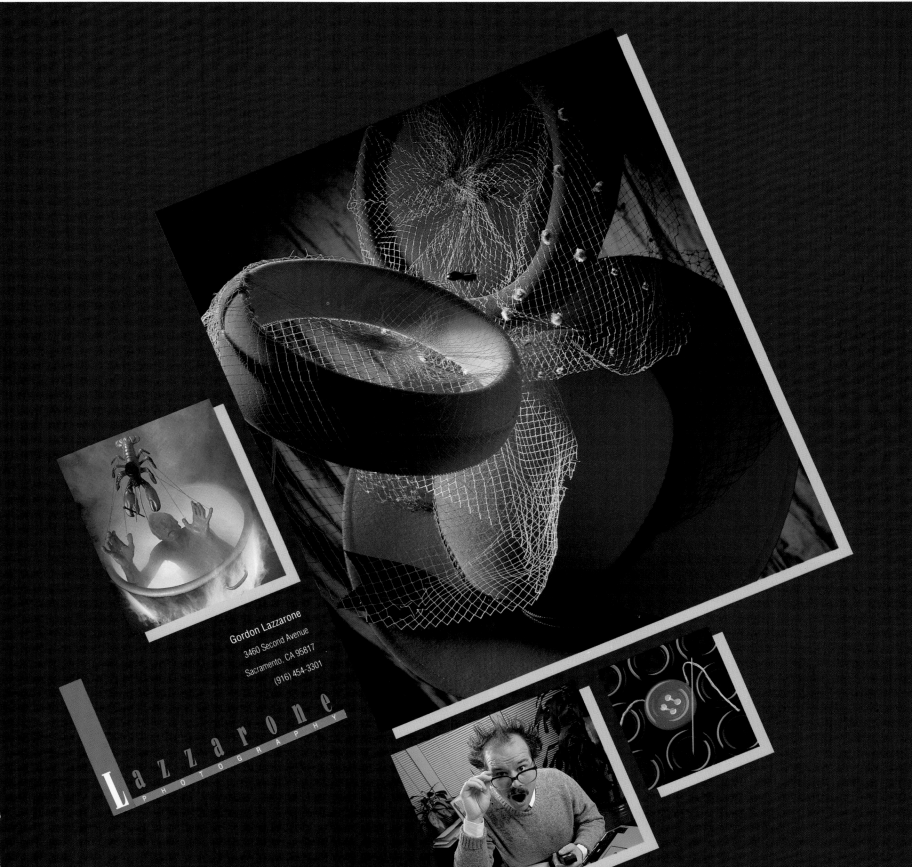

David LeBon

David Le Bon Studios
8950 Ellis Avenue
Los Angeles, CA 90034
(213) 204-1001 FAX (213) 204-1005

1. Chiat/Day/Mojo Corey Stolberg, Art Director
2. Chiat/Day/Mojo Steve Sweitzer, Art Director
3. Rubin Postaer Vicki Stolberg, Art Director
4. Chiat/Day/Mojo Corey Stolberg, Art Director
5. Chiat/Day/Mojo Victoria Filice, Art Director
6. J. Walter Thompson Don McCormick, Art Director
7. Della Femina Rick Carpenter, Art Director
8. Chiat/Day/Mojo Pam Cunningham, Art Director

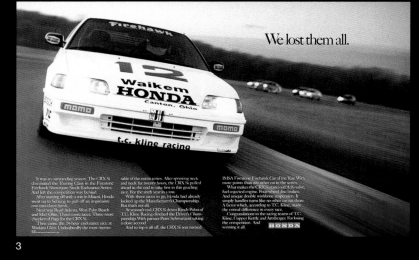

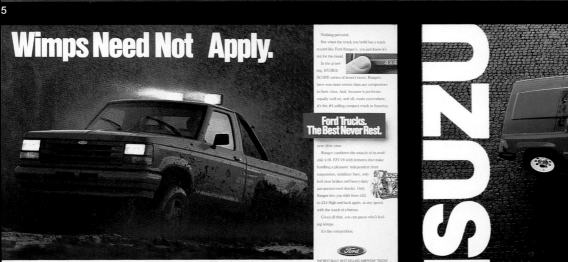

Introducing the new Sentra.

NISSAN

5

Wimps Need Not Apply.

6

7

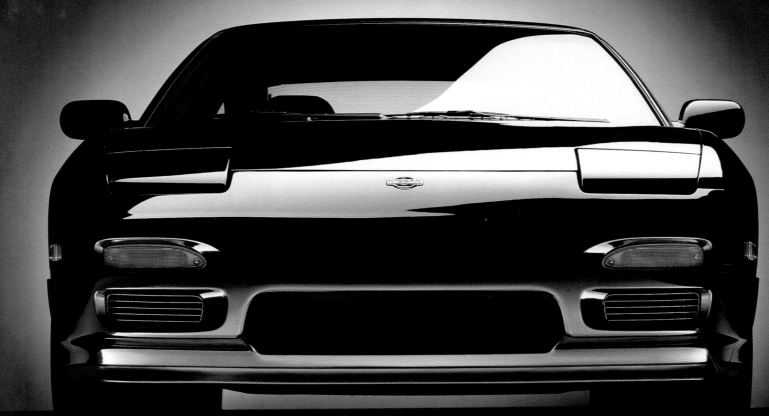

There are "sports cars" and there are sports cars. We make the kind without the quotes.

The 240 SX doesn't require punctuation. Or sporty decals. Or any of the other accoutrements some people believe can transform a "wanna-be" into a true sports car.

Because here at Nissan, we build the real thing. That's why the 240 SX was designed from the beginning with rear-wheel drive. Multi-link independent rear suspension. And nearly perfect weight distribution.

It's also why, this year, we're introducing a 155-horsepower, 16-valve engine. A new, more aerodynamic front

end. And, as an option, Super HICAS. The same 4-wheel steering system found on our Turbo Z that delivers superb handling and stability.

This is the kind of engineering that separates the sports cars from the "sports cars."

So the only quotes you can expect from us are the kind that can be found in the editorial section of this magazine.

Call 1-800-NISSAN-6 for more information.

The New 240 SX.

NISSAN

Built for the Human Race.

8

David Levy

David Levy - Photographer
P.O. Box 1354
Lexington, Kentucky 40590
(606) 268-9713

Specialty: Architecture/Location Lighting

Clients include: National and International; Architects, Interior Designers, Advertising & Art Agencies, Magazines, and Corporations.

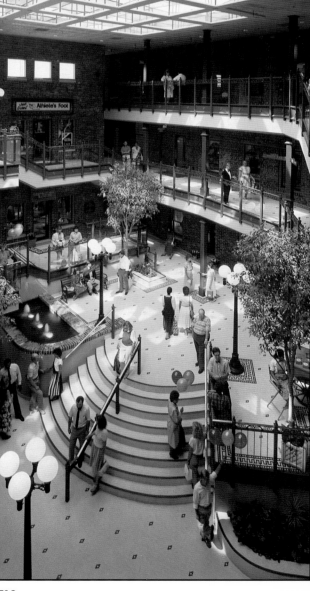

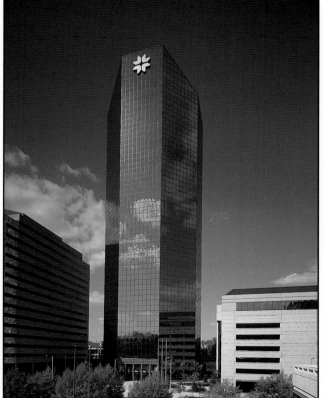

DAVID LEVY
PHOTOGRAPHER

Paul Liebhardt

Brooks Institute Faculty
Paul Liebhardt Photography
814 East Pedregosa
Santa Barbara, CA 93103
(805) 966-3888

Specialty: ## Journalism and Documentary Photography

Paul serves on both the photographic and general education faculties at Brooks, teaching courses in Photo History and Photojournalism. He is the author of a 1985 coffee-table book titled *Discovery—The Adventure of Shipboard Education.* A second book, *Odyssey—Tales of the Universe,* is due out in September 1991. In addition to teaching and writing, Paul adds approximately 5,000 images yearly to his current stock of 30,000 black and white and color travel/documentary photographs which he self-markets and distributes worldwide.

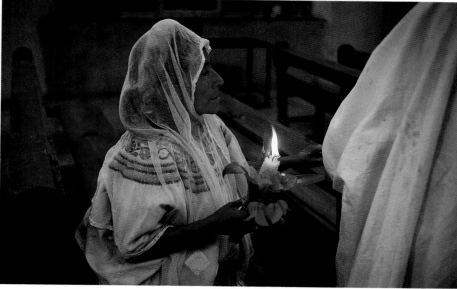

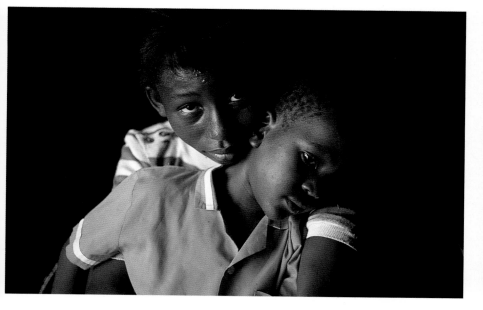

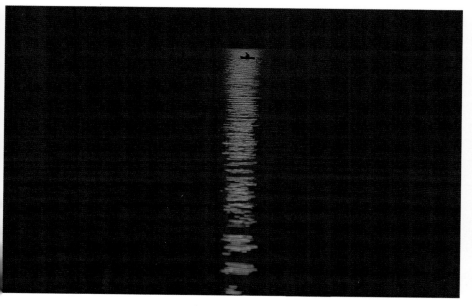

Harry Liles

Brooks Institute Faculty
Harry Liles Productions, Inc.
5940 Highridge Road
Hidden Hills, California 91302
(213) 466-1612 FAX (818) 348-0794

Specialty: Advertising/Corporate Photography, Computer Imaging

In addition to teaching, Harry is a founding member of APA, and has an active client list including: Avis, FTD Florists, Honda, Tree Sweet Orange, RC Cola, Toyota, Goodyear, Arrowhead Water, Princess Cruise Lines, Toshiba, Baskin Robbins, Turtle Wax, Isuzu, and many more. Harry is doing extensive work in the area of digital retouching and has developed a system to match perspective and lighting for computer compiled images.

©1991 HARRY LILES

Mark Lisk

Lisk Studio
518 Americana Blvd.
Boise, Idaho 83702
(208) 338-1516

Specialty: American Landscapes

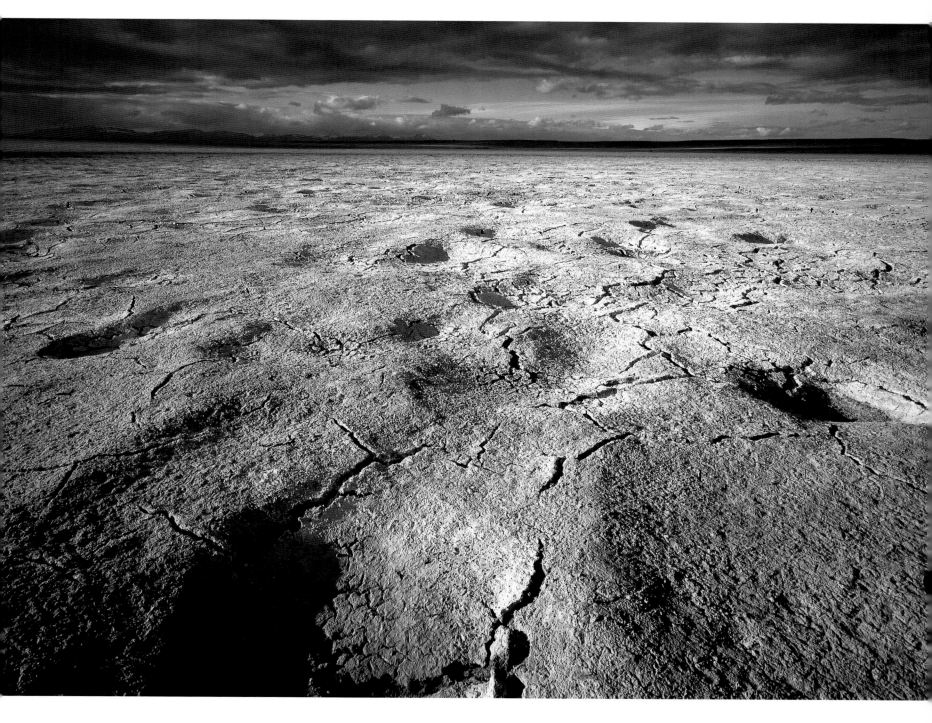

Mark Lisk 518 Americana Blvd. Boise, ID 83702 208-338-1516

Lisk
STUDIO

David Litschel

Brooks Institute of Photography Faculty
801 Alston Road
Santa Barbara, CA 93108
(805) 966-3888

Specialty: Architectural/Interior, Travel and Fine Arts

David teaches Advanced Color, Architectural, and Lower Division classes. He has participated in the University of Pittsburgh's Semester at Sea voyage as photographic faculty. He is currently Project Director for the California/Siberia Photographer's Exchange Project, supported by the Brooks Research and Development Foundation and the Peninsula Advertising Photographers Association. David is contracted with West Educational Publishing for the 1992 publication of a forthcoming textbook on basic black and white photography that he is co-authoring.

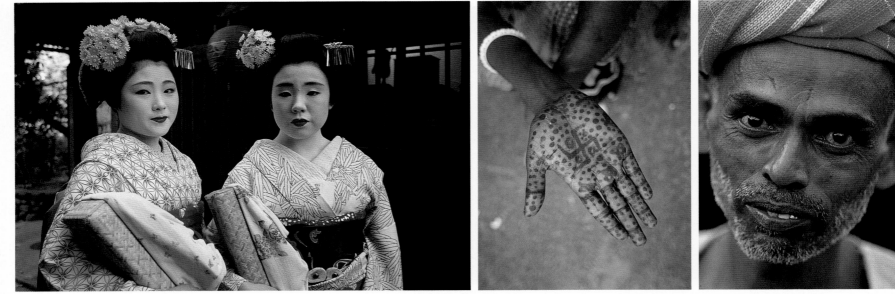

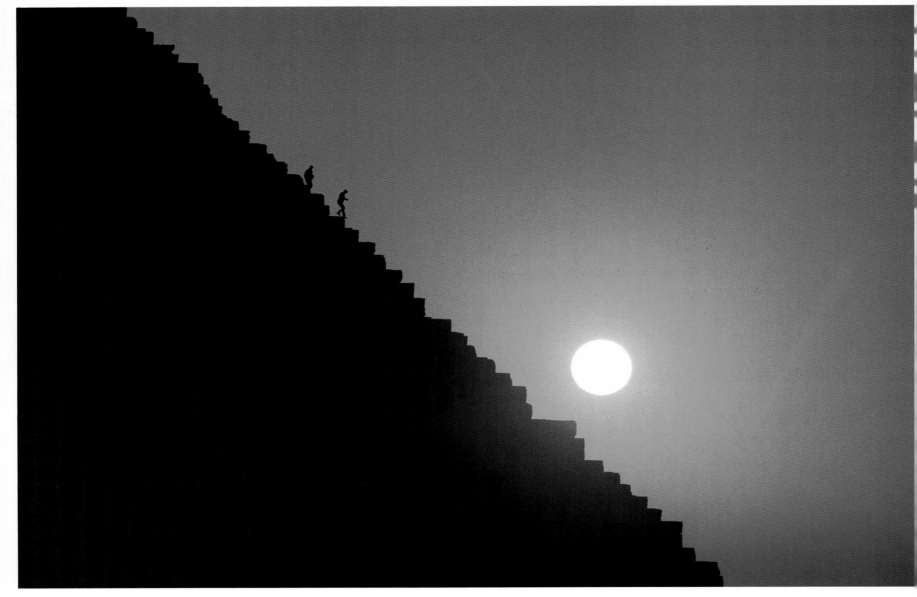

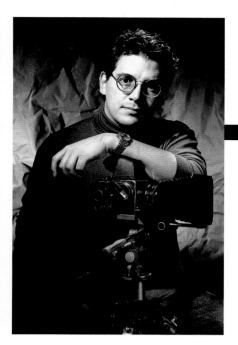

Rodrigo Llorente Peters

Rodrigo Llorente Peters
Solon #304, Polanco
11560 Mexico D.F., Mexico City
(525) 520-7245 FAX (525) 520-7526

Specialty: Advertising/Illustration/Product/Fashion

A fully-equipped studio in Mexico City for advertising, product, food & drink, fashion, editorial and corporate photography. Travel, tourism and industrial stock and assignment photography. Recent clients include Diner's Club International, Coca-Cola, BASF, Herman Miller Righetti, Resistol, Banamex, Tane, Tetra-Pak, Oneida, Luxor-Mohawk, Grisi and Johnson.

A wide range of work, including major advertising accounts as well as annual reports and corporate photography. Portfolio upon request.

Grupo Industrial Cierres Ideal
GICISA

Estados
Financieros
1 9 8 8

85

Jess Lopatynski

Jess Lopatynski Photographer
2099 Elsinore Road
Riverside, CA 92506
(714) 788-8111

Specialty: Fine Art, Decor, Stock

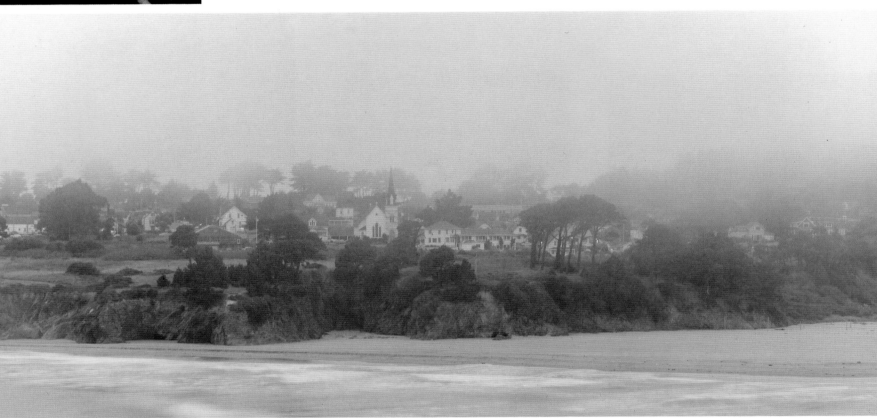

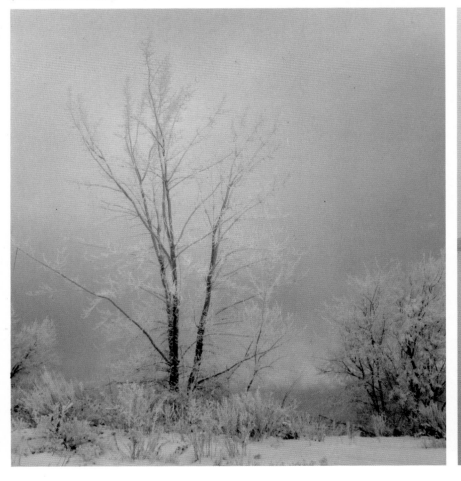

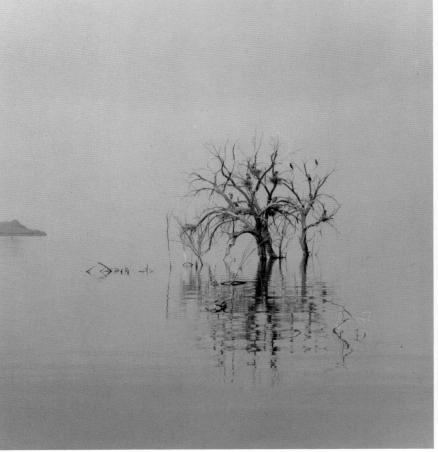

James David Macari

The Studio
201 W. Montecito Street, Suite B
Santa Barbara, CA 93101
(805) 965-3255

Fourteen years of photography has allowed his camera to work within the United States and Canada. He had a two year apprenticeship with Yousuf Karsh and has since 1980 operated his own business, photographing people, places, and products. During that time he has photographed for stock, landscapes of Alaska, Canada, and the western states of the U.S.A. Some of his clients are: Alan Scientific Corporation, Corso Productions International, Disc Drive Services, MariPro (SAIC), Pacific Machining, and Stout & Gerald, Inc. Architects.

THE STUDIO

805 • 965 • 3255

Don Mason

Don Mason Photography
4700 Easton Drive, Suite 31
Bakersfield, California 93309
(805) 323-3477

Specialty: Architectural, Industrial, Commercial

Client list: Armstrong Roses, Bechtel Inc., Calcot Ltd., Castle and Cooke Development Corp., Contel Corp., Chrysler Corp., Eaton Corp., Magnum Enterprises, Mobil Corp., Occidental Petroleum, Rain For Rent, Shell Western E.& P., Inc., Texaco Refining, Unocal Corp., Valza Corp.

Doug McLaughlin

Doug McLaughlin Photography
406 W. 34th Street, Suite 802
Kansas City, Missouri 64111
(816) 229-6897

Specialty: Commercial, Location, Publications

Client-focused is a good way of describing Doug McLaughlin. With 25 years of experience, Doug knows board rooms as well as construction sites. Specializing in location photography with a photojournalistic style, Doug is eager to fulfill the concepts of the art director or find his own viewpoint and graphic solutions. Doug's reputation has proven him to be eager, friendly, versatile and effective. He is very concerned with the human factor in his photography, portraying the proper emotional energy to fit the assignment. Award winning, technically exacting photography from original concept to final published product, Doug McLaughlin should be part of your publication team.

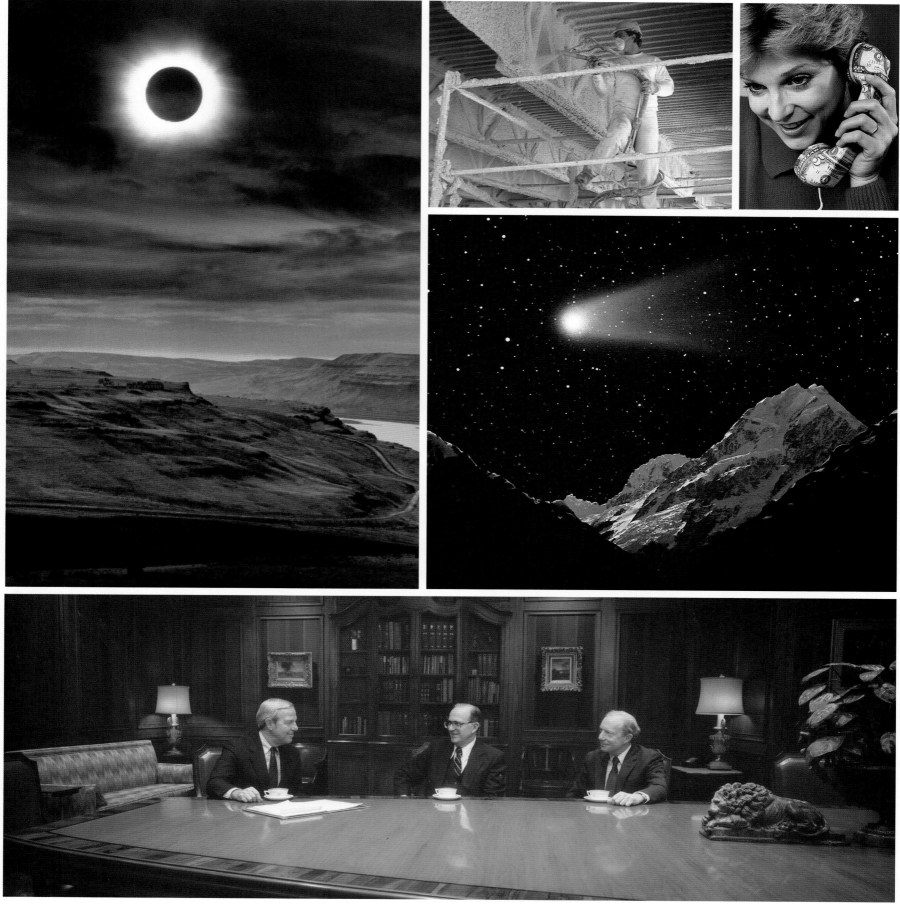

Miguel Angel Matos

M.A.M. Photography
1319 Kalakaua Avenue, Suite #4
Honolulu, Hawaii 96826-1909
(808) 944-2554

Specialty: ## Hotel, Travel, Resorts

Bilingual: Spanish and English. Clients include: Creative Casting—Honolulu, Global Performing Arts Institute Hawaii, Colony Hotels and Resorts, Hawaii Department of Education, Global Telemarketing Inc., Stryker-Weiner Associates Inc., Hawaii Business Magazine, Chaminade University of Honolulu.

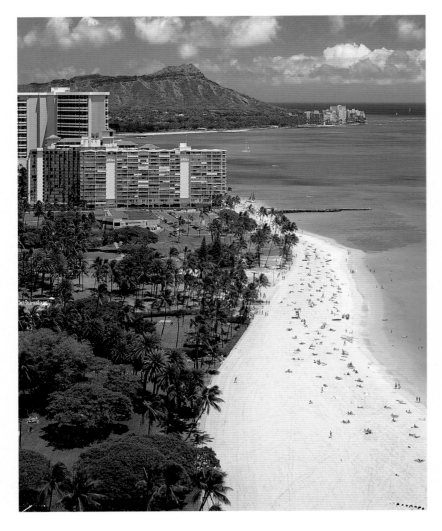

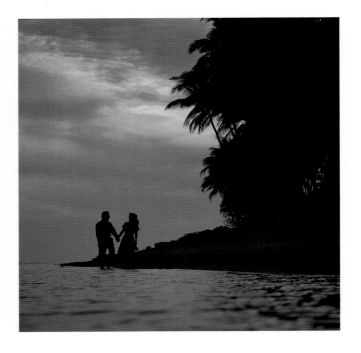

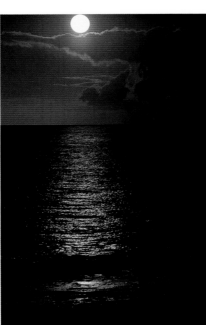

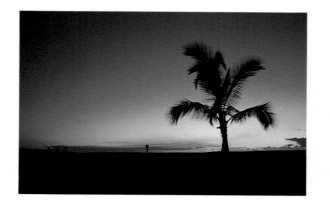

Miguel Angel Matos

M A M
PHOTOGRAPHY

1319 Kalakaua Avenue, Suite 4
Honolulu, Hawaii 96826–1909
Phone: (808) 944-2554

Jeffery S. McPhie

The Speaker Support Group, Inc.
214 Carnegie Center, Suite 206
Princeton, New Jersey 08540
(609) 520-9200

Specialty: Audio Visual Communications

Computerized Slide Making; Optical Special Effects; Slide Duplication; Original Photography; PC & Mac Imaging; Desktop Publishing; Multi-Image Production; Staging; Meetings; Video Production; Wavefront 3D Video Animation.

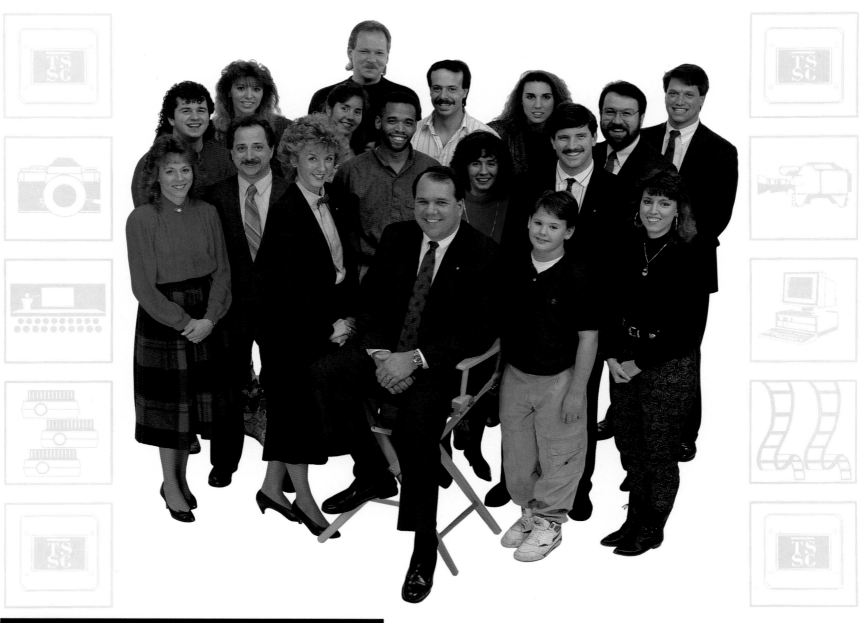

...where quality, service and fair price are the unquestionable standards.

Paul R. Meyer

Brooks Institute of Photography Faculty
801 Alston Road
Santa Barbara, CA 93108
(805) 966-3888

Specialty: Travel, Destination, and Hotel Photography

Paul teaches in the Lower Division classes and was an Outstanding Achievement Award winner when he graduated from Brooks in 1981. He worked on the popular Shroud of Turin project and majored in Industrial/Scientific Photography. His clients include: Parklane Hotel Hong Kong, Hyatt Hotel Manila and Tienjin China, Beverly Wilshire Hotel, Swimming World Magazine, Islands Magazine, Textra, Mennen, Forms and Surfaces. Paul also has an extensive stock file.

Scott Miles

Scott Miles / Landmark Photography
14 Mill Stream Road
Stamford, CT 06903
(203) 968-2696

Specialty: Architectural interiors and exteriors

As owner of Landmark Photography, Scott Miles has photographed commercial and residential architectural design for architects, interior designers and other clients in the building industry. The images have been published in numerous trade and consumer magazines including *Interior Design, Connecticut Architect and Specifier, Buildings,* and other publications.

Brad Milliken

Brad Milliken Photography
3341 Bryant Street
Palo Alto, California 94306
(415) 424-8211

Specialty: Location Specialist

Photography on location has its own set of problems, especially if the location is overseas. Brad worked for TRW Inc. after graduating from Brooks Institute, and refined the special skills necessary for corporate work on location, across the country and abroad. Now working from Palo Alto, California as his home base, Brad shoots for clients in Silicon Valley, as well as traveling extensively for domestic and international assignments.

Rand Evan Molnar

Brooks Institute of Photography Faculty
801 Alston Road
Santa Barbara, CA 93108
(805) 966-3888

Specialty: Application of Photographic Sciences

Rand is Dean of Graduate Studies and Chairman of the Color Technology Department of Brooks Institute. He is currently working on educational techniques utilizing the latest in computer technology. Rand is also acting advisor for a variety of photographic research and development projects involving new materials and processes including film acceleration and computation of reciprocity effect of most popular films.

David M. Morris

David M. Morris
1821 N.E. Diablo Way
Bend, Oregon 97701
(503) 389-8516

Specialty: Landscape/Nature

Exploring and photographing the western landscape, the changing moods, hues, and patterns of its rugged coast, mountain ranges and high desert, with 4x5, 2¼, and 35mm formats in color and black and white. Stock and assignments. Published in Sierra Club Calendars, Backpacker Magazine, Oregon Travel Guide, Central Oregon Vacation Guide, Oregon Calendar, and Down East Magazine.

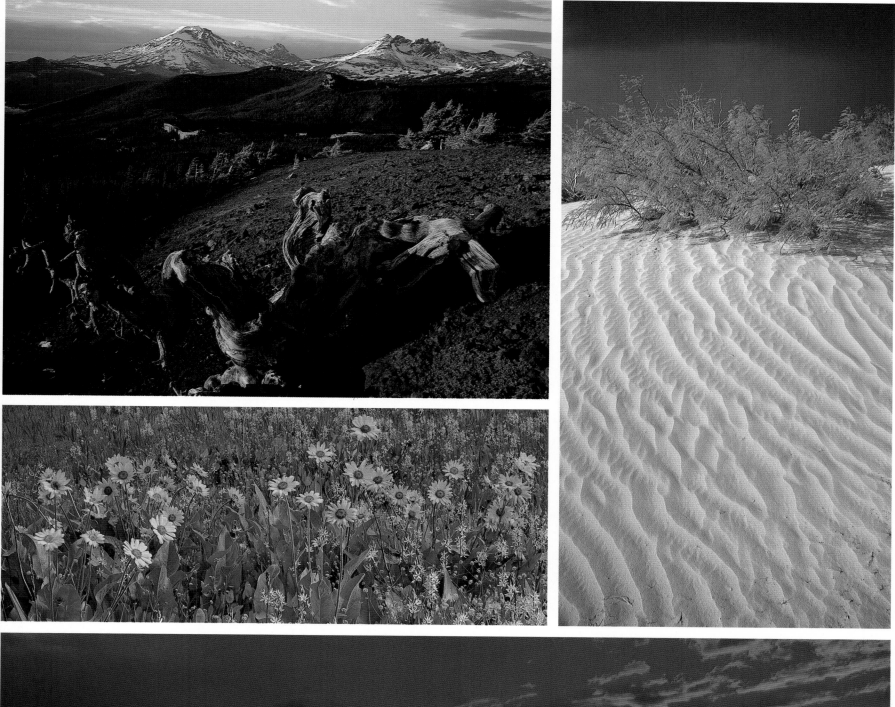

Keith H. Murakami

Robert Fujioka Studios, Inc.
715 North Shoreline Boulevard
Mountain View, CA 94043
(415) 960-3010 FAX (415) 960-3919

Specialty: ## Still-Life

I was born on an island and lived in the shadow of the magnificent Haleakala.
My vision is influenced by — light reflecting off the sea — colors of the tropical environment — warmth and mixture of the culture.
My vision is refined by — formal knowledge shared by a distant institution — experience — high expectations from creative clients — confidence in the ability to feel and sculpt light.

M U R A K A M I

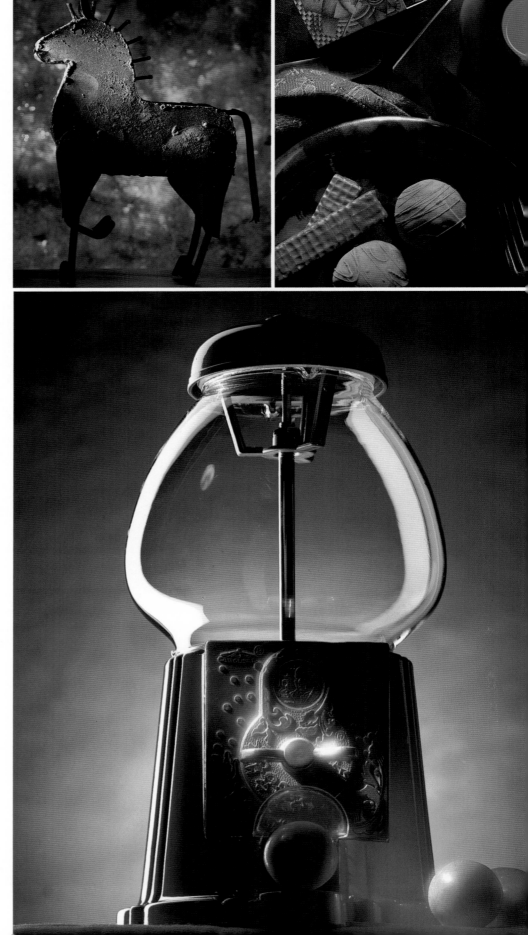

Steve Nelson

Steve Nelson/Photographer
RR 2, Box 690
Underwood, MN 56586
(218) 495-3594

Specialty: Products, People, Food & Travel

Clients include: 3M, Akai America, Alza Medical Corporation, Amigo Tours, Brawley Lures, Bruton Compasses, Buena Park Hotel, Colt Firearms, Computerland, Cordata Computers, Dentsu, Fingerhut, Flambeau, Franklin Brass, Freedom Arms, Gould Industries, Hitachi, In & Out Burger, Kurta Computer Systems, Maintenance Engineering, Optimus International, Penn Reels, Reliance, Rijola Jewelry, Sanyo, Sizzler, Tall Grass Computer Systems, Tomy Toys, Toshiba, Toyota Industrial, Transamerica, Uniden, Young & Rubicam.

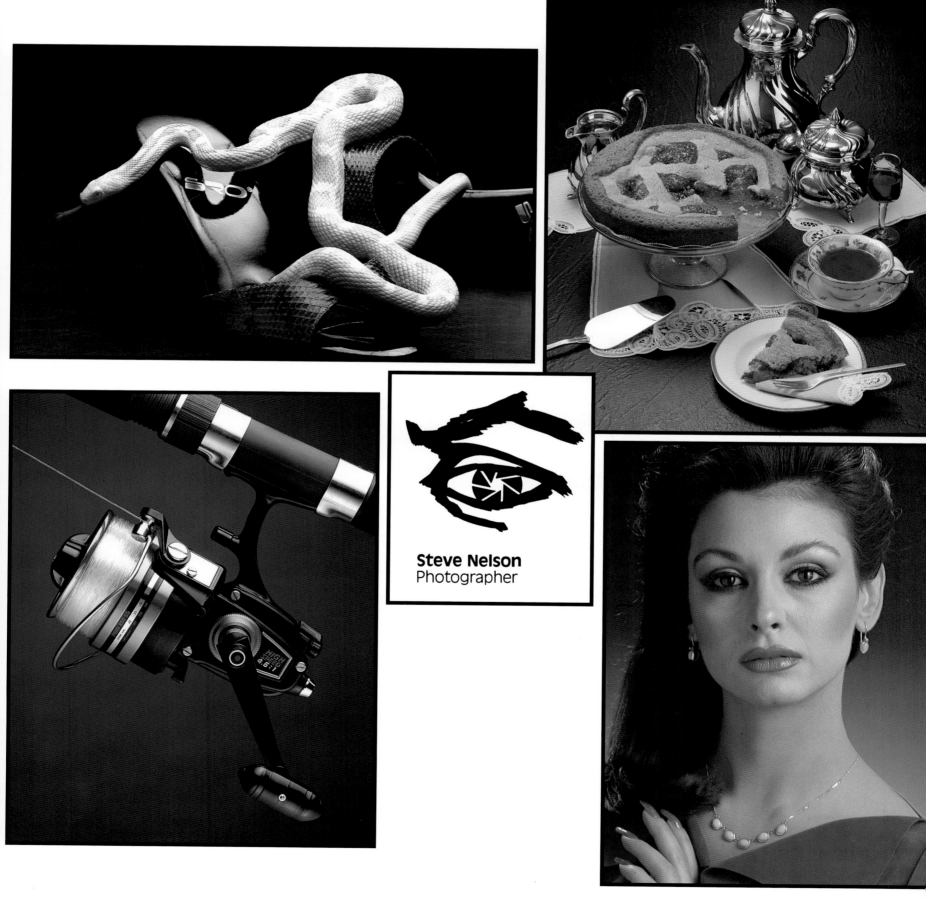

Steve Nelson
Photographer

Julie Nightingale

Nightingale Photography
535 Post Road East
Westport, CT 06880
(203) 454-0451

Specialty: Commercial Photography

Clients include: Bristol Myers, Cadbury Schweppes/Canada Dry, Crush, Hires, Citi-Bank, Conair, Dak Hams, General Electric, General Foods, Guinness Beer, Kal Kan, Pepsi-Co, Plumrose, Richardson Vicks, Ultra Slim Fast, Zotos.

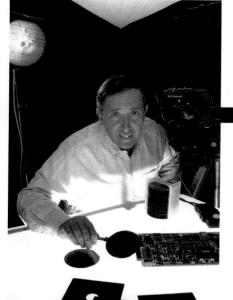

Pete Nuding

Pete Nuding Photography
2423 Old Middlefield Way, Suite K
Mountain View, Calif. 94043
(415) 967-4854

Specialty: Corporate, Advertising and Aerial

Pete Nuding is a Silicon Valley–based corporate and advertising photographer. He maintains a full service studio including both black and white and color printing, thus serving the varying needs of his many corporate clients. His assignments include annual reports, print ads, electronic trade magazine covers, and executive portraits. Pete has been a private pilot for twenty-five years and uses his own plane in many of his aerial assignments. He has operated in the San Francisco area since the 60's and his clients include: Hewlett Packard, Litton Industries, Pacific Telesis, Schlumberger, Signetics, Wells Fargo Bank, Transamerica Corp., Westinghouse Marine, and Varian.

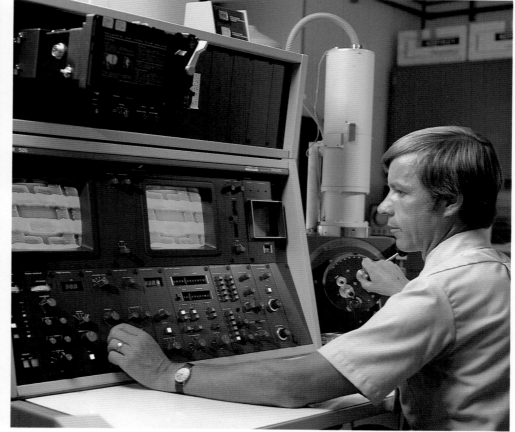

Ken Osburn

6026 Silverbrooke West
West Bloomfield, MI 48322
(313) 960-1809

Specialty: Advertising - Editorial - Industrial - Stock

20 years experience on four continents with over 6 years work in Europe and South America. Clients include most major advertising agencies in Europe and the United States. Extensive stock files and portfolio are available on request. ASMP member.

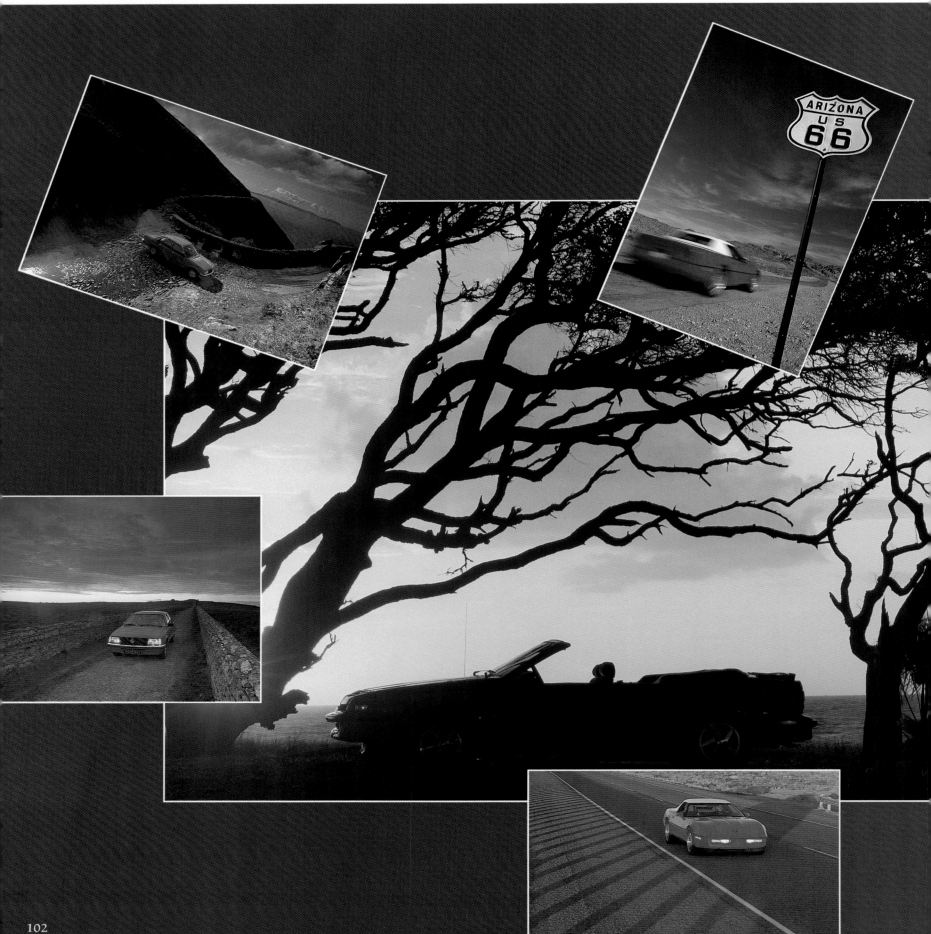

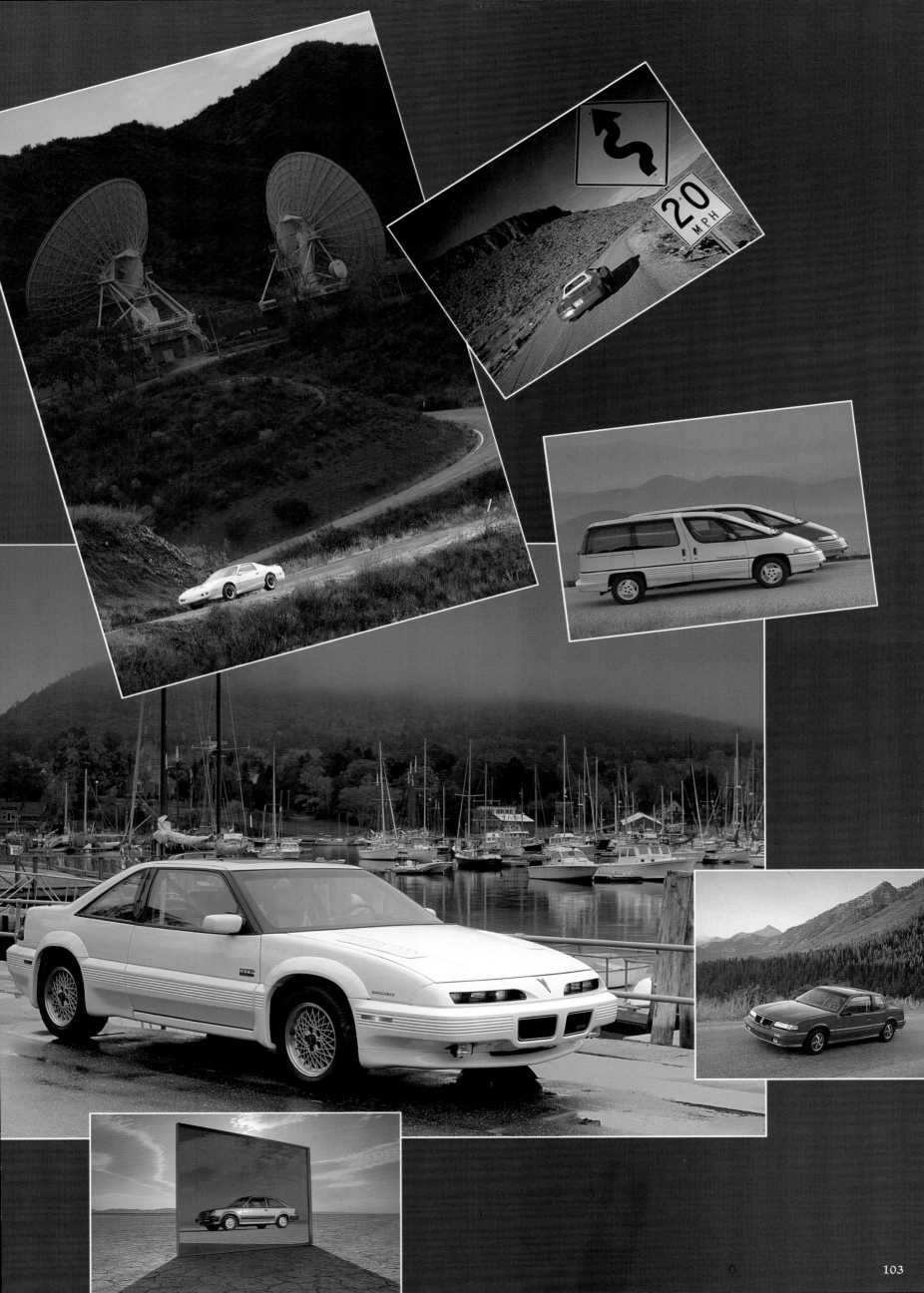

Kelly Henson

Kelly O'Neil Photography
1317 O Street N.E.
Auburn, Wash. 98002
(206) 833-8126

Specialty: Commercial, Location, Marine

Clients include: Mirage Marine, All Fab, Crystalite Skylite Manufactures, Cascade Savings Bank, K&H Printers, 48 Degrees Sailing Magazine, Yachting, Sailing World, Stock Newport, Ski Lifts Inc., Winch Tobiason & Company.

Location, advertising, editorial and weddings. I have my own boat to get on the water anywhere for marine photography. Member of the Nikon Professional Services.

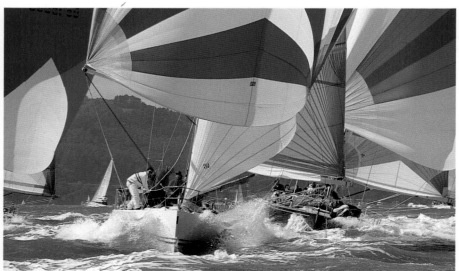

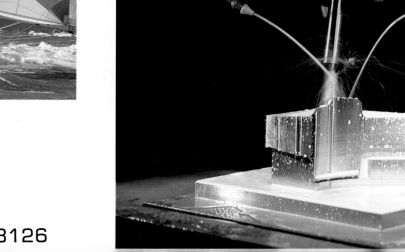

Kelly O'Neil
PHOTOGRAPHY (206) 833-8126

Joseph A. Panzarella

Image Creations
7525 Mission Gorge Road
San Diego, CA 92120
(619) 582-2516

Specialty: Industrial/Commercial/Architecture

Ability to design: specializing in product illustration, architecture, and interiors. Location and full service studio with cove capabilities available. Custom in-house B&W lab. Member ASMP.

Clients include: Williams Development Corp., Desert Chiropractic, Radisson Hotel (Rancho Bernardo), Desert Outpatient Oncology Center, Palm Springs Life Magazine, and Sam Bork Original Shoes.

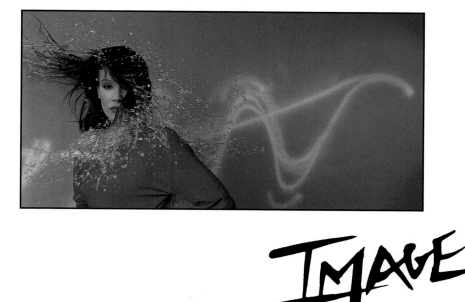

IMAGE
CREATIONS

Creating Ideas Into A Visual Reality

David Papazian

618 NW Glisan
Portland, OR 97209
(503) 227-2930

Specialty: Architecture, Food, Product Shots

Clients: Red Lion, Nike, Home magazine, Western Wood Products Association, US Bank, Visa card, Northwest Natural Gas, The Oregonian, Ford, Pacific Power, Norco Windows, Stash Tea and Rodda Paints.

Sig Kato

PERIF, inc
940 East 2nd Street, Suite 3
Los Angeles, CA 90012
LA (213) 617-0708 FAX (213) 617-0701

Specialty:

Special Effects/Illustration

Specializing in image-shot and high-tech still life.
All special effects are produced in camera.
Photographs are not retouched.
See American Showcase Volume 14.
Portfolio available upon request.
TOKYO (03) 5608-0764. OSAKA (06) 772-1116. FAX (06) 772-8282.

SIG KATO

B. Kenneth Patterson

The Image Source, West
255 S.W. Harrison #17C
Portland, OR 97201
(503) 223-0001

Having flown over 700,000 miles in the past two years, I've photographed various points around the globe: Saudi Arabia, London, Paris, Beijing, Shanghai, Bangkok, Seoul, Taipei, the Cayman Islands, Jamaica, the Lesser Antilles, and places not even your mother told you about. When on land, I also enjoy photographing people, including corporate work with: The DeBartolo Corporation, Sotheby's, the Menninger Foundation, and Humana Hospitals, Inc., and portraits of Elizabeth Dole, Roger McDowell of the Philadelphia Phillies, and stunt flyer Patty Wagstaff. Clients include Northwest Airlines, Midway Airlines and Skies America Publishing Company.

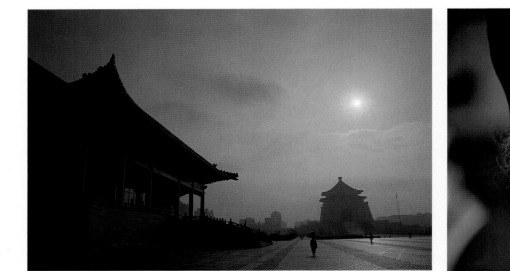

The IMAGE SOURCE

W E S T

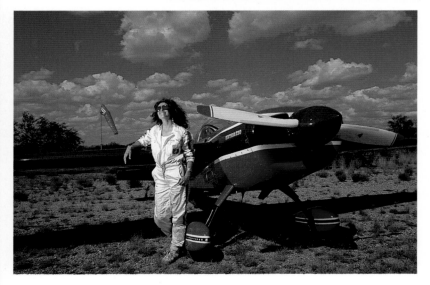

Robert Patterson

Robert Patterson Photography
202-A East Stevens Avenue
Santa Ana, CA 92707
(714) 751-7503

Specialty: Folks & Fun

Ten minutes from the shimmering blue Pacific, five minutes from John Wayne "intergalactic" airport, about an hour south of L.A., a comfortable, well-equipped studio, and the weather is nice just about year-round. These are a few other reasons to come to Orange County and shoot with Bob. Please call for more.

ROBERT PATTERSON
p h o t o g r a p h y
202-A E. Stevens Avenue · Santa Ana. Ca. 92707
714-751-7503

109

Rick Pazen

Rick Pazen Photography
P.O. Box 1186
Citrus Heights, CA 95611-1186
(916) 723-4345
Represented in L.A. by Maggie Hamilton (213) 931-2474.

Specialty: ## Automobiles & Motorcycles/Studio & Location

Clients include: Toyota, Bank of America Public Relations, Car and Driver, Mariah Automobiles, Carmichael Honda, Tower Records, Pulse Magazine, Ethan Wade Beach Wear, New West Graphics . . .
Winner: Toyota/Car & Driver National Shootout

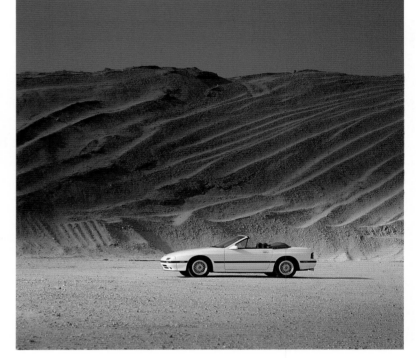

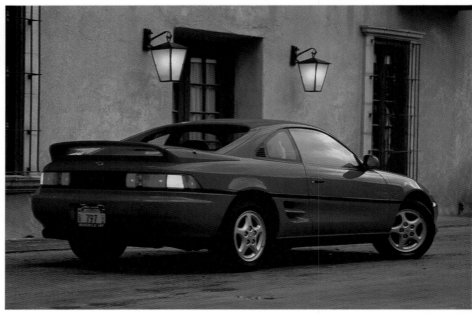

Douglas Peck

Douglas L. Peck Photography
854 Rorke Way
Palo Alto, CA 94303
(415) 424-0105

Specialty: Corporate and Editorial Photography

Clients include: 3Com Corporation, Bank of Agriculture and Commerce, CBS, Consilium, IBM, Klutz Press, KPMG Peat Marwick, Media West, PINC, Reebok International, Runner's World, Select Data Systems, Sierra Club, Stanford University, Street Electronics Corporation, T3plus Networking and the United States Olympic Committee.

Jan Perry

First Cut, Inc.
3131 Turtle Creek, Suite 707
Dallas, TX 75214
(214) 559-0344

Specialty: Commercial Post Producer

Clients: American Airlines
NCNB Bank
Long John Silver's
Borden's
Sears

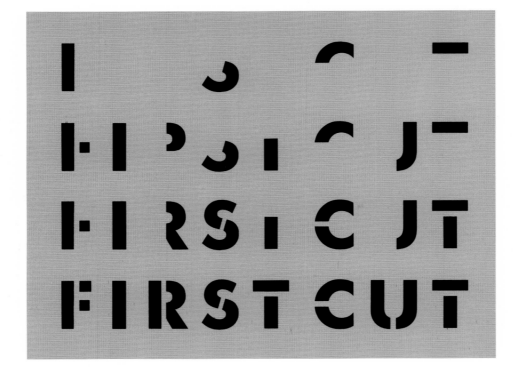

FIRST CUT . . .
Offers the ultimate in
Creative editorial services
Featuring nonlinear, random access editing
CMX compatible ³/₄" A/B roll offline editing
And the best people anywhere!

FIRST CUT . . .
Always on the cutting edge!

3131 Turtle Creek, Suite 707
Dallas, Texas 75219
(214) 559-0344
(214) 520-1429 (fax)

John Perryman

JP Photography
8815 West 70th Terr.
Shawnee Mission, Kansas 66204
(913) 432-0374

Specialty: Photo Stock—
Travel/Panoramas/Landscape/Scenics

Clients include: Hallmark Cards Inc., Swingster Company, Readers Digest, McGrew Graphics, Word Inc., United, Impact Southwest, Inc., Misel Photo Chrome Corp., Stihl Corp.; contributor of photographs for six books with the Kansas City Art of Entertaining.

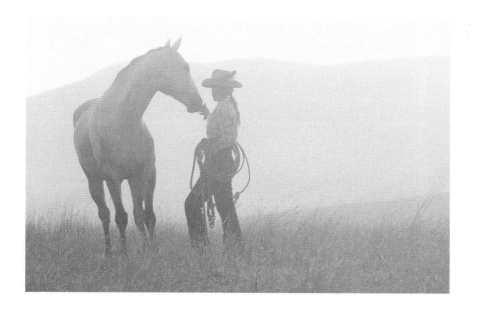

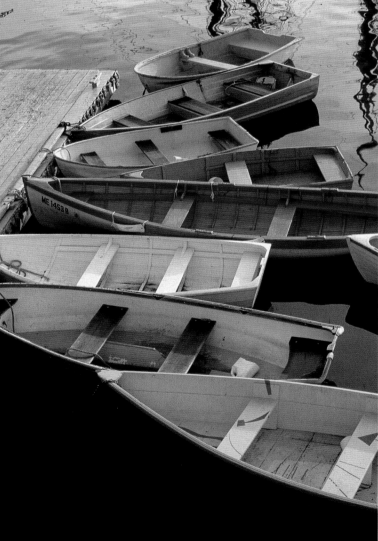

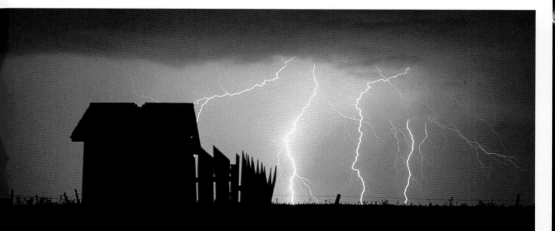

Jeff Peters

313 Brokaw Road
Santa Clara, CA 95050
(408) 727-3113

Specialty: Commercial Photography

Graduated February, 1986.
Studio and location photography in Silicon Valley. My work includes advertising photography, annual reports, executive portraiture, and aerial photography. Stock photography of Silicon Valley available, including aerial and ground images.

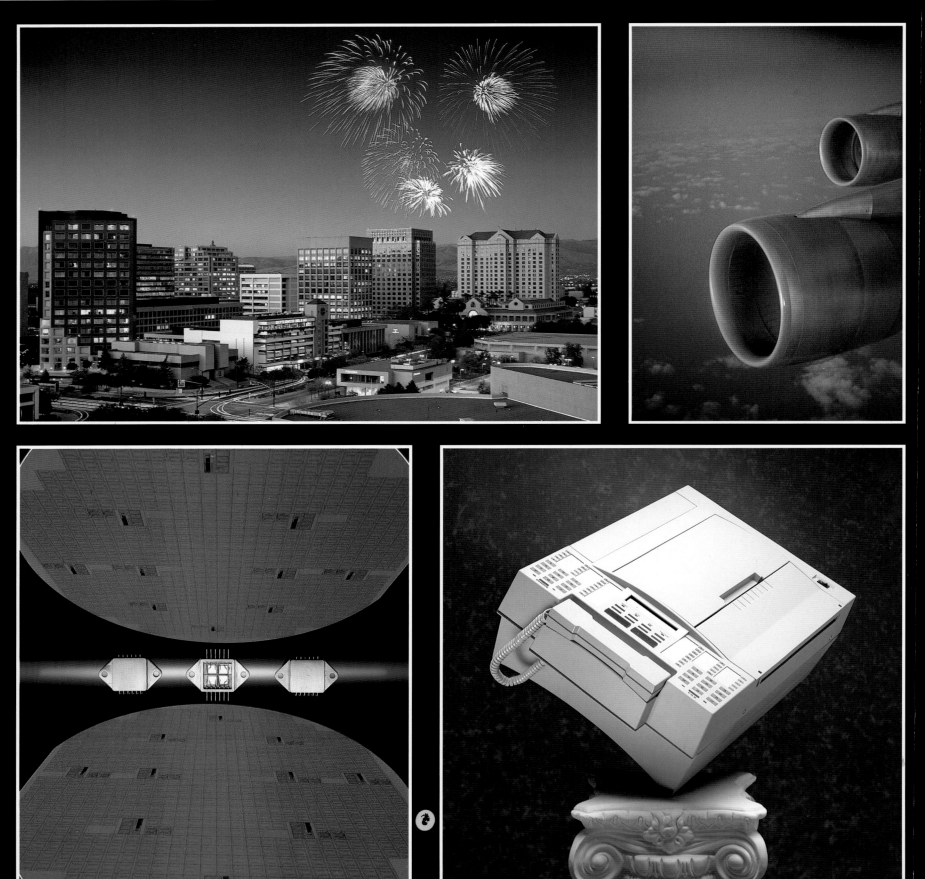

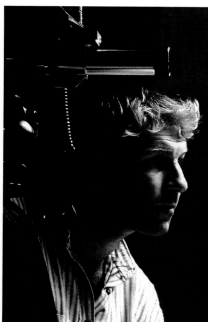

Steve Pollock

Pollock Studios
1652 Edinger, Suite C
Tustin, CA 92680
(714) 259-9717

Specialty: ## Commercial/Corporate/Food/Studio Sets

Clients include: Aprica, Beatrice Hunt–Wesson Foods, Boys Club of America, Century 21, Coors Distributing, Dunn & Bradstreet, Entenmanns/Oroweat, Entrepreneur Magazine, Fujitsu, Hiram Walker, In & Out Burger, Kal Kan, Kerr Glass, Knott's Berry Farm, Kraco, Liebert Corp., M&M Mars, Mikasa, Mitsubishi Electronics, Sinclair Paint, TRW.

LA CHOY

POLLOCK

STEVE POLLOCK STUDIOS 1652 EDINGER AVE
SUITE C TUSTIN CALIFORNIA 92680 TEL 714 259 9717

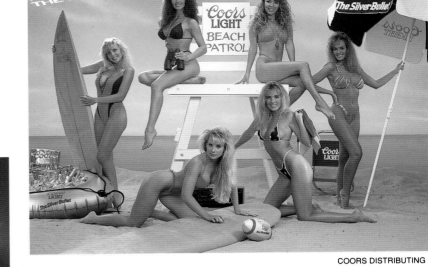

COORS DISTRIBUTING

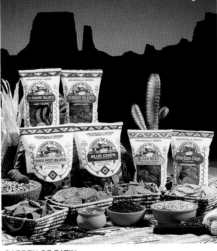

GARDEN OF EATIN

KRACO

ENTENMANN'S

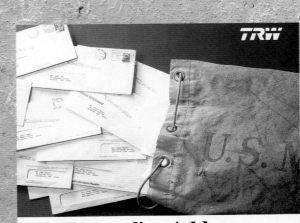

TRW

STEVE POLLOCK STUDIOS 1652 EDINGER AVE
SUITE C TUSTIN CALIFORNIA 92680 TEL 714 259 9717

SWISS MISS

GENERAL AUTOMATION

ADD-ON SYSTEMS

NEWPORT SURGICAL

AMERICAN INDUSTRIES

STEVE POLLOCK STUDIOS 1652 EDINGER AVE
SUITE C TUSTIN CALIFORNIA 92680 TEL 714 259 9717

BEATRICE INTERNATIONAL

HUNT WESSON FOODS

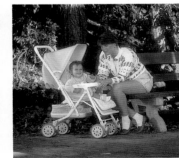

APRICA

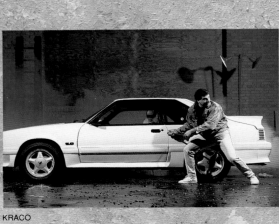

KRACO

Jeffrey K. Plummer

Moreau Studio
39 Hudson Street
So. Glens Falls, New York 12803
(518) 793-2454

Specialty: Studio and Location Portraiture

Bachelor of Arts Degree June 6, 1980. Portrait Photographer Samuels Studio July 1980–November 1983. Sole Proprietor Moreau Studio April 1984–Present.

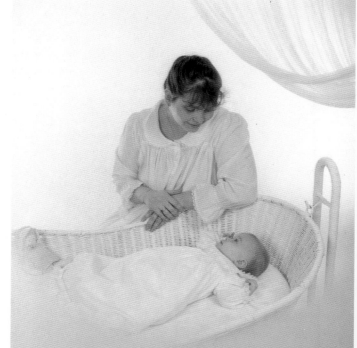

Ralph Portillo Jr.

Portillo Photography
415 Clyde, Suite 103
Mountain View, CA 94043
(415) 964-0964
765 Minna Street
San Francisco, CA 94103
(415) 255-9983

Ralph Portillo has been creating innovative photography for art directors for over 15 years. A partial client list in the past and present have included some distinguished companies as Apple, Brueners, Bullock's, Del Monte, Everex, Fujitsu, Hewlett-Packard, Intel, Macy's of California.

His photographs have appeared in USA Today, Architectural Digest, Byte, Mac-World, MacWeek, PC Week, PC World, Wine and Food, and Scene Magazine.

From in studio product to architectural location shots, Ralph Portillo Jr. has proven time and time again that attention to detail solves photographic problems and that efficiency saves the client time and money.

Ralph Portillo is currently president of the Advertising Photographers of America-San Francisco chapter and also Technical director of Photoflex Inc.

David Quinney

David Quinney–Studio Q
423 East Broadway
Salt Lake City, UT 84111
(801) 363-0434

Specialty: Illustration, Architecture, Corporate
Communications

A working professional for the past ten years, David has studio and location
capabilities specializing in advertising and corporate communications. Light, con-
trast, and strong graphic design create the dynamics of imagery which help define
David's style. The working atmosphere is laid back and easy, yet professional. "If you
don't have fun doing what you're doing, then you should be doing something else."
Studio Q has a way of imparting that attitude to its clients. The resulting rapport
only enhances communication and creativity. Our client list includes: American Bar-
rick, Apple, Chevron, Coldwell Banker, DOD Electronics, Evans & Sutherland, Hoyt
USA, Jackson Hole, Jetway, UNISYS, US Film Festival, and WordPerfect.

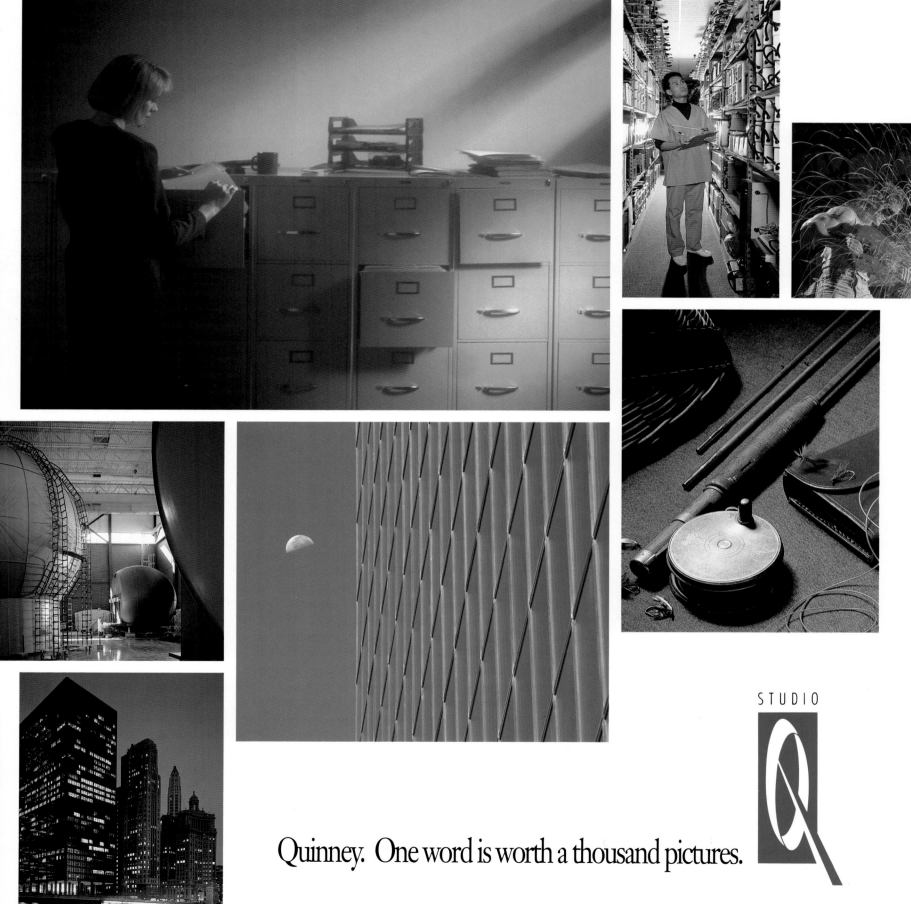

STUDIO

Q

Quinney. One word is worth a thousand pictures.

William Ramsey

William Ramsey Photography
15431 Red Hill, Suite E
Tustin, CA 92680
(714) 258-0432 FAX (714) 259-1566

Specialty: Commercial/Location/Stock

Clients include: California Business Magazine, Casino & Cabaret Magazine, Clearegance Inc., Coffman Systems, Entrepreneur Magazine, National Geographic Magazine, Saudi Arabian Parsons LTD, Stallion Motorcar Coachworks, Star Week Magazine, West Orange Medical Group. Stock available from: Africa, Middle East, Asia.

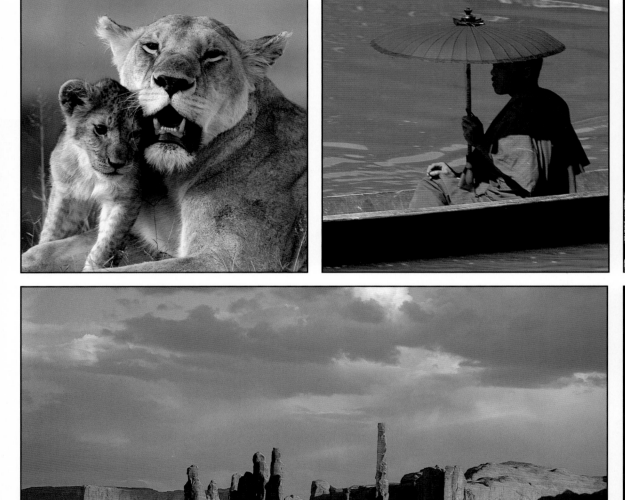

William Ramsey

William Ramsey Photography
15431 Red Hill, Suite E
Tustin, CA 92680
(714) 258-0432 FAX (714) 259-1566

Specialty: Commercial/Location/Stock

Clients include: California Business Magazine, Casino & Cabaret Magazine, Clearegance Inc., Coffman Systems, Entrepreneur Magazine, National Geographic Magazine, Saudi Arabian Parsons LTD, Stallion Motorcar Coachworks, Star Week Magazine, West Orange Medical Group. Stock available from: Africa, Middle East, Asia.

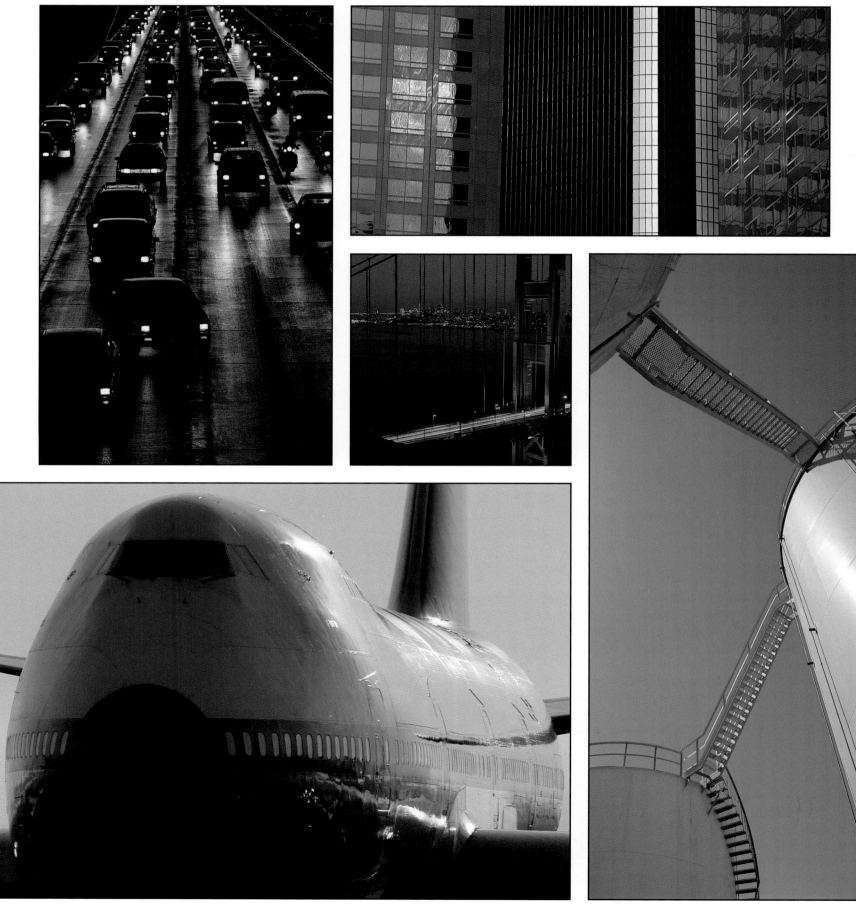

Brian D. Ratty

Brian D. Ratty
P.O. Box 1563
Lake Grove, OR 97035
1-800-888-TAPE

Specialty: Instructional Videos on Photography

The 'On Assignment' photography series, developed and hosted by Brian D. Ratty, consists of eight 90-minute instructional videos designed for the amateur to professional photographer. Mr. Ratty, a graduate of Brooks Institute of Photography, also holds an Honorary Master of Science degree. Years of research, planning, development and photography have gone into this award-winning series. 'On Assignment' is available in twenty countries and six languages. This nationally acclaimed series, produced with a blend of graphics and spectacular locations, brings a fresh, practical approach to the craft of photography. Rated "FIVE STAR" Video Choice Magazine.

Joseph T. (Chuck) Ropel

Burien Studio
447½ 152 S.W.
Seattle, WA 98166
(206) 242-4433

Specialty:

Humanity

Mr. Ropel specializes in appropriate sized, custom designed wall decor. During the pre-portrait design consultation, consideration is given to the portrait location, the desired mood, clothing, and then where the canvased portrait will be proudly displayed in the client's environment.

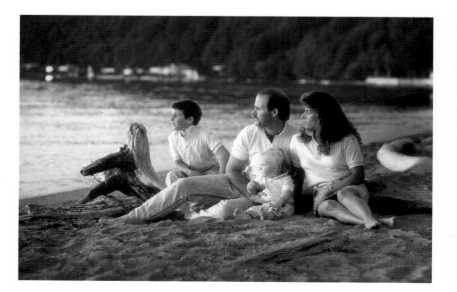

Ronald R. Riehs

4254 Via Marcina
Carpinteria, CA 93013
(805) 684-6487

Specialty: Photo / Graphic Illustrator

Clients: CNN, Exxon Company U.S.A., Exxon Pipeline Company, Institute of Offshore Engineering, Licata Studios, Pini Ceramics, Ritchie Brothers Auctions, Tannaromes Jewelry, Valdez Convention & Visitors Bureau.

Publications: *Peterson's Photographic Magazine, Profile Magazine, The Pipeliner Magazine, A Field Guide to Prince William Sound, Environmental Recovery in Prince William Sound and Gulf of Alaska, Two Years After the Spill: Environmental Recovery in Prince William Sound and Gulf of Alaska.*

SELF-PROMOTION

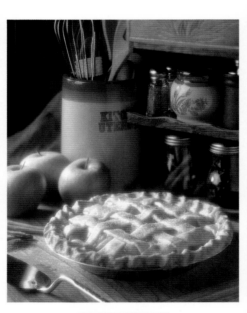

SELF-PROMOTION

PINI CERAMICS

TANNAROMES JEWELRY

SELF-PROMOTION

PIONEER PEAK, ALASKA

RONALD R. RIEHS
PHOTO / GRAPHIC ILLUSTRATOR

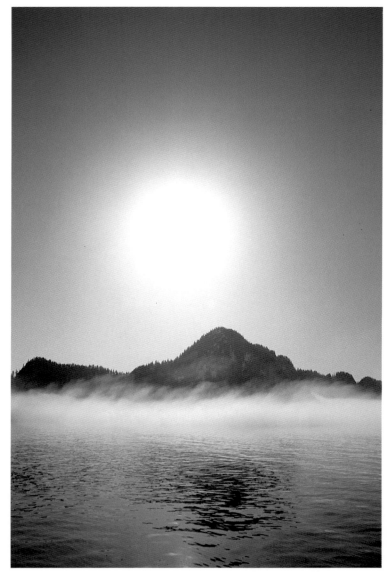
BARREN ISLANDS, G.O.A.

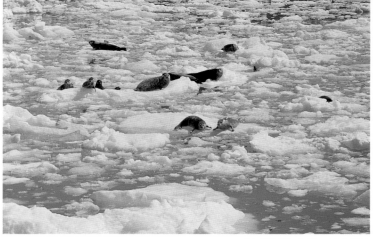
GLACIER BAY, ALASKA

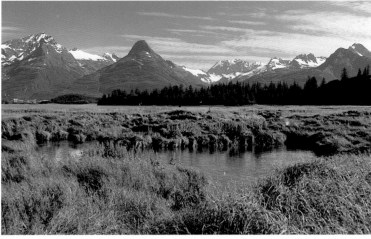
VALDEZ CONVENTION & VISITORS BUREAU

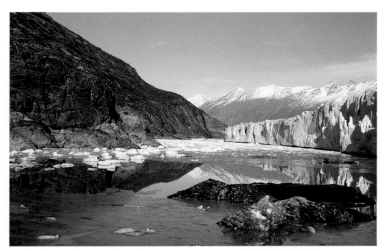
KNIK GLACIER, ALASKA

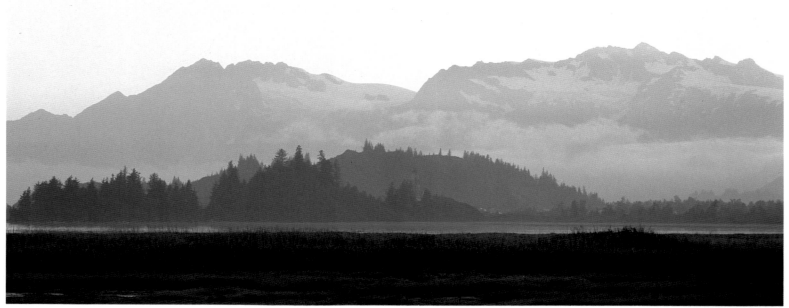
VALDEZ, ALASKA

Alan Rosenberg

Rosenberg Photography
3024 Scott Blvd.
Santa Clara, CA 95054
(408) 986-8484 FAX (408) 986-8485

Specialty: Commercial, Studio and Location

Clients include: IBM, Northern Telecom, MasterCard, Skyway Freight, Worlds of Wonder, and Xerox.

.

.

.

Jim Russi

Photo: Russi
2649 Palos Verdes Drive West
Palos Verdes Estates, California 90274
(213) 376-4344 Studio (213) 544-8804 Office

Specialty: Fashion/Sports Action Wear

Clients include: Ame sunglasses, Billabong Sportswear, Club Sportswear, Coors Light, Body Glove Wetsuits, Hobbie Sportswear, Island Snow Hawaii, Mossimo Sportswear, Oakley Sunglasses, Offshore Sportswear, O'Neill Wetsuits, Ose Swimwear, Pamila Swimwear, Reef Sandals, Rip Curl Wetsuits, Side-Out Sportswear, Vuarnet Sunglasses and Sportswear.

Magazines include: Surfer Publications, Surfer, Beach Culture, Powder, Snowboarder, Volleyball Monthly, Fairchild Publications, Sport Style, Sports Illustrated, Surf Session—France, Surfin' Life—Japan, Now—Brasil.

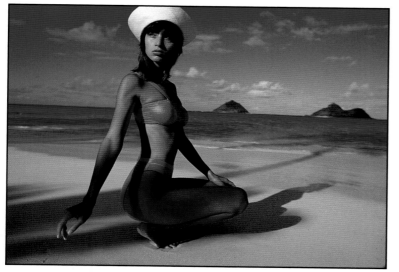

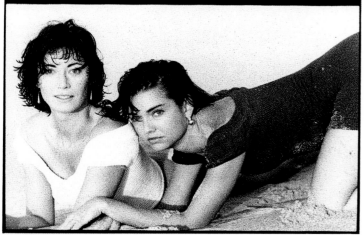

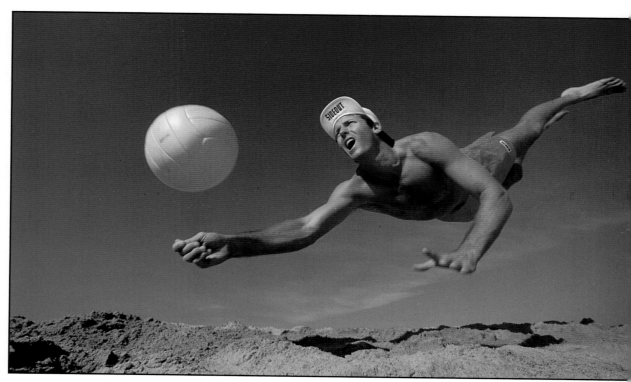

Don Rutt

Don Rutt Photography
2785 North Garfield Road
Traverse City, Michigan 49684
(616) 946-2727 FAX (616) 946-2728

Specialty: Food, people, and boats

Clients include: Sara Lee, Heinz, Domino's Pizza, Super Foods, Dow Chemical, PPG, Daiwa, and Four Winns Boats.

James Scherzi

James Scherzi Photography, Inc.
5818 E. Molloy Road
Syracuse, NY 13211
(315) 455-7961

Specialty: Studio/Product/Food/Location

Clients include: Alcan, Bausch & Lomb, Blue Cross/Blue Shield, Bristol-Meyers, Carrier Corporation, Cellular One, Chrysler Corporation, Crouse-Hinds, Divi Hotels, Eveready, General Electric, Harden Furniture, Magnavox, Niagara Mohawk Power, Norwich-Eaton Pharmaceuticals, Oneida Silversmiths, Smith-Corona Corporation, Stickley Furniture, Timex Corporation, Union Carbide, Welch Allyn.

Tony Salazar

612 Lighthouse Avenue
Pacific Grove, CA 93950
(408) 375-4624 (408) 373-2416 FAX 646-9826
South America: Phone 011-582-661-7011 CLAVE 8021 / 011-582-915267
FAX 011-582-745476

Specialty: Advertising, Corporate Image and Editorial Assignments

We work with most of the advertising agencies, designers, corporations and magazines in Northern California. A partial list of clients includes: Concord Records, Eñe Advertising, Monterey Life Magazine, Vintners International, Jeff Mitchell Advertising, Pacific Bell, Pacific/Guest Life Magazine, Smith Bowen Advertising, and many others.

SALAZAR
PHOTOGRAPHY

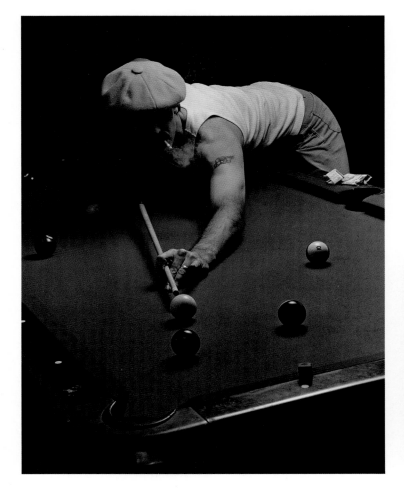

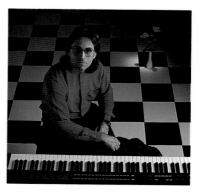

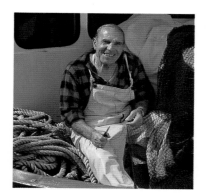

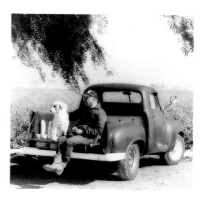

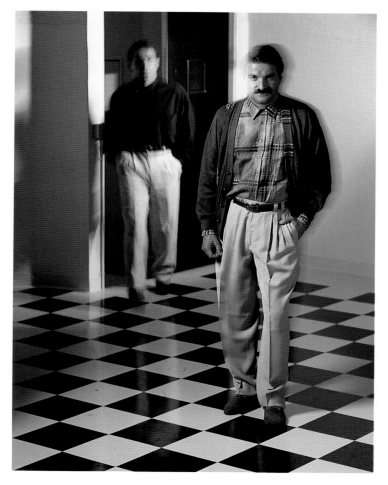

612 LIGHTHOUSE AVE.
PACIFIC GROVE
CALIFORNIA 93950
408 375 4624

SALAZAR
P H O T O G R A P H Y

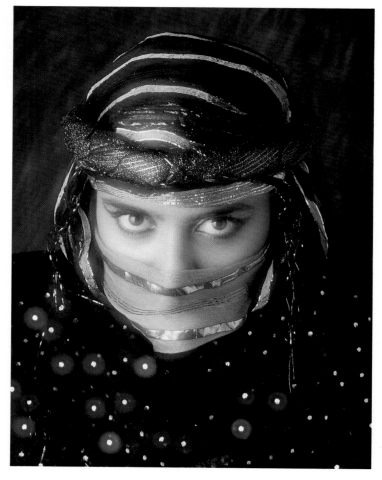

Kurt Schoenbach

Kurt Schoenbach's "Classic Images"
881 Medford Place
Ventura, CA 93004
(805) 659-1005

Specialty: People & Products For Advertising

Clients include: Castoro Cellars, Culligan Soft Water, Double Deal Pizza, Excalibur Limousine Service, H&H Oil Tool, Magical-X Productions, Nautilus Of California, Underground Technology Inc., U.S. Agri Women, Ventura County Medical Center.

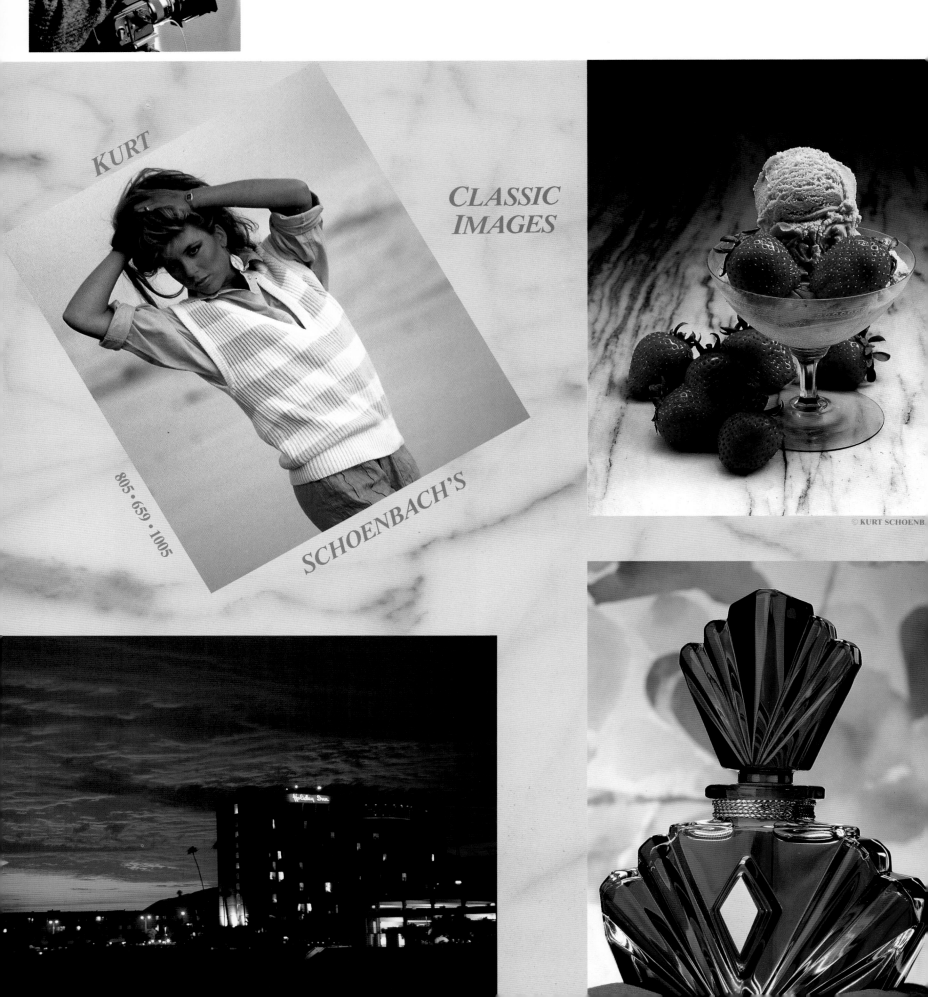

KURT

CLASSIC IMAGES

805 • 659 • 1005

SCHOENBACH'S

© KURT SCHOENB

Henry T. Schulz

Smith & Guilliatt Design Team
990 Industry Drive
Seattle, WA 98188
(206) 575-3233

Specialty: People, Location, Lighting

A graduate of the class of 1984. I've worked with Smith & Guilliatt Design Team for the past 4 years. Clients include: The Boeing Co., Brenco Enterprises, Cascade Coffee Inc., Cole & Weber, Continental Mills, Country Stoves, Eagle Hardware & Garden, Intermec Corp., MicroScan, Polyform U.S. Ltd., Red Dot Corp., Samson Ocean Systems, Weyerhaeuser Corp.

Cascade Coffee - Point of Sale Display

Intermec Corp. - Packaging

One Sport/Brenco - Trade Show Booth

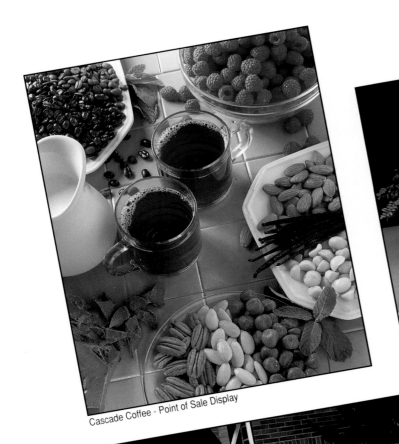

Greg James Productions - Advertising

Boeing Co./Cole & Weber - Advertising

A full service Graphic Design and production firm- Specializing in Marketing Support, Advertising and Collateral Materials that work! **WE MEAN BUSINESS!**

Graphic Design
Production &
Commercial Photography

R.T. Seymour

Still & Motion Inc.
2079 30th Street
Boulder, CO 80301
(303) 442-0400

Specialty: Advertising, Magazines, Stock, Cinematography

STILL: Sea Life Park, B.P. Inc., Hawaii; Heriot Watt University, Lothian Region S/W Dept. Scotland; Agrigenetics Corp., Celestial Seasonings, Century Media, Reading and Bates Offshore, Pulse Inc. C.A.N. / C.A.L. Dive Pty. Ltd.
& MOTION: Walt Disney Prod., BBC, Bill Burrud Prod., ABC, Discovery Channel, Lockheed Aerospace Division, Light House Prod. - Script writer, 33mm theatrical release, Lyon Prod. Port Royal Expedition, The Utilla Project, underwater cinematography.

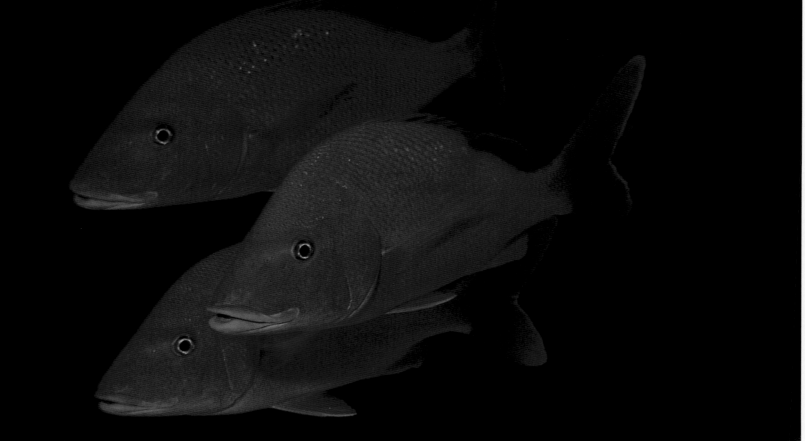

Roger Montgomery Short

Roger M. Short Photography
Post Office Box 850497
Yukon, Oklahoma 73085
(405) 354-9970

Accepting assignments for editorial as well as industrial, corporate and product photography. Annual reports, advertising catalogs and books.

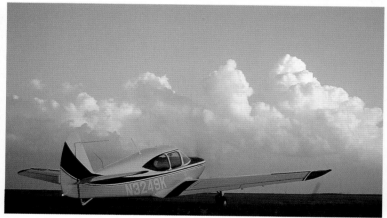

Jay Silverman

Jay Silverman Productions
920 North Citrus Avenue
Hollywood, CA 90038
(213) 466-6030 FAX (213) 466-7139

Specialty: Advertising Photographer and Director T.V. Commercials

Operating a state of the art production company in Los Angeles with a creative support crew of seven and an 8,000 sq. ft. facility, Jay is prepared to handle any challenges that come his way. His ability to capture people both real and famous has landed him both National and International accounts. In 1989 Jay broadened his creative base by producing and directing T.V. commercials in addition to print advertising.

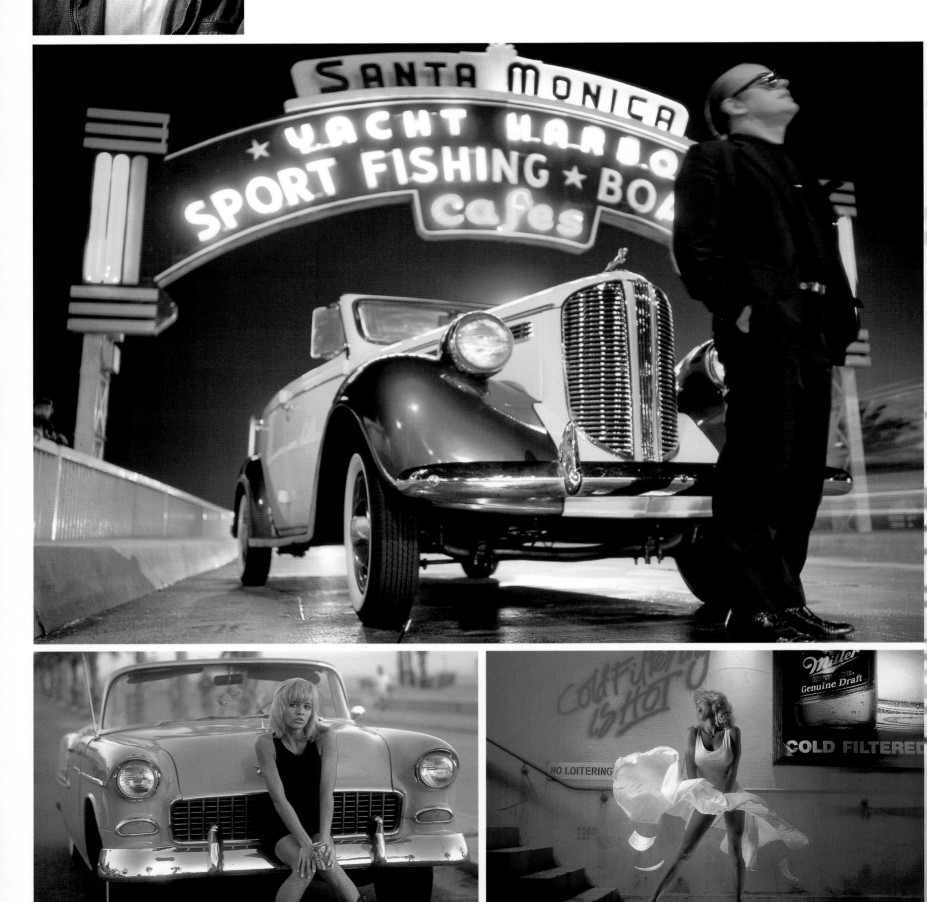

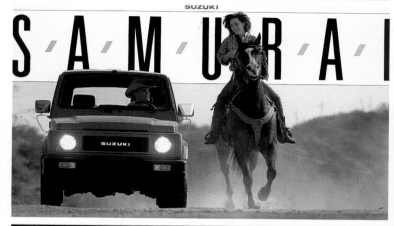

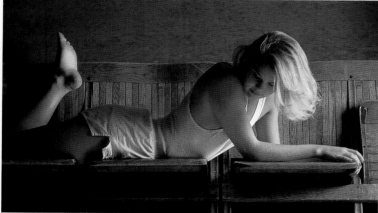

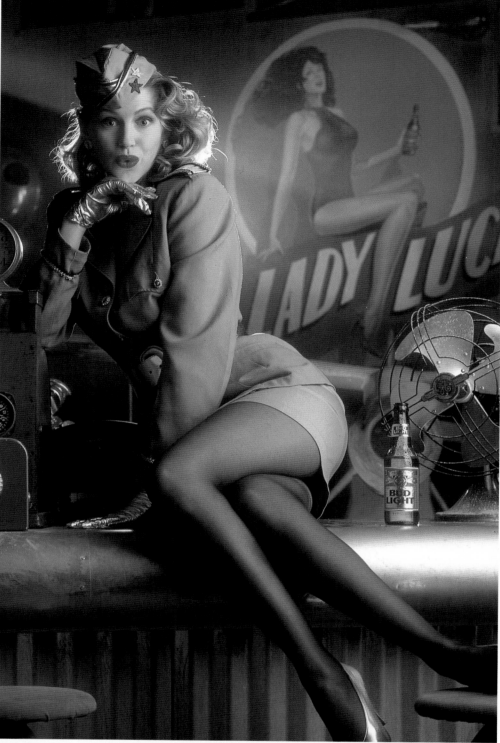

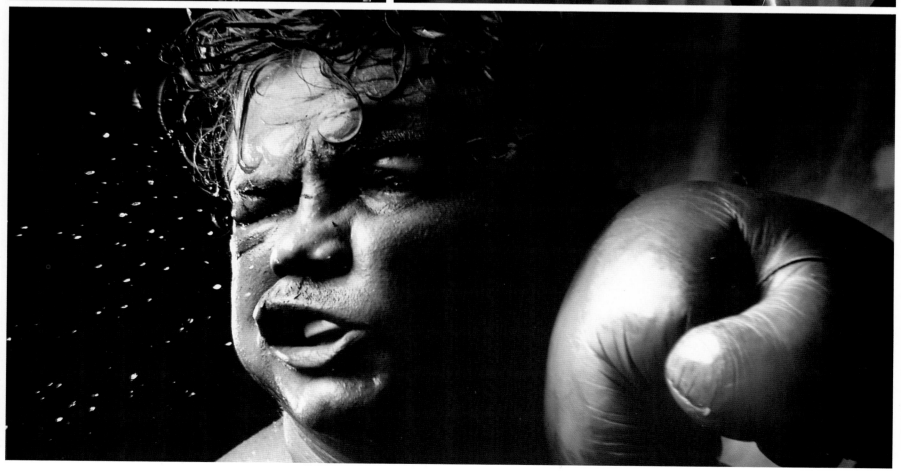

Robert G. Smith

Brooks Institute Faculty
Robert G. Smith Photographer
8995 Denver Street
Ventura, CA 93004
(805) 647-3522

Specialty: Fine Art, Portraiture and Corporate

Bob's work searches for the abstract and the visually exciting relationships between shape and texture. His work has been exhibited in numerous galleries and shows around the United States. Bob holds a BA and an MS from Brooks Institute and, after working professionally for many years, has returned to teach at Brooks where he is the Chairman of the Illustration Department.

Randall Spaur

Randall Spaur Photo-Graphics
887 Valle Vista
Vallejo, CA 94590-3542
(707) 553-8318

Specialty: Advertising, Architecture and Stock Images

Clients include: Snuffy's Magical Clown Review, Sons of September Productions, Spring Mountain Winery, Stewing Corporation, Today's Home Magazine (A Scripps Publication), United States Marine Corps and Wooden Valley Winery.

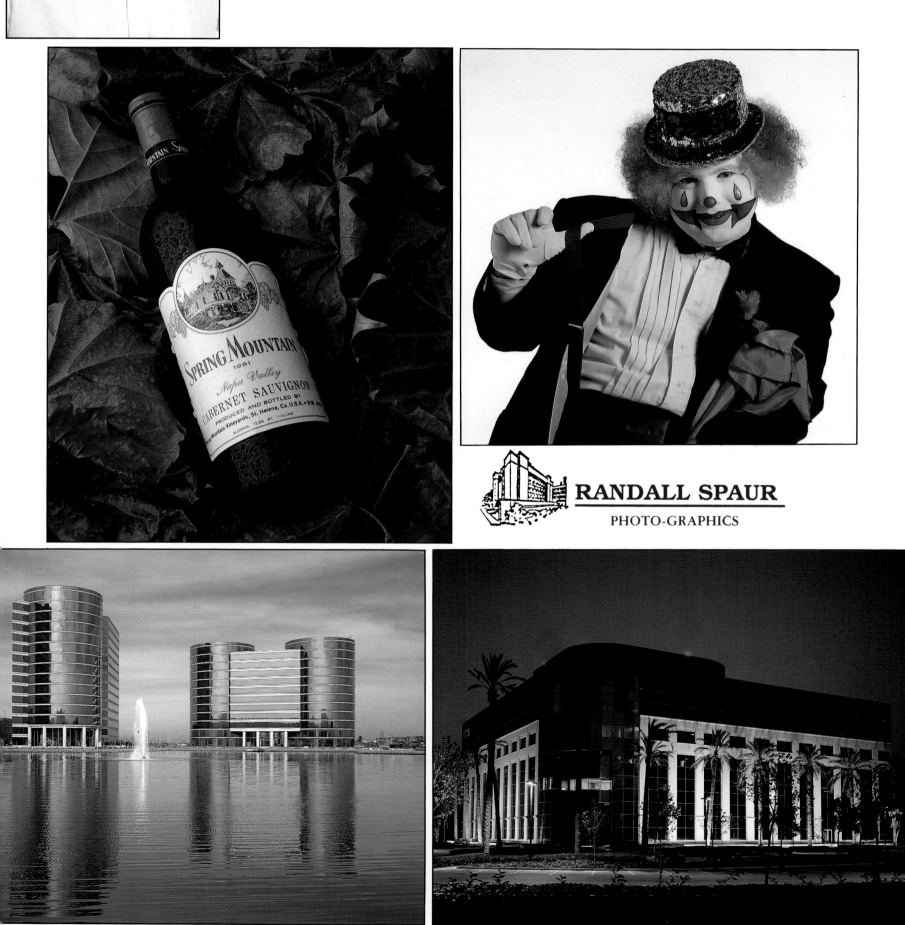

RANDALL SPAUR
PHOTO-GRAPHICS

Jim Stevens

Stevens Photography, Inc.
510 S. Mason Road, Suite A
Katy, Texas 77450
(713) 392-8708

Specialty: Commercial Photography

Stevens Photography, Inc. has been serving its clients for over five years with fine commercial photography, specializing in corporate portraiture both Color and Black & White.

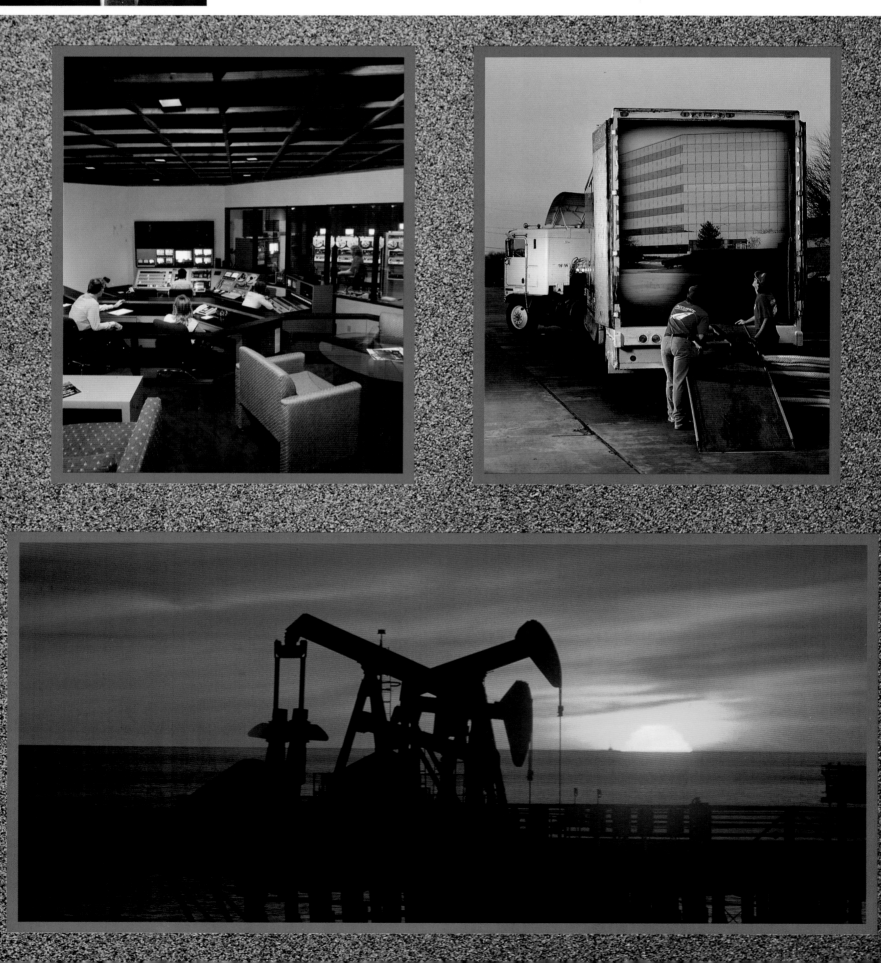

Jim Stevens

Country Park Portraits
510 S. Mason Road, Suite A
Katy, Texas 77450
(713) 392-8707

Specialty: Fine Outdoor & In-Home Portraiture

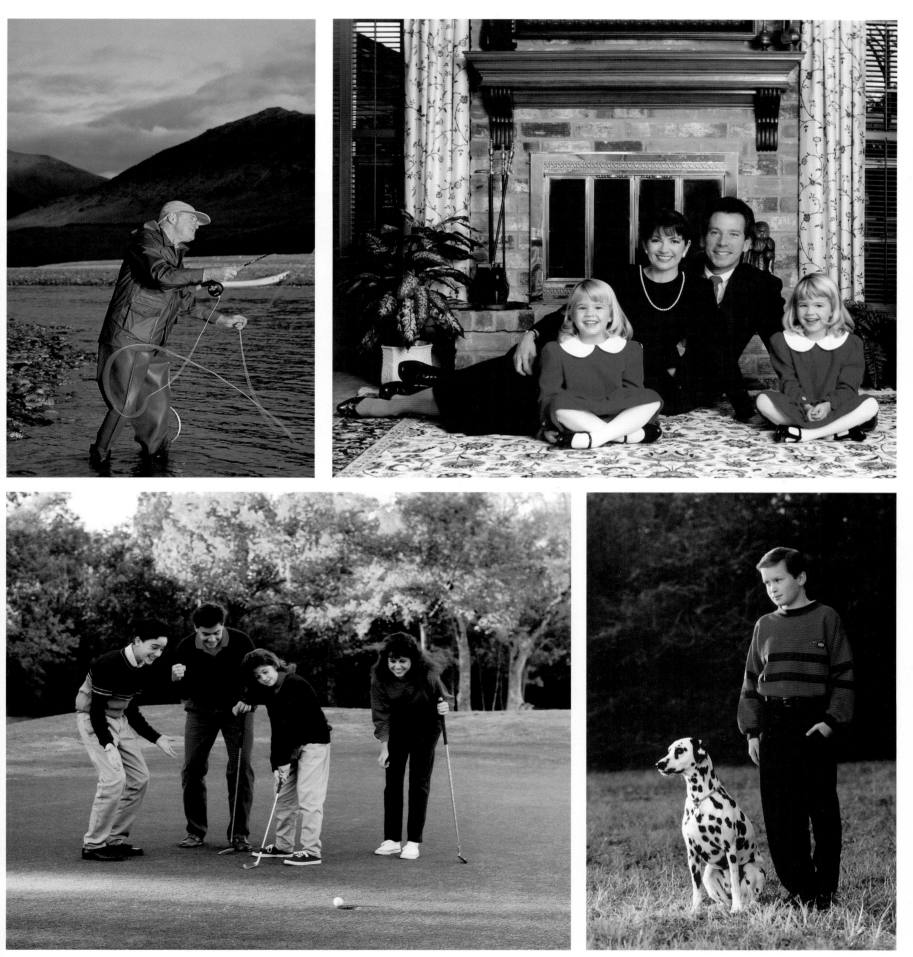

Chris Pflanzer and Victoria Summers

Visually Speaking Photography
5710 Atlantic Avenue
Long Beach, CA 90805
(213) 984-5250 FAX (213) 428-1944

Specialty: Product, People and Locations

Chris and Victoria met while still students at Brooks. After graduation, the resulting partnership grew, both personally and professionally, into the Los Angeles-based Visually Speaking. Chris, noted for his high-energy techniques, concentrates on people and corporate assignments, while Victoria specializes in product and the exquisite tabletop photographs that have become her hallmark. Their talent, enthusiasm and hard work have brought them to the attention of clients such as Makita, Marriott Hotels, Bell Helmets, Republic Pictures, Beno's, and Warner Brothers.

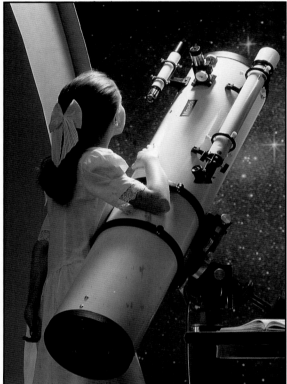

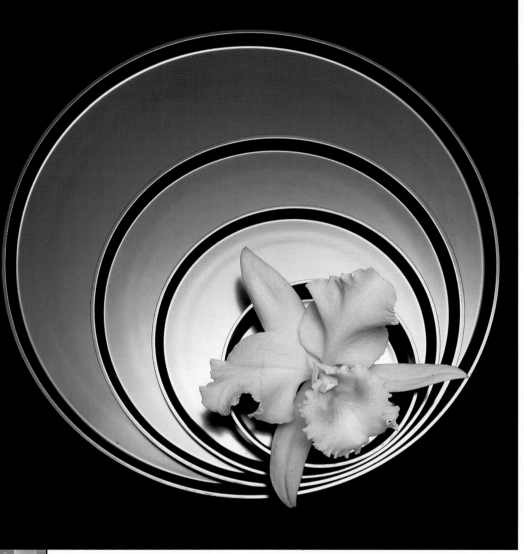

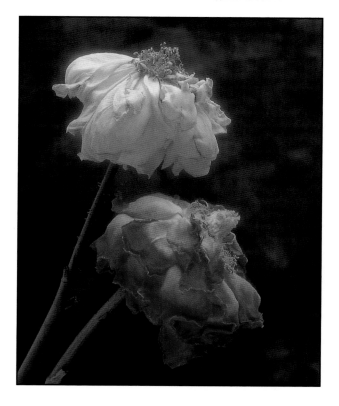
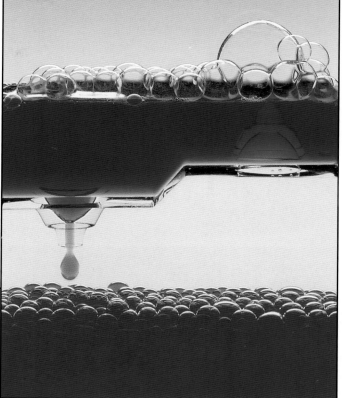
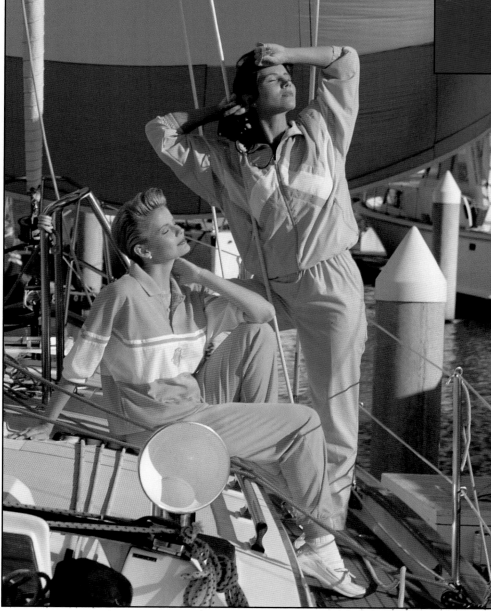
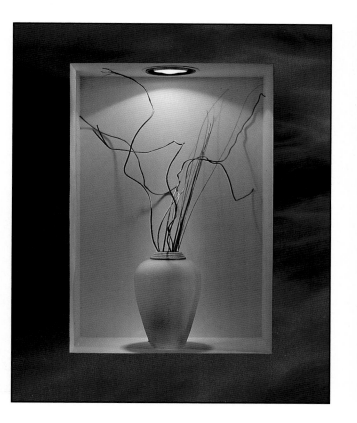

CHRIS PFLANZER and VICTORIA SUMMERS
5710 Atlantic Ave., Long Beach, CA 90805
(213)984-5250 • FAX (213)428-1944

Stephen Sperduto

Stephen Sperduto Photography
18 Willett Avenue
Port Chester, New York 10538
(914) 939-0296 FAX (914) 939-3577

Specialty: ## Innovative Solutions to Challenges

Stephen Sperduto Photography specializes in grace under pressure.
Strengths: People & Product Photography in studio or on location.
Services: Specialists in Prop & Food Styling, Set Design & Construction, Model Consultation & Booking, and Location Scouting.
Achievements: Results, Meeting Deadlines, Working within Budget.
Clients: Ad Agencies / Design Firms / Corporate Marketing Divisions.
Ambitions: Your Next Project. And The One After That.
Portfolio: Promotional Portfolio for future reference available on request.

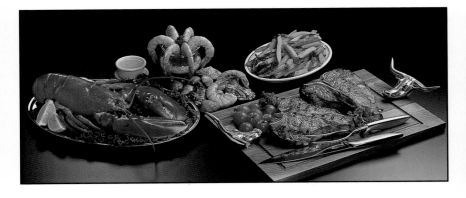

Joy Olsen Surbey

Surbey Photography, Suite 127
2510-G Las Posas Rd., P.O. Box 6041
Camarillo, CA 93011
(805) 987-9835

Specialty: ## Photography through the Microscope

Joy Olsen Surbey has created "MICROSCAPES," landscapes from the Lilliputian world of a polarizing microscope. With over 600 to choose from, these images can form backgrounds for copy or transform walls with art for the imagination and the soul. They range from soft, muted, continuous tones to riotous colors and designs and everything in between. From out of the ordinary world of nature, an extraordinary art form.

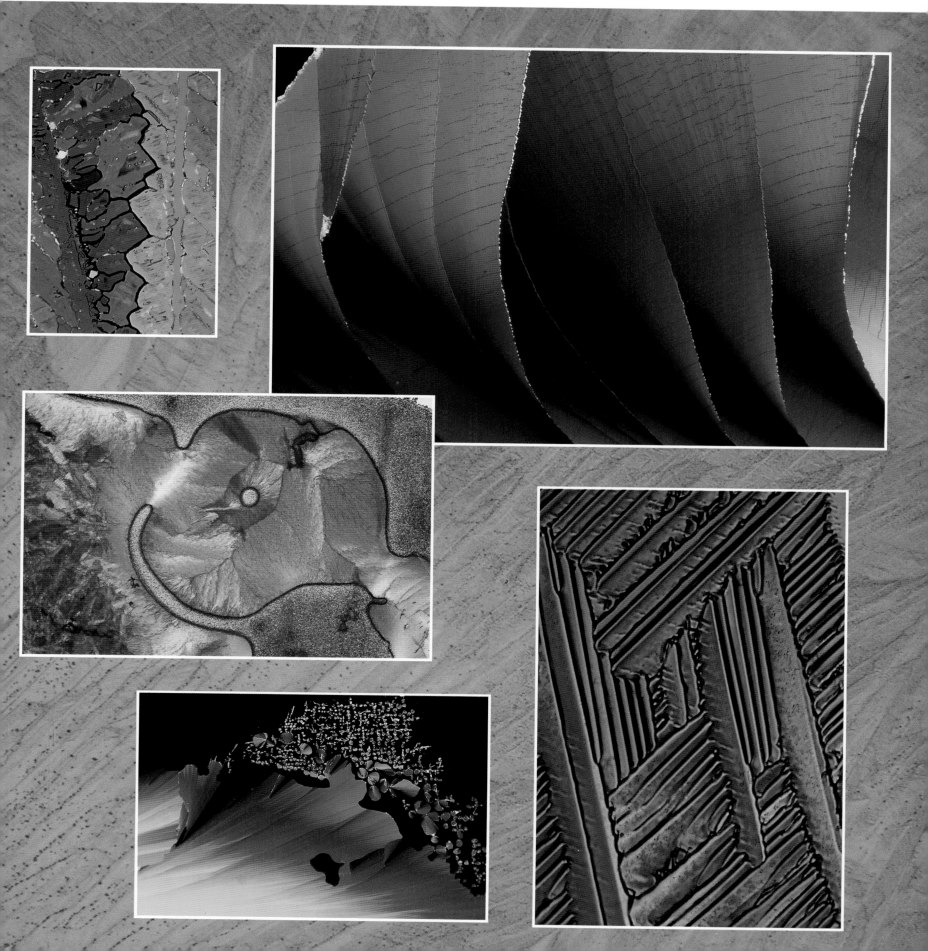

Kan Suzuki

Laquan Studio
1-4-11 Honcho, Kichijoji
Musashino, Tokyo 180 Japan
0422-21-2111

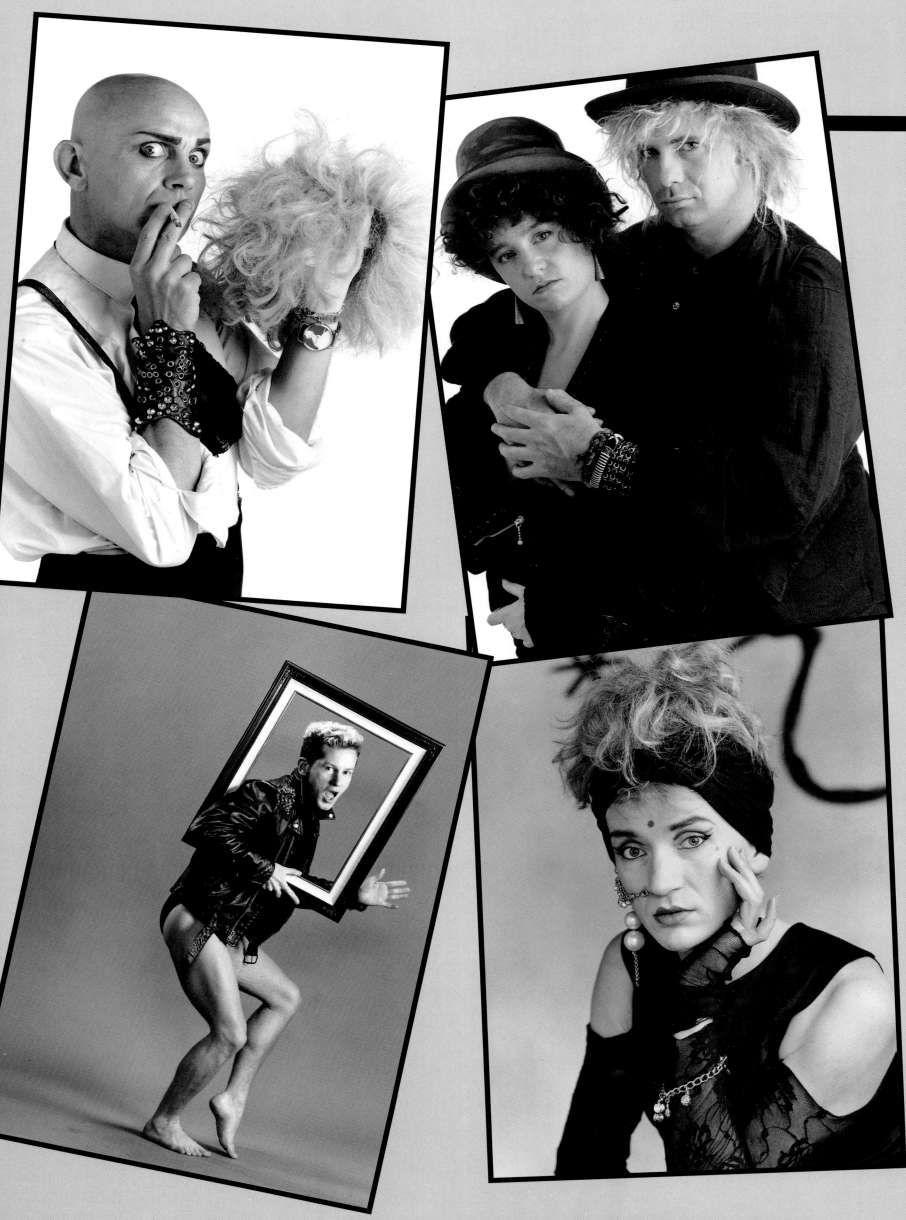

LAQUAN STUDIO

Terry Thibeau

Thibeau Studio
P.O. Box 917
Cardiff, CA 92007
(619) 632-8057

Specialty: Commercial/Location Lighting

Clients include: Bullocks Wilshire, Chickendale's, Hoist Fitness Systems, Horton Plaza, Hyatt Regency, I. Magnin, Jazzercise, Marie Callender's, NCR, the N.F.L. (New Orleans Saints, San Diego Chargers, Washington Redskins), Paramount Pictures, San Diego Magazine, See's Candies, Solo-Golf and Toyota.

TOYOTA

NEW ORLEANS SAINTS

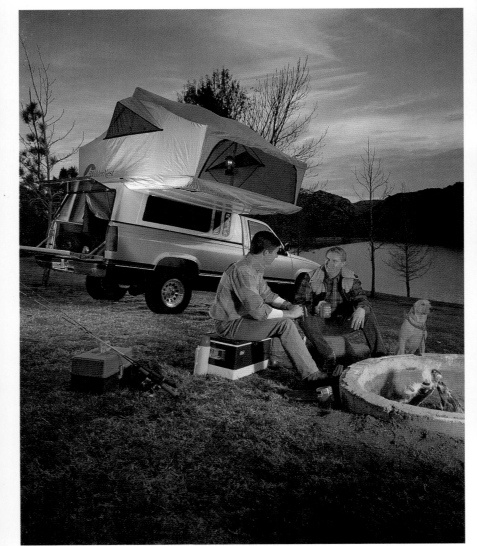

WILDERNEST CAMPERS

FINELIGHT

BOSTON & MAINE FISH CO.

REBORN AUTO

TERRY·T
THIBEAU
STUDIO

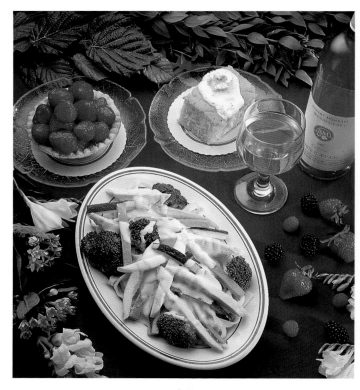
MARIE CALLENDER'S

HOIST FITNESS SYSTEMS

Gary Tarleton

P.O. Box 183
Corvallis, Oregon 97339
(503) 752-3759

Specialty: Architectural, Industrial and Corporate

Published in magazines such as *Architecture Record, Progressive Architecture, Fine Home-building, Roads and Bridges, Corporate Design and Realty, Celebrate Health* and *Newsweek.* Clients include: GM, IBM, Sperry/Unisys, Northwestern Bell Telephone, Henningson Durham and Richardson Inc., Mobay Chemical, CH2M Hill, Honeywell Marine Systems, U.S. Forest Service, and Oregon State University. Member ASMP.

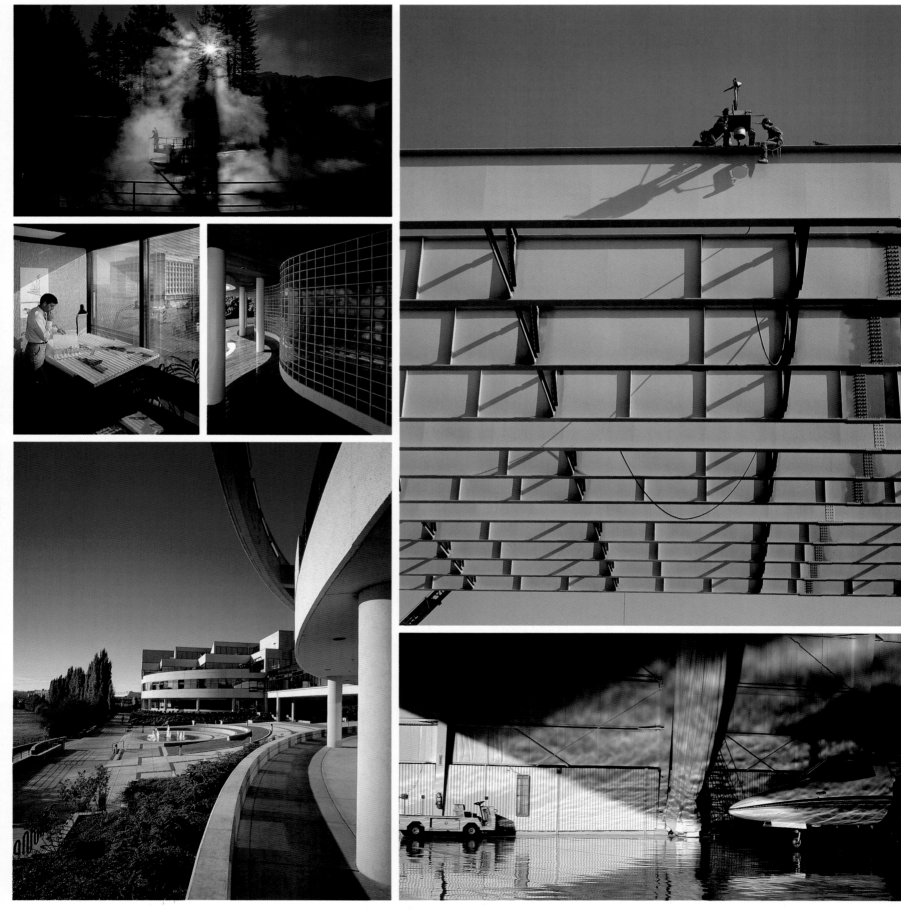

Larry Tibbetts & Randy Carlson

Multi Media Communications
5380 Overpass Road, Studio B
Santa Barbara, CA 93111
(805) 967-8922

Specialty: Advertising, Corporate, Annual Reports

We listen to what our clients need, want, wish for and can't live without. Then we create; in color or B&W, with or without art direction, in our studio or on location. Then we listen to their comments, and they (hopefully) continue to use words and phrases we have heard before, such as, innovative, patient, attention to detail, congenial, dynamic, creative . . . really, just ask them, General Motors, DuPont, Husky Oil, Sunkist, Johnson & Johnson, McGraw Hill Publishing, Sheraton Hotels, United Airlines, Scandinavian Airlines, General Electric and more. So give us a call, give us a shot.

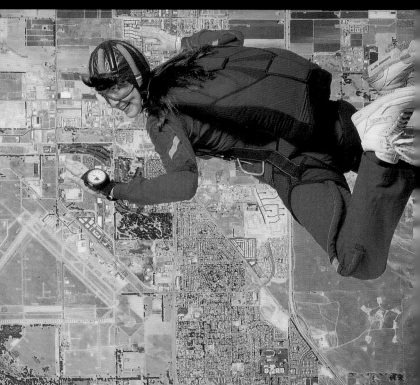

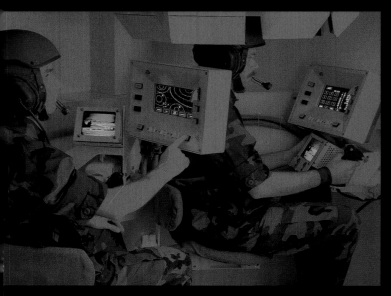

John Tinker

3133 Maple Drive, Suite 200
Atlanta, GA 30305
(404) 237-1760

Specialty: Advertising/Corporate/Digital Imaging

Clients include: American Express, FMC, Amoco, Kawasaki,
Coca-Cola USA, I.B.M., Ciba-Vision, Charter Medical,
Chevron Oil, Dunhill International Ltd., Hewlett-Packard,
Eastman Kodak, Polaroid, AT&T, Kimberly-Clark and Valvoline Oil.

P.C. MAGAZINE

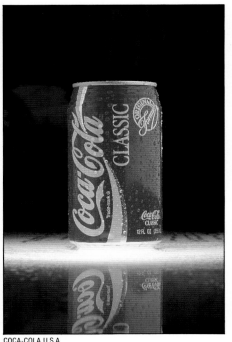

COCA-COLA U.S.A

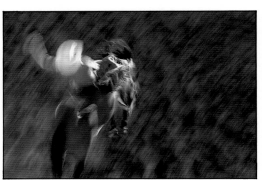

R.J. REYNOLDS/WINSTON

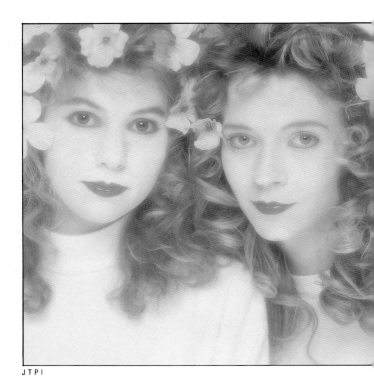

JTPI

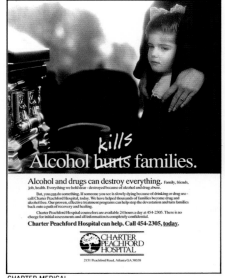

CHARTER MEDICAL

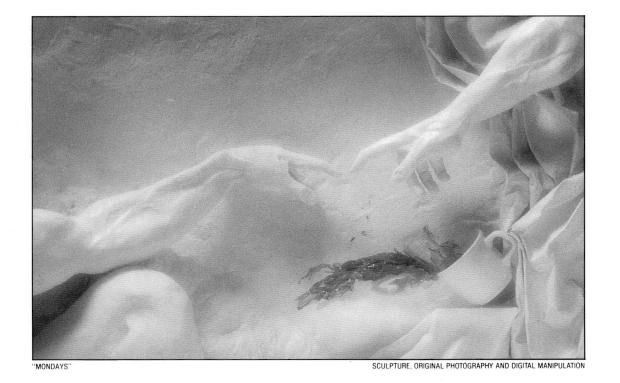

"MONDAYS"

SCULPTURE, ORIGINAL PHOTOGRAPHY AND DIGITAL MANIPULATION

Tracy Trotter

Director of Photography
Represented by: THE DIRECTORS NETWORK
Contact: Susie Goldberg, Steve Lewis
(818) 506-3696 FAX (818) 506-4662

Specialty: National Commercials

Clients include: Goodyear, Jamaica Tourist Board, Diet Coke, Minute Maid, Perry Ellis, Maxwell House Coffee, Southern California Gas, Frusen Gladje, Disney, Wrigley's Gum, GTE, Miller's Outpost.

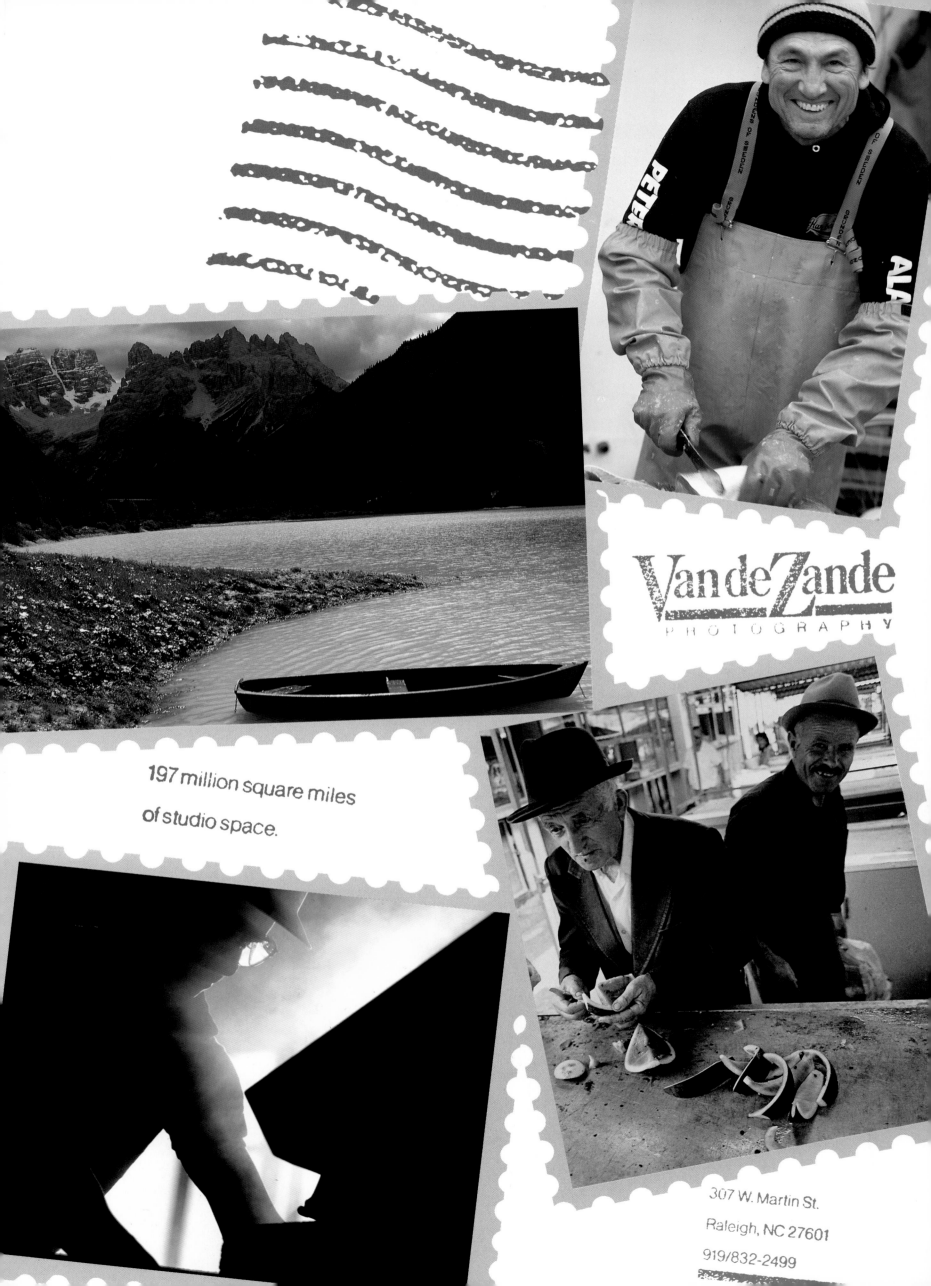

197 million square miles
of studio space.

VandeZande
PHOTOGRAPHY

307 W. Martin St.
Raleigh, NC 27601
919/832-2499

Doug Van de Zande

Van de Zande Photography
307 W. Martin Street
Raleigh, NC 27601
(919) 832-2499 FAX (919) 832-2499

Specialty: Studio & Location

Client include: American Airlines, Black & Decker, Blue Cross/Blue Shield, CBS Records, Cooper Tools, Country Journal magazine, Fruedenburg Spunweb, General Electric, Glaxo, Hardee's, Howard Johnson's, IBM, Kaiser Permanente, Martin Marietta, McDonald's, Memorex Telex, Northern Telecom, Radisson, Linda Stuhmer, Texasgulf, U.S. Floor Systems, United Way, Westinghouse, Willamette Industries.

Rilla B. Underwood

Rilla B. Underwood - Photographer/Artist
P.O. Box 67
Carpinteria, CA 93014
(805) 684-1244

Specialty: Nature Animals People

Rilla Underwood, native of Western Colorado Rockies, now resides and teaches photography and art in Santa Barbara. She holds degrees in both Art and Photography from the University of Northern Colorado, and Brooks Institute of Photography in Santa Barbara, California. Her work has appeared in *Modern Maturity, Western Horseman, Horse and Horseman, San Diego Magazine, Santa Barbara Magazine, Landmark* and *Walden Calendars*, various trade magazines and publications. Her paintings are in private collections of Paul Hogan, Linda Kozlowski, Jeremy Railton, the Ollie Carey estate, Rancho Monte Alegre, and other collections and galleries nationwide. Member ASMP—Recipient of the Soroptomist TAP Award two years running.

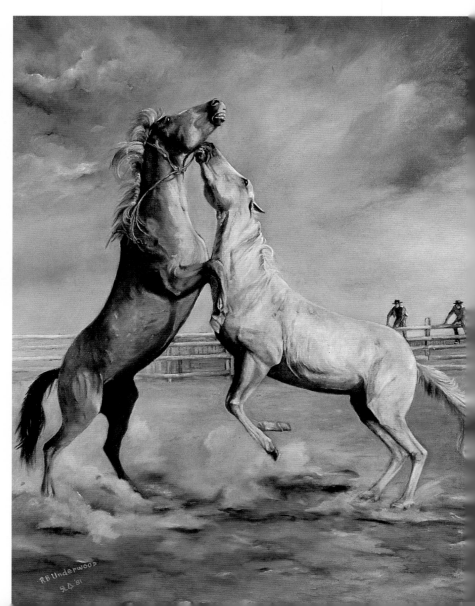

Michael Verbois

Brooks Institute of Photography
Administration/Faculty
801 Alston Road
Santa Barbara, CA 93108
(805) 966-3888

Specialty: Travel Photography

As Vice President of Brooks Institute, Mike has broadened the scope of the curriculum. He has taught in several areas of the school as well as numerous workshops, sharing his experince in commercial/advertising, corporate, and industrial photography. Mike has worked as the designer/creative director and photographer on several books and brochures. Additionally, he has traveled extensively, led photographic safaris to Africa and was the photographic faculty member on the Fall '88 voyage of the University of Pittsburgh's Semester at Sea program.

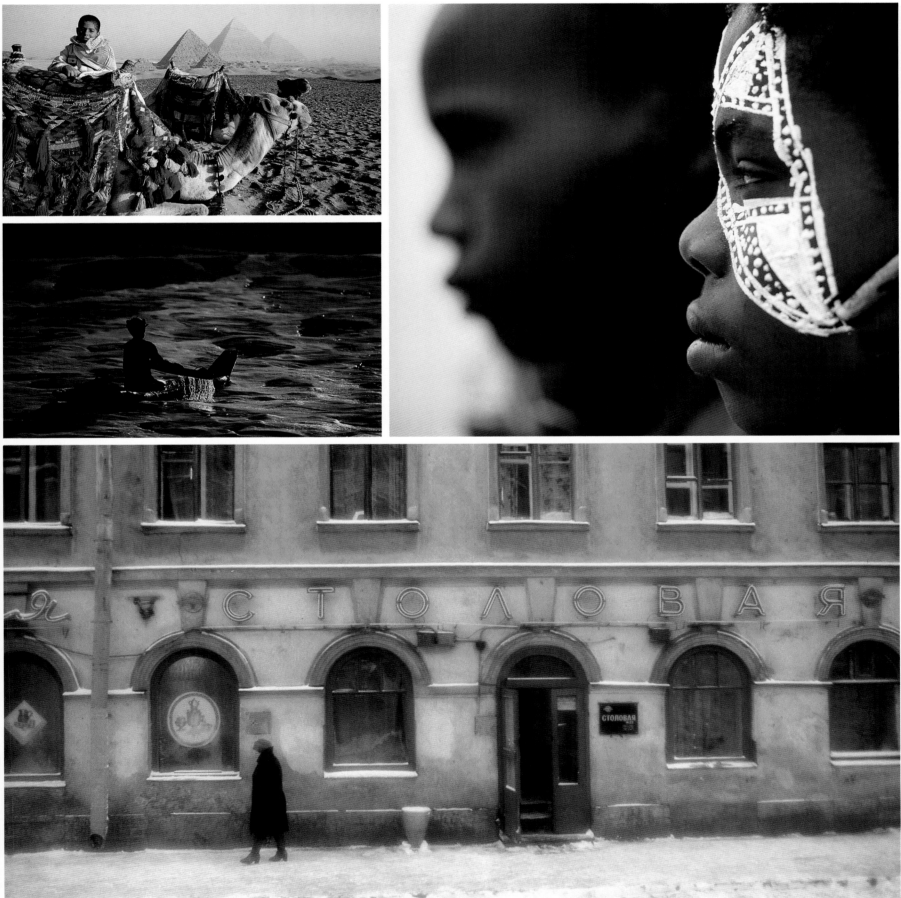

Peter Vogel

Peter Vogel Photography
528 Canal Street #4
New York, NY 10013
(212) 274-0435

Specialty: Portraits, Fashion

J. Kent von Isser

von Isser Photography
2329 North Tucson Blvd.
Tucson, Arizona 85716
(602) 323-9008

Specialty: Commercial/Illustrative
Portraiture/Wedding

Studio and location photography for jobs including Annual Reports, Architecture, Advertising Illustration, Corporate, Editorial, Product Still Life, Lifestyle & Traditional Portraiture, Weddings and almost any other application where still photography is required.

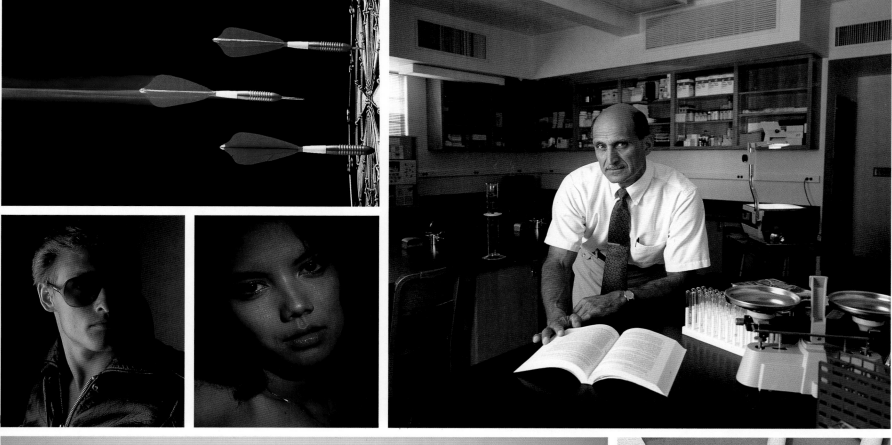

William G. Wagner

Wagner Photography
208 North Avenue West
Cranford, New Jersey 07016
(908) 276-2002

Specialty:

I Photograph Everything!

In the seventeen years that I have been in business I have won numerous state, national and international awards for a prestigious group of clients.

A partial list of those clients includes: Victor Hasselblad, Sinar Bron, Ilford, AT&T, Johnson & Johnson, Pentax Instruments, Smithkline & French Laboratories, Merck & Co., Inc., Fisons Pharmaceuticals, Parke-Davis, Warner Lambert, American Cyanamid Co., Schering Plough, Abbott Laboratories, Siemens Corporation, Shop-Rite Food Stores, Foodtown Food Stores, North American Philips Lighting Corp., and Santori Liquors.

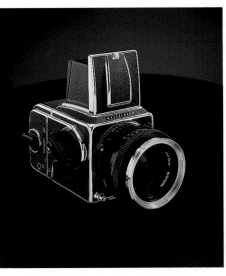

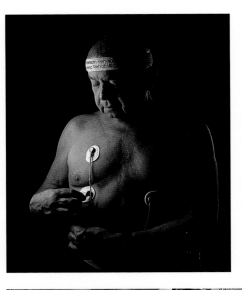

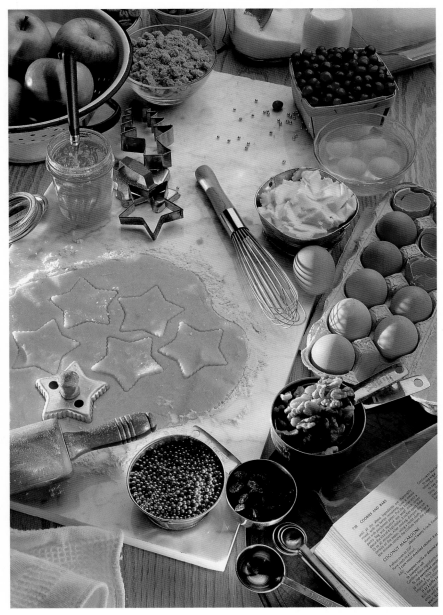

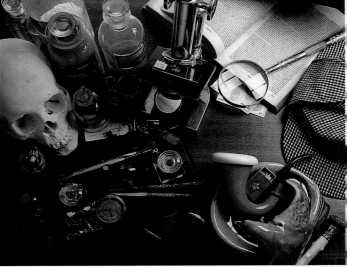

Lisa E. Wallace

Light Language
117 West Coal Avenue
Gallup, NM 87301
(505) 722-5850

Specialty: Photo Illustrator

Lisa Wallace believes the studio environment should not be a cold, dispassionate backdrop. Lisa's small, personal photography studio, located among the red cliffs in Gallup, New Mexico, allows for a less hectic pace and more time to be spent with clients. She specializes in caring about problem solving, working closely with customers to understand their needs, adding her personal sense of style and taking the time necessary to obtain the image the client requires. Lisa has perfected the art of jewelry presentation in photography and is considered one of the best photographers in the Southwest for capturing the essence and beauty of Native American jewelry and crafts. Her work has appeared in a wide range of magazines from *Rolling Stone* to *Southwest Art*.

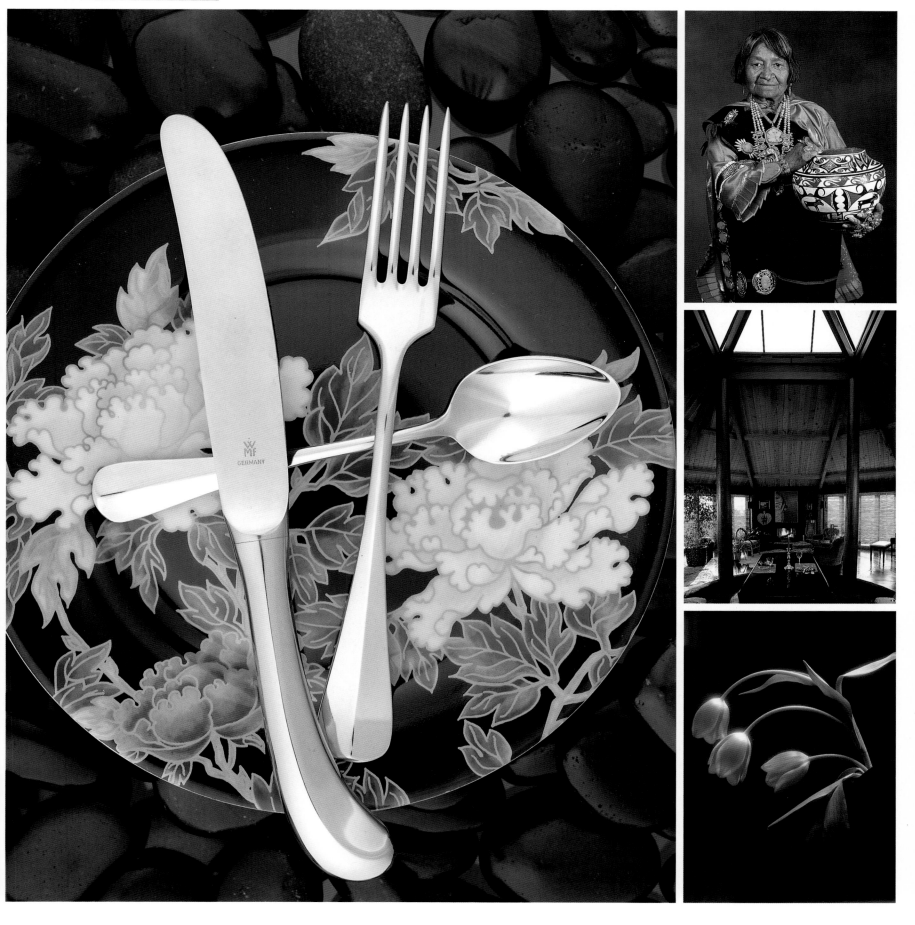

Steve Welsh

Welsh Photography
1191 Grove Street
Boise, Idaho 83702
(208) 336-5541

Specialty: Commercial/Location

Clients include: Boise Cascade, Weight Watchers, Ore-Ida, Simplot, Micron Technology, Zilog, Hewlett Packard, U.S. Bancorp, Trus Joist, West One, Morrison Knudsen, Smith Sport Optics, Kit RV's.

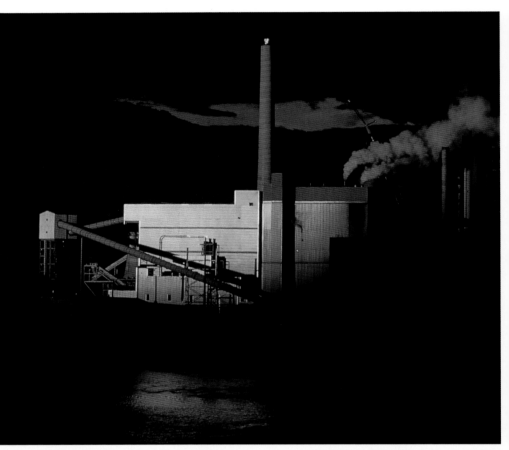

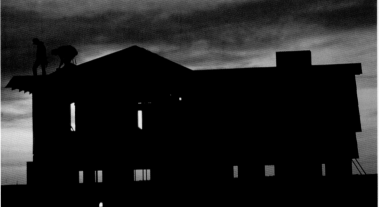

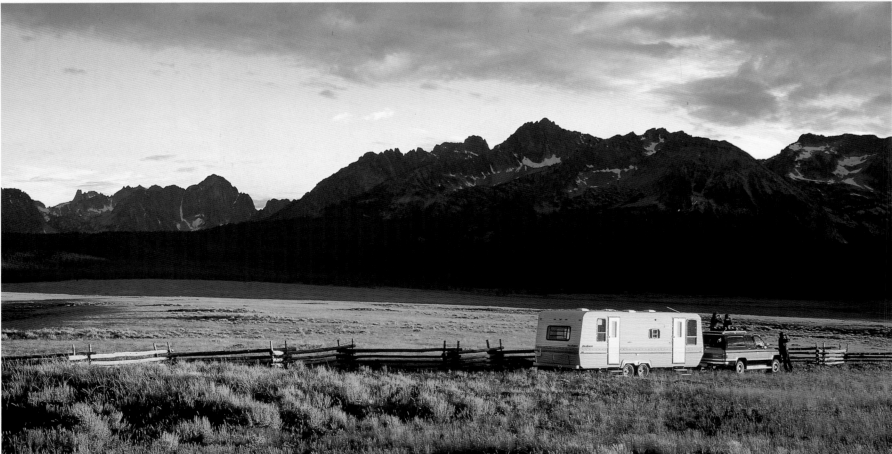

Bob Werre

Bob Werre Photography
2437 Bartlett Street
Houston, Texas 77098
(713) 529-4841 FAX (713) 529-4130

Specialty: Studio/Location, Advertising & Corporate

I have 20 years experience in finding and creating images for an array of interesting clients. I use a blend of problem solving, design, quick thinking, sensitivity and patience to make every project a success.

Brian Willecke

Brian Willecke - Photographer
4205 Stadium Drive, Suite 150-B
Fort Worth, Texas 76133
(817) 926-6250

Specialty: ## Commercial/Illustration/Catalog

Clients include: Miller Brewing Company, DacEasy Inc., Memorex (Memtek Products), Sears (Hessco), YMCA, Morgan Spas, Soloflex, Pangburn Candy Corp., Samsill Corp., NTS, Tecnol, Craftmade International, Uniplast, Stevens Graphics Corp., Clarke Products, Decotrol, Bluff Manufacturing, Master Media, Sweet Publishing, Sneeds Jewelers, Media Recovery, Panther Industries, Overton Park Bancshares.

Sonny Williams

Sonny Williams Photography, Inc.
555 Dutch Valley Road, N.E.
Atlanta, GA 30324
(404) 892-5551 FAX (404) 872-1336

Specialty: Corporate / Advertising

Clients include: Aaron Rents, Inc., Bank South, The Coca-Cola Company, HBO & Company, HealthQuest, IBM, ITW/Paslode, Medical Economics Magazine, Southwire, Sports Illustrated for Kids, Thomson Co., Yamaha Golf Carts.

©Michael Lothner

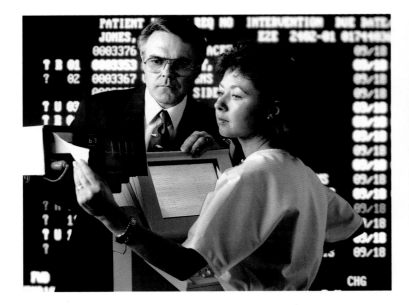

SONNY WILLIAMS
PHOTOGRAPHY, INC.
555 DUTCH VALLEY RD.
ATLANTA GEORGIA 30324
4 0 4 · 8 9 2 · 5 5 5 1

Robert L. Winner

Brooks Institute Faculty
Robert Winner Photography
P.O. Box 42246
Santa Barbara, CA 93140-2246
(805) 684-6338

Specialty: Contemporary Commercial Photography

Prior to joining Brooks Institute, Rob created images for such companies as May Company, Nikon, Nike, Tokina Optical Corporation and many others. He continues to work professionally, staying abreast of the ever-changing technology in today's photographic industry. He recently returned from documenting ten countries around the world as the photographic faculty aboard the S.S. Universe, a floating campus sponsored by the University of Pittsburgh.

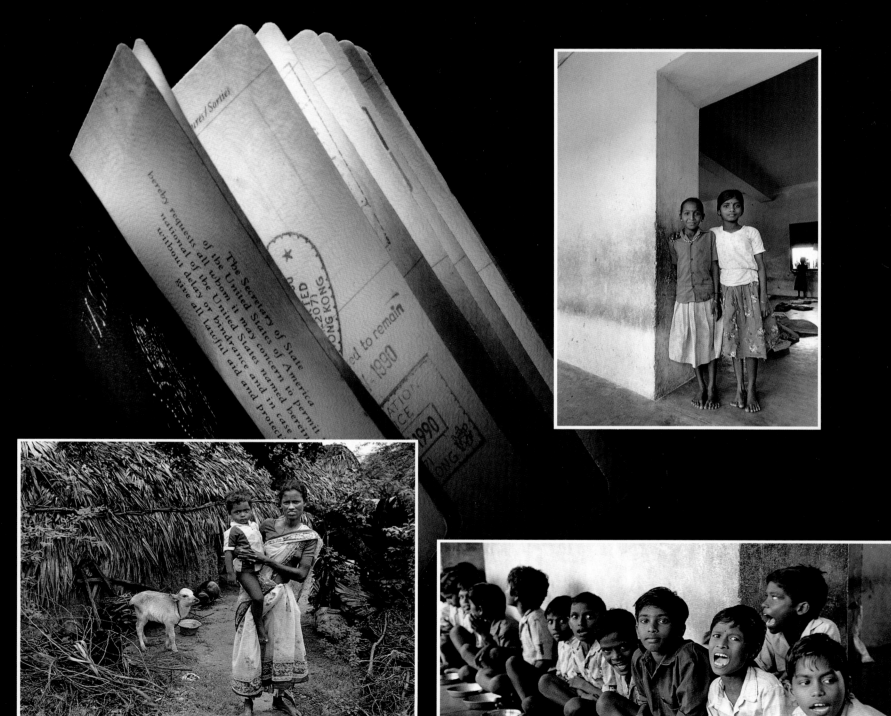

Monie Photography

Monie Photography
15 East Valerio #A
Santa Barbara, CA 93101
(805) 682-9603

Specialty:

Specialty: People and Places

Monie Photography, a Santa Barbara based photographer, specializes in capturing the warmth of people. Among her clients are: Hospice, Cottage Hospital, Visiting Home Nurse Association and Success Systems. Her work has appeared in *Fine Homebuilding, Prime Real Estate, Veterinary Publishing, The Independent* and *Working Woman* and several fashion publications.

Monie Photography
15 East Valerio
Santa Barbara, CA 93101
(805) 682-9603

Charlie Yapp

Yapp Studios, Inc.
723 West Randolph Street
Chicago, Illinois 60661
(312) 558-9338 FAX (312) 558-9337

Specialty: Photographic Illustration for Advertising

Charlie operates his studios in the Windy City, producing print ads for national and local accounts such as: Quaker Oats, Borden, Bell and Howell, Siemens, Corona Beer, Hyatt, Maremont, Hill and Knowlton, Iroquois Popcorn, McDonald's, Stone Container, Eureka X-Ray, Fenner Fluid Power, Heller Spice, Beatreme, Nutra Sweet, and many other great clients.

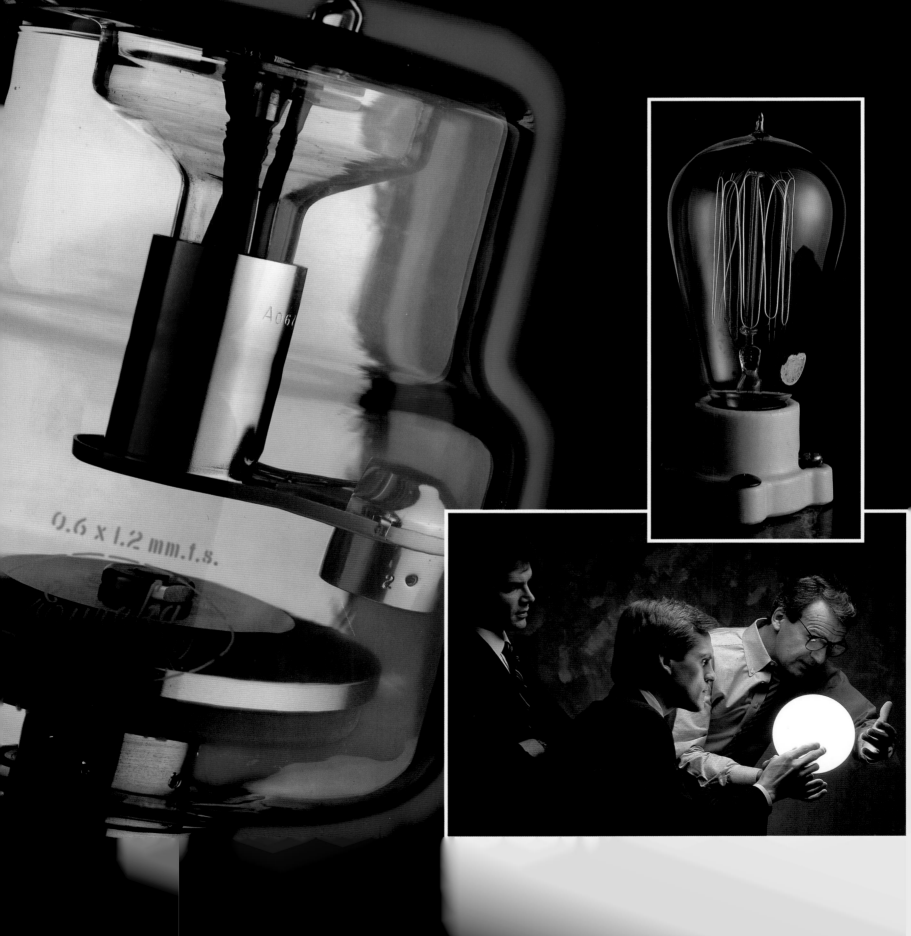

Although the photographic styles may differ, our foundation is the same – we all attended Brooks Institute. We now offer you a look into the unique learning environment from which our careers have grown.

ALUMNI ASSOCIATION
BOARD OF DIRECTORS

Robert Carothers
Jim Childress, President
Robert Copeland
Donald Kish
Jesse Lopatynski
James Macari

Doug McLaughlin
Steven R. Nelson
Douglas Peck
Robert Ranoa
Brian Ratty

Brooks Institute Today...

"It is the mission of Brooks Institute of Photography to continually strive to be a recognized world leader in photographic and motion picture education. In our undergraduate and graduate programs, Brooks Institute offers the highest level of academic and technical instruction in the widest range of photographic specialties. Our goal is to create a technical and creative learning center for students in an environment where freedom to explore and develop individual capabilities is encouraged. Brooks Institute is committed to providing an intellectual and technical foundation to students and professional photographers which will serve to enhance visual communications worldwide."

This was the vision of Ernest H. Brooks when he founded the school in 1945. It was at this time that he recognized the void in professional photographic education. His goal was to establish a school combining the talents of experienced faculty and a carefully structured curriculum. He realized that as photography became more complex, the traditional method of apprenticeship was no longer a valid means of acquiring the skills necessary in an industry of changing demands.

In 1945 he opened the first campus with about 30 students in the downtown area of Santa Barbara, California. Currently spread over three beautiful campuses with 600 students from 40 different countries, Brooks Institute has become the reality of Ernest Brooks' dream. In 1971 Mr. Brooks turned the leadership of the school over to his son, Ernest H. Brooks II, who has served as President of the Institution since. Under his guidance the school has become more international in its scope and has adapted rapidly to keep up with the changing technology associated with the visual communications industry.

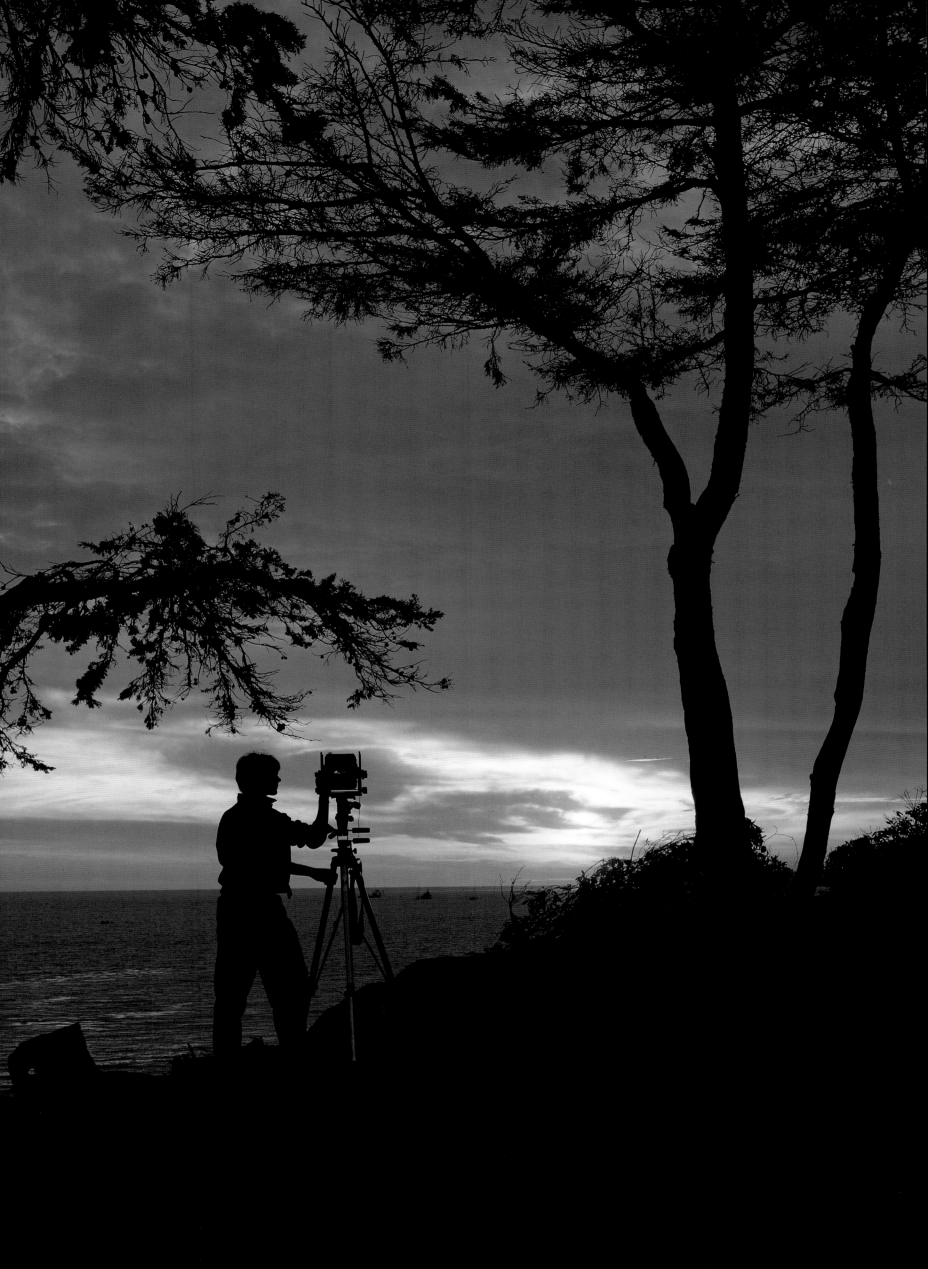

The great challenge in education is to turn ideas into experience. The curriculum at Brooks is designed precisely to do just that. Students are given assignments that simulate on-the-job professional situations and then, together with faculty, engage in a comprehensive review of the work to assure that maximum creative and technical effort has been expended. After a year of concentration in the photographic fundamentals, students can choose from a

wide variety of majors leading to a B.A. or M.S. degree in the following photographic disciplines: advertising/illustration, industrial/scientific, media, motion picture/video, portraiture, commercial, or color technology.

The Institute recognizes that those involved in image making must be able to think critically and analytically; to write and speak well; to witness the power of expression, not only through film but through literature and the arts. Thus, great emphasis is placed on the General Education and Business courses, completing the educational framework for a successful profession in photography, film, or video.

Committed to the education of our students is Brooks' outstanding faculty. These are dedicated, experienced, award-winning professionals with the unique ability to impart their knowledge. Their work has been featured in publications such as National Geographic, Oceans, and Time magazines. Their contributions have appeared in advertising and editorial campaigns for major companies; they have written, directed, and produced movies and television shows, and have photographed and filmed all over the world.

The program is further enhanced by the Institute's state-of-the-art photographic equipment and facilities housed on the school's three campuses. Our newest facility, the Media Center, located in downtown Santa Barbara is fully outfitted with two sound stages, flatbed film editors, audio mixing, film and video projection, and a Beta editing bay for broadcast quality video post production.

The magnificent Montecito campus, a twenty acre wooded estate with breathtaking views of Santa Barbara and the Pacific Ocean is home to the color technology department, portrait studios, black and white laboratories and the admissions office.

Overlooking Santa Barbara and the Channel Islands is the Jefferson Campus where most classes are conducted and the administration offices are located. The latest addition to this facility is the "Cove": a double-ended studio with curved floors and ceilings, ideal for automobile photography. The world renowned Brooks Photographic Library is also housed at the Jefferson campus with over 5,000 volumes of photographically oriented books, and twenty-year collection of trade publications and technical pamphlets.

Without question, Brooks Institute provides one of the most distinctive and attractive educational environments in the world.

There is no location more ideally suited for a photographic school than Santa Barbara, California. Here, students can develop their skills and expand their photographic vision in this culturally enriched, beautiful location on the Pacific Coast.

Cradled by the Santa Ynez Mountains on one side and the Pacific Ocean and Channel Islands on the other, Santa Barbara offers a truly inspirational educational environment. Home to numerous art galleries and museums, Santa Barbara also sponsors an International Film Festival and boasts proudly of its civic orchestra. Even though it is a relatively small population of about 80,000, Santa Barbara enjoys many amenities found only in large cities. Once a major center for motion picture production, this coastal paradise continues to be home to many top writers, producers and actors. Though conveniently close to Los Angeles and San Francisco and well serviced by road, rail, and air transportation, Santa Barbara enjoys the unique flavor of a small, friendly community, free from the frantic pace of a bustling metropolis.

Students from Brooks can be seen on street corners, at the beach, in front of the Mission, at the Harbor, on the Wharf, all shooting assignments to stretch their creative and technical abilities. With its quality of life and comfortable climate it's no wonder that Ernest Brooks Sr. chose Santa Barbara for his photographic institution. Santa Barbara — an ideal location for an institution which nurtures creativity and launches careers in visual communications.

For almost fifty years the philosophy of the educational process has been to maintain a foundation of essential techniques balanced with the student's creative freedom. This serves to insure the success of a graduate as they move into the professional arena and face the everchanging technologies dealing with visual communications.

When a single still photograph is not enough it is often necessary to combine images in a variety of innovative and creative ways. Through audio visual, motion picture, and video courses, students create projects that open up a whole new world in visual communication. This is a high tech and rapidly evolving area in which the imagination is the only limitation.

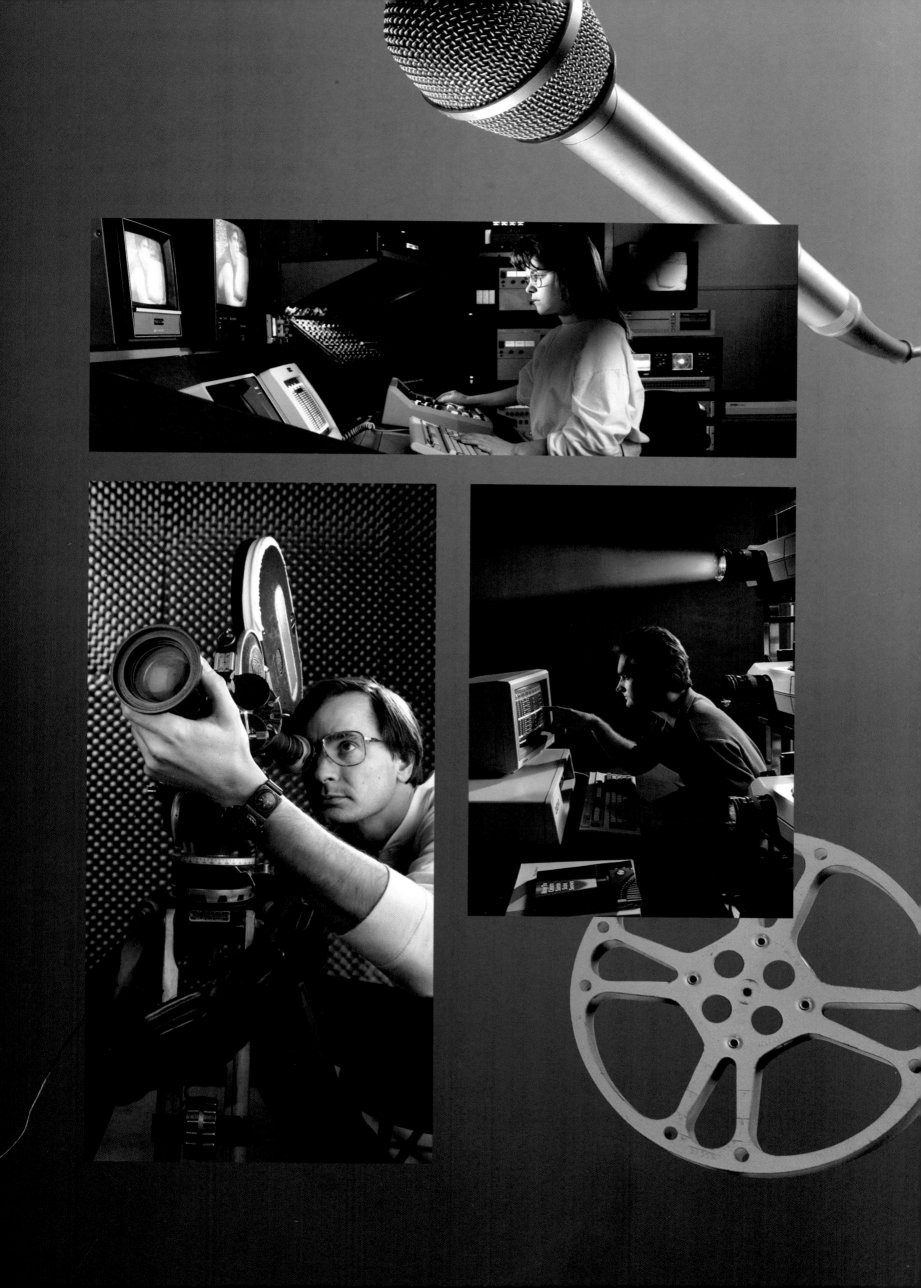

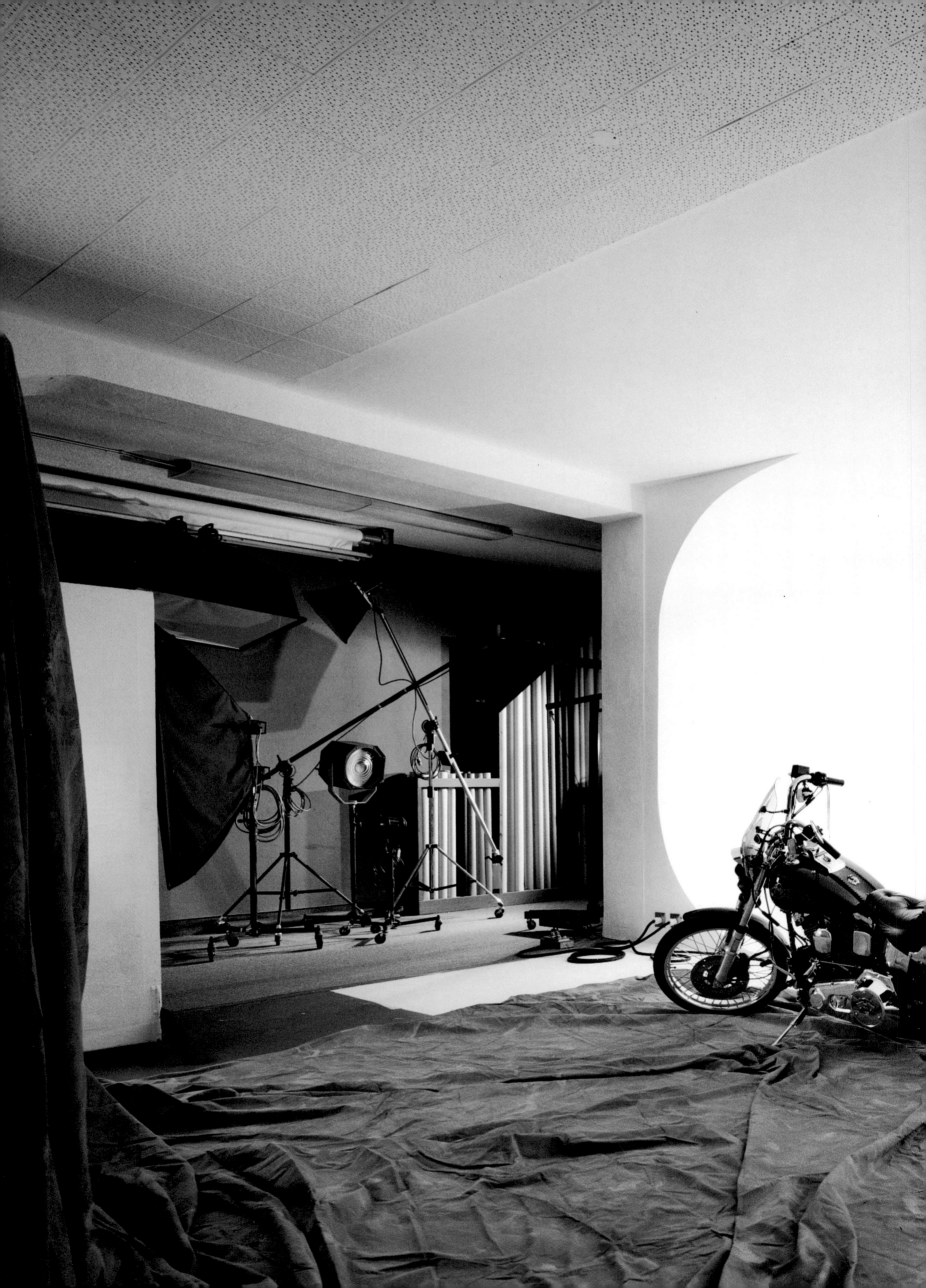

State-of-the-art facilities, which often mirror the studios and locations of professional photographers, enhance the students' overall educational experience. These real-world working environments prepare students for a smooth transition into the profession.

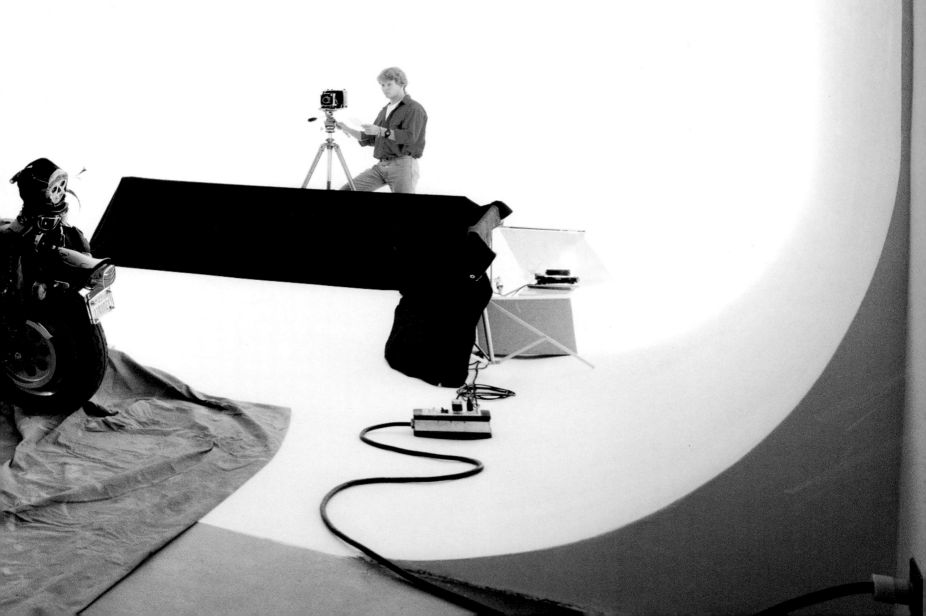

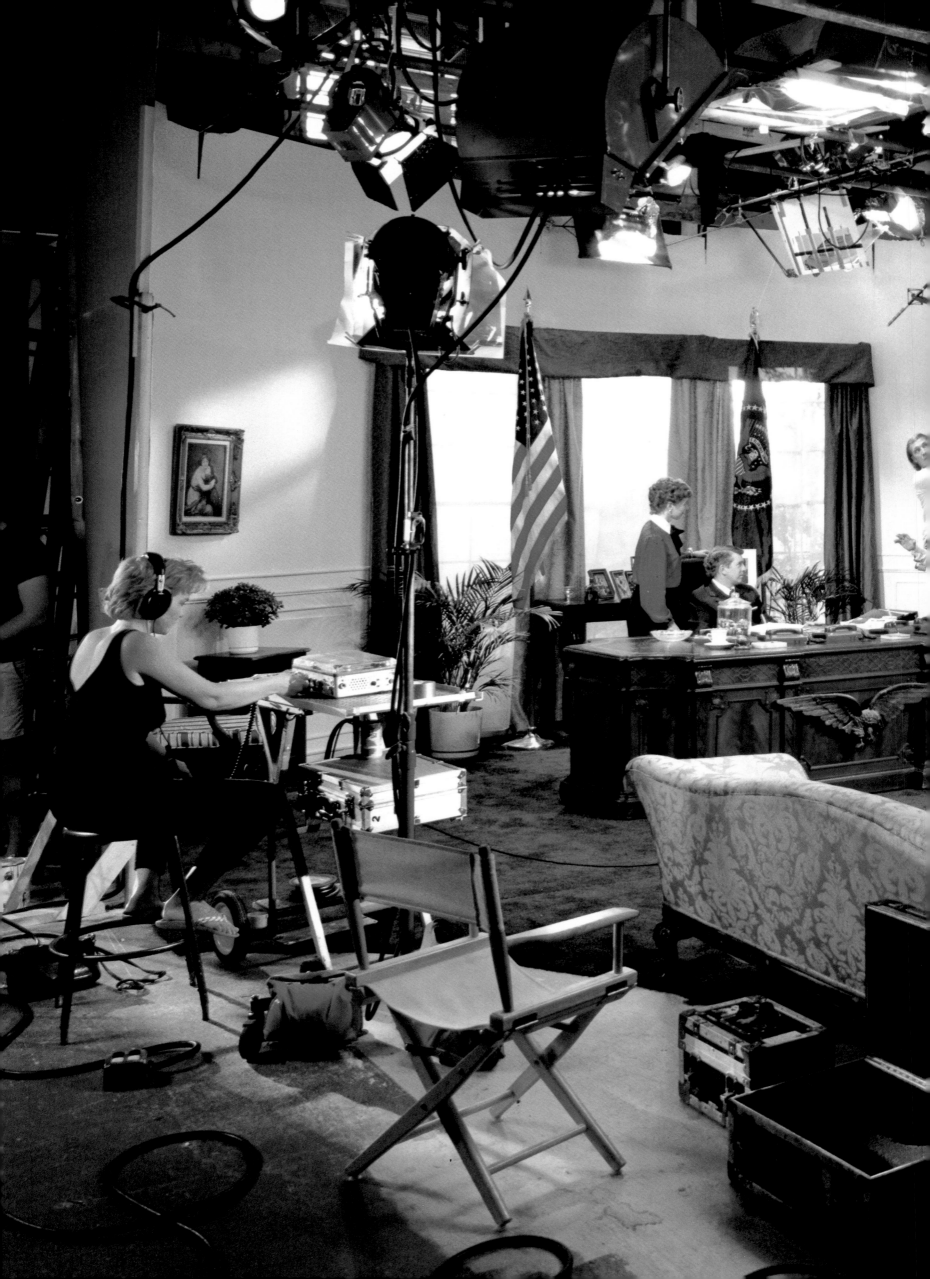

Large set construction is an integral component of the motion picture program. Students often share responsibility and work in production teams on major projects.

Future Alumni...

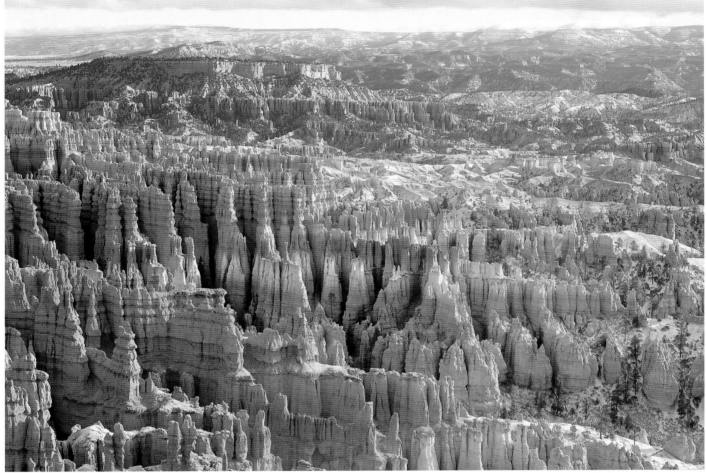

Cheryl Opperman

Chalermpon Poungpeth

Tim Mantoani

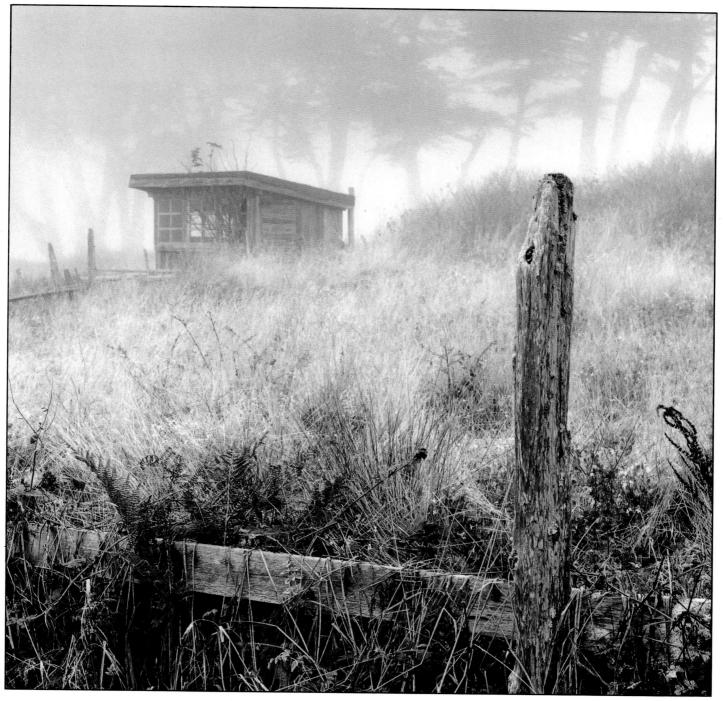

Dale Horchner

Cheryl Opperman

Tracey Maurer

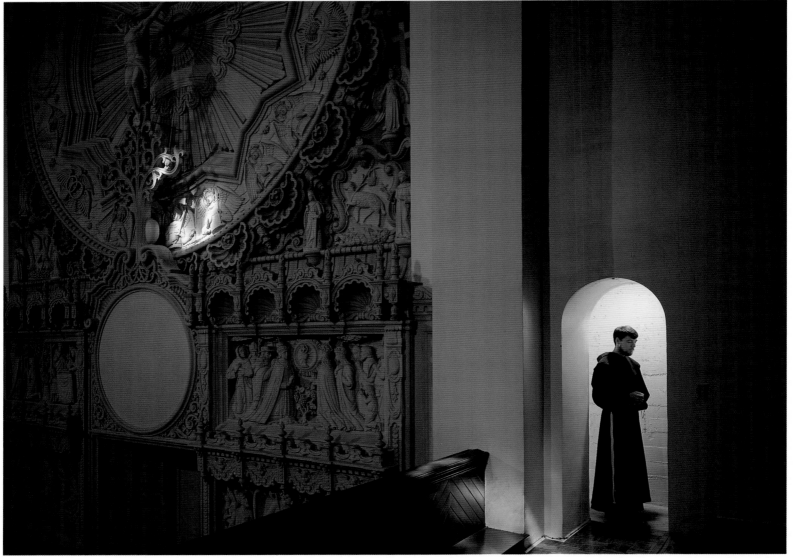

Ricardo Belcher

W. Thomas Seawell IV

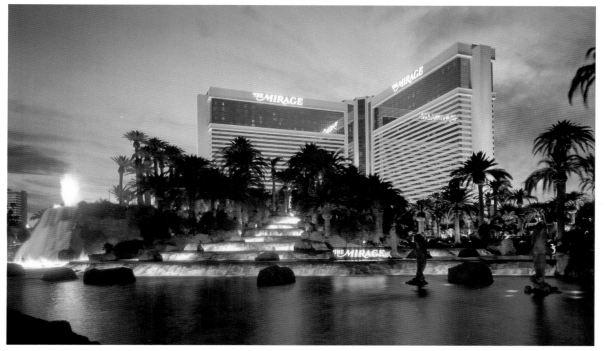

W. Thomas Seawell IV

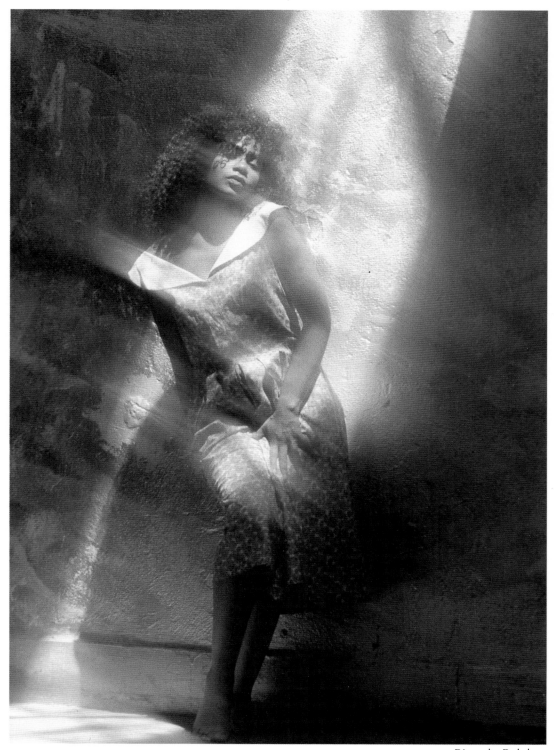

Ricardo Belcher

189

Erhard Pfeiffer

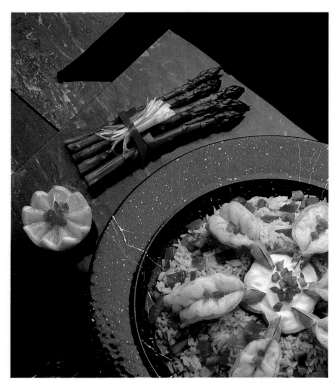

William Cash

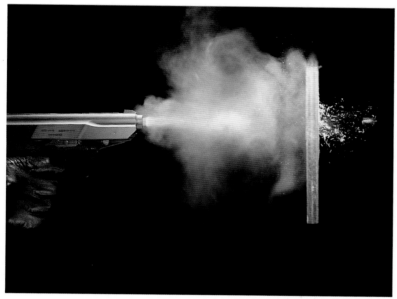

Louise Walker and Lisa Roote

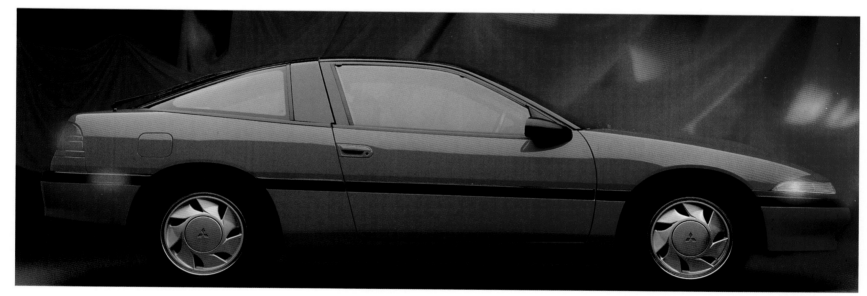

William Cash

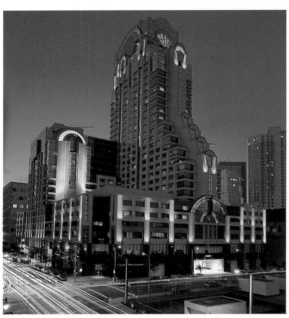

Erhard Pfeiffer

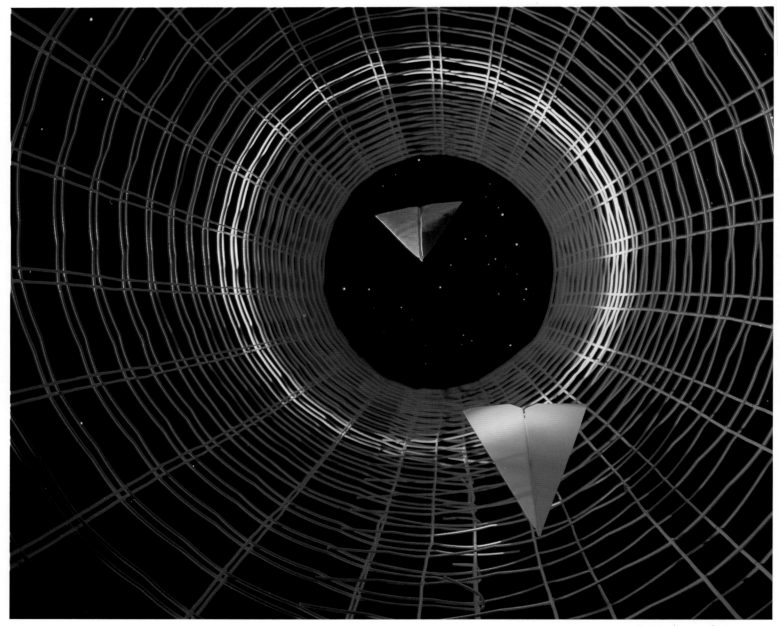

Ravindra Nath Papineni

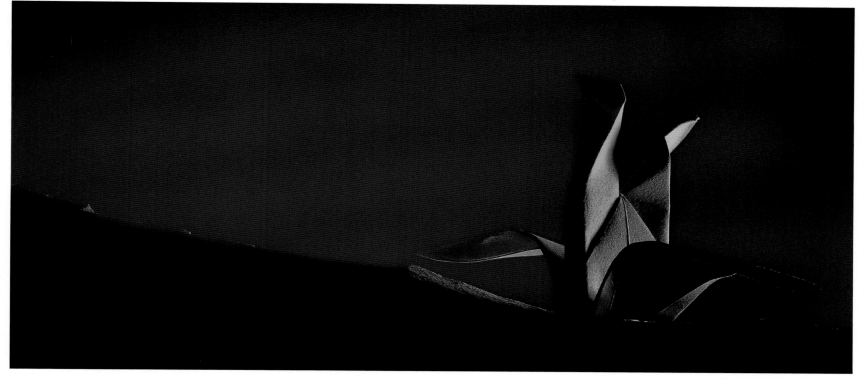

Chalermpon Poungpeth

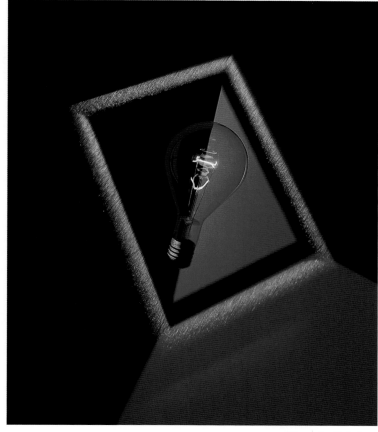

Ricardo Belcher

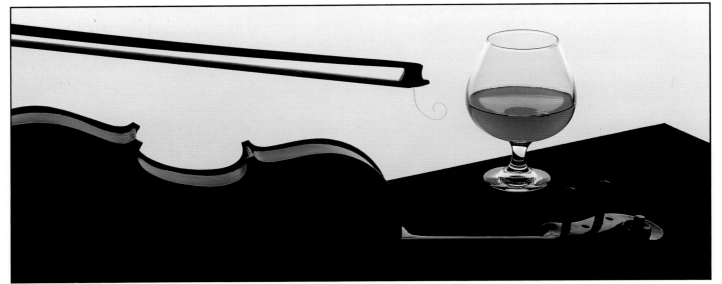

Phil Shockley

Chalermpon Poungpeth

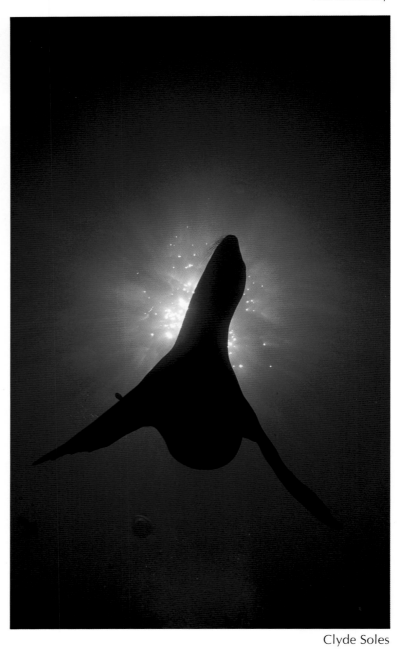

Clyde Soles

Bruce Kendall

William Cash

Chalermpon Poungpeth

Chalermpon Poungpeth

Michael Darter

Michael Darter

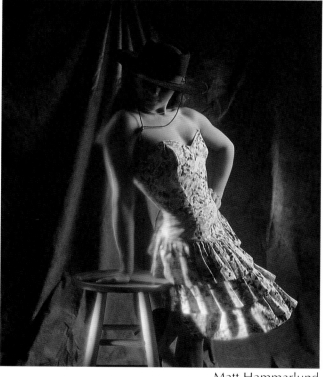

Matt Hammarlund

Brooks Institute Alumni Directory

Brooks Institute Alumni Association
801 Alston Road
Santa Barbara, CA 93108
(805) 966-3888

ALPHABETICAL LISTING

– A –

AASHEIM, Helmer T. '46
56 Kimberly Court
Napa, CA 94558
ABBOTT, Brian S. '84
1334 12th St. Unit "D"
Manhattan Beach, CA 90266
ABBOTT, Douglas K. '82
3814 Amberwood Ln.
Bakersfield, CA 93309
ABBOTT-DALTON, Sally '87
3558 Avenida Amarosa
Escondido, CA 92025
ABERNATHY, James L. '79
224 Louisa
Ferguson, MO 63135
ABOLIN, R.W. "Ozzie" '57
309 Los Encinos St.
San Jose, CA 95134
ABRAHAM, Carol Jeanne '88
932 Cheltenham Way
Santa Barbara, CA 93105
ABRESCH, Zoraida '83
P.O. Box 21453
Santa Barbara, CA 93121
ABROMS, Edward '83
11815 Hesby St.
N. Hollywood, CA 91607
ABRUSCATO, Lawrence '72
P.O. Box 5604
Santa Barbara, CA 93108
ABTEY, Jean Pierre '70
234 Los Alamos
Santa Barbara, CA 93109
ACCARDO, Nathan J. '57
2120 West 59th Street
Shawnee Mission, KS 66208
ACEVEDO, Lourdes '82
Empresa #108-2 Mixcoal
Mexico, DF 03920, Mexico
ACKERMAN, Arnold D. '78
P.O. Box 715
Kealakekua Ko, HI 96750
ACKERMAN, Ronald B. '75
70 Walnut Valley Dr. R.D. #12
Springfield, IL 62707
ADAMS, Carolyn A. '90
230 Painted Cave
Santa Barbara, CA 93105
ADAMS, Paul R. '74
1061 River Haven Cir.
Birmingham, AL 35244
ADAMS, Wayne R. '77
13933 Dittmar Dr.
Whittier, CA 90605
ADAMS, William '66
114 Blake Ave.
Greenwood, SC 29646
ADELMAN, Brian '72
13904 Fiji Way #333
Marina Del Rey, CA 90291
AEBY, James T. '80
11450 S. E. Mather Rd.
Clackamas, OR 97015
AEGISSON, Thor '87
Undraland 6
Reykjavik, 108, Iceland
AFORISMO, Robert '62
480 New Britain Ave.
Rocky Hill, CT 06067
AGER, Sharon S. '76
1653 Lake Front Road
Lake Oswego, OR 97034
AGINS, Judd '86
2973 Harbor Blvd., #111
Costa Mesa, CA 92626
AGUIAR, Ruben L
1281 Hudspeth St.
Simi Valley, CA 93065
AGUILAR, W. Barry '75
129 Orano Road
Los Lunas, NM 87031
AGUINALDO, Edward
8350 Burnet Ave #32
Sepulveda, CA 91343-6645
AHERN, William '69
33 W. Franklin St.
Centerville, OH 43459
AHLBOM, Steven B. '70
417 Fairfax Dr.
Exton, PA 19341
AHMED, Mohamoud
P.O. Box 1617
Khartoum, Sudan
AIRTH, David '80
1721 Harbor Way
Seal Beach, CA 90740
AKERS JR., Charley '77
1200 Foster St .
Atlanta, GA 30318
AKTUTAY, Duhndar '58
P.O. Box 282
Hollywood, CA 90028
ALBERN, Donald W. '77
848 Keko Dr.
Loveland, CO 80537
ALCON, Jodye '86
5603 Lake Lindero Drive
Agoura, CA 91301
ALDINGER, Charlie '78
9919 Mimosa Path
Salinas, CA 93907
ALDRICH, Larry R. '76
7440 Old Pacific Hwy. North
Castle Rock, WA 98611
ALEXANDER, Rick L. '70
7112 New Town Rd.
Weddington, NC 28173
ALFTER FIELDING, Judy M. '84
P.O. Box 2562
Bakersfield, CA 93303
ALI, Amina M. '86
31397 Mound Rd B
Warren, MI 48092
ALKIRE, Candace '88
1209 S E 6th Terr
Cape Coral, FL 33990-2905

ALLEN III, James B. '85
4534 Maryland Street
San Diego, CA 92116
ALLEN, Donald '57
5241 Dam Lake Road
Eagle River, WI 54521
ALLEN, Frank L.
430 East Silver Lake Rd
Oak Harbor, WA 98277
ALLEN, Glenn B. '83
12-B East Cota
Santa Barbara, CA 93101
ALLEN, Jimmie E. '75
5600 W Lovers Lane 212
Dallas, TX 75209
ALLEN, Robert J. '73
148 Allston Ave.
Worcester, MA 01604-3344
ALLEN, Tom E. '87
P.O. Box 66791
Los Angeles, CA 90066
ALLISON, Lee '66
47-707 Halemanu St.
Kane, HI 96744
ALMAREZ, Charles '79
P.O. Box 184
Eagle Rock, VA 24085
ALMOS, Robert A. '74
204 Columbia Street
Kelso, WA 98626
ALPERIN, Michael '69
1275 Country Club Drive
Ben Lomond, CA 95005
ALRICH, Diana Meek '64
2329 Edwards Street
Berkeley, CA 94702
ALTENBURG, Sue A. '83
700 E. Sahara Avenue
Las Vegas, NV 89104
ALTMAN, Michael '79
1734 Camp Ave.
Merrick, NY 11566
ALVAREZ, CESAR H. '88
7324 South Pickering #A
Whittier, CA 90602
ALVIS, David C. '83
3231 "U" Street
N. Highland, CA 95660
ALVIS, Gary '79
21072 Juniperhaven
Bend, OR 97708
AMATO, Mark S. '78
730 W. Hinsdale Ave.
Hinsdale, IL 60521
AMEEN, Sam '87
719 Alameda Padre Serra
Santa Barbara, CA 93103
AMESTOY, Sharon Gayler '74
P.O. Box 6083
Portland, OR 97228
AMMON, Scott A '88
2025 W. Middlefield
Mountain View, CA 94043
AMONSON, David '71
0405 SW California
Portland, OR 97219
AMOS, David V. '81
5632 W 39th St
Minneapolis, MN 55418-2837
AMOS, Karen '89
25866 Vista Drive West
Capistrano Bch, CA 92624
AMOS, Thomas '74
202 E 19th Street
Lumberton, NC 28358
ANDE, Stephen '71
3511 South Flagler Dr.
W. Palm Beach, FL 33405
ANDERS, Peter D. '71
968 Nambe Loop
Los Alamos, NM 87544
ANDERSON, D. Steven '86
28188 Moulton Pkwy #423
Laguna Niguel, CA 92656
ANDERSON, Eric '86
425 East Murphy Street
Blythe, CA 92225
ANDERSON, Gordon '58
616 S. Maryland
Conrad, MT 59425
ANDERSON, Hampton '77
3618 61st Street
Lubbock, TX 79413
ANDERSON, Jean R. '79
417 W. 40th Street
San Pedro, CA 90731
ANDERSON, Jon Bryant '86
38 St. Pauls Ave.
Staten Island, NY 10301
ANDERSON, Kenneth H '88
19284 S.E. Neck Rd.
Dayton, OR 97114
ANDERSON, Lorraine '71
304 Calle Miramar #A
Redondo Beach, CA 90277
ANDERSON, Michael K. '75
18444 Edminton Dr
Cupertino, CA 95014-6408
ANDERSON, P. Kip '70
8723 13th St. N W
Seattle, WA 98117
ANDERSON, Paul G. '79
9805 N E 116th St. #7249
Kirkland, WA 98034
ANDERSON, Richard '89
900 Calle De Los Amigos #W-12
Santa Barbara, CA 93105
ANDERSON, Thomas B '88
1750 Prospect St.
Santa Barbara, CA 93101
ANDERTON, Gary A. '81
5161 Avenida Oriente
Tarzana, CA 91356
ANDREAS, Peter '77
1241 Boynton St.
Glendale, CA 91205

ANDREE, Henrik '87
5101 Collins Ave.
Miami Beach, FL 33140
ANDREEN, Donald '57
1163 Valley Creek Rd
Downington, PA 19335
ANDRESEN, Clifford '71
396 5th Ave.
Granite Falls, MN 56241
ANDREWS, Susan K. '78
3008 N. Lincoln
Chicago, IL 60657
ANDREWS, Timothy N. '78
933 Alturas Way
Mill Valley, CA 94941
ANDRIOT, John W. '76
1811 Westmoreland St.
Mc Lean, VA 22101
ANGEL, Don '55
111 East Kirkwood
Claremont, CA 91711
ANGELES, Theodore J. '86
3144 Brittan Avenue
San Carlos, CA 94070
ANGULO, Timothy E. '78
1862 Kirkby Rd.
Glendale, CA 91208
ANOLICK, Albert '52
3112 Calle Noguera
Santa Barbara, CA 93105
ANTHONY, Claude '61
2303 Cedar Run Place
Wilson, NC 27893
ANTHONY, Glen '73
3913 Birchman
Fort Worth, TX 76107
ANZEVINO, Patrick M. '77
7001 Mc Cauley Trail
Minneapolis, MN 55435
APARICIO, Alfonso '52
C. El Progreso 2838
San Salvador, El Salvador
APARICIO, Luisa '52
C. El Progreso 2838
San Salvador, El Salvador
APPEL, John '68
P.O. Box 566
Grand Canyon, AZ 86023
APPELMAN, Guy '79
7409 Sky Court Circle NE
Albuquerque, NM 87110
APPLEGATE, Brian J. '80
12650 Lakewood Blvd 103
Downey, CA 90242-4547
APPLIN, Susan '87
P.O. Box 93
Island Heights, NJ 08732
APSLEY-MC VEY, Anita '87
205 E. McElhany "G"
Santa Maria, CA 93454
ARBOGAST, William '53
969 Matadero Ave.
Palo Alto, CA 94306
ARCENEAUX, Jules '82
Clg. Americano Del Nord
Rome, 696 1, Italy
ARCHER, Robert T. '65
3720 Arden Dr. South
Fresno, CA 93703
ARCHER, Suzanne '71
170 N. Fir Villa Rd.
Dallas, OR 97338
ARCURI, Joseph A. '78
3626 S.E. 84th Avenue
Portland, OR 97266
ARDEVOL, Jose M. '84
Enrique Gimenez 21-23 2-2
Barcelona 34, Spain
ARELLANO, ALAN '87
One Casper Street
Danberry, CT 06820
ARENDT, Gilbert '58
878 Greenwood Dr. N. E.
Salem, OR 97303
ARENZ JR., Robert F. '83
454 Arapahoe Ave. #2
Boulder, CO 80302
ARIAV, Avi '90
12-18 Hill St. Flat #10
London W1x7fu, England
ARIAV, Haim R. '85
145 East 29th #7-A
New York, NY 10016
ARKUT, Funda '86
40 Celine Drive
Santa Barbara, CA 93105
ARMATA, Laura M. '89
409 E 21st St 5
Oakland, CA 94606
ARMENAKI, Arledge '78
22331 Stathern St.
Canoga Park, CA 91304
ARMFIELD, James H. '70
132 Hartwood Dr.
Woodstock, GA 30188
ARMITAGE, Frederick '86
78 Norwood #4
Redlands, CA 92373
ARMSTRONG, Brian W. '83
1290 E. Elm Ave. #P
San Gabriel, CA 91775
ARMSTRONG, Joel '81
23l7 North 63rd Street
Lincoln, NE 68507
ARMSTRONG, Judy M. '88
152 Ave Barcelona
San Clemente, CA 92672
ARMSTRONG, Larry '66
1924 Camino Del Prado
Santa Rosa, CA 95403
ARMSTRONG, Richard B. '76
1905 Robbins St.
Santa Barbara, CA 93101
ARNESON, Eric '69
1345 Virginia Rd.
Santa Barbara, CA 93108

ARNESON, Jim '86
2801 East Valley Road
Santa Barbara, CA 93108
ARNETT, Danielle '86
2072 Stonesgate Rd.
Westlake Village, CA 91361
ARNOLD, Gurdon C. '70
2721 Edgewood S.
St Louis Park, MN 55426
ARNOLD, Robert W. '79
1500 Lynn Avenue
Detroit Lakes, MN 56501
ARNOLD, Steven D. '82
15628 Carrousel Drive
Canyon Country, CA 91351
ARNONE, KENNETH '72
3886 Ampudia St.
San Diego, CA 92110
ARNOT, Melville '62
219 Junipero Court
Capitola, CA 95010
ARONIAN, Scott '73
8033 Sunset Blvd 4
Hollywood, CA 90046
ARONSON, Andrew S. '90
1473 Miramonte 8
Los Altos, CA 94024
ARRABITO, James R. '83
2621 Grand Ave.
Everett, WA 98206
ARRIOLA, William '50
P.O. Box 1011
Victorville, CA 92392
ARSLANIAN, Ovah '77
344 W. 14th St. Apt. C2
New York, NY 10014
ARTH, Raymond G. '75
2208 N. Arthur Ave.
Fresno, CA 93705
ARTHUR, David Ray '64
1741 Westwood
Troy, MI 48083
ARTHUR, Dianne '82
48591 Pineview 302
Utica, MI 48087
ARVESEN, Knut '86
Morgesdalsum 18
Oslo 3, 0378, Norway
ASA, Bert F. '87
16058 Village Dr.
Victorville, CA 92392
ASH, Adrienne '72
3025 E. 1st St.
Tucson, AZ 85716
ASHE, Richard W. '89
21593 Blacklane
Cottonwood, CA 96022
ASHE, Terry '76
6220 Berlee Drive
Alexandria, VA 22312
ASHMUN, ROBERT T. '75
1143 E. Caro Road
Caro, MI 48723
ATCHISON, Povy Kendal '90
750 Marion Street
Denver, CO 80218
ATHMER, Scott '83
75 Broad St.
Carlstadt, NJ 07072
ATKINSON, Monica D '90
4851 Balfour Road
Detroit, MI 48224
ATLAS, Joseph '82
1308 Factory Pl. Studio 33
Los Angeles, CA 90013
ATWATER, Brian S. '84
3629 Perada Dr
Walnut Creek, CA 94598-2743
AU, George '59
2401 Burlington
Oakland, CA 94602
AUBERT, Richard J. '90
424 Fieldston Rd.
Bellingham, WA 98225
AUER, Michael J. '79
11564 Mapledale
Whitmore Lake, MI 48189
AUGUSTIN, Philip V. '83
3954 Rockwood Park Dr. N.E.
Salem, OR 97305
AUROYE, Carol M. '85
542 Sixth Avenue
Singapore, 1027, Singapore
AUSTIN, Douglas M. '82
22 Indian Ridge Rd
New Milford, CT 06776
AUSTIN, Jeffrey M. '78
32115 105th Pl SE C302
Auburn, WA 98002
AUSTIN, William '60
Rt. #1, Box #414
Rockwell, NC 28138
AVELAR, Kim D. '90
11911 Weddington St. #209
N. Hollywood, CA 91607
AVERY, Charles '87
6775 W 26th Avenue
Denver, CO 80214
AVNERI, Ronit M. '85
117 E. 24th St. #6B
New York, NY 10010-2937
AVOTS, John '73
801-A 26th Street
Santa Monica, CA 90403
AXE, Christopher E. '77
1429 Crownhill Dr.
Arlington, TX 76012
AXEN, Brad D. '82
13242 Ethelbee Way
Santa Ana, CA 92705
AYAKAWA, CLAUDE S. '62
94-889 Waipahu Street
Waipahu, HI 96797
AYOTTE, Don '72
140 Indian Pond Rd.
Kingston, MA 02364-2007

AZAD, M. A. '57
Box 194 Harley Street
R Pindi, Pakistan

– B –

BABA, Mahmud Bin '74
Lot 2915, 6th Milestones
Lumpur City Kuala, Malaysia
BABBITT, Norma
7611 Queens Ferry Ln.
Dallas, TX 75248
BACHTLER-CUSHMAN, Robin '75
625 S. River Rd.
Cottage Grove, OR 97424
BACKUS, John '74
4917 N.E. 97th
Seattle, WA 98115
BACON, D. Garth '78
18576 Bucknall Rd.
Saratoga, CA 95070
BACON, Mark '76
161 Del Parque
Santurce, 00911, Puerto Rico
BACZKOWSKI, Richard '75
261 Vista Rd.
Lake Zurich, IL 60047
BAHM, Dave '70
711 Commercial
Belton, MO 64012
BAHNER, Robert '73
3403 NE 32nd Ave.
Portland, OR 97212
BAHR, Trenton '87
2755 River Plaza Drive 223
Sacramento, CA 95833
BAILEY, Arthur '64
11818 SE Mill Plain Blvd 311 A
Vancouver, WA 98634
BAILEY, Julie D. '85
519 42nd St.
Sacramento, CA 95819
BAILEY, Nolan W. '70
309 Gene Ln.
Natchitoches, LA 71457
BAIN, Delvin '72
4501 Larchwood Pl.
Riverside, CA 92506
BAIRD, Michael Scott '84
P.O. Box 3308
Glendale, CA 91221
BAIRD, Richard '54
1909 Bur Oak Dr.
Modesto, CA 95354
BAITZ, OTTO '68
130 Maple Ave., Ste. 9B1
Red Bank, NJ 07701
BAKER, Charles T. '89
16626 Nordhoff St.
Sepulveda, CA 91343-3613
BAKER, FRANK '79
21462 La Capicca
Mission Viejo, CA 92691
BAKER, Gary '67
3653 Fifth Avenue
La Crescenta, CA 91214
BAKER, Gregory D. '80
4630 Charles St.
Rockford, IL 61108
BAKER, Judson '90
2200 Post Oak #702
Houston, TX 77056
BAKER, Lane C. '84
4627 E. Monte Way
Phoenix, AZ 85044
BAKER, William L. '69
265 29th St.
Oakland, CA 94611
BALDERAS, Michael D. '80
5837-B Mission Gorge Rd
San Diego, CA 92120
BALDRIDGE, Michael '69
65 Cherokee Dr.
Memphis, TN 38111
BALDWIN, Dick '71
9301 109th Street S.W.
Tacoma, WA 98498
BALDWIN, Lauren D '86
P.O. Box 305
Friday Harbor, WA 98250
BALDWIN, Lewis '64
2514 E. Willow St. #305
Signal Hill, CA 90806
BALL, Kenneth C. '76
424 S. Lincoln
Casper, WY 82601
BALL, Thomas R. '75
4801 Rhoads Avenue
Santa Barbara, CA 93111
BALLIN, Richard A. '75
834 W. Spring St.
Appleton, WI 54914
BALOGH, Robert Dean '72
610 N.E. Conifer Dr.
Bremerton, WA 98310
BALTZLEY, Mark C. '90
11601 W 75th Ter 18
Shawnee, KS 66214
BANKO, Phillip '79
16844 101st St SE
Renton, WA 98055
BANNER, Tom
1201 Washington Blvd.
Venice, CA 90291
BANNISTER, Chris S. '81
392 Oxford St. E.
London, N6A 1V7, Canada
BANNISTER, Robert B. '78
817 North X Street
Lompoc, CA 93436
BARAGAR, Ken W. '75
817 Irving Pl.
Anaheim, CA 92805
BARBALACE, Philip K. '77
2150 Westglen Ct.
Vienna, VA 22180

BARBE, Raymond R. '51
155 26th Ave.
Santa Cruz, CA 95062
BARBER, Charles J. '55
9506 Emerald Grove Ave.
Lakeside, CA 92040
BARBER, Karla Wolf '56
9506 Emerald Grove Ave.
Lakeside, CA 92040
BARCLAY, Robert A. '76
438 S. Fancher Ave.
Mt. Pleasant, MI 48858
BARDEN, Brad S. '79
96301 West Commons, Suite 308
South Bend, IN 46635
BARDICK, David '70
44 Helena Avenue
Santa Barbara, CA 93101
BARDIN, James A. '85
1111 Villa View Drive
Pacific Palisades, CA 90272
BARE, JOHN R. '76
3001 Red Hill Ave.
Costa Mesa, CA 92626
BARFKNECHT, Bill '86
694 Northpark Blvd.
San Bernardino, CA 92407
BARK, Jeffrey W. '86
2014 Foothill Road
Santa Barbara, CA 93105
BARKER, Dennis '79
35 Buffard Dr.
Rochester, NY 14610
BARKER, Kenneth D. '84
535 Summit Avenue E, Unit 304
Seattle, WA 98102
BARKER, Robert P. '79
35 Buffard Drive
Rochester, NY 14610
BARNARD, Richard K. '76
1810 Charmeron Avenue
San Jose, CA 95124
BARNES, Arthur '67
8935 Occidental Road
Sebastopol, CA 95472
BARNES, John '90
415 Nathan Hunt Drive
High Point, NC 27260
BARNES, Larry M. '75
200 W Gary Street
Broken Arrow, OK 74012
BARNES, Rex '72
1307 Rucker Drive
Everett, WA 98201
BARNES, Robert E. '86
101 S. Mason
Saginaw, MI 48602
BARNEY, Wayne '61
Rte 1 Box 165
Johnstown, NY 12095
BARNHARDT, Rebecca F '90
1136 Skyline Drive
Laguna Beach, CA 92651
BARNHART, Jim '79
730 E Ave K 4
Lancaster, CA 93535
BARNOSKY, Jack '74
6409 Southeastern
Indianapolis, IN 46203
BARONIAN, Danny '72
1865 Farm Bureau Road
Concord, CA 94519
BAROS, Barbara '83
3560 Ottawa Ave.
San Diego, CA 92117
BARR, Neal '57
222 Central Park So.
New York, NY 10019
BARR, Steve '76
125 Las Ondas
Santa Barbara, CA 93109
BARRENTINE, Scott '86
901 Vista Verde Way
Bakersfield, CA 93309
BARRETO, Patrick W. '81
153 Waterside Ave.
Northport, NY 11768
BARSBY-BULAT, Lori '80
922 N. 67th St.
Seattle, WA 98103
BARSNESS, Terrence '74
2673 Magnolia Ave.
San Diego, CA 92109
BARTH, Christopher '85
308 N. 72nd St. A
Seattle, WA 98103
BARTH, Michael '68
7705 Fay Avenue
La Jolla, CA 92037
BARTSCH, James A '88
6 Harbor Way #213
Santa Barbara, CA 93109
BARTSCH, Jerry Lee '70
413 Terrace Drive
Columbia Falls, MT 59912
BASS, David J. '77
1525 Asbury St.
St. Paul, MN 55108
BASSETT, Denman '72
720 N. Milpas St.
Santa Barbara, CA 93103
BASTARDO, Jimmy '89
101 President Street
Brooklyn, NY 11231
BASTIAN, Christine '83
62 Norfolk
Wichita, KS 67206
BATES, Arthur '67
10709 Morengo Drive
Cupertino, CA 95014
BATES, Frank G. '79
5158 Highland View Ave.
Los Angeles, CA 90041
BATES, Lawrence '72
1315 Klauber Ave.
San Diego, CA 92114

BATES, Russell B. '70
12427 N.E. 29th St.
Bellevue, WA 98006
BATOR, Joseph E. '78
2011 Washington Ave.
Golden, CA 80401
BATT, Howard E. '74
3610 Aberdeen Wy
Houston, TX 77025
BAUER, Keith '72
P.O. Box 422
Lakebay, WA 98349
BAUER, Scott '90
1706 W. Progress
Littleton, CO 80120
BAUMGARTNER, William (Hans) '76
4084 Canyon Drive
Rapid City, SD 57709
BAXTER, Kevin C. '81
3608 So. Urbana
Tulsa, OK 74135
BAYLIS, Dane F '88
P.O. Box 480172
Los Angeles, CA 90048
BEACH, Russell '61
56 Konale Place
Kihei, HI 96753
BEAGEN, Andrew J. '87
19 Lytherland Pl.
Providence, RI 02909
BEAIRD, Jennifer L. '78
94 Rosewell Ct.
Atlanta, GA 30305
BEAN, Bradley L. '85
515 Bethany Road
Burbank, CA 91504
BEAN, James P. '85
20561 Highline Rd
Tehachapi, CA 93561
BEAN, Stanley B. '82
1459 Gordon St., Apt. A-5
Redwood City, CA 94061
BEANE, William '84
P.O. Box 309
Broad Run, VA 22014
BEAR, Brent J. '75
8659 Hayden Place
Culver City, CA 90232
BEARD, Glynn D. '87
P.O. Box 90631
Santa Barbara, CA 93190
BEARDSLEY, Keith '74
2527 Helena Lane
Everett, WA 98204
BEASLEY, Thomas O. '86
8390 E. Via De Ventura
Scottsdale, AZ 85258
BEATON-AHERN, Kathleen R. '83
3822 Brookdale Blvd.
Castro Valley, CA 94546
BEATTIE, Franklin H. '86
38 East 9th St
Derby, CT 06418
BEATY, Edwin '72
P.O. Box 185 Cayman Brac
British West Indies, Cayman Islands
BEAUREGARD, Medford '76
4636 Jessie Ave.
La Mesa, CA 92041
BECK, D. Paul '86
230 Lakeview Ave. N.E.
Atlanta, GA 30305
BECK, Michael Craig '77
246 Oak Tree Lane
Midlothian, TX 76065
BECK, Phillip D. '77
13525 48th Pl. West
Edmond, WA 98020
BECKER, Kenneth W. '80
720 N. Milpas
Santa Barbara, CA 93103
BECKER, Martin '50
P.O. Box 8
Philo, CA 95466
BECKER, Paul D. '77
2110 Ardis Dr.
San Jose, CA 95125
BECKER, Steven D. '82
301 Pine Forest Drive 7
Maunelle, AR 72118
BECKER, Wes A. '85
5836 E. Irish Pl.
Englewood, CO 80112
BECKETT, JAMES B. '78
965 Miramonte Drive #1
Santa Barbara, CA 93104
BECKLEY, Richard Douglas '80
911 Kenly Ave.
Hagerstown, MD 21740
BEDNARK, Walter '66
17 Chickadee Lane
Centerville, MA 02632
BEEBE, Dennis '87
1425 N. Chelton Rd.
Colorado Springs, CO 80909
BEEBE, Harley '50
4747 Arlington St.
Love Park, IL 61111
BEEDE, Mark D. '78
877 Santa Fe
Denver, CO 80204
BEER, William '72
74 Chappell Street
North Windham, CT 06256
BEGLEY, Maureen A. '80
12101 Stonebrook Drive
Los Altos, CA 94022
BEHR, Charlotte S. '86
1465 W. 33 Street #103
Minneapolis, MN 55408
BEHRENBRUCH, William '74
1210 Cacique Street
Santa Barbara, CA 93103
BEITZEL, Terry D. '87
Rt. 1 Box #104
Accident, MD 21520
BELCOVSON, Joseph M. '73
449 Old Coast Hwy. #5-b
Santa Barbara, CA 93103

BELEM-WALTH, Alda Maria '87
2633 36th Ave. S.
Minneapolis, MN 55406
BELKNAP, Daniel C '87
P.O. Box 3813
Minneapolis, MN 55403-0813
BELKNAP, Robin C. '83
201 Antioch Rd.
Easley, SC 29640
BELL, David K. '82
2418 Loveland Avenue
Erie, PA 16506
BELL, Frank '74
Box 1637
Perth Amboy, NJ 08862
BELL, James A. '78
119-20 Union Turnpike #40-2
Kew Gardens, NY 11415
BELL, James H. '75
1809 Blackfoot Dr.
Fremont, CA 94539
BELLAS, Johanna D. (Yo) '82
2540 White Horse Rd.
Berwyn, PA 19312
BELLINGHAM, Michael T '85
1000 Franklin St. #101
San Francisco, CA 94119
BELLO, Felipe X. '84
Av. Sojo, Edif. Marlene
Caracas, 1060, Venezuela
BELMONTE, Frank '82
P.O. Box 4147
Irvine, CA 92716
BELSON, David H. '79
7112 E. Prairie Rd.
Chicago, IL 60645
BELVILLE, Everett '68
Cond. Montebello, Apt. J-320
Trujillo Alto, PR 00760
BELZER, David E. '86
1619 W. Crescent Ave., #V122
Anaheim, CA 92801
BEMIS, Warren '71
Route 1 Box 93
Canehill, AR 72717
BENCE, David L. '79
1224 Shenandoah
Rochester, MI 48064
BENHARDT, Susan K '86
P.O. Box 30899
Santa Barbara, CA 93130
BENJAMIN, Beth E. '82
343 State St.
Rochester, NY 14650
BENNETT, Benjamin '88
6701 West Isanogel Road
Muncie, IN 47304
BENNETT, Gregory '73
899 N. Kellogg Ave.
Santa Barbara, CA 93111
BENNETT, James '78
280 Cajon St.
Laguna Beach, CA 92651
BENNETT, Robert E. '66
P.O. Box 1591
Shelton, WA 98584
BENSON, Donald '68
6743 Fair Oaks Blvd.
Carmichael, CA 95608
BENSON, Henry '79
653 Bryant St.
San Francisco, CA 94107
BENSON, Leroy '64
3825 Center St., #5
San Diego, CA 92103
BENTZRUD, Connie '88
Gimleveien 42
Kristiansand, 4600, Norway
BERENGUER, Andres '90
Zumaya No 3
Madrid 28023, Spain
BERENY, Brett '87
10164 Baywood Court
Los Angeles, CA 90077
BERG, Finn '86
Traktorun 5 B
Oslo 6, 93101, Norway
BERG, Lawrence '56
1231 E. 9th St.
Duluth, MN 55805
BERG, Randel L. '77
40043 Avenida Venida .
Murrieta, CA 92362
BERGER, Mark S. '90
793 Clayton St. Unit "A"
San Francisco, CA 94117
BERGHER, Keith R. '78
203 S. Ohio St., #23
Anaheim, CA 92805
BERGLUND, Robert E. '83
1260 Swantown Road
Oak Harbor, WA 98277
BERGMAN, Bruce '74
8835 S.E. 28th Avenue
Milwaukie, OR 97222
BERGTHOLD, Lee '86
41331 20th St. West
Lancaster, CA 93534
BERKEN, C. Geoffrey '74
426 Sutton Ave.
Folsom, PA 19033
BERMUDEZ, Jorge '83
16322 Devonshire St
Granada Hills, CA 91344
BERNAL, Lionel '72
6725 Partridge Dr.
Ventura, CA 93003
BERNASCONI, Ricardo '81
1411 Tasso Street
Palo Alto, CA 94301
BERNAY, Laurence '79
23696 N Raleigh Drive
Prairie View, IL 60069-2000
BERNSTEIN, David M. '56
67 Columbia Street
New York, NY 10002
BERNSTEIN, Karl '63
P.O. Box 98
Scotts Hill, TN 38374-0098

BERNSTEIN, Robert A. '69
7551 Atherton Lane
Canoga Park, CA 91304
BERR, KEITH W. '77
1220 W. 6th St. #608
Cleveland, OH 44113
BERRY, Michael A. '78
455 S. 156 Street #214
Bellevue, WA 98148
BERRY, Richard K. '76
11 Fimisterre
Rockport, TX 78358
BERTINELLI, David '87
31736 Broad Beach Road
Malibu, CA 90265
BERTOLIN, Richard '48
8741-14th Avenue N.W.
Seattle, WA 98117
BESHK-BUD, Kim A. '85
25492 Terrano Dr.
Mission Viejo, CA 92691
BESSENT, Lisa A. '83
P.O. Box 1299
Robert Lee, TX 76945
BETEL, Michael '84
780 Cummer Avenue
Willowdale, ON M2HIE7, Canada
BETLEY, Joseph '72
30 Pine Arbor #203
Vero Beach, FL 32962
BETTENCOURT, Dennis '73
1103 Gardner Blvd.
San Leandro, CA 94577
BETTENHAUSEN, Robert '86
1229 Second Ave, SW
Jamestown, ND 58401
BEYT, Peter D. '84
505 Woodvale Ave.
Lafayette, LA 70503
BIBO, Douglas J. '85
5455 8th St. Apt. #72
Carpinteria, CA 93013
BIDDULPH, Reed '51
945 Garcia Road
Santa Barbara, CA 93103
BIENSTOCK, Amir '81
12380 Chandler Blvd. #D
N. Hollywood, CA 91607
BIES, William J. '83
21-29 41st Street
Astoria, NY 11105
BIGGERSTAFF, Douglas '78
4419 Deerview Court
Indianapolis, IN 46268
BILLINGS, Richard '71
1221 Sunset Pl.
Ojai, CA 93023
BILLINGS, Robert C. '73
1444 S Norfolki
Tulsa, OK 74120
BINKS, Phil '58
4717 Berwick Dr.
San Diego, CA 92117
BIONDI, Honey '79
96517 Ashmede Drive
Ellicott, MD 21043
BIRCH, Michael L. '83
2015 Kensington Dr 17
Waukesha, WI 53188-5624
BIRD, Harold L. '78
P.O. Box 7632
South Lake Tahoe, CA 95731
BISCHETSRIEDER, Joseph '72
2442 E. Tryon
Anaheim, CA 92806
BISSELL III, Stephen A. '70
811 Cliff Drive #B1
Santa Barbara, CA 93109
BIZZARO, Douglas H. '90
621 S. Dunsmuir
Los Angeles, CA 90036
BJERKE, David R. '81
823 - 12th Street
Santa Monica, CA 90403
BJOIN, Henry E. '78
146 N. La Brea Avenue
Los Angeles, CA 90036
BLACK, Noel D. '78
P.O. Box 715
Kealakekua Ko, HI 96750
BLACK, Raymond '89
1429 De La Vina St. #4
Santa Barbara, CA 93101
BLAIR, Timothy A. '79
3520 Hughes Ave 114
Los Angeles, CA 90034
BLAKE, Duncan L. '84
115 Virginia Avenue
O'Falllu, HI 96865
BLANCHARD, John W. '88
1591 Frazier Street
Camarillo, CA 93010
BLANDIN, Lynda M. '83
4045 Blackbird Way
Calabasas, CA 91302
BLANK, Morgan J. '86
117-D Maunalua Avenue
Honolulu, HI 96821
BLANKENBECKLER, Kenneth '66
P.O. Box 246
Bristol, TN 37621
BLANKINSHIP, John '71
9622 Jaywood Dr.
Houston, TX 77040
BLANKINSHIP, Martin '58
5040 Camp Way
Soquel, CA 95073
BLANTON, William '50
427 Elmwood Lane
Hayward, CA 94541
BLEDSOE, Susanne '85
4861 Sunrise Valley Drive
El Cajon, CA 92020
BLEIBTREU, Jason J. '84
Primer Calle Jon
1630 Tegusigalpa, Honduras
BLIER, Stephen M. '86
1130 San Andres St. #28
Santa Barbara, CA 93101

BLOCK, ERNIE '76
1138 Cambridge Circle Dr.
Kansas City, KS 66103
BLOCK, Randall '80
3120 Cumberland Dr.
Laurenceburg, IN 47025
BLOK, Christiaan J. '90
208 Equestrian Ave
Santa Barbara, CA 93101
BLOM, John L. '75
2601 Blackthorn St.
Newport Beach, CA 92660
BLOMDAHL, David A. '82
166 N.E. Fair Oaks Terrace
Chehalisty, WA 98532
BLONDIN, Bruce R. '61
5310 Monticello Rd.
Napa, CA 94558
BLOODGOOD, David '73
1108 De La Vina Street
Santa Barbara, CA 93101
BLUEBAUGH, David R. '78
1051 E. 88th Avenue
Denver, CO 80229
BLUMENFELD, Klaus
2204 E. Jackson Ave.
Orange, CA 92667
BLUMENTHAL, Len '56
1326 Lindsay Lane
Meadowbrook, PA 19046
BOATRIGHT, Allan '72
2144 Colquitt St.
Houston, TX 77098
BOCK, Artie '75
1649 Furlong Road
Sebastopol, CA 95472
BODNAR, Joe '55
2817 Selby Avenue
Los Angeles, CA 90064
BOETTGER, Claus H. '78
3923 Vista Ct.Rd.
La Crescenta, CA 91214
BOGART, Scott '86
4096 Via Real Apt. #53
Carpinteria, CA 93013
BOGEAR, Gary '71
130 Anderson Street
San Francisco, CA 94110
BOGER, Henry R '88
6840 Balboa Blvd 501
Van Nuys, CA 91406
BOGIE, Herb '49
9 Santa Ana Avenue
Santa Barbara, CA 93111
BOGUE, Bradley '75
6110 160th Street East
Puyallup, WA 24450
BOLDEROFF, Michael '64
12418 Klingerman
El Monte, CA 91732
BOLDING, Kathryn M. '89
1509 E Madison St 201
Seattle, WA 98122
BOLERJACK, Kent '61
3228 W. Tufts Ave.
Englewood, CO 80110
BOLES, Christopher P. '77
3235 Meadow Oak
Cottonwood, CA 96022
BOLLASON, Asgeir '88
940 N. Mansfield Ave.
Los Angeles, CA 90038
BOLT, William K '88
801 West 53rd Terrace
Kansas City, MO 64112
BOLTON, Jeffrey '72
3470 E. Hidden Cove Rd.
Coeur D'alene, ID 83814
BOMIER, Robert '72
Rt. 1 Box 258
St. Peter, MN 56082
BONCORPS, Christian M. '68
345 W. 30th St. #10D
New York, NY 10001
BOND, James R. '76
1220 164th St. SE G103
Mill Creek, WA 98012-1245
BOON, Bertram B. '84
1415 West Valerio
Santa Barbara, CA 93101
BOONISAR, Pete '72
5212 Magdalena Avenue
Atascadero, CA 93422
BOOTHBY, Robert A. '80
2177 N. Quince Avenue
Rialto, CA 92376
BORDNICK, Barbara
39 E. 19th St.
New York, NY 10003
BORGES, Martin F. '82
4837 Watt Ave.
N. Highland, CA 95660
BORGES, Ray '47
89 Lassen Dr
Santa Barbara, CA 93111
BORGMAN, Herbert '79
8840 Lowell Street
St. Louis, MO 63147
BORGSTROM, Lee A. '83
1338 Hunn Rd. #9
Yuba City, CA 95991
BORLAND, Charlie '80
5540 SW 183rd Ave
Beaverton, OR 97007
BORLAND, Tracy '83
2612 Harkness Street
Sacramento, CA 95818
BORST, Roger William '69
2322 Brooke Road
Fallbrook, CA 92028
BOSCH, Marc Mc Gregor '86
5616 Lake Lindero Dr.
Agoura, CA 91301
BOSLER, Daniel Eric '82
2647 S.E. 8th St.
Portland, OR 97266
BOSWORTH-HENSLEY, Sally C. '75
1024 Wee Burn Dr.
Juneau, AK 99801

BOTKIN, Bradley S '87
7270 North Wade Road
Tucson, AZ 85743
BOUARI, Samira '86
P.M. Bag 5084
Ibadan, Nigeria
BOUCHER, Edward '69
1781 1/2 W. 3rd Ave.
Durango, CO 81301
BOUCHER, Hal '50
751 Woodland Drive
Santa Barbara, CA 93108
BOWDEN, Ronald L. '79
4600 N 4th Ave
Sioux Falls, SD 57104
BOWEN, Thomas H. '84
Box 30-B
Rocky Gap, VI 24366
BOWER, Gene L. '69
5416 W. Garden Dr.
Glendale, AZ 85304
BOWERS, Roy '62
7920-120th Ave.
Edmonton Alberta, T5BOXB, Canada
BOXER, WILLIAM M. '80
11835 Canon Blvd. Ste. C-104
Newport News, VA 23606
BOYD, Gardner '53
9 Dibble
Rowayton, CT 06853
BOYD, Virginia C. '84
675 Euclid Avenue
Toronto Ontario, M6G 2T8, Canada
BOYD, William '74
1079 Woodland Ave.
Ojai, CA 93023
BOYER JR., Wallace '63
22 Mountain St.
Northampton, ME 01060
BOYLAN, Michael D. '86
6512 Olympic Place
Los Angeles, CA 90035
BRACKEN, David S. '82
3128 Chisholm Trl
Irving, TX 750624417
BRACKLEY, Arthur '74
P.O. Box 881655
San Diego, CA 92108
BRADFORD, Robert '73
892 Sunnyhills Rd.
Oakland, CA 94610
BRADLEY, AIDEN J. '80
721 E. Gutierrez Street
Santa Barbara, CA 93101
BRADSHAW, Thomas '71
7 North Main Street
Lexington, VA 24450
BRADY, Kathleen E. '83
3600 Carleton Ave.
Anchorage, AK 99517
BRADY, Stephen A. '79
5250 Gulfton #2G
Houston, TX 77081
BRAGG, Robert E. '58
2216 North Shore
Benton, AR 72015
BRAGG, Will '49
P.O. Box 4003
Rocky Mountain, NC 2780-3003
BRAKER, Robert W. '79
15031 Parkway Loop, Suite B
Tustin, CA 92680
BRANDES, Mark L. '79
2426 Townsgate Rd.
Westlake Village, CA 91361
BRANDOS, Donald C. '79
2429 Lake Forest St.
Escondido, CA 92026
BRANEN, Karla J. '90
1074 Cheltenham Rd.
Santa Barbara, CA 93105
BRANIGER, Michael J. '84
11114 Montlake Dr.
Riverside, CA 92505
BRANNON, Herbert '70
5267 Calle Barquero
Santa Barbara, CA 93111-1715
BRASS, Michael '86
14808 La Cuarta Street
Whittier, CA 90605
BRASSEUR, Vincent H. '82
Avenue Jeanne
Brussels, B1050, Belgium
BRASWELL, Mark '68
10209 Catalina
Overland Park, KS 66207
BRAUER, Richard D. '77
628 Washington
Traverse City, MI 49684
BRAUN, David R. '77
2640 E. Main
Ventura, CA 93003
BRAUN, Robert '60
P.O. Box 547755
Orlando, FL 32854
BRAVO, Jesse '61
7659 Southcliff Dr.
Fair Oaks, CA 95628
BREAULT, Jerry '73
2114 Floyd P O Box 10637
Burbank, CA 91510
BREAZEALE, Ronald R. '77
Rt. 32, Box #154-F
Hodges, SC 29653
BRECKHEIMER, Gary '86
145 E 29th St 7A
New York, NY 10016
BREEDLOVE, Michele '82
P.O. Box 3591
Sedona, AZ 86340
BREITBORDE, Steven H. '79
727 Terrace 49
Los Angeles, CA 90042
BRELSFORD, Mark G '88
18616 Sagewood Drive
Dallas, TX 75252
BRENDLE SR., Robert Lester '49
129 Louise Terr.
Glen Burnie, MD 21061

BRERETON, Richard D. '77
9475 Wynfield Rd
Montgomery, AL 36117
BREUTZMAN, Phil '56
1503 14th St. NW
Rochester, MN 55901
BREWER, Jeffrey A. '72
6108 109th Ave. SE
Renton, WA 98056
BRIAN, Terry L. '74
1012 W. Chestnut
Lompoc, CA 93436
BRIAN, TERRY
36 Tamarack Ave. Suite 101
Danbury, CT 06811
BRICHER, Robert D. '78
3883 Via Las Brisas
Santa Barbara, CA 93110
BRICK, Jim '61
820 Sweetbay Dr.
Sunnyvale, CA 94086
BRIGGS, Patrick D. '89
2526 Tresure Drive, Apt. A
Santa Barbara, CA 93105
BRIGHT, David A. '74
4255-9 E. Main Street
Ventura, CA 93003
BRIGHT, Robert H. '75
11618 1/2 Riverside Dr.
Toluca Lake, CA 91602
BRIMMER, Roger '73
5366 Pecan Blossom Drive
San Jose, CA 95123
BRISBANE, Margaret '77
438 S. Fancher
Mt. Pleasant, MI 48858
BRITT, Charles M. '86
1460 Ramona Drive
Thousand Oaks, CA 91320
BRITTAIN, Charles '73
P.O. Box 25
Santa Barbara, CA 93102
BRITTON, Howard W. '60
24602 Raymond Way, Q-110
El Toro, CA 92630
BRODIE, Mark D. '89
2525 Arapahoe Ave E4 259
Boulder, CO 80302
BRODY, James '74
2819 Sageman Avenue
Pittsburgh, PA 15226
BROGAN, Chester '53
2272 A1A Highway
Satellite Beach, FL 32937
BROHAUGH, Keith '73
RR 1, Box 81
Shelly, MN 56581
BROOKES, Donn D. '77
548 Wellesley
Cincinnati, OH 45224
BROOKFIELD, Betty B. '76
23 Lemans Ct.
Prairie Village, KS 66208
BROOKS, David B. '57
3423 13th Ave., S.W.
Seattle, WA 98134
BROOKS, David F. '78
3019 65th Street
Sacramento, CA 95820
BROOKS, Deborah '76
855 W. Black Hawk
Chicago, IL 60622
BROOKS, Douglas Fernandez '75
855 West Black Hawk
Chicago, IL 60622
BROOKS II, ERNEST '62
801 Alston Road
Santa Barbara, CA 93108
BROOKS, Joyce '56
(see Kurtz, Joyce)
BROOKS, Mark A. '81
7690 El Chaco Dr.
Buena Park, CA 90620
BROOKS, Steve '74
P.O. Box 2129
Toluca Lake, CA 91610-0129
BROOKS, William '73
Route 2, #3831 M-140
Eau Claire, MI 49111
BROUGHER, Martha L. '86
2131 Melrose Apt 22
Ann Arbor, MI 48104
BROUGHTON, Christopher '85
714 Oak Ave
Carpinteria, CA 93013
BROUS, Andrew '69
P.O. Box 621411
Seaview, WA 98644
BROWN, Alexander P. '82
915 East Beach
Pass Christian, MS 39571
BROWN, Charles T. '76
119 Rutledge Avenue
Newmarket, ON L3Y 5T5, Canada
BROWN, Daniel '67
1314 Portland Street
Walla Walla, WA 99362
BROWN, EDWARD A. '88
410 Raymondale #4
South Pasadena, CA 91030
BROWN, Franklin '73
2081 W. Tenaya Way
Fresno, CA 93711
BROWN, Graham '81
3200 Kentucky Ave. So.
St. Louis Park, MN 55426
BROWN, Josephine J. '83
225 Ocean Dr. W.
Stamford, CT 06902
BROWN, Larry '60
13035 NW Sue
Portland, OR 97229
BROWN, Melanie '82
P.O. Box 3876
Santa Barbara, CA 93130
BROWN, Patrick V. '85
P.O. Box 7128
Carmel, CA 93921

BROWN, Scott '87
P.O. Box 1038
Mammoth Lakes, CA 93546
BROWN, Timothy S '90
1469 S Jameson
Montecito, CA 93108
BROWN, Timothy W '90
1230 Market Street Ste 730
San Francisco, CA 94102
BROWN, William Aulden '86
407 Marin Ave.
Mill Valley, CA 94941
BROWNE, Eric W '89
11162 Camarillo St., #402
N. Hollywood, CA 91602
BROWNE, Rick '70
145 Shake Tree Lane
Scotts Valley, CA 95066
BROWNING, Robert L. '78
6121 W Michelle Dr
Glendale, AZ 85308
BRUBAKER, Chris R. '82
25529 Jaclyn Ave.
Moreno Valley, CA 92387
BRUBAKER, Craig M. '77
Rt. L, Box 712 Phillips Rd.
Hillsboro, OR 97124
BRUCE, Bradley H. '76
572 Cutter Lane
Longboat Key, FL 34228-3706
BRUCE, Robert '62
360 Nassau Dr.
Springfield, MA 01129
BRUKIEWA, Larry B. '78
9514 Delco Ave.
Chatsworth, CA 91311
BRUMBAUGH, Wilbur '48
1980 Astor Way
Woodburn, OR 97071
BRUNDEGE, Barbara '89
P.O. Box 2409
Los Gatos, CA 95031
BRUNER, Roderick S. '83
P.O. Box 6677
Tahoe City, CA 95730
BRUNER, Thomas '74
287 Brentwood
Ventura, CA 93003
BRUNS, Barry L. '79
105 Maywood Ct.
St. Peters, MO 63376
BRUTON, John '73
9806 Litzsinger Road
St. Louis, MO 63124
BUBAR, JULIA ANNE '84
545 Rimini Rd
Del Mar, CA 92014
BUBB, Gregory E. '83
P.O. Box 19752
St. Paul, MN 55119
BUCK, Bruce W. '77
9 Argyle Rd.
Montclair, NJ 07043
BUCK, Richard '59
2021 Plaza Dr.
Billings, MT 59102
BUCK, Warren '73
8905 N. 27th St.
Lake Elmo, MN 55042
BUCKLEY, Stephen J. '89
5242 Fino Dr
San Diego, CA 92124-2014
BUCKNER, Kenneth D. '71
2038 Holly Drive #8
Los Angeles, CA 90068
BUDDEE, John '64
211 E. 17th St.
New York, NY 10003
BUDNICK, Victor '73
955 Nowita Pl
Los Angeles, CA 90291-3838
BUECHLER, Barbara Thompson '84
14021 Marquesas Way #110C
Marina Del Rey, CA 90292
BUEHLER, Karen S '87
30 Bridlewood Road
Northbrook, IL 60062
BUENDIA, Richard K. '78
338 Sandalwood
San Antonio, TX 78216
BUETTNER, Susanne '86
Luitfriedstr. 1
Munich 50, 8000, West Germany
BUFFINGTON, John David '76
2401 S. Ervay #105
Dallas, TX 75215
BUGHWAN, Nalin Dennis '77
Crown Studios, 244 Grey St.
Durban Natal, South Africa
BULL, Margaret
6225-108th Place N.E.
Kirkland, WA 98033
BUMPAS, Robert '62
6162 Field Ave.
Arvada, CO 80004
BUNNELL, David D. '86
2554 Lincoln Blvd. #543
Los Angeles, CA 90291
BUOP, Daniel '70
387 Soundview Road
Guilford, CT 06437
BURATOVICH JR, Nick '76
497 E. Nebraska Ave.
Dinuba, CA 93618
BURGE, Mark '87
4882 McGrath, Suite 100
Ventura, CA 93003
BURGER, Jeffery F. '86
4400 Cleveland Place
Metairie, LA 70001
BURHOLM, Perry '61
5632 Ladybird Ln.
La Jolla, CA 92037
BURINGTON, Stephen H. '88
Tamarark Drive
Hopewell Jct., NY 12533
BURJOSKI, David G. '82
511 West Dr.
St. Louis, MO 63130

BURK, Thomas L. '60
3063 N. Conestoga Ave.
Tucson, AZ 85749
BURKE, Gail P. '73
221 W. Stroube St.
Oxnard, CA 93030
BURKE, James E. '89
12 Mesa Way
Watsonville, CA 95076
BURKE, John '73
5220 Bridle Pathway
Schenectady, NY 12303
BURKE, Kevin '74
1015 N. Cahuenga Blvd.
Los Angeles, CA 90038
BURKEY, Darrell D. '77
28 Bindaga Place.
Aranda ACT 2614, Australia
BURKHARDT, Bruce J '88
P.O. Box 16261
Irvine, CA 92713
BURKHOLDER, F. Dan '80
7003 Forest Meadow St
San Antonio, TX 78240
BURNETT, Christopher '75
4896 Daffodil Dr.
Mariposa, CA 95338
BURNS, Michael J. '76
1905 Castillo St.
Santa Barbara, CA 93101
BURNS, Robert Steven '76
6532 Friends Ave
Whittier, CA 90601
BURNS, Steven T. '81
6075 Cotton Tail Road NE
Rio Rancho, NM 87124
BURR, James Allyn '88
P.O. Box 230
Lincoln City, OR 97367
BURRUS JR., Wiley '76
P.O. Box 1374
Brady, TX 76825
BURRY, Dennis L. '74
115 Bajo Sol Crt.
Scotts Valley, CA 95066
BURT, Jennifer '85
10225 E Girard Ave E106
Denver, CO 80231-5052
BURTON, Elizabeth T. '83
13056 Rose Ave.
Los Angeles, CA 90066
BUSH, Robert '61
1 American Square
Indianapolis, IN 46282
BUTTNER, David M. '85
18 Jersey Street
Bloomfield, NE 07003
BUUR, Jan A. '62
715 Roberto Ave.
Santa Barbara, CA 93109
BYSTROM, Jack R. '79
351 Creekview Dr.
Morgan Hill, CA 95037

– C –

CABOT, Mark W. '74
Elgjartun Veien
Ski, 1400, Norway
CAFFEE, Jessie L. '77
P.O. Box 1141
Sacramento, CA 95814
CAHILL, Donald '73
125 W. Davis St.
Tiffin, OH 44883
CALADO, Procopio '58
851 Cornucopia
Exeter, CA 93221
CALDWELL, Edward G. '82
6349 Broadway Terrace
Oakland, CA 94618
CALHOUN, Graham G. '82
P.O. Box 7776
Atlanta, GA 30309
CALL, Susan C. '80
1021 Stonespring Way
Louisville, KY 40223
CALLAHAN, Daniel '76
4600 Downers Dr., F
Downers Grove, IL 60515
CALLAWAY, Alex '67
9105 Orangevale Ave.
Orangevale, CA 95662
CALNEN, Robert F. '71
5512 Stairs Pl.
Halifax, NS B3K 2C8, Canada
CAMPBELL, Bruce L. '75
1738 Wilson Ave.
Upland, CA 91786
CAMPBELL, Dennis '74
11000 Theodore Trecker Way
West Allis, WI 53214
CAMPBELL, Martin '65
307 W. Spain Street
Sonoma, CA 95476
CAMPBELL, Robert B. '86
3628 E. 17th Ave. #6
Denver, CO 80206-1833
CAMPBELL, Tom '71
P.O. Box 2010
Moorpark, CA 93020
CAMPOLI, Bernie '74
2400 Beech Street
Panama City Beach, FL 32407
CANADAY, Robert F. '83
5764 E. 2nd St.
Long Beach, CA 90803
CANCELMO, Jessie '72
4059 Merrick
Houston, TX 77025
CANCHOLA, Wendy '86
1626 Hick Street
Oceanside, CA 92054
CANNADY, Kimberly '88
3016 Via Buena
Rolling Hills, CA 90274
CANNON, Scott D. '83
22050 Delvalle
Woodland Hills, CA 91364

CANTRELL, Gary '68
5431 Trentham Drive
Atlanta, GA 30338
CAPEK, John D. '61
324 8th Street
Idaho Falls, ID 83401
CAPORALE, Dominic '66
25 Arch St.
New Britain, CT 06051
CAPRITTO, Philip T. '83
6723 Wordsworth Way
Ventura, CA 93003
CAPUTO, Anthony I. '78
1040 N. Las Palmas
Los Angeles, CA 90038
CARBETTA, James D. '87
101 Abingdon Way
Atlanta, GA 30342
CARDENAS, Alicia Rico '87
Rio Sinaloa #36 Pte. Col
6 PE Culiacan, Sinaloa, Mexico
CARDINAL, Gille '87
6900 Etiwanda Ave.
Reseda, CA 91335
CARLISLE, Allan '74
17391 122nd N.
Palm Beach, FL 33478
CARLSON, Patricia W. '86
911 Camino Viejo
Santa Barbara, CA 93108
CARLSON, Randy W. '76
5380 Overpass Rd.
Santa Barbara, CA 93111
CARLTON, Charles B. (Chuck) '81
215 W. Burnett
Louisville, KY 40208
CARMODY, Richard J '86
25188 Panama Avenue.
Webster, MN 55088
CARNEVALE, John J. '75
14 Spring Mill Dr.
Sewell, NJ 08080
CAROTHERS, Robert '49
158 Sea Park Blvd.
Satellite Beach, FL 32937
CARPENTER, William D. '77
7910 Caldwell Ave.
Niles, IL 60648
CARR, Robert W '86
1232 North 71st Street
E. St. Louis, IL 62203
CARRASCO, R. Ted '86
704 Yorkshire Court
El Paso, TX 79922
CARROLL, David M. '81
600 Dolliver Street
Pismo Beach, CA 93449
CARTER, Peter C. '84
1085 Woodland Ave
Elm Grove, WI 53122
CARTER, Randie L. '82
4405 Middlebrook Dr.
Arlington, TX 76016
CARTER, Reginald L. '83
2045 #B 38th St. S.E.
Washington, DC 20020
CARTER, Robert '68
301 S.W. 46th Street
Oklahoma City, OK 73109
CARTER, Stuart '53
701 Newport Blvd.
League City, TX 77573
CARTER, William B. '55
74 Pine Forest Drive
Jesup, GA 31545
CARTER-KELL, Laurette D. '79
3032 Ernst
Franklin Park, IL 60131
CARVER, THOMAS L. '86
64 Main Street
Stonington, CT 06378
CASAVANT, Jayson P. '82
22 Catherine Dr.
Rutland, VT 05701
CASH, William C. '90
25715 Mesa Dr.
Carmel, CA 93922
CASPER JR., Robert J. '83
212 Reef Ct.
Santa Barbara, CA 93109
CASTIEL-DAHAN, Linda '87
8306 Wilshire Blvd., Ste. 519
Beverly Hills, CA 90211
CASTLE, James Charles '88
25 Cornell Crt.
Pleasant Hill, CA 94523
CASTLE, Paul '48
17240 Timber Ln./P.O. Box #160
Soulsbyville, CA 95372
CASTLETON, Glen '52
3434 Feast 88th Street
Anchorage, AK 94507
CASTRO, Ronald '59
545 W. Santa Paula St.
Santa Paula, CA 93060
CATENA, JAMES J. '82
P.O. Box 2128
Union, NJ 07083
CATERINA, Patricia A '87
6016 Ewing Ave. S.
Edina, MN 55410
CAUGHEY, Michael '70
397 N. Kellogg Ave.
Santa Barbara, CA 93111
CAVANAUGH-GRIMES,
 ELIZABETH A. '87
207 W. Fourth St.
Austin, TX 78701
CAWLEY, Kenneth '52
2302 Monte Carlo
Modesto, CA 95350
CELLI, Michael '89
5870 Mandarin Ave
Goleta, CA 93117
CEPPAS, Cristiana '87
1450 Chestnut #201
San Francisco, CA 94123
CEPPI, Donald J. '77
11876 Coral Reef
Malibu, CA 90265

CESPEDES, Jaime '85
Jamaica 110 Hipodromo
Mexico City, DF, Mexico
CHAE, Jay '88
10001-A Long Point
Houston, TX 77055
CHAFFEE, Jim '59
1322 Post Avenue
Carpinteria, CA 93013
CHAMBERLAIN, Fred G. '81
24761 Valley Way
Carmel, CA 93923
CHAMBERLAIN, Lynn Atkin '80
P.O. Box 100
Toquerville, UT 84774
CHAMBERS, George H. '80
2319 S. Arch St.
Little Rock, AR 72206
CHAN, David '59
6033 N. Sheridan Rd.
Chicago, IL 60660
CHAN, Johnny L. '85
2-3-6 Todoroki #106
Setagaya Tokyo, 180, Japan
CHANDLER, Ross C. '80
61512 West Ridge Avenue
Bend, OR 97702
CHANEY, Bradley L. '77
1750-H Army Street
San Francisco, CA 94124
CHANG, Miao-Yu '86
41 Ching I Road
Keelung, Taiwan
CHAO, Jackson R. C. '83
201 West Montecito Street
Santa Barbara, CA 93101
CHAPARRO, Steven A. '82
3463 State Street
Santa Maria, CA 93108
CHAPIN, Douglas S. '90
P.O. Box 466
Mt. Vernon, MO 65712
CHAPMAN, Edwin '52
831 Murphy Avenue
Joplin, MO 64801
CHAPMAN, Mel '72
383 52nd Street
Delta, BC V4M 2Y5, Canada
CHAPONOT, Robert '65
760 Beader Ln
Byron, CA 94514
CHARREY, Francis T. '66
282 Chartwell Rd.
Oakville Ontario, L6T329, Canada
CHARTER, Robert R. '83
8204 23rd Ave. N.E.
Seattle, WA 98115
CHASE, George B. '74
RR 7 Box 239A
Arcadia, FL 33821-9807
CHASE, Julianne '81
400 Treat Ave., Unit E
San Francisco, CA 94110
CHAUVIN, William '71
417 Eliza St.
New Orleans, LA 70114
CHEN, Ching Shyang '89
5116 San Lucas Way
Santa Barbara, CA 93111
CHEN, JAMES '66
1917 Anacapa St.
Santa Barbara, CA 93101
CHEN, Tzu-Yu '90
544 Sussex Court
Goleta, CA 93117
CHENEY, Catherine A. '76
215 Cherry
Mount Angel, OR 97362
CHERIOT, John
1924 Emerson
Santa Barbara, CA 93103
CHESNUT, Richard J. '76
414 Anton Pl.
Lake Peekskill, NY 10537
CHESNUT, Russell '90
4520 W. 69th Avenue
Westminster, CO 80030
CHESSER, Michael '73
5290 W. Washington Blvd.
Los Angeles, CA 90016
CHESTER, William Max '64
3627 Little Road
Lutz, FL 33549
CHILD, Douglas R. '83
P.O. Box 1027
Ashland, OR 97520
CHILDRESS, JIM '82
5048 50th Street
Lubbock, TX 79414
CHILDRESS, Joe '71
12642 Annette Circle
Garden Grove, CA 92640
CHIN, Cary J. '78
310 Pacheco Street
San Francisco, CA 94116
CHINN, Robert J. '53
106 Colorado Avenue
Pueblo, CO 81004
CHISHOLM, William '73
505 Blake B3
Kansas City, KS 66111
CHISWELL, Kirk B. '88
4604 75th St./ NW / Apt. 2
Calgary Alberta, 53B 2M9, Canada
CHOLKE, Robert C. '77
1724 7th Avenue
Rockford, IL 61108
CHONG, Jeffrey '83
235 W. 22nd St. #7S
New York, NY 10011
CHONG, Lloyd '82
721 Menehune Ln., #104
Honolulu, HI 96826
CHOPPE, GARY R. '83
19200 Soledad Canyon Rd
Canyon Country, CA 91351
CHOU, Chih-Ping (Ricky) '84
447 S. Hewitt
Los Angeles, CA 90013

CHOW, Sterling '88
5446 Newcastle Avenue #110
Encino, CA 91316
CHRISTENSEN, David S. '70
2487 Spring Street #2
Redwood City, CA 94063
CHRISTENSEN, Paul H. '75
286 5th Avenue
New York, NY 10001
CHRISTIAN, Paul '53
1906 Browdway
Scottsbluff, NE 69361
CHRISTMAN, Teri '81
22110 Ybarra Rd.
Woodland Hills, CA 91364
CHRYSSANTHIS, Debra '80
2709 Shawn Leigh Drive
Vienna, VA 22181
CHUA, Henry S. '83
4017 Holly Knoll Dr.
Los Angeles, CA 90027
CHUAN, Jason '86
19471 Sandcastle Lane
Huntington Beach, CA 92648
CHUNG, Won Young '73
17313 Blossom View Dr.
Olney, MD 20832
CHURCH, James N. '75
Rt. 1, Box 19
Ashburn, VA 22011
CIANCIO, Michael J. '83
1819 Peeters Road #7
Irving, TX 75061
CICCONE, Bruno A. '87
863 Lois Ave.
Newbury Park, CA 91320
CICERO, Carl '71
1304 East Mcelhaney
Santa Maria, CA 93454
CICETTI, Richard A. '72
415 San Vicente Blvd.
Santa Monica, CA 90402
CLABOUGH, Thomas R. '70
4834 Alpine Park Drive
Rockford, IL 61108
CLAES, Jan '62
523 East Olive Ave
Turlock, CA 95380
CLARE, James '88
P.O. Box 992
Santa Barbara, CA 93102
CLARK, Barry '81
2641 Spinnaker
Port Hueneme, CA 93041
CLARK, Blair R. '78
14 Darby Ln.
Sandia Park, NM 87047
CLARK, Dennis Mc Kinley '72
8007 Flanders Drive
San Diego, CA 92126
CLARK, Henry A. '80
3531 N. Cleveland
Kansas City, MO 64117
CLARK, Norris R. '74
1929 W. 9th Ave.
Kennewick, WA 99336
CLARK, Robert G. '76
P.O. Box 310
Woodstock Ontario, Canada
CLARK, Timothy R. '78
21740 Los Alimos St.
Chatsworth, CA 91311
CLARK, William D. '88
148 Hennessey Way
Gilroy, CA 95020
CLASE, Jack K. '62
523 E. Olive Ave.
Turlock, CA 95380
CLASON, Harold W. '57
5595 Huntington Drive
Santa Barbara, CA 93111
CLAUDY, Guy '74
5139 Hesperia Ave.
Encino, CA 91316
CLAUS, Joseph W. '86
1005 Via Esmeralda
Santa Maria, CA 93455
CLEARY, Stephanie A '88
2227 W. Farlington St.
West Covina, CA 91790
CLEGG, Richard M. '90
4504 Jamerson Pl.
Orlando, FL 33807
CLEMENTS, Kenneth '86
1768 Mendocino Way
Redlands, CA 92374
CLEVENGER, George '72
5999 Stanton Avenue
Highland, CA 92346
CLEVENGER, RALPH A. '79
138 Santa Rosa Pl.
Santa Barbara, CA 93109
CLEVENGER-O'HARE, Janis M. '80
3044 Aspen Drive
Santa Clara, CA 95051
CLIFFORD, Richard M. '90
35831 N Hewitt's Pt.
Oconomowoc, WI 53066
CLIFTON, David A. '77
4705 Rockmoor Lane
Fort Worth, TX 76116
CLINNIN, Kate '88
321 Laurel Place
San Rafael, CA 94901
CLISE, Eric '77
2803 Magnolia Blvd West
Seattle, WA 98199
CLOHAN, Roderick R. '87
8784 Edenberry St.
Dublin, CA 94568
CLOUTHIER, Kimberly '88
8333 Austin, Apt. 4-B
Kew Gardens, NY 11415
CLUETT, Christina G. '76
P.O. Box 5824
Montecito, CA 93108
CLUTINGER, Thomas M. '88
7741 Lansing Dr
Lemon Grove, CA 920454438

COATES-EDWARDS, Marilyn '87
4975 Sandyland Road #310
Carpinteria, CA 93013
COBARR, Gregg '71
14345 Morningside Drive
Atascadero, CA 93422
COBB, Bruce L. '77
22 Mission Ave.
San Rafael, CA 94901
COBEEN, Kenneth M. '68
P.O. Box 3595
Eureka, CA 95501
COCHET, Paul '74
P. O. Box #1214
Blythe, CA 92225
CODISPOTI, Joseph '72
622 Caudill St.
San Luis Obispo, CA 93401
CODY, Susan C. '88
1735 Glenoaks Dr.
Santa Barbara, CA 93108
COHEN, Arthur B. '78
21601 Erwin St. #282
Woodland Hills, CA 91367
COHEN, Jeffrey S. '89
22765 Barlovento
Mission Viejo, CA 92692
COLE, Robert B. '75
317 Greenwood Dr.
Panama City Beach, FL 32407
COLE, Russell H. '87
316 Waverly
Palo Alto, CA 94301
COLINA, Jorge '79
P O Box 2300
Mashpee, MA 02649
COLLAVO, Kim O. '90
51 Grand Avenue
Johnson City, NY 16056
COLLIER, Thomas '65
P.O. Box 801
Spearman, TX 79081
COLLIN, Francis '82
295 Park Ave. South #2-C
New York, NY 10010
COLLINS, Arthur J. '84
230 Walnut St 104C
Chico, CA 959285052
COLLINS, Gary '71
1713 Middlefield St.
Stockton, CA 95204
COLLINS, James P. '88
7401 H Auburn Oaks Crt
Citrus Heights, CA 95621
COLLINS, Robert H. '75
1310 South Catalina, #203
Redondo Beach, CA 90277
COLMENARES, Angel '82
7504 Hampton Avenue
Los Angeles, CA 90046-5503
COLVIN, George T. '72
779 Palermo Dr.
Santa Barbara, CA 93105
COLVIN, Peter L. '66
1615 Castillo #6
Santa Barbara, CA 93101
COMEAUX, Andre' L. '90
1220 Monterey Blvd
Hermosa Beach, CA 90254
CONANT, Herman '68
3594 Township Ave.
Simi Valley, CA 93063
CONGER, Cydney M. '87
P.O. Box 62
Sun Valley, ID 83353
CONGOTE, Carlos E. '82
Ave 9 AN 24/25 PO Box AA
Cali, 6188, Columbia
CONLEY, Mary V. '79
3509 Littledale Rd.
Kensington, MD 20795
CONN (LAPIN), Peter '71
1338 Edgemont St.
San Diego, CA 92102
CONNELL, Martin H. E. '79
Connall Homestead
Spencerville, Ontario KOE 1XO,
Canada
CONNER, Bruce A. '77
520 Virginia Avenue Aud
Indianapolis, IN 46203
CONNER, Donald L. '64
5255 Via Geraldina
Yorba Linda, CA 92686
CONRAD, Christopher '81
1717 16th Ave.
Seattle, WA 98122
CONRAD, Douglas '71
74 B Elm Street
Framingham, MA 01701
CONTRERAS, Sue '74
P.O. Box 6075
Santa Fe, NM 87502
CONWAY, Curtis A. '75
8404 Indian Hills Dr.
Omaha, NE 68114
CONWAY, Robert J. '68
988 Capital S W
Springfield, MI 49015
CONWAY, Thomas H. '82
385 S. Franklin
Denver, CO 80209
COOK, Barry S. '80
2202 Linden Drive
Hagerstown, MD 21740
COOK, Craig C. '84
75 Coromar Dr.
Goleta, CA 93117
COOK, Daniel L. '82
184 Peninsula Rd.
Medicine Lake, MN 55441
COOK, Donald '63
1434 Martin Luther King Way
Berkeley, CA 94709
COOK, Leland A. '48
70 Berkeley Ave.
Colonia, NJ 07067
COOK, Robert H. '83
27646 Morning Star Ln.
San Juan Capistrano, CA 92675

COOK, Robert I. '77
311 Redwood Ln.
Key Biscayne, FL 33149
COOK, Willis W. '50
2345 Edgemont Rd.
Huntington, WV 25701
COOKE, Colin A. '76
380 Lafayette St.
New York, NY 10003
COOKE, M. E. (Ed) '73
4086 Lawther Ct.
San Jose, CA 95135
COOPER, III
310 River Side
New York, NY 10025
COOPER, Warren R. '48
420 Arbol Verde
Carpinteria, CA 93013
COOPER, William '55
401 Pala Way
Sacramento, CA 95819
COPELAN-MALOVICH, Verna Pat '79
3531 Cherry Blossom Ln.
Lake Elsinor, CA 92330
COPELAND, Charles A. '81
16 Davis Avenue 9
Brookline, MA 02144
COPELAND, James H. '77
3700 Greenhill Dr.
Chamblee, GA 30341
COPELAND, ROBERT W. '78
801 Vine Street
Chattanooga, TN 37403
CORALNICK, David G. '87
20881 Charwood Lane
Huntington Beach, CA 92646
CORDERY, Donald '61
395 Hacienda Drive
Yuma, AZ 85364
CORDOVA, Phil A '88
P.O. Box 1057
Summerland, CA 93067
CORELLA, Jeffrey S. '89
5936 Via Real 4
Carpinteria, CA 93013-2823
CORKILL, Albert '51
4933 Maxwell Road
El Paso, TX 79904
CORLEY, Michael D. '73
3 Joyce Court
Eatontown, NJ 07724
CORMANY, Charles H. '86
11131 Sunshine Terrace
Studio City, CA 91604
CORMANY, George J. '78
11959 Weeping Willow Ln.
Fontana, CA 92335
CORNELL, Anna R. '82
400 Lafayette St. #301
New York, NY 10003
CORNICK, William R. '86
4310 H'Piilani #301
Lahaina, HI 96761
COROIN, James L. '55
2712 Nipoma St.
San Diego, CA 92106
CORRADA, Fernando B. '85
17 Oak Creek Drive
S. Burlington, VT 05401
CORRALES, Filo '58
1520 Joycedale St.
West Covina, CA 91790
CORREIA, Robert S. '89
6117 N Haven Drive
N. Highland, CA 95660
CORTEZ, Jon R. '90
2738 Sierra Vista
Bishop, CA 93514
CORY, Gordon '52
1780 Ventura Blvd
Camarillo, CA 93010
COSKO, Jackie N. '90
402 14th Street
Santa Monica, CA 90402
COSTA, Arthur F. '84
SOS 303, Bl. "D", Apt. 304
Brasilia, DF 70 336, Brazil
COSTANZA, Robert '86
2600 Right Hand Canyon Rd.
Reno, NV 83510
COSTLEY, Jim '68
1448 Sheldon Dr.
Modesto, CA 95350
COSTLEY, Sue Maurer '68
1448 Sheldon Drive
Modesto, CA 95350
COTE, Daryl J. '87
9325 150 St
Edmonton Alberta, T5R1G5, Canada
COTE, Guy '67
6457 Pitcairen St.
Cypress, CA 90630
COTHREN, Howard B. '78
3725 Avenida Palo Verde
Bonita, CA 92002
COTTEN, Robin '90
28562 Buena Vista Ln.
Highland, CA 92346
COTTLE, Pete '71
P.O. Box 300
Santa Ynez, CA 93460
COUGHENOUR, Charles B. '81
14802 Anola
Whittier, CA 90604
COUNTRYMAN, Mike '77
3131 Wintergreen Ter.
Grapevine, TX 76051
COURSOLLE, Thomas '71
1120 McArthur Drive #1304
Carrollton, TX 75007
COVEY, Norman E. '60
3876 Vista Largo
Las Vegas, NV 89121
COWAN, Lourdes Acevedo '82
Ave. De Las Fuentes #280-1
01900, 20 DF, Mexico
COWEN, Jeffrey O. '86
320 Date Street
Barstow, CA 92311

COWEN, John J. '86
320 Date Street
Barstow, CA 92311
COWSERT, Frank '53
11785 Washington Ave.
Courtland, CA 95615
COX, Dennis G. '69
R. R. #1
Humboldt, IA 50548
COX, James S. '65
923 Shumway
Shakapee, MN 55379
COX, John L. '64
400 Collins Rd. MS 105-162
Cedar Rapids, IA 52498
COX, Luther W. '68
10423 Oso Grande N.E.
Albuquerque, NM 87111
COYNE, Patrick '86
255 Timber Lane
Cheshire, CT 06410
CRABB, Martin D. '78
1633 York St.
Denver, CO 80206
CRAFT, Bill '74
1513 Thistlewood Dr.
De Soto, TX 75115
CRAIG, Bob '85
7190 Georgetown Rd
Goleta, CA 93117
CRAIG, John Kent Thomas '74
10209 Kerrigan St.
Santee, CA 92071
CRAMER, David '86
539 Robert J Quigly Dr.
Scottsville, NY 14546
CRANE, David '81
22637 W Copperhill Dr 90
Saugas, CA 91350
CRANE, Stephen C. '82
905 Arthur Dr
Kindred, ND 585012442
CRAWFORD, Del '75
5400 Glen Haven Road
Soquel, CA 95073
CRAWFORD, Ron '68
6075 SW Chestnut
Beaverton, OR 97005
CREAGER, Richard '75
105 Berryman St.
Grass Valley, CA 95945
CREELMAN, Peter G. '90
20432 S. Santa Fe Ave. Ste. F
Long Beach, CA 90810
CRESS, Bobbi L. '85
6313 N. 181st Ave.
Waddell, AZ 85355
CRISAFULLI, Charlene '78
471 Coralie Drive
Walnut Creek, CA 94596
CRISOSTOMO, Herman A. '79
P.O. Box 2028
Agana, 96910, Guam
CROCKETT, Joseph '65
301 Michael
Springdale, AR 72764
CROSBY, Edwin K. '75
1010 Clement St.
Lake Charles, LA 70601
CROSBY, Ken '75
1413 S. Silver
Deming, NM 88030
CROSS, Michael '70
11920 Deodar Way
Reno, NV 89506
CROSSFIELD, Roy '61
P.O. Box 286
Athens, AL 35611
CROTTY, Daniel '83
820 Dean Avenue
Highland Park, IL 60035
CROUCH, Michael L. '76
2334 W. Naranja
Mesa, AZ 85202
CROUCH, Michael L. '76
87 Camp Moween Rd.
Lebanon, CT 06249
CROUCH, Newel '74
1310 Beta St.
Carlsbad, NM 88220
CROWLEY, Elliot '76
3221 Benda Pl.
Los Angeles, CA 90068
CRUFF, Kevin L. '79
1818 E. Luke Avenue
Phoenix, AZ 85016
CRUISE, Barry '72
2283 Bruce Dr.
Pottstown, PA 19464
CRUMLY, Lamar '76
14A Wellsville Ave
New Milford, CT 06776
CRYE, Don P. '87
1821 Thompson Blvd. #5
Ventura, CA 93001
CUERDEN, Glen
1730 Gaylord Street
Denver, CO 80206
CUEVAS, Nancy Lee '86
P.O. Box 403151
Miami Beach, FL 33140-1151
CULBERTSON, Thomas '82
317 Hall Road
Santa Paula, CA 93060
CULVER, David S. '76
2525 Seagull
Ventura, CA 93003
CULVER, James P. '74
746 S.W. Birdsdale
Gresham, OR 97080
CULVER, Robert '79
2609 Union Ave.
Pennsauken, NJ 08109
CUMMINGS-ROSENBERY,
Ellen M. '81
15757 Sunset Blvd. #2
Pacific Palisades, CA 90272
CUNNINGHAM, Robert F. IV '81
P.O. Box 733
Glenwood Springs, CO 81602

CURIEL, Yorum '75
1956 South Nome Street
Aurora, CO 80014
CURTIS SR., Steven A. '89
36 Cedar Crest Court
Newbury Park, CA 91320
CURTIS, David O. '71
51 W. Salisbury Drive
Wilmington, DE 19809
CURTIS, Todd M. '86
36 Cedar Cresta Ct.
Newbury Park, CA 91320

– D –

D'ESTRUBE, Robert '72
1542 Athlone Drive
Victoria, BC, Canada
D'LOUHY, Thomas '74
100 Cement Hill Rd. Ste. 540
Fairfield, CA 94533
DACANAY, Joe '76
1745 3rd St.
Napa, CA 94559
DALE, Craig '89
4815 Rivervaled Drive
Soquel, CA 950739727
DALE, Gary L. '88
2012 N. Ann Arbor Pl.
Oklahoma City, OK 73127
DAME, James '75
107 Bundy Circle
Buellton, CA 93427
DANERI, Carole '88
2586 Puesta Del Sol
Santa Barbara, CA 93105
DANFORTH, John '58
404 4th Street
Encinitas, CA 92024
DANIEL, John N. '69
8358 Walker St.
La Palma, CA 90623
DANIELS, Gregg '72
Rr 12 #2 Pleasant Valley
Springfield, IL 62707
DANNEHL, Dennis M. '80
3303 Beverly Blvd
Los Angeles, CA 90004
DAPELO, Scott L. '81
134 Palisades
Santa Barbara, CA 93109
DARK, JOHN L. '78
11 Cortez
Santa Barbara, CA 93101
DASE, Kenneth A '88
2191 Tyner St.
Port Coquitlan, BC V3C 2Z3, Canada
DASHNAW, Michael C. '87
3660 Jackson Oaks Court
Morgan Hill, CA 95037
DASTUR, Jennifer R. '82
Fir Haven Est. 78-81 S Beach Roa
Madras, 600028, India
DAUGHERTY, Christopher '81
425 Las Palmas
Santa Barbara, CA 93110
DAUGHERTY, Harry '52
682 S. Walnut Lane
Santa Barbara, CA 93111
DAVENPORT, William '72
1006 Beach Crt.
Fort Pierce, FL 34950
DAVID, Ronald '70
525 N. Jay
Chandler, AZ 85224
DAVIDSON, Bruce '79
160 W Lake View Way
Salem, UT 84653-2068
DAVIDSON, Donald P. '80
P.O. Box 3589
Riverside, CA 92519
DAVIDSON, Fred '52
491 Gladstone Dr.
Thousand Oaks, CA 91360
DAVIDSON, Jerry '80
1057 8th Place
Hermosa Beach, CA 90254
DAVIDSON, Robert S. '70
1539 S. Twain
Fresno, CA 93704
DAVIDSON, Walter D. '83
5121 Santa Fe St B
San Diego, CA 92109
DAVIES, Stephen R. '81
106 Claim Court
El Dorado Hills, CA 95630
DAVIS JR., Jess T. '51
3970 The Woods Dr. A. 1010
San Jose, CA 95136
DAVIS, Carol E. '84
12480 E. Prince Rd.
Tucson, AZ 85749
DAVIS, Charles A. '78
1324 W 19th St
San Pedro, CA 90732
DAVIS, Clyde '62
222 E. 2nd Street
Hope, AR 71801
DAVIS, Dale '64
1821 Weepah Way
Hollywood, CA 90046
DAVIS, Gary H. '67
1505 W. Myrtle Ave.
Visalia, CA 93277
DAVIS, James K. '59
10701 Empire Grade Road
Santa Cruz, CA 95060
DAVIS, Julie K. '78
2602 Louisiana
Lawrence, KS 66046
DAVIS, Kenneth '62
14538 Dalwood Avenue
Compton, CA 90650
DAVIS, Michael J. '75
1196 Edgemound Drive
Santa Barbara, CA 93105
DAVIS, Scott R. '82
7201 Melrose Avenue
Hollywood, CA 90046

DAVIS, Terry C. '76
1009 New Haw Creek Rd.
Asheville, NC 28805
DAVIS, Vernon '50
8314 Second St., #C
Paramount, CA 90713
DAVIS, William A '71
7007 Sea World Drive
Orlando, FL 32821
DAVISON, Michael R. '72
12125 Cantura St.
Studio City, CA 91604
DAWSON, Robert R. '61
1112 W. Mulberry St.
Kokomo, IN 46901
DAY, Raymond W. '48
1420 Colusa
Chowchilla, CA 93610
DAYTON, Ted '76
316 N. Maple, Apt. #134
Burbank, CA 91505
DE BOER, David J. '77
RR # 1, Box 32
Hollandale, MN 56045
DE BRASK, Robert '86
66 Oceanview Ave 54
Santa Barbara, CA 93103
DE COUX, Peter '72
235 Oak St.
Butler, PA 16001
DE GIERE, Terence '71
P.O. Box 1534
Fairfield, IA 52556
DE GIULIO, Robert A. '75
3923 Burke Ave. N
Seattle, WA 98103
DE LA GUARDIA, Maurice '76
2707 S St. S.E.
Auburn, WA 98002
DE LA PORT, Marc C. '79
P.O. Box 488
Hope Valley, RI 12832
DE LA PORTE, Victor '54
107 Frances Rd.
Norwood, Johannesburg, 2192,
South Africa
DE LELLIS, C. Matthew '90
801 Alston Rd.
Santa Barbara, CA 93108
DE LELLIS, Joseph C. '82
1892 Loreto Glen
Escondido, CA 92027
DE LEON, Martin '83
286 5th Avenue
New York, NY 10001
DE LESPINASSE, Hank '65
7728 Robindale Cr.
Las Vegas, NV 89123
DE MELLO, Michael C. '87
1348 Wilder Ave. "B"
Honolulu, HI 96822
DE MONET, Ricardo '72
15 Greenview Lane
Hillsboro, CA 94010
DE PHILLIPO, Dean J. '89
722 Calle Alella
Santa Barbara, CA 93109
DE ROOS, Ricky L. '81
P.O. Box 3241
Santa Barbara, CA 93105
DE SHON III, Rex C. '78
736 S. Dale Court
Denver, CO 80219
DE SOUZA, Alex '90
15325 2 Lassen St
Mission Hills, CA 91345
DE WIT, Monica T '88
15 E Valerio St A
Santa Barbara, CA 93101
DEE, Robert R. '87
1214 E. Mason Apt. B
Santa Barbara, CA 93103
DEERING, E. Joseph '69
6007 Wister Crt.
Houston, TX 77008
DEGENNARO, Daniel '77
2653 Gill Dr.
Concord, CA 94520
DEGROOD, Timothy '75
553 Harrison Avenue
Buffalo, NY 14223
DEIBLER, Debora K '88
P.O. Box 3809
Hollywood, CA 90028
DEICHMAN, J.C. (Chip) '71
1404 N. Catalina Street
Los Angeles, CA 90027
DEKKER, NICHOLAS '68
237 Carlo Drive
Goleta, CA 93117
DEL GAIZO, Joseph '55
35415 Blackburn Dr.
Newark, CA 94560
DELAHAY, Jess H. '82
1216 Diana Lane
Santa Barbara, CA 93103
DELANEY, Tim '84
5836 Pawnee
Lincoln, NE 68506
DELAREULLE II, Robert '82
4411 1/4 Ambrse Ave.
Los Angeles, CA 90027
DELGADO, Jose '59
P.O. Box 1165
Agana, 96910, Guam
DELIANTONI, Richard '84
1807 E. 14th St.
Oakland, CA 94606
DELMAGE, Sherman H. '47
34 Apache M H Park
Myrtle Beach, SC 29577
DEMELLO, JOHN '86
720 Iwilei Road #260
Honolulu, HI 96744
DEMETRIOU, Georgios '83
6045 Cramer Ave. #5
N. Hollywood, CA 9160690
DEMIN, Anthony R '88
P.O. Box 1542
Aspen, CO 81612

DENIER, Philippe A. '88
4621 Jacques St.
Torrance, CA 90505
DENISON, Rebecca S '87
4532 Hackett Ave.
Lakewood, CA 90713
DENLINGER, Paul '85
70-74 Lin-Hsi Road
Shihlin, Taipe, Ta 111, Rep Of China
DENNING, Wayne H. '81
5925 Fair Oaks Blvd 4B
Carmichael, CA 95608
DENNY, Robert J. '87
50 Turkey Plain Road
Bethel, CT 06801
DERBYSHIRE, Glen A. '87
3463 State St. #107
Santa Barbara, CA 93105
DERN-WOLFGRAM, Jane R. '88
296 Marborough St. #7
Boston, MA 02116
DEROBERTIS, Mark '83
10888 Chalon Road
Los Angeles, CA 90037
DEROSA, Michael '77
2300 Fairview Rd G202
Costa Mesa, CA 92626-6409
DERRY, Mark W. '76
545 N. W. 9th Avenue
Canby, OR 97013
DES GEORGES, Joseph '90
120 Aragon Avenue
Los Alamos, NM 87544
DEWEY, William B. '75
3746 Keefer
Chico, CA 95926
DEWITT, Danny '75
2970 Quay St.
Lakewood, CO 80215
DIANGELO BURCH, Lisa M. '82
24371 Ave De La Carlota
Laguna Hills, CA 92653
DIAZ, Armando '68
19 S. Park
San Francisco, CA 94107
DIBBLEE, Walter '47
1545 Mesa Street
Redding, CA 96001
DICKENS, Laura L. '78
6992 El Camino Real #104-253
Carlsbad, CA 92009
DICKERSON, Earl L. '80
12183 Nita Drive
Moreno Valley, CA 92387
DICKEY, William '87
1611 Michael Lane
Pacific Palisades, CA 90272
DICKIESON, Garry T. '79
5530 Sashabaw
Clarkston, MI 48016
DICKINSON, Roger L. '79
3554 Gladiola Dr.
Calabasas, CA 91302
DIEBOLD, Mark S. '77
210 Bluepoint
Kemah, TX 77565
DIGBY, James '57
3315 Herb Court
Loveland, CO 80537
DILLON, Dwight R. '80
4002 W. Berridge Lane
Phoenix, AZ 85019
DILLON, George '70
P.O. Box 1409
Cupertino, CA 95014
DINSFRIEND, Karen S. '79
982 Astro Court
Sacramento, CA 95831
DIPPOLD, Sue '82
P.O. Box 796
Hendersonville, TN 37077
DIXON, Cynthia M. '87
P.O. Box 15722
Newport Beach, CA 92659
DIXON, Dean D. '75
1046 4th Ave. South
Nashville, TN 37210
DIXON, Lynn '72
1911 13th St.
Everett, WA 98201
DIXON, Michelle Ann '90
1901 Mockingbird Ln
Altus, OK 73521
DOBRY, Merlin '63
406 N. Ontare Rd.
Santa Barbara, CA 93105
DODD, H. Lee '87
P.O. Box 250
Madison Heights, VA 24572
DODD, Kathryn '88
15102 NE 19th Circle
Vancouver, WA 98684
DODDS, P. Michael '70
18500 Germain St.
Northridge, CA 91326
DODGE, Ellen '82
103 Hampton Court Rd.
Butler, PA 16001
DODGE, John W. '71
804 Mitchell Ave.
Waterloo, IA 50702
DOE, Brian W. '87
1400 10th Street N.W.
Austin, MN 55912
DOLL, James '68
740 S. Mission St.
Wenatchee, WA 98801
DOLYAK, Neil M. '84
2120 De La Vina #C
Santa Barbara, CA 93105
DOMINGO, James M. '74
20 Union Street
N.S.W., 2043, Australia
DONAHO, Linda L. '86
11714 Fidelia Court
Houston, TX 77024
DONAHUE, Thomas '78
P.O. Box 622
Montauk, NY 11954

DONG, Harry G. '85
1612 Mission Street
Santa Cruz, CA 95060
DOOLEY-COLLINS, Kit '77
33190 S.E. Regan Hill Road
Estacada, OR 97023
DORFMANN, Paniela B. '83
1380 Canterbury Way
Potomac, MD 20854
DORSHEIMER, Edward V. '77
5268 Meridian
San Jose, CA 95118
DOTY, Tom '75
1316 Carpinteria Street
Santa Barbara, CA 93103
DOUBILET, David '67
1040 Park Ave.
New York, NY 10028
DOUCET III, Edward J. '80
253 Park St.
Troy, MI 48084
DOUGLAS, Walter C. '48
648 Calle Rinconada
Santa Barbara, CA 93105
DOUGLASS, John W. '86
8383 Manitoba St
Playa Del Rey, CA 90293-8210
DOURAN, Yvon M. '89
1009 Newton Rd
Santa Barbara, CA 93101
DOVAL, John '73
1333 Weller Way
Sacramento, CA 95818
DOVEY, Dean '82
1917 N. Milwaukee Ave.
Chicago, IL 60647
DOW, George '62
54 Bunny Lane
Marshfield, MA 02050
DOW, Gerald E. '62
202 Cooper Rd.
Santa Barbara, CA 93109
DOW, JEFFREY S. '89
4890 Aircenter Circle #209
Reno, NV 89502
DOWDALL, James A. '80
1654 Noreen Drive
San Jose, CA 951243829
DOWLER, Lauren K. '79
P.O. Box 761
Paoli, PA 19301
DOWLING, W. Lescher '66
12345 El Monte Rd.
Los Altos Hills, CA 94022
DOZOIS, Phil J. '47
3969 Modesto Drive
San Bernardino, CA 92404
DRAFAHL, Jack '73
1187 N.E. 25th Avenue
Hillsboro, OR 97124
DRAKE, Jennifer L '89
780 Acacia Walk #F
Goleta, CA 93117
DRELL, Ellen Covela '79
25915 Adolfo Ct.
Valencia, CA 91355
DREYFUS, Joshua '83
727 South Dearborn Street
Chicago, IL 60605
DRISKEL, Dana '72
1150 North Fairview Rd
Goleta, CA 93117
DROZ, Frederick C. '79
17430 Amethyst Drive
Fort Bragg, CA 95437
DRUMMOND, Kathi D. '85
2417 S 222nd A6
Seattle, WA 98198
DUBE, Anthony P. '89
131 Edgerton St.
Manchester, CT 06040
DUBLIN, Richard '70
414 3rd Avenue N.
Minneapolis, MN 55401
DUCHAINE, Randall D. '78
200 W. 18th St. #4-F
New York, NY 10011
DUCHART, Wayne '72
1791 Harvey Avenue
Kelowna BC, Canada
DUECY, Charles M. '78
1854 N. Brighton Cir.
Mesa, AZ 85207
DUENES, Richard '68
2319 Holly Ave.
Tucson, AZ 85713
DUFORE, Joseph '71
150 Fir Street
Camarillo, CA 93010
DUGAS, Gary '90
4811 Cyress Ave.
Carmichael, CA 95608
DUGAW, SUSAN M. '77
8 South Main St.
Port Chester, NY 10573
DUGAY, Peter '71
94-1031 Akihiloa St.
Waipahu, HI 96797
DUKE, Stephen C. '89
79 Daily Dr 209
Camarillo, CA 93010
DULLEA, Lawrence F. '79
P.O. Box 569
Green Harbor, MA 02041
DUNCAN, William '65
1121 Orcutt Rd. #69
San Luis Obispo, CA 93401
DUNEHEW, Darren L. '82
41111 Country Ln.
Visalia, CA 93277
DUNN, Roger '81
544 Weddell Drive
Sunnyvale, CA 94089
DUPUIS, Cathy M. '90
125 Belvale Dr
Los Gatos, CA 95030
DURAN, Juan '79
2137 W. Whitendale Ave.
Visalia, CA 93277

DURHAM, Jennifer L. '87
777 North Los Robles #6
Pasadena, CA 91104
DURKIN, Michael '57
West 1924 Augusta
Spokane, WA 99205
DUSSEAULT, George '61
37 Dearborn Place #75
Goleta, CA 93117
DUTHIE, Peter L. '81
328 10th Street N.W.
T2N 1V8, Canada
DYER, Kent A. '85
P.O. Box 9
Bailey, CO 80421
DYESS, Samuel Todd '85
P.O. Box 5599
W. Palm Beach, FL 33406

– E –

EADS, Andrew C. '76
Rt. #3, Box #3312 Lot #13
Kennewick, WA 99337
EADS, Sidney '63
196 Pine Drive
Louisville, TX 75067
EAGLE, Edward '74
240 Athol Avenue
Oakland, CA 94606
EARLY, John R. '87
10746 Francis Place #205
Los Angeles, CA 90034
EASOP, Thomas A. '86
25 Dallas Street
Staten Island, NY 10310
EASTABROOK, William R. '56
3281 Oakshire Dr
Los Angeles, CA 90068
EASTWOOD, Henry C. '71
127 Kentucky Ave. S.E.
Washington, DC 20003
EATON, Peter M. '73
C/O Box 816, Wolfville
Nova Scotia, Canada
EBBERS, Russell B. '85
844 S Sycamore
Los Angeles, CA 90036
EBSEN, Mark D '88
3610 S.W. Pasadena
Portland, OR 97219
ECHEMANN, Raphael A. '79
P.O. Box 656
Sidney, OH 43565
ECKERSTROM, Russell '48
974 Via Campobello
Santa Barbara, CA 93105
EDBLOM, Jock J. '64
1415 Circle Blvd.
Corvallis, OR 97330
EDELSTEIN, Andrew M. '90
1323 Olive E
Santa Barbara, CA 93101
EDWARD HUNERLACH, Brian '90
24151 "C" Hollyoak
Laguna Hills, CA 92656
EDWARDS, Glenn '77
12322 Amado
Houston, TX 77065
EDWARDS, Glenn W. '77
12322 Amado
Houston, TX 77065
EDWARDS, Grant '73
1470 Rancho Encinitas Dr.
Encinitas, CA 92024
EDWARDS, J. Hudson '56
2408 Grandby Dr.
San Jose, CA 95130
EDWARDS, Peter '70
Box #473 B, Rt. #6
Bolton, CT 06040
EGGERS, Joseph R. '75
2416 Washington St.
Two Rivers, WI 54241
EGLE, William L. '76
4548 Biloxi Aveneue
N. Hollywood, CA 91602
EHART, John R. '83
94 West 4th Street
Yuma, AZ 85364
EHDE, Staffan '83
Box 3063
Vasteras, 72003, Sweden
EHLKE, Robert '57
948 N. Saffron
Mesa, AZ 85205
EIBE, M. Bruce '68
P.O. Box 2
Miami, FL 33261
EICHENLAUB, Robert S. '71
7834 Vicky Ave.
Canoga Park, CA 91304
EICKHORN, John '73
15922 E. Princeton
Aurora, CO 80013
EKBLAD, Dana A. '78
P.O. Box 16233
S. Lake Tahoe, CA 95706
EKLOW, Fred S.H. '75
6569 Ripplewood Lane
Cincinnati, OH 45230
ELDER, Phillip '68
1220 E. 20th St.
Tulsa, OK 74120
ELDORADO, Carla Jean '77
2554 Lincoln Blvd. #315
Marina Del Rey, CA 90292
ELEAZER, G.D. '52
3318 Northshore Road
Columbia, SC 29206
ELFRINK-WADMAN, Danette L. '82
7 Green Field Rd
Montague City, MA 01376
ELKEN-MULD, Tina R. '83
6222 - 37th N.E.
Seattle, WA 98115
ELLEFSON, Dwight T. '72
453 South Wisconsin
Villa Park, IL 60181

ELLINGTON, Robert '89
1459 S Jameson Ln
Montecito, CA 93108-2820
ELLIOTT, Bradley '84
4949 Rhoads Ave
Santa Barbara, CA 93111
ELLIOTT, Brian M. '73
RR#2 Box 40
Thompson, CT 06277
ELLISON, Greg '81
6755 S.w. Canyon Drive
Portland, OR 97225
ELSMAN, Kenneth R. '85
292 Morning Sun
Mill Valley, CA 94941
ELSNER, Mary J. '88
2420 North Terrace Avenue
Milwaukee, WI 53211
EMBERY, Richard B. '78
3117 E. Northridge
Mesa, AZ 85213
EMERICK, Laura L. '87
111 Sullivan St. #3B
New York, NY 10012
EMERY, Gregory R. '77
9292 Butler Warren Rd.
Cincinnati, OH 45241
EMERY, Kerry '86
14674 Stonebridge Dr.
Saratoga, CA 95070
EMMONS, Russell A. '86
1314 Cardinal Creek
Duncanville, TX 75137
ENDE, Brian '86
9013 Fairlane Drive
Bridgeview, IL 60455
ENDICOTT, Carol J '89
P.O. Box 5222
Santa Barbara, CA 93150
ENDLER, Michael S. '80
3748 Redwood Ave.
Los Angeles, CA 90066
ENGEL, Thomas H. '81
1528 Copperville Road
Cheyenne, WY 82001
ENGELMAN, John R. '80
Rt. #2/Central Ridge Rd.
Mt. Olivet, KY 41064
ENGH, Barbeau '66
205 Ralston Ave.
Mill Valley, CA 94941
ENGRAFF, John A. '77
2656 McBurney Court
San Diego, CA 92154
ENGSTROM, Steven '83
17846 Elkwood Street
Reseda, CA 91335
EPLEY, Paul '71
9100 Sardis Forest Drive
Charlotte, NC 28226
EPPS, SUSAN '85
2747 Emerald Dr.
Jonesboro, GA 30236
EPSTEIN, Greg E. '83
3145 La Suvida Dr.
Los Angeles, CA 90068
EPSTEIN, Joseph J. '77
2858 Lawndell
Brentwood, MO 63144
ERDKAMP, Michael J '88
299 S. Lime
Orange, CA 92668
ERICKSON, James W. '80
21500 Treeline Drive
Corcoran, MN 55340
ERLER, Ernest R. '66
427 West Merle Ct.
San Leandro, CA 94577
ERRAMOUSPE-WALLACE, LISA D. '81
P.O. Box 2991
Gallup, NM 87305
ERVIN, William J. '76
4826 Macintosh Pl
Boulder, CO 803012214
ESPARZA, Sergio A. '86
Fresas #27 Colonia Del Valle
Mexico City, DF 03100, Mexico
ESPERO, EDGAR C. '79
45-430 Waliwali Place
Kaneohe, HI 96744
ESSAD, Robert D. '78
8524 4th Ave. N.E.
Seattle, WA 98115
ESSENBERG, James '57
154 Standish
Holland, MI 49423
ESSIG, Steve '71
300 1/2 Jasmine
Corona Del Mar, CA 92625
ESTRADA, Kenneth A C '90
6245 Aberdeen
Goleta, CA 93117
ETIENNE, Elizabeth '89
820 Arbor Lane
Glenview, IL 60025-3234
EVANS, CHARLES E. '88
515 N. 8th Street
Carbondale, CO 81623
EVANS, D. Clarke '85
102 Arcadia Pl. #702
San Antonio, TX 78209
EVANS, Lawrence '73
1165 N.Clark St.
Chicago, IL 60610
EVANS, Mark S. '77
3181 SW Sam Jackson Park Rd.
Portland, OR 97201
EVANS, Norman W. '56
7653 Walsh Way
Sacramento, CA 95832
EVANS, Robert M. '78
1769 Valley Park
Hermosa Beach, CA 90254
EVANS, Scot '89
6700 Franklin Place, Apt. 101
Hollywood, CA 90028
EVANS, Thomas W. '81
P.O. Box 524
Brigham City, UT 84302

EVERITT, Arthur L. '90
560 Beloit Avenue
Los Angeles, CA 90049
EVERLEY, Robert '78
9515 Lee Blvd.
Leawood, KS 66206
EWELL, Timothy A. '87
2056 Elinora Dr
Pleasant Hill, CA 94523-2844
EWERS, Richard '50
2223 Main Street #40
Huntington Beach, CA 92648

– F –

FABER II, Urban '72
1238 Folkstone Ct
Wheaton, IL 60187
FABRE, Stephen J. '85
1954 Port Bristol Cir.
Newport Beach, CA 92660
FAHEY, Clifford G. '81
350 S. Belmont
Wichita, KS 67218
FAIFER, Stephen '72
208 Dana Dr.
Collinsville, IL 62234
FAIN, Nat '60
109 Venetian Drive
Islamorada, FL 33036
FAIRBANK, Rodney G. '86
P.O. Box 289
Youngstown, NY 14174
FALBO-HERMOSILLO, Arlene M. '77
2474 Manet Lane
Simi Valley, CA 93063
FALK, Eugene '62
P.O. Box 2131
Sedona, AZ 86336
FALKE, Terry G. '79
814 Misty Glen
Dallas, TX 75232
FANCHER, Christine '82
3684 Ardilla Drive
Santa Barbara, CA 93105
FARHAD, Shukri '87
3463 State St 122
Santa Barbara, CA 93105
FARHOOD, Haghi
#20 6th Alley, Nillofar St.
Apadana Ave Tehran, 15338, Iran
FARNER, Barry A '86
29976 Monroe Drive
Evergreen, CO 80439
FARQUHAR, George '65
1305 W. 10th St.
Port Angeles, WA 98362
FARRALL, Donald R. '79
2821 Jackson Drive
Lincoln, NE 68502
FARRAR, Carl R. '47
2514 Moore Street
Alton, IL 62002
FARRELL, William P. '77
140 Lazy Brook Rd.
Monroe, CT 06468
FARRIS, Stephen G. '85
2933 NE 35th Place
Portland, OR 972122725
FARRUGGIO, Matthew '81
23 Orben Place
San Francisco, CA 94115
FAUBEL, Warren A. '83
627 S. Highland Ave.
Los Angeles, CA 90036
FAULKNER, William R. '87
571 - 5th St. #2B
Brooklyn, NY 11215
FAYAZ, Leyla M. '80
10 Porchester Mews
London, W2, England
FEASTER, Mark S. '82
100 Clinton St. #4A
Hoboken, NJ 07030
FECHTMAN, Henry L. '66
P.O. Box 3132
Santa Barbara, CA 93130
FEDRIGO, Thomas A. '82
15782 Golfview
Livonia, MI 48154
FEIGER, Beth '85
14 Tanglewood Drive
Livingston, NE 07039
FEIGHNER, Peter C. '88
173 Ciara St.
San Francisco, CA 94107
FEILING, David A. '76
7804 Ravenswood Lane
Manlius, NY 13104
FEKETE, Victoria M. '87
704 Hillcrest Avenue S.W.
Calgary, T25 0N4, Canada
FELIPE, Rodolfo '74
1607 South Main Street
Corona, CA 91720
FELIX GREEN, Stefanie A. '78
915 Talbot Ave
Albany, CA 947062019
FELTUS, John '52
P.O. Box 631
Minden, LA 71055
FELZMAN, Joseph D. '73
P.O. Box 3618
Portland, OR 97208
FERENZ JR., John J. '88
36 Galaxy Way
Lompoc, CA 93436
FERGUSON, Daniel S '88
109 Mima St
San Francisco, CA 94105
FERGUSON, John W. '85
22 Alborn Road
Ellington, CT 06029
FERGUSON, Richard D. '86
10603 Morning Mist Trail
Fort Wayne, IN 46804
FERGUSON, Robert '83
7306 E. Diamond Avenue
Mesa, AZ 85208

FERNEY, Connie Barnes '86
5909 W. 153rd Street
Overland Park, KS 66223
FERRAN, Robert C. '87
1036 E. Haley St. "B"
Santa Barbara, CA 93103
FERRARIS, Franco '86
Via Rouani 6 Monza
Milano, 20052, Italy
FERRI, Mark A. '81
463 Broome St.
New York, NY 10013
FERRISS, James '72
4900 S.E. Thiessen Rd.
Milwaukie, OR 97267
FETTIG, Carl '70
P.O. Box 184
Romeo, MI 48065
FEUERSTEIN, Robert Wayne '72
20020 Donora Avenue
Torrance, CA 90503
FIAT, Gideon '79
31 Thornwood Drice
New York, NY 10956
FIDLER, Glenn A. '81
1232 Irwin Street 4
San Rafael, CA 94901
FIELDS, John '53
P.O. Box 802
Marshall, CA 94940
FIKE, Stephen '71
2913 W. Virginia Ave.
Mc Henry, IL 60050
FILARY, Katrina M. '85
286 Fifth Ave. #1206
New York, NY 10001
FILONE, Nick '80
3312 Swede Rd.
Norristown, PA 19403
FINDLEY, Paul '86
11 W. Illinois
Chicago, IL 60610
FINDYSZ, Mary A. '78
3550 E. Grant Road
Tucson, AZ 85716
FINK, Ted J. '82
34479 Care Terrace
Fremont, CA 94555
FINLEY, Frank C. '82
P.O. Box 480
Jefferson City, MO 65102
FINLEY, MARK
12607 East Philadelphia St.
Whittier, CA 90601
FINLEY, Russell C. '80
13272 Parkview Ave.
Uniontown, OH 44685
FINLEY, Thomas Scott '68
265 Prodo Rd. Ste #4
San Luis Obispo, CA 93401
FINSON, STEVE '89
217 Greenwich Dr.
Pleasant Hill, CA 94523
FIRESTONE, Jeff R. '81
139 Washington Blvd.
Fremont, CA 94539
FISCHER, Joyce '89
895 Idlwood Drive
Issaquah, WA 98027
FISCHER, Thomas B. '75
P.O. Box 91284
Anchorage, AK 99509
FISH, STEVEN D. '76
5285 Elam Young Pkwy. Ste. B-500
Hillsboro, OR 97124
FISHER, Dennis L. '75
1361 Stubblefield Road
Santa Maria, CA 93455
FISHER, Gail L '88
P. O. Box 2955
Orcutt, CA 93455
FISHER, Kenneth S. '82
420 N. Genesee Ave.
Los Angeles, CA 90036
FISHER, Scott L. '81
Box 56 Cruz Bay
St. John Island, 00830, Virgin Islands
FITCH, David A. '80
344 West Stonegate Raod
Peoria, IL 61614
FITZGERALD, Beth '86
141 12th Street N.E. #7
Washington, DC 20002
FITZGERALD, Dan '77
P.O. Box 65961
Los Angeles, CA 90065
FITZGERALD, Sheelin S. '88
140A Carter Beach Road
Friday Harbor, WA 98171
FITZPATRICK, Michael R. '77
1309 N. Rosewood Pl.
Anaheim, CA 92805
FLACK, Cary A. '85
8817 Whitaker
Sepulveda, CA 91343
FLAHERTY, John M. '77
3013 Amy Dr.
Library, PA 15129
FLEISHMAN, Bryan E. W. '89
23411 White Harbour Court
Seneca, SC 29678
FLEMING, John P. (Jack) '78
5666 Calle Real
Goleta, CA 93117
FLEMING, Lori '86
667 Romero Canyon Dr.
Santa Barbara, CA 93108
FLEMMING, Paul '87
119 Coffee Street
San Fernando Tobago, Rep Of Trinida
FLESHMAN, Roger G. '84
6151 Mountain Vista #713
Henderson, NV 89014
FLOOD, KEVIN J. '75
1329 Macklind Ave.
St Louis, MO 63110
FLOOK, Lyman R. '78
4543 North Hamilton Ave. #3-W
Chicago, IL 60625

FLOREA, George '53
500 N. Stewart St.
Creve Coeur, IL 61611
FLORIAN, Thomas J. (TJ) '84
517 Madison Street, Apt. 2
Waukesha, WI 53188
FLOWERS, James '66
1708 Aaronwood Dr
Old Hickory, TN 37138-4251
FLYNN, Dale W. '76
1765 14th St.
Los Osos, CA 93402
FLYNN, Timothy J. '78
2109 N. Brandywine Street
Arlington, VA 22207
FOBAR, James L. '81
282 Council Ave
Clawson, MI 480171165
FODREA, Edith (Gitte) '87
306 Barranca Ave. #4
Santa Barbara, CA 93109
FOGATA, Robert A. '70
601 E. Santa Paula St.
Santa Paula, CA 93060
FOGERTY, Barry '82
12 Oak Hollow Road
Shawnee, OK 74801
FOGLE, CLAYTON A. '78
P.O. Box 2354
Goleta, CA 93118
FONSECA, Sonia '82
Rua Thomaz Carvalhal
Sao Paulo, 04006, Brazil
FORBES, Kenneth J. '90
4634 E. Brown
Fresno, CA 93703
FORCHT, James D. '82
506 British Crt.
Arlington, TX 76018
FORD, David '74
2020 N. Main #222
Los Angeles, CA 90031
FORD, Michael H. '76
R. Da Paz 49
Sao Paulo, 10064, Brazil
FORD, Tedroe J '90
919 W Mission Street
Santa Barbara, CA 93101
FORLIVESI-AMARAL, Lisa '83
40 Waterhouse Street
Somerville, MA 02144
FORREST, Alan '82
4640 Bryant Ave
Minneapolis, MN 55409
FORT, David '74
P.O. Box 2042
Lompoc, CA 93438
FORTNER, George C. '75
2040 Phalarope Court
Costa Mesa, CA 92626
FORTON, Peter S. '78
305 Cochlin
Traverse City, MI 49684
FOSS, Frederick '60
710 Lions Gate Drive
Oxnard, CA 93030
FOSS, Terrell D. '86
Rt. 3, Box 76F
Richmond, TX 77469
FOSSAT, William '54
Helper, UT 84526
FOSSON, Connie L. '85
1911 Crook Street
Ashland, KY 41101
FOSTER, Andrew '61
2017 Carrington Court
Stone Mountain, GA 30087
FOSTER, Ivan M. '81
718 West Garfield Blvd.
Chicago, IL 60609
FOSTER, Jay C. '85
5998 Jeanine Dr.
Sacramento, CA 95842
FOSTER, Leroy D. '69
12 Greenfield Crt.
San Anselmo, CA 94960
FOSTER, Mark W. '77
7026 E. Slauson Ave.
City Of Commerce, CA 90040
FOTI, Ann Erin '82
318 Warwick Ave.
Douglaston, NY 11363
FOULKE, DOUGLAS B. '79
140 W. 22nd St.
New York, NY 10011
FOURNIER, Charles '68
P.O. Box 130
Kent, WA 98031
FOWLER, Chris E. '83
3946 SW Garden Home
Portland, OR 97219
FOWLER, Eve M. '87
1526 Noble Road
Jenkintown, PA 19046
FOX, Charles K. '83
7904 Crystal Blvd
Diamond Springs, CA 95619
FOX, Deborah
P.O. Box 1177
Damariscotta, ME 04543
FOX, George '70
9064 Azalea Glen Rd
Glendale, OR 97442
FOX, Steven A. '83
1965 Nautilus Street
La Jolla, CA 92037
FOX, Merle T. '64
129 Prospect
Jacksonville, IL 62650
FOX, Patrick '81
420 North 5th Street
Minneapolis, MN 55401
FRANCESCUTTI, Alan '68
P.O. Box 10068
Bainbridge Island, WA 98110
FRANCO, Theodore '52
815 Dolores Dr.
Santa Barbara, CA 93109

FRANDSEN, Robert A. '77
310 Jackson St.
Denver, CO 80206
FRANK, Lois '85
2436 Armstrong Ave
Los Angeles, CA 90057
FRANK, Robert A. '73
2913 Forrest Hills Ln.
Richardson, TX 75080
FRANKE, Richard '72
196 Washington St.
Pittsburgh, PA 15223
FRANKEL, Georgina E. '86
824 Sudden Valley
Bellingham, WA 98226
FRANZ, Diane G. '89
1415 W. North St. #904
Anaheim, CA 92801
FRANZ, Gregory '83
6151 31St N.W.
Washington, D.C, 20015
FRAUGHTON, Paul H. '77
956 Yale Ave.
Salt Lake City, UT 84105
FRAZIER, Jeff '84
1025 8th Ave. South
Nashville, TN 37203
FRAZIER, Ned '70
243 Barker Road
Nashville, TN 37214
FREDERICK, Jack '61
612 Timmons Street
Scobey, MT 59263
FREDERICK, James R. '90
1234 N. Las Palmas #301
Los Angeles, CA 90038
FREDIN, Peter M. '90
P.O. Box 24105
Denver, CO 80224
FREDRIKSZ, Winnie '81
3257 Oakshire Drive
Los Angeles, CA 90068
FREEDMAN, Holly R. '89
2312 Cheryl Place
Los Angeles, CA 90049
FREEMAN, Kirk A. '82
1622 Briargrove Drive
Dallas, TX 75181
FREITAS, Joe I. '75
6621 North Colonial
Fresno, CA 93704
FRENCH, Bob '77
6621 North Colonial
Fresno, CA 93704
FRENCH, Lanny R. '77
2244 Hidalgo St
Mercedes, TX 73570-9608
FRENCH, Robert C. '77
10500 Sea World Drive
San Antonio, TX 78251
FRENCH, Steve R. '74
138 No. Sycamore
Willows, CA 95988
FRENN, Thomas '72
1250 S.W. Medford Ave.
Topeka, KS 66604
FRESHWATER, Jeremy E. '78
2055 N. Highway 69
Brigham City, UT 84302
FREY, Karen E. '89
1633 West 5th Place
Mesa, AZ 85201
FREYTAG, Arnold '74
8560 Sunset Blvd.
Los Angeles, CA 90069
FRICK, Dean '74
3527 Addison Street
South Bend, IN 46614
FRIDRIKSSON, Fridrik '83
Vogabraut 10
300 Akranes, Iceland
FRIED, Matthew I. '79
16760 Staff Street #220
Van Nuys, CA 91406
FRIEDLANDER, William D. '75
209 White Oak Dr.
Santa Rosa, CA 95405
FRIEDMAN, Leonard '90
3075 Paseo Del Descanso
Santa Barbara, CA 93105
FRIEDNASH, Michael '83
3155 S. Elmira Ct.
Denver, CO 80231
FRISKE, Carol Carter '54
115 Fairway Lane
Fort Collins, CO 80525
FRISKE, Richard '55
1255 Old Topanga Cyn.rd.
Topanga, CA 90290
FROEBE, Douglas F. '80
6022 Cochran St
Simi Valley, CA 93063
FROOK, Curtis '64
10441 W. Bay Shore Dr.
Traverse City, MI 49684
FROST, Jack '56
10715 E 27th Ave
Spokane, WA 99206
FRUDEGER, Jon '87
2663 Taft Street
Lakewood, CO 80215
FRY, Christopher J. '78
P.O. Box 787
Monterey, CA 93940
FRY, Steven A. '78
30052 Running Deer Lane
Laguna Niguel, CA 92677
FU-BRADFORD, Sabina '73
892 Sunnyhills Rd.
Oakland, CA 94610
FUGATE, RANDY '75
6754 Eton Avenue Warner Center
Canoga Park, CA 91303
FUGNETTI, Dennis M. '71
5500 Paseo Joaquin
Yorba Linda, CA 92686
FUHR, Nicholas J. '82
1034 Loney St.
Philadelphia, PA 19111

FUJII, Roger '61
350 Hahani Street
Kailua Oahu, HI 96734
FUJIMOTO, Clifford M. '86
1723 Santa Barbara St.
Santa Barbara, CA 93101
FUJIMOTO, Kazuya '62
95 Devere Way
Sparks, NV 89431
FUKUDOME, Kenji Jacklio '89
1506 Portesuello
Santa Barbara, CA 93105
FULLER III, George '70
P.O. Box J
San Luis Obispo, CA 93401
FULLER, David D. '78
29432 Dry Dock Cove
Laguna Niguel, CA 92677
FULLER, Richard L. '89
26712 Las Ondas Drive
Mission Viejo, CA 92692
FULLERTON, Seth M. '85
730 Miramonte Drive
Santa Barbara, CA 93109
FULTON, Douglas J. '84
2950 Cedarwood Court S.E.
Albany, OR 97321
FULTON, Robert '73
P.O. Box 505
Bernardsville, NJ 07924
FULWIDER, Jay '75
16227 131 Ave. S. E.
Renton, WA 98058
FUNICELLE, John
2301 B Sierra Madre Ct.
Rancho Cordova, CA 95670
FURORE, Dominic B. '83
6 Tremont Ave
Bethel, CT 06801
FUTTRUP, Inge Lise '82
6525 Camino Vista #2
Anaheim, CA 92807
FYEN, Daniel '74
30 Brentwood
Dollard Des Ormeaux, QU H9A 2P7,
Canada

– G –

GABBARD, Ernest '73
621 Courtney Court
Newbury Park, CA 91320
GABLE, James '74
11011 Magdalena Ave.
Los Altos Hills, CA 94022
GACKLE, Delton '72
P.O. Box 12
Brockway, MT 59214
GAFFNEY, Edward James '50
1550 Arcade Blvd. #11
Sacramento, CA 95815
GAGE, James P. '74
Washington Island
Washington Island, WI 54246
GAGE, Rob
789 Pearl St.
Laguna Beach, CA 92651
GAGGIA, Mark '74
535 East Marine View Drive
Freeland, WA 98249
GAIL, Michael L. '80
1117 N. Wright
Santa Ana, CA 92701
GALINDO III, Pedro '78
Leones 145 Col.
Aguilas, DF 20, Mexico
GALIPO, Frank '78
908 Fifth Ave., Apt. G2
Interlaken, NJ 01712
GALLAGHER, Frank B. '75
2406 201st Ave
Issaquah, WA 98027
GALLAGHER, Thomas '74
3270 Sunset Blvd.
Redding, CA 96001
GALLAND, Sean '86
429 N Orange Dr
Los Angeles, CA 90036-2611
GALLEGOS, Arthur M '86
3109 Porter Lane
Ventura, CA 93003
GALLER, Eric M. '89
159-44 91st St.et
Howard Beach, NY 11414
GALLIANO, Michael J. '86
137 S. Broadway #6
Redondo Beach, CA 90277
GALLINGER, Michele '85
2607 64Th Street N.W.
Gig Harbor, WA 98335
GALLOWAY, James '68
3852 Shore Crest Drive
Dallas, TX 75209
GALLYON, Charles M. '78
1310 N. Myers St.
Burbank, CA 91506
GAMBLE, Robert '73
17 Willow Street
Waterbury, CT 06710
GAMBLE, Wesley B. '77
12223 Foxpoint Drive
Maryland Height, MO 63043
GAMMELL, Curtis W. '78
P.O. Box 7156
Tacoma, WA 98407
GAMMON, Bryan K. '88
2100 Tannehill #2036
Houston, TX 77008
GANASSA, Rina M. '89
P.O. Box 42013
Santa Barbara, CA 93140
GANO, Michael A. '77
306 Bob Court
Evansville, IN 47711
GARCIA, Edwin '75
2490 Scott
Clovis, CA 93612
GARCIA, Elma '81
2565 3rd St. #308
San Francisco, CA 94107

GARCIA, Enrique '74
140 E 57th St.
New York, NY 10022
GARCIA, Patrick V. '80
2194 Bristolwood Ln.
San Jose, CA 95132
GARCIA, William G. '83
10014 Vashon Highway, SW
Vashon, WA 98070
GARDINER, Cory A. '78
1300 Solano Ave.
Albany, CA 94706
GARDNER, Christopher '86
1624 Gillespie St
Santa Barbara, CA 93101
GARDNER, Richard E. '75
114 Bungalow Terr.
Syracuse, NY 13207
GARDUNO, Rey '71
414 Vassar N E
Albuquerque, NM 87106
GARFIELD, Philip '80
901 Saddle River Rd.
Fair Lawn, NJ 07410
GARLAND, Michael E. '81
26 Avenue 28
Venice, CA 90291
GARN, MYK '77
38 Erie Drive
Fairport, NY 14450
GARNETT, Donald G. '81
320 Tweedsmuir Av. #107
Toronto Ontario, Canada
GARRISON, Ruben J. '79
1235 Live Oak Dr.
Nogales, AZ 85621
GARVEY, Richard G. '77
P.O. Box 7
La Conner, WA 98257
GASS, Neal E. '76
33901 Mariana #6
Dana Point, CA 92629
GATES, Robin L '86
920 W. Pedregosa St.
Santa Barbara, CA 93101
GATHERUM, Ken '73
1700 Chuckar Dr.
W. Richland, WA 99352
GATZ, WILLIAM L. ("LARRY") '75
5250 Gulfton, 3-B
Houston, TX 77081
GATZKE, Scott K. '83
9426 W. 14th St.
St. Louis Park, MN 55426
GAUCH, Cathy '85
1085 14th St. Suite #1347
Boulder, CO 80302
GAUDET, Joseph M. '81
2410 Farrington
Dallas, TX 75207
GAUTREAU, David A. '80
4568 Live Oak Canyon Rd.
La Verne, CA 91750
GAVILAN, CARLOS P. '79
Cda. Del Popocatepetl 55-I
Mexico, D.F. 03330
GAY, Garry '73
1275 Fourth Street #365
Santa Rosa, CA 95404
GAY, Jerry '68
4201 35th West
Seattle, WA 98199
GEBHARDT, Richard H. '66
2535 S. Tracy Dr.
Erie, PA 16505
GEDDES, Brian L. '79
1506 F Street
Bellingham, WA 98225
GEDEKOH, Clifford '52
409 Ekin Ave.
Elizabeth, PA 15037
GEE, Ronald '87
2412 E 16th Street
Des Moines, IA 50316
GEHRIG, Penny '85
3377 Blake St 104
Denver, CO 80229
GEHRING, Susan M. '86
P.O. Box 1230
Healdsburg, CA 95448
GEIER, Donald '60
304 N. Washington Lane
Lombard, IL 60148
GEIGER, Adam '80
50 Brakeneck Road
Sturbridge, MA 01566
GEIGER, Gary '74
P.O. Box 2905
Carmel, CA 93921
GEIKEN, STACY
268 Carlton Avenue
Los Gatos, CA 95032-2630
GEISSERT, William '72
327 Buckingham Way
Fresno, CA 93704
GENDREAU, Richard '71
168 Donner Cirlce
Sunnyvale, CA 94086
GENDREAU, Stephen '73
2345 Peachtree Ln.
San Jose, CA 95128
GENTILE, Silvio '86
Via G.B. De Rossi 3
Rome, 00161, Italy
GENTRY, Robert '59
1293 Catwaba Street
Kingsport, TN 37660
GEORGIA, Frederica '86
P.O. Box 296
Tryon, NC 28782
GERBASE, Kimberly E. '86
3305 Harlou
Billings, MT 59102
GERE, Earl Tibbetts '65
P.O. Box 190
Brush Prairie, WA 98606
GERMANY, Robert R. '82
2104 Pearl Ln
Irving, TX 75060

GERSBACH, Gregory S. '76
P.O. Box 61
Danbury, WI 54830-0061
GERSPACHER, Anthony '50
2959 Neal Rd.
Paradise, CA 95969
GERVAIS, Lois F. '77
923 East 3rd Street, Ste 404
Los Angeles, CA 90013
GERVASE, Mark C. '82
P.O. Box 38573
Los Angeles, CA 90038
GETTIG, Eugene J. '78
8731 Antioch Rd 101
Salem, WI 531689373
GHEYSSARIEH, Abbas '78
1404 Lucky
Oceanside, CA 92054
GIACHETTO, Richard '66
121 W. Jones St.
Santa Maria, CA 93454
GIANELLE, Frank '75
3448 Utah Street
St. Louis, MO 63118
GIANELLI, Robert A. '84
P.O. Box 1147
Angels Camp, CA 95222
GIARD, Louis Scott '83
2708 Crestview Drive
Las Cruces, NM 88001
GIBBS, Craig '81
50 Schroeder Ct. #105
Madison, WI 53711
GIBBS, Terri L. '83
1520 Oxford Pl.
Mesquite, TX 75149
GIBBS, Tommy '74
216 "K" Street
Monroe, LA 71201
GIGLIO, Al '52
165 Winthrop St. #301
Taunton, MA 02780
GIL, Federico B. '78
Cda Bosque De Ciclamoros 25
Mexico City, DF 01520, Mexico
GILBERTSON, Virgie '78
78 Newcastle Circle
Goleta, CA 93017
GILES, Jeffery '80
1030 Meadow Sweet Drive
Corte Madera, CA 94925
GILISSEN, Cynthia M. '90
68675 Senora Road
Cathedral City, CA 92234
GILLESPIE, Mark T. '90
P.O. Box 92226
Santa Barbara, CA 93190
GILLHAM, Steve R. '78
13641 Jackson St.
Whittier, CA 90602
GILLNER, Michael G. '82
9723 Innwood West
Interlochen, MI 49643
GILLSON, Dennis '68
18845 Lafayette Ave.
Oregon City, OR 97045
GILMORE, Ed '74
637 Natoma St.
San Francisco, CA 94103
GILMORE, Steve '81
184 Doolan Dr.
Ukiah, CA 95482-6304
GILMORE, Susan '79
8415 Wesley Drive
Minneapolis, MN 55427
GILROY, JOHN '66
474 North 2nd Stewart
Kalamazoo, MI 49009
GIONFRIDDO, Robert '72
406 South 7th Street
Fulton, NY 13069
GIOVANNETTI, Mark L. '83
406 S. 7th Street
Fulton, NY 13069
GIOVANNI, Edward '81
3666 Westwood Blvd 203
Los Angeles, CA 90034-6750
GIRAUD, Steve '74
2960 Airway Ave. "B-103"
Costa Mesa, CA 92628
GIUNCA, G. Edward '82
6546 Hollywood Blvd
Hollywood, CA 90028
GLASS, Kenneth A. '74
7620 S Wellington St
Littleton, CO 80122
GLASSMAN, Helene C. '82
5078 Ella Lane
Santa Barbara, CA 93111
GLEASON, Bill '66
P.O. Box 1135
Boise, ID 83701
GLENN, Richard B. '78
3579 Schaefer St
Culver City, CA 90232-2420
GLISPIE, Oliver '58
4650 W. Washington Blvd.
Los Angeles, CA 90016
GLOVER, John G. '64
5919 Crestview Cir.
Paradise, CA 95969
GLUTZ JR, Robert '77
502 Cinti-Batavia Pike
Cincinnati, OH 45244
GOBLE, Brian P. '79
365 First Ave.
New York, NY 10010
GOBLE, Jeffrey R. '76
43132 S. E. 176th St.
North Bend, WA 98045
GOETTINGS, Jon Michael '82
P.O. Box 17573
Mesa, AZ 85202
GOFF, Dale V '88
7512 Oxnard Circle
Pleasanton, CA 94568
GOHRKE, Timothy G. '77
2850 39th Avenue W
Seattle, WA 98199

GOLDBERG, Rennie N. '78
8418 N. Third St.
Fresno, CA 93710
GOLDEN, Anthony R. '74
215 University Place
Syracuse, NY 13244
GOLDEN, Bob '76
Box 542 RD1
Germantown, NY 12526
GOLDMAN, Jack J. '56
1223 Holly St.
Denver, CO 80220
GOLDMAN, Marian B. '82
227 Prospect Park West
Brooklyn, NY 11215
GOLDMAN, Robert D. '88
1223 Holly St.
Denver, CO 80220
GOLDSMITH, Gregory A. '79
1113 West Oak Ave.
Lompoc, CA 93436
GOLDSMITH, Howard C. '76
12343 Culbeertson Drive
Edinboro, PA 16412
GOLDSMITH-GREEN,
Deborah Lynn '79
5801 Calle Real Ave.
Goleta, CA 93117
GOLDSTEIN, Gene '70
5505 N. Macarthur
Oklahoma City, OK 73122
GOLDSTEIN, Steven '83
747 S Genesee
Los Angeles, CA 90036
GOLIGHTLY, Welch Edward '86
19530 Springport
Rowland Heights, CA 91748
GOLINSKI, Greg P. '87
1208 Knottingham Crt 1A
Schaumburg, IL 60193
GOLOVCHINSKY, Ken '89
15731 Morrison
Encino, CA 91436
GOMENA, J. Peter '90
1 Jefferson Pky 172
Lake Oswego, OR 97035-8813
GOMEZ-KUCINE, Barbara M. '85
51 Norwood St.
Portland, ME 04103
GONSALVES, Peter '64
3291 Teardrop Circle
Colorado Springs, CO 80917
GONZALEZ, Veda Smith '80
7041 E. Paseo Escondido
Prescott Valley, AZ 86314
GOODAN, Robert Lee '55
2333 Knobcane Avenue
Anderson, CA 96007
GOODMAN, Daniel M. '90
3851 Petersburg Circle
Stockton, CA 95209
GOODMAN, Todd F. '83
917 S Stanley Ave
Los Angeles, CA 90036-4601
GOODVIN, Jeffrey T. '90
210 Mill Pond Road
Roswell, GA 30076
GOODYEAR, Richard '71
909 Parkwatch Dr.
Manchester, MO 63011
GORAUM, Steve '83
1911 Myrtle Ave.
Mobile, AL 36606
GORBY, Richard L. '71
4361 Mc Kay Dr. South
Salem, OR 97302
GORDON, Eric '86
1401 Key Drive
Alexandria, VI 22302
GORDON, Harry L. '67
P.O. Box 576, RR 8
Boerne, TX 78006
GORDON, Robert '67
524 Grand Canyon
Los Alamos, NM 87544
GORDON, Scott L. '90
2040 Palisades Drive
Pacific Palisades, CA
GORDON, William E. '70
218 1/2 B Jefferson
Port Clinton, OH 43452
GORDON-BROADWAY, Cheryl L. '84
4516 S 248th Pl
Kent, WA 98032-4719
GORETSKY, Nancy S. '86
237 Franklin Ave. #26
Cliffside Park, NJ 07010
GORMAN, Synca '89
15734 Aldine Westfield Rd
Houston, TX 77032
GOTTLIEB, Jeffrey A '88
11162 Camarillo St 108
N. Hollywood, CA 91602
GOUBEAUX, John '90
935 Mariposa Ln.
Montecito, CA 93108
GOULD, Gerald L. '79
P.O. Box 671
Carpinteria, CA 93014
GOULD, William A. '82
1440 Woodland Drive Sw
Rochester, MN 55902
GRAF, Michael J. '90
1137 Cypress Point Ln 102
Ventura, CA 93003
GRAFIUS, Guy '85
140 Carlson Pky 220
Hopkins, MN 55343-3871
GRAHAM, Ashton C '88
1000 Arbor Rd.
Winston-Salem, NC 27104
GRAHAM, Bradley T. '84
5653 Riley St 103
San Diego, CA 92110
GRAHAM, James '80
3321 Oak Grove Ave.
Dallas, TX 75204-2355
GRAHAM, Jared M. '77
317 NE Conifer Blvde #5
Corvallis, OR 97330

GRAHAM, Rick G. '83
933 E. Coronado
Phoenix, AZ 85006
GRAHAM, Steven P. '88
5035 Coldwater Canyon 109
Sherman Oaks, CA 91423-1634
GRAND, Michael '86
20 Myron Road
Plainview, NE 11803
GRANT, Bob '54
2905 S.W. Marshall
Pendleton, OR 98701
GRANT, Gregory '90
P.O. Box 1377
Solvang, CA 93464
GRANT, Kimberly '77
73 Tuttle St.
Dorchester, MA 02125-1434
GRANT-AESCHLIMAN, Barbara '86
8798 Denver St
Ventura, CA 930042535
GRASSI, THOMAS G. '81
143 Essex Street
Haverhill, MA 01832
GRAY, Dennis '74
8705 West Washington Blvd
Culver City, CA 90230
GREEN JR., Donald W. '80
12830 Interurban Ave. So.
Seattle, WA 98168
GREEN, Barbara Lynn '86
1603 1/2 Occidental
Los Angeles, CA 90026
GREEN, George '63
51-555 Monroe #17
Indio, CA 92201
GREEN, Harry I. '80
2901 4th Street #101
Santa Monica, CA 90405
GREEN, Harvey '57
6767 Hollister Ave
Goleta, CA 93117
GREEN, Ian '87
1450 Chestnutt Apt. 201
San Francisco, CA 94123
GREEN, Jeremy '76
1720 Lancaster St.
Baltimore, MD 21231
GREEN, Lewis S. '57
6204 Watt Ave North
N. Highland, CA 95660
GREEN, Sharon A. '85
3065 Jackson Street
San Francisco, CA 94117
GREEN, Suzanne J '86
357 South Maple
Beverly Hills, CA 90212
GREEN, William '73
1338 Vallecito Road.
Carpinteria, CA 93013
GREENAWALD, Todd W '89
215 N. Screenland Dr.
Burbank, CA 91506
GREENE, Richard '73
15 Duvall Dr.
Hampton Bays, NY 11946
GREENGARD, Ronald T. '83
1500 East Boston
Seattle, WA 98112
GREENWELL, Richard K. '77
1112 W. Beacon Road, #154
Lakeland, FL 33803
GREENWOOD, Bernard '55
P.O. Box 144
Hopkinton, IA 52237
GREENWOOD, John T. '81
111 S. Stewart
Genesseo, IL 61254
GREER, Paul '72
900 Roanoke Dr 90
Martinez, CA 94553-6148
GREER, Ronald R. '86
6115 Brooklyn Avenue, N.E.
Seattle, WA 98115
GREGG, Barry C. '75
7568 NE Emerald Way
Bainbridge Island, WA 98110
GRIFFIN, Gregory A. '82
109 West 26th Street #11
New York, NY 10001
GRIFFIN-VILLAVECCHIA, Roberta '76
8517 Hearth Dr. #21
Houston, TX 77054
GRIFFITH, Herbert '60
2303 128th Ave SE
Bellevue, WA 98005
GRIGGS, Gary W. '85
414 Princeton Avenue
Ventura, CA 93003
GRIMES, David '87
207 W. Fourth St.
Austin, TX 78701
GRIMM III, Richard '68
600 S.W. 16th St.
Fort Lauderdale, FL 33315
GRIMSHAW, Paul W. '81
851 North Kings Road #311
Los Angeles, CA 90069
GRIVAS, John P. '85
1768 Denkinger
Concord, CA 94521
GROHOL, John V. '82
P.O. Box 770933
Eagle River, AK 99577
GROO, Stephen W. '81
1037 Diamond Road
Churchton, MD 20733
GROSS, Del M. '78
405 7th Street
Pine City, MN 55063
GROVE, Vern '72
2301 15th Ave
Austin, MN 55912
GROVE, Victoria '89
4632 W. 36th Ave.
Denver, CO 80212
GROVES, John M. '81
358 S. Ramona Blvd.
San Jacinto, CA 92383

GRUBEL, Heidi '89
1201 Lameys Mill Rd 33
West Vancouver, V6H358, Canada
GRUCHALA, Keith P. '90
573 Marlin Court
Redwood City, CA 94065
GUANZON, Robert W. '79
1309 Opua Street
Honolulu, HI 96818
GUENTHER, Christian J. '86
Fischerstr.8
8065 Guggenberg, West Germany
GUERCIO, Philip '77
5511 Duncan Kenner Ave
Baton Rouge, LA 70820
GUERRERO, Charles E. '73
5807 Bullard Drive
Austin, TX 78731
GUILER, Kevin '83
80 Varick St. #214
New York, NY 10013
GUILLOT, Robert J. '81
7746 Nikau Drive
Longmont, CO 80501
GULLSTROM, Charles J. '82
8600 S W 17th Ave Rd
Ocala, FL 32676-6759
GULLVAG, Jo Grim '79
Hvalstadjordet 2, 1364
Hvalstad, Norway
GUMAER, Glenn F. '86
1065 Meadow Que
North Pole, AK 99705
GUNDERSEN, Rolf '76
3226 Ebners Coulee Road
La Crosse, WI 54601
GUNDERSON, Craig E. '80
8556 Ashworth Ave
Seattle, WA 98103
GURLEY, David L. '89
922 Post St 305
San Francisco, CA 94109-5825
GUSTAFSON, Mark '79
21 Riverside Dr.
Tiverton, RI 02878
GUTZMER, Ron '74
630 Caudill Road
La Selva Beach, CA 95076
GUTZMER, Walter L. '81
3141 4th Ave. South
Minneapolis, MN 55408
GUY, Roland S. '86
450 Linden Drive Apt 20
Oxnard, CA 93033

– H –

HAAG, Steve '72
26 Victoria Road
Burlingame, CA 94010
HAALAND, RONALD M. '89
1350 Camino Cristobal
Thousand Oaks, CA 91360
HAAVIND, Thorbjoern '89
Graabroedre VN 15
0379 Oslo 3, Norway
HADISOEWONDO, Soeroto '63
Setbran Tengah I/1
Semarang Cntrl Java, Indonesia
HAEBLER, William '81
2672 Nido Way
Laguna Beach, CA 92651
HAGEMAN, Jare '60
P.O. Box 865
Lafayette, CA 94549
HAHN, Sherry L. '86
2000 Emerson Ave.
Santa Barbara, CA 93103
HAJEK, Terry M. '77
5329 Tiburon Way
Sacramento, CA 95841
HALEK, Thomas '71
Rr 1 Box 272
Rush City, MN 55069
HALIM, Rachmat '85
C/O Condor Inter. Rm 1201 Fortre
Red North Point, 250 King, Hong Kong
HALL, Debra '80
P.O. Box 1218
Clatskanie, OR 97016
HALL, James Wolfe '80
1931 Valdosta Court
Pleasanton, CA 94566
HALL, Jeff H. '65
1325 Whittier Drive
Davis, CA 95616
HALL, Kenneth '53
1931 Valdosta Court
Pleasanton, CA 94566
HALL, Kimball R. '83
6719 W 86th Place 3
Los Angeles, CA 90045
HALL, Matthew H. '86
5654 Berkeley
Goleta, CA 93117
HALL, Nicholas C. '80
3426 East Hillery Dr
Phoenix, AZ 85032
HALL, Robert '72
45 Hawthorne Way
San Jose, CA 95110
HALL, Robert '72
5276 Hollister Ave., Suite 101
Santa Barbara, CA 93111
HALL, Timothy D. '86
13533 39th NE
Seattle, WA 981258
HALLE, KEVIN F. '86
8615 Commerce Ave.
San Diego, CA 92121
HALLENBACK, Robert '52
P.O. Box 781
Anza, CA 92306
HALLER, Kurt '87
5364 Jed Smith Road
Calabasas, CA 91302
HALLIDAY, Steve '47
16445 Lisbon Street
East Liverpool, OH 43920

HALLINAN, Peter R. '77
3815 SW Hamilton Street
Portland, OR 97221

HAM, Kevin K. '83
430 Hualani Street
Honolulu, HI 96815

HAMBLIN, Steven P. '77
3914 Double Oak Lane
Irving, TX 75061

HAMILTON, Chuck '75
11030 Sela Lane
Houston, TX 77072

HAMILTON, Donald '75
11847 United St.
Mojave, CA 93501

HAMILTON, Gloria D. '81
813 East Anapumu Street
Santa Barbara, CA 93103

HAMILTON, Kenneth '74
2512 J St.
Sacramento, CA 95816-4815

HAMM, Robert B. '89
13642 S. 41st Place
Phoenix, AZ 85044

HAMM, Robert B. '89
14216 Telegraph Rd.
Santa Paula, CA 93060

HAMMACK, Ben '83
65 Arrowhead Drive
Carson City, NV 89701

HAMMARLUND, Vern '57
5654 South Adams Way
Bloomfield Hill, MI 48013

HAMMOND, Alan M. '58
27710 146th Ave.
Porterville, CA 93257

HAMMOND, Paul W. '85
1200 Carlisle Dr.
San Mateo, CA 94402

HAND, Guy C. '79
25 W Padre Street
Santa Barbara, CA 93105-3931

HANDLOSER, John S. '75
148 Hermosillo Drive
Santa Barbara, CA 93108

HANER, Dorothy '71
2183 Lummi Shore Road
Bellingham, WA 98226

HANER, Malcolm '72
2656 Mackenzie Road
Bellingham, WA 98226

HANEY, Larry K. '80
355 North Post Oak Lane #834
Houston, TX 77024

HANEY, William V. '77
Paradise Cove #234
Malibu, CA 90265

HANGE, Robert '69
6473 Bryson Drive
Mentor, OH 44060

HANIUS, Richard
P.O. Box 856
Searchlight, NV 89046

HANNAH, Sidney '55
705 Willow Ave
Manteca, CA 95336

HANSEN, Bradley K. '84
P.O. Box 17347
Tucson, AZ 857317347

HANSEN, Dale '63
5574 Easton Street
Kearns, UT 84118

HANSEN, David L. '55
1542 S. 14th St. East
Salt Lake City, UT 84105

HANSEN, Kenneth W. '88
1310 G. Street
San Diego, CA 92101

HANSEN, Mark G. '76
19126 Bagley Ave
Faribault, MN 55021

HANSEN, Robert A. '78
25801 Obrero
Mission Viejo, CA 92691

HANSEN, Timothy J. '87
41 Bairfield Ct.
Ormond Beach, FL 32074

HANSEN-GAMBLIN, Leslie '80
87 West Crescent Drive
San Rafael, CA 94901

HANSON, Bryan N. '85
3312 Sierra Oaks Dr
Sacramento, CA 95864

HANSON, Carol '73
1212 Truman St.
Redwood City, CA 94061

HANSON, Dale B. '82
8107 Pillsbury Ave
Bloomington, MN 55420

HANSON, Perry W. '89
P.O. Box 50531
Santa Barbara, CA 93150-0531

HAPNER, Jeff '89
21984 Kingshill
Mission Viejo, CA 92691

HARADA, Joe '66
3836 Sherview Drive
Sherman Oaks, CA 91403

HARASTY, Peter '89
30-28th Ave.
Venice, CA 90291

HARBAUGH, Gregory '76
5540 West Fifth Street #130
Oxnard, CA 93030

HARBINSON, Leah '83
5307 Joseph Lane
San Jose, CA 95118

HARDAN, Gary '75
236 Carrel Springs Rd
Bellingham, WA 98226

HARDER, Brian P. '83
4031 American River Drive
Sacramento, CA 95825

HARDING, K. Dana '72
12155 Turtle Beach Rd.
North Palm Beach, FL 33408

HARGER, Eric S. '90
2325 3rd Street, Suite 343
San Francisco, CA 94107

HARGER, Neil '71
10401 E. 40 Hwy
Independence, MO 64055

HARLAN, Adriene J. '84
12405 W 2nd Place 13206
Lakewood, CO 80228

HARLINE, Hugh D. '88
1085 Alderbrook Lane
San Jose, CA 95129

HARMON, James H. '65
388 Evonshire Ave
Santa Barbara, CA 93111

HAROLD, Keenan
80 Topstone Drive
Danbury, CT 06810

HARPER, Steve '71
512 Myrtle Street
Newton, KS 67114

HARRAH, Robert '48
2030 Wilbur Avenue
San Diego, CA 92109

HARRELL, King '86
1147 Meadow Creek Circle South
Irving, TX 14588

HARRINGTON, Blaine G. '86
#2 Virginia Ave
Danbury, CT 06810

HARRIS, Dale E. '73
2020 Yorba Drive
Pomona, CA 91768

HARRIS, Fred '49
8238 Cardiff Circle
Dublin, CA 94568

HARRIS, Robert S. '66
4205 Suisun Valley Road
Suisun City, CA 94585

HARRIS, Ron '71
5023 Stanhope Dr.
Houston, TX 77084

HARRIS, Walter K. '50
P.O. Box 18
Gasquet, CA 95543

HARRISON, Chad R. '90
5733 Bevis
Van Nuys, CA 91411

HARROP, Thomas R. '83
28054 Ermine Street
Canyon Country, CA 91351

HART, Dominic E. '90
2639 Kring Dr.
San Jose, CA 95125

HART, Douglas W. '70
P.O. Box 11311
Reno, NV 89510

HART, Edmund '74
4612 N.E. Alameda
Portland, OR 97213

HART, Gerald K '80
780 Bryant Street
San Francisco, CA 94107

HART, Vikki W. '80
780 Bryant Street
San Francisco, CA 94107

HARTIGAN, John '85
964 Country Commons Ln
Lake Oswego, OR 97034-1638

HARTMAN, Raiko Z. '78
4216 Sunnyside Ave.
Los Angeles, CA 90066

HARTMANN, Paul F. '85
10610 South 48th Street #1025
Phoenix, AZ 85044

HARTNESS, Tracy Sierakowski '82
905 South Ironwood
Broken Arrow, OK 74012

HARVEY, Douglas '86
113 Darnell Road
Lake Cowichan, VOR 260, Canada

HARVEY, Jesse R. '75
5471 Putnam Drive
W. Bloomfield, MI 48033

HARVEY, Philip J. '86
1195 Oak Street
San Francisco, CA 94117

HARWOOD, E. Bruce '87
2872 Marshall Way
Sacramento, CA 95818

HARWOOD, Lawrence A. '81
MCDB Box 347
Boulder, CA 80309

HASHIMOTO, Masahide '87
427 West Montecito #D
Santa Barbara, CA 93101

HASKIN, David A. '86
101 Holly Ridge Road
Slidell, LA 70451

HASNERL, Edward '55
Rr 2 Box 426
Salem, IN 47167

HASS, Barbara '86
1595 Las Tunas
Santa Barbara, CA 93108

HASS, Kevin Lee '70
10401 Lurline Ave.
Chatsworth, CA 91311

HASTINGS, Ryan W '87
309 S. Cloverdale #C-24
Seattle, WA 98108

HATCHER, Robert '79
356 South La Jolla
Los Angeles, CA 90048

HATHAWAY, Roger '72
2105 Summit Drive
New Port Richey, FL 34655

HATHAWAY, STEVEN W. '78
400 Treat Ave. Unit F
San Francisco, CA 94110

HATHON, Elizabeth '78
8 Green Street
New York, NY 10013

HATTAWAY, Michael E. '78
74 Ranch House Loop
Angleton, TX 75515

HATTORI, Gordon M. '79
8231 172nd Street Ne
Redmond, WA 98052

HATZIMARKOS, John (X'Markos) '79
45 Seaview Dr.
Montecito, CA 93108

HAUBERT, Roger '70
1000 Florence Street
Aurora, CO 80010

HAUER, Ursula M. '64
Box 232 Ch-8027
Zuerichenge, 1, Switzerland

HAUGEN, Harry A. '87
4111 Crannog St.
Anchorage, AK 99502-5174

HAUN, John T. '85
2616 234Th Street
Torrance, CA 90505

HAUSER, Duane '74
4836 Skyview Court
Eagan, MN 55122

HAVAC, Julian '80
910 Vincente Way
Santa Barbara, CA 93105

HAVNER, Patricia A. '83
HHC 3rd DBE 8th ID, APO
APO New York, NY 09028

HAWKINS, PETER D. '84
HCR 73, Box 249
Walker, MN 56484

HAWKINSON, Donald G. '86
1011 20th Street
Golden, CO 80401

HAWLEY, Larry J. '77
6502 Santa Monica Blvd.
Los Angeles, CA 90038

HAYASHIDA, Frank '60
1513 West 152nd Street
Gardena, CA 90247

HAYDEN, Allan T. '77
1212 42nd Ave.
San Francisco, CA 94122

HAYES, David M. '83
4096 Via Real #47
Carpinteria, CA 93013

HAYES, Doug '72
262 E. Highland Ave.
Sierra Madre, CA 91024

HAYES, Jon '65
14302 Overbrook Lane
Houston, TX 77077

HAYNES, Tom '60
330 W. Hwy. 246 #190
Buellton, CA 93427

HAYS, Edward A. '51
211 West Vine Street
Lodi, CA 95240

HAYS, L. Scott '83
7318 East Las Palmeritas
Scottsdale, AZ 85258

HAYWARD-CANCHOLA,
Wendy K. '86
1626 Hicks Street
Oceanside, CA 92054

HAZELWOOD, Jack L '86
3919 North St. Clair
Wichita, KS 67204

HEARD-WILLIAMSON, Shelley C. '84
66 West Way Shirley, Croydon
Surrey, CRO8RD, England

HEARN, Edd '49
636 Birmingham Road
Burbank, CA 91504

HECKETHORN, Gregg A. '79
2359 San Francisco Ave
Long Beach, CA 90806

HEDGCOCK, Charles A. '81
P.O. Box 43511
Tucson, AZ 85733

HEDLIN, Peter '74
3822 Woodvale Road
Western Springs, IL 60558

HEDRICH, Sandi '78
2127 N. Kenmore
Chicago, IL 60614

HEGRE, Thomas '50
3800 Ballard Drive
Carmichael, CA 95608

HEIL, Peter E. '80
913 West Van Buren Drive
Chicago, IL 60607

HEIMANN, Juergen S. '87
13030 Moorpark Street, Apt. 5
Studio City, CA 91604

HEINECK, James T. '87
1318 Iris Crt.
San Jose, CA 95125

HEINZ, John D. '73
3667 Clearington Avenue
Los Angeles, CA 90034

HELDERMAN, C. Rocky '79
4453 West 4th Street #102
Los Angeles, CA 90020

HELIN, Art '51
2232 NE 19th Street
Portland, OR 97212

HELLMAN, Avery M. '75
6540 Hayvenhurst Ave.
Van Nuys, CA 91406

HELLYER, Melinda R. '84
1805 Grand Ave. Apt E
Santa Barbara, CA 93013

HELMAR, Dennis '71
416 W Broadway #1rear
South Boston, MA 02127-2216

HELSEM, Randall J. '82
700 East Packham Lane #53
Sherman Oaks, CA 91403

HELSTROM, Richard L. '76
330 North Institue
Colorado Springs, CO 80903

HEMINWAY, Truman '64
P.O. Box 44209 F54825
Cincinnati, OH 45244

HEMMING-JETTE, Margaret '82
2612 Tanager Dr.
Wilmington, DE 19808

HENDERSON, Edwin B. '83
5023 W 12th St
Los Angeles, CA 90019-1637

HENDERSON, James '50
5101 Columbia Street
Dallas, TX 75214

HENDERSON, William Manning '88
1011 B East De La Guerra
Santa Barbara, CA 93103

HENDRICKS, William G. '81
1932 Eastman Avenue
Ventura, CA 93003

HENDRICKSON, Mike '70
4922 Thunder Rd.
Addison, TX 75244

HENNEG, Robert A. '75
148 Brenner St
Hercules, CA 94547

HENNEMAN, Steven '74
70 Coleman Drive
San Rafael, CA 94901

HENNESSEY, Joseph C. '65
280 San Napoli Drive
Goleta, CA 93117

HENRICKS, Nicole E. '87
11482 Buckeye Crt.
Penn Valley, CA 95946

HENRY, Christine E. '90
39 San Marcos Trout Club
Santa Barbara, CA 93105

HENRY, Eddie L. '78
6475 SW Alice Lane
Beaverton, OR 97005

HENRY, J. GREG '88
438 N. Sycamore
Los Angeles, CA 90036

HENRYSON, Gary L. '79
2505 Yorktown Court
College Station, TX 77840

HENSON, Lawrence M. '87
2565 Calle Galicia
Santa Barbara, CA 93109

HENSON, Pamela G. '85
47 Amador
Goleta, CA 93117

HENSZEY, Barbara E '85
959 Brook Tree Lane
Santa Barbara, CA 93108

HERBST, Gary B. '73
36 Acton Road
Columbus, OH 43214

HERKEL, Joseph '71
2519 10th Street
Sanger, CA 93657

HERNANDEZ HERRERO, Isaac '90
316 Coleman Ave.
Santa Barbara, CA 93109

HERNANDEZ, Mario '53
2023 Modoc Road
Santa Barbara, CA 93101

HERNANDEZ, Richard '81
302 W. Lindbergh
Universal City, TX 78148

HERRERA, Hector A. '82
Crater #161, Pedregal De San
Mexico City 20, 01900, Mexico

HERSKOWITZ, David S. '87
Cherry Hill, NJ 08003-0914

HERWEGH, Lauranne A. '82
1651 18th Street
Manhattan Beach, CA 90266

HERZFELDT, Kim
3515 Hancock Street
San Diego, CA 92110

HERZFELDT, Paul '66
3515 Hancock Street
San Diego, CA 92110

HESS, Douglas '70
705 16th Street
Eureka, CA 95501

HESS, J. Daniel '83
8751 W. Washington Blvd.
Culver City, CA 90232

HESS, Jeffery '74
15346 84th Street N
Palm Beach Garn, FL 33418

HESS, Peter H. '88
6141 Concord Hill Lane
Minnetonka, MN 55345

HESSEELS, Lloyd '73
P.O. Box 728
West End, NJ 27376

HESSEMER, David E. '79
184360 SW Tualata Ave
Lake Oswego, OR 97035

HETHORN, John '86
326 10th St.
Madras, OR 97741

HETLER, Jeffrey D. '77
P.O. Box 47810
Wichita, KS 67201

HEUBERGER, William '79
140 West 22nd Street
New York, NY 10011

HEUERMAN, Robert H. '82
8818 1/2 Duarte Rd.
San Gabriel, CA 91775

HEUSSNER, Robert R. '80
403 East Washington Street
Lake Mills, WI 53551

HEWITT, Edward (Ted) W. '71
Rte 4, Box 134
Ontario, KOE 1L0, Canada

HEYWOOD, Robert S. '75
113 North May St
Chicago, IL 60607

HIBBARD, Mark '83
14691 Valley Vista Blvd,
Sherman Oaks, CA 91403

HOGUE, Dale '70
Rt1 Box #525 Jolly Roger MM59 #2
Marathon, FL 33050

HICKS, Charles '56
Rte 7 Box 1169
Hickory, NC 28602

HICKS, Stephen '78
11600 Washington Place
Los Angeles, CA 90066

HIETER, David C. '82
6161 Vendura Ave
Goleta, CA 93117

HIGGINBOTHAM, James '79
333 East 49th Street Apt. LK
New York, NY 10017

HILL, Christian L. '77
122 W. Micheltorena St, "C"
Santa Barbara, CA 93101

HILL, Ronnie R. '90
1402 "C" Pitos St.
Santa Barbara, CA 93103

HILLS, David K. '73
2666 S. Steele
Denver, CO 80210

HILLYER, Lisa '86
8217 Brinkland
Minocqua, WI 54548

HILTON, Michael '69
2807 Bagley Avenue
Los Angeles, CA 90034

HILTON, Ronald E. '86
740 Turner #28
Missoula, MT 59802

HIMBURG-BIONDI, Honey '79
9617 Ashmede Dr.
Ellicott, MD 21043

HINCKER, Lawrence G. '77
403 Ridgeview Drive
Blacksburg, VA 24060

HINES, Scott J. '86
3 Curtin Avenue
Sidney, Australia

HINES, Sherman '68
S. Hines Photographic Ltd.
Toronto, ON M5R 1B2, Canada

HINOSTRO, Robert '59
1218 South "G" Street
Oxnard, CA 93030

HINSON, Bruce W. '76
329 Kenwood Circle
Colorado Springs, CO 80910

HIRAOKA, Nari
1264 Aupapaohe Street
Kailua, HI 96734

HIRSHAN, Karen '87
555 S Barrington Avenue
Los Angeles, CA 90049

HIRST, Frank '55
1744 South Main Street
Orem, UT 84058

HISLOP, Scott B. '83
507 Vista Verde Way
Bakersfield, CA 93309

HITZ, Brad '81
219 Fawn Meadows Drive
Ballwin, MO 63011

HITZ, Brad '81
95 Horatio Street 9X
New York, NY 10014

HIXON, Stanley O. '90
410 Winterscreek Drive
Doraville, GA 30360-2334

HIXON, William '71
204 E Avenida Ramona
San Clemente, CA 92672

HOAGLAD, Harold '50
6251 Aberddeen Ave.
Goleta, CA 93017

HODGDON, Donald Paul '82
378 1/2 West California Avenue
Glendale, CA 91203

HODGES, Brett E. '86
4425 Via Esperanza
Santa Barbara, CA 93110

HODGES, Glen H. '81
317 W. Ortega
Santa Barbara, CA 93101

HODGES, Janet Viney '72
54 8th Street
Carbondale, CO 81623

HODGES, Kirvin D. '72
54 8th Street
Carbondale, CO 81623

HODGSON, Anne '86
P.O. Box 1177
Basalt, CO 81621

HODGSON, Leonard '50
902 North River Road
Mc Henry, IL 60050

HODNICK, James A. '80
14721 S W 35th Terrace Rd.
Ocala, FL 32673

HOFF, Theresa M. '77
P.O. Box 155
June Lake, CA 93529

HOFFMAN, Lori '85
616 Camino Campana
Santa Barbara, CA 93111-1425

HOFFMAN, Richard T. '74
P.O. Box 49277/Delkern Station
Bakersfield, CA 93382

HOFFMAN, Thomas '74
3890 Motz Drive
Bath, OH 44210

HOFMANN, Bret '83
6177 White Water Way
Reno, NV 89523

HOFMANN, Rudy '80
501 E. 82nd St., #4W
New York, NY 10021

HOGAN, Reed '74
1801 Ceres Way
Sacramento, CA 95864

HOGENSEN, Lee '74
15920-78 Ave.
Puyallup, WA 98371

HOGG, PETER '66
1221 South La Brea
Los Angeles, CA 90019

HOHMANN, Alvin '73
P.O. Box 34435
Greenville, SC 29614

HOHWEILER, Rita A. '82
1830 South Lookout Drive
Oxnard, CA 93033

HOILAND, Ralph '88
3018 Millbrook Drive
San Jose, CA 95148

HOKE, David C. '82
236 Dawns Edge
Montgomery, TX 77356

HOLDEN, Andrew '86
11411 Arroyo
Santa Ana, CA 92705

HOLDEN, Jerome T '86
1257 Fairview Court
Ojai, CA 93023

HOLDERMAN, Steve C. '85
9611 N.E. 34Th
Bellevue, WA 98004

HOLE, Jeffrey '72
P.O. Box 10637
Burbank, CA 91510

HOLGUIN, Carl A. '78
111 S. Grandview Blvd.
Waukesha, WI 53188

HOLLENBECK, Douglas '87
#2 Lindworth Ln.
St. Louis, MO 63124

HOLLEY III, William C. '90
3511 Yuba Ave.
San Jose, CA 95117

HOLLINGSWORTH JR, Robert B. '69
3124 98th St. East
Highland, IN 46322

HOLLIS, Barry '86
133 E De La Guerra 225
Santa Barbara, CA 93101

HOLLOWAY, H. Kay '84
571 Woodland Hills Pl
Jackson, MS 39216

HOLSCHER, David C. '82
2226 Blue Rock Lane
Grove City, OH 43123

HOLT, Syndee L '76
150 Calla Ave.
Imperial Beach, CA 92032

HOLT, Thomas M. '83
1712 Nw 67th Street
Seattle, WA 98117

HOLTZ, Ronald J. '83
9153 Brookville
Silver Springs, MD 20910

HOLTZMAN, Leslie W. '78
1727 Prospect Ave
Santa Barbara, CA 93101

HOLZHUETER (HOLZ),
Richard (Rick) '75
221 E. Cullerton
Chicago, IL 60610

HOLZMAN, John Eric '88
2509 S. Brentwood
Lakewood, CO 80227

HOOGENDIJK, Robert '87
Bankastraat, #16
Meppel, 1 103, Netherlands

HOOGNER, Mike '70
1515 Floribunda Avenue
Burlingame, CA 94010

HOOKER, Ken C. '85
377 Laureldale Lane
Grants Pass, OR 97527

HOOPER, Robert F. '71
45-243 Kulauli St.
Kane, HI 96744

HOPE, Francois M '86
209 San Anita Rd
Santa Barbara, CA 93105

HORN, Albert '55
76 Greenwood Circle
Wormleysburg, PA 17043

HORN, Shawn E. '83
1520 Oxford Place
Mesquite, TX 75149

HORNER, Laura Jean '57
5535 SW Radcliff Drive
Portland, OR, 97219

HORROCKS-SCHNEIDER, Diane L. '86
1529 Buckskin
Simi Valley, CA 93065

HORTIGAN, John T.
32588 Deguirdre
Warren, MI 48092

HORTON, Peter D. '70
6578 Hamilton Ave.
Westhampton Beach, NY 11978

HOSSFELD-TARNOWSKI,
Elizabeth '69
5109 Harriet Ave. S.
Minneapolis, MN 55419

HOSSLER, Kevin D. '84
6718 West Pfeiffer Road
Bartonville, IL 61607

HOUGH, Chuck '62
1601 North Edgewood Ave
Appleton, WI 54914

HOUGHLAND, Richard S. '78
5614 Miner Circle
Rocklin, CA 95677

HOULDIN, Cindy N. '78
P.O. Box 2685
Encinitas, CA 92024

HOUSE, Jack '66
P.O. Box 2863
Anderson, IN 46018

HOWARD, Dave '70
13413 East Ave. D-8
Lancaster, CA 93535

HOWARD, Ralph '53
2419 Ramm Drive
Anaheim, CA 92804

HOWARD, Ronald P. '84
501 Michael Street
Boise, ID 83705

HOWELL, Herbert '49
109 Pacific Ave.
Shafter, CA 93263

HOWRANI, AMEEN
2820 E. Grand Blvd.
Detroit, MI 48211

HROMADIK, Randall '89
156 Saint Thomas Dr.
Ojai, CA 93023

HUANG, Eduviges Y. '68
177 Alfonso XIII San Juan
Metro Manila, Philippines

HUANG, Frederick '68
177 Alfonzo XIII
San Juan, Philippines

HUBBARD, Wood '72
3709 Kennedy Ave
Bakersfield, CA 93309

HUCKABY, Dennis '74
6054 Elmer Ave.
N. Hollywood, CA 91606

HUDSON, Mark
P.O. Box 21801
Santa Barbara, CA 93121
HUDSON, Stephen M. '75
453 Brookhill Drive
Abingdon, VA 24210
HUEBERGER, William '79
39371 Jordan Road
Scio, OR 97374
HUEBNER, Glen M. '76
2146 North 58th Street
Milwaukee, WI 53208
HUERTA, Jack '79
12415 NW Haskell Ct 19
Portland, OR 97229
HUFFMAN, Robert E. '50
7551 Danube Drive
Huntington Beach, CA 92647
HUGET, Erik P. '88
4424 N. E. 39th Ave.
Portland, OR 97211
HUGHES, Joseph '66
10961 Chery St.
Los Alamitos, CA 90720
HUGHES, Patricia J. '78
223 West York Street
Norfolk, VA 23510
HUGHSON, Walter L. '76
P.O. Box 3707
Seattle, WA 98124
HUGLI, Brian F. '79
925 Lilac Drive
Santa Barbara, CA 93108
HULING, Rodney C. '76
8913 Ravenna Ave N.E.
Seattle, WA 98115
HULTEN, Pernilla '90
1943 Tamrind Ave., #208
Los Angeles, CA 90068
HUMBERD, Hara L. '81
P. O. Box #50605
Santa Barbara, CA 93150
HUME, Peter '89
259 Dunvegan Road
Toronto, M5P 209, Canada
HUNSLEY, Wallace '63
3417 Central Avenue NE
Albuquerque, NM 87106
HUNT, Ann Prevost '65
6961 South Madison Way
Littleton, CO 80122
HUNT, Gary R. '90
38 S. La Cumbre
Santa Barbara, CA 93105
HUNT, James '54
P.O. Box 82626
San Diego, CA 92138-2626
HUNT, John J. '76
8682 Empire Court
Cincinnati, OH 45231
HUNTLEY, Laura '88
1120 Western Avenue #1
Glendale, CA 91201
HUNTLEY, Mark '87
1120 Western Ave #1
Glendale, CA 91201
HURD, R. David '73
3034 Gold Canal Drive Ste B
Rancho Cordova, CA 95670
HURST, John '74
232 South Sea Pines Drive
Hilton Head Island, SC 29928
HURTER, Bill '77
8490 Sunset Blvd.
Los Angeles, CA 90069
HUTCHESON, James '59
26074 Bay Avenue
Moreno Valley, CA 92360
HUTCHISON, Ann M. '81
5007 Bromley Lane
Richmond, VA 23226
HUTSELL, David D. '79
25117 167th SE Ave
Kent, WA 98042
HYATT, David '82
1013 Pujo Street
Lake Charles, LA 70601
HYDE, Alex C. '77
2024 21st Street
Santa Monica, CA 90404
HYDE, Victor '79
26461 Park Circle Drive
San Juan Capistrano, CA 92675
HYINK, Paul A. '71
44 Ninigret Street
Warwick, RI 02889
HYLAND, Greg '80
11505 Via Montana Ave
Yuma, AZ 85365
HYPPA, Carl John '66
1403 Thayer Ave
Ashtabula, OH 44004

– I –

IBARRA, Ralph '87
705 Lombardo Ave
Modesto, CA 95351
ICAZA, Francisco '85
Muille De Txurruka
Getxo Las Aren, Vi, Spain
ICAZA, Patxo '85
Muelle De Churruca No. 4
Getxo Vizcaya, Spain
IDRIS, E. A. '63
P.O. Box 1617
Khartoum, Sudan
IGER, Gregory '66
211 H Street
Bakersfield, CA 93304
IKEMIYA, Tom '54
514 North La Brea Ave
Los Angeles, CA 90036
ILLIG, Russell '50
3800 S W Trail Rd
Tualatin, OR 97062
INDIEK, Kathryn A. '89
50 Hillsdale
Newport Beach, CA 92660

INFANTE, Juan Diaz '82
Parral 64
Mexico DF, Mexico
INGERSOLL-HARRISON, C. '86
P.O. Box 7786
Auburn, CA 95604
IRWIN, Joe B. '79
147 Brewster Street
Waco, TX 76706
IRWIN, Robin E. '89
45654 Private Shore Lane
Mt. Clemens, MI 48045
ISGETT, H. NEIL '83
4303 D. South Blvd.
Charlotte, NC 28209
ISGRIG, Michael J. '89
1511 Dutton St. D
Santa Barbara, CA 93105
ISHEE, James '60
2525 Turtle Creek 205
Dallas, TX 75219
ISHIKAWA, Jonell '83
4648 Linkini Street
Honolulu, HI 96818
ISHIKAWA, Kakoto '73
2-16 Rokuban-Cho
Chiyoda Ku Tokyo, Japan
ISHIKAWA, Koryo '89
4-5-6 Ichibann-Cyo
Senndai Miyagi, 980, Japan
ISLER, Rudolph '82
Ruetistrasse 26
Zollikon, 8702, Switzerland
ITAMI, Alfredo Aki '76
Galeana 23 San Jeronimo
Mexico, DF 10200, Mexico
ITO, Motoi '85
2-7 Tenoudouri
Tushima Aichi, 496, Japan
IVERSON, Elmo '49
6254 Guava
Goleta, CA 93017
IVERSON, Helen M. '89
P.O. Box 167278
Irving, TX 75015
IVES, George '61
515 4th Place
Solvang, CA 93463
IZARD, Charles '58
P.O. Box 60511
Bakersfield, CA 93386

– J –

JABLONSKI, Anthony J. '76
6925 Tayloe Street
Dallas, TX 75227
JACKL, Pat A. C. '80
P.O. Box 327
Salyer, CA 95563
JACKSON, Gerry L. '78
2620 "G" Street
Sacramento, CA 95816
JACKSON, O. Emmette '69
178 Westridge Drive
Huntsville, TX 77340
JACKSON, William J. '81
3421 Kanell Loop S "A"
Wahiawa, HI 96786-4432
JACOB, Robert E. '79
3264 E Avenue S 4
Palmdale, CA 93550
JACOB, Teodorico '84
1710 Barry Ave, #8,
Los Angeles, CA 90025
JACOBS, Carolyn S. '77
P.O. Box 2710
Carmel, CA 93921
JACOBS, George R. '80
443 Carrier N.E.
Grand Rapids, MI 49505
JACOBS, James R. '82
1201 West 7th Street
Chester, PA 19013
JACOBS, Steven H. '81
2501 Esmond Avenue
Richmond, CA 94804
JACOBS, Willem F. '83
Van Der Mijleweg 7
1910 K D Castricum, Netherlands
JACOBSON, Neil '72
220 1/2 N Larchmont Blvd.
Los Angeles, CA 90004-3707
JAFFE, Peter L. '61
2945 Surfrider Ave
Ventura, CA 93001
JAFFE, Robert N. '77
140 Nursery Street
Ashland, OR 97520
JAHIEL, Adam D. '80
8033 Sunset Blvd, #2651
Hollywood, CA 90046
JAHNS, Jo Lynn '76
218 20th Street
Newport Beach, CA 92663
JAMES, David A. '83
127 1/2 38th Street
Newport Beach, CA 92663
JAMES-HIGH, Janie L. '83
MCR 61 Box 1930
Dewey, AZ 86327
JANG, George P. '76
2472 E. 12th Ave.
Vancouver B C, V5M 2C2, Canada
JANKINS, John '77
1738 N. Palm Ave.
Upland, CA 91786
JANSONS, Robert V. '79
2926 Scott Blvd.
Santa Clara, CA 95054
JARRETT, MICHAEL D. '78
16812 Redhill
Irvine, CA 92714
JAY, James A. '88
P.O. Box 13
Somis, CA 93066
JAZZAR, Asya '89
5686 Ruth Crt.
Milton, FL 32583

JEANNIN, Bruno '82
10 Rue Due Preiure
Ecully, 1, France
JEE, Tjin Hin '88
1919 Red Rose Way
Santa Barbara, CA 93103
JEFFRESS, Anthony '67
516 Delmont Dtreet
Pittsburgh, PA 15210
JEFFREY, James '71
5706 West Airdrome
Los Angeles, CA 90019
JENKIN, Bruce '85
7122 Heil Ave 2
Huntington Beach, CA 92647
JENKINS, John F. '77
9747 Peachtree Lane
Alta Loma, CA 91701
JENNINGS, Penny S. '81
2137 20th Street #6
Santa Monica, CA 90405
JENSEN, Lisa A. '90
2691 Glencroft Road
Vienna, VA 22181
JENSEN, Quincy M. '53
1910 Bittern Drive
Idaho Falls, ID 83406
JENSEN, Ralph '52
3769 Loretta Drive
Salt Lake City, UT 84106
JEONG, Woo Young '89
C-6 Mill St.
Athens, OH 45701
JESKE, Rebecca A. '76
227 E Anapamu 164
Santa Barbara, CA 93101
JEZEK, George R '89
6444 Lance Court
San Diego, CA 92120
JIMENEZ, Robert J. '85
25 Priscilla Circle
Bridgeport, CT 06610
JISKRA, Donald '55
1100 Bristlecone Court
Darien, IL 60559
JOHNSON, Al '63
11612 Marquette Ave NE
Albuquerque, NM 87123
JOHNSON, Ami L. '89
4549 Alamo St C
Simi Valley, CA 93063-1795
JOHNSON, Carl '86
P.O. Box 23184
Seattle, WA 98125
JOHNSON, Christopher W. '87
1501 Hara Street #2107
Vancouver, V6G 1G4, Canada
JOHNSON, Daniel W. '85
531 13th Avenue
Bethlehem, PA 18018
JOHNSON, David A. '78
6840 15th Ave. N.E.
Seattle, WA 98115
JOHNSON, David Kent '85
6840 15th Ave. N.E.
Seattle, WA 98115
JOHNSON, Douglas '89
2711 So. Norfolk #301
San Mateo, CA 94403
JOHNSON, Edward '72
705 S Washington Ave
Warrensburg, MO 64093-2236
JOHNSON, Eric A. '87
5725 Oakgreen Avenue N.
Stillwater, MN 55082
JOHNSON, Fredrick O. '83
5 Roble Circle
Berkeley, CA 94705
JOHNSON, Grant D. '82
St. Pierre De Wakefield
Quebec, J0X 3J0, Canada
JOHNSON, Keith S. '79
316 3/4 North Ridgwood Place
Los Angeles, CA 90004
JOHNSON, Kevin P. '80
211 Merrill Street #413
Birmingham, MI 48009
JOHNSON, Len '76
8907 Butler Circle
Austin, TX 78737
JOHNSON, Linda '89
17427 W. 67th Terr.
Shawnee Mission, KS 66217
JOHNSON, Lowell M. '58
2133 Atlanta Street
Anaheim, CA 92802
JOHNSON, Mark A. '90
152 B North Kalaheo
Kailua, HI 96734
JOHNSON, Mark C. '86
1088 Grandview Ave
Fullerton, CA 92635
JOHNSON, Mark R. '76
1219 Elk St.
Beatrice, NE 68310
JOHNSON, Michael R. '79
6850 Casa Loma Ave
Dallas, TX 75214
JOHNSON, Paul M. '84
P.O. Box 416
Kalispell, MT 59901
JOHNSON, Rick '82
13211 Woodland Drive
Tustin, CA 92680
JOHNSON, Robert E. '86
525 73rd St.
Brooklyn, NY 11209
JOHNSON, Robin F. '72
2546 Assinboine Cres.
Winnepeg, MB R3J 0B2, Canada
JOHNSON, Robin N. '83
10810 Rogmar Dr.
Palo Cedro, CA 96073
JOHNSON, Roger Lewis '76
813 Orange Blossom Way
Danville, CA 94526
JOHNSON, Victoria L. '86
20656 View Oaks Way
San Jose, CA 95120

JOHNSON, Wayne R. '64
614 E. 15th St.
Minneapolis, MN 55404
JOHNSON, William '73
316 Robins St.
Tupelo, MS 38801
JOHNSON, William D. '77
33 Pine Drive
Santa Barbara, CA 93103
JOHNSON, William M. '86
660 Scarsdale Road
Crestwood, NE 10707
JOHNSTON, Howard H. '75
10365 S.W. Johnson Street
Tigard, OR 97223
JOHNSTON, Laura L '88
9 Crane Court
Orinda, Ca 94563
JOHNSTON, Stanton '68
3159-East Kapaka Street
Honolulu, HI 96819
JOHNSTONE, Stephen '72
310 Old Ranch Road
Sierra Madre, CA 91024
JONES, C. Bryan '66
1642 Courtlandt
Houston, TX 77008
JONES, Charles C. '81
8049 Deer Water Dr
Sacramento, CA 95825
JONES, Dale '71
12417 SW Terwilliger
Portland, OR 97219
JONES, Deborah F. '82
17413 Posetano Road
Pacific Palisades, CA 90272
JONES, Dianne '89
1125 South Bronson Avenue
Los Angeles, CA 90019
JONES, Donald T. '81
5026 Masheena Lane
Colorado Springs, CO 80917
JONES, Harry Lynn '60
P.O. Box 250
Terrell, TX 75160-0250
JONES, Jon L. '82
4821 Oxford Ct.
Bensalem, PA 19020
JONES, Paul B. '79
1602 Renate Drive
Woodbridge, VA 22192
JONES, Thomas M. '71
8738 E Whitton Ave
Scottsdale, AZ 85251-5070
JONES, Wendy R. '82
1621 Castle Circle
Houston, TX 77006
JONSDOTTIR, Solrun '88
33 Prospect Ave G
San Francisco, CA 94110-5130
JOSEPH, Nancy
838 Milwaukee
Denver, CO 80202
JOSLIN, Rodney P. '80
861 1/2 Northwest Blvd.
Columbus, OH 43212
JOVANOVICH, Joseph S. '86
1932 S. Halsted #510
Chicago, IL 60608
JOY IV, Henry Bourne '90
Lockwood Lake Ranch
Atlanta, MI 49709
JOY, Frederic C. '77
P.O. Box 1681
Jackson, WY 83001
JOYCE, Carole '88
1455 Mandlay Beach Road
Oxnard, CA 93030
JOYCE, Dennis '58
P.O. Box 1816
Bismarck, ND 58502
JOYCE, Lisa M. '90
7340 S.W. 110 Terrace
Miami, FL 33156
JOYCE, Nancy A. '85
235 West Broadway
Bismarck, ND 58501
JOYCE, William '88
9208 N. W. 18Th St.
Coral Springs, FL 33065
JUDD, Edward H '55
Route 1 Box 245-A
Argyle, TX 76226
JUE, Gary K. '80
3560 San Simeon Ave
Oxnard, CA 93033
JUSTICE, KEN
4706 Kester Ave. #12
Los Angeles, CA 91403

– K –

KACHMAN-ASARO, Cynthia '81
21 Coral Tree Lane
Rolling Hills, CA 90274
KAHN, M. Rasheed
4090 Via Zorro #B
Santa Barbara, CA 93110
KAICHEN, David R. '76
2758 U.K. Circle
Winter Park, FL 32792
KAISER, Bill '75
51693 35 1/2 St.
Paw Paw, MI 49079
KALAN, Mark '77
24 Hardwood Dr.
Tappan, NY 10983
KALLAS, E.S.
98 Via Encina
Monterey, CA 93940
KANE, Betsy A. '82
P.O. Box 773
Amagansett, NY 11930
KAO, Ray C. '85
1135 Oakfair Lane
Harbor City, CA 90710
KAPLAN, Dick '74
975 West Gage Lane
Lake Forest, IL 60045

KAPLER, Jerry '65
34 Emery Bay Drive
Emeryville, CA 94608
KARDINAAL, Philippe '84
44651 18th Street East
Lancaster, CA 93535
KARLIN, Alan P. '76
2594 Dysart Rd.
University Heights, OH 44118
KARMA, Arlene '88
21231 Hawthorne Blvd., Ste 350
Torrance, CA 90503
KARNER, Fred '49
750 Royal Crest Circle #445
Las Vegas, NV 89106
KARPINSKI, Michael '78
P.O. Box 119
Williams, OR 97544
KARPYNKA, Walter '72
244 Carlo Drive
Goleta, CA 93017
KASALA, Vicky '85
P.O. Box 1171
Kalispell, MO 59911
KASBEKAR, Atul A '88
4/2 Moti Mahal, J. Tata Rd.
Churchgate, Bo 400 020, India
KASINGER, John '73
P.O. Box 313
Selah, WA 98942
KASSAYE, Samson M. '89
323 W. Arrellaga St
Santa Barbara, CA 93101
KASTEN, John '72
2283 West Dunlop
San Diego, CA 92111
KATZ, Jocelyn '86
1130 Countryside Drive
Harrisburg, PA 17110
KAU, Colin W. '87
1960 Kapiolani Blvd., Ste 113-35
Honolulu, HI 96826
KAUFFMAN, Edward '49
8425 43rd Ave.
Kenosha, WI 53142
KAUFFMAN, Haskell '56
324 Windsor Drive
Cherry Hill, NJ 08002
KAUFMAN, Andrew L. '83
436 N E 57th Ave
Portland, OR 97213-3716
KAUSCH, Christopher P. '85
4217 N Fruit Ave 104
Fresno, CA 937051520
KAWAMICHI, Marvin '59
P.O. Box 217
Chicago Park, CA 95712
KAY, Philip '64
101 Coughlan Street
Vallejo, CA 94590
KAYE, Elizabeth A. '89
1409 Robbins St
Santa Barbara, CA 93101
KAYLER, Eric '64
2528 Central Ave
Alameda, CA 94501
KAYS, Robert L. '61
12785 Rajah St.
Sylmar, CA 91342
KAZAN, Michael R. '86
135 East 54Th Street Apt. 16B
New York, NE 10022
KEANZLER, Paul
27 Blenheim Avenue
Center Post, NY 11721
KEARNS, James '87
1753 Glen Oaks Drive
Santa Barbara, CA 93108
KEATING, Cyril '87
919 Isleta St.
Santa Barbara, CA 93109
KEATING, John '79
405 West Highland
Electra, TX 76360
KECHELE, John P. '79
421 S. Brevara Apt 5
Cocoa Beach, FL 32931
KEE, Richard '74
P.O. Box 378
Monrovia, CA 91010
KEEFER, Lena '85
6341 North 35th Street
Paradise Valley, AZ 85253
KEEN, JIM '69
5341 Glen Haven Rd.
Soquel, CA 95073
KEESAL, Carolyn '87
16255 Pacific Cir. #201
Huntington Beach, CA 92649
KEEVIL, J. David '86
1350 The Crescent
Vancouver, BC , Canada
KELLER, GREG
769 22nd St.
Oakland, CA 94612
KELLER, John '70
222 S.W. Columbia
Portland, OR 97201
KELLER, Robert G. '84
6127 Falcon Avenue
Long Beach, CA 90803
KELLEY, Helen '66
184 Highland Dr.
San Luis Obispo, CA 93401
KELLY, Bradford J. '84
1420 Creekside Drive #5
Walnut Creek, CA 94596
KELLY, Eton
87 Willow Ave.
N. Plainfield, NJ 07060
KELLY, Thomas A. '75
87 Willow Ave North
N. Plainfield, NJ 07060
KEM, Patrick T. '80
603 Whittier Pky
Severna Park, MD 21146
KEMPER, Jim '87
3960 Brookline Way
Redwood City, CA 94062

KENDALL-HASTINGS, Katherine L '88
309 S. Cloverdale, Suite C-24
Seattle, WA 98108
KENER, Paul W. '67
P.O. Box 881
Rancho Cucamonga, CA 91730
KENNEDY, David '70
P.O. Box 254
Cerrillos, NM 87010
KENNEDY, Paul E. '78
1517 Ridgewood Circle
Gallatin, TN 37066
KENNEDY, W. Patrick '86
3622 San Pablo Lane
Santa Barbara, CA 93105
KENNER, Jack W. '80
P.O. Box 3269
Memphis, TN 38173
KENNEY, I. '75
2114 Houston Avenue
Valdosta, GA 31602
KEPNER, Steve C. '83
4370 Ransom Road
Clarence, NY 14031
KERN, Geoffrey W. '77
240 Turnpike Ave.
Dallas, TX 75208
KERN, Jonathan Q. '88
10915 Bluffside Dr. #126
Studio City, CA 91604
KERNS, Ray J. '78
55 North St. John Ave.
Pasadena, CA 91103
KERR, Maurice '68
204 Law Street
Aberdeen, MD 21002
KESLER, Douglas B. '81
601 North Fant Street
Anderson, SC 29621
KESLER, Kevin Williams '80
601 N. Fant St.
Anderson, SC 29621
KESNERS, Andris '64
3620 Oro Blanco Drive
Colorado Springs, CO 80917
KESSLER, Aran D. '80
715 Woodbridge Drive
Flint, MI 48504
KETTEL, Morten '89
120 Point San Pedro Road
San Rafael, CA 94901
KETTER, Mark L. '81
1707 N. W. 58th St. #4
Seattle, WA 98107
KEYS, Michael '69
304 Gettysburg Circle
Medford Lakes, NJ 08055
KEYSER, John H. '87
404 S. Maple
Lamoni, IA 50140
KEYSER, Peter R. '60
1924 Pelican Ave.
Ventura, CA 93003
KHOURY, Fouad R. '81
4229 N. Rio Cancion 101
Tucson, AZ 857187144
KIENER, Paul W. '67
P.O. Box 881
Rancho Cucamonga, CA 91730
KIESOW, Paul '73
3800 Brentwood Rd H
Raleigh, NC 276041760
KILEY, Ralph '70
6368 Branch Hill Miamiville Rd
Loveland, OH 451407503
KILLIAN, Danial '76
31323 70th Ave.
Roy, WA 98580
KILLION, Jeffrey '70
1526 Lydia Drive
Tulare, CA 93274
KILMER, Richard H. '76
217 Washington Street
Port Clinton, OH 43452
KIM, Beom C. '83
4 West 31 Street, #1405
New York, NY 10001
KIM, Seung Bum '88
71-3 Ku-Eui-Dong
Seong-Dong-Ku, Se 133, Korea
KIM, Todd '82
1131o Victoria Ave.
Los Angeles, CA 90066
KIM, Young-Soo '82
Arts/Photo. Dept./180-29
AnSung-Kum, KyngkiD, Korea
KIMBALL, Kenneth '67
3135 31st St.
San Diego, CA 92104
KIMBLE, Robert E. '55
112 Broadcastle Way
Monte Sereno, CA 95030
KIMM, Glennelle L. '84
99-639 Kaulainahee Place
Aiea, HI 96701
KIMOTO, Walter '72
343 State St.
Rochester, NY 14650
KINCH, Jason A. '77
513 S 10th Ave
Cornelius, OR 97113-6934
KING, Floyd '52
15415 Wyandotte St.
Van Nuys, CA 91406
KING, H. Edmunds (Ted) '72
P.O. Box 382
Medina, WA 98039
KING, John David '63
4050 Pinebrook Lane
Bettendorf, IA 52722
KING, Kathryn M. '75
419 Center Street
Beach Haven, NJ 08008
KIRCHNER, Paul '82
850 26th Ave.
San Francisco, CA 94121
KIRCHOFF, Michael '89
2440 Blueberry Drive
Oxnard, CA 93030

KIRILUK, John D. '82
120 MacDougal St. #18
New York, NY 10012
KIRK, Debra A. '84
4913 East 97Th Avenue
Crown Point, IN 46307
KIRKEBY, M. Brian '90
1062 Coast Village Rd. #A2
Montecito, CA 93108
KIRKENDALL, THOMAS '80
18819 Olympic View Drive
Edmond, WA 98020
KISER, Steve '65
3302 Vernon Terrace
Palo Alto, CA 94303
KISH, DONALD S. '72
71 Chopin Blvd.
Winnipeg, MB R2G2C9, Canada
KITZMAN, John R. '77
2722 E. 3rd Street #2
Long Beach, CA 90814
KJARNES, Erling '87
Tangen Terrasse 23
Nesoddtangen, 1450, Norway
KJELLAND, James P. '90
3442 Blackhawk Rd.
Lafayette, CA 94549
KJOLLESDAL, Hallstein '84
Sinsenveien 48
Oslo 5, 93101, Norway
KLASSEN, Ernie '81
32090 So. Fraser Way
Clearbrook, BC V2T 1Z7, Canada
KLAUKE, Christoph '86
P.O. Box 1738
New York, NY 10011
KLAUSS, Cheryl A. '81
451 Broome Street 7E
New York, NY 10013
KLAWITTER, Michael A. '75
3078 Wauneta Street
Newbury Park, CA 91320
KLAYMAN, Kerry '86
410 Beechmont Drive
New Rochelle, NY 10804
KLEENE, Gerald J. '73
1803 Gary Spirit Lake
Spirit Lake, IA 51360
KLEIN, Richard C. '81
920 Hillcrest
Placerville, CA 95667
KLEINMAN, Sam O. '82
4844 Hartwick St.
Los Angeles, CA 90041
KLIMAN, Kari Ellen '88
14 La Senda Place
South Laguna, CA 92677
KLIMCZAK M. A., Wladyslaw
Cracow Photographic Society
Cracow 1, P.O., BX 13 30 960, Poland
KLIMOWICZ, Rick A. '88
12511 Golf Road
Franksville, WI 53126
KLINE, Kurt '82
10491 Love Creek
Ben Lomond, CA 95005
KLYNJAN, Nora '81
132 North Poinsettia Ave
Monrovia, CA 91016
KNACKSTEDT, Kenneth '57
91 Renault Ave
Medford, OR 97501
KNAUS, Hugh C. '73
1801 Homer Drive
Fort Collins, CO 80521
KNIGHT, Thomas M. '88
P.O. Box 41233
Santa Barbara, CA 93140
KNIGHT, Warren '66
2350 S.W. 172nd Circle
Aloha, OR 97006
KNIGHT, Woodie S. '86
P.O. Box 305
Millry, AL 36558
KNISELY, Patrick A. '84
4232 Fari Ave #12
Toluca Lake, CA 91602
KOBAYASHI, Kenneth R. '78
30 Sanchez
San Francisco, CA 94114
KOCHAVI, Ilan '68
Ehaad Haar St.
Haders, Israel
KOCHEROV, Sam '58
9960 Timbers Drive
Cincinnati, OH 45242
KOCUREK, Phillip M. '88
1850 Wesat Ave J12 0107
Lancaster, CA 93534
KODACHI, Yasuzo '82
1-17-12 Higashikomagata #306
Sumida Tokyo, 130, Japan
KOEHLER, Richard '78
1006 Westbrook Street
Corona, CA 91720
KOENIG, Jerry '65
1152 Rambling Road
Simi Valley, CA 93065
KOENTJORO, Hengki '90
2323 Turk Blvd.
San Francisco, CA 94118
KOEPER, Craig H. '84
1405 Eden Ave #C-27
San Jose, CA 95117
KOHLHOFF, Frederick '76
67-67 Burns Street
Forest Hill, NY 11375
KOHN, Robert H. '71
2616 Las Positas Rd.
Santa Barbara, CA 93105
KOHRING, Gene W. '58
1647 S.R. 748
Hamilton, OH 45013
KOITMAA, Mark T. '86
204 La Rossa Ct
San Jose, CA 95125-1256
KOJAN, Mette '85
Blueline Studio
Oslo 4, 0488, Norway

KOKIN, Kenneth J '86
3129 Granville Avenue
Los Angeles, CA 90066
KONING, Erika
344 West 14th Street Apt. C2
New York, NY 10014
KOPACKA, Gregory '80
1868 Bandera Hwy.
Helotes, TX 78023
KOPELS, Stephen '72
2213 Belmont Blvd
Nashville, TN 37212
KOPPEL, Alicia '87
1123 W Valerio St
Santa Barbara, CA 93101-4748
KORBA, Anthony '64
11 Moss Glen
Irvine, CA 92715
KORNICKER, Peter J. '78
235 East 22nd Street #2P
New York, NY 10010
KORROW, Chris C. '83
4705 Aragon Street
Carpinteria, CA 93013
KOSTENBAUDER, Robert '64
5411 Tyrone Apt. #203
Van Nuys, CA 91401
KOSTOCK, Bill '77
4855 Payton Street
Santa Barbara, CA 93111
KOTT, Harry '47
454 Marin Drive
Burlingame, CA 94010
KOVACH, Michael '76
1600 Brentwood
Irving, TX 75061
KOWALCZYK, Richard D. '81
300 Jackson Ave.
Oshawa Ontario, L1H 3C5, Canada
KOZAK, RICHARD E. '80
3426 Pike Ridge Road
Edgewater, MD 21037
KOZINA, Daniel P. '77
819 Monroe Ave.
S. Milwaukee, WI 53172
KRAMER, William R. '81
117 Browning Ave.
Hamburg, NY 14075
KRANZLER, PAUL A. '84
1553 Platte Street #207
Denver, CO 80202-1167
KREBS, Robert '66
8847 Cleveland Ave.
N. Canton, OH 44720
KREIPE, Francis H. '74
2002 Holcombe Blvd.
Houston, TX 77030
KREKLOW, Peter '76
249 South Hwy 101
Solana Beach, CA 92075
KRESGE, Dennis C. '76
206 E. Main St.
Palmyra, PA 17078
KRETSCHMER, Douglas
785 Dos Hermoanos Drive
Santa Barbara, CA 93111
KRIVDO, Donna '55
4820 N Scout Way
Prescott Valley, AZ 86314-5206
KRIVDO, Jack K. '55
4820 N Scout Way
Prescott Valley, AZ 86314-5206
KROGH, Jennifer '88
522 E. 6th St. #3
New York, NY 10009-6609
KRUEGER, Gregory '78
45 San Mateo Ave
Goleta, CA 93117
KRUM, Stephen C. '86
4269-2AA West Dickman Road
Springfield, MI 49015
KRUPP, Peter '65
S3060 N.W. Manzanita Place
Corvallis, OR 97330
KUBAT, Anthony J. '81
3448 Chicago Ave.
Minneapolis, MN 55407
KUCH, Harvey '74
9659 Stonehurst Ave
Sun Valley, CA 91352
KUCHARSKI, John '73
3813 57th Ave.
Hyattsville, MD 20784
KUCINE, Cliff G. '85
51 Norwood Street
Portland, ME 04103
KUCK, George '64
High Tor Ranch, 9700 Hwy 101
Redwood Valley, CA 95470
KUCZERA, Michael G. '79
48 Pine Lane
Landing, NJ 07850
KUGA, David '87
29 B Noe Street 3
San Francisco, CA 94114
KUHLMAN, Chris L. '76
12403-B Scarsdale Blvd.
Houston, TX 77089
KUHN, Leanne A. '89
4090 Cuervo Avenue
Santa Barbara, CA 93110
KUMMER, Robert S '87
116 Los Alamos
Santa Barbara, CA 93109
KUROSAKI, Bruce T. '78
14715 Cumspton Street
Van Nuys, CA 91411
KURTZ, Joyce '56
1310 Hanover Lane
Ventura, CA 93001
KURVINK, Reid M. '83
518 Lakshore
Sarnia Ontario, Canada
KUSANO, Takahisa '82
3-9-503 Nirenokidai Asahigaoa
Cho 3321 Choba, 281, Japan
KVARDA, Jerry '62
24245 Walden Way
Red Bluff, CA 96080

KWIECIEN, Norman '70
11657 Stout Street
Detroit, MI 48228
KYLE, Franklin Mark '77
909 West 21st Street C
Austin, TX 78705

– L –

LA COUNT, James K. '77
17340 Saticoy Street
Van Nuys, CA 91406
LA FORTUNE, John M. '86
4444 Oak Rd.
Tulsa, OK 741054223
LA POINT, Joseph F. '80
41 Fraser Circle
Walnut Creek, CA 94596
LA TONA KEVIN D '76,
159 Western Ave. West
Seattle, WA 98119
LA TURNER, Douglas '82
N. 5811 Fotheringham
Spokane, WA 99208
LACKER, Peter W. '82
2709 Burning Tree Lane
Irving, TX 75062
LAGER, Bruce G. '65
5415 North 2nd Street
Rockford, IL 61111
LAI, John Y. F. '80
1000 Spruce Lane
Pasadena, CA 91101
LAINE, Curtis S. '76
1312 W. Burke Ave.
Roseville, MN 55414
LAIRD, Bruce G. '88
130 W. Padre Street, #1
Santa Barbara, CA 93105
LALLY, Daniel '80
2847 E. Madison Ave.
Orange, CA 92667
LAMA, STEVEN '90
742 Coeur Dalene Circle
El Paso, TX 79922
LAMONICA, Tracy S. '85
2030 N. Vermont Avenue
Los Angeles, CA 90027
LAMORENA, Alberto A. '78
20 Angela Ct.
Dadedo, 96912, Guam
LAMOTTE, Mary Ellen Donohue '74
35 Echo St. - Dellwood
White Bear Lake, MN 55110
LANDGRAF, Luiz '82
2520 N. Beachwood Dr. #11
Los Angeles, CA 90068
LANDOT, Greg L. '86
3360 Sagunto St.
Santa Ynez, CA 93460
LANDRETH, Douglas S. '79
1940 124th Avenue N.E. A108
Bellevue, WA 98005
LANDRUM, Jerry L. '80
1468 East 2nd Place
Mesa, AZ 85203
LANDWEHR, Eric H. '89
901 1/2 E. 4th Ave.
Mitchell, SD 57301
LANE, Matthew G. '78
379 Avenida Arboles
San Jose, CA 95123
LANFORD, William '70
1249 Chelan Lane
Ventura, CA 93004
LANG, Arthur '67
808 Mountain Laurel Lane
Bedford, TX 76021
LANG, Charles '46
2002 West View
Los Angeles, CA 90016
LANG, Mark H. '88
8438 Calderon Circle
San Diego, CA 92129
LANG-PIERSON, Molli '79
5115 Columbia Hts. Rd.
Longview, WA 98632
LANGE, Herbert '72
620 Grand Ave
Elgin, IL 60120
LANGER, Marcia '71
140 Dryden Drive
Meriden, CT 06450
LANGFORD, MARK '80
7349 Reindeer Trail
San Antonio, TX 78238
LANGLEY, Norman G. '80
1645 Clark Avenue 314
Long Beach, CA 90815
LANTZ, Chris '87
5390 Berkeley Rd
Santa Barbara, CA 93111
LANTZ, Steven T. '85
4526 East Via Estrella
Phoenix, AZ 85028
LAPINE, Robert E. '75
1540 Country Hills Drive
Ogden, UT 84403
LAQUAN, Kan Suzuki '86
2099 Tateno Nerima
Tokyo, 177, Japan
LARKINS, Thomas '71
4626 S.W. Washington Street
Milwaukie, OR 97222
LARSON, Carrie E '87
7652 Woodview Ct.
Minneapolis, MN 55435
LARSON, John Scott '86
5700 New Chapel Hill Rd.
Raleigh, NC 27607
LASSOFF, Marc S. '84
703 North Alta Drive
Beverly Hills, CA 90210
LATONA, Kevin '76
159 Western Ave./West Studio 454
Seattle, WA 98119
LAU, Graham J. '88
840 N. Kenter Ave.
Los Angeles, CA 90049

LAUBACHER, Kevin '79
3706 N E 19th
Portland, OR 97212
LAUENSTEIN, John P. '78
8415 Wesley Drive
Minneapolis, MN 55427
LAUFER, Robert E. '89
8042 Burnet Ave
Van Nuys, CA 91402
LAUGE, Dominique '86
3 Passages De Jardins
Clavette, 17220, France
LAURENCE, Peter '86
441 El Rio Rd.
Danville, CA 94526
LAURENZO, Sandro '84
Via Castello 21
Dolce Acqua, Italy
LAURICELLA, Anne M. '80
109 Idaho Ave. #5W
Pueblo, CO 81004-1244
LAURINO, Don '78
51 Boulder Ridge Road
Scarsdale, NY 10583
LAURITSEN-VAN ZANDBERGEN,
Lesli '81
111 Bean Creek Rd. #29
Scotts Valley, CA 95066
LAUTH, Lyal '70
833 West Chicago Ave.
Chicago, IL 60622
LAUVE, Leonard '67
UC San Diego H-206
La Jolla, CA 92093
LAVENSON, Dean '86
2946 Borderlinks
Visalia, CA 93291
LAVIGNE, John Paul '86
P.O. Box 772
Caribou, ME 04736
LAW, Shawna R. '85
1024 Moreno Way
Sacramento, CA 95838-2743
LAWDER, John '74
2117 North Greenleaf
Santa Ana, CA 92706
LAWRENCE, Robert S. '78
P.O. Box 249
Kihei, HI 96753
LAWRENCE, Steven C. '84
1788 Albert Ave.
San Jose, CA 95124
LAWSON, Emmert '53
3959 Maricopa Drive
Santa Barbara, CA 93110
LAX, William J. '79
16035 North 49th Place
Scottsdale, AZ 85254
LAZZARONE, GORDON C. '79
3460 2nd Ave.
Sacramento, CA 95817
LE BLANC, Gary P. '86
8954 Wonderland Ave.
Hollywood, CA 90046
LE BON, DAVID M. '75
8950 Ellis Ave.
Los Angeles, CA 90038
LE TOURNEAU, Jerrold '81
2529 Corning Ave. #101
Ft. Washington, MD 20744
LEACOCK, Jonathan '89
P.O. Box 1393
Nederland, CO 804661393
LEARY, Daniel '74
560 Arbol Verde
Carpinteria, CA 93013
LEARY, Gregory W. '81
P.O. Box 1051
Molbourne, FL 32902
LEAVITT, Charles G. '58
2078 North Ivar Ave
Los Angeles, CA 90068
LEAVITT, Frank A. '75
2537 Terah Maria Drive
Salt Lake City, UT 84118
LEAVITT-CASTLEBERRY, Debra R. '78
2029 West Armitage
Chicago, IL 60647
LEBOEUF, Robert '71
615 Persimmon Road
Walnut Creek, CA 94598
LEBON, David M. '75
8950 Ellis Ave
Los Angeles, CA 90034
LECATE, Robert H. '76
1 Television Place
Charlotte, NC 28205
LECHTMAN, Joseph '75
Apartado Aero #7645
Bogata Columbia, South America
LECOMPTE, James '60
770 Juanita Ave.
Santa Barbara, CA 93109
LEDDY, Patricia '80
104 La Vereda Ln.
Santa Barbara, CA 93108
LEDESMA, Randall P. '86
3002 N Sutter
Stockton, CA 95204
LEE, Danny '86
3025 S. Eden St.
Oxnard, CA 93033
LEE, Ju Yong '85
L9l, Dandae-Dong,
Sung Nam, Korea
LEE, Mel '74
440 S. Zurich Ave.
Tulsa, OK 74112
LEE, Nan-kyu '85
622-10 Hyosung Dong Buk-Ku
Incheon City, South Korea
LEE, Roderic '87
15540 Carousel Drive
Canyon Country, CA 91351
LEEVER, David E. '88
3857 Corina Way
Palo Alto, CA 94303
LEFKOWITZ-O'BRIAN, Linette '76
1720 Sheffield Drive
Lompoc, CA 93436

LEFLER, David A. '79
250 E. Houston St. #8G
New York, NY 10002
LEHMAN, Danny '76
51 Verano Loop
Santa Fe, NM 87505
LEIBHARDT-GOODMAN, Leslie '90
P.O. Box 894
Santa Barbara, CA 93102
LEIDY, Gerald T. '72
211 Woodlawn Ave.
Martinsburg, PA 166625
LEINGANG, Scott L. '85
2839 South Monroe
Denver, CO 80210
LEINS, Mark R. '87
13030 Moorpark Street #5
Studio City, CA 91604
LEMIRE, Alan J. '89
147 Grandview.
Sierra Madre, CA 91024
LEMOINE, Jim '75
1423 Branard
Houston, TX 77006
LEMON, Mark R '88
942-B Redding Way
Upland, CA 91786
LENAKER, Donald '68
440 Skylark Dr.
San Bernardino, CA 92400
LENART, Mihaly '68
P.O. Box 1821
Palm Springs, CA 92263
LENDRUM, Jeff '83
626 Congress St
Neenah, WI 549363479
LENO, Greg A. '86
1630 N.E. Bell Dr.
Portland, OR 97220
LENZ, Brian K. '82
2028 De La Vina St. B
Santa Barbara, CA 93101
LEON JR., Warren E. '73
Calle Alberto Navarro # 19
Panama 5 Republic, Panama
LEONARDI, Indra '87
K.H. Hasyim Ashari No. 36
Jakarta Pusat, Indonesia
LEONARDI, Iskandar '88
82 Sutomo St.
Medan, Indonesia
LEONG, Janet M. '84
365 E. Lincoln Way
Sparks, NV 89431
LEONG, Victor '89
12672 Lamplighter Sq.
St. Louis, MO 63128
LEPP, George D. '72
P.O. Box 6240
Los Osos, CA 93412
LEPPALA, Eija M. '85
Pujupillinjie 17 C 32
Helsinki, 00420, Finland
LESCHOFS, John '80
2555 Mt. Pleasant
San Jose, CA 95148
LESH, Corey D. '84
2038 Meridian Ave F
S. Pasadena, CA 91030
LESLIE, Judy '77
724 Penitencia St.
Milpitas, CA 95035
LESTER, Clifford '78
8187 E. Woodsboro Avenue
Anaheim, CA 90278
LESTER-DEATS, Christine A. '80
2428 Baseline Avenue
Solvang, CA 93463
LETZRING, Michael J. '86
P.O. Box 9
Kasilof, AK 99610
LEVINE, Cynthia J. '85
719 S. Los Angeles St. Ste 42
Los Angeles, CA 90049
LEVINE, Hugh S. '80
3713 Antelope Creek Drive
Ontario, CA 91761
LEVY, DAVID P. '78
444 S. Ashland Ave. #A4
Lexington, KY 40507
LEVY, Robert J. '82
12211 Cantura St.
Studio City, CA 91604
LEWIS, Brian L. '81
3858 Richmond
Shreveport, LA 71106
LEWIS, Gene G. '85
13610 N. Scottsdale Rd.
Scottsdale, AZ 85254
LEWIS, Gerwyn '69
153 Windermere Avenue
Lansdowne, PA 19050
LEWIS, John C. '82
541 Bella Drive
Newbury Park, CA 91320
LEWIS, John R. '76
1266 Washington St
Wrightstown, WI 54180
LEWIS, Warren D. '76
427 Hillcrest Road
San Carlos, CA 94070
LI, Zai Yang '88
619 Park Lane
Santa Barbara, CA 93108
LIANE, Kirk
1312 W. Burke Ave.
St. Pau!, MN 55113
LID, Trond I. '82
Industri 4 Reklane Foto
Skien, 3710, Norway
LIEBHARDT, PAUL W. '76
814 E. Pedregosa St.
Santa Barbara, CA 93103
LIGHTEL, George C. '56
P.O. Box 1876
Cottonwood, AZ 86326
LILJEROS, Raymond '87
Avenyn 37
41136 Gothenburg, 011 46, Sweden

LIM, Stephen S. h. '86
264 Holland Road
Singapore, 1027, Singapore
LIMA, Paulo '80
Rua Do Russel
Rio De Janeiro, 22210, Brasil
LIND, Bill '73
1413 Lexington Astoria
Astoria, OR 97103
LINDBLOM, Thora M.
426 Flower St.
Turlock, CA 95380
LINDQUIST, Robert F. '89
1725 W. Seldon Lane
Phoenix, AZ 85021
LINDSAY, Kurt W. '79
3643 Beach Drive S.W.
Seattle, WA 98116
LINDSTROM, Brent '69
319 11th St.
San Francisco, CA 94103
LINK, Tina L. '78
5000 Minnesota Ave.
Duluth, MN 55802
LINKOUS, Larry G. '73
512 Indian Valley Crt
Rossford, OH 43460
LINNINGER, Melvin Wesley '64
1082 Cortez Crt.
San Luis Obispo, CA 93401
LINSTER, Charles '55
1710 SE Macgregor Rd
South Bend, IN 46614
LIOU, Larry '86
2550 Skyfarm Drive
Hillsboro, CA 94010
LIRETTE, Stuart K. '84
150 Alameda Del Prado
Novato, CA 94947
LISK, MARK W '87
518 Americana
Boise, ID 83702
LITHERLAND, Jeffrey D. '90
309 Sunrise Canyon
Universal City, TX 78148
LITMAN, Dennis '59
104 East Colorado
Pasadena, CA 91105
LIVINE, Cynthia
434 Beach 136 Street
Bell Harbor, NY 11694
LLORENTE, RODRIGO '81
S.A. Apratado Postal 105-225
Colonia Polanco 11581 DF, Mexico
LLOYD, Carrie S '88
834 43rd
Sacramento, CA 95819
LLOYD, Victor S. '77
4058 Whittle Ave.
Oakland, CA 94602
LOBEIRA, Cristina '86
Apartado #42 Col. Del Valle
Monterey N.L., Mexico
LOBER, Robert '50
2555 2nd Street
La Verne, CA 91750
LOCKE, Adrienne E. '81
1096 South Bedford Drive
Los Angeles, CA 90035
LOCKHART, James E. '76
7043 Berry Hill Circle
Orangevale, CA 95662
LOCY, Frank '74
306 41st N.E.
Olympia, WA 98506
LOFASO, John C. '88
San Marcos Trout Club #39
Santa Barbara, CA 93105
LOGAN, Lawrence L. '77
12344 Addison Street
Universal City, CA 91608
LOGUE, James Allen '68
9579 Clock Tower Ln.
Columbia, MD 21046
LOHMAN, Mark T. '80
832 15th #3
Santa Monica, CA 90403
LOHR, Michael V. '85
1226 Alameda Padre Serra
Santa Barbara, CA 93103
LOHRKE JR., Otto '74
1410 Garden Street #2
Santa Barbara, CA 93101
LONDOT, Greg '86
3123 E Michigan Ave
Phoenix, AZ 85032
LONESKE, Bob '63
28130 Peacock Ridge Rd. #303
Rolling Hills, CA 90274
LONG, Dylan '89
4016 Addison Street
South Bend, IN 46614
LONG, Mark A. '77
7041 Verdure Way
Elk Grove, CA 95624
LONG, Roderick H. '79
10740 North Park Ave N
Seattle, WA 98133
LONNINGE, Lars A. '79
461 W. 24th St.
New York, NY 10011
LOOK, Catherine J. '86
129 Northtown Drive
Blaine, MN 55434
LOOMIS, Julie M. '81
1273 Rich Court
San Luis Obispo, CA 93401
LOPATYNSKI, JESSE V. '76
2099 Elsinore Road
Riverside, CA 92506
LOPEZ, Julie A '88
2334 NW Kearney St. #1
Portland, OR 97210
LORA, Carlos '87
10135 S. W. 115 Crt.
Miami, FL 33176
LORANCE, David W. '75
P.O. Box 762
Loomis, CA 95650

LORD, Suzanne '88
191 Fells Rd.
Essex Fells, NJ 07021

LORENZ, Gregory L. '90
11911 Weddington St 209
N. Hollywood, CA 916070

LORENZ, William J '73
R R 1, Box 500
Richmond, VT 05477

LORFING, Greg M. '83
1900 W. Alabama
Houston, TX 77098

LOTH, Lawrence '58
1752 25th Ave. So.
Clinton, IA 52732

LOTT, Laurie Ann '81
200 Virginia St 6
El Segundo, CA 90245-3612

LOUGHREN, Cynthia Ann '79
3460 Live Oak Road
Santa Ynez, CA 93460

LOUNSBURY, Thomas M. '86
148 San Marcos Trout Club
Santa Barbara, CA 93105

LOVE, Russell A. '78
1414 Calle Cecelia
San Dimas, CA 91773

LOVELACE, Tracey A. '86
444 North 32nd Street West
Bradenton, FL 34205

LOVELL, Craig I. '80
41 Laurel Drive
Carmel Valley, CA 92924

LOVETT, Brian R. '86
13823 Southwest 84Th Street
Miami, FL 33183

LOWE, Edmund C. '80
11616 Seila Beach Drive SW
Seattle, WA 98146

LOWE, Robert H. '90
6119 Manzanillo Dr
Goleta, CA 93117

LOWENTHAL, James B. '84
3720 Eureka Drive
Studio City, CA 91604

LUCAS, Pamela A. '89
4101 Tennyson Rd
University Park, MD 20782

LUCE, Alvah C. '71
P.O. Box 55
Brunswick, ME 04011

LUCKOW, Fred '74
1650 168th Ave. N. E.
Bellevue, WA 98008

LUEDERS, Eric A. '84
624 East Haley Street
Santa Barbara, CA 93103

LUKE, John J. '82
1500 West Pine Street
Appleton, WI 54914

LUKE, Keely L '88
P.O. Box 4122
Kaneohe, HI 96744

LUNA, ANTHONY C. '82
19805 Valley View Drive
Topanga, CA 90290

LUND, Nils '87
Konglefaret 29B
1343 Eiksmarka Oslo, Norway

LUNDGREN DE MIRANDA, Arthur '78
Rua Rainha Guilhermina 70/101
Rio De Janeiro, 20000, Brazil

LUNDSTROM, Nils O. '87
Hagerstensvagen 129
126 48 Hagersten, Sweden

LUNG, Arone H '87
8 FL. Sec.2, 57-2 Chung Ching
S Rd Taipei Taiwan, Rep Of China

LUSSIER, Michael J. '89
23 Cedar Drive
Granby, MA 01033

LUSSO LONG, Carol '71
P.O. Box 5045
Page, AZ 86040

LUXMOORE, Carolyn '85
13028 45th Ave. North
Plymouth, MN 55442

LYNAUGH, Kathy '88
26 New Hampshire Ave.
Long Island, NY 11758

LYNCH, Warren '69
3501 Ramblin Creek
Louisville, KY 40299

LYNGHOLM, Alan C. '71
1520-B Richmond Road
Ridgecrest, CA 93555

– M –

MAAS, Curtiss W. '79
6530 N.W. 48th St.
Johnston, IA 50131

MAC ALLISTER, Keith '61
2845 Moorpark Ave. #206
San Jose, CA 95128

MAC COLLUM, William V. '85
1515 Hummingbird Ln.
Sierra Vista, AZ 85635

MAC CULLEN, Mark S. '78
3531 Gaviota Ave.
Long Beach, CA 90807

MAC DONALD, Bob '56
311 Belmont Drive
Romeoville, IL 60441

MAC DONALD, Dennis '82
1335 N Orange Dr
Hollywood, CA 900287507

MAC DONALD, Donald J. '48
15711 W. Telegraph #J73
Santa Paula, CA 93060

MAC DONALD, Mark L. '85
229 Siesta
Thousand Oaks, CA 91360

MAC DONALD, Ronald P. '88
5305 Highland Ave
Yorba Linda, CA 92686

MAC INNES, James '51
221 N. 64th Ave. W.
Duluth, MN 55800

MAC VICAR, Norman '56
8027 Aberdeen Rd.
Bethseda, MD 20814

MACARI, JAMES D. '77
201 W Montecito Street B
Santa Barbara, CA 93101

MACAULEY, Gerald '70
1268 North Laurel
Upland, CA 91786

MACHADO, Ignacio '90
Plaza San Juan De La Cruz 8
Madrid, 28003, Spain

MACHO, John E. '72
P.O. Box 675
Arnold, CA 95223

MACK, Karyn S. '85
811 Bernard St.
Alexandria, VA 22314

MADATIC, Ted '77
201 Darley Dr.
La Plata, MD 20646

MADDEN-WOOD, Lisa G. '86
303 St. Francis
Kennett, MO 63857

MADDOX, Michael R. '75
1416 West Cuyler
Chicago, IL 60613

MADER, Rich '87
7005 Lanewood Ave. #210
Hollywood, CA 90028

MADRID, Najib George '78
Av. Aragua #100 Campo
Venezuela, South America

MAES, Manuel '79
3205 Claremont
Albuquerque, NM 87107

MAGDALENO, Karen K '88
821 Traction Ave 105
Los Angeles, CA 90013

MAGEE, Robert R. '54
2450 W. 3956 South
West Valley, UT 84119

MAGGI, Julie M. '84
P O Box 549g Street
Fulton, CA 95439

MAGURANY, Joseph E. '50
324 Acton Ave.
Woodriver, IL 62095

MAHER, James C. '80
1411 Chino Street
Santa Barbara, CA 93101

MAHONEY, James R. '85
346 So. Montezuma
Prescott, AR 86301

MAJOCCHI, Nicola S. '87
96 10 Continental Avenue
Forest Hill, NY 11375

MAKEPEACE, Marilyn A. '83
955 Garcia Road
Santa Barbara, CA 93103

MAKI, Yoshimasa '66
375 Higashiyoko Mach
Suzaka City Nacano, Japan

MALAN, Julie A. '87
1674 NW 4th Street
Bend, OR 97701

MALDONADO JR., Rafael '75
6781 Sueno Rd.
Isla Vista, CA 93117

MALLAN, Osmer '50
6224 Luckey John Rd
Paradise, CA 95969

MALLETT, Ian P. '85
18 Overland Rd
Swansea, Great Britain

MALLOY, Brian S. '81
6511 W. State St.
Wauwatosa, WI 53213

MALLOY, Robert M. '88
339 W. 8Th Street
West Wyoming, PA 18644

MALONE, Mary '80
201 Stanford St.
Palo Alto, CA 94306

MALONE, Stanley R. '86
735 N. Sycamore Ave. #11
Los Angeles, CA 90038

MALONE, Steve '72
4961 Foothill Road
Carpinteria, CA 93013

MALONEY, John '80
6149 Anita Drive
Dallas, TX 75214

MALOVICH, Pat '74
3531 Cherryblossom Lane
Lake Elsinor, CA 92330

MALOY, Marcy '82
3435 Army St. #326
San Francisco, CA 94110

MANCHESTER, Scott '81
P.O. Box 675
Arnold, CA 95223

MANDESE, Vince '52
429 N. Milpas St.
Santa Barbara, CA 93103

MANKOFSKY, Isidore '57
1734 N. Orange Grove Ave.
Los Angeles, CA 90046

MANLY III, Charles F. '89
229 W. Danner "E"
W. Memphis, AR 72301

MANN, L. Paul '80
P.O. Box 149
Carpinteria, CA 93013

MANNING, Roy F. '88
8423 N Hull Drive 1222
Kansas City, MO 64154

MANNO, Paul '51
311 W. Valerio St.
Santa Barbara, CA 93103

MANTECON, Scott B. '90
25241 Via Piedra Bianca
Laguna Niguel, CA 92677

MANTLO, Kenneth '86
27598 Elder View Drive
Valencia, CA 91355

MARAIST, Bryant D. '90
5655 Eastex Freeway
Beaumont, TX 77706

MARC, Julian '88
459 Estate Drive
Tulare, CA 93274

MARCHIONE, Nicholas '79
1208 Primrose Ct.
Lompoc, CA 93436

MARCUS, Kimberly '87
14 Mount Vernon Circle
Livingston, NJ 07039

MAREK, Vern '50
P.O. Box 518
Toledo, WA 98591

MARINELLI, Lawrence '90
3512 Alma Ave.
Manhattan Beach, CA 90266

MARK, Brian '83
1601 South Washington Street
Denver, CO 80210

MARKOWSKI, Leon Francis '68
8 Keith Street
Turner Falls, MA 01375

MARKUSSON, Sigthor '90
425 S Salinas St 2
Santa Barbara, CA 93103

MARLER, Daniel '90
6756 NE Twin Spits Rd
Hansville, WA 98340

MAROTT, Frank '87
5333 N. Mac Arthur Blvd. #1108
Irving, TX 75038

MARQUEZ, Elias '76
3587 Ruffin Rd 118
San Diego, CA 92123-8556

MARRA, Ben '72
310 1st Ave. South
Seattle, WA 98104

MARRIOTT, John '74
1830 Mcallister Street
San Francisco, CA 94115

MARRS, Ira '49
8235 Frontier Lane
Brentwood, TN 37027

MARSALL, Jacqueline '73
11349 Hannum Ave.
Culver City, CA 90230

MARSHALL, Glenn H. '86
5480 Aurora Drive 13
Ventura, CA 93003

MARSHALL, Gregory A. '66
5779 Haleola Street
Honolulu, HI 96821

MARSHALL, James W. '80
382 North 1st Avenue
Phoenix, AZ 85003

MARSHALL, Roger '66
8338 A. Comanche, N.E.
Albuquerque, NM 87110

MARSHALL-EDNEY, Robin E '88
67 Molino Ave.
Mill Valley, CA 94941

MART, Loren '72
2044 Rose Hill Road
Carrollton, TX 75007

MARTIN, Anderson '70
9335 Madison Ave.
La Mesa, CA 92041

MARTIN, Bill '51
3445 Peachtree Rd. N. E.
Atlanta, GA 30326

MARTIN, Donald W. '83
1508 Duke Drive
Bakersfield, CA 93305

MARTIN, Jill '87
P.O. Box 969
Rancho Santa Fe, CA 92067

MARTIN, Maryska '81
2033 N. Hobart Blvd.
Los Feliz, CA 90027

MARTIN, Sherry Kay '89
12265 S.W. 72nd
Tigard, OR 97223

MARTIN, William L. '79
8602 East Rancho Vista Drive
Scottsdale, AZ 85253

MARTINEZ, Adriana '86
4433 Sunrise Avenue
Las Vegas, NV 89110

MARTINEZ, Joseph '73
201 Spence Ave.
Milpitas, CA 95035

MARTINEZ, Joseph '89
1535 Armacost Ave. #4
Los Angeles, CA 90025

MARTINEZ, Laura A. '90
3206 North 15th
Tacoma, WA 98416

MARTINEZ, Richard '79
1020 N. 10th St.
Colton, CA 92324

MARTINI, Juliet T. '76
Floriansmuehlstr. 6
Muenchen 45, D 8000, West Germany

MARVIN, Edward L. '80
9402 Burlington Lane
Highlands Ranch, CO 80126

MASASSO, Anthony W. '79
1667 N. Mountain Ave. #120
Upland, CA 91786

MASHO, William E. '79
2808 Manhattan Ave.
Manhattan Beach, CA 90266

MASON, DONALD C. '79
4700 Easton Dr., Suite 31
Bakersfield, CA 93309

MASON, Stephen R. '85
P.O. Box 856
Ketchum, ID 83340

MASON, Thomas J. '88
1731 U Street NW
Washington, DC 20009

MASTEN, William N. '71
4010 Canyon Dell
Altadena, CA 91001

MASTERSON, Vance '82
359 Corte Maria
Chula Vista, CA 92010

MASTRES, Tony J. '90
3573 Ridge Road
Oceanside, CA 92056

MATCHINSKE, Steven G. '88
11717 Sorrento Valley Rd.
San Diego, CA 92121

MATHEW, Craig T. '83
5865 Larboard Lane
Agoura Hills, CA 91301

MATHEWS, Mat '68
300 Lindsay
Gainesville, TX 76240

MATHEWS, William '86
1723 Loma Street
Santa Barbara, CA 93103

MATHIESEN, Tim '70
15471 Columbia Ln.
Huntington Beach, CA 92647

MATIS JR., Alan J. '90
22412 Sentar Road
Woodland Hills, CA 91364

MATOS, MIGUEL A. '83
1319 Kalakaua Ave 4
Honolulu, HI 96826

MATSUDA, Paul J. '78
920 Natoma St.
San Francisco, CA 94103

MATSUMOTO, Motoaki '86
7245 Hillside Avenue #112
Hollywood, CA 90046

MATSUMOTO, Richard '86
3469 Maona Street
Lihue, HI 96766

MATTESON, Robert '53
1118 Thornbush Circle N.
Arlington, TX 76013

MATTHEUS, David L '85
467 Paseo Mira Mar
Pacific Palisades, CA 90272

MATTHEWS, Tony T '89
89 Indian Head Rd
Riverside, CT 06878

MATTIE, Gary C. '79
122 Carlton Ave.
Marlton, NJ 08053

MATTINGLY, Roger R. '76
944 Shady Tree Lane
Chicago, IL 60090

MATTIVI, Mark T. '90
320 Santa Cruz
Santa Barbara, CA 93109

MATZDORFF, Michael G. '90
1308 Factory Pl 50
Los Angeles, CA 90013

MAVES, D. Roger '75
9217 Lamar Street
Westminster, CO 80030

MAXTONE-GRAHAM, Ian '83
117 W. 78Th
New York, NY N 9

MAY, Jeffery F. '81
676 Pismo
San Luis Obispo, CA 93401

MAY, R. Douglas '81
1719 Camino De La Costa
Redondo Beach, CA 90277

MAY, Robert J. '78
1838 Queens Drive
Longmont, CO 80501

MAYER, Dennis '75
1129 "A" Folsom
San Francisco, CA 94103

MAYES, Terrence '71
1625 Browning Drive
Arlington, TX 76010

MAYNARD, Bruce '74
111 W Main St
Visalia, CA 93291

MC ADAMS, Beth M. '89
9632 Paseo Montril St.
San Diego, CA 92129

MC ALISTER, Steve G. '80
710 Williams Way
Richardson, TX 75080

MC BRIDE III, Paul A. '89
19027 S. E. May Valley Rd.
Issaquah, WA 98027

MC BRIDE, Jacqueline '82
22484 Queen Street
Castro Valley, CA 94546

MC BRIDE, Michael '82
6500 Yosemite Road
Bakersfield, CA 93309

MC BRIDE-KELLER, Rebecca '79
933 Jessica
Ridgecrest, CA 93555

MC CABE, Serge '83
14940 S W 109th Ave
Tigard, OR 97224-3677

MC CALL, Basil '53
1206 Atkins
Visalia, CA 93277

MC CALLUM, Bruce '76
925 West Fairfield Circle
Fox Point, WI 53217

MC CARTY, George W. '73
1609 N. 18th St.
Monroe, LA 71201

MC CAUL, George '81
720 Aegean Drive
Lafayette, CO 80026

MC CAULEY, Robert L. '76
1240 Dana Drive., Apt 14
Fairfield, CA 94533

MC CLELLAN, Robert L. '72
5926 Via Real #4
Carpinteria, CA 93013

MC CONN, David A. '88
119 Washington Apt 3
Hoboken, NJ 07030

MC CORMICK, Bret A. '80
2741 Ryan Avenue
Fort Worth, TX 76110

MC COY, Constance '75
Lucia Lodge
Big Sur, CA 93920

MC COY, H. Patrick '76
3710 Briarwood Drive
Catlettsburg, KY 41129

MC CRACKEN, James A. '84
320 Margaret Avenue
Baltimore, MA 21221

MC CREERY, Scott H '88
250 Bradley
Morro Bay, CA 93442

MC CROREY, Larry '80
2119 Tulane
Long Beach, CA 90815

MC CULLOCH, William N. '86
269 E. Boston #1
Seattle, WA 98102

MC CULLOUGH, George '82
960 Fountain Avenue
Monterey, CA 93940

MC CULLUM, Dawn L. '90
2100 N Beachwood Drive 407
Los Angeles, CA 90068

MC CURLEY, Budd K. '52
5102 Sutton Pl.
Alexandria, VA 22304

MC DONALD, Gregorio '83
P. O. Box 1392
Cypress, CA 90630-6392

MC DONOUGH, Molly '90
903 West Pedregosa St.
Santa Barbara, CA 93101

MC ELROY, Jerry '77
204 W. Williams Sup. Rte.
Louisville, CO 80027

MC ELROY, Rod H. '77
P.O. Box 14118
Arlington, TX 76094

MC FADZEN-MARKS, Annette L. '80
419 Pacific Terr.
Klamath Falls, OR 97601

MC GARRAH, Daniel '82
18 Stetson Street
Greenbrae, CA 94904

MC GINNIS, Michael G. '81
442 Union Street South
Concord, NC 28025

MC GLOTHEN, Steven R. '73
P.O. Box 1002
Pacific Palisades, CA 90272

MC GRAIL, John A. '76
6576 Senator Ln.
Bensalem, PA 19020

MC GRAW, Robert D. '79
1799 S.E. 17th Street
Fort Lauderdale, FL 33316-3000

MC GREGOR, Lauren E. '83
13018 Kimberley Lane
Houston, TX 77079

MC GUIRE, Mike '65
934 Calle Collado
Thousand Oaks, CA 91360

MC GUIRE, Shauna K. '80
14024 Mint Trail
San Antonio, TX 78232

MC INTOSH, Robert W. '56
1215 Elmwood
Wilmette, IL 60091

MC INTYRE, Wayne (Gerry) '80
3385 Lanatt Way # B
Sacramento, CA 95819

MC KAIN, John M. '84
2501 Regan
Boise, ID 83702

MC KEE, David E. '81
1934 Rambline Ridge Lane
Carrollton, TX 75007

MC KEE, David William '90
1833 Castillo St
Santa Barbara, CA 93101

MC KEE, Michael '74
4727 Holly Lake Dr.
Lake Worth, FL 33463

MC KEETA, Regis J. '62
R. D. #4, Box #41
Finleyville, PA 15332

MC KEMY, Lee '71
2900 Live Oak Ave.
Fullerton, CA 92635

MC KENNEY, Herb '59
P.O. Box 42235
San Francisco, CA 94142

MC KINLEY, Richard S. '79
791 Pine Bay Ave.
Holland, MI 49424

MC KINSEY, Brian '76
976 Greenwood Crt
Sanibel, FL 33957

MC KNIGHT, H. Morris '82
P.O. Box 221
Lewisville, NC 27023

MC LAIN, Stephen T. '71
110 Dorothy Ln.
Troy, OH 45372

MC LAREN, Julie K. '90
320 Mesa Ln.
Santa Barbara, CA 93109

MC LAUGHLIN, DOUG '72
406 W. 34th St., Suite 802
Kansas City, MO 64111

MC LAURY, Virginia '89
1 Maritime Plaza Suite 1300
San Francisco, CA 94111

MC LEAN, Steven D. '89
9293 Hightop Terrace
Lakeside, AZ 12040

MC LEOD, Robert '75
895 Flower Street
Lakewood, CO 80215

MC MANUS, Kelly M. '80
165 Alderbrook Drive
Santa Rosa, CA 95401

MC MILLAN, Cathy T. '82
4064 25th St.
San Francisco, CA 94114

MC MULLEN, Andrew
'73621 S. Spring St., Ste 507
Los Angeles, CA 90014

MC NALLY, John '76
6540 S.W. 178th Place
Aloha, OR 97007

MC NALLY, Kevin '78
4020 Lusk Drive
Sacramento, CA 95825

MC NAMARA, Wendy '80
1355 Columbia
Glendale, CA 91205

MC NEIL, Larry C. '78
71 Witching Hour Crt.
Citrus Heights, CA 95621

MC NEILL, Diana J. '90
18320 Clifftop Way
Malibu, CA 90265

MC TAVISH, Fiona M. '85
33 Millstone Rdd #2
Madison, WI 53717

MC VEY, Richard '62
2428 15th Ave.
San Francisco, CA 94116

MC WILLIAMS, Douglas M. '60
430 Spruce St.
Berkeley, CA 94708

MC WILLIAMS, Ted '59
P.O. Box 2507 MZ 4-37
Pomona, CA 91769

MCNIEL, Samuel L. '87
1626 North 30th Street
Fort Dodge, IA 50501

MCPHIE, JEFF '76
214 Carnegie Center #206
Princeton, NJ 08540

MDRIS, El Sayed A. R. '63
P.O. Box 1617
Khartown, Sudan

MEAD, Michael G '86
133 E. De La Guerra 410
Santa Barbara, CA 93101

MEADE, H. Randolph '76
3702 Christian
San Diego, CA 92117

MEADE, Kenneth W. '75
P.O. Box 387
Hillsboro, IL 62049

MEADOR, Steve '82
985 S. E. Alexander Ave.
Corvallis, OR 97333

MEAGHER, Michael E. '86
4532 East Colorado Ave.
Las Vegas, NV 89104

MEANS, Laura L. '87
950 Escondido Court
Alamo, CA 94507

MEE, John '71
3153 Carly Way
Sacramento, CA 95816

MEHLMAN, Mara A. '78
2940 Terraza Place
Placentia, CA 92631

MEHLMAN, Marla '78
2940 Terraza Pl.
Fullerton, CA 92631

MEINHOLD, Thomas L. '87
468 Westmont
San Luis Obispo, CA 93401

MEISS, Lou '67
16415 Armstead Street
Granada Hills, CA 91344

MELARA, Joseph E. '84
8025 N. W. Everton St.
Kansas City, MO 64152

MELBY, Orville '49
1356 Dakota Court
Friendship, WI 53934

MELLOR, Kenneth W. '78
P.O. Box 1400
Springfield, OR 97477

MELTZER, Andrea C. '82
11415 Chatten Way
Houston, TX 77024

MELUSO, Louis '83
17985 Pacific Coast Hwy
Malibu, CA 90265

MENDOZA, Douglas M. '86
320 West Mission St. #3
Santa Barbara, CA 93101

MENTOR, James O. '90
1533 A Fifth Street
Oakland, CA 94607

MERCER, Joseph '74
P.O. Box 2324
Globe, AZ 85502

MERCIER, Allan G. '76
622 E Bidwell St
Folson, CA 95630-3121

MEREDITH, Diane '86
6203 Westcott St
Houston, TX 77007-2036

MERRIFIELD, Douglas C. '75
324 16th Street
Manhattan Beach, CA 90266

MERRITT, Charlene '82
1001 Portola Road
Ventura, CA 93003

MERRITT, S. Lewis (Mike) '47
900 Calle De Los Amigos 3110L
Santa Barbara, CA 93105

MERRYWEATHER, John D. '85
5300 Foxcreek Road
Pacific, MO 63069

MESA, Scott A. '87
14733 Cole Drive
San Jose, CA 95125

METHOD, Douglas J. '86
1315 San Miguel
Santa Barbara, CA 93103

METYKO, James H. '83
50 East Broad Oaks
Houston, TX 77056

MEVORACH, Natan '83
8340 Harding #203
Miami Beach, FL 33141

MEYER, Barry J. '79
4103 N Belt St
Spokane, WA 99205-1435

MEYER, Daniel '75
713 Page St.
Lindsay, CA 93247

MEYER, PAUL R. '81
27B E Arrellaga
Santa Barbara, CA 93101

MICHELOTTI, Robert '49
1537 E. Sierra
Fresno, CA 93726

MICHELS, Robert J. '79
4104 85th Ave S.E.
Mercer Island, WA 98040

MIDDLETON, Gordon '73
9615 Palm Beach Lane
San Diego, CA 92129
MIDDLETON, Melani L. '83
203 N., 36th Street
Colorado Springs, CO 80904
MIDDLETON, Wiley J. '84
225 East 10Th
Leadville, CO 80461
MIDGETTE, Danielle '88
17200 Burbank Blvd 363
Encino, CA 91316
MIER, James F. '76
9785 Elm Dr.
Carmel, IN 46032
MILAM, Kay '87
624 Baxter
Louisville, KY 40204
MILANI, Farimah '87
33 Pond Ave 1224
Brookline, MA 02146
MILBURN, David L. '82
P.O. Box 13084
Atlanta, GA 30324
MILES, W. SCOTT '82
14 Mill Stream Rd.
Stamford, CT 06903
MILIGAN, Thomas E. '81
308 N. Rossmore #31
Los Angeles, CA 90004
MILLENER, Richard A. '76
40116 Highland Road
Big Bear Lake, CA 92315
MILLER, Bruce A. '83
1422 North 31
Milwaukee, WI 53208
MILLER, Daniel D. '48
P.O. Box 4203
Bakersfield, CA 93387
MILLER, Daniel Leo '87
5229 South Clovis Ave.
Fresno, CA 93725
MILLER, Eugene C. '74
2826 North Jamison
Flagstaff, AZ 85001
MILLER, H. Brookings '81
345 No. Dickson
Warson Woods, MO 63122
MILLER, John '73
7771 E. Valley Vista
Scottsdale, AZ 85253
MILLER, Karen L. '81
312 Venice Way
Venice, CA 90291
MILLER, Kenneth J. '61
853 Clark Rd.
Santa Barbara, CA 93110
MILLER, Kevin E. '75
4185 Arch Dr. #106
Studio City, CA 91604
MILLER, Kevin J. '90
5737 Vanessa Court
Woodland Hills, CA 91367
MILLER, Lawrence '76
8252 Ammons Circle
Arvada, CO 80005
MILLER, R. Wayne '84
2325 Westmoreland Dr.
San Jose, CA 95124
MILLER, Scott '80
5517 Oakwood Cv 3
Austin, TX 78731
MILLER, Vern '60
438 Loma Alta
Santa Barbara, CA 93109
MILLER, William S. '73
2325 Westmoreland
San Jose, CA 95124
MILLER-ARZAMENDI, Janet E. '83
903 Elliot Pl.
Lodi, CA 95240
MILLIKEN, BRADLEY B. '82
3341 Bryant Streeet
Palo Alto, CA 94306
MILLINGTON, Carl '51
38-252 Charlesworth Wy
Cathedral City, CA 92234
MILLS, David '87
16 Masters Circle
Little Rock, AR 72212
MILLS, Jack '73
8225 Glenwood Ave.
Oklahoma City, OK 73114
MILLS, Nathan H '86
Pine Point Road
Bryant Pond, ME 04219
MIMS, Allen '79
1802 Harbert Ave.
Memphis, TN 38104
MINEAU, William J. '75
8921 National Blvd.
Los Angeles, CA 90034
MINIGHAN, David P. '82
4915 Crossbow Dr.
Roanoke, VA 24014
MINNOCK, Marion P. '77
116 Federal Street, #310
Pittsburgh, PA 15212
MINTZ, Ira S. '81
P.O. Box 93577
Los Angeles, CA 90093
MIRABELLI, Manrico '88
2022 San Juan Rd. #246
Sacramento, CA 95833
MIRAGLIA, Joseph J. '72
108 S. 4th Street
Yakima, WA 98901
MISHIMA, Thomas E. '88
178 North Cresent Drive, #5
Beverly Hills, CA 90210
MISSERIAN, David '86
39975 Cedar Blvd, #330
Newark, CA 94560
MISTROT, Christopher L. '90
2415 N. Franklin
Colorado Springs, CO 80907
MITCHELL, Cameron '82
1616 N. Fuller Ave. #329
Hollywood, CA 90046

MITCHELL, Daniel P. '86
36 Coventry Lane
Laguna Hills, CA 92656
MITCHELL, Donald M. '80
490 Higos Way
Nipomo, CA 93444
MITCHELL, John B. '66
P.O. Box 4966
Cleveland, TN 37311
MITCHELL, Joseph R. '76
P.O. Box F
Stockton, MO 65785
MITCHELL, Josh '76
1932 Weepah Way
Hollywood, CA 90046
MITCHELL, Linda S. '89
P.O. Box 143111
Anchorage, AK 99514
MITCHELL, Michael P. '78
530 East Iris Drive
Nashville, TN 37204
MITCHELL, Michael W. '80
6012 Monticilla Circle
Ocean Springs, MS 39564
MITZENMACHER, Patricia A. '86
1134 East Caroline Court
Ontario, CA 91764
MOCHIZUKI, Dan '86
5721 Vineyard Ave.
Oxnard, CA 93030
MODDELMOG, Emily J. '89
1800 Midlothian Drive
Altadena, CA 91001
MOE-NILSSEN, Leif '75
Vinjesgt 5
5000 Bergen, Norway
MOERMAN, Chris '88
7608 Mason Ave 3
Canoga Park, CA 91306
MOFFAT, Ronald '72
63 Meadowbrook Road
Brick, NJ 08723
MOHAMED, Iqbal '87
5/2-3, Benson Cross Road
Benson Tn Banagalor, 560 046, India
MOLE, Craig R. '78
55 Red Rock Way 0 207
San Francisco, CA 94131
MOLLATH, Brad '78
1920 Rockford Avenue
Modesto, CA 95351
MOLNAR, RAND '77
914 W. Anapamu
Santa Barbara, CA 93101
MOLSICK, Lisa J. '81
575 Lorraine Avenue
Santa Barbara, CA 93110
MONAHAN, William '59
673 Via Ondulando
Ventura, CA 93003
MONEY, Catherine E. '83
515 Meadowlawn
Mentor, OH 44060
MONIAN, William '62
3950 Maricopa Dr.
Santa Barbara, CA 93110
MONIE, Allan '77
443 Pine Ridge Rd
Glide, OR 97443
MONNAT, Nanci A. '78
5218 Plaza Lane
Wichita, KS 67208
MONSOUR JR., Victor '77
516 Ashland
Lake Charles, LA 70605
MONTALBANO, Michelle D. '90
Cabin 39 San Marcos Trout Club
Santa Barbara, CA 93105
MONTELONGO, John E. '79
2113 Webster
Sanger, CA 93657
MONTES DE OCA, Arthur '72
4302 Melrose Avenue
Los Angeles, CA 90029
MONTGOMERY, Michael R. '89
1550 Fillmore 307
San Francisco, CA 94115
MONTOYA, Priscilla Y. '83
1601 S. Washington
Denver, CO 80210
MOODY, Alan F. '71
11 Janice Ln.
N. Attleboro, MA 02760
MOODY, Dana L. '83
15107 Burton St.
Panorama City, CA 91402
MOONEY, Gail A. '75
87 Willow Avenue
N. Plainfield, NJ 07060
MOORE, Carl '64
198 Silvera Street
Milpitas, CA 95035
MOORE, Joe L. '69
619-62nd St
Oakland, CA 94609
MOORE, John J. '60
38 Hazelwood Avenue
Morden Surrey, England
MOORE, John S. '90
9230 Rock Oak Ln
Fair Oaks, CA 95628
MOORE, Michael '64
198 Skyline Drive #78
Thousand Oaks, CA 91360
MOORE, Robert '80
105 Ellingwood Drive
Rochester, NY 14618
MOORE, Ronald '72
2405 Elm Ave.
Manhattan Beach, CA 90266
MOORE, William '73
6108 Blake Ridge Rd.
Edina, MN 55436
MORDECAI, Dean '66
7055 Lennox Ave. #8
Van Nuys, CA 91405
MORDUCHOWICZ, Daniel '85
600 Moulton Avenue #203
Los Angeles, CA 90031

MORE, Arthur R. '63
2847 S.W. Chickaree Place
Loveland, CO 80537
MORETT, Lauren J. '76
226 E. Main Street
Huntington, NY 11743
MORGAN JR., S. Shane '90
2244 N Geyer Rd
St. Louis, MO 63131
MORGAN, Christian '85
31 Crits-De-Champel
1206 Geneve, Switzerland
MORGAN, Gwen E. '85
65 Havenwood
Irvine, CA 92714
MORGAN, James '49
5006 Alan Court
Carmichael, CA 95605
MORGAN, Michael P. '78
23421 Red Robin Lake
El Toro, CA 92630
MORI, Frank '48
1206 Harbor Hills Drive
Santa Barbara, CA 93109
MORI, Kazutoshi '90
2-16-16 Hishiichinoe, Edoganao-K
Tokyo, Japan
MORIARTY, Thomas J. '81
450 South Dearborn Ave #B
Kankakee, IL 60901
MORNEAU, Jerry '86
6750 Hawaii Kai Drive
Honolulu, HI 96825
MORNEAU, Robert F. '77
275 Santa Ana Court
Sunnyvale, CA 94086
MORREAL, Mary Lou '82
7956 Laurelridge Road
San Diego, CA 92120
MORRIS, Brian C. '87
4329 S.E. 3rd Street
Renton, WA 98059
MORRIS, DAVID M. '75
1821 N.E. Diablo Way
Bend, OR 97701
MORRIS, Mark W. '86
11226 N E 68th St E
Kirkland, WA 98033-7181
MORRIS, Matilda '89
226 Calle Manzanita
Santa Barbara, CA 93105
MORRISON, Betsy J. '87
1495A Loma Dr.
Ojai, CA 93023
MORRISSEAU, William '71
P.O. Box 113
Bridgton, ME 04009
MORRISSEY, Wesley O. '77
16252 E. Construction Cir.
Irvine, CA 92714
MORSE, Anita '82
15 Milton Street
Fairfield, CT 06430
MORSE, Thomas '69
2783 Ben Lomond Drive
Santa Barbara, CA 93105
MORTON, Jeffrey D. '83
P.O. Box 61
Castaic, CA 91310
MOSELEY, Daniel '70
1364 Vallejo Dr.
Corona, CA 91720
MOSELEY, Lawrence '71
4184 Joan Ave.
Concord, CA 94521
MOSELEY, Sam '71
1505 Sylvan Way
Louisville, KY 40205
MOSHER, Douglas F. '89
407 E. Chestnut
Orange, CA 92667
MOSICHUK, Joseph '69
10310 Jockey Club Drive
Houston, TX 77065
MOSIER, Greg A. '90
P.O. Box 1085
Thousand Oaks, CA 91360
MOSIER, Philip '69
2728 Bridgeford Dr.
Sacramento, CA 95833
MOSKOWITZ, Sheldon G. '78
15057-B Sherman Way
Van Nuys, CA 91405
MOSS, Raymond V. '89
15911 Myrtle Ave
Tustin, CA 92680
MOSTOWITZ, Joshua '78
1550 North Athenian
Wichita, KS 67203
MOTIWALLA, Dadiba '81
P.O. Box 1479, Deira
United Arab Dubai, Emirates
MOTTER, Leon E. '53
1305 N. 6th #1104
Harrisburg, PA 17102
MOTTO, Katherine Umbaugh '71
P.O. Box 639
Glenpool, OK 74033
MOULTON, Steve '81
8820 Wakefield Avenue
Panorama City, CA 91402
MOYERS, Eric
P.O. Box 26800
Albuquerque, NM 87125
MUDGE, Allan W. '62
3481-B Lemon Ave
Long Beach, CA 90807
MUETING, Don W. '52
P.O. Box 228
Bass Lake, CA 93604
MUIRHEAD, Diana '87
49 Seafirth
Tiburon, CA 94920
MULBRY, Matthew W. '80
18156 Daves Ave.
Monte Sereno, CA 95030
MULLER, John '82
636 N Detroit St
Los Angeles, CA 90036-1946

MULVIN, Edward '80
3400 54th Street
Des Moines, IA 50310
MUMAW, Gary W. '77
9869 Candlewood Ct.
Rancho Cucamonga, CA 91730
MUNGER, James '71
800 Pinon Drive #111
Ames, IA 55010
MUNN, Winston B. '75
1321 Lindale
Norman, OK 73069
MUNSON, Dan K '88
403 South Washington
Wheaton, IL 60187
MUNSON, James '49
23721 Walter Avenue
Torrance, CA 90501
MURAKAMI, KEITH H. '86
1136 Capuchino #3
Burlingame, CA 94010
MURASHIMA, Harry '58
1034 West Terrace
Fresno, CA 93705
MURO, Ruben Z. '80
629 South Avenue #60
Los Angeles, CA 90042
MURPHY, David Lee '86
2639 Oak Bend Lane
Dallas, TX 75227
MURPHY, Dennis J. '78
40 West 24th St.
New York, NY 10010-3215
MURPHY, James D. '77
13721 Cullen Street
Whittier, CA 90605
MURPHY, W. Timothy '90
18320 Clifftop Way
Malibu, CA 90265
MURRAY, Carl '74
4105 Federal Avenue
Everett, WA 98203
MURRAY, Charles Michael '78
15431 Redhill, Ste. E
Tustin, CA 92680
MURRAY, Dave H. '80
1916 Church Street
Costa Mesa, CA 92627
MURRAY, James K. '76
3107 Placer Street
Fort Collins, CO 80526
MUSTARD, Robert '86
1323 Amethyst Apt C
Redondo Beach, CA 90277
MYERS, Christine '56
16 Rue Louis
Paris, 75020, France
MYERS, James R. '78
7130 Greenbrook Lane
Dallas, TX 75214
MYERS, Lawrence J. '73
358 Copperfield Lane
Herndon, VA 22070
MYERS, William L. '78
1907 Ardith Drive
Pleasant Hill, CA 94523

— N —

NAB, Adrie '74
3 Parkview Apt. 4
Orono, ME 04473
NACHTIGALL, Kelly '78
1177 E. Shaw #105
Fresno, CA 93710
NAFFIN, Cynthia K. '77
875 Calle Cedro
Thousand Oaks, CA 91360
NAGAMINE JR., Harold '70
275 Moali St.
Kahului Maui, HI 96732
NAHMIAS, Eyal '88
1427 Laguna St 74
Santa Barbara, CA 93101
NAIDEAU, Harold E. '78
139 Oakland Road
Maplewood, NJ 07040
NAKAMICHI, Glenn '78
3400 Mc Call Ave. Ste. #112
Selma, CA 93662
NAKAMOTO, Rodney S. '80
1860 San Juan Hollister Road
San Juan Boutista, CA 95045
NAKAMURA, George '61
875 Jordan Ave.
Los Altos, CA 94022
NAKAO, Yoshihiro '88
54-4 Nihonmatucho Yoshida
Sakyoku Kyoutoshi, 606, Japan
NAKAOKA, Yasuhiro '82
1-18-16 Matubara #101
Setagaya Ku Tokyo, 156, Japan
NANA, Somsak A. '69
96/6 Soi Nuan Noi
Bangkok 10110, Thailand
NANIA, Scott
815 Lowena Dr
Santa Barbara, CA 93103
NASH, Gerald A. '77
11211 W. 108th St.
Overland Park, KS 66210
NASS, Nicholas '71
P.O. Box 129
Park City, UT 84060
NATALE, Carmen J. '85
7 Vultee Drive
Florham Park, NE 07932
NATROP, Jeffrey '79
5840 Lk Sarah Hgts Dr N.W.
Greenfield, MN 55373
NATROP, Jeffrey L. '79
5840 Lake Sarah Heights
Rockford, MN 55373
NAUD, Jean-guy '64
54 Stover Road
Rochester, NY 14624
NAUMAN, Marvin '74
7220 40th St. N.W.
Gig Harbor, WA 98335

NAVASERO, Luz Amandolina C.
 (Mandy) '81
1097 Pasong Tamo, Makati
Manila Metro, Philippines
NAY, Richard K. '75
9046 Leaside Drive
Dallas, TX 75238
NEGRETE, Norma A '88
20069 Grand Ave. A
Santa Barbara, CA 93103-1927
NEGRIN, Ted '81
1305 E. 91st St
Brooklyn, NY 11236-4213
NEIHOUSE, James '76
P.O. Box 905
Cocoa, FL 32923
NELSON, Barbara '69
14833 S.E. Jones Pl.
Renton, WA 98058
NELSON, Dale L. '86
601 North Byrkit
Mishawaka, IN 46544
NELSON, David Paul '83
27417 Goddard Road
Romulus, MI 48174
NELSON, Douglas M. '88
10340 Canoga Av. #104
Beverly Hills, CA 91311
NELSON, John M. '80
P.O. Box 90637
Anchorage, AK 99509
NELSON, John P. '85
117 Spring Valley
Anderson, IN 46011
NELSON, John William '81
Star Route #29
Peach Springs, AZ 86434
NELSON, Matthew T. '90
5733 Bevis
Van Nuys, CA 91411
NELSON, Ramon L. '75
P.O. Box 127
Earlimart, CA 93219
NELSON, Richard A. '75
934 Pitts Ave.
Panama City, FL 32404
NELSON, STEVEN R. '76
R R 2, Box #690
Underwood, MN 56586
NELSON, Thomas J. '87
767 Prospect
Kankakee, IL 60901
NERSVEEN, Joseph R. '88
397 Imperial Way #136
Daly City, CA 94015
NESBIT, Roland '83
3005 Rhodelia Ave
Claremont, CA 91711
NETO, Victorino Oliveira '85
Praia Jose Bonitacio #77 -
Rio De Janeiro, 12J, Brazil
NETTLES, Robert '49
356 Tucker Drive
Charleston, SC 29414
NETZEBAND, Kenneth '75
32812 Sailway
Dana Point, CA 92629
NEWBORN, Bruce J. '80
6445 Ldderer Ave
West Hills, CA 91307
NEWBY, Thomas W. '83
323 27th St.
Manhattan Beach, CA 90266
NEWCOMB, Von S. '89
605 E. Common Wealth Ave.
Alhambra, CA 91801
NEWLIN, Julye G. '89
3819 Bluff Lane
Lake Charles, LA 70605
NEWLIN-ENGLANDER, Maury A. '81
43 Fifth Ave.
New York, NY 10003
NEWMAN, Gregory B. '78
1356 Brampton Road
Pasadena, CA 91105
NEWMAN, Kerry D. '84
1444 Pioneer Way #17
El Cajon, CA 92020
NEWMAN, Michael W. '80
750 N. St. Andrews Pl. #101
Los Angeles, CA 90038
NEWMAN, William T. '83
2 Fairway Lane
Greenwich, CT 06830
NEWPORT, Barbara '66
500 W. Santa Maria Street
Santa Paula, CA 93060
NEWTON, Dwayne '81
1145 Hayes #7
San Francisco, CA 94117
NEWTON, Jennifer E. '88
25411 109th Court SE Q 202
Kent, WA 98031
NEWTON, Jerry L. '75
2237 Thomas Avenue
Santa Cruz, CA 95062
NG, David '90
3231 1/2 Huron St 2
Los Angeles, CA 90065
NG, Kevin '89
1001 Front Street
San Francisco, CA 94111
NG, Lester K. '75
1036 Greenwood Place
Salinas, CA 93901
NG, Ronald '88
214 Pinewood Dr.
Thornhill, Ontario, L4J5R6, Canada
NGUYEN, Nghia '88
1501 North Western Avenue
St. Paul, MN 55117
NIBECKER, Paul '86
7919 Roble Place
Carlsbad, CA 92009
NIBLE, Richard C. '79
200 Queen St
Philadelphia, PA 19147-3319
NICHOLS, Gregory J. '84
208 El Tovar Court
Bakersfield, CA 93309

NICHOLS, Philip S. '80
8033 Sunset Blvd. #587
Los Angeles, CA 90046
NICHOLS, Reed '80
32403 Ortega Hwy.
Lake Elsinor, CA 92330
NICHOLS, Stephen J. '64
P.O. Box 486
Kent, CT 06757
NICHOLSON, Janet C. Mcminn '76
5555 Bell Road
Auburn, CA 95603
NICOLES, Michael A. '85
346 20th Ave.
Bricktown, NJ 08724
NICOLSON, James R.V. '86
Middleback Station
Via Whyalla, 5600, Australia
NIEDOPTALSKI, David '76
1415 E. Union Street
Seattle, WA 98102
NIEMANN, Michael '83
654 New Dorsett
San Jose, CA 95136
NIENSTED, Jerry '69
809 Fairledge
Lake Orion, MI 48035
NIGH-STRELICH, Alison M. '84
234 Stanley Drive
Santa Barbara, CA 93105
NIGHTINGALE, Julie '79
535 Post Road East
Westport, CT 06880
NIKAIDO, Victor '69
P.O. Box 2412
Canoga Park, CA 91306
NIKOLIC, Jovan '86
929 Arbolado Road
Santa Barbara, CA 93103
NILSSON, Phillip D. '85
615 North Myers Street
Burbank, CA 91506
NIPPOLDT, David '86
5182 Avenue 400
Dinuba, CA 93618
NISBETT, Mark F. '76
6435 Channing Circle S.E.
Ada, MI 49301
NIX, Adrian '50
1435 Baywood Dr.
New Haven, IN 46774
NOEL, Albert '71
P.O. Box 755
Lompoc, CA 93438
NOEL, Charles M. '89
P.O. Box 501
Alto, NM 88312
NOFZIGER, Christopher '85
173 Lafayette Street
New York, NY 10013
NOLA, John A. '79
1253 Midland-Beaver Rd
Ohiovlee-Indus, PA 15052
NOLAN, Kelly K '88
1702 Northwood Road
Austin, TX 78703
NOLTE, Stephanie '87
7275 S.W. Benz Park Drive
Portland, OR 97225
NOLTE, Steve '83
2626 Dewitt Street
Irving, TX 75062
NOON, Charles R. '77
6847 Xana Way
Carlsbad, CA 92009
NORDSET, Rebecca '82
2351 Jackson Street, 5
San Francisco, CA 94115
NORDSTROM, Cecilie '87
Kastellhagen 7
Oslo 11, 1170, Norway
NORDSTROM, Helen C. '87
Kastellhagen 7 1176
Oslo II, 1176, Norway
NORMAN, Margaret M. '90
330 A McHenry Rd
Glendale, CA 91206
NORRIS, Mark John '89
1235 S. Alfred St. #2
Los Angeles, CA 90035
NORRIS, Ronald T. '80
2941 Plaza Drive
Fort Wayne, IN 46806
NORTHCUTT, Roy Harrison '86
400-F Woodchase Lane
Marietta, GA 30067
NORTON, Paul '72
4 School Street
Upton, MA 01568
NORWOOD BROWN, Angela M. '89
11162 Camarillo St 402
N. Hollywood, CA 91602
NORWOOD, David S. '76
4 Fairway Drive
Manhattan Beach, CA 90266
NORWOOD, George G. '80
2500 Abaco Ave
Miami, FL 33133
NOWAK, Thomas '89
Star Route Box 293
Albuquerque, NM 87043
NUDING, Pete '62
2423 Old Middlefield Way, #K
Mountain View, CA 94043
NUESS, Joseph H. '82
P.O. Box 863
Medical Lake, WA 99022
NUFER, David '87
405 Montano NE Suite 1
Albuquerque, NM 87107
NUGENT, Jay E. '77
2824 N.W. 55th Avenue
Lauderhill, FL 33313
NUGENT, Michael B. '89
2928 Kings Rd 221
Dallas, TX 752191259
NUTLEY, Timothy '90
5939 Riverside Drive
Redding, CA 96001

NYLANDER, Simo J. '77
1503 North Mc Clelland
Santa Maria, CA 93454

– O –

O'BRIEN, George "O.B." '79
3532 West Peralta
Fresno, CA 93722

O'BRIEN, Steve '84
4387 Laclede Ave.
St. Louis, MO 63108

O'BRIEN-BELL, Catharine '84
21 E. 5th Ave.
Vancouver, BC V5T 1G7, Canada

O'BRIEN-MISSERIAN, Sarah D. '87
39975 Cedar Blvd #330
Newark, CA 94560

O'CONNOR-FITZGERALD,
Kathryn '86
433 1/8 Iris Avenue
Corona del Mar, CA 92625

O'DONOVAN, Robert D. '79
13560 S.W. 9th Court
Fort Lauderdale, FL 33325

O'KEEFFE, James W. '80
1033 North Mentor Ave
Pasadena, CA 91104

O'LEARY, Cindra '85
300 Lincoln Way #3
Auburn, CA 95603

O'NEIL (KELLY), CATHARINE
FRATT '82
1317 O St. NE
Auburn, WA 89002

O'NEIL, Jay '86
14 King Road
Middletown, RI 02840

O'REILLY, Kathleen '80
6240 Auckland Ave.
N. Hollywood, CA 91606

O'SHOCK, Curtis C. '89
1319 Bath St. #6
Santa Barbara, CA 93101

O'TOOLE, Michael J. '86
3465 White Oak School Road
Eureka, MO 63025

OBENCHAIN, Edith E. '89
14102 Jankowski Rd
Woodstock, IL 60098

OBRIG, Timothy G. '81
80 Rambling Ln. #37-B
Battle Creek, MI 49015

OCANA, Teresa '83
17150 Newhope Suite 601
Fountain Valley, CA 92708

ODERMAN, Dawn R. '90
1155 S E 52nd
Portland, OR 97215

ODETT, Carolyn R. '80
1165 East Vallectio Road
Carpinteria, CA 93013

ODGERS, Kristen Gray '86
902 Manhattan Ave. "B"
Hermosa Beach, CA 90254

ODLE, Patrice '86
7 Mc Kevett Heights Rd.
Santa Paula, CA 93060

OGILVIE, John B. '86
10643 Hardisty Drive
Edmonton Alberta, T6A3T9, Canada

OH, Hyoung Kewn '88
136-46 Itaewon
Yongsangu Seoul, Korea

OHLGREN, Brent '70
2027 17th Street
Forest Grove, OR 97116

OHLSON, Brian '72
P.O. Box 272
Conway, NH 03818

OKAMOTO, Noboru '86
1-8-27 Yamamoto-Cyo
Yao Osaka, 581, Japan

OKAZAKI, Cary A. '85
6826 1/2 Camrose Drive #1
Los Angeles, CA 90068

OKUDA, Mariko '88
101-1 Takaoka-Cyo
Matuyama Ehime, 791, Japan

OLAFSDOTTIR, Sigridur '90
Aland 11
Reykjavik, Iceland

OLESON, J. Chris '79
2481 North 1050 West
Layton, UT 84041

OLIVER, David M. '75
6550 Lexington Drive #33
Beaumont, TX 77706

OLLIS, Donald '47
622 Colfax Court
Goleta, CA 93117

OLSEN, David R. '88
2312 E. Avalon
Santa Ana, CA 92701

OLSEN, Paul D. '80
9319 N Joyce Ave
Milwaukee, WI 53224

OLSEN, Trond '89
412 Grand Blvd. #2
Venice, CA 90291

OLSON, Gerald '68
3601 11th Avenue North
Grand Forks, ND 58201

OLSON, Jon Raymond '76
5904 Camray Circle
Carmichael, CA 95608

OLSON, Kenneth L. '71
408 Laek Street
Spirit Lake, IA 51360

OLSON, Mark S. '88
P.O. Box 162571
Altamonte Springs, FL 32716

OLSON, Stephen '81
117 Los Altos St.
Oxnard, CA 93035

ONDUSKY, Nicholas '78
1698 Clark Lake Rd.
Brighton, MI 48116

OPP, Kathryn A. '83
11180 S.W. Bel Aire
Beaverton, OR 97005

ORDONES, Daniel '84
2403 Market Avenue
Fort Worth, TX 76106

ORDWAY, Robert J. '85
P.O. Box 326
Kings Beach, CA 95719

ORENSTEIN, Amy E. '90
5161 Rice Rd. #79
Antioch, TN 37013

ORHALEIN, Michael '80
RD 1, Box 34
Ocean View, DE 10997

ORMANDY, Tracey '78
13334 Valley Vista Blvd.
Sherman Oaks, CA 91423

ORTIZ, Almudena '87
Sierra Tezonco 120
Mexico City, 11000, Mexico

ORTIZ, Cecilia M '89
1813 Pelican Avenue
Ventura, CA 93003

ORTIZ, John '79
P.O. Box 613
Eugene, OR 97440

ORTIZ, Roberto '82
Cerrada Del Pedregal #50
Mexico DF, 04000, Mexico

ORTIZ, Rosa Del C. '84
Box G
Cabo Rojo, 00623, Puerto Rico

ORVIS, Walter R. '58
9767 Geneva Ave.
Montclair, CA 91763

ORY, Philippe '87
3 Rue De Venise
Paris, 75004, France

OSBORN, David J '86
610 Aster St.
Escondido, CA 92025

OSBORN, James L. '87
6745 Sabado Tarde
Goleta, CA 93117

OSBORN, Nathan W. '80
204 Francis Drive
Grass Valley, CA 95949

OSBORN, Robert '59
13465 N.W. Overton
Portland, OR 97229

OSBURN, KEN '69
6026 Silverbrooke West
W. Bloomfield, MI 48322

OSHILADE, Israel G. '57
153 Brickfield Road
Nigeria, West Africa

OSKOOIE, Ardeeshir R. '82
10412 Diane Dr.
Knoxville, TN 37922

OSWALD, Jan '74
921 Santa Fe Drive
Denver, CO 80204

OTIS, Robert W. '69
1288 Blair Lane
Schaumburg, IL 60194

OTT, Thorsten '89
15 Black Creek Lane
St. Louis, MO 63124

OUSLEY, Renee D. '86
11996 Valley Home Road
Oakdale, CA 95361

OVERTON III, Niel (A.D.) '89
1120 S 8th St
Rogers, AR 72755

OVREGAARD, Keith W. '79
765 Clementina Street
San Francisco, CA 94103

OWEN, Clifford '63
70 Oak Valley Drive
Holland, MI 49424

OWEN, Edy L. '87
P.O. Box 4373
San Francisco, CA 94101

– P –

PACE, Robert '59
407 Santa Roza Drive
Yakima, WA 98901

PACK, William R. '81
107 Cornelia Ave.
Mill Valley, CA 94941

PACURA, Timothy G. '83
4149 W Villa Rita
Glendale, AZ 85308

PAGE, Bryan J. '81
53 Railroad Ave.
Southington, CT 06489

PAGTER, Corbin C. '90
P.O. Box 2258
Santa Barbara, CA 93190-2258

PAKALKA GERMANY, Barbara J. '82
2104 Pearl Lane
Irving, TX 75060

PALAU, Daisy B. '81
P.O. Box 1000
Laguna Beach, CA 92651

PALMER, Douglas S. '90
4303 South Blvd.
Charlotte, NC 28209

PALMER, James H. '50
P.O. Box 445
Eastsound, WA 98245

PALMERS, Jan '86
Jardines De Calahonda 2 & 3
Mijas Costa, Spain

PALMIERI JR, Dominic '64
4128 Pescardaro Crt. Box #7
Orlando, FL 32817

PALMIERI, Lance '86
2674 E Main St 0192
Ventura, CA 93003

PAN, Chien Hung '87
257 Brandon Drive
Goleta, CA 93117

PANNIER, Fredrick P. '82
8-04 36th Street, #2L
Long Island City, NY 11105-1908

PANTON, Gary T. '79
24359 East Sylvan Gleen Road
Diamond Bar, CA 91765

PANZARELLA, JOSEPH A. '89
6142 Nancy Drive
La Mesa, CA 92042

PAPAZIAN, DAVID S. '81
618 NW Glisan
Portland, OR 97209

PARDEE, David P. '79
30 Mason Street
Lake Hopatcong, NJ 07849

PARENT, Howard '67
322 Willis Ave.
Ashland, WI 54806

PARIS, Constantine N. '56
6520 41st Ave. North
Minneapolis, MN 55427

PARISEK, Charlie '87
P.O. Box 5050, Shinjuku
Tokyo, 1 6 3, Japan

PARISH, Bill '68
2523 Blue Lake Court
Apopka, FL 32703

PARK, Craig W. '84
25375 Adams Rd
Los Gatos, CA 95030

PARK, MOO '86
5186 Don Pio Dr.
Woodland Hills, CA 91364

PARKER, James R. '81
519 Evergreen Road
Severna Park, MD 21146

PARKER, Lawrence L. '82
312 N. Legonier St.
Latrobe, PA 15650

PARKER, Stephen L. '79
2545 East Main Street
Ventura, CA 93003

PARKER, Timothy '74
285 Lincoln
Pomona, CA 91767

PARON, David W. '74
20 Fuller Avenue
Toronto, ON M6R 2C3, Canada

PARRA LEIBOWITZ, Maureen '63
20801 Plum Cyn Rd
Saugas, CA 91350

PARRIS, Michael O. '71
22825 Highbank Drive
Birmingham, MI 48010

PARSONS, Herbert N. '83
Box 75
Johanneshov, 12122, Sweden

PARSONS, Larry '75
1523A San Andres Street
Santa Barbara, CA 93101

PARSONS, Samuel G. '71
8915 Trujillo Way
Sacramento, CA 95826

PASCOE, Wayne '68
388 North 700 East
Bountiful, UT 84010

PASION, Mark '83
6705 San Ansemlo Way 3
San Jose, CA 95119

PATE, Hudson H. '77
812 East Highland Cirlce
Upland, CA 91786

PATERNO-CASTELLO, Guido '84
Via Vittorio Emanuele 113
Acireale, Italy

PATRICK, Gerald M. '78
2130 Hollywood Place
South Bend, IN 46616

PATTERSON, BRETT '88
255 SW Harrison 17C
Portland, OR 97201

PATTERSON, Grady S. '81
233 Rosehaven Drive
Raleigh, NC 27609

PATTERSON, John G. '84
900 S.W. 13th Street
Portland, OR 97205

PATTERSON, Nolan
21405 Colina Drive
Topanga, CA 90290

PATTERSON, ROBERT E. '76
202 A E. Stevens Ave.
Santa Ana, CA 92707

PAUL, Kerry Hiroshi '86
1491 Chukar Court
Sunnyvale, CA 94087

PAUL, Roger A. '80
13700 Meadow Acres Pl.
Burnsville, MN 553374511

PAULEY, Thomas D. '78
760 North Warwick Ave #11
Thousand Oaks, CA 91360

PAWELKO, Greg '77
3170 Parker Road
St. Louis, MO 63033

PAWLEY, Roger '78
4710 University Way N.E. #1126
Seattle, WA 94945

PAZEN, RICHARD K. '89
12801 Fair Oaks Blvd 102
Citrus Heights, CA 95610-5177

PEABODY II, Richard R. '67
20120 Lavender Place
Germantown, MD 20874

PEAK, Brian '85
9140 Gramercy Drive #295
San Diego, CA 92123

PEARLSON, Gary '85
1422 N. Sweetzer Avenue #205
Los Angeles, CA 90069

PEARSHALL, Donald '71
291 Hanover Drive
Costa Mesa, CA 92626

PEARSON, Charles J. '81
2103 Margaret PlaceE.
Mt. Vernon, WA 98273

PEARSON, Duane B. '81
756 South Sycamore Ave.
Los Angeles, CA 90019

PEARSON, Lee E. '83
1261 S Stanley Ave
Los Angeles, CA 90019

PEARSON, Roxanne Bogner '75
910 South Real Road
Bakersfield, CA 93309

PEASE, James R. '84
17817 Burke Place N.
Seattle, WA 98133

PEASE-ACQUINO, Mary '72
P.O. Box 662
Bridgehampton, NY 11932

PECK, DOUGLAS L. '82
854 Rorke Way
Palo Alto, CA 94303

PECK, Nina '89
1 Sunrise Hill Rd.
Santa Barbara, CA 93108

PEDERSEN, Knut K. '83
Anton Tschudisv 31
1344 Haslum, Norway

PEDERSEN, Rocki '82
2924 2nd Street
Santa Monica, CA 90405

PEDUTO, Joseph '89
P.O. Box 3000 #217
Santa Barbara, CA 93130

PEIRCE, David C. '73
5200 Hilltop Dr.
Brookhaven, PA 19015

PEISHEL, Allen '81
4530 Carpinteria Ave #42
Carpinteria, CA 93013

PELAN, Michael '64
7212 Eve Court
Las Vegas, NV 89128

PELON, David L '88
1126 Ravenwood Rd.
Boulder, CO 80303

PELTEKIAN, Barkev '61
918 North Clybourn Ave.
Burbank, CA 91505

PENA JR., Julian '76
3914 S. Topanga Canyon Ln.
Malibu, CA 90265

PENA, Jose '69
3801 W. Temple Ave.
Pomona, CA 94707

PENN, Eric '70
3589 Flint Creek Drive
San Jose, CA 95148

PENNINGTON, Carol L. '83
4623 Birmingham Way
Stockton, CA 95207

PENNINGTON, Sally J. '76
1226 Carlotta Ave.
Berkeley, CA 94707

PENNY, Donald G. '79
505 West 23rd Street Penthouse
New York, NY 10011

PENSINGER, Douglas A '85
156 South Carlisle Street
Greencastle, PA 17225

PEREZ, Charles '74
1701 East Edinger #J6
Santa Ana, CA 92705

PEREZ-GAVILAN, L. C. '80
CDA Popocatepetl 55-I
Mexico, DF 03330, Mexico

PERRIN, Gregory A. '86
10701 West River Road
Minneapolis, MN 55443

PERRON, Paul '88
3802 Caravelle Pkwy. #575
Corpus Christi, TX 78415

PERRY, JANICE S. '80
3131 Turtle Creek Blvd. #707
Dallas, TX 75219

PERRYMAN, JOHN G. '63
8815 West 70th Terrace Street
Shawnee Mission, KS 66204

PETERS, David '71
711 Furlong Road
Sebastopol, CA 95472

PETERS, JEFF '86
1225 Vienna Dr. #200
Sunnyvale, CA 94089

PETERS, Jill Simmons '73
711 Furlong Rd.
Sebastopol, CA 95472

PETERS, Jon '67
339 South Cherry Street
Itasca, IL 60143

PEDERSEN, Phred S. '85
314 13Th Ave. N.E.
Jamestown, ND 58401

PETERSON, Bob
17 Pergola
Irvine, CA 92715

PETERSON, Burt '73
2733 S W Troy St
Portland, OR 97219-2552

PETERSON, James '61
P.O. Box 275
Ringsted, IA 50578

PETERSON, Jeffrey D. '61
46 Robinhood Drive
Novato, CA 94945

PETERSON, Jon '70
4000 South Maple Ave
Broken Arrow, OK 74011

PETERSON, Mary
13407 Greenwood Ave N 318
Seattle, WA 98133

PETERSON, Robert A. '78
25 Sandstone
Irvine, CA 92714

PETERSON, Scott L. '86
735 Harrison
San Francisco, CA 94107

PETREY, John M. '81
4402 Glenview Lane
Winter Park, FL 32790

PETROFF, Carl '55
9831 North 15th Ave.
Phoenix, AZ 85000

PETSEL, Joseph C '86
2711 Summit Rd A
Columbia, MO 65203-1337

PETTIT, Robert L. '80
111 Pattee Canyon Dr 17
Missoula, MT 59803-1635

PFLANZER, Chris A. '84
14503 Aranza Dr.
La Mirada, CA 90638

PFRANG, Terry J. '83
1205 Magnolia Ave.
Carlsbad, CA 92008

PHILLIPPE, Greg '73
1625 Hillcrest Drive
Laguna Beach, CA 92651

PHILLIPS, John R. (Dick) '64
1918 Pike St. N.E.
Auburn, WA 98002

PHILLIPS, Virgil W. '78
4516 North Bresee Ave.
Baldwin Park, CA 91706

PHILPS, Steven '73
3415 N.E. 62nd Street
Portland, OR 97213

PHIPPS JR, Russell S. '63
5601 North Brooklyn Street
Kansas City, MO 64118

PICHE, Karen B. '84
P.O. Box 224
High Rolls, NM 88325

PIERCE, Allen '75
888 Olive Street
Arroyo Grande, CA 93420

PIERCE, Dale J. '77
5015 Elsby Ave.
Dallas, TX 75209

PIERCE, Richard '79
241 West 36th Street
New York, NY 10018

PIEROTTI, David M. '78
127 1/2 Primrose Ave.
Placentia, CA 92670

PIERSON, Marvin W. '79
5115 Columbia Hts. Road
Longview, WA 98632

PIESER, Robert '51
2545 E. Main St.
Ventura, CA 93003

PIETSCH, Teresa '83
405 Fellowship Road
Santa Barbara, CA 93109

PINNEGAR, Fred G. '63
4938 Walnut Ave.
Sacramento, CA 95841

PINTER, Mark W. '83
409 East Willow Raod
Fox Point, WI 53217

PITHAWALA, Urvix D. '87
12 Kaveriappa Layout
Bangalore, 560052, India

PIZER, Thomas S. '82
49ch Machery Chambesy
Geneva, 1292, Switzerland

PLANTE JR., Ronald O. (Jay) '90
1442 Sioux Trace
St. Charles, MO 63301

PLASKETT, David L. '90
20131 Knollwood Dr.
Saratoga, CA 95070

PLASKO, Walter G. '79
20498 Norwood Drive
Detroit, MI 48234

PLEMAN, Teresa M '86
2908 Shadow Brook Lane
Westlake Village, CA 91361

PLESHAR, Robert '66
201 South Warwick
Darien, IL 60559

PLICHTA, Daniel '57
7001 West Oklahoma Drive
West Allis, WI 53219

PLUMMER, Bill '67
963 Yorkshire Court
Lafayette, CA 94549

PLUMMER, JEFFREY K. '80
P.O. Box 674
Glens Falls, NY 12801

POE, Faith '90
1425 N Sierra Bonita 320
Hollywood, CA 90046

POE, Steven R. '86
5092 Moorpark Ave.
San Jose, CA 95129

POLEO, Javier A. '82
Urb Washington Miranda
Qla Caracas, Venezuela

POLLACK, Gerald A. '78
160 N Fairview Ave D269
Goleta, CA 93117

POLLETTI, William '53
P.O. Box 449
Pioneer, CA 95666

POLLOCK, Marcia A. '84
840 Caribou Terrace
Brentwood, CA 94513

POLLOCK, STEPHEN F. '81
1652 Edinger Suite C
Tustin, CA 92680

POMEROY II, Donald '68
P.O. Box J
Boulder Creek, CA 95006

POMEROY, James '79
4274 S Hazelcrest Drive
Las Vegas, NV 89121

PONCIA, Linda R. '80
2220 Stone Mountain Circle
Reno, NV 89504

PONGSAPIPATT, Malin '90
P. O. Box 393
Summerland, CA 93067

PONTARELLI, Robert '77
5837 Lewis Ct
Bettendorf, IA 52722

POPOVICH, Peter '77
286 Corliss St
Pittsburgh, PA 15220-4814

PORTER, David '72
10037 8th Ave N.W.
Seattle, WA 98177

PORTER, Gregory A. '86
4404 Seashore Drive
Newport Beach, CA 92663

PORTER, James '73
3955 Birch Street Unit F
Newport Beach, CA 92660

PORTILLO, Anthony R. '83
219 East Puente E
Covina, CA 91723

PORTILLO, RALPH '75
765 Minra Alley
San Francisco, CA 94103

PORTTEUS, Steve '83
7130 East Mercer Way
Mercer Island, WA 98040

POSEY, Steve '77
67 Maxwell Ave
St. Simons Island, GA 31522

POST, Edward '72
839 Cambridge Drive
Santa Barbara, CA 93111

POTERA, Paul B. '81
5904 Mt Eagle Dr. #701
Alexandria, VA 22303

POUCEL, Guillermo '76
4500 South Four Mile Run Drive
Arlington, VA 22204

POWELL, Gary R '88
247 E. Broadway
New York, NY 10002

POWELL, John R. '75
8325 Otto Street
Downey, CA 90240

POWER III, Charles '73
P.O. Box 802
Los Gatos, CA 95030

PRATT, Dean '78
114 Stephanie Ln
Vista, CA 92084-5316

PRATT, Renee '83
114 Stephanie Ln
Vista, CA 920845316

PRAZAN, John J. '77
12612 N.E. 113th Court
Kirkland, WA 98033

PRECHTEL, Brian C. '90
5595 N. E. Sandycrest Terr #1
Portland, OR 97213

PREDIKA, Jerry '64
1536 Mansfield Street
Santa Cruz, CA 95062

PREGENT, Nick '73
15960 Plummer
Sepulveda, CA 91343

PRESLEY, Ted '48
3217 Eagle Drive N.E.
Olympia, WA 98506

PRESTON, Michael '83
1705 Rusdell Drive
Las Colinas, TX 75060

PRESTON, Stuart W. '83
2526 Laurel Ln.
Costa Mesa, CA 92627

PRETE, Gregory Eugene '89
13622 Yellowstone Drive
Santa Ana, CA 92705

PRICE, Richard D. '88
374 Laguna Way
Simi Valley, CA 93065

PRIESONT, Lloyd '67
324 Cochran Suite #4
Los Angeles, CA 90036

PRIMAS, Teresa '86
729 S. Harvard
Villa Park, IL 60181

PRIME, Jonathan S. '82
109 Saranac Avenue
Lake Placid, NY 12946

PRIVETTE, Herman '76
P.O. Box 1085
Sausalito, CA 94965

PROCHNOW, Robert L. '82
3639 172 Street 72
Flushing, NY 11358

PROSSACK-SEIFFERT, Kyle R. '83
186 N. Village Knoll Circle
The Woodlands, TX 77381

PROVADA, Fred '73
6238 Rutherglenn Drive
Houston, TX 77096

PROVINE, Robert A. '77
1526 Harrison Ave.
Boulder, CO 80303

PRUNA, Andres F. '86
2620 N.E. 135 Street #1A
Miami, FL 33181

PTASYNSKI, Lisa J. '86
1515 Brookview Drive
Casper, WY 82602

PUGA-HEGENWALD, Ursula '88
1439 Urbino Ave 3
Miami, FL 33146

PUGH, Christopher J. '82
1090 Bentoak Lane
San Jose, CA 95129

PUJOL, Sylvie '86
"La Revolay" Grenay
Heyrieux, 38540, France

PURSEL, Robert '59
11236 Gladhill Rd
Whittier, CA 90604

PYLE, Helen
5237 N. Baltimore
Kansas City, MO 64118

– Q –

QABAZARD, Bader '90
1425 North Sierra Bonita Avenue
Hollywood, CA 90046

QABAZARD, Khalil A. '88
2430 Pine Drive
Santa Barbara, CA 93105

QUADE, Jonathan D. '86
2119 Markham Dr.
Chapel Hill, NC 27514

QUALMAN, Mike '89
5491 Montua Court
San Diego, CA 92124

QUARANTA, Vince '74
618 East Gutierrez Street
Santa Barbara, CA 93103

QUICK, Daniel L. '69
P.O. Box 3410
Soldotna, AK 99669
QUIENALTY, Michael C. '85
P.O. Box 1210
Lake Charles, LA 70602
QUINN, John T. '87
P.O. Box 45041
Los Angeles, CA 90045
QUINNEY JR., DAVID E. '81
423 East Broadway
Salt Lake City, UT 84111
QUINTANA, Mario E. '83
6289 Parkhurst Ave
Goleta, CA 93117
QUINTARD, Bryan '74
2237 Gehringer Drive
Concord, CA 94520
QVALE, Knut '87
Nordheimbk. 22
Oslo 3, 13781, Norway

– R –

RABINOWITZ, Barry '71
515 Willow Street
Waterbury, CT 06710
RABON, Roger '83
917 Lake Ave.
Chowchilla, CA 93610
RACO, Rocky '80
1187 Arrowwood Drive
Pittsburgh, PA 15243
RADCLIFF, Robert '65
3011 Delta
Modesto, CA 95355
RADFORD, Neal '80
4 Mckinly St.
Lincoln Park, NJ 07035
RADSTONE, Richard M. '85
4055 Spencer St 235
Las Vegas, NV 891195251
RAGSDALE, James '59
3841 North Cascade #3
Colorado Springs, CO 80907
RAHEB, Jeffrey E. '89
6468 40th Ave. N.
St. Petersburg, FL 33710
RAHN, Reed S. '84
610 West 11th Street
Tempe, AZ 85281
RAINES, Robert D. '76
7 May Street
Cornelia, GA 30531
RAINES, Sid G. '90
1916 Viborg Road
Solvang, CA 93463
RAINIER, Chris G. '80
P.O. Box 222633
Carmel, CA 93922
RALSTON, Rod S. '77
8660 200th Street S.W.
Edmond, WA 98020
RAMES, J. Douglas '73
111 Runnion Rd E
Sequim, WA 98382-9403
RAMIREZ JR., Daniel '86
2254 Crestmont Drive
Ventura, CA 93003
RAMSAUR, E.A. (Ted) '75
P.O. Box 1688
Greenville, SC 29602
RAMSAUR, Jack '73
120 North Pattison
Olympia, WA 98506
RAMSAY, Roger '85
23621 Del Cerro Circle
Canoga Park, CA 91304
RAMSAY, Thomas '70
1104 Cherokee Ave. West
West St. Paul, MN 55118
RAMSEY, WILLIAM E. '80
8229 Lowman
Pico Rivera, CA 90660
RANGEL, Andrew '71
648 Wheeler Street
Santa Rosa, CA 95404
RANGER JR., Philip F. '74
1628 Parrot Circle
Ventura, CA 93003
RANKIN, Jon '85
10 Vista Ladera
Carmel Valley, CA 93924
RANOA, Robert A. '82
102 Worcester Ln
Los Gatos, CA 95032-6324
RASMUSSEN, Eric J. '82
92 Horatio Street, Apt 4-H
New York, NY 10014
RATTY, BRIAN '68
10255 S. W. Arctic Dr.
Beaverton, OR 97005
RAUDABAUGH, Bruce '77
6755 Portage N.W.
N. Canton, OH 44720
RAWLINGS, Daniel '67
Hcr 2 Box 745
Hollister, MO 65672
RAY, Christopher B. '90
770 West End Ave.
New York, NY 10025
RAY, Jace '71
2340 Goldsmith
Houston, TX 77030
RAY, Kathleen J '87
3246 South Barcelona Street
Spring Valley, CA 92077
RAY, Steven L. '79
3500 S.E. 22nd Avenue
Portland, OR 97202
RAYL, J. Edward '81
708 Gladys Ave.
Long Beach, CA 90804
RAYLES, Ronald A. '75
1930 South Havana
Aurora, CO 80014
RAYMER, John F '72
3024 35th Avenue SW
Federal Way, WA 98023

RAZA, Asif '82
10 K 4th Gizri Ln., Defense
Karachi, Pakistan
REDD, True '73
3215 Jacotte Circle
Dallas, TX 75214
REDMAN, Bruce M. '84
9369 W Preece
Boise, ID 83704
REED JR., Randolph R. '55
418 Inwood Dr.
Bridge City, TX 77611
REED, Geoffrey M. '84
7 Sunrise Dr.
Gillette, NJ 07933
REED, Joe '80
3401 W. Fifth St., Ste. 120
Oxnard, CA 93030
REED, Kellie L. '82
18850 N. W. Rock Creek Cir. #312
Portland, OR 97229
REED, Kenneth '61
3138 W Dakota #75
Fresno, CA 93711
REED, Richard R. '84
25-09 27th Street
Astoria, NY 11102
REED, Robert '74
1816 North Vermont Ave.
Los Angeles, CA 90027
REED, William B. '77
1300 Eastman Ave 101
Ventura, CA 930038010
REEDY, Ralph '86
7355 Florey Crt.
San Diego, CA 92126
REEVES, Jaydee A. '87
P.O. Box 78171
San Francisco, CA 94107
REGAN, William A. '79
654 Parkman Ave
Los Angeles, CA 90026
REIFSCHNEIDER, Roberta L. '89
7690 Nolensville Rd 224
Nolensville, TN 37135-3458
REILLY, Thomas M. '75
1 Ermine Road
Scituate, MA 02066
REISMAN, Alex '49
5909 Wheelhouse Lane
Agoura, CA 91301
REISMAN, Yvonne Blumberg '67
7239 Currin Drive
Dallas, TX 75230
REISNER-PROBASCO, Frances L. '85
2400 Whitetail Drive
Antioch, CA 94509
REKOW, James M. '81
311 73rd Way
Brooklyn Park, MN 55444
RENTMEESTER, Earl '76
519 West La Belle Ave.
Oconomowoc, WI 53066
RENTZ, David E. '70
320 Brett Street
Pittsburgh, PA 15205
RETHORN, Peter B. '77
19841 Estuary Ln
Huntington Beach, CA 92646
REUSS, Timothy S. '90
22361 W.Chestnut Ridge Rd.
Long Grove, IL 60047
REVELS, Suzanne C. '87
1902 N. Walnut St.
Lumberton, NC 28358
REVOIR, Jack '66
6180 North 24th Street
St. Paul, MN 55119
REYES, Manuel '65
P.O. Box 3200
San Francisco, CA 94119
REYES, Raymond '50
1932 Shortridge Drive
San Jose, CA 95116
REYNOLDS, Albert E. '73
P.O. Box 24012
Las Vegas, NV 89101
REYNOLDS, David A. '80
1125 W. Baselin Rd. Ste. #2-3
Mesa, AZ 85210
REYNOLDS, David A. '82
2525 North Farrell Drive
Palm Springs, CA 92262
REYNOLDS, Richard A. '76
109 Biggs Street
Goldsboro, NC 27530
REYNOLDS, Roger G. '77
20753 Cypress Drive
Morrison, CO 80145
REYNOLDS, Susan A. '79
P.O. Box 2758
Stateline, NV 89449
REZAIENIA, Mehdi '84
30725 Davey Jones Drive
Agoura, CA 91301
RHEAULT, Michel J. '81
95 Prince Rd
Montreal, H3C2M7, Canada
RHO, Hyo Woon '90
308 Dawson Lane
Jericho, NY 11753
RHOAD, Timothy P. '78
P.O. Box 154-B
Bluffton, SC 29910
RHOADES, Stefanie '87
P.O. Box 7054
APO New York, NY 09012
RHODES, Eugene W. '78
2608 Cropper Court South
Richmond, VA 23235
RHODES, James '72
3601 East Bonaza Rd. #2016
Las Vegas, NV 89110
RHODES, Richard '90
1545 Birthwright Street
Charleston, SC 29407
RHODY, Kurt '87
7104 38th Street
Gig Harbor, WA 98335

RICCI, Dale '71
295 West Spain Street
Sonoma, CA 95476
RICE, Michael D. '70
2199 Willmott Dr.
Salt Lake City, UT 84109
RICH, Joel F. '80
1245 South Stearns Drive
Los Angeles, CA 90035
RICHARDSON, Jim '72
900 E. 55th Street
Austin, TX 78751
RICHARDSON, William R. '77
2655 Harland Drive
Hudson, OH 44236
RICHMOND, Earl B. '86
658 Chalk Hill Road
Solvang, CA 93463
RICHTIK, Kevin C. '90
2267 Dario Circle
Stockton, CA 95209
RICKABAUGH, Keith D '88
1736 Olive Avenue
Santa Barbara, CA 93101
RICKEN, Guillermo '87
P.O. Box 70232
Caracas, 1071A, Venezuela
RICO, Alicia '87
Rio Sinaloa #36 Pte. Col. Gpe
Culiacan, 80220, Mexico
RICONO, Mary Jane '87
P.O. Box 4143
Santa Barbara, CA 93140
RIDER, Robert D. '75
475 Anita Drive
Milbrae, CA 94030
RIEBE, Daniel C. '83
P.O. Box 7633
Olympic Valley, CA 95730
RIEDEL, Michael A. '85
2619 S Halm Ave
Los Angeles, CA 90034-2423
RIEDER, Robert J. '78
38 Hideaway Trail
Eureka, MO 12860
RIEGER, Arthur R. '67
9350 Shoshone Ave.
Northridge, CA 91325
RIEHLE, Jesse D. '53
2619 Mckinney Lake Road
Grand Rapids, MN 55744
RIEHS, RONALD '89
3301 "C" St.
Anchorage, AK 99501
RIENDEAU, Jack '59
9136 West 91st Street
Hickory Hills, IL 60457
RIERSON, Barton '86
16021 Cattle Drive
Sisters, OR 97759
RIGDON, Steve '69
P.O. Box 1831
Ruidoso Downs, NM 88346
RIGELHOF, John H. '86
527 Barington #16
Los Angeles, CA 90049
RIGGS, Dale A. '75
P.O. Box 1394
Great Bend, KS 67530
RIGGS, Sheldon '75
R R # 3, POB 1394
Great Bend, KS 67530
RINALDI, Renee '90
343 Texas St
San Francisco, CA 94107-2930
RINGMAN, Steve F. '76
1226 Carlotta Ave
Berkeley, CA 94707
RINKENBERGER, Steve M. '78
9606 South 43rd Place
Phoenix, AZ 85044
RIPP, Ronald A. '80
2804 Palo Verde N.E.
Albuquerque, NM 87112
RIXON, Michael L. '82
One Meadow Ln.
Concord, NH 03304
RIZZO, Maria Elena '86
443 Hicks St. #4-E
Brooklyn, NY 11201
ROBB, Alex M. '77
P.O. Box 1764
Telluride, CO 81435
ROBBINS JR., Joe D. '74
9406 Meadowglen Road
Houston, TX 77063
ROBERTS, Ben K. '70
6876 Del Playa Dr.
Isla Vista, CA 93117
ROBERTS, Charles '87
P.O. Box 383
Trona, CA 93562
ROBERTS, Dick '68
P.O. Box 6191
Fort Myers, FL 33911
ROBERTS, Eric O '86
401 Alston Road
Santa Barbara, CA 93108
ROBERTS, Mark A. '89
P.O. Box 1166
Benton City, WA 99320
ROBERTS, Patricia L. '80
200 Palmetto Rd.
Belleair, FL 33516
ROBERTS, Patrick L. '75
6527 2nd Avenue NW
Seattle, WA 98117
ROBERTS, Paul '74
143 Minor Ave.
Chula Vista, CA 92010
ROBERTS, Shawn R. '83
333 Capitola Place Apt. #2
Porterville, CA 93257
ROBERTS, Wen '61
325 E. Florence Ave.
Inglewood, CA 90301
ROBERTS, Wendy L. '86
631 South Adria Street
Anaheim, CA 92802

ROBERTSON, Ken S. '81
13242 N. E. 131st Pl.
Kirkland, WA 98034
ROBIN, Leslie '71
366 Mira Monte Ave.
Santa Barbara, CA 93108
ROBINSON, Kenneth E. '89
P.O. Box 1410
Atascadero, CA 93423
ROBINSON, M. Raymond '61
2205 Imperial Palm Drive
Largo, FL 34641
ROBINSON, Richlain '72
931 N. Citrus Ave.
Los Angeles, CA 90038
ROBINSON, Skeffington '74
1758 Hays Dr.
Newbury Park, CA 91320
ROBINSON-BOURS, Jesus R. '82
Avenida Technologico #401
Guanajuato, 38010, Mexico
ROBISON, Thomas J. '79
212 Harbor Point Pwy
Dunwoody, GA 30350
ROCHE, Cynthia '87
526 Owen Road
Santa Barbara, CA 93108
ROCHESTER, Anna Lou '52
408 North Eighth Street
Alpine, TX 79830
ROCHESTER, Dr. Alfred '52
408 N. Eighth St.
Alpine, TX 79830
ROCKWELL, Edwin '52
P.O. Box 597
Bishop, CA 93514
RODALE, Anthony A '87
2098 South Cedar Crest Blvd.
Allentown, PA 18103
RODDIE, Challenge S '88
3306 Buckethorn Ct.
Dallas, TX 75042
RODGERS, John W. '90
P.O. Box 612
Diablo, CA 94528
RODGERS, Michael S. '75
65 Mount Vernon Ave, Apt 2
Pittsburgh, PA 15229
RODRIGUEZ, Daniel '79
3907 Silver Maple
Carrollton, TX 75007
RODRIGUEZ, John A. '82
106 Ventura St., Suite B
Santa Paula, CA 93060
RODRIGUEZ, Rodolfo '86
1811 Credt Ridge
Dallas, TX 75228
RODVOLD, Richard '69
7378 East Singing Wood Drive
Anaheim, CA 92808
ROEPE, Brian E. '81
364 Powerville Rd.
Boonton, NJ 07005
ROESIES, Robert '86
1810 N Decatur Blvd 103
Las Vegas, NV 89108
ROGERS, James A. '78
40 N Bellmore Rd
Levittown, NY 11756
ROHLFING, Robert '71
22 Anacapa Street
Santa Barbara, CA 93101
ROHRBACKER, Jeffrey D. '88
2819 Harvard Drive
Visalia, CA 93277
ROLEDER, Jonathan W. '83
1625 Flower Ave.
Torrance, CA 90503
ROLLE, Roderick G. '86
236 South Salinas Street, Apt C
Santa Barbara, CA 93103
ROMAN, David I. '79
10304 Paradise Blvd
Treasure Island, FL 33706
ROMASANTA, Lisa '88
939 Via Tranquila
Santa Barbara, CA 93110
ROMEO, Joseph '88
4095 Championship Dr.
Annandale, VA 22003
ROMERO, Amadeo C. '64
816 21st Street
Sacramento, CA 95814
ROOP, Robert G. '74
7315 South View Court
Fairfax Station, VA 22039
ROOPNARINE, Roderick R. '83
Agnes St. Marabella
Trinidad, West Indies
ROOT, Ken W. '90
2515 200th Ave S E
Issaquah, WA 98027
ROPEL, JOSEPH T. '77
35122 28th Ave South
Federal Way, WA 98003
ROSE SORRELL, Annette C. '81
1482 East Mountain Drive
Santa Barbara, CA 93108
ROSE, Joe '60
803 East Ave D
Jerome, ID 83338
ROSE, Kevin M. '86
1513 Nelson Drive
Garland, TX 75040
ROSE, Linda R. '81
360 Caribbean Road
Key Biscayne, FL 33149
ROSEMANN, Guido H. '89
Russrasse 40
5000 Cologne 41, W. Germany
ROSEN, Allen I. '76
676 Alijo Drive
Pittsburgh, PA 15241
ROSEN, Jim E. '79
P.O. Box 2048
Homer, AK 996032048
ROSEN-WALSTROM, Leslie '86
6136 Wrigley Way
Fort Worth, TX 76133

ROSENBERG, ALAN J. '79
3024 Scott Blvd.
Santa Clara, CA 95054
ROSENTHAL, Ian '64
138 Lethbridge Circle
Copley, OH 44321
ROSENTHAL, Marshal '79
231 West 18th Street
New York, NY 10011
ROSNER, Eric H. '77
816 North Newkirk Street
Philadelphia, PA 19130
ROSS, Alexander (Sandy) '57
2038 Eastridge Drive
Anchorage, AK 99501
ROSS, Brad '89
2038 Eastridge Drive
Anchorage, AK 99501
ROSS, Jonsie '80
22506 W Ash Court
Saugas, CA 91350
ROSS, Mark S '88
570 Irwin Lane
Santa Rosa, CA 95401
ROSSI-WALSH, Terri '82
5828 207th Place S.W.
Brier, WA 98036
ROSSMEISSL, Kirk J. '82
P.O. Box 344
Barnnegat Light, NJ 08006-0344
ROSSNAGEL-PROCTOR, Pamela R. '80
18126 Center Avenue
Homewood, IL 60430
ROTH, David L. '81
3020 De La Vina St.
Santa Barbara, CA 93101
ROTH, Terry '71
230 Cypress Way
Casselberry, FL 32707
ROTHMAN, Michael '73
1816 North Vermont Ave.
Los Angeles, CA 90027
ROTHWELL, Mike '69
341 Arnold Byway
Arnold, CA 95223
ROUHI, Keyhan '86
P.O. Box 5190
Beverly Hills, CA 90210
ROULETTE, Ryan S. '73
3714 4th Ave.
San Diego, CA 92103
ROWAN, Robert '65
3296 Scotia Road
Newport, WA 99156-1709
ROWAN, Thomas '72
41 Golden Court
Cheektowaga, NY 14225
ROWLAND, Marshir '87
222 Royal Oaks
San Antonio, TX 78209
ROWLAND, Shawn M. '86
P.O. Box 1073
Indian Rocks Beach, FL 34635
ROY, David K. '55
62091 Valley View Circle
Joshua Tree, CA 92252
ROYER, Ramon D. '65
917 La Bonne Pky
Manchester, MO 63021
RUBENSTEIN, Marcia S. '86
723 N Alisos Street
Santa Barbara, CA 93103
RUBIN, Phillip J. '78
616 Topeka Drive
Reseda, CA 91335
RUDD, David L. '81
10914 Rose Avenue
Los Angeles, CA 90034
RUDOLPH, John '62
P.O. Box 134
Summerland, CA 93067
RUGGIERI, Anthony V. '87
1438 Las Positas Place
Santa Barbara, CA 93105
RUGGLES, Linda L. '86
1117 Harborgate Drive
Mt. Pleasant, SC 29464
RUMMEL, William G. '78
519 South Main Street
Frankenmuth, MI 48734
RUPERT, John '68
2020 Alameda Padre Serra, #201
Santa Barbara, CA 93103
RUSH, Jim '73
11571 Magnolia Blvd.
N. Hollywood, CA 91601
RUSSEL, Don J. '72
5169 Hessel Ave.
Sebastopol, CA 95472
RUSSELL, Anita E. '76
517 Dexter Ave.. North
Seattle, WA 98109
RUSSELL, Gary & Rhodonna '78
2420 Hickory Ridge Drive
Chattanooga, TN 37421
RUSSELL, Harry '74
8920 Twin Falls Drive
Sacramento, CA 95826
RUSSI, JAMES E. '79
2649 Palos Verdes Drive West
Palos Verdes Estates, CA 90274
RUTGERS, James
Box 511
Pepote, Tahiti
RUTT, DONALD R. '75
324 Munson Ave.
Traverse City, MI 49684
RYAN, Shirley J. '77
P.O. Box 206
Janesville, WI 53547-0206
RYKERT, Maurice A. '59
6812 Bratcher Street
Portage, MI 49081

– S –

SABAN, Donald V. '74
409 E Islay
Santa Barbara, CA 93101

SABATINI, Kenneth J. '82
1806 Belmont Lane B
Redondo Beach, CA 90278
SADASIVAN, Gyaneshwar '90
220 Ladera St 108
Santa Barbara, CA 93101
SADIQ, Zahid '82
Zubada Gardens, A-2 314, Kath
Karachi, KYC, Pakistan
SAEHLENOU, Kevin A. '77
1658 Eudora
Denver, CO 80220
SAFFORD, Scott '73
7252 Romero Drive
La Jolla, CA 92037
SAFRON, Marshal H. '71
1041 North Mc Cadden Place
Los Angeles, CA 90038
SAGA, Frank '57
1738 West Rose Street
Stockton, CA 95203
SAGE, Gerald '64
21 Sydney Dr. S.W.
Calgary, Alberta, T2W 0S7, Canada
SAIDI, Marjaneh '88
17 Rocky Knoll "H"
Irvine, CA 92715
SAINT GERMAIN, Steve '83
4674 Verdugo Place
Santa Barbara, CA 93110
SAKAI, Naoki '86
1013 Kitakase #302
Saiwai Ku Kawasaki, 21131, Japan
SALAMA, Ricardo '57
P.O. Box 798
Cochambamba, Bolivia
SALAS, Rick H. '79
5835 South Eastern Ave.
Los Angeles, CA 90040
SALAZAR, LUIS (TONY) '85
612 Lighthouse Avenue
Pacific Grove, CA 93950
SALGUERO, Agustin R.
Calle 17, Sur 537
Guyman Sonora, Mexico
SALISBURY JR., James '75
5763 Suitland Rd
Suitland, MD 20746
SALLS, Roger D '74
421 Laughlin Road
Stratford, CT 06497
SALVATORI, Allan J. '73
33 Shady Valley Court
Chesterfield, MO 63017
SANBORN, Thomas E. '84
191 Banana Grove Lane
San Jose, CA 95123
SANDAHL, Fredrik '90
Osteraaskroken 1
Osteraas 1345, Norway
SANDER, Warren J. '86
326 Mellifont Avenue
Santa Barbara, CA 93103
SANDERS, Key '85
5637 Cedar Creek
Houston, TX 77056
SANDERS, Michael '86
1628 Kirkwood Rd
Memphis, TN 381167938
SANDIFORD, Peter H. '61
1611 Bayview Ave.
Toronto Ontario, M4G 3B5, Canada
SANDMAN, Clarice F '89
1145 S. 216th St.
Desmoines, WA 98198
SANDMIRE-MUNDA, Cheryl B. '83
P.O. Box 1269
Helena, MT 59624
SANDOVAL, Ronald L. '84
13713 Benbrook Drive
La Puente, CA 91746
SANFORD, John A. '80
1824 Baker Street 7
San Francisco, CA 94115
SANFORD, John S. '90
221 14th St
San Francisco, CA 94013
SANGILLO, Tom '67
120 Ely Street
Boonton, NJ 07005
SANSONI, Henry '49
1547 Racquet Club Drive
Los Banos, CA 93635
SANTINI, Jamie P. '83
1046 Madden Ave.
San Diego, CA 92154
SARKISSIAN, Katherine '86
525 73rd St.
Brooklyn, NY 11209
SARPA, J. Jeffry '80
13056 Rose Ave.
Los Angeles, CA 90066
SASAKI, Larry '74
P.O. Box 592
Concord, CA 94522
SASSANO, Anthony '50
1481 3rd Ave. #165
Chula Vista, CA 92011
SATER, Jennifer D '88
1009 Brighton St.
Burbank, CA 91506
SATO, Kunio '59
726 Neal Ave.
San Carlos, CA 94070
SATO, Luis A. '78
Jr. Huallaga 551
Lima 1, Peru
SAVAGE, David '61
16367 Goldenrod Way
Parker, CO 80134
SAVAGE, Deborah '79
168 Rickey Ave.
Ft. Walton Beach, FL 32548
SAWADA, Spencer K '71
1333 West Pratt Blvd #5
Chicago, IL 60626
SAWYER, Gerald '83
P.O. Box 14
Fairview, KS 66425

SAWYER, Thomas E. '85
25812 Mendoza Drive
Valencia, CA 91355

SAYLOR, Mark W. '80
720 Fitzwatubun Road
Willow Grove, PA 19090

SCARLATA, John '74
P.O. Box 797
Valle Crucis, NC 28691

SCARLETT, Donald '83
1717 Novato Blvd #28
Novato, CA 94947

SCHABARUM, Thomas T. '85
521 Dorchester Rd.
San Mateo, CA 94402

SCHAFER, Suanne '83
103 Westwood Apt. #263
Lafayette, LA 70506

SCHAFFER, Amy Michal '89
544 A. Ardmore
Cranbury, NJ 08512

SCHAPIRO, Martin Bennett '86
5311 Aldea Avevue
Encino, CA 91316

SCHAUER, Brent '69
8495 S.W. Cashmur Lane
Portland, OR 97225

SCHAUER, Kenneth C. '86
23930 Ocean Avenue Apt. #150
Torrance, CA 90505

SCHEER, William E '87
21706 Coloma Dr
Palo Cedro, CA 960739505

SCHELLER, Justin F. '87
5290 Appian Way
Long Beach, CA 90803

SCHEN, Karen L. '89
1120 S 8th St
Rogers, AR 72756

SCHENKER, Lawrence R. '79
2830 South Robertson Blvd.
Los Angeles, CA 90034

SCHERZI, JAMES '71
5818 East Molloy Road
Syracuse, NY 13211

SCHILL, Kevin '82
12115 Hollyglen Pl.
Studio City, CA 91604

SCHLATTER, David C '87
7347 East Solcito Lane
Scottsdale, AZ 85253

SCHLOCKER, Albert J. '84
5840 Bucknell Avenue
N. Hollywood, CA 91607

SCHLOTMAN, Larry '69
Route 2 Box 83
Brookston, IN 47923

SCHMAUTZ, Alan '74
200 Egan Rd.
Kalispell, MT 59901

SCHMIDT, Brad '83
999 Paladora
Pasadena, CA 91104

SCHMIDT, Nancy Ann '87
P.O. Box 584
Summerland, CA 93067

SCHMIDT, Ronald D. '84
1332 18th Street #5
Santa Monica, CA 90404

SCHMIDT, Ronald J. '90
333 Hemlock Street
Roselle Park, NJ 07204

SCHMIDT, Thomas '75
1935 Pine Street
Redding, CA 96001

SCHMITZ, David J. '88
24420 S. Meteor Ct.
Chandler, AZ 85248

SCHMITZ, Jack '65
536 Julie Street
Colton, CA 92324

SCHMUCKI, Michael '87
N6155 Wren Road
Beaver Dam, WI 53916

SCHNEIDER, Dana P. '76
6380 Hollister Avenue
Goleta, CA 93117

SCHNEIDER, Robert '64
2515 Franklin Blvd.
Cleveland, OH 44113

SCHNESE, Paula M. '90
1288 Church St
San Francisco, CA 94114

SCHNITTER, Hans '45
3253 San Simeon Court
Reno, NV 89509

SCHNOEKER, Kent '77
6880 Seaspray Ln
Carlsbad, CA 92009

SCHNORF, Max '65
43 Interlacken Drive
Springfield, IL 62704

SCHOCHAT, Kevin R. '82
150 East 18th Street
New York, NY 10003

SCHOENBACH, KURT '85
881 Medford Place
Ventura, CA 93004

SCHOENHUT, Robert J. '74
346 North Maple Drive #8
Beverly Hills, CA 90210

SCHOENING, Carina '85
4776 Pescadero Ave.
San Diego, CA 92107

SCHOFIELD, James V. '51
1850 Lincoln Street Sp. #198
El Centro, CA 92243

SCHONHOFEN, Margaret S. '89
22135 Edison Avenue
Dearborn, MI 48124

SCHOON, Alvin '52
282 Hidden Lake Road
Hendersonville, TN 37075

SCHOR, Jeffrey S. '86
2490 Kendall Dr 104F
San Bernardino, CA 92407-2418

SCHOU, Donna L. '88
26 Fairfield Ave 3F
Norwwalk, CT 06854

SCHRADER, Dann P. '80
27091 Nogal
Mission Viejo, CA 92692

SCHREIER, Ronald S. '82
21 Morningside Drive
San Francisco, CA 94132

SCHROEDER, J. Erik '89
1067 Koohoo
Kailua, HI 96734

SCHROLL, Todd '56
3737 South Washington Road
Fort Wayne, IN 46802

SCHRUM, Terrence L. '76
13432 Joshua Place
Chino, CA 91710

SCHUBAUER, Gretchen '82
Coon Hollow Road
Huntington, NY 11743

SCHUELER, Lawrence '64
809 Stitch Rd.
Lake Stevens, WA 98258

SCHUIT, Tammy '86
1433 Camino Trillado
Carpinteria, CA 93013

SCHULMAN, Scott C. '88
4311 Lyceum Ave.
Los Angeles, CA 90066

SCHULTZ, Marius '86
Vestre Vei 93B
1315 Nesoya, Norway

SCHULTZ, Zackary R. '81
8018 Bagley Ave North
Seattle, WA 98103

SCHULWOLF, Sanford '88
215 Coboll Avenue
Mill Valley, CA 94941

SCHULZ, Henry T. '84
990 Industry Drive
Seattle, WA 98188

SCHULZ, John C '88
2894 Lone Jack Rd.
Encinitas, CA 92024

SCHUMACHER, Sam '87
378 S Corona
Denver, CO 80209

SCHUMACHER, Stacey '86
3469 West Benjamin Holt Dr. 462
Stockton, CA 95209

SCHWAB, Thomas '65
5135 Grape
Houston, TX 77096

SCHWARM, Arthur Brad '88
P.O. Box 369
Jackson, WY 83001

SCHWARTZ, Barry '72
712 S Grand View St 5D
Los Angeles, CA 90057-3908

SCHWARTZ, David S. '61
P.O. Box 32283
Washington, DC 20007

SCHWARTZ, Gregory '84
118 Georgetown Drive
Casselberry, FL 32707

SCHWARTZ, Michael '77
1912 Grismer Ave. #A
Burbank, CA 91504

SCHWARTZ, Rick '82
130 Mc Cormick #107
Costa Mesa, CA 92626

SCHWARTZ, Samy '88
7128 N. W. 50th Street
Miami Springs, FL 33166

SCHWARTZMAN, Ron '61
3398 Meder Road
Shingle Spring, CA 95682

SCHWENTKER, Harry N. '72
706 Lookout Dr. #3
Los Angeles, CA 90012

SCIALLO, Ken J. '86
2516 Montgomery Drive
Santa Rosa, CA 95405

SCOLMAN, James '69
20715 123rd Street S.E.
Snolomish, WA 98290

SCOTT, Hans W. '86
2320 E. 3rd Street
Mishawaka, IN 46544

SCOTT, Michael C. '86
813 West 4th
Larned, KS 67550

SCOTT, Shelley L. '88
2117 Ardis Drive
San Jose, CA 95125

SCOTT, William J. '77
1502 Cottonwood
Richland, WA 99352

SCRUGGS, Roger '74
25 Sloop Drive
Cocoa Beach, FL 32931

SEAMAN, William M. '76
610 North Chestnut Street
Scottsdale, PA 15683

SEAVER, Keven Ann '77
P.O. Box 6357
San Rafael, CA 94903

SEAWELL IV, Thomas W. '90
495 Pinewood Dr.
San Rafael, CA 94903

SEBASTIAN, Ted M. '86
7816 Lill Court
Niles, IL 60648

SEELIG, Edwin'74
11628 Victor
N. Hollywood, CA 91606

SEEMAN, Leigh Ann '80
3816-D Run Of The Oaks
Austin, TX 78704

SEGALO, Walter A. '65
6866 Babcock Ave.
N. Hollywood, CA 91605

SEGERBLOM, Lia A. '80
1278 Glemmeyre Street #161
Laguna Beach, CA 92651

SEIFERT, Thomas A. '83
186 North Village Knoll Cir.
The Woodlands, TX 77381

SELF II, Ed '65
300 N Redbud Ln
Muncie, IN 47304

SELVIDGE, Tom '78
12603 Ruggs Lake Rd.
Everett, WA 98208

SENGEL, Marc
4415 Gerald Place
Nashville, TN 37205

SEQUEIROS, David
1657 Lou Graham
El Paso, TX 79936

SERAT, Julia Ann '87
719 Center Ave.
Martinez, CA 94553

SESLAR, R. Budd '60
3131 Western Ave 517
Seattle, WA 981211028

SESSIONS, David D. '77
2210 Western Blvd.
Santa Monica, CA 90403

SETZER, William T. '76
1757 Legare Lane
Virginia Beach, VA 23464

SEWELL, Richard Kirk '77
630 S. State
Springfield, IL 62704

SEXTON, Michael J. '89
24925 Estribos
Mission Viejo, CA 92692

SEYLE, Albert '69
2218 N. Via Tomas
Camarillo, CA 93010

SEYMOUR, ROBERT
2079 30th St.
Boulder, CO 80301

SFETKU, Stephen A. '86
P.O. Box 91
Carpinteria, CA 93013

SHACKELFORD, Robert '72
1515 Lomita Ave.
Richardson, TX 75080

SHAFER, Doyle M. '69
3554 Quebec St NW
Washington, DC 20016

SHAFER, Robert C '79
3554 Quebec Street N.W.
Washington, DC 20016

SHAHROUZI, Ali '87
220 Grove Lane
Santa Barbara, CA 93105

SHANKEL, L. Mark '81
93 Sacramento Ave.
San Anselmo, CA 94960

SHANKMAN, Sam '50
6600 Paseo Fiesta
Anaheim, CA 92807

SHANNON, Russell P. '88
12921 NE 78th Place
Kirkland, WA 98033

SHAPIRO, Mark '82
38 Strathcona Avenue
Toronto Ontario, M4K1K7, Canada

SHARER-PORTER, Holly '70
2117 Calle Tecolote
Santa Fe, NM 87505

SHARKEY, Ethan C. '89
2065 Oak Creek Place
Hayward, CA 94541

SHARP, Robert A. '62
117 Nieto Ave A
Long Beach, CA 90803-3356

SHARP, Sterling '70
P.O. Box 39
Glenhaven, CA 95443

SHAW, Brad '74
9950 Roan Meadows Drive
Boise, ID 83709

SHAW, James '86
Box 17 Mount Gardner Park
Bowen Island, BC V0N 1G0, Canada

SHAW, Raymund O. '76
1101 No. "F" Street
Lompoc, CA 93436

SHAW, Richard G. '84
812 West Sola St.
Santa Barbara, CA 93101

SHEA, Michael P. '82
210 Newbury Lane
Newbury Park, CA 91320

SHEDD, Charles F. '75
1 Television Place
Charlotte, NC 28205

SHELDEN, Steven M. '85
15239 Magnolia Blvd. #A
Sherman Oaks, CA 91403

SHELDON, Benjamin L. '83
550 Merritt Avenue
Camarillo, CA 93010

SHELDON, Janice M. '80
P.O. Box 5571
Berkeley, CA 94705

SHEMDEAN, Ghandi H. '72
P.O. Box 7247
Tahoe City, CA 95730

SHEPARD, G. Dean '85
4939 Wells Drive
Roeland Park, KS 66205

SHEPARD, Thomas '88
P.O. Box 188
Anahola, HI 96703

SHEPERD, Carolyn '87
6975 York Ave. S.
Minneapolis, MN 55435

SHEPHERD, Michael L. '83
2308 NW 25th Street
Oklahoma City, OK 73107

SHEPPARD, Jeff A. '86
1029 East Gutierrez #A
Santa Barbara, CA 93103

SHERMAN, Sharon '86
1087 Visalia Drive
Costa Mesa, CA 92626

SHERRILL, Bryan
1446 Fremont Ave
Casper, WY 82604

SHERWOOD, Hugh C. '84
10600 Northmark Dr
Eden Prairie, MN 55344-4001

SHICK, Jim R. '83
1744 Sunset Cliffs Blvd.
San Diego, CA 92107

SHIELDS, Gregory W. '82
5044 La Ramada
Santa Barbara, CA 93109

SHIEW, Eddie '85
502 Pajaro St.
Salinas, CA 93901-3313

SHILL, Sterling '86
2514 North Mesa Drive
Mesa, AR 85201

SHIMIZU, Sam '61
112 32 Ave.
Seattle, WA 98122

SHIMOMURA, Ricky Y. '82
33 Central Ave.
Wailuku, HI 96793

SHIPPEE, Bruce '77
420 Tesconi Cir Suite B2
Santa Rosa, CA 95401

SHIRAHAMA, Grant '79
2824 N.E. 21st Ave.
Portland, OR 97212

SHIRE, Michael '88
1921 Montecito Ave 7
Mountain View, CA 94043-4301

SHOHAM, Shlomo '80
10 Ishayaho St.
Haifa, 35702, Israel

SHOLL, Jerry '69
18165 Shamrock
Big Rapids, MI 49307

SHORT, ROGER '68
1053 Mabel Fry
Yukon, OK 73085

SHU, Morning '87
496 Coyote Creek Circle
San Jose, CA 95116

SHULEM, Steven E. '85
108 West Mission
Santa Barbara, CA 93101

SHUMAKER, Maria C. '81
6539 Bayou Glen
Houston, TX 77057

SIBLEY, John A. '77
10216 Aldea Ave.
Northridge, CA 91324

SIEBLER, John '86
3463 State Street #407
Santa Barbara, CA 93105

SIEGEL, Donna R. '78
6343 Del Monte Dr.
Houston, TX 77057

SIEGEL, William '77
P.O. Box 3589
Riverside, CA 92519

SIEGLER, Gary G '86
360 Liberty Avenue
Hillsdale, NJ 07642

SIERSMA, David '72
1438 Date Street
Oxnard, CA 93030

SILPAVCANG, M.P. '75
8 Pho Panch Rd.
Bangkok, Thailand

SILVA, Flavio H. '76
Rua Joseph Bloch 49, Apt. C01
Rio De Janiero, Z C 07, Brazil

SILVER, Karen S. '86
1150 Noria Street
Laguna Beach, CA 92651

SILVERMAN, JAY E. '75
920 N. Citrus Ave.
Los Angeles, CA 90038

SILVERMAN, Norman '70
4734 Belfield Drive
Dublin, OH 43017

SILVERMAN, Robert J. '79
2119 W. Beach Blvd. #225
Fort Lauderdale, FL 33312

SILVERSON, Jane '89
1473 Miramonte Ave. #8
Los Altos, CA 94024

SILVESTER, Keith '82
1199 Carpenter Hill Rd.
Medford, OR 97501

SIMIC, Jennifer J. '90
6700 Franklin Pl. #101
Hollywood, CA 90028

SIMMONS, Frederick B. '68
312 S. 52nd Pl.
Springfield, OR 97478

SIMMONS, Jimm
1607 Kelly St.
Santa Rosa, CA 95401

SIMON, Jerry L. '89
1945 North Lincoln Avenue 2F
Chicago, IL 60614

SIMON, Timothy '70
1896 Pacific Ave. #804
San Francisco, CA 94109

SIMPSON, S. Charles '80
28 Jessup Street
San Rafael, CA 94901

SINCLAIR, Gerald '73
1207 Sibley
Calumet City, IL 60409

SINGER, Michael J '88
7309 N Nichols Rd
Oklahoma City, OK 73120

SINGER, Russell L. '79
415-1/2 W. Main Ave.
Spokane, WA 99201

SINKLIER, Scott R. '78
5860 Merle Hay Road
Johnston, IA 50131

SIOE, Ing Ming '86
Krekot Bunder XII/9
Jakarta, 10710, Indonesia

SIPPEL, James W '87
401 Drummond
Ridgecrest, CA 93555

SIRACUSA, Dean '86
1459 South Jameson
Santa Barbara, CA 93108

SISSMAN, Robert R. '75
3124 Goodview Trl
Los Angeles, CA 90068-1713

SISTA, Apu V. '88
702 Bakhtavar
Bombay, 400 005, India

SITTERLY, Donald '71
159 N. Ridgeland Ave.
Oak Park, IL 60302

SKADBERG, John '73
2947 Edell Place
San Diego, CA 92117

SKANSGAARD, Ronald '56
1101 5th Avenue South
Virginia, MN 55792

SKARSTEN, Michael L. '81
1062 N. Rengstorff, Unit E
Mountain View, CA 94043

SKINNER, Robert B. '83
662 Warren St.
Brooklyn, NY 11217

SKOTT, Michael '73
Box 660 Route 1
EastSound, WA 98245

SKUFCA, Frank J. '76
3916 Foothill Rd.
Santa Barbara, CA 93110

SKUPENSKI, Frederick '81
4242 Whitsett Ave. #1
Studio City, CA 91604

SKUTCH, Lindsay E. '77
3656 Glenridge Drive
Sherman Oaks, CA 91423

SLATER, Douglas B. '88
1752 N. Serrano #504
Los Angeles, CA 90027

SLINGERLAND, Bernard '86
633 Sunfish Way
Port Hueneme, CA 93041

SLOAN, Ron '67
1790 E. Bayshore Road #7
Redwood City, CA 94063

SLOBEN, Julia G. '83
7834 Nightingale Way
San Diego, CA 92123

SLOMAN, Jean P. '80
801 Coronado Ave.
Coronado, CA 92118

SLUCHAK, Jan E. '79
30 Keats
Mill Valley, CA 94941

SMAIL, L. Richard '73
1064 Summerwood Ct.
San Jose, CA 95132

SMALLEY, James L. '77
6043 NW Newbeary Hill Rd
Silverdale, WA 98383

SMITH, Alice '85
5204 Abercrombie Drive
Minneapolis, MN 55435

SMITH, Bud '69
P.O. Box 870691
Wasilla, AK 99687

SMITH, Charles J. '78
2030 Via Tiendo
Cardiff, CA 92007

SMITH, Charles R. '90
938 Huntington Dr. Unit K
Duarte, CA 91010

SMITH, Clark C. '80
808 Katlau Drive
Dalton City, GA 30720

SMITH, David '79
33 Sovereign Way
Fort Pierce, FL 34949

SMITH, Harold E. "Bud" '71
4300 So. 2nd St.
Louisville, KY 40214

SMITH, Herman Lee '73
8636 NE Sacramento
Portland, OR 97220

SMITH, James '68
8376 So. 10th Street
Kalamazoo, MI 49009

SMITH, Jordan F. '85
2707 Benedict Canyon
Beverly Hills, CA 90210

SMITH, Kathleen C. '88
4541 Falkirk Bay
Oxnard, CA 93035

SMITH, Kevin M. '77
1300 Flower Street
Glendale, CA 91201

SMITH, Michael A. '80
14351 Starsia
Westminster, CA 92683

SMITH, Peter '74
P.O. Box 913
Lemon Grove, CA 92045

SMITH, Randy F. '90
1020 G Street
Anchorage, AK 99501

SMITH, Richard H. '79
415 Vernet St.
Richardson, TX 75080

SMITH, Rick W. '81
925-B Merchants Walk
Huntsville, AL 35801

SMITH, Rickey E. '79
1013 E. St. Louis Avenue
Las Vegas, NV 89104

SMITH, ROBERT G. '82
8995 Denver St.
Ventura, CA 93004

SMITH, Russell L. '80
281 Country Club Drive
San Francisco, CA 94080

SMITH, S. Lee '79
410 Townsend St.
San Francisco, CA 94107

SMITH, Scott A. '81
13953 Panay Way
Los Angeles, CA 90291

SMITH, Stephen '87
420 S. La Fayette Park Pl. #213
Los Angeles, CA 90057

SMITH, Terry M. '85
4141 Mattos Drive
Fremont, CA 94536

SNEAD, Eugene E. '78
402 Cactus Cir.
Mechanicsville, VA 23111

SNEERINGER, Thomas '67
175 Maureen Cir.
Pittsburg, CA 94565

SNETHEN, Julie I '87
343 Salida Del Sol
Santa Barbara, CA 93108

SNIPES, Dan '76
P.O. Box 786
Dana Point, CA 92629

SNOOK, James J. '65
735 S. Ardmore
Villa Park, IL 60181

SNYDER, Harry S. '50
5080 Oleander Place
Santa Barbara, CA 93111

SNYDER, Ronald J. '76
1200 E. Acacia St.
El Segundo, CA 90245

SNYDER, Steve W. '71
3360 White Alder
Sonoma, CA 954766077

SODERSTROM, Hans '83
Via A/S
Oslo 6, 0603, Norway

SOERJANTO, Iswanto '90
Jl. Otoiskandardinata 51
Bogor 16143, Indonesia

SOHN, In Hee
6363 Wilshire Blvd.
Los Angeles, CA 90048

SOLARI, Marc E. '86
1600 Garden #25
Santa Barbara, CA 93101

SOMSEN, Steven L. '88
4426 Cahuenga Blvd 205
Toluca Lake, CA 91602-2379

SONDGROTH, Robert '80
769 22nd St.
Oakland, CA 94612

SONGER, James M. '80
1403 Hawthorne Terrace
Berkeley, CA 94708

SORENSEN, Wayne '58
414 W. 4th St. Ste. H
Santa Ana, CA 92701

SORIA, Robin F. '89
3911 Antone Rd.
Santa Barbara, CA 93110

SOSENSKY, Steven '87
10834 Blix Street #213
Toluca Lake, CA 91602

SOSKINE, Michael '75
10 Rue De Serigne
Paris, 75004, France

SOTELO, Ralph B. '59
17165 Pacato Crt.
San Diego, CA 92128

SOTO, Donald '58
P.O. Box 1392
Huntington Beach, CA 92646

SPAFFORD, Baron Erik '74
1727 Villa Ave.
Santa Barbara, CA 93101

SPANGLER, Glenn '51
1930 East 22nd Street
Oakland, CA 94606

SPARKS, Julie Ann '85
P O Box 3271
Glendale, CA 91201

SPATHIS, Dimitrios '86
801 Minnesota #10
San Francisco, CA 94107

SPAUR, RANDALL '89
887 Valle Vista
Vallejo, CA 94590

SPEAKER, Paul S. '77
2444 Ocean View Drive
Upland, CA 91786

SPENCE, Michael '72
266 Viejo St.
Laguna Beach, CA 92651

SPENCER, James '71
P.O. Box 726
Key Largo, FL 33037

SPERDUTO MOTO, STEVE '76
18 Willett Avenue
Port Chester, NY 10573

SPICER, Rodney J '88
5645 Wallace Pl.
Fremont, CA 94538

SPIELER, Tone '86
Flaskebekktjernet
1450 Nesodden, Norway

SPIERING, Scott Nathan '82
100 South Street 317
Sausalito, CA 94965

SPISAK, Chuck '74
P.O. Box 250808
San Francisco, CA 94125

SPOTO, Marie L. '86
831 Calle Laredo
Thousand Oaks, CA 91360

SPRING, Vicky '81
18819 Olympic View Dr.
Edmond, WA 98020

SPRINGER, Martin '73
RR #4, Box 311
Menomonie, WI 54751

SPRINGER, Tom '77
7142 Wildgrove Avenue
Dallas, TX 75214

SQUIER, James M. '78
3061 S. Robertson Blvd. #18
Los Angeles, CA 90034

SRODA, Dick '57
P.O. Box 981
Yucca Valley, CA 92286

SROKA, Michael J. '77
414 1411 7th Avenue NW
Calgary Alberta, T2N 0Z3, Canada

ST. JOHN, Tracy Ann '83
6204 Vista Del Mar
Playa Del Rey, CA 90293

STAAB, Kent '73
4276 Aloha Pl.
San Diego, CA 92103

STADE, Robert '53
150 Swett Road
Woodside, CA 94062

STAFFORD, Christine '89
23335 Maltby Place
Harbor City, CA 90710

STAKE, Tim '82
3002 S 208th St H15
Seattle, WA 98198
STALEY, Thomas M. '74
8720 Oakmont St.
Gaithersburg, MD 20877
STAMBAUGH, Debi '76
140 Robert Quigley Dr.
Scottsville, NY 14546
STAMBLER, Wayne J. '79
515 No Alta Dr.
Beverly Hills, CA 90210
STAMM, Brian D. '86
24282 Ensenada
Mission Viejo, CA 92691
STAMPS-HODNIC, Patricia '80
25633 Coulston St. #1
Loma Linda, CA 92354
STANARD-BARRINGTON, Wendy '86
3710 26th Place 104
Seattle, WA 98199
STANCIL, Laurence P. '84
2824 Arnott Street
San Diego, CA 92110
STANCLIFF, Robin L. '84
3441 N. Calle De Beso
Tucson, AZ 85715
STANGER, James R '87
250 West Curtice
West St. Paul, MN 55107
STANISZEWSKI, Ron M. '78
1817 Tawakoni Ln.
Plano, TX 75075
STANLEY, Robert C. '81
44100 Canyon Way
Lancaster, CA 93535
STAPLES, Thomas '86
6985 Isleview Road
West Vancouver, BC V7W2L1, Canada
STARR, Dale '83
5100 N. Ninth Ave. #C-335
Pensacola, FL 32504
STARR, G. Scott '86
5424 Rincon Beach Park Dr
Ventura, CA 930019721
STARRY, Frederick B. '61
P.O. Box 675
Richmond, CA 94808
STATEN, Troy B. '83
522 S. 31 Street
Mesa, AZ 85204
STAUB, Michael A. '86
311 Fairview Ave
S. Pasadena, CA 91030-1714
STECKLER, Steven '86
524 East Valerio
Santa Barbara, CA 93103
STECKLEY, Steven '77
330 Hillcrest St.
Madras, OR 97741
STEELE JR., Charles E. '88
2070 Brigden Rd
Pasadena, CA 91104-3341
STEEN, Alison
823 North Citrus Ave.
Los Angeles, CA 90013
STEENMARK, Gunner '52
Odelbergsvagen 76
12237 Enskede, Sweden
STEINER, Glenn '73
301 8th St. #212
San Francisco, CA 94103
STEINHARDT, Dan '79
7000 Boulevard East
Guttenberg, NJ 07093
STELCK, Douglas A. '81
1323 Robbins Street
Santa Barbara, CA 93101
STELLMAN, Beverly J. '84
Rt. 2, Box 253
Cokato, MN 55321
STENGEL, Marc K. '81
2042 Galbraith Dr.
Nashville, TN 37215
STEPHENSON, Mark '83
900 East 1st Street , #314
Los Angeles, CA 90012
STERBA, William T. '75
P.O. Box 359
Mineral Point, WI 53565
STERGIOPOULOS, Peter '87
198 Senior Drive Northcliff
Johanesburg, 2195, South Africa
STERLING-BREWER, Robin R. '88
16537 NE 33rd Court WW102
Redmond, WA 98052
STERN, Alison '84
1337 Cordilleras Ave.
San Carlos, CA 94070
STERNBERG, Steven '72
9 South Hawthorne Street
Manchester, CT 06040
STEUHMER, Robert '49
1594 Trumbower Avenue
Monterey Park, CA 91754
STEURY, Robin W. '81
4218 Rita Lane, #3
Bonita Springs, FL 33923
STEVENS JR., William '68
20 Highland Ave.
Madison, NJ 07940
STEVENS, Diane D. '83
15711 Pensacola Street
Westminster, CA 92683
STEVENS, JAMES R. '86
510 S. Mason Road Suite #A
Katy, TX 77450
STEVENSON, Harold '53
3639 San Remo Dr. #30
Santa Barbara, CA 93105
STEWARD, Eric Bradley '86
P.O. Box 12606
Salem, OR 97309-0606
STEWARD, Stephen D. '79
128 Rankin Street
Santa Cruz, CA 95060
STEWART, Buddy '67
Hwy. 25 South
Amory, MS 38821

STEWART, Cameron F. '76
46 West 37th Street
New York, NY 10018
STEWART, David L. '77
14408 E. Oxford Circle
Moorpark, CA 93021
STEWART, John '68
17644 L57th Ave. S.E.
Renton, WA 98058
STEWART, Leighton '51
P.O. Box 1296
Ventura, CA 93002-1296
STEWART, Lewis '62
P.O. Box 113
Port Costa, CA 94569
STEWART, Steve G. '77
25476 Buckly
Murrieta, CA 92362
STEWART, Thomas H. '77
P.O. Box 5063
Portland, OR 97208
STILLIANS, Christopher '74
2209 Wendy Way
Manhattan Beach, CA 90266
STILLMAN, Joseph '74
Box 155, 14 Spring Street
Gilbertsville, NY 13776
STOCK, Charles H. '84
P.O. Box 60303
Santa Barbara, CA 93160
STOCKMAN, Robert J. '85
802 N 40Th Ave, #39
Yakima, WA 98908
STODDARD, Ernest R. '75
6304 SE 20th Street
Portland, OR 97202
STODDARD, Scott K. '82
631 S. Adria St.
Anaheim, CA 92802
STOEBNER, Douglas A '86
1535 Rugby Circle
Thousand Oaks, CA 91360
STOFFER, Douglas L. '80
Box 524
Brigham City, UT 84302
STOKMO, Rune '89
496-A Hudson St. Suite "G-8"
New York, NY 10014
STOLKIN, Robert B. '83
1810 Harrison St 3
San Francisco, CA 94103
STOLTZ, Larry '69
124 Palisades Dr.
Santa Barbara, CA 93109
STONE, Kelly '84
487 Union Street
Brooklyn, NY 11231
STONER, Katherine A. '86
5953 Riverside Blvd 329
Sacramento, CA 95831
STOOTS JR., James '74
1130 Mission Ridge Dr
Manteca, CA 95336
STORY, Lisa A. '88
P.O. Box 705
Los Olivos, CA 93441
STOUT, Evans Ann '77
734 E. Anapamu Street
Santa Barbara, CA 93103
STOY, James '65
P.O. Box 723
Durham, CA 95938
STRAESSLE, Sebastian '85
31 Quai Anatole France
Paris, 75007, France
STRAKA, Robert '62
113 N. 3rd Street
Toronto, OH 43964
STRAND, Thomas L. '88
6937 Russell Ave. So.
Minneapolis, MN 55423
STRANGE, Roger '71
417 Mckenzie Drive
Henderson, NV 89015
STRANO, Aldo '73
10 Dennis Road
Newburgh, NY 12550
STRATTON, Ann E. '80
53 Gansevoort, 5th Fl.
New York, NY 10014
STRAUSBAUGH, Debbie J. 79
5224 SW Buddington St
Portland, OR 97219-7374
STRAUSS, Jeff L. '89
370 Imperial Way 129
Daly City, CA 94015
STREET, Brian '88
1459 S. Jameson Ln.
Santa Barbara, CA 93108
STREETER, Eugene '65
1323 Rialto Lane
Santa Barbara, CA 93105
STRICKLAND, Georgia M. '86
135 La Vuelta
Santa Barbara, CA 93108
STRINGFELLOW, Cecil '69
425 N. Central Expressway
Richardson, TX 75080
STRIPLIN, Patrick '79
10927 Roma Street
Fairfax, VA 22030
STRONG, Lawrence '86
Olive St.
Santa Ana, CA 92707
STRONG, Ronald '77
19046 Spindler (Dumbleton)
E. Detroit, MI 48021
STRONG, Russ '77
331 Beaumier Lane
Sobieski, WI 54171
STROUP, James R. '79
P.O. Box 8022
Mammoth Lakes, CA 93546
STRUBBE-HUMBARGER, Angela '87
1009 Red Oak Pl.
Chula Vista, CA 92010
STRUCKUS, Rommel P. '79
P.O. Box 321
Moffett Field, CA 94035

STUARD, Robert '72
P.O. Box 138
Oakwood, TX 75855
STUART, Ralph L. '81
2000 North Ivar, #14
Los Angeles, CA 90068
STUCKY, David A. '85
139 David Post Rd
Annandale, NJ 08801
STUDEBAKER, Daryl P. '75
240 E. 30 ST. #5B
New York, NY 10016
STUEDEMANN, Rebecca L. '90
6508 Parkdale Drive
Davenport, IA 52807
STURDEVANT, Jon F. '79
P.O. Box 300341
Denver, CO 80203
STUTZMAN, John H. '50
1625 Jefferson St.
Napa, CA 94559
SUAREZ, Andrew '70
1536 Ashley Rd.
Ramona, CA 92065
SUDA, Brian H. '90
62 3rd Ave. #2
Daly City, CA 94014-2634
SUDERMAN, William J. '76
6216 Prairie Rd NE
Albuquerque, NM 87109
SUDMEIER, Pat '80
P.O. Box 9467
Aspen, CO 81612
SUED, Yamil R. '85
425 Fairfield Ave., Bldg #4
Stamford, CT 06902
SUKIASIAN, George '78
2101 Smith Flat Road
Placerville, CA 95667
SULLIVAN, John Sanford '73
2319 E. Delmar Ave.
Pasadena, CA 91107
SULLIVAN, Kelly '90
921 W Mission
Santa Barbara, CA 93101
SUMMERHAYS, Vincent '88
296 Pebble Hill Place
Santa Barbara, CA 93111
SUMMERS, Christopher '79
1519 Tulane
Houston, TX 77008
SUMMERS, Timothy L. '86
1416 Clearview
Santa Barbara, CA 93101
SUMMERS, VICTORIA '84
3609 E. Olympic Blvd.
Los Angeles, CA 90023
SUNDT, Eric '87
1633 W 5th Place
Mesa, AZ 85201
SUNG, Sunny '79
145 Kings Road 12/B
North Point, Hong Kong
SUPPLE, David C. '77
3843 Chatwin Avenue
Long Beach, CA 90808
SURBEY, JOY O. '86
2517 Pepperwood Drive
Camarillo, CA 93010
SURES, Fred '64
33546 Emery Street
Los Angeles, CA 90023
SUTHERLIN, Jerry '75
P.O. Box 835
Clouderoft, NM 88317
SUTHERLIN, Miriam S. '70
P. O. Box 835
Clouderoft, NM 88317
SUTTER, Douglas D. '86
112 Sewall Street
Ludlow, MA 01056
SUZUKI, KAN '86
1-4-11 Kichijoji, Honcho
Musashino-shi Tokyo, 180, Japan
SVENSSON, Johan '84
Scand-Video AB, Huvudkontor 66055
500 06, 48 50 Box Boras 6, Sweden
SVOBODA, John '77
3211B South Shannon Street
Santa Ana, CA 92704
SVOBODA, Victor
3211 "B" S. Shannon St.
Santa Ana, CA 92704
SWAN, David L. '61
1000 SW Silver Lake Blvd.
Bend, OR 99702
SWANSON, David A. '86
847 West "B" Street
Ontario, CA 91762
SWANSON, Dennis M. '84
17710 Chatsworth St.
Granada Hills, CA 91344
SWANSON, Don '73
1162 W. Bobbie St.
Covina, CA 91722
SWARTZ, Bernard '84
40 Camino Alto
Santa Barbara, CA 93103
SWARTZ, Fred Kenneth '86
1029 A East Gutierrez
Santa Barbara, CA 93103
SWARTZ, Janet E '86
4930 Sportsman Drive
Anchorage, AK 99502
SWEARINGEN, G. Van '57
1817 Timber Trail N. W.
Cleveland, TN 37311
SWEEDEN, Virgil '71
P.O. Box 387
College Corner, NY 45003-0387
SWEENEY, Michael '60
2366 Rogue River Dr.
Sacramento, CA 95826
SWEENEY-FRANCIS, Carleen '83
P.O. Box 7772
Mammoth Lakes, CA 93546
SWEET, Helen R. '82
P.O. Box 1514
Culver City, CA 90232

SWENSON, John R. '77
P.O. Box 16535
Santa Fe, NM 87506
SWETT, Timothy '75
23511 S.E. 221st St.
Maple Valley, WA 98038
SWITZER, Michael J. '79
4704 176th St. SW, Apt. 8307
Lynnwood, WA 98037
SYKES, Drew G '88
140 Patterson #406
San Antonio, TX 78209
SYLVAN, Jeffrey '72
4329 Fireside
Moorpark, CA 93021
SYMS, Kevin '79
P.O. Box 2610
Sun Valley, ID 83353

– T –

TAFFURI, Richard '80
131 Brick Church Rd.
Spring Valley, NY 10977
TAFLAN, Jeff '81
12839 Moore Park Street, #16
Studio City, CA 91604
TAGGART, Kelly E. '86
1622 Edinger Ste. A
Tustin, CA 92680
TAKAHASHI, Koji '86
3-1-7 Chifuneho Matuyama
Ehime, 790, Japan
TALARICO, Roberto S. '78
3011 Gilbert Drive
Bensalem, PA 19020
TALBOTT, Arnold L. 71
DET 1, 1369th AVS/DUV
Kirkland AB, NM 87116
TALLEY, Keith E. '85
5337 10th Ave. S.
Minneapolis, MN 55417
TAM, Ronald K. '77
14 Essex Crescent
Kowloon Tong, Hong Kong
TANAKA, Randall K. '75
8035 Airlane Avenue
Los Angeles, CA 90045
TANG, David '73
4224 E. Fourth Street
Tucson, AZ 83711
TANNENBAUM, Dennis I. '75
105 5th Ave. #9A
New York, NY 10003
TANNER, Kyle '87
P.O. Box 6313
Burbank, CA 91510-6313
TAPSCOTT, Carolyn Jacobs '77
3062 Willowood Dr.
Bettendorf, IA 52722
TAPSCOTT, Rand '76
Deere And Company
Moline, IL 61265
TARLETON, JAMES G. (GARY) '80
P.O. Box 183
Corvallis, OR 97339
TARNOWSKI, John 69
P.O. Box 1268
Marathon, FL 33050
TARR, Robert '56
3100 Clubhouse Dr.
Sacramento, CA 95823
TATE, Marcus H. '78
5039 Hersholt Avenue
Lakewood, CA 90712
TATEISHI, Donald '67
1464 Shirley Dr.
Sacramento, CA 95822
TATSCH, Eldon '49
440 Alan Rd.
Santa Barbara, CA 93109
TAYLOR, Blaine E. '90
326 Juanita Way
San Francisco, CA 94127
TAYLOR, Christopher '85
1760 N. Decatur #29
Las Vegas, NV 89108
TAYLOR, Daniel K. '83
114 North Indian Hill Blvd #K
Claremont, CA 91711
TAYLOR, David '64
P.O. Box 59
Marshall, MN 56258
TAYLOR, Dennis D. '85
10855 Terra Vista Pkwy #84
Rancho Cucamonga, CA 91730
TAYLOR, Gail T. '80
35 Prospect Avenue
Bryn Mawr, PA 19010
TAYLOR, Gerald '85
2121 Stanwood Drive
Santa Barbara, CA 93103
TAYLOR, Glen '68
908 Seahorse Court
Ventura, CA 93003
TAYLOR, Jeffrey J. '77
17855 24th Pl. N.E.
Seattle, WA 98155
TAYLOR, John M '84
2214 E 7th St B
Charlotte, NC 28204-3387
TAYLOR, Stephen L. '90
431 Half Cooper Lane
Hot Springs, AR 71913
TCHERASSI, Samuel '88
1912 Whitley Avenue #305
Los Angeles, CA 90068
TEJADA, Adelaida L. '85
303 E. Seneca Street
Tahlequah, OK 74464
TELFER, David B. '87
816 Holiday Court
Stockton, CA 95207
TERCEIRA, Robert S. '77
875 Calle Cedro
Thousand Oaks, CA 91360
TERREBONNE, Wayne '71
2535 East 68th Street
Indianapolis, IN 46220

TERRY, James David '79
P.O. Box 89
Hood River, OR 97031
TESS, Stanley '76
8144 N. 33rd Avenue #129-5
Phoenix, AZ 85051
TEX, Steven A. '86
1886 Wedgemere Road
El Cajon, CA 92103
THERIOT, John '49
1924 Emerson
Santa Barbara, CA 93103
THIBEAU, TERRENCE J '87
P.O. Box 917
Cardiff, CA 92007
THISTLE, Todd A. '85
3521 Jersey Ridge Rd.
Davenport, IA 52807
THOM, Wayne '68
2905 No. Beachwood Drive
Los Angeles, CA 90068
THOMAS, Edward '86
8940 Rt. 34
Yorkville, IL 60560
THOMAS, James (Trey) '87
8340 Greensboro Drive
Mc Lean, VA 22103
THOMAS, Jonathan D. '90
812 N Euclid St
Fullerton, CA 92632
THOMAS, Kevin '90
1554 Knoll Cir Dr
Santa Barbara, CA 93103
THOMAS, Laura C. '86
590 San Clemente Drive
Ventura, CA 93003
THOMAS, Marguerite A. '86
3437 Dixiana Driveway
Lexington, KY 40517
THOMAS, Mark W. '83
141 West 26th Street
New York, NY 10001
THOMAS, Neil '77
655 Lambeth Ct.
Sunnyvale, CA 94087
THOMAS, Todd L. '88
P.O. Box 23116
Santa Barbara, CA 93121
THOMASON, Kenneth '60
502 West Heber
Glendora, CA 91740
THOMPSON, Alan D. '79
308 Appalachian Way
Martinez, CA 94553
THOMPSON, David L. '77
3326 Tilden Avenue
Los Angeles, CA 90034
THOMPSON, Elizabeth Bakhaus '81
237 Holiday Road
Lexington, KY 40502
THOMPSON, Jacqueline '85
522 W. Canon Perdido 52
Santa Barbara, CA 93101
THOMPSON, James E. '80
14803 E 24th Ave
Aurora, CO 80011
THOMPSON, John R. '76
2155 Geary Dr.
Santa Rosa, CA 95404
THOMPSON, Jon Q. '76
3313 24th Street
Lubbock, TX 79410
THOMPSON, Keith A. '81
2347 Eagle Drive
La Verne, CA 91750
THOMPSON, Michael J. '78
9318 215th St. S. W.
Edmond, WA 98020
THOMPSON, Michael P. '84
487 Union Street
Brooklyn, NY 11231
THOMPSON, Stephen '85
P.O. Box 2493
Southport, NC 28461
THOMPSON, T. Stephan '77
333 Pemberton Brown Mills Rd
New Lisbon, NJ 08064
THOMS, Hal D. '78
13341 Ethelbee Way
Santa Ana, CA 92705
THOMSON, Lance M. '82
298 Berry Street
Winnipeg Manitoba, R3J 1N2, Canada
THORMODSSON, Anna '83
Karfavog 26
Reykavik, 104, Iceland
THORMODSSON, Tryggvi '83
Karfavog 26
Reykjavik, 104, Iceland
THORP, Gordon A. '80
2205 Thorp Road
Green Cove Spri, FL 32043
THREADGILL, Tobin E. '80
6218 Victor Rd.
Dallas, TX 75241
THROOP, Enos T '72
P.O. Box 28
Washington Grove, MD 20880
TIBBETTS, LAWRENCE '76
5300 Overpass Rd. #B
Santa Barbara, CA 93111
TIERNEY, Stephen L. '90
2662 Montrose
Santa Barbara, CA
TILAS, Nicholas J. '80
33-34 75th Street
Jackson Heights, NY 11372
TILGHMAN, Michael S. '79
9042 West Glen
Dallas, TX 75228
TILTNES, Ingrid '87
Hoybovn. 14 D
Oslo 1, 1098, Norway
TIMM, Monique '88
116 N. Loop Dr.
Camarillo, CA 93010
TIMME, Johne '77
237 D Street
Salida, CO 81201

TIMMERMAN, William L. '76
63 E. Vernon Ave.
Phoenix, AZ 85004
TIMMONS, Terry '73
406 Sespe Ave.
Filmore, CA 93015
TINGDALE, Thomas S. '77
P.O. Box 869051
Plano, TX 75086
TINKER, JOHN ' 71
3133 Maple Drive #200
Atlanta, GA 30305
TINSMAN, R.B.
431 Caloric Circle
Topton, PA 19562
TIPPETT, Corinne '88
936 Commercial St
Palo Alto, CA 94303
TIPPETT, Jeffrey M. '84
6837 Nancy Ridge Drive, Suite G
San Diego, CA 92121
TIPTON, Scott A. '86
1268 E. Ramon #10
Palm Springs, CA 92262
TKACH, Daniel G. '78
554 Jasmine Lane
Santa Maria, CA 93455
TOENSING, Fredrick '75
60 E. 3rd North
Tooele, UT 84074
TOKUNAGA, Stanley '71
Local 659, 907 Vena Avenue
Arleta, CA 91331
TOLMAS, Jodi Y. '90
6108 Kentland Avenue
Woodland Hills, CA 91367
TOMACCIO, Ralph '74
50 Franklin St.
Framingham, MA 01701
TOMAS-HAMMOND, Alejandro '79
449 Old Coast Hwy., Suite 7B
Santa Barbara, CA 93103
TONG, Nanci '82
1522 Greencastle Ave.
Rowland Heights, CA 91748
TOONEY, Stephen '71
41 Second Avenue
Ilion, NY 13357
TORAASEN, Svein-Erik '87
Post Boks 93, Kjelsaas
Olso 4, 0411, Norway
TORREANO, David J. '84
1005 Pintail Lane
Wausau, WI 54401
TORRENCE, Ed '60
1856 E. Hawthorne St.
Ontario, CA 91764
TORRES, Ernesto J. '82
C/O Martin Torres
Moras 316 4th Piso, 12 D F, Mexico
TORRES, Jose L. '84
2301 Augusta Drive
Jefferonville, IN 47130
TOUSIGNANT, John C. '86
21 Basswood Street
Whitehorse Yukon, Y1A4P4, Canada
TOWNSEND, John '65
2073 Highway 200
Trout Creek, MT 59874
TRAHAN, Gerald (Jerry) '70
P.O. Box 66100
Chicago, IL 60666
TRAMONTANA, Brian J. '84
2174 Casa Mia Drive
San Jose, CA 95124
TRAVIS, John '72
9180 Riverside Drive
Brighton, MI 48116
TRAVIS, Thomas '80
1219 South Pearl
Denver, CO 80210
TREAT, Van H. '68
P.O. Box 247
Ponca City, OK 74604
TREIMAN, Dovida '87
13333 Constable Ave.
Granada Hills, CA 91344
TREXLER, Peter L. '79
1033 S Tyndall Ave
Tucson, AZ 85719
TRIMNELL, Philip '86
29 Bornu Crescent
Apapa, La , Nigeria
TRINDL, Joani R. '76
14030 Sylvan St .
Van Nuys, CA 91401
TRINIDAD, Max D. '80
1529 Marble Ct.
Chula Vista, CA 92011
TRIPENY, James T. '85
2831 Eye Street
Bakersfield, CA 93301
TROPIANO, Frank V. '76
10500 American Road
Cleveland, OH 44144
TROTTER, TRACY '73
8265 Kirkwood Drive
Hollywood, CA 90046
TROTZUK, G. Patrick
3608 Timberview Road
Dallas, TX 75229
TROVATO, Luca E. '87
496 A Hudson St. Suite G8
New York, NY 10014
TROWER, Thomas N. '77
1005 Elsie Mae Dr.
Boulder Creek, CA 95006
TROXELL, Paul '71
305 N. Reserve St.
Muncie, IN 47303
TRUAX, Lysbeth '87
3 Twin Lakes Circle
Corona Del Mar, CA 92625
TRUE, Joyce '81
215 Market Street
San Francisco, CA 94106
TRUESDALE, Greg '74
8525 Hudson Drive
San Diego, CA 92119

TRUESDALE, Kenneth '87
1448 Camino Lujan
San Diego, CA 92111

TRUESDELL, Helen Renee '77
8132 NW 78th Terrace
Oklahoma City, OK 73132

TSAI, Nicholas '83
2106 Mt. Olympus Drive
Hollywood, CA 90046

TSCHIRHART, Philip '80
1404 Jeffrey Drive
Cadillac, MI 49601

TSUTSUMI, Ako '90
1-11-13 Shimodori Kumamoto-Shi
Kumamoto, 860, Japan

TUAN, Ruh Kang (Joseph) '87
204 Brunswick Avenue
Toronto Ontario, M5S 2M5, Canada

TUCKER, John '87
3600 Eubank Blvd NE 1C
Albuquerque, NM 87111

TUCKER, Thomas E. '86
339 East Piru Street
Los Angeles, CA 90061

TUCKER, Timothy L. '86
818 Cambridge Place
Wheeling, IL 60090

TURNER JR., Ronald R. '87
195 W Portland Ave
Fresno, CA 937116041

TURNER, Richard E. '69
3501 Kentucky St.
Racine, WI 53405

TURNER, Richard W. '76
14 Choetaw Trail
Ormond Beach, FL 32074

TURNER, Robert '73
2384 SW Madison
Portland, OR 97205

TURNER, Terry '63
1307 N. 7th
Garden City, KS 67846

TURNER, Timothy '80
22 W. Bob White St.
Apopka, FL 32712

TUROUSKE, Ronald E. '79
94 Mayfield
Akron, OH 44313

TURVEY, Joyce M. '53
P.O. Box 141
East Glacier P, MT 59434

TUTTLE, Sandra
1769 Karameos Ct.
Sunnyvale, CA

TUTTLE, Steven '69
12 Fort Williams Pkwy.
Alexandria, VA 22304

TUTTLE, Tom '72
P.O. Box 6912
Santa Barbara, CA 93160

TWARDY, Joseph '69
2923 Middletown Road
Pittsburgh, PA 15204

TWINE JR., Robert E. '79
720 Kingston Drive
Virginia Beach, VA 23452

TWIST, Steven '85
14708 Nimshew Rd
Magalia, CA 95954

TWOMBLY, Craig E. '90
P.O. Box 192781
San Francisco, CA 94119

TYLER, Dennis A. '90
370 Imperial Way 129
Daly City, CA 94015

TYLER, Laura L. '85
1024 Moreno Way
Sacramento, CA 95838

TYLKA, Robert V. '61
6274 Noble Ave.
Van Nuys, CA 91411

TYNAN, Dana '83
425 Broome
New York, NY 10013

TYRRASH, Peter '73
4326 36th Ave. W.
Seattle, WA 98199

– U –

UCHIDA, Alesia K. '86
26710 Encinal Road
Salinas, CA 93908

UHL, Kathryn M. '83
3075 South Klencoe Street
Denver, CO 80222

ULISSI, John '71
178 N. Broadway
Pennsville, NJ 08070

ULLEMEYER, Michael '83
6253 Guava Ave
Goleta, CA 93117

UMANN, Mike A '87
22727 Haynes Street
Canoga Park, CA 91307

UMEMOTO, Ernie '62
433 London Park Crt.
San Jose, CA 95136

UNDA, Gabriel '72
102 Muir Circle
Woodland, CA 95695

**UNDERWOOD, RILLA B. '78
P.O. Box 67
Carpinteria, CA 93014**

UPSON, Stephen S. '79
MSIN A1-15, Room 124
Richland, WA 99352

URBANEK, Michael '74
P.O. Box 195
Ojai, CA 93024

URDAL, Arthur '75
803 Robin Ave.
Palm Harbor, FL 34683

UY, Lilen S. '90
Midtown Exe Homes Unt 11 1268 Un
Paco Manila, 1007, Philippines

UYECHI, Kojiro '52
234 S. Voluntario Street #I
Santa Barbara, CA 93103-3464

– V –

VACHON, Jean '81
95 Rue Prince
Montreal Quebec, H3E2M7, Canada

VADA, Jay '76
371 Greenport Dr.
West Carrollto, OH 45449

VAGT, Tyler A. '75
2340 Road L
Redwood Valley, CA 95470

VALA, Scott F. '76
7521 S E Knight St.
Portland, OR 97206

VALDIMARSSON, Halldor K. '84
P.O. Box 5488
Reykjavik, 125, Iceland

VALENTI, Grace M. '84
623 Holiday
Hazelwood, MI 63042

VALIQUETTE, Jacqueline N. '90
592 Lantana #93
Santa Barbara, CA 93101

VALLANCE, Walter Scott '87
4313 Campus
San Diego, CA 92103

VAN BLANKENSHIP, Debra D. '79
Illustration Ser. VCD, Surge II
Davis, CA 95616

VAN BYLEVELT, Suzette '82
2664 S. Santa Fe
Los Angeles, CA 90058

VAN CLEAVE-O'DONNELL,
Gretchen '80
17703 Moss Point Dr.
Spring, TX 77379

VAN DE MARK, Tracy L. '85
40655 N. 11th St. West
Palmdale, CA 93551

**VAN DE ZANDE, DOUGLAS '79
307 W. Martin Street
Raleigh, NC 27601**

VAN EWIJK TWEEDY, Elisabeth '88
4463 Greens Court
Livermore, CA 94550

VAN GIESON, Paul '69
1867 River Valley Drive
Germantown, TN 38138

VAN KRIEKEN, Donald '88
150 W. Plumstead Ave.
Yeadon, PA 19050

VAN METER, William Kent '77
761 St. Johns Ave.
Highland Park, IL 60035

VAN OOSTEN, Helen '87
G. Kasteinweg
Den Haag 2597 N2, Holland

VAN OPPENS, Caroline (Coco) '90
P.O. Box 640087
San Francisco, CA 94164

VAN OTTEREN, Juliet '84
15 Sussex Court
San Rafael, CA 94903

VAN OTTEREN, Thomas '84
15 Sussex Crt.
San Rafael, CA 94903

VAN PATEN, Dick '63
5233 Gaylord Dr.
San Diego, CA 92117

VAN PEBORGH, Paul E. '85
18693 McFarland
Saratoga, CA 95070

VAN PELT, Harold L. '51
752 N. Seward St.
Los Angeles, CA 90038

VAN SCIVER, Diane '86
3500 SE 22nd Ave
Portland, OR 97202

VAN SCOTT, David J. '83
3 Hidden Lane
Abington, PA 19001

VAN SCOY, William L. '80
4051 Glencoe Avenue #5
Marina Del Rey, CA 90292

VAN ZANDBERGEN, Kirk '81
Road 1, Box 339-B
Brackney, PA 18812

VAN ZANDBERGEN, Leslie '81
Road 1, Box 339-B
Brackney, PA 18812

VANDALE, Bruce E. '76
3886 State St.
Santa Barbara, CA 93105

VANDENBOSCH, Kim '86
5997 N. Thunderhill Rd.
Parker, CO 80134

VANDERWAL, Carol L. '79
5929 Elmonte
Fairway, KS 66205

VANDOROS, Alexander S. '89
Lichtensternstr 55
Floss Bavaria, 8485, West Germany

VANVOAST, Gregory S. '63
828 N. Ewing
Helena, MT 59601

VARELA, Richard Brent '90
27431 Bethanzo 5
Mission Viejo, CA 92692

VARGAS, Mario B. '89
996 Lawrence Drive, Unit 117
Menlo Park, CA 94025

VARGHA, Ruhi '85
2 Dallas Road
Ealing W.S., Lo, England

VARGO, Theresa Ann '87
2130 Bay Street
San Francisco, CA 94123

VARNEY, Paul R. '76
20 Rumson Road
Livingston, NJ 07039

VASQUEZ, James J '86
2046 Diffley Road
Eagan, MN 55122

VASSALLO, Toni Maria '85
P.O. Box 1892
Rancho Cordova, CA 95741

VASSALLUZZO, Italo A. '62
1059 Maple Ave.
Ardsley, PA 19038

VASSAR, William G. '80
1167 Sapphire Dr.
Livermore, CA 94550

VAUGHAN, Garth '86
321 Grace
Pueblo, CO 81004

VEBLEN, Laura H. '78
838 Via Covello
Santa Barbara, CA 93110

VEGA, Larry '82
7400 Stockdale Hwy C
Bakersfield, CA 93309

VELTROP, Todd '86
1234 N Las Palmas 301
Los Angeles, CA 90038

VENABLE, Ronald L. '83
4762 Driftwood Dr
Fremont, CA 94536

VENTOLA, Giorgio '78
368 West Huron 4th
Chicago, IL 60610

**VERBOIS, J. MICHAEL '72
P.O. Box 50406
Santa Barbara, CA 93150**

VEREBES, Tony '68
5757 Ranchita Ave.
Van Nuys, CA 91408

VERSTEEGH, Rolf R. '90
Peltlaan 51
Utrecht, Netherlands

VERSTRAETEN, Xavier '82
Billinghurst 1742 4th Fl.-L
1425 Buenos Aires, Argentina

VIDAL, Marc J. '79
22 Hoye St.
Terryville, CT 06786-1220

VIDARSSON, Gudmundur '88
Hladnamrar 46
Reykjavik, 112, Iceland

VIDELL, Dennis '73
629 220th Street So. West
Bothell, WA 98011

VILLEGAS, David E. '82
24374 Welby Way
Canoga Park, CA 91307

VILLEGAS, Theodore '86
12030 Downey Ave. #312
Downey, CA 90242

VINCENT, Jo Ann '78
1201 Mc Duffle #128
Houston, TX 77019

VINCENT, Kevin R. '78
1356 East Mountain Street
Pasadena, CA 91104

VIRNIG, Joseph A. '84
9094 Tamarind Ave
Fontana, CA 92335-5076

VIZCARRA, Paul '75
860 E. 238th St.
Carson, CA 90745

VLAHAKIS, Lana J. '80
543 Forest Avenue
Evanston, IL 60202

VOGEL, Hermann '64
19641 N.E. 12th Court
North Miami Beach, FL 33161

**VOGEL, PETER '88
528 Canal Street #4
New York, NY 10013**

VOGELER, Eduardo A. '83
Carrera Buenos Aires 5 Campo
Puerto Ordaz, Venezuela

VOGES, Deborah C. '89
10834 Stone Canyon Rd.
Dallas, TX 75230

VOIGT, Richard R. '75
4852 Washburn Ave S
Minneapolis, MN 55410-1850

VOLKMAN, Albert '73
7430 Saybrook Dr.
Citrus Heights, CA 95621

VOLMERT, John M '86
P.O. Box 280904
San Francisco, CA 94128

VON HOFFMAN, Bernard '78
2 Creenvillage Road
Madison, NJ 07940

**VON ISSER, KENT '83
2329 N. Tucson Blvd.
Tucson, AZ 85716**

VON SAROSDY, Anne Marie '85
111 Kirchfeldstrasse
Duesseldorf 1, D 4000, West Germany

VON TAGEN III, Walter H. '89
14875 Olive Avenue
Morgan Hill, CA 95037

VON WIESENBERGER, Arthur '75
P.O. Box 5658
Santa Barbara, CA 93150

VOORHEES, Steven '67
20850 Edgewood Drive
Big Rapids, MI 49307

VOZEL, Lawrence '70
550 Orange Ave. #106
Long Beach, CA 90802

VULTE, Pamela E. '83
740 Adella Lane
Coronado, CA 92118

– W –

WACHS, Ted '75
420 West End Ave., Apt 10 A
New York, NY 10024

WADDELL, Robert M. '81
155 Entrada Drive, #4
Santa Monica, CA 90402

WADE, Bill '47
2 Valleyview Rd.
Jacksonville, IL 62650

WADE, Kurt '80
P.O. Box 318
Jacksonville, IL 62651

WADE, Ted '71
7497 First St. N E.
St. Petersburg, FL 33702

WADSWORTH, Larry '79
819 Yegua #1
Bryan, TX 77801

WAGERS, Ralph '53
3282 Silverton Rd. N. E.
Salem, OR 97303

WAGGONER, Michael '82
P.O. Box 849
Kailua, HI 96734

WAGNER, Douglas J. '81
551 Grand Fir Avenue
Sunnyvale, CA 94086

WAGNER, Timothy L. '78
P.O. Box 9489
N. Hollywood, CA 91609

**WAGNER, WILLIAM '64
208 N. Avenue W.
Cranford, NJ 07016**

WAINGROW, Brian '81
12021 Wilshire Suite 612
Los Angeles, CA 90025

WAISMAN, Howard S '85
782 W. 52nd Avenue
Vancouver, BC V6P164, Canada

WAKEFIELD, Morton C. '48
9608 Samoline St.
Downey, CA 90240

WALCZAK, Kenneth J. '89
1008 Melbrook Drive
Munster, IN 46321

WALDO, John A. '83
2536 Cinderella Way
San Diego, CA 92045

WALDRON, Mark B. '90
5936 Fern Street
El Cerrito, CA 94530

WALDRON, William P. '81
451 Broome St. 7E
New York, NY 10013

WALDRUM, Stephen B. '75
P.O. Box 252
Happy Camp, CA 96039

WALKER, Angela D. '89
3102 S. Manitoba Drive
Santa Ana, CA 92704

WALKER, Donald L '86
P.O. Box 23021
Santa Barbara, CA 93121

WALKER, Leslie A. '86
P.O. Box 213
Beatty, NV 89003

WALKER, Vicke L. '83
22030 Lynette
Santa Clarita, CA 91380

WALLACE, Lisa E. '81
P. O. Box 2991
Gallup, NM 81301

WALLACE, Patrick R. '78
4362 SW Fraser Ave
Portland, OR 97225

WALLERS, Dennis '68
P.O. Betty's Bay
Cape Providence, 7141, South Africa

WALOWICZ, George '78
1188 Webster
Birmingham, MI 48009

WALSH, Allen R. '82
5828 207th Place S.W.
Lynnwood, WA 98036

WALSH, Joseph '71
4907 Yale Street
Amarillo, TX 79109

WALTER, Adrienne '88
3326 Camino Arroyo
Santa Ynez, CA 93460

WALTER, Richard '68
1150 Anchorage Ln.
San Diego, CA 92106

WALTERS, Daniel W. '85
P.O. Box 864
Pleasanton, CA 94566

WALTERS, Dean '73
831 A West Arrellaga
Santa Barbara, CA 93101

WALTERSCHEID, Eric A. '79
3356 Grand Ave.
Huntington Park, CA 90255

WALTH, Daniel M. '87
2633 36th Ave S.
Minneapolis, MN 55406

WALTON, George (Ted) '84
901 Pleasant Grove
Rogers, AR 72756

WALTZ, Robert E. '51
650 Tank Farm Rd.
San Luis Obispo, CA 93401

WARD, Richard O. '76
161 Shelter Cove. Dr.
Half Moon Bay, CA 94019

WARDROP, James R. '72
315 Academy Avenue
Sewickley, PA 15143

WARE, Laura R '87
1480 Edgewood Drive
Palo Alto, CA 94301

WARHOLAK, Fred J. '84
836 Brookwood Lane East
Rochester, MI 48063

WARNER, Larry L.
513 'N. Isabel
Glendale, CA 91206

WARNER, Whitey '72
1048 Livingston Ave.
North Brunswick, NJ 08902

WARNICKI, Joseph W. '76
6316 Jackson St.
Pittsburgh, PA 15206

WARNOCK, Kevin J. '86
86 Cragmont Avenue
San Francisco, CA 94116

WARREN, Leslie C. '83
3829 W Camino Real
Glendale, AZ 85310

WARREN, Pamela Erehwon '72
7354 Matilija Ave.
Van Nuys, CA 91405

WASHBURN, Dorothy '52
2110 Canyon Close Rd.
Pasadena, CA 91107

WASHINGTON, Michael '87
4600 Bohannon Dr.
Menlo Park, CA 94025

WASIUDDIN, Khwaja Shahab '84
1-2, Mymensingh Road
Dhaka 1000, Bangladesh

WASKEVICH, Thomas '53
P.O. Box 747
Menlo Park, CA 94026

WASVARY, Lawrence '64
15734 Harrison
Romulus, MI 48174

WATERMANN, Gregory '84
107 Reade St
New York, NY 10013

WATKINS, Phillip '80
1920 Arcdale Ave.
Rowland Heights, CA 91748

WATSON, James W. '67
3024 Conrow Dr.
Manhattan, CA 90025

WATSON, Jonathan Craig '89
9844 Tunney Ave.
Northridge, CA 91324

WATT, William J. '87
399 Shenstone Road
Riverside, IL 60546

WATTERS, Steve '83
1527 Channel Court
Fort Wayne, IN 46825

WAXMAN, Jeffry '77
5623 York Place
Goleta, CA 93117

WEAVER, Cheryl A '88
1187 Coast Village Rd., Ste. 119
Santa Barbara, CA 93108

WEBB, Drayton C. '81
5455 Dashwood Suite #300
Bellaire, TX 77401

WEBB, Harry '52
4506 46th S.W.
Seattle, WA 98116

WEBBER, Garth L. '85
211 E. Colmbine #A
Santa Ana, CA 92707

WECKHORST, Peter '86
2800 Gudlane Street
Las Vegas, NV 89122

WECKLER, Chad '76
7 St. Marks Avenue
Brooklyn, NY 11217

WEED, Andrew D. '84
436 Walden Lane
Hockessin, DE 19707

WEEDMAN, Blair '77
923 Clay
Hartford, KY 42347

WEEDMAN, Brent '73
106 Southburn Ct A
Hendersonville, TN 37075

WEEKS, Sandra L. '87
P.O. Box 69
Yountville, CA 94599

WEEKS, Bryne Dana '82
8022 Whitethorn Ave.
Cleveland, OH 44103

WEGST, Andrew '90
5420 Pawnee Ln.
Fairway, KS 66205

WEHMAN, Bruce '69
4747 Harrison Ave P.O. Box 7002
Rockford, IL 61125

WEICKUM, Sally J. '82
1733 Lucile Ave 11
Los Angeles, CA 90026

WEINBERG, Matthew D. '80
5683 Calle Pacific
Carpinteria, CA 93013

WEINPER, Bryan V. '84
407 North Elizabeth
Chicago, IL 60622

WEINSTEIN, Bruce T. '72
666 W. Shaw Ave. Std. #120
Fresno, CA 93704

WEINSTOCK, Carol A. '84
2028 Anacapa St.
Santa Barbara, CA 93105

WEINTRAUB, Larry S. '80
4654 Vista De Oro
Woodland Hills, CA 91364

WEIR, Gregg W. '87
2554 N. Beachwood Dr. #1
Los Angeles, CA 90068

WEISS, Stacy D. '86
2125 Westridge Road
Brentwood, CA 90049

WELCH, Colin E. '71
320 John Aselford Drive RR 1
Kanata Ontario, K2K 1X7, Canada

WELCH, Gary D. '75
302 Prairie Ridge Rd.
Highlands Ranch, CO 80126

WELCH, Tom '68
2113 Benbrook Dr.
Carrollton, TX 75006

WELCH, William J. '78
P.O. Box 1117
Santa Barbara, CA 93102

WELLER, Lawrence '71
406 6th Ave NW
Mandan, ND 58554

WELLER, Stephen D. '81
P.O. Box 211
Hampton, NH 03842

WELLS, Celeste A. '89
2009 Mezes
Redwood City, CA 94062

WELLS, John '72
P.O. Box 424
Anahola, HI 96703

WELLS, Marla T. '77
15502 Banff
Houston, TX 77062

WELSH, Dale R. '86
#5 Buckeye
Irvine, CA 92714

**WELSH, STEVEN C. '79
1191 Grove Street
Boise, ID 83702**

WEMYSS, John K. '85
400 Ortega #104
Mountain View, CA 94040

WENZLIK, Ted '75
9 Camino Castenada
Camarillo, CA 93010

WERLING, Scott D. '68
2758 Las Encinas West
Santa Barbara, CA 93105

WERNING, Paul G. '90
8020 Spartan Drive
Youngstown, OH 44512

**WERRE, BOB '71
2437 Bartlett St.
Houston, TX 77098**

WESLEY, Richard '74
3715 Canfield Ave. #210
Los Angeles, CA 90034

WESNER, Timothy J. '89
7455 Chaminade Ave.
Canoga Park, CA 91304

WEST, David Z. '74
Rt. #1, Box #5-11
Fritch, TX 79036

WESTELL, Lise Ann '86
1211 Pear Tree Lane
Houston, TX 77073

WESTLIND, Gregory '71
205 13th St.
Cando, ND 58324

WESTMAN, Jeffrey '83
4770 San Pablo Suite D'
Emeryville, CA 94608

WESTON, Matthew '81
18726 103rd Ave. N.E.
Bothell, WA 98011

WETTRE, Haakon '90
1943 Tamrind Ave., #208
Los Angeles, CA 90068

WHEATON, Martie '88
19 Alameda Padre Serra
Santa Barbara, CA 93103

WHEELER, Gary '72
244 Albion Street
Denver, CO 80201

WHEELER, Scott D. '85
1037 NE 113th Avenue
Portland, OR 97220-2211

WHELESS JR., Robert '73
5350 Amhurst Dr.
Norcross, GA 30092

WHICHER, Monna J. '77
P.O. Box 77
Wiarton, ON N0H 2T0, Canada

WHIELDON, J. Charles '76
P.O. Box 219
Point of Rocks, MD 21777

WHIPPLE, Barbara J. '69
755 International Blvd. T-107
Houston, TX 77024

WHISENANT, Charles '69
352 W 12th St
Eugene, OR 97401

WHITE, Bryne Dana '82
210 Newbury Lane
Newbury Park, CA 91320

WHITE, Carole '84
#1 Stanley Crescent S.W.
Calgary Alberta, T25161, Canada

WHITE, Gary W. '74
1835 Terminal Drive
Richland, WA 99352

WHITE, Jonathan R. '80
234 Lakeville Rd.
Great Neck, NY 11020

WHITE, Jordan K. '81
2643 Stoughton Way
Sacramento, CA 95827

WHITE, Perry E. '78
1228 Utah St.
Fairfield, CA 94533

WHITE, Robin '87
601 Minnesota St. #213
San Francisco, CA 94107-3026

WHITEHILL, Stephen '68
Department Of Philosophy
Albuquerque, NM 87131

WHITESIDE, Frank D. '76
4114 E. Mitchell Dr.
Phoenix, AZ 85018

WHITFIELD, Brent W. '83
816 S. Grand Ave
Los Angeles, CA 90017

WHITING, Maria L. '89
111 Dearborn Pl 85
Goleta, CA 93117-3504

WHITNEY, Robert '50
2269 Stratford Dr.
San Jose, CA 95124

WHITNEY, Stephen '69
78 Sagamore Rd.
Cranston, RI 02920

WHITTAKER, David A. '85
5831 Goodland Ave.
N. Hollywood, CA 91607

WHITTEN, Robert '54
2720 Concord Pike
Wilmington, DE 19803

WICKLIFFE, Louis "Clark" '71
548 College Avenue
Clemson, SC 29631

WIEBEN, Marvin '74
430 Main Street
El Centro, CA 92243

WIENER, Ronald '61
24413 Neece Avenue
Torrance, CA 90505

WIGHT, Timothy D. '90
1953 Elise Way "E"
Santa Barbara, CA 93109

WIKE, Marla D. '77
10944 224th Avenue
Bristol, WI 53104

WILBY, Terry '73
2952 Valencia Drive
Santa Barbara, CA 93105

WILCOX, William '61
12910 Rampart Dr.
Sun City West, AZ 85375

WILDE, Edward A. '76
7231 Franklin Ave. #7
Hollywood, CA 90046

WILDER, Arthur '74
7444 Saraview Way
Sebastopol, CA 95472
WILDER, Carolyn '84
119 Cedar Lane
Santa Barbara, CA 93108
WILDI, Ernst
10 Madison Road
Fairfield, NJ 07006
WILKEY, Linda '89
1841 Carmelina Drive
San Diego, CA 92116
WILKINSON, Jeffrey F. '88
6704 Corte Segunda
Martinez, CA 94553
WILKINSON, Lee '63
Rt. #5, Box 71
Maryville, TN 37801
WILL, John '54
4836 Winding Way
Santa Barbara, CA 93111
WILLECKE, BRIAN D. '86
4205 Stadium Dr. #150B
Fort Worth, TX 76133
WILLIAMS, Christopher S. '82
14 Chestnut St #A
Boston, MA 021083602
WILLIAMS, Dale '57
2925 E. Douglas
Wichita, KS 67211
WILLIAMS, Harold H. '79
705 Bayswater Avenue
Burlingame, CA 94010
WILLIAMS, HARRY L (SONNY) '84
555 Dutch Valley Rd. NE
Atlanta, GA 30324
WILLIAMS, Harry L. '86
2818 Carson Drive
Columbus, GA 31906
WILLIAMS, Jack '59
P.O. Box 1528
Sun Valley, ID 83353
WILLIAMS, Keith E. '88
P.O. Box 17891
Irvine, CA 92713
WILLIAMS, Marshall T. '90
1310 G Street
San Diego, CA 92102
WILLIAMS, Richard W. '56
14 Tyler St.
Novato, CA 94947
WILLIAMS, Ronald C. '79
105 A Space Park Dr.
Nashville, TN 37211
WILLIAMS, Todd A. '83
3636 Rio Loma Way
Sacramento, CA 95834
WILLIAMS, William T. '52
P.O. Box 1773
Smithfield, NC 27577
WILLIS, Gordon H. '80
3910 Buena Vista 23
Dallas, TX 75204
WILLIS, John W. '63
230 E. 6th Ave.
Escondido, CA 92025
WILLIS, William '49
1308 Lincoln
Pekin, IL 61554
WILLS, Bret '82
245 W. 29th St.
New York, NY 10001
WILLS, Russell A. '84
901 Pleasant Grove
Rogers, AR 72756
WILMOTT, Gary '85
87 Newcomb Drive
Ventura, CA 93003
WILMOTT, Gary '86
P.O. Box 1921
Ventura, CA 93002
WILSON, Christina M. '90
1288 Church Street
San Francisco, CA 94114
WILSON, Ina Marie '89
18 Grace Court
Corte Madera, CA 94925

WILSON, J. Diane '87
820 E. Lemon Ave.
Glendora, CA 91740
WILSON, Jim '65
1228 Hilltop Cove
San Marcos, CA 78666
WILSON, Kurt '88
1542-1/2 Vanderbuilt Place
Glendale, CA 91205
WILSON, Mark S. '81
2316 E. Main Street
Ventura, CA 93003
WILSON, Robert C. '75
8401 E. Cambridge
Scottsdale, AZ 85257
WINBURN, Gail T. '85
100 Little Melody Ln.
Lake Forest, IL 60045
WINDER-CORTOPASSI, Karen '76
2 Alba East
Irvine, CA 92720
WINDHAM-EHART, Anita J. '83
94 W 4th St .
Yuma, AZ 85364
WINDLE, Donald W. (Bill) '59
8208 E. Northland Dr.
Scottsdale, AZ 85251
WINES, Craig J '86
13911 Parkland Dr.
Rockville, MD 20853
WINEY, Gerald '73
1130 Rancho Rd
Ojai, CA 93023
WINGREN, John H. '88
326 Sunfield Street, N.
Sun Prairie, WI 53590
WINKLER, Mark '65
12150 Santa Ana
Atascadero, CA 93422
WINKLER, Ralph '63
19055 Quail Hollow Dr.
Brookfield, WI 53005
WINNER, David E. '86
722 Calle Alella
Santa Barbara, CA 93109
WINNER, ROBERT L. '82
1045 Palmetto Way I
Carpinteria, CA 93013
WINSLOW, James C. '85
525 W Walnut
Monrovia, CA 91016
WINSLOW, Kenelm H. '80
1811 Esters Rd. #2068
Irvine, TX 75061
WINSLOW, Laura '55
15 East Lenox Street
Chevy Chase, MD 20015
WINTERS, Vincent M. '84
5599 Hunter St.
Ventura, CA 93003
WINTHER, Lisa '80
12340 Rochester Ave. #223
Los Angeles, CA 90025
WISEMAN, Patrick L. '85
P.O. Box 62
Chatham, MA 02633
WITHROW, Jim '76
840 Kyle Street
San Jose, CA 95127
WITT, Karl Brock '82
8611 West Hampden #17-208
Lakewood, CO 80227
WITZENS, Bryan M. '82
1275 N. Maguire
Tucson, AZ 85715
WNUK, Alan J. '78
17 Picadilly Crt.
San Rafael, CA 94903
WOLCOTT, John S. '90
1600 W. Struck Ave.
Orange, CA 92667
WOLF, Thomas L. '88
3008 Genessee
Fort Wayne, IN 46809
WOLFE JR., Mal '62
5340 Parejo Dr
Santa Barbara, CA 93111

WOLFE, Daryl '79
P.O. Box 368
Smithburg, MD 21783-0368
WOLFE, William K. '87
700 Westmoreland Ave.
Portsmouth, VA 23707
WOLFGRAM, Craig G. '89
296 Marlborough St. #7
Boston, MA 021161612
WONDERS, Douglas Russel '69
P.O. Box 1342
Wilsall, MT 59086
WONG, Glenn '86
2601 S.E. 33 Place
Portland, OR 97202
WONG, Wang Yuen '90
201 W Montecito
Santa Barbara, CA 93101
WONG, William Y. '82
1113 Palo Alto Way.
Salinas, CA 93901
WOOD III, Merrell A. '71
Biarritz #76 Penthouse
Mexico City, 7, Mexico
WOOD, Donald W. (Bill) '59
11694 Pepper Avenue
Hesperia, CA 92345
WOOD, Byrne '86
303 St. Frances
Kennett, MO 63857
WOOD, C. Russell '74
416 Waverly St.
Menlo Park, CA 94025
WOOD, Cynthia L. '85
1760 N. Decatur Blvd. #29
Las Vegas, NV 89108
WOOD, Dana '67
11325 Isleta St.
Los Angeles, CA 90049
WOOD, Eliot '88
100 Oak Island Place
Santa Rosa, CA 95405
WOOD, Vernon '71
10756 W 12th Lane 3
Lakewood, CO 80215
WOOD, William Greg '86
19 Hillgrass
Irvine, CA 92715
WOODARD, Suzanne '85
2002 Plateau Drive
Gallup, NM 87301
WOODLIFF, Charles E. '77
11 W. Huling Ave.
Memphis, TN 38103
WOODRUFF, Kenneth G '56
258 Lakeview Circle
Mira Loma, CA 91752
WOODS, Charles '67
579 Corbett, #5
San Francisco, CA 94114
WOODS, David O. '77
7314 Hydrus Dr.
Harrison, TN 37341
WOODS, Dennis G. '77
6953 Wigwam Way
Reynoldsburg, OH 43068
WOODS, Jack '56
108 North 3rd Street
Hamilton, OH 45011
WOODS, James '76
3687 Las Posas Rd 186
Camarillo, CA 93010
WOODS, John J. '75
P.O. Box 625
Marina, CA 93933
WOODS, Kaelin '89
Pound Hollow Road
Old Brookville, NY 11545
WOODS, Loren '69
415 Montgomery Street
Hollidaysburg, PA 16648
WOODS, Paul '51
3950 Via Real #230
Carpinteria, CA 93013
WOODSON, Rod '66
2941 Wilson Ave.
Redding, CA 96001

WOODWARD, Thomas W. '83
6 Cherry St.
Petaluma, CA 94952-2168
WOODWORTH, Roger '69
7200 Devonshire Lane
Missoula, MT 59801
WOOLSLAIR, James C. '77
171 Admiral Way
Costa Mesa, CA 92627
WOOLSTRUM, Richard '62
23438 Bruella Rd.
Acampo, CA 95220
WOOTTON, Scott W '87
29800 Goldspike Rd
Tehachapi, CA 93561
WORMSER, Laurence K. '60
404 W. Highland Ave.
Redlands, CA 92373
WRIGHT, Christopher P. '89
485 Bethany Street
Thousand Oaks, CA 91360
WRIGHT, Jeffrey B. '87
571 Fifth St Apt 2B
Brooklyn, NY 11215
WRIGHT, Jennifer L. '83
1314 Olive St.
Santa Barbara, CA 93101
WRIGHT, Jonathan F '69
5810 N. River Forest Drive
Milwaukee, WI 53209
WRIGHT, Paul Douglas '80
1308 Conant
Dallas, TX 75207
WRIGHT, Robert '75
14600 Foothill Road
Golden, CO 80401
WRIGHT, Timothy H. '79
4920 Cleveland St. Ste. 104
Virginia Beach, VA 23462
WROBEL, David J. '83
1955 Yosemite St.
Seaside, CA 93955
WROOBEL, Barry '81
4446 Summerglen Court
Moorpark, CA 93021
WUCHENICH, Robert J. '77
1093 Freeport Road
Mars, PA 16046
WURST, James H. '72
Rd. #2, Box #346
Monroeville, NJ 08343
WYCKOFF, Julie A. '74
2990 V Drive, N.
Battle Creek, MI 49017-8818
WYCKOFF, Theodore '74
2990 V Drive North
Battle Creek, MI 49017-8818
WYLLIE, Dan '67
2506 Chandler Ave. #254
Simi Valley, CA 93065
WYLLIE, Donald '67
3117 Americano Crt.
Fairfield, CA 70733

– X –
X'MARKOS, JOHN
45 Seaview Drive
Montecito, CA 93018

– Y –
YAECKER, Kenneth A. '78
225 Triunfo Cyn. Rd. #223
Westlake Village, CA 91361
YAEGER, Linda A. '81
2894 Lausanne Ct.
San Jose, CA 95132
YAGHOUBZADEH, Babak '84
Premium Point
New Rochelle, NE 10801
YAMADA, Masato '78
12 E. 86th St. #628
New York, NY 10028
YAMADA-LAPIDES, Ricky '80
314 Capitola Ave.
Capitola, CA 95010

YAMPOLSKY, Gail '79
120 1/2 Coral Ave.
Balboa Island, CA 92662
YAPP, CHARLES '74
723 W. Randolph St.
Chicago, IL 60606
YARBER, Patricia A. '82
50120 Jackson St.
Coachella, CA 92236
YATES, Bradley '86
2140 Mentone Bl. #146
Mentone, CA 92359
YEANY, Keith A. '64
1430 Master Circle #163
Delray Beach, FL 33445
YEATES, Calvin B. '64
P.O. Box 2108
Sedona, AZ 86336
YELLIN, Jan M. '86
P.O. Box 81
N. Hollywood, CA 91603
YESKE, Donald A. '52
4804 Perina Way
N. Highland, CA 95660
YIN, Joseph Teh-Yuo '79
499 King's Rd., 10/F, North
North Point, Hong Kong
YINGLING, John '73
3120 Arrowwood Circle N.W2
Bemidji, MN 56601
YIP, Tommy Q. '81
4889 Tiffany Park Cir.
Santa Maria, CA 93455
YOCKEY, Fred '78
109 Jackson St.
Coldwater, MI 49036
YODER, Delvon K. '75
7 Benington St.
Needham Hts., MA 02192
YOUNG, George R. '69
667 Tennyson Ave.
Palo Alto, CA 94301
YOUNG, N. Eric '80
9700 Overbrook
Leawood, KS 66206
YOUNG, Robert '69
50 Ansel Avenue
Providence, RI 02907
YOUNG-WOLFF, David '78
1642 Ocean Park Blvd.
Santa Monica, CA 90405
YOUSSEF, Ashraf F '88
1216 Monroe St
Salinas, CA 93906-2735
YRISARRI, David W '88
1445 Melody Lane
Roanoke, TX 76262
YU, Charlene M. '88
2070 Brigden Rd
Pasadena, CA 91104-3341
YU, Oliver '84
711 Zeyn St.
Anaheim, CA 92805
YUEN, Andrew B.Y. '86
1749 N. Serrano Ave. #304
Los Angeles, CA 90027

– Z –
ZACCARDI, Michael J. '76
780 Sherwood Avenue
St. Paul, MN 55106
ZADOK, Clifford '74
20908 Calimali Rd
Woodland Hills, CA 91364
ZAMUDIO, Maria (Lupita) '88
211 Alpine Street
Oxnard, CA 93030
ZANONI, Enrique C. '89
J F Segui
Buenos Aires, 417, Argentina
ZEFTON, Tyler '83
1872 Cottonwood
Ballard, CA
ZEIGLER, Reid '72
P.O. Box 2000
Rathway, NJ 07065

ZEILER, Tracie L. '86
7733 Lucia Court
Carlsbad, CA 92008
ZELDIS, William F. '80
3631 San Gabriel Lane
Santa Barbara, CA 93105
ZELL, Victor J. '76
28 Willard Street
Binghamton, NY 13904
ZELLER, Nick '72
2922 S W Canterbury Ln
Portland, OR 972011808
ZIEGLER, Blake A. '76
3019 Janessa Way
Stockton, CA 95205
ZIMMER, Robert '71
4207 Sierra Morena Ave.
Carlsbad, CA 92008
ZIMMERMAN, David J. '81
36 W. 20th St. #10 Fl.
New York, NY 10011-4212
ZIMMERMAN, Gary E. '73
600 E. Rumble Rd.
Modesto, CA 95350
ZIMMERMAN, John D. '88
640 Lake Samm. Ln. N. E.
Bellevue, WA 98008
ZIMMERMAN, Michael '80
7821 Shalimar St.
Miramar, FL 33023
ZIPPER, Morry D. '77
6475-B E. Pacific Coast Hwy.
Long Beach, CA 90803
ZIRION, Kirk '74
2520 Gail Pl.
San Luis Obispo, CA 93401
ZLOTOROWICZ, Leonard '72
181 N. Baldwin Ave.
Sierra Madre, CA 91024
ZOSNOWSKI, James E. '87
10440 Brennan Road
Avoca, MI 48006
ZSARNAY, Christopher L. '88
502 E Santa Paula St
Santa Paula, CA 93060-2060
ZUBACK, William R. '88
2712 S. 102nd St.
West Allis, WI 53227
ZUBER, Jon A. '87
6831 Fortuna Road
Isla Vista, CA 93117
ZUCK, Betty F. '81
5829 Encina Road, #203
Goleta, CA 93117
ZUEHLKE, William A. '80
1832 E 38th St So.
Minneapolis, MN 55407
ZUGAY, Gary A. '76
3403 W. Maple Grove Rd
Farwell, MI 48622
ZULFICAR, Cherif '56
15 Marchly Street
Zamalek Cairo, Egypt
ZUMDAHL, Gary '61
690 Zink Avenue
Santa Barbara, CA 93105
ZUNIGA, Gilberto '80
Salina Cruz #7
Mexico City, 06760, Mexico
ZUNIGA, Maria C. '86
Av. Polanco #91
Mexico D F, 11560, Mexico
ZYBER, Thomas K. '84
Pratt Road
Jericho, VT 05465

GEOGRAPHICAL LISTING
INTERNATIONAL

ARGENTINA

Verstraeten, Xavier '82
Zanoni, Enrique C. '89

AUSTRALIA

Burkey, Darrell D. '77
Domingo, James M. '74
Hines, Scott J. '86
Nicolson, James R.V. '86

BANGLADESH

Wasiuddin, Khwaja Shahab '84

BELGIUM

Brasseur, Vincent H. '82

BOLIVIA

Salama, Ricardo '57

BRAZIL

Costa, Arthur F. '84
Fonseca, Sonia '82
Ford, Michael H. '76
Lima, Paulo '80
Lundgren De Miranda, Arthur '78
Neto, Victorino Oliveira '85
Silva, Flavio H. '76

CANADA

Bannister, Chris S. '81
Betel, Michael '84
Bowers, Roy '62
Boyd, Virginia C. '84
Brown, Charles T. '76
Calnen, Robert F. '71
Chapman, Mel '72
Charrey, Francis T. '66
Chiswell, Kirk B. '88
Clark, Robert G. '76
Connell, Martin H. E. '79
Cote, Daryl J. '87
D'estrube, Robert '72
Dase, Kenneth A '88
Duchart, Wayne '72
Duthie, Peter L. '81
Eaton, Peter M. '73
Fekete, Victoria M. '87
Fyen, Daniel '74
Garnett, Donald G. '81
Grubel, Heidi '89
Harvey, Douglas '86
Hewitt, Edward (Ted) W. '71
Hines, Sherman '68
Hume, Peter '89
Jang, George P. '76
Johnson, Christopher W. '87
Johnson, Grant D. '82
Johnson, Robin F. '72
Keevil, J. David '86
KISH, DONALD S. '72

Klassen, Ernie '81
Kowalczyk, Richard D. '81
Kurvink, Reid M. '83
Ng, Ronald '88
O'Brien-Bell, Catharine '84
Ogilvie, John B. '86
Paron, David W. '74
Rheault, Michel J. '81
Sage, Gerald '64
Sandiford, Peter H. '61
Shapiro, Mark '82
Shaw, James '86
Sroka, Michael J. '77
Staples, Thomas '86
Thomson, Lance M. '82
Tousignant, John C. '86
Tuan, Ruh Kang (Joseph) '87
Vachon, Jean '81
Waisman, Howard S '85
Welch, Colin E. '71
Whicher, Monna J. '77
White, Carole '84

CAYMAN ISLANDS

Beaty, Edwin '72

COLUMBIA

Congote, Carlos E. '82

EGYPT

Zulficar, Cherif '56

EL SALVADOR

Aparicio, Alfonso '52
Aparicio, Luisa '52

UNITED ARAB EMIRATES

Motiwalla, Dadiba '81

ENGLAND

Ariav, Avi '90
Fayaz, Leyla '80
Heard-Williamson, Shelley C. '84
Moore, John J. '60
Vargha, Ruhi '85

FINLAND

Leppala, Eija H. '85

FRANCE

Jeannin, Bruno '82
Lauge, Dominique '86
Myers, Christine '56
Ory, Philippe '87
Pujol, Sylvie '86
Soskine, Michael '75
Straessle, Sebastian '85

GREAT BRITAIN

Mallett, Ian P. '85

GUAM

Crisostomo, Herman A. '79
Delgado, Jose '59
Lamorena, Alberto A. '78

HOLLAND

Van Oosten, Helen '87

HONDURAS

Bleibtreu, Jason J. '84

HONG KONG

Halim, Rachmat '85
Sung, Sunny '79
Tam, Ronald K. '77
Yin, Joseph Teh-Yuo '79

ICELAND

Aegisson, Thor '87
Fridriksson, Fridrik '83
Olafsdottir, Sigridur '90
Thormodsson, Anna '83
Thormodsson, Tryggvi '83
Valdimarsson, Halldor K. '84
Vidarsson, Gudmundur '88

INDIA

Dastur, Jennifer R. '82
Kasbekar, Atul A '88
Mohamed, Iqbal '87
Pithawala, Urvix D. '87
Sista, Apu V. '88

INDONESIA

Hadisoewondo, Soeroto '63
Leonardi, Indra '87
Leonardi, Iskandar '88
Sioe, Ing Ming '86
Soerjanto, Iswanto '90

IRAN

Farhood, Haghi

ISRAEL

Kochavi, Ilan '68
Shoham, Shlomo '80

ITALY

Arceneaux, Jules '82
Ferraris, Franco '86
Gentile, Silvio '84
Laurenzo, Sandro '84
Paterno-Castello, Guido '84

JAPAN

Chan, Johnny L. '85
Ishikawa, Kakoto '73
Ishikawa, Koryo '89
Ito, Motoi '85
Kodachi, Yasuzo '82
Kusano, Takahisa '82
Laquan, Kan Suzuki '86
Maki, Yoshimasa '66
Mori, Kazutoshi '90
Nakao, Yoshihiro '88
Nakaoka, Yasuhiro '82
Okamoto, Noboru '86
Okuda, Mariko '88
Parisek, Charlie '87
Sakai, Naoki '86
SUZUKI, KAN '86
Takahashi, Koji '86
Tsutsumi, Ako '90

KOREA

Kim, Seung Bum '88
Kim, Young-Soo '82
Lee, Ju Yong '85
Oh, Hyoung Kewn '88

MALAYSIA

Baba, Mahmud Bin '74

MEXICO

Acevedo, Lourdes '82
Cardenas, Alicia Rico '87
Cespedes, Jaime '85
Cowan, Lourdes Acevedo '82
Esparza, Sergio A. '86
Galindo III, Pedro '78
GAVILAN, CARLOS P. '79
Gil, Federico B. '78
Herrera, Hector A. '82
Infante, Juan Diaz '82
Itami, Alfredo Aki '76
LLORENTE, RODRIGO '81
Lobeira, Cristina '86
Ortiz, Almudena '87
Ortiz, Roberto '82
Perez-Gavilan, L. C. '80
Rico, Alicia '87
Robinson-Bours, Jesus R. '82
Salguero R., Agustin
Torres, Ernesto J. '82
Wood III, Merrell A. '71
Zuniga, Gilberto '80
Zuniga, Maria C. '86

NETHERLANDS

Hoogendijk, Robert '87
Jacobs, Willem F. '83
Versteegh, Rolf R. '90

NIGERIA

Bouari, Samira '86
Trimnell, Philip '86

NORWAY

Arvesen, Knut '86
Bentzrud, Connie '88
Berg, Finn '86
Cabot, Mark W. '74
Gullvag, Jo Grim '79
Haavind, Thorbjoern '89
Kjarnes, Erling '87
Kjollesdal, Hallstein '84
Kojan, Mette '85
Lid, Trond I. '82
Lund, Nils '87
Moe-Nilssen, Leif '75
Nordstrom, Cecilie '87
Nordstrom, Helen C. '87
Pedersen, Knut K. '83
Qvale, Knut '87
Sandahl, Fredrik '90
Schultz, Marius '86
Soderstrom, Hans '83
Spieler, Tone '86
Tiltnes, Ingrid '87
Toraasen, Svein-Erik '87

PAKISTAN

Azad, M. A. '57
Raza, Asif '82
Sadiq, Zahid '82

PANAMA

Leon Jr., Warren E. '73

PERU

Sato, Luis A. '78

PHILIPPINES

Huang, Eduviges Y. '68
Huang, Frederick '68
Navasero, Luz Amandolina C.
(Mandy) '81
Uy, Lilen S. '90

POLAND

Klimczak M. A., Wladyslaw

PUERTO RICO

Bacon, Mark '76
Ortiz, Rosa Del C. '84

REP OF CHINA

Denlinger, Paul '85
Lung, Arone H '87

REP OF TRINIDAD

Flemming, Paul '87

SINGAPORE

Auroye, Carol M. '85
Lim, Stephen S. h. '86

SOUTH AFRICA

Bughwan, Nalin Dennis '77
De La Porte, Victor '54
Stergiopoulos, Peter '87
Wallers, Dennis '68

SOUTH AMERICA

Lechtman, Joseph '75
Madrid, Najib George '78

SOUTH KOREA

Lee, Nan-kyu '85

SPAIN

Ardevol, Jose M. '84
Berenguer, Andres '90
Icaza, Francisco '85
Icaza, Patxo '85
Machado, Ignacio '90
Palmers, Jan '86

SUDAN

Ahmed, Mohamoud
Idris, E. A. '63
Mdris, El Sayed A. R. '63

SWEDEN

Ehde, Staffan '83
Liljeros, Raymond '87
Lundstrom, Nils O. '87
Parsons, Herbert N. '83
Steenmark, Gunner '52
Svensson, Johan '84

SWITZERLAND

Hauer, Ursula M. '64
Isler, Rudolph '82
Morgan, Christian '85
Pizer, Thomas S. '82

TAHITI

Rutgers, James

TAIWAN

Chang, Miao-Yu '86

THAILAND

Nana, Somsak A. '69
Silpavcang, M.P. '75

VENEZUELA

Bello, Felipe X. '82
Poleo, Javier A. '82
Ricken, Guillermo '87
Vogeler, Eduardo A. '83

VIRGIN ISLANDS

Fisher, Scott L. '81

WEST AFRICA

Oshilade, Israel G. '57

WEST GERMANY

Buettner, Susanne '86
Guenther, Christian J. '86
Martini, Juliet T. '76
Rosemann, Guido H. '89
Vandoros, Alexander S. '89
Von Sarosdy, Anne Marie '85

WEST INDIES

Roopnarine, Roderick R. '83

UNITED STATES

ALABAMA

ATHENS
Crossfield, Roy '61

BIRMINGHAM
Adams, Paul R. '74

HUNTSVILLE
Smith, Rick W. '81

KASILOF
Letzring, Michael J. '86

MILLRY
Knight, Woodie S. '86

MOBILE
Goraum, Steve '83

MONTGOMERY
Brereton, Richard D. '77

ALASKA

ANCHORAGE
Brady, Kathleen E. '83
Castleton, Glen '52
Fischer, Thomas B. '75
Haugen, Harry A. '87
Mitchell, Linda S. '89
Nelson, John M. '80
RIEHS, RONALD '89
Ross, Alexander (Sandy) '57
Ross, Brad '89
Smith, Randy F. '90
Swartz, Janet E '86

EAGLE RIVER
Grohol, John V. '82

HOMER
Rosen, Jim E. '79

JUNEAU
Bosworth-Hensley, Sally C. '75

NORTH POLE
Gumaer, Glenn F. '86

SOLDOTNA
Quick, Daniel L. '69

WASILLA
Smith, Bud '69

ARIZONA

CHANDLER
David, Ronald '70
Schmitz, David J. '88

COTTONWOOD
Lightel, George C. '56

DEWEY
James-High, Janie L. '83

FLAGSTAFF
Miller, Eugene C. '74

GLENDALE
Bower, Gene L. '69
Browning, Robert L. '78
Pacura, Timothy G. '83
Warren, Leslie C. '83

GLOBE
Mercer, Joseph '74

GRAND CANYON
Appel, John '68

MESA
Crouch, Michael L. '76
Duecy, Charles M. '78
Ehlke, Robert '57
Embery, Richard B. '78
Ferguson, Robert '83
Frey, Karen E. '89
Goettings, Jon Michael '82
Landrum, Jerry L. '80
Reynolds, David A. '80
Staten, Troy B. '83
Sundt, Eric '87

NOGALES
Garrison, Ruben J. '79

PAGE
Lusso Long, Carol '71

PARADISE VALLEY
Keefer, Anna Lee '85

PEACH SPRINGS
Nelson, John William '81

PHOENIX
Baker, Lane C. '84
Cruff, Kevin L. '79
Dillon, Dwight R. '80
Graham, Rick G. '83
Hall, Nicholas C. '80
Hamm, Robert B. '89
Hartmann, Paul F. '85
Lindquist, Robert F. '89
Londot, Greg '86
Marshall, James W. '80
Petroff, Earl '55
Rinkenberger, Steve M. '78
Tess, Stanley '76
Timmerman, William L. '76
Whiteside, Frank D. '76

PRESCOTT VALLEY
Gonzalez, Veda Smith '80
Krivdo, Donna '55
Krivdo, Jack K. '55

SCOTTSDALE
Beasley, Thomas O. '86
Hays, L. Scott '83
Jones, Thomas M. '71
Lax, William J. '79
Lewis, Gene G. '83
Martin, William L. '79
Miller, John '73
Schlatter, David C '87
Wilson, Robert C. '75
Windle, Donald W. (Bill) '59

SEDONA
Breedlove, Michele '82
Falk, Eugene '62
Yeates, Calvin B. '64

SIERRA VISTA
Mac Collum, William V. '85

SUN CITY WEST
Wilcox, William '61

TEMPE
Rahn, Reed S. '84

TUCSON
Ash, Adrienne '72
Botkin, Bradley S '87
Burk, Thomas L. '60
Davis, Carol E. '84
Duenes, Richard '68
Findysz, Mary A. '78
Hansen, Bradley K. '84
Hedgcock, Charles A. '81
Khoury, Fouad R. '81
Stancliff, Robin L. '84
Tang, David '73
Trexler, Peter L. '79
VON ISSER, KENT '83
Witzens, Bryan M. '82

WADDELL
Cress, Bobbi L. '85

YUMA
Cordery, Donald '61
Ehart, John R. '83
Hyland, Greg '80
Windham-Ehart, Anita J. '83

ARKANSAS

BENTON
Bragg, Robert E. '58

CANEHILL
Bemis, Warren '71

HOPE
Davis, Clyde '62

HOT SPRINGS
Taylor, Wayne '75

LITTLE ROCK
Chambers, George H. '80
Mills, David '87

MAUNELLE
Becker, Steven D. '82

MESA
Shill, Sterling '86

PHOENIX
Lantz, Steven T. '85

PRESCOTT
Mahoney, James R. '85

ROGERS
Overton III, Niel (A.D.) '89
Schen, Karen L. '89
Walton, Fred (TED) '84
Wills, Russell A. '84

SPRINGDALE
Crockett, Joseph '65

W. MEMPHIS
Manly III, Charles F. '89

CALIFORNIA

ACAMPO
Woolstrum, Richard '62

AGOURA
Alcon, Jodye '86
Bosch, Marc Mc Gregor '86
Reisman, Alex '49
Rezaienia, Mehdi '84

AGOURA HILLS
Mathew, Craig T. '83

ALAMEDA
Kayler, Eric '64

ALAMO
Means, Laura L. '87

ALBANY
Felix Green, Stefanie A. '78
Gardiner, Cory A. '78

ALHAMBRA
Newcomb, Von S. '89

ALTA LOMA
Jenkins, John F. '77

ALTADENA
Masten, William N. '71
Moddelmog, Emily J. '89

ANAHEIM
Baragar, Ken W. '75
Belzer, David E. '86

Bergher, Keith R. '78
Bischetsrieder, Joseph '72
Fitzpatrick, Michael R. '77
Franz, Diane G. '89
Futtrup, Inge Lise '82
Howard, Ralph '53
Johnson, Lowell M. '58
Lester, Clifford '78
Roberts, Wendy L. '86
Rodvold, Richard '69
Shankman, Sam '50
Stoddard, Scott K. '82
Yu, Oliver '84

ANDERSON
Goodan, Robert Lee '55

ANGELS CAMP
Gianelli, Robert A. '84

ANTIOCH
Reisner-Probasco, Frances L. '85

ANZA
Hallenback, Robert '52

ARLETA
Tokunaga, Stanley '71

ARNOLD
Macho, John E. '72
Manchester, Scott '81
Rothwell, Mike '69

ARROYO GRANDE
Pierce, Allen '75

ATASCADERO
Boonisar, Pete '72
Cobarr, Gregg '71
Robinson, Kenneth E. '89
Winkler, Mark '65

AUBURN
Ingersoll-Harrison, C. '86
Nicholson, Janet C. Mcminn '75
O'Leary, Cindra '85

BAKERSFIELD
Abbott, Douglas K. '82
Alfter Fielding, Judy M. '84

Barrentine, Scott '86
Hislop, Scott B. '83
Hoffman, Richard T. '74
Hubbard, Wood '72
Iger, Gregory '66
Izard, Charles '58
Martin, Donald W. '83
MASON, DONALD C. '79
Mc Bride, Michael '82
Miller, Daniel D. '48
Nichols, Gregory J. '84
Pearson, Roxanne Bogner '75
Tripeny, James T. '85
Vega, Larry '82

BALBOA ISLAND
Yampolsky, Gail '79

BALDWIN PARK
Phillips, Virgil W. '78

BALLARD
Zetton, Tyler '83

BARSTOW
Cowen, Jeffrey O. '86
Cowen, John J. '86

BASS LAKE
Mueting, Don W. '52

BEN LOMOND
Alperin, Michael '69
Kline, Kurt '82

BERKELEY
Alrich, Diana Meek '64
Cook, Donald '63
Johnson, Fredrick O. '83
Mc Williams, Douglas M. '60
Pennington, Sally J. '76
Ringman, Steve F. '76
Sheldon, Janice M. '80
Songer, Julia G. '83

BEVERLY HILLS
Castiel-Dahan, Linda '87
Green, Suzanne J '86
Lassoff, Marc S. '84
Mishima, Thomas E. '88

CALIFORNIA (continued)

Nelson, Douglas M. '88
Rouhi, Keyhan '69
Schoenhut, Robert J. '74
Smith, Jordan F. '85
Stambler, Wayne J. '79

BIG BEAR LAKE
Millener, Richard A. '76

BIG SUR
Mc Coy, Constance '75

BISHOP
Cortez, Jon R. '90
Rockwell, Edwin '52

BLYTHE
Anderson, Eric '86
Cochet, Paul '74

BONITA
Cothren, Howard B. '78

BOULDER CREEK
Pomeroy II, Donald '68
Trower, Thomas N. '77

BRENTWOOD
Pollock, Marcia A. '84
Weiss, Stacy D. '86

BUELLTON
Dame, James '75
Haynes, Tom '60

BUENA PARK
Brooks, Mark A. '81

BURBANK
Bean, Bradley L. '85
Breault, Jerry '73
Dayton, Ted '76
Gallyon, Charles M. '78
Greenawald, Todd W '89
Hearn, Edd '49
Hole, Jeffrey '72
Nilsson, Phillip D. '85
Peltekian, Barkev '61
Sater, Jennifer D '88
Schwartz, Michael '77
Tanner, Kyle '87

BURLINGAME
Haag, Steve '72
Hoogner, Mike '70
Kott, Harry '47
MURAKAMI, KEITH H. '86
Williams, Harold H. '79

BYRON
Chaponot, Robert '65

CALABASAS
Blandin, Lynda M. '83
Dickinson, Roger J. '79
Haller, Kurt '87

CAMARILLO
Blanchard, John W. '88
Cory, Gordon '52
Dufore, Joseph '71
Duke, Stephen C. '89
Seyle, Albert '69
Sheldon, Benjamin L. '83
SURBEY, JOY O. '86
Timm, Monique '88
Wenzlik, Ted '75
Woods, James '76

CANOGA PARK
Armenaki, Arledge '78
Bernstein, Robert A. '69
Eichenlaub, Robert S. '71
FUGATE, RANDY '75
Moerman, Chris '88
Nikaido, Victor '69
Ramsay, Roger '85
Umann, Mike A '87
Villegas, David E. '82
Wesner, Timothy J. '89

CANYON COUNTRY
Arnold, Steven D. '82
CHOPPE, GARY R. '83
Harrop, Thomas R. '83
Lee, Andrew '83

CAPISTRANO BEACH
Amos, Karen '89

CAPITOLA
Arnot, Melville '62
Yamada-lapides, Ricky '80

CARDIFF
Smith, Charles J. '78
THIBEAU, TERRENCE J '87

CARLSBAD
Dickens, James L. '78
Nibecker, Paul '86
Noon, Charles R. '77
Pfrang, Terry J. '83
Schnoeker, Kent '77
Zeiler, Tracie L. '86
Zimmer, Robert '71

CARMEL
Brown, Patrick V. '85
Cash, William C. '90
Chamberlain, Fred G. '81
Geiger, Gary '74
Jacobs, Carolyn S. '77
Rainier, Chris G. '80

CARMEL VALLEY
Lovell, Craig I. '80
Rankin, Jon '85

CARMICHAEL
Benson, Donald '68
Denning, Wayne H. '81
Dugas, Gary '90
Hegre, Thomas '50
Morgan, James '49
Olson, Jon Raymond '76

CARPINTERIA
Bibo, Douglas J. '85
Bogart, Scott '86
Broughton, Christopher '85
Chaffee, Jim '59
Coates-Edwards, Marilyn '87
Cooper, Warren R. '48
Corella, Jeffrey S. '89
Gould, Gerald L. '79
Green, William '73
Hayes, David M. '83
Korrow, Chris C. '83
Leary, Daniel '74
Malone, Steve '72
Mann, L. Paul '80
Mc Clellan, Robert L. '72
Odett, Carolyn R. '80
Peishel, Robert W. '81
Schuit, Tammy '86
Sfetku, Stephen A. '86
UNDERWOOD, RILLA B. '78
Weinberg, Matthew D. '80
WINNER, ROBERT L. '82
Woods, Paul '51

CARSON
Vizcarra, Paul '75

CASTAIC
Morton, Jeffrey D. '83

CASTRO VALLEY
Beaton-Ahern, Kathleen R. '83
Mc Bride, Jacqueline '82

CATHEDRAL CITY
Gilissen, Cynthia M. '90
Millington, Carl '51

CHATSWORTH
Brukiewa, Larry B. '78
Clark, Timothy M. '78
Hass, Kevin Lee '70

CHICAGO PARK
Kawamoto, Marvin '59

CHICO
Collins, Arthur J. '84
Dewey, William B. '75

CHINO
Schrum, Terrence L. '76

CHOWCHILLA
Day, Raymond W. '48
Rabon, Roger '83

CHULA VISTA
Masterson, Vance '82
Roberts, Paul '74
Sassano, Anthony '50
Strubbe-Humbarger, Angela '87
Trinidad, Max D. '80

CITRUS HEIGHTS
Collins, James P. '88
Mc Neil, Larry C. '78
PAZEN, RICHARD K. '89
Volkman, Albert '73

CITY OF COMMERCE
Foster, Mark W. '77

CLAREMONT
Angel, Don '55
Nesbit, Roland '83
Taylor, Daniel K. '80

CLOVIS
Garcia, Edwin '75

COACHELLA
Yarber, Patricia A. '82

COLTON
Martinez, Richard '79
Schmitz, Jack '65

COMPTON
Davis, Kenneth '62

CONCORD
Baronian, Danny '72
Degennaro, Daniel '77
Grivas, John P. '85
Moseley, Lawrence '71
Quintard, Bryan '74
Sasaki, Larry '74

CORONA
Felipe, Rodolfo '74
Koehler, Richard '78
Moseley, Daniel '70

CORONA DEL MAR
Essig, Steve '71
O'Connor-Fitzgerald, Kathryn '86
Truax, Lysbeth '87

CORONADO
Sloman, Jean P. '80
Vulte, Pamela E. '83

CORTE MADERA
Giles, Jeffery '80
Wilson, Ina Marie '89

COSTA MESA
Agins, Judd '86
BARE, JOHN R. '76
Derosa, Michael '77
Fortner, George C. '75
Giraud, Steve '74
Murray, Dave H. '80
Pearshall, Donald '71
Preston, Stuart W. '83
Schwartz, Rick '82
Sherman, Sharon '86
Woolslair, James C. '77

COTTONWOOD
Ashe, Richard W. '89
Boles, Christopher P. '77

COURTLAND
Cowsert, Frank '53

COVINA
Portillo, Anthony R. '83
Swanson, Don '73

CULVER CITY
Bear, Brent J. '75
Glenn, Richard B. '78
Gray, Dennis '74
Hess, J. Daniel '83
Marsall, Jacqueline '73
Sweet, Helen R. '82

CUPERTINO
Anderson, Michael K. '75
Bates, Arthur '67
Dillon, George '70

CYPRESS
Cote, Guy '67
Mc Donald, Gregorio '83

DALY CITY
Nersveen, Joseph R. '88
Strauss, Jeff L. '89
Suda, Brian H. '90
Tyler, Dennis A. '90

DANA POINT
Gass, Neal E. '76
Netzeband, Kenneth '75
Snipes, Dan '76

DANVILLE
Johnson, Roger Lewis '76
Laurence, Peter '86

DAVIS
Hall, Jeff H. '65
Van Blankenship, Debra D. '79

DEL MAR
BUBAR, JULIA ANNE '84

DIABLO
Rodgers, John W. '90

DIAMOND BAR
Panton, Gary T. '79

DIAMOND SPRINGS
Fox, Charles K. '83

DINUBA
Buratovich Jr, Nick '76
Nippoldt, David '86

DOWNEY
Applegate, Brian J. '80
Powell, John R. '75
Villegas, Theodore '86
Wakefield, Morton C. '48

DUARTE
Smith, Charles R. '90

DUBLIN
Clohan, Roderick R. '87
Harris, Fred '49

DURHAM
Stoy, James '65

EARLIMART
Nelson, Ramon L. '75

EL CAJON
Bledsoe, Susanne '85
Newman, Kerry D. '84
Tex, Steven A. '86

EL CENTRO
Schofield, James V. '51
Wieben, Marvin '74

EL CERRITO
Waldron, Mark B. '90

EL DORADO HILLS
Davies, Stephen R. '81

EL MONTE
Bolderoff, Michael '64

EL SEGUNDO
Lott, Laurie Ann '81
Snyder, Ronald J. '76

EL TORO
Britton, Howard W. '60
Morgan, Michael P. '78

ELK GROVE
Long, Mark A. '77

EMERYVILLE
Kapler, Jerry '65
Westman, Jeffrey '83

ENCINITAS
Danforth, John '58
Edwards, Grant '73
Houldin, Cindy N. '78
Schulz, John C '88

ENCINO
Chow, Sterling '88
Claudy, Guy '74
Golovchinsky, Ken '89
Midgette, Danielle '88
Schapiro, Martin Bennett '86

ESCONDIDO
Abbott-Dalton, Sally '87
Brandos, Donald C. '79
De Lellis, Joseph C. '82
Osborn, David J '86
Willis, John W. '63

EUREKA
Cobeen, Kenneth M. '68
Hess, Douglas '70

EXETER
Calado, Procopio '58

FAIR OAKS
Bravo, Jesse '61
Moore, John S. '90

FAIRFIELD
D'Iouhy, Thomas '74
Mc Cauley, Robert L. '76
White, Perry E. '78
Wyllie, Donald '67

FALLBROOK
Borst, Roger William '69

FILMORE
Timmons, Terry '73

FOLSON
Mercier, Allan G. '76

FONTANA
Cormany, George J. '78
Virnig, Joseph A. '84

FORT BRAGG
Droz, Frederick C. '79

FOUNTAIN VALLEY
Ocana, Teresa '83

FREMONT
Bell, James H. '75
Fink, Ted J. '82
Firestone, Jeff R. '81
Smith, Terry M. '85
Spicer, Rodney J '88
Venable, Ronald L. '83

FRESNO
Archer, Robert T. '65
Arth, Raymond G. '75
Brown, Franklin '73
Davidson, Robert S. '70
Forbes, Kenneth J. '90
Freitas, Joe I. '75
French, Bob '77
Geissert, William '72
Goldberg, Rennie N. '78
Kausch, Christopher P. '85
Michelotti, Robert '49
Miller, Daniel Leo '87
Murashima, Harry '58
Nachtigall, Kelly '78
O'Brien, George "O.B." '79
Reed, Kenneth '61
Turner Jr., Ronald R. '87
Weinstein, Bruce T. '72

FULLERTON
Johnson, Mark C. '86
Mc Kemy, Lee '71
Mehlman, Marla '78
Thomas, Jonathan D. '90

FULTON
Maggi, Julie M. '84

GARDEN GROVE
Childress, Joe '71

GARDENA
Hayashida, Frank '60

GASQUET
Harris, Walter K. '50

GILROY
Clark, William D. '88

GLENDALE
Andreas, Peter '77
Angulo, Timothy E. '78
Baird, Michael Scott '84
Hodgdon, Donald Paul '82
Huntley, Laura '88
Huntley, Mark '87
Mc Namara, Wendy '80
Norman, Margaret M. '90
Smith, Kevin M. '77
Sparks, John Ian '85
Warner, Larry L.
Wilson, Kurt '88

GLENDORA
Thomason, Kenneth '60
Wilson, J. Diane '87

GLENHAVEN
Sharp, Sterling '70

GOLDEN
Bator, Joseph E. '78

GOLETA
Celli, Michael '89
Chen, Tzu-Yu '90
Cook, Craig C. '84
Craig, Bob '85
DEKKER, NICHOLAS '68
Drake, Jennifer L '89
Driskel, Dana '77
Dusseault, George '61
Estrada, Kenneth A C '90
Fleming, John P. ("Jack") '78
FOGLE, CLAYTON A. '78
Gilbertson, Virgie '78
Goldsmith-Green, Deborah Lynn '79
Green, Harvey '57
Hall, Matthew H. '86
Hennessey, Joseph C. '65
Henson, Pamela G. '85
Hieter, David C. '82
Hoaglad, Harold '50
Iverson, Elmo '49
Karpynka, Walter '72
Krueger, Gregory '78
Lowe, Robert H. '90
Ollis, Donald '47
Osborn, James L. '87
Pan, Chien Hung '89
Pollack, Gerald A. '78
Quintana, Mario E. '83
Schneider, Dana P. '76
Ullemeyer, Michael '83
Waxman, Jeffry '77
Whiting, Maria L. '89
Zuck, Betty F. '81

GRANADA HILLS
Bermudez, Jorge '83
Meiss, Lou '67
Swanson, Dennis M. '84
Treiman, Dovida '87

GRASS VALLEY
Creager, Richard '84
Osborn, Nathan W. '80

GREENBRAE
Mc Garrah, Daniel '82

HALF MOON BAY
Ward, Richard O. '76

HAPPY CAMP
Waldrum, Stephen B. '75

HARBOR CITY
Kao, Ray C. '85
Stafford, Christine '89

HAYWARD
Blanton, William '50
Sharkey, Ethan C. '89

HEALDSBURG
Gehring, Susan M. '86

HERCULES
Henneg, Robert A. '75

HERMOSA BEACH
Comeaux, Andre' L. '90
Davidson, Jerry '80
Evans, Robert M. '78
Odgers, Kristen Gray '86

HESPERIA
Wood, Brent J. '77

HIGHLAND
Clevenger, George '72
Cotten, Robin '90

HILLSBORO
De Monet, Ricardo '72
Liou, Larry '86

HOLLYWOOD
Aktutay, Duhndar '58
Aronian, Scott '73
Davis, Dale '64
Davis, Scott R. '82
Deibler, Debora K '88
Evans, Scot '89
Giunca, G. Edward '82
Jahiel, Adam D. '89
Le Blanc, Gary P. '86
Mac Donald, Dennis '82
Mader, Rich '87
Matsumoto, Motoaki '86
Mitchell, Cameron '82
Mitchell, Josh '89
Poe, Faith '90
Qabazard, Bader '90
Simic, Jennifer J. '90
TROTTER, TRACY '73
Tsai, Nicholas '83
Wilde, Edward A. '76

HUNTINGTON BEACH
Chuan, Jason '86
Coralnick, David G. '87
Ewers, Richard '50
Huffman, Robert E. '50
Jenkin, Bruce '85
Keesal, Carolyn '87
Mathiesen, Tim '70
Rethorn, Peter B. '77
Soto, Donald '58

HUNTINGTON PARK
Walterscheid, Eric A. '79

IMPERIAL BEACH
Holt, Syndee L '76

INDIO
Green, George '63

INGLEWOOD
Roberts, Wen '61

IRVINE
Belmonte, Frank '82
Burkhardt, Bruce J '88
JARRETT, MICHAEL D. '78
Korba, Anthony '64
Morgan, Gwen E. '85
Morrissey, Wesley O. '77
Peterson, Bob
Peterson, Robert A. '78
Saidi, Marjaneh '88
Welsh, Dale R. '86
Williams, Keith E. '88
Winder-Cortopassi, Karen '79
Wood, William Greg '86

ISLA VISTA
Maldonado Jr., Rafael '75
Roberts, Ben K. '70
Zuber, Jon A. '87

JOSHUA TREE
Roy, David K. '55

JUNE LAKE
Hoff, Theresa M. '77

KINGS BEACH
Ordway, Robert J. '85

LA CRESCENTA
Baker, Gary '67
Boettger, Claus H. '74

LA JOLLA
Barth, Michael '68
Burholm, Perry '61
Fox, Ken '83
Lauve, Leonard '67
Safford, Scott '73

LA MESA
Beauregard, Medford '76
Martin, Anderson '70
PANZARELLA, JOSEPH A. '89

LA MIRADA
Pflanzer, Chris A. '84

LA PALMA
Daniel, John N. '69

LA PUENTE
Sandoval, Ronald L. '84

LA SELVA BEACH
Gutzmer, Ron '74

LA VERNE
Gautreau, David A. '80
Lober, Robert '50
Thompson, Keith A. '81

LAFAYETTE
Hageman, Jare '60
Kjelland, James P. '90
Plummer, Bill '67

LAGUNA BEACH
Barnhardt, Rebecca F '90
Bennett, James '78
Gage, Rob
Haebler, William '81
Palau, Daisy B. '81
Phillippe, Greg '73
Segerblom, Lia A. '80
Silver, Karen S. '86
Spence, Michael '72

LAGUNA HILLS
Diangelo Burch, Lisa M. '82
Edward Hunerlach, Brian '90
Mitchell, Daniel P. '86

LAGUNA NIGUEL
Anderson, D. Steven '86
Fry, Steven A. '78
Fuller, David D. '78
Mantecon, Scott B. '90

LAKE ELSINOR
Copelan-Malovich, Verna Pat '79
Malovich, Pat '79
Nichols, Reed '80

LAKE PEEKSKILL
Chesnut, Richard J. '76

LAKESIDE
Barber, Charles J. '55
Barber, Karla Wolf '56
Mc Lean, Steven D. '89

LAKEWOOD
Denison, Rebecca S '87
Tate, Marcus H. '78

LANCASTER
Barnhart, Jim '79
Bergthold, Lee '86
Howard, Dave '70
Kardinaal, Phillippe '84
Kocurek, Phillip M. '88
Stanley, Robert C. '81

LEMON GROVE
Clutinger, Thomas M. '88
Smith, Peter '74

LINDSAY
Meyer, Daniel '75

LIVERMORE
Van Ewijk Tweedy, Elisabeth '88
Vassar, William G. '80

LODI
Hays, Edward A. '51
Miller-Arzamendi, Janet E. '83

LOMA LINDA
Stamps-Hodnic, Patricia '80

LOMPOC
Bannister, Robert B. '78
Brian, Terry L. '74
Ferenz Jr., John J. '88
Fort, David '74
Goldsmith, Gregory A. '79
Lefkowitz-O'Brian, Linette '76
Marchione, Nicholas '79
Noel, Albert '71
Shaw, Raymund O. '76

LONG BEACH
Canaday, Robert F. '83
Creelman, Peter D. '88
Heckethorn, Gregg A. '79
Keller, Robert G. '84
Kitzman, John R. '77
Langley, Norman G. '80
Mac Cullen, Mark S. '78
Mc Crorey, Larry '80
Mudge, Alan W. '62
Rayl, J. Edward '81
Scheller, Justin F. '87
Sharp, Robert A. '62
Supple, David C. '75
Vozel, Lawrence '70
Zipper, Morry D. '77

LOOMIS
Lorance, David W. '75

LOS ALAMITOS
Hughes, Joseph '66

LOS ALTOS
Aronson, Andrew S. '90
Begley, Maureen A. '80
Nakamura, George '61
Silverson, Jane '89

LOS ALTOS HILLS
Dowling, W. Lescher '66
Gable, James '74

LOS ANGELES
Allen, Tom E. '87
Atlas, Joseph '82
Bates, Frank G. '79
Baylis, Dane F '88
Bereny, Brett '87
Bizzaro, Douglas H. '90
Bjoin, Henry E. '78
Blair, Timothy A. '79
Bodnar, Joe '55
Bollason, Asgeir '88
Boylan, Michael D. '86
Breitborde, Steven H. '79
Buckner, Kenneth D. '71
Budnick, Victor '73
Bunnell, David D. '86
Burke, Kevin '74
Burton, Elizabeth T. '83
Caputo, Anthony I. '78
Chesser, Michael '73
Chou, Chih-Ping (Ricky) '84
Chua, Henry S. '83
Colmenares, Angel '82
Crowley, Elliot '79
Dannehl, Dennis M. '80
Deichman, J.C. (Chip) '71
Delareulle II, Robert '82
Derobertis, Mark '83
Early, John R. '87
Eastabrook, William R. '56
Ebbers, Russell B. '85
Endler, Michael S. '80
Epstein, Greg E. '83
Everitt, Arthur L. '90
Faubel, Warren A. '83
Fisher, Kenneth S. '82
Fitzgerald, Dan '77
Ford, John M. '81
Frank, Lois '85
Frederick, James R. '90
Fredriksz, Winnie '81
Freedman, Holly R. '89
Freytag, Arnold '74
Galland, Sean '86
Gervais, Lois F. '77
Gervase, Mark C. '82
Giovanni, Edward '81
Glispie, Oliver '58
Goldstein, Steven '83
Goodman, Todd F. '83
Green, Barbara Lynn '86
Grimshaw, Paul W. '81
Hall, Kimball R. '83
Hartman, Raiko Z. '78
Hatcher, Robert '79
Hawley, Larry J. '77
Heinz, John D. '73
Helderman, C. Rocky '79
Henderson, Edwin B. '83
HENRY, J. GREG '88
Hicks, Stephen '78
Hilton, Michael '69
Hirshan, Karen H. '87
HOGG, PETER '66
Hulten, Pernilla '90
Hurter, Bill '77
Ikemiya, Tom '54
Jacob, Teodorico '84
Jacobson, Neil '72
Jeffrey, James '71
Johnson, Keith S. '79
Jones, Dianne '89
JUSTICE, KEN
Kim, Todd '82
Kleinman, Sam O. '82
Kokin, Kenneth J '86
Lamonica, Tracy S. '85
Landgraf, Luiz '82
Lang, Charles '46
Lau, Graham J. '88
LE BON, DAVID M. '75
Leavitt, Charles G. '58
Lebon, David M. '75
Levine, Cynthia J. '85
Locke, Adrienne E. '81
Magdaleno, Karen K '88
Malone, Stanley R. '86
Mankolsky, Isidore '57
Martinez, Joseph '89
Matzdorff, Michael G. '90
Mc Cullum, Dawn L. '90
Mc Mullen, Andrew
Miligan, Thomas E. '81
Mineau, William J. '75
Mintz, Ira S. '87
Montes De Oca, Arthur '72
Morduchowicz, Daniel '85
Muller, John '82
Muro, Ruben Z. '80
Newman, Michael W. '80
Ng, David '90
Nichols, Philip S. '80
Norris, Mark John '89
Okazaki, Cary A. '85
Pearlson, Gary '85
Pearson, Duane B. '81
Pearson, Lee E. '83
Priesont, Lloyd '67
Quinn, John T. '87
Reed, Robert '74
Regan, William A. '79
Rich, Joel F. '80
Riedel, Michael A. '85
Rigelhot, John H. '86
Robinson, Richlain '72
Rothman, Michael '73
Rudd, David L. '81
Safron, Marshal H. '71
Salas, Rick H. '79
Sarpa, J. Jeffry '80
Schenker, Lawrence R. '79
Schulman, Scott C. '88
Schwartz, Barry '72
Schwentker, Harry N. '72
SILVERMAN, JAY E. '75
Sissman, Robert A. '75
Slater, Douglas B. '88
Smith, Scott A. '81
Smith, Stephen '87
Sohn, In Hee
Squier, James M. '78
Steen, Alison
Stephenson, Mark '83
Stuart, Ralph L. '81
SUMMERS, VICTORIA '84
Sures, Fred '64

CALIFORNIA (continued)

Tanaka, Randall K. '75
Tcherassi, Samuel '88
Thom, Wayne '68
Thompson, David L. '77
Tucker, Thomas E. '86
Van Bylevelt, Suzette '82
Van Pelt, Harold L. '51
Veltrop, Tad '86
Waingrow, Brian '81
Weickum, Sally J. '82
Weir, Gregg W. '87
Wesley, Richard '84
Wettre, Haakon '90
Whitfield, Brent W. '83
Winther, Lisa '80
Wood, Dana '67
Yuen, Andrew B.Y. '86

LOS BANOS
Sansoni, Henry '49

LOS FELIZ
Martin, Maryska '81

LOS GATOS
Brundege, Barbara '89
DuPuis, Cathy M. '90
GEIKEN, STACY
Park, Craig W. '84
Power III, Charles '73
Ranoa, Robert A. '82

LOS OLIVOS
Story, A. Lisa '88

LOS OSOS
Flynn, Dale W. '76
Lepp, George D. '72

MAGALIA
Twist, Steven '85

MALIBU
Bertinelli, David '87
Ceppi, Donald J. '77
Haney, William V. '77
Mc Neill, Diana J. '90
Meluso, Louis '83
Murphy, W. Timothy '90
Pena Jr., Julian '76

MAMMOTH LAKES
Brown, Scott '87
Stroup, James R. '79
Sweeney-Francis, Carleen '83

MANHATTAN BEACH
Abbott, Brian S. '84
Herwegh, Lauranne A. '82
Marinelli, Lawrence '90
Masho, William E. '79
Merrifield, Douglas C. '75
Moore, Ronald '72
Newby, Thomas W. '83
Norwood, David S. '76
Stillians, Christopher '74

MANTECA
Hannah, Sidney '55
Stoots Jr., James '74

MARINA
Woods, John J. '75

MARINA DEL REY
Adelman, Brian '72
Buechler, Barbara Thompson '84
Eldorado, Carla Jean '77
Van Scoy, William L. '80

MARIPOSA
Burnett, Christopher '75

MARSHALL
Fields, John '53

MARTINEZ
Greer, Paul '72
Serat, Julia Ann '87
Thompson, Alan D. '79
Wilkinson, Jeffrey F. '88

MENLO PARK
Vargas, Mario B. '89
Washington, Michael '87
Waskevich, Thomas '53
Wood, C. Russell '74

MENTONE
Yates, Bradley '86

MILBRAE
Rider, Robert D. '75

MILL VALLEY
Andrews, Timothy N. '78
Brown, William Aulden '86
Elsman, Kenneth R. '85
Engh, Barbeau '66
Marshall-Edney, Robin E '88
Pack, William R. '81
Schulwolf, Sanford '88
Sluchak, Jan E. '79

MILPITAS
Leslie, Judy '77
Martinez, Joseph '73
Moore, Carl '64

MIRA LOMA
Woodruff, Kenneth G '56

MISSION HILLS
De Souza, Alex '90

MISSION VIEJO
BAKER, FRANK '79
Beshk-Bud, Kim A. '85
Cohen, Jeffrey S. '89
Fuller, Richard L. '89
Hansen, Robert A. '78
Hapner, Jeff '89
Schrader, Dann P. '80
Sexton, Michael J. '89
Stamm, Brian D. '86
Varela, Richard Brent '90

MODESTO
Baird, Richard '54
Cawley, Kenneth '52
Costley, Jim '68
Costley, Sue Maurer '68
Ibarra, Ralph '87
Mollath, Brad '78
Radcliff, Robert '65
Zimmerman, Gary E. '73

MOFFETT FIELD
Struckus, Rommel P. '79

MOJAVE
Hamilton, Donald '75

MONROVIA
Kee, Richard '74
Klynjan, Nora '87
Winslow, James C. '85

MONTCLAIR
Orvis, Walter R. '58

MONTE SERENO
Kimble, Robert E. '55
Mulbry, Matthew W. '80

MONTECITO
Brown, Timothy S '90
Cluett, Christina G. '76
Ellington, Robert '89
Goubeaux, John '90
Hatzimarkos, John (X'Markos) '79
Kirkeby, M. Brian '90
X'MARKOS, JOHN

MONTEREY
Fry, Christopher J. '78
Kallas, E.S.
Mc Cullough, George '82

MONTEREY PARK
Steuhmer, Robert '49

MOORPARK
Campbell, Tom '71
Stewart, David L. '77
Sylvan, Jeffrey '72
Wroobel, Barry '81

MORENO VALLEY
Brubaker, Chris R. '82
Dickerson, Earl L. '85
Hutcheson, James '59

MORGAN HILL
Bystrom, Jack R. '79
Dashnaw, Michael C. '87
von Tagen III, Walter H. '89

MORRO BAY
Mc Creery, Scott H '88

MOUNTAIN VIEW
Ammon, Scott A '88
Nuding, Pete '62
Shire, Michael '88
Skarsten, Michael L. '81
Wemyss, John K. '85

MURRIETA
Berg, Randel L. '77
Stewart, Steve G. '77

N. HIGHLAND
Alvis, David C. '83
Borges, Martin F. '82
Correia, Robert S. '89
Green, Lewis S. '57
Yeske, Donald A. '52

N. HOLLYWOOD
Abroms, Edward '83
Avelar, Kim D. '90
Bienstock, Amir '81
Browne, Eric W '89
Demetriou, Georgios '83
Egle, William L. '76
Gottlieb, Jeffrey A '88
Huckaby, Dennis '74
Lorenz, Gregory L. '90
Norwood Brown, Angela M. '89
O'Reilly, Kathleen '80
Rush, Jim '73
Schlocker, Albert J. '84
Seelig, Edwin '74
Segalo, Walter A. '65
Wagner, Timothy L. '78
Whittaker, David A. '85
Yellin, Jan M. '86

NAPA
Aasheim, Helmer T. '46
Blondin, Bruce R. '61
Dacanay, Joe '76
Stutzman, John H. '50

NEWARK
Del Gaizo, Joseph '55
Misserian, David '86
O'Brien-Misserian, Sarah D. '87

NEWBURY PARK
Ciccone, Bruno A. '87
Curtis Sr., Steven A. '89
Curtis, Todd M. '86
Gabbard, Ernest '73
Klawitter, Michael A. '75
Lewis, John C. '82
Robinson, Skeffington '74
Shea, Michael P. '82
White, Bryne Dana '82

NEWPORT BEACH
Blom, John L. '75
Dixon, Cynthia M. '87
Fabre, Stephen J. '85
Indiek, Kathryn A. '89
Jahns, Jo Lynn '76
James, David A. '83
Porter, Gregory A. '86
Porter, James '73

NIPOMO
Mitchell, Donald M. '80

NORTHRIDGE
Dodds, P. Michael '70
Rieger, Arthur R. '67
Sibley, John A. '77
Watson, Jonathan Craig '89

NOVATO
Lirette, Stuart K. '84
Peterson, Jeffrey D. '61
Scarlett, Donald '83
Williams, Richard W. '56

OAKDALE
Ousley, Renee D '86

OAKLAND
Armata, Laura M. '89
Au, George '59
Baker, William L. '69
Bradford, Robert '73
Caldwell, Edward G. '82
Deliantoni, Richard '84
Eagle, Edward '74
Fu-Bradford, Sabina '73
KELLER, GREG
Lloyd, Victor S. '77
Mentor, James O. '90
Moore, Joe L. '69
Sondgroth, Robert '80
Spangler, Glenn '51

OCEANSIDE
Canchola, Wendy '86
Gheyssarieh, Abbas '78
Hayward-Canchola, Wendy K. '86
Mastres, Tony J. '90

OJAI
Billings, Richard '71
Boyd, William '74
Holden, Jerome T '86
Hromadik, Randall '69
Morrison, Betsy J. '87
Urbanek, Michael '74
Winey, Gerald '73

OLYMPIC VALLEY
Riebe, Daniel C. '83

ONTARIO
Levine, Hugh S. '80
Mitzenmacher, Patricia A. '86
Swanson, David A. '86
Torrence, Ed '60

ORANGE
Blumenfeld, Klaus
Erdkamp, Michael J '88
Lally, Daniel '80
Mosher, Douglas F. '89
Wolcott, John S. '90

ORANGEVALE
Callaway, Alex '67
Lockhart, James E. '76

ORCUTT
Fisher, Gail L '88

ORINDA
Johnston, Laura L '88

OXNARD
Burke, Gail P. '73
Foss, Frederick '60
Guy, Roland S. '86
Harbaugh, Gregory '76
Hinostro, Robert '59
Hohweiler, Rita M. '82
Joyce, Carole '88
Jue, Gary K. '80
Kirchoff, Michael '89
Lee, Danny '86
Mochizuki, Dan '86
Olson, Stephen '81
Reed, Joe '80
Siersma, Richard '72
Smith, Kathleen C. '88
Zamudio, Maria(Lupita) '88

PACIFIC GROVE
SALAZAR, LUIS (TONY) '85

PACIFIC PALISADES
Bardin, James A. '85
Cummings-Rosenbery, Ellen M. '81
Dickey, William '87
Gordon, Scott L. '90
Jones, Deborah F. '82
Mattheus, David L '85
Mc Glothen, Steven R. '73

PALM SPRINGS
Lenart, Mihaly '68
Reynolds, David A. '82
Tipton, Scott A. '86

PALMDALE
Jacob, Robert E. '79
Van De Mark, Tracy L. '85

PALO ALTO
Arbogast, William '53
Bernasconi, Ricardo '81
Cole, Russell H. '87
Kiser, Steve '65
Leever, David E. '88
Malone, Mary '80
MILLIKEN, BRADLEY B. '82
PECK, DOUGLAS L. '82
Tippett, Corinne '88
Ware, Laura R '87
Young, George R. '69

PALO CEDRO
Johnson, Robin N. '83
Scheer, William E '87

PALOS VERDES ESTATES
RUSSI, JAMES E. '79

PANORAMA CITY
Moody, Dana L. '83
Moulton, Steve '81

PARADISE
Gerspacher, Anthony '50
Glover, John G. '64
Mallan, Osmer '50

PARAMOUNT
Davis, Vernon '50

PASADENA
Durham, Jennifer L. '87
Kerns, Ray J. '78
Lai, John Y. F. '80
Litman, Dennis '59
Newman, Gregory B. '78
O'Keeffe, James W. '80
Schmidt, Brad '83
Steele Jr., Charles E. '88
Sullivan, John Sanford '73
Vincent, Kevin R. '78
Washburn, Dorothy '52
Yu, Charlene W. '88

PENN VALLEY
Henricks, Nicole E. '87

PETALUMA
Woodward, Thomas W. '83

PHILO
Becker, Martin '50

PICO RIVERA
RAMSEY, WILLIAM E. '80

PIONEER
Polletti, William '53

PISMO BEACH
Carroll, David M. '81

PITTSBURG
Sneeringer, Thomas '67

PLACENTIA
Mehlman, Mara A. '78
Pierotti, David M. '78

PLACERVILLE
Klein, Richard C. '81
Sukiasian, George '78

PLAYA DEL REY
Douglass, John W. '86
St. John, Tracy Ann '83

PLEASANT HILL
Castle, James Charles '88
Ewell, Timothy A. '87
FINSON, STEVE V. '89
Myers, William L. '78

PLEASANTON
Goff, Dale V '88
Hall, James Wolfe '80
Hall, Kenneth '53
Walters, Daniel W. '85

POMONA
Harris, Dale E. '73
Mc Williams, Ted '59
Parker, Timothy '74
Pena, Jose '69

PORT COSTA
Stewart, Lewis '62

PORT HUENEME
Clark, Barry '81
Slingerland, Bernard '86

PORTERVILLE
Hammond, Alan M. '58
Roberts, Shawn R. '83

RAMONA
Suarez, Andrew '70

RANCHO CORDOVA
Funicello, John
Hurd, R. David '73
Vassallo, Toni Maria '85

RANCHO CUCAMONGA
Kener, Paul W. '67
Kiener, Paul W. '67
Mumaw, Gary W. '77
Taylor, Dennis D. '85

RANCHO SANTA FE
Martin, Jill '87

RED BLUFF
Kvarda, Jerry '62

REDDING
Dibblee, Walter '47
Gallagher, Thomas '74
Nutley, Timothy '90
Schmidt, Thomas '75
Woodson, Rod '66

REDLANDS
Armitage, Frederick '86
Clements, Kenneth '86
Wormser, Laurence K. '60

REDONDO BEACH
Anderson, Lorraine '71
Collins, Robert H. '75
Galliano, Michael J. '86
May, R. Douglas '81
Mustard, Robert '86
Sabatini, Kenneth J. '82

REDWOOD CITY
Bean, Stanley B. '82
Christensen, David S. '70
Gruchala, Keith P. '90
Hanson, Carol '73
Kemper, Jim '87
Sloan, Ron '67
Wells, Celeste A. '89

REDWOOD VALLEY
Kuck, George '64
Vagt, Tyler A. '75

RESEDA
Cardinal, Gille '87
Engstrom, Steven '83
Rubin, Phillip J. '78

RIALTO
Boothby, Robert A. '80

RICHMOND
Jacobs, Steven H. '81
Starry, Frederick B. '61

RIDGECREST
Lyngholm, Alan C. '71
Mc Bride-Keller, Rebecca '79
Sippel, James W '87

RIVERSIDE
Bain, Delvin '72
Braniger, Michael J. '84
Davidson, Donald P. '80
LOPATYNSKI, JESSE V. '76
Siegel, William '73

ROCKLIN
Houghland, Richard S. '78

ROLLING HILLS
Cannady, Kimberly '88
Kachman-Asaro, Cynthia '81
Loneske, Bob '63

ROWLAND HEIGHTS
Golightly, Welch Edward '86
Tong, Nanci '82
Watkins, Phillip '80

SAN DIMAS
Love, Russell A. '78

SAN FRANCISCO
Bellingham, Michael T '85
Benson, Henry '79
Berger, Mark S. '90
Bogear, Gary '71
Brown, Timothy W '90
Ceppas, Cristiana '87
Chaney, Bradley L. '77
Chase, Julianne '81
Chin, Cary J. '78
Diaz, Armando '68
Farruggio, Matthew '81
Feighner, Peter C. '88
Ferguson, Daniel S '88
Garcia, Elma '81
Gilmore, Ed '74
Green, Ian '87
Green, Sharon A. '85
Gurley, David L. '89
Harger, Eric S. '90
Hart, Gerald K '80
Hart, Vikki W. '82
Harvey, Philip J. '86
HATHAWAY, STEVEN W. '78
Hayden, Allan T. '77
Jonsdottir, Solrun '88
Kirchner, Paul '82
Kobayashi, Kenneth R. '78
Koentjoro, Hengki '90
Kuga, David '87
Lindstrom, Brent '69
LAZZARONE, GORDON C. '79
Lloyd, Carrie S '88
Mc Intyre, Wayne (Gerry) '80
Mc Nally, Kevin '78
Mee, John '71
Mirabelli, Manrico '88
Mosier, Philip '69
Maloy, Marcy '82
Marriott, John '74
Matsuda, Paul J. '78
Mayer, Dennis '75
Mc Kenney, Herb '59
Mc Laury, Virginia '89
Mc Millan, Cathy T. '82
Mc Vey, Richard '62
Mole, Craig R. '78
Montgomery, Michael R '89
Newton, Dwayne '81
Ng, Kevin '89
Nordset, Rebecca '82
Ovregaard, Keith W. '79
Owen, Edy L. '87
Peterson, Scott L. '86
PORTILLO, RALPH '75
Reeves, Jaydee A. '87
Reyes, Manuel '65
Rinaldi, Renee '90
Sanford, John A. '80
Sanford, John S. '90
Schnese, Paula M. '90
Schreier, Ronald S. '82
Simon, Timothy '70
Smith, Russell L. '80
Smith, S. Lee '79
Spathis, Dimitrios '86
Spisak, Chuck '74
Steiner, Glenn '73
Stolkin, Robert B. '83
Taylor, Blaine E. '90
True, Joyce '81
Twombly, Craig E. '90
Van Oppens, Caroline (Coco) '90
Vargo, Theresa Ann '87
Volmert, John M '86
Warnock, Kevin L. '86
White, Robin '90
Wilson, Christina M. '90
Woods, Charles '67

SAN GABRIEL
Armstrong, Brian W. '83
Heuerman, Robert H. '82

SAN JACINTO
Groves, John M. '81

SAN JOSE
Abolin, R.W. "Ozzie" '57
Barnard, Richard K. '76
Becker, Paul D. '77
Brimmer, Roger '73
Cooke, M. E. (Ed)
Davis Jr., Jess T. '51
Dorsheimer, Edward V. '77
Dowdall, James A. '80
Edwards, J. Hudson '56
Garcia, Patrick V. '80
Gendreau, Stephen '73
Hall, Robert '72
Harbinson, Leah '83
Harline, Hugh B. '79
Hart, Dominic E. '90
Heineck, James T. '87
Hoiland, Ralph '88
Holley III, William C. '90
Johnson, Victoria L. '86
Koeper, Craig H. '84

Matchinske, Steven G. '88
Mc Adams, Beth M. '89
Meade, H. Randolph '76
Middleton, Gordon '73
Morreal, Mary Lou '82
Peak, Brian '85
Qualman, Mike '89
Reedy, Ralph '86
Roulette, Ryan S. '73
Santini, Jamie P. '83
Schoening, Carina '85
Shick, Jim R. '83
Skadberg, John '73
Sloben, Marvin '73
Sotelo, Ralph B. '59
Staab, Kent '73
Stancil, Laurence P. '84
Tippett, Jeffrey M. '84
Truesdale, Greg '74
Truesdale, Kenneth '87
Vallance, Walter Scott '87
Van Paten, Dick '63
Waldo, John A. '83
Walter, Richard '68
Wilkey, Linda '89
Williams, Marshall T. '90

SAN JUAN BOUTISTA
Nakamoto, Rodney S. '80

SAN JUAN CAPISTRANO
Cook, Robert H. '73
Hyde, Victor '79

SAN LEANDRO
Bettencourt, Dennis '73
Erler, Ernest R. '66

SAN LUIS OBISPO
Codispoti, Joseph '72
Duncan, William '65
Finley, Thomas Scott '68
Fuller III, George '70
Kelley, Helen '66
Linninger, Melvin Wesley '64
Loomis, Julie M. '81
May, Jeffery F. '81
Meinhold, Thomas L. '87
Waltz, Robert E. '51
Zirion, Kirk '74

SAN MATEO
Hammond, Paul W. '85
Johnson, Douglas '89
Schabarum, Thomas T. '85

SAN PEDRO
Anderson, Jean R. '79
Davis, Charles A. '78

SAN RAFAEL
Clinnin, Kate '88
Cobb, Bruce L. '77
Fidler, Glenn A. '81
Hansen-Gamblin, Leslie '80
Henneman, Steven '74
Kettel, Morten '89
Seaver, Keven Ann '77
Seawell IV, W. Thomas '90
Simpson, C. Charles '80
Van Otteren, Juliet '84
Van Otteren, Thomas '84
Wnuk, Alan J. '78

SANGER
Herkel, Joseph '71
Montelongo, John E. '79

SANTA ANA
Axen, Brad D. '82
Gail, Michael L. '80
Holden, Andrew '86
Lawder, John '74
Olsen, David R. '88
PATTERSON, ROBERT E. '76
Perez, Charles '74
Prete, Gregory Eugene '89
Sorensen, Wayne '58
Strong, Lawrence '86
Svoboda, John '77
Svoboda, Victor
Thoms, Hal D. '78
Walker, Angela D. '89
Webber, Geoff E. '85

SANTA BARBARA
Abraham, Carol Jeanne '88
Abresch, Zoraida '83
Abruscato, Lawrence '72
Abtey, Jean Pierre '70
Adams, Carolyn A. '90
Allen, Glenn B. '83
Ameen, Sam '87
Anderson, Richard '89
Anderson, Thomas B '84
Anolick, Albert '52
Arkut, Funda '86
Armstrong, Richard B. '76
Arneson, Eric '69
Arneson, Jim '86
Ball, Thomas R. '75
Bardick, David '70
Bark, Jeffrey W. '86
Barr, Steve '76
Bartsch, James A '88
Bassett, Denman '72
Beard, Glynn D. '87
Becker, Kenneth W. '80
BECKETT, JAMES B. '78
Behrenbruch, William '74
Belcovson, Joseph M. '77
Benhardt, Susan K '86
Bennett, Gregory '73
Biddulph, Reed '51
Bissell III, Stephen A. '70
Black, Manvrone B '89
Blier, Stephen M. '86
Blok, Christiaan J. '84
Bloodgood, David '73
Bogie, Herb '49
Boon, Robert B. '84
Borges, Ray '47
Boucher, Hal '50
BRADLEY, AIDEN J. '80
Branen, Karla J. '90
Brannon, Herbert '70

CALIFORNIA (continued)

Bricher, Robert D. '78
Briggs, Patrick D. '89
Brittain, Charles '73
BROOKS, II, ERNEST ' 62
Brown, Melanie '82
Burns, Michael J. '76
Buur, Jan A. '62
Carlson, Patricia W. '86
Carlson, Randy W. '76
Casper Jr., Robert J. '83
Caughey, Michael '70
Chao, Jackson R. C. '83
Chaparon, Steven A. '80
CHEN, JAMES '66
Cheriot, John
Clare, James '88
Clason, Harold W. '57
CLEVENGER, RALPH A. '79
Cody, Susan C. '88
Colvin, George T. '72
Colvin, Peter L. '66
Daneri, Carole '88
Dapelo, Scott L. '81
DARK, JOHN L. '78
Daugherty, Christopher '81
Daugherty, Harry '52
Davis, Michael J. '75
De Brask, Robert '86
De Lellis, C. Matthew '90
De Phillipo, Dean J. '89
De Roos, Ricky L. '81
De Wit, Monica T '88
Dee, Robert R. '87
Delahay, Kevin J. '82
Derbyshire, Glen A. '87
Dobry, Merlin '63
Dolyak, Mary J. '84
Doty, Tom '75
Douglas, Walter C. '48
Douran, Yvon M. '89
Dow, Gerald E. '62
Eckerstrom, Russell '48
Edelstein, Andrew M. '90
Elliott, Bradley W.
Endicott, Carol J '89
Fancher, Christine '82
Farhad, Shukri '87
Fechtman, Henry L. '66
Ferran, Robert C. '87
Fleming, Lori '86
Fodrea, Edith (Gitte) '87
Ford, Tedroe J '90
Franco, Theodore '52
Friedman, Leonard '90
Fujimoto, Clifford M. '86
Fukudome, Kenji Jacklio '89
Fullerton, Seth M. '85
Ganassa, Rina M. '89
Gardner, Christopher '86
Gates, Robin L '86
Gillespie, Mark T. '90
Glassman, Helene C. '82
Hahn, Sherry L. '86
Hall, Robert '72
Hamilton, Gloria D. '81
Hand, Guy C. '79
Handloser, John S. '75
Hanson, Perry W. '89
Harmon, James H. '65
Hashimoto, Masahide '87
Hass, Barbara '86
Havac, Julian '80
Hellyer, Melinda R. '84
Henderson, William Manning '88
Henry, Christine E. '90
Henson, Lawrence M. '87
Henszey, Barbara E '85
Hernandez Herrero, Isaac '90
Hernandez, Mario '53
Hill, Christian L. '77
Hill, Ronnie R. '90
Hodges, Brett E. '86
Hodges, Glen H. '81
Hoffman, Lori '85
Hollis, Barry '86
Holtzman, Leslie W. '78
Hope, Francois M '86
Hudson, Mark
Hugli, Brian F. '79
Humberd, Hara L. '81
Hunt, Gary R. '90
Isgrig, Michael J. '89
Jee, Tjin Hin '88
Jeske, Rebecca A. '76
Johnson, William D. '77
Kahn, M. Rasheed
Kassaye, Samson M. '89
Kaye, Elizabeth A. '89
Kearns, James '87
Keating, Cyril '87
Kennedy, W. Patrick '86
Knight, Thomas M. '88
Kohn, Robert H. '71
Koppel, Alicia '87
Kostock, Bill '77
Kretschmer, Douglas
Kuhn, Leanne A. '89
Kummer, Robert S '87
Laird, Bruce G. '88
Lantz, Chris '87
Lawson, Emmett '55
Lecompte, James '60
Leddy, Patricia '80
Leibhardt-Goodman, Leslie '90
Lenz, Brian K. '82
Li, Zai Yang '88
LIEBHARDT, PAUL W. '76
Lofaso, John C. '88
Lohr, Michael V. '85
Lohrke Jr., Otto '74
Lounsbury, Thomas M. '86
Lueders, Eric A. '84
MACARI, JAMES D. '77
Maher, James C. '80
Makepeace, Marilyn A. '83
Mandese, Vince '52
Manno, Paul '51
Markusson, Sigthor '90

Mathews, William '86
Mattivi, Mark T. '90
Mc Donough, Molly '90
Mc Kee, David William '90
Mc Laren, Julie K. '90
Mead, Michael G '86
Mendoza, Douglas M. '86
Merritt, S. Lewis (Mike) '47
Method, Douglas J. '86
MEYER, PAUL R. '81
Miller, Kenneth J. '61
Miller, Vern '60
MOLNAR, RAND '77
Molsick, Lisa J. '81
Monian, William '62
Montalbano, Michelle D. '90
Mori, Frank '48
Morris, Matilda '89
Morse, Thomas '69
Nahmias, Eyal '88
Nania, Scott
Negrete, Norma A '88
Nigh-Strelich, Alison M. '84
Nikolic, Jovan '86
O'Shock, Curtis C. '89
Pagter, Corbin C. '90
Parsons, Larry '75
Peck, Nina '89
Peduto, Joseph '89
Pietsch, Teresa '83
Post, Edward '72
Qabazard, Khalil A. '88
Quaranta, Vince '74
Rickabaugh, Keith D '88
Ricono, Mary Jane '87
Roberts, Eric O '86
Robin, Leslie '71
Roche, Cynthia '87
Rohlfing, Robert '71
Rolle, Roderick G. '86
Romasanta, Lisa '88
Rose Sorrell, Annette C. '81
Roth, David L. '81
Rubenstein, Marcia S. '86
Ruggieri, Anthony V. '87
Rupert, John '68
Saban, Donald W. '74
Sadasivan, Gyaneshwar '90
Saint Germain, Steve '83
Sander, Warren J. '86
Shahrouzi, Ali '87
Shaw, Richard G. '84
Sheppard, Jeff A. '86
Shields, Gregory W. '82
Shulem, Steven E. '85
Siebler, Simon '86
Siracusa, Dean '86
Skufca, Frank J. '76
Snethen, Julie I '87
Snyder, Harry S. '50
Solari, Marc E. '86
Soria, Robin F. '89
Spafford, Baron Erik '74
Steckler, Steven '86
Stelck, Douglas A. '81
Stevenson, Harold '53
Stock, Charles H. '84
Stoltz, Larry '69
Stout, Evans Ann '77
Street, Brian '88
Streeter, Eugene '65
Strickland, Georgia M. '86
Sullivan, Kelly '90
Summerhays, Vincent '88
Summers, Timothy L. '86
Swartz, Bernard '84
Swartz, Fred Kenneth '86
Tatsch, Eldon '49
Taylor, Gerald '85
Theriot, John '49
Thomas, Kevin '90
Thomas, Todd L. '88
Thompson, Jacqueline '85
TIBBETTS, LAWRENCE '76
Tierney, Stephen L. '90
Tomas-Hammond, Alejandro '79
Tuttle, Tom '72
Uyechi, Kojiro '52
Valiquette, Jacqueline N. '90
Vandale, Bruce E. '76
Veblen, Laura H. '78
VERBOIS, J. MICHAEL '72
Von Wiesenberger, Arthur '75
Walker, Donald L '86
Walters, Dean '73
Weaver, Cheryl A '88
Weinstock, Carol A. '84
Welch, William J. '78
Werling, Bob '68
Wheaton, Martie '88
Wight, Timothy D. '90
Wilby, Terry '73
Wilder, Carolyn '84
Will, John '54
Winner, David E. '90
Wolfe Jr., Mal '62
Wong, Wang Yuen '90
Wright, Jennifer L. '83
Zeldis, William F. '80
Zumdahl, Gary '61

SANTA CLARA
Clevenger-O'hare, Janis M. '80
Jansons, Robert V. '79
ROSENBERG, ALAN J. '79

SANTA CLARITA
Walker, Vicke L. '83

SANTA CRUZ
Barbe, Raymond R. '51
Davis, James K. '59
Dong, Harry G. '85
Newton, Jerry L. '75
Predika, Jerry '64
Steward, Stephen D. '79

SANTA MARIA
Apsley-Mc Vey, Anita '87
Cicero, Carl '71

Claus, Joseph W. '86
Fisher, Dennis I. '75
Giachetto, Richard '66
Nylander, Simo J. '77
Tkach, Daniel G. '78
Yip, Timmy Q. '81

SANTA MONICA
Avots, John '73
Bjerke, David R. '81
Cicetti, Richard A. '72
Cosko, Jackie N. '90
Green, Harry I. '80
Hyde, Alex C. '77
Jennings, Penny S. '81
Lohman, Mark T. '80
Pedersen, Rocki '82
Schmidt, Ronald D. '84
Sessions, David D. '77
Waddell, Robert M. '81
Young-wolff, David '78

SANTA PAULA
Castro, Ronald '59
Culbertson, Thomas '82
Fogata, Robert A. '70
Hamm, Robert B. '89
Mac Donald, Donald J. '48
Newport, Barbara '66
Odle, Patrice '86
Rodriguez, John A. '82
Zsarnay, Christopher L. '88

SANTA ROSA
Armstrong, Larry '66
Friedlander, William D. '75
Gay, Garry '73
Mc Manus, Kelly M. '80
Rangel, Andrew '71
Ross, Mark S '88
Sciallo, Ken J. '86
Shippee, Bruce '77
Simmons, Jimm
Thompson, John R. '76
Wood, Eliot '88

SANTA YNEZ
Cottle, Pete '71
Landot, Greg L. '86
Loughren, Cynthia Ann '79
Walter, Adrienne '88

SANTEE
Craig, John Kent Thomas '74

SARATOGA
Bacon, D. Garth '78
Emery, Kerry '86
Plaskett, David L. '90
Van Peborgh, Paul E. '85

SAUGAS
Crane, David '81
Parra Leibowitz, Maureen '63
Ross, Jonsie '80

SAUSALITO
Privette, Herman '76
Spiering, Scott Nathan '82

SCOTTS VALLEY
Browne, Rick '70
Burry, Dennis L. '74
Lauritsen-Van Zandbergen, Lesli '81

SEAL BEACH
Airth, David '80

SEASIDE
Wrobel, David J. '83

SEBASTOPOL
Barnes, Arthur '67
Bock, Artie '75
Peters, David '71
Peters, Jill Simmons '73
Russel, Don J. '72
Wilder, Arthur '74

SELMA
Nakamichi, Glenn K. '78

SEPULVEDA
Aguinaldo, Edward
Baker, Charles T. '89
Flack, Cary A. '85
Pregent, Nick '73

SHAFTER
Howell, Herbert '49

SHERMAN OAKS
Graham, Steven P. '88
Harada, Joe '66
Hibbard, Mark '83
Ormandy, Tracey '78
Shelden, Steven M. '85
Skutch, Lindsay E. '77

SHINGLE SPRING
Schwartzman, Ron '61

SIERRA MADRE
Hayes, Doug '72
Johnstone, Stephen '72
Lemire, Alan J. '89
Zlotorowicz, Leonard '72

SIGNAL HILL
Baldwin, Lewis '64

SIMI VALLEY
Aguiar, Ruben L
Conant, Herman '68
Falbo-Hermosillo, Arlene M. '77
Froebe, Douglas F. '80
Horrocks-Schneider, Diane L. '86
Johnson, Ami L. '89
Koenig, Jerry '65
Price, Richard D. '88
Wyllie, Dan '67

SOLANA BEACH
Kreklow, Peter '76

SOLVANG
Grant, Gregory '90
Ives, George '61
Lester-Deats, Christine A. '80
Raines, Sid G. '90
Richmond, Earl B. '86

SOMIS
Jay, James A. '88

SONOMA
Campbell, Martin '65
Ricci, Dale '71
Snyder, Steve W. '71

SOQUEL
Blankinship, Martin '58
Crawford, Del '75
Dale, Craig '89

KEEN, JIM '69

SOULSBYVILLE
Castle, Paul '48

SOUTH LAGUNA
Kliman, Kari Ellen '88

SOUTH LAKE TAHOE
Bird, Harold L. '78
Ekblad, Dana A. '78

SOUTH PASADENA
BROWN, EDWARD A. '88

SPRING VALLEY
Ray, Kathleen J '87

STOCKTON
Collins, Gary '71
Goodman, Daniel M. '90
Ledesma, Randall P. '86
Pennington, Carol L. '83
Richtik, Kevin C. '90
Saga, Frank '57
Schumacher, Stacey '86
Telfer, David B. '87
Ziegler, Blake A. '76

STUDIO CITY
Cormany, Charles H. '86
Davison, Michael R. '72
Heimann, Juergen S. '87
Kern, Jonathan Q. '88
Leins, Mark R. '87
Levy, Robert J. '82
Lowenthal, James '66
Miller, Kevin E. '75
Schill, Kevin '82
Skupenski, Frederick '81
Taflan, Jeff '81

SUISUN CITY
Harris, Robert S. '66

SUMMERLAND
Cordova, Phil A '88
Pongsapipatt, Malin '90
Rudolph, John '62
Schmidt, Nancy Ann '87

SUN VALLEY
Kuch, Harvey '74

SUNNYVALE
Brick, Jim '61
Dunn, Roger '81
Gendreau, Richard '71
Morneau, Robert F. '77
Paul, Kerry Hiroshi '86
PETERS, JEFF '86
Thomas, Neil '81
Tuttle, Sandra
Wagner, Douglas J. '81

SYLMAR
Kays, Robert L. '61

TAHOE CITY
Bruner, Roderick S. '83
Shemdean, Ghandi H. '72

TARZANA
Anderton, Gary A. '81

TEHACHAPI
Bean, James P. '85
Wootton, Scott W '87

THOUSAND OAKS
Britt, Charles M. '89
Davidson, Fred '52
HAALAND, RONALD M. '89
Mac Donald, Mark L. '85
Mc Guire, Mike '65
Moore, Michael '64
Mosier, Greg A. '90
Naffin, Cynthia K. '77
Pauley, Thomas D. '78
Spoto, Marie L. '86
Stoebner, Douglas A '86
Terceira, Robert S. '77
Wright, Christopher P. '89

TIBURON
Muirhead, Diana '87

TOLUCA LAKE
Bright, Robert H. '75
Brooks, Steve '74
Knisely, Patrick A. '84
Somsen, Steven L. '88
Sosensky, Steven '87

TOPANGA
Friske, Richard '55
LUNA, ANTHONY C. '82
Patterson, Nolan

TORRANCE
Denier, Philippe A. '88
Feuerstein, Robert Wayne '72
Haun, John T. '85
Karma, Arlene '88
Munson, Julia A '87
Roleder, Jonathan W. '83
Schauer, Kenneth C. '86
Wiener, Ronald '61

TRONA
Roberts, Charles '87

TULARE
Killion, Jeffrey '70
Marc, Julian '88

TURLOCK
Claes, Jack '62
Clase, Jack K. '62
Lindblom, Thora M.

TUSTIN
Braker, Frank '79
Johnson, Rick '82
Moss, Raymond V. '88
Murray, Charles Michael '78
POLLOCK, STEPHEN F. '81
Taggart, Kelly E. '86

UKIAH
Gilmore, Steve '85

UNIVERSAL CITY
Logan, Lawrence L. '77

UPLAND
Campbell, Bruce L. '75
Jankins, John '77
Lemon, Mark R '88
Macauley, Gerald '70
Masasso, Anthony W. '79
Pate, Hudson H. '77
Speaker, Paul S. '77

VALENCIA
Drell, Ellen Covela '79
Mantlo, Kenneth '86
Sawyer, Thomas E. '85

VALLEJO
Kay, Philip '64

VAN NUYS
Boger, Henry R '88
Fried, Matthew I. '79
Harrison, Chad R. '90
Hellman, Avery M. '75
King, Floyd '52
Kostenbauder, Robert '64
Kurosaki, Bruce T. '78
La Count, James K. '77
Laufer, Robert E. '89
Levy, Robert J. '82
Mordecai, Dean '66
Moskowitz, Sheldon G. '78
Nelson, Matthew T '90
Trindl, Joani K. '76
Tylka, Robert V. '61
Verebes, Tony '68
Warren, Pamela Erehwon '72

VENICE
Banner, Tom
Garland, Michael E. '81
Harasty, Peter '89
Miller, Karen L. '81
Olsen, Trond '89

VENTURA
Bernal, Lionel '72
Braun, David R. '77
Bright, David A. '74
Bruner, Thomas '74
Burge, Mark '87
Capritto, Philip T. '83
Crye, Don P. '87
Culver, David S. '76
Gallegos, Arthur M '86
Graf, Michael J. '90
Grant-Aeschliman, Barbara '86
Griggs, Gary W. '85
Hendricks, William G. '81
Jaffe, Peter L. '61
Keyser, Peter R. '60
Kurtz, Joyce '56
Lanford, William '70
Marshall, Glenn H. '86
Merritt, Charlene '82
Monahan, William '59
Ortiz, Cecilia M '89
Palmieri, Lance '86
Parker, Stephen L. '79
Pieser, Robert '51
Ramirez Jr., Daniel '86
Ranger Jr., Philip F. '74
Reed, William B. '77
SCHOENBACH, KURT '85
SMITH, ROBERT G. '82
Starr, G. Scott '86
Stewart, Leighton '51
Taylor, Glen '68
Thomas, Laura C. '86
Wilmott, Gary '85
Wilmott, Gary '86
Wilson, Mark S. '81
Winters, Vincent M. '84

VICTORVILLE
Arriola, William '50
Asa, Bert F. '87

VISALIA
Davis, Gary H. '67
Dunehew, Darren L. '82
Duran, Juan '79
Lavenson, Bruce '74
Maynard, Bruce '74
Mc Call, Basil '53
Rohrbacker, Jeffrey D. '88

VISTA
Pratt, Dean '78
Pratt, Renee '83

WALNUT CREEK
Atwater, Brian S. '84
Crisafulli, Charlene '79
Kelly, Bradford J. '84
La Point, Joseph F. '80
Leboeuf, Robert '71

WATSONVILLE
Burke, James E. '89

WEST COVINA
Cleary, Stephanie A '88
Corrales, Filo '58

WEST HILLS
Newborn, Bruce J. '80

WESTLAKE VILLAGE
Arnett, Danielle '86
Brandes, Mark L. '79
Pleman, Teresa M '86
Yaecker, Kenneth A. '78

WESTMINSTER
Smith, Michael J. '80
Stevens, Diane P. '83

WHITTIER
Adams, Wayne R. '77
ALVAREZ, CESAR H. '88
Brass, Michael J.
Burns, Robert Steven '76
Coughenour, Charles B. '81
FINLEY, MARK
Gillham, Steve R. '78
Murphy, James D. '77
Pursel, Robert '59

WILLOWS
French, Steve R. '74

WOODLAND
Unda, Gabriel '72

WOODLAND HILLS
Cannon, Scott D. '83
Christman, Teri '81
Cohen, Arthur B. '78
Matis Jr., Alan J. '90
Miller, Kevin J. '79
PARK, MOO '86
Tolmas, Jodi Y. '90
Weintraub, Larry S. '80
Zadok, Clifford '74

WOODSIDE
Stade, Robert '53

YORBA LINDA
Conner, Donald L. '64
Fugnetti, Dennis M. '71
Mac Donald, Ronald P. '88

YOUNTVILLE
Weeks, Sandra L. '87

YUBA CITY
Borgstrom, Lee A. '83

YUCCA VALLEY
Sroda, Dick '57

COLORADO

ARVADA
Bumpas, Robert '62
Miller, Lawrence '76

ASPEN
Demin, Anthony R '88
Sudmeier, Pat '80

AURORA
Curiel, Yorum '75
Eickhorn, John '73
Haubert, Roger '70
Rayles, Ronald A. '75
Thompson, James E. '80

BAILEY
Dyer, Kent A. '85

BASALT
Hodgson, Anne '86

BOULDER
Arenz Jr., Robert F. '83
Brodie, Mark D. '89
Ervin, William J. '76
Gauch, Cathy '85
Harwood, Lawrence A. '81
Pelon, David L '88
Provine, Robert A. '77
SEYMOUR, ROBERT

CARBONDALE
EVANS, CHARLES E. '88
Hodges, Janet Viney '72
Hodges, Kirvin D. '72

COLORADO SPRINGS
Beebe, David '86
Gonsalves, Peter '64
Helstrom, Richard L. '76
Hinson, Bruce W. '76
Jones, Donald T. '81
Kesners, Andris '64
Middleton, Melani L. '83
Mistrot, Christopher L. '90
Ragsdale, James '59

DENVER
Atchison, Povy Kendal '90
Avery, Charles '87
Beede, Mark D. '78
Bluebaugh, David R. '78
Burt, Jennifer '85
Campbell, Robert B. '86
Conway, Thomas H. '82
Crabb, Martin D. '78
Cuerden, Glen
De Shon III, Rex C. '78
Frandsen, Robert A. '77
Fredin, Peter M. '90
Friednash, Michael '83
Gehrig, Penny '85
Goldman, Jack J. '56
Goldman, Robert D. '88
Grove, Victoria '89
Hills, David K. '73
Joseph, Nancy
KRANZLER, PAUL A. '84
Leingang, Scott L. '85
Mark, Brian '83
Montoya, Priscilla Y. '83
Oswald, Jan '74
Saehlenou, Kevin A. '77

Schumacher, Sam '87
Sturdevant, Jon F. '79
Travis, Thomas '80
Uhl, Kathryn M. '83
Wheeler, Gary '72

DURANGO
Boucher, Edward '69

ENGLEWOOD
Becker, Wes A. '85
Bolerjack, Kent '61

EVERGREEN
Farner, Barry A '86

FORT COLLINS
Friske, Carol Carter '54
Knaus, Hugh C. '73
Murray, James K. '76

GLENWOOD SPRINGS
Cunningham, Robert F. IV '81

GOLDEN
Hawkinson, Donald G. '86
Wright, Robert '75

HIGHLANDS RANCH
Marvin, Edward L. '80
Welch, Gary D. '75

LAFAYETTE
Mc Caul, George '81

LAKEWOOD
Dewitt, Danny '75
Frudeger, Jon '87
Harlan, Adriene J. '84
Holzman, John Eric '88
Mc Leod, Robert '75
Witt, Karl Brock '82
Wood, Vernon '71

LEADVILLE
Middleton, Wiley J. '84

LITTLETON
Bauer, Scott '90
Glass, Kenneth A. '74
Hunt, Ann Prevost '65

LONGMONT
Guillot, Robert J. '81
May, Robert J. '78

LOUISVILLE
Mc Elroy, Jerry '77

LOVELAND
Albern, Donald W. '77
Digby, James '57
More, Arthur R. '63

MORRISON
Reynolds, Roger G. '77

NEDERLAND
Leacock, Jonathan '89

PARKER
Savage, David '61
Vandenbosch, Kim '86

PUEBLO
Chinn, Robert J. '53
Lauricella, Anne M. '80
Vaughan, Garth '86

SALIDA
Timme, Johne '77

TELLURIDE
Robb, Alex M. '77

WESTMINSTER
Chesnut, Russell '76
Maves, D. Roger '75

CONNECTICUT

BETHEL
Denny, Robert J. '87
Furore, Dominic B. '83

BOLTON
Edwards, Peter '70

BRIDGEPORT
Jimenez, Robert J. '85

CHESHIRE
Coyne, Patrick '86

DANBERRY
ARELLANO, ALAN '87

DANBURY
BRIAN, TERRY, '74
Harold, Keenan
Harrington, Blaine G. '86

DERBY
Beattie, Franklin W. '86

ELLINGTON
Ferguson, John W. '85

FAIRFIELD
Morse, Anita '82

GREENWICH
Newman, William T. '83

GUILFORD
Buop, Daniel '70

KENT
Nichols, Stephen J. '64

LEBANON
Crouch, Michael L. '76

MANCHESTER
Dube, Anthony P. '89
Sternberg, Steven '72

MERIDEN
Langer, Marcia '71

MONROE
Farrell, William P. '77

Column 1

CONNECTICUT (continued)

NEW BRITAIN
Caporale, Dominic '66

NEW MILFORD
Austin, Douglas M. '82
Crumly, Lamar '76

NORTH WINDHAM
Beer, William '72

NORWWALK
Schou, Donna L. '88

RIVERSIDE
Matthews, Tony T '89

ROCKY HILL
Aforismo, Robert '62

ROWAYTON
Boyd, Gardner '53

SOUTHINGTON
Page, Bryan J. '81

STAMFORD
Brown, Josephine J. '83
MILES, W. SCOTT '82
Sued, Yamil R. '85

STONINGTON
CARVER, THOMAS L. '86

STRATFORD
Salls, Roger D '74

TERRYVILLE
Vidal, Marc J. '79

THOMPSON
Elliott, Brian M. '73

WATERBURY
Gamble, Robert '73
Rabinowitz, Barry '71

WESTPORT
Nightingale, Julie '79

DELAWARE

HOCKESSIN
Weed, Andrew D. '84

OCEAN VIEW
Orhalein, Michael '80

WILMINGTON
Curtis, David O. '71
Hemming-Jette, Margaret '82
Whitten, Robert '54

DISTRICT OF COLUMBIA

WASHINGTON
Carter, Reginald L. '83
Eastwood, Henry C. '71
Fitzgerald, Beth '86
Franz, Gregory '83
Mason, Thomas J. '88
Schwartz, David S. '61
Shafer, Doyle M. '69
Shafer, Robert C '79

FLORIDA

ALTAMONTE SPRINGS
Olson, Mark S. '88

APOPKA
Parish, Bill '68
Turner, Timothy '80

ARCADIA
Chase, George B. '74

BELLEAIR
Roberts, Patricia L. '80

BONITA SPRINGS
Steury, Robin W. '81

BRADENTON
Lovelace, Tracey A. '86

CAPE CORAL
Alkire, Candace '88

CASSELBERRY
Roth, Terry '71
Schwartz, Gregory '84

COCOA
Neihouse, James '76

COCOA BEACH
Kechele, John P. '79
Scruggs, Roger '74

CORAL SPRINGS
Joyce, William '88

DELRAY BEACH
Yeany, Keith A. '64

FORT LAUDERDALE
Grimm III, Richard '68
Mc Graw, Robert D. '79
O'Donovan, Robert D. '79
Silverman, Robert J. '79

FORT MYERS
Roberts, Dick '68

FORT PIERCE
Davenport, William '72
Smith, David '79

FT. WALTON BEACH
Savage, Deborah '79

GREEN COVE SPRI
Thorp, Gordon A. '80

INDIAN ROCKS BEACH
Rowland, Shawn M. '86

ISLAMORADA
Fain, Nat '60

KEY BISCAYNE
Cook, Robert I. '77
Rose, Linda R. '81

Column 2

KEY LARGO
Spencer, James '71

LAKE WORTH
Mc Kee, Michael '77

LAKELAND
Greenwell, Richard K. '77

LARGO
Robinson, M. Raymond '61

LAUDERHILL
Nugent, Jay E. '77

LONGBOAT KEY
Bruce, Bradley H. '76

LUTZ
Chester, William Max '64

MARATHON
Hogue, Dale '70
Tarnowski, John 69

MIAMI
Eibe, M. Bruce '68
Joyce, John H. '90
Lora, Carlos '87
Lovett, Brian R. '86
Norwood, George G. '80
Pruna, Andres F. '86
Puga-Hegenwald, Ursula '88

MIAMI BEACH
Andree, Henrik '87
Cuevas, Nancy Lee '86
Mevorach, Natan '83

MIAMI SPRINGS
Schwartz, Samy '88

MILTON
Jazzar, Asya '89

MIRAMAR
Zimmerman, Michael '80

MOLBOURNE
Leary, Gregory W. '81

NEW PORT RICHEY
Hathaway, Roger '72

NORTH MIAMI BEACH
Vogel, Hermann '64

NORTH PALM BEACH
Harding, K. Dana '72

OCALA
Gullstrom, Charles J. '82
Hodnick, James A. '80

ORLANDO
Braun, Robert '60
Clegg, Robert '64
Davis, William A '71
Palmieri Jr, Dominic '64

ORMOND BEACH
Hansen, Timothy J. '87
Turner, Richard W. '76

PALM BEACH
Carlisle, Allan '74

PALM BEACH GARN
Hess, Jeffery '74

PALM HARBOR
Urdal, Arthur '75

PANAMA CITY BEACH
Campoli, Bernie '74
Cole, Robert B. '75

PANAMA CITY
Nelson, Richard A. '75

PENSACOLA
Starr, Dale '83

SANIBEL
Mc Kinsey, Brian '76

SATELLITE BEACH
Brogan, Chester '53
Carothers, Robert '49

ST. PETERSBURG
Raheb, Jeffrey E. '89
Wade, Ted '71

TREASURE ISLAND
Roman, David I. '79

VERO BEACH
Betley, Joseph '72

W. PALM BEACH
Ande, Stephen '71
Dyess, Samuel Todd '85

WINTER PARK
Kaichen, David R. '76
Petrey, John M. '81

GEORGIA

ATLANTA
Akers Jr., Charley '77
Beaird, Jennifer L. '78
Beck, D. Paul '86
Calhoun, Graham G. '82
Cantrell, Gary '68
Carbetta, James D. '87
Martin, Bill '51
Milburn, David L. '82
TINKER, JOHN ' 71
WILLIAMS, HARRY L
(SONNY) '84

CHAMBLEE
Copeland, James H. '77

COLUMBUS
Williams, Harry L. '86

CORNELIA
Raines, Robert D. '76

DALTON CITY
Smith, Clark C. '80

Column 3

DORAVILLE
Hixon, Stanley O. '90

DUNWOODY
Robison, Thomas J. '79

JESUP
Carter, William B. '55

JONESBORO
EPPS, SUSAN '85

MARIETTA
Northcutt, Roy Harrison '86
Phillips, David L. '78

NORCROSS
Wheless Jr., Robert '73

ROSWELL
Goodvin, Jeffrey T. '90

ST. SIMONS ISLAND
Posey, Steve '77

STONE MOUNTAIN
Foster, Andrew '61

VALDOSTA
Kenney, H. '75

WOODSTOCK
Armfield, James H. '70

HAWAII

AIEA
Kimm, Glennelle L. '84

ANAHOLA
Shepard, Thomas '88
Wells, John '72

HONOLULU
Blank, Morgan J. '86
Chong, Lloyd '82
De Mello, John '86
DEMELLO, JOHN '86
Guanzon, Robert W. '79
Ham, Kevin K. '83
Ishikawa, Jonell '83
Johnston, Stanton '68
Kau, Colin W. '87
Marshall, Gregory A. '66
MATOS, MIGUEL A. '83
Morneau, Jerry '86

KAHULUI MAUI
Nagamine Jr., Harold '70

KAILUA
Hiraoka, Nari
Johnson, Mark A. '90
Schroeder, J. Erik '89
Waggoner, Michael '82

KAILUA OAHU
Fujii, Roger '61

KANE
Allison, Lee '66
Hooper, Robert F. '71

KANEOHE
ESPERO, EDGAR C. '79
Luke, Keely L '88

KEALAKEKUA KO
Ackerman, Arnold D. '78
Black, Noel D. '78

KIHEI
Beach, Russell '61
Lawrence, Robert S. '78

LAHAINA
Cornick, William R. '86

LIHUE
Matsumoto, Richard '86

O'FALLLU
Blake, Duncan L. '84

WAHIAWA
Jackson, William J. '81

WAILUKU
Shimomura, Ricky Y. '82

WAIPAHU
AYAKAWA, CLAUDE S. '62
Dugay, Peter '71

IDAHO

BOISE
Gleason, Bill '66
Howard, Ronald P. '84
LISK, MARK W '87
Mc Kain, John M. '84
Redman, Bruce M. '84
Shaw, Brad '74
WELSH, STEVEN C. '79

COEUR D'ALENE
Bolton, Jeffrey '72

IDAHO FALLS
Capek, John D. '61
Jensen, Quincy M. '53

JEROME
Rose, Joe '60

KETCHUM
Mason, Stephen R. '85

SUN VALLEY
Conger, Cydney M. '87
Syms, Kevin '79
Williams, Jack '59

ILLINOIS

ALTON
Farrar, Carl R. '47

BARTONVILLE
Hossler, Kevin D. '84

BRIDGEVIEW
Ende, Brian '86

Column 4

CALUMET CITY
Sinclair, Gerald '73

CHICAGO
Andrews, Susan K. '78
Belson, David H. '79
Brooks, Deborah '76
Brooks, Douglas Fernandez '75
Chan, David '59
Dovey, Dean '82
Dreyfus, Joshua '83
Evans, Lawrence '73
Findley, Paul '86
Flook, Lyman R. '78
Foster, Ivan M. '81
Hedrich, Sandi '74
Heil, Peter E. '80
Heywood, Robert S. '75
Holzhueter (Holz), Richard '75
Jovanovich, Joseph S. '86
Lauth, Lyal '70
Leavitt-Castleberry, Debra R. '78
Maddox, Michael R. '75
Mattingly, Roger R. '76
Sawada, Spencer K. '71
Simon, Jerry L. '89
Trahan, Gerald (Jerry) '70
Ventola, Giorgio '78
Weinper, Bryan V. '84
YAPP, CHARLES '74

COLLINSVILLE
Faifer, Stephen '72

CREVE COEUR
Florea, George '53

DARIEN
Jiskra, Donald '55
Pleshar, Robert '66

DOWNERS GROVE
Callahan, Daniel '76

E. ST. LOUIS
Carr, Robert W '86

ELGIN
Lange, Herbert '72

EVANSTON
Vlahakis, Lana J. '80

FRANKLIN PARK
Carter-Kell, Laurette D. '79

GENESSEO
Greenwood, John T. '81

GLENVIEW
Etienne, Elizabeth '89

HICKORY HILLS
Riendeau, Jack '59

HIGHLAND PARK
Crotty, Daniel '83
Van Meter, William Kent '77

HILLSBORO
Meade, Kenneth W. '75

HINSDALE
Amato, Mark S. '78

HOMEWOOD
Rossnagel-Proctor, Pamela R. '80

ITASCA
Peters, Jon '67

JACKSONVILLE
Fox, Merle T. '64
Lawrence, Robert S. '78
Wade, Bill '47
Wade, Kurt '80

KANKAKEE
Moriarty, Thomas J. '81
Nelson, Thomas J. '87

LAKE FOREST
Kaplan, Dick '74
Winburn, Gail T. '85

LAKE ZURICH
Baczkowski, Richard '75

LOMBARD
Geier, Donald '60

LONG GROVE
Reuss, Timothy S. '90

LOVE PARK
Beebe, Harley '50

MC HENRY
Fike, Stephen '71
Hodgson, Leonard '50

MOLINE
Tapscott, Rand '76

NILES
Carpenter, William D. '77
Sebastian, Ted M. '86

NORTHBROOK
Buehler, Karen S '87

OAK PARK
Sitterly, Donald '71

PEKIN
Willis, William '49

PEORIA
Fitch, David A. '80

PRAIRIE VIEW
Bernay, Laurence '79

RIVERSIDE
Watt, William J. '87

ROCKFORD
Baker, Gregory D. '80
Cholke, Robert C. '77
Clabough, Thomas R. '70
Lager, Donald R. '65
Wehman, Bruce '69

ROMEOVILLE
Mac Donald, Bob '56



SCHAUMBURG
Golinski, Greg P. '87
Otis, Robert W. '69

SPRINGFIELD
Ackerman, Ronald B. '75
Daniels, Gregg '72
Schnorf, Max '65
Sewell, Richard Kirk '77

VILLA PARK
Ellefson, Dwight T. '72
Primas, Paul '86
Snook, James J. '65

WESTERN SPRINGS
Hedlin, Sandi '74

WHEATON
Faber II, Urban '72
Munson, Dan K '88

WHEELING
Tucker, Timothy L. '86

WILMETTE
Mc Intosh, Robert W. '56

WOODRIVER
Magurany, Joseph E. '50

WOODSTOCK
Obenchain, Edith E. '89

YORKVILLE
Thomas, Edward '86

INDIANA

ANDERSON
House, Jack '66
Nelson, John P. '85

BROOKSTON
Schlotman, Larry '69

CARMEL
Mier, James F. '76

CROWN POINT
Kirk, Debra A. '84

EVANSVILLE
Gano, Michael A. '77

FORT WAYNE
Ferguson, Richard D. '86
Norris, Ronald T. '80
Schroll, Todd '56
Watters, Steve '83
Wolf, Thomas L. '88

HIGHLAND
Hollingsworth Jr, Robert B. '69

INDIANAPOLIS
Barnosky, Jack '74
Biggerstaff, Douglas '78
Bush, Robert '82
Conner, Bruce A. '77
Terrebonne, Wayne '71

JEFFERONVILLE
Torres, Jose L. '84

KOKOMO
Dawson, Robert R. '61

LAURENCEBURG
Block, Randall '80

MISHAWAKA
Nelson, Dale L. '86
Scott, Hans W. '86

MUNCIE
Bennett, Benjamin '88
Self II, Ed '65
Troxell, Paul '71

MUNSTER
Walczak, Kenneth J. '89

NEW HAVEN
Nix, Adrian '50

SALEM
Hasnerl, Edward '55

SOUTH BEND
Barden, Brad S. '79
Frick, Dean '74
Linster, Charles '55
Long, Dylan '89
Patrick, Gerald M. '78

IOWA

AMES
Munger, James '71

BETTENDORF
King, John David '63
Pontarelli, Robert '77
Tapscott, Carolyn Jacobs '77

CEDAR RAPIDS
Cox, John L. '64

CLINTON
Loth, Lawrence '58

DAVENPORT
Stuedemann, Rebecca J. '90
Thistle, Todd A. '85

DES MOINES
Gee, Ronald '87
Mulvin, Edward '80

FAIRFIELD
De Giere, Terence '71

FORT DODGE
McNiel, Samuel L. '87

HOPKINTON
Greenwood, Bernard '55

HUMBOLDT
Cox, Dennis G. '69

Column 6

JOHNSTON
Maas, Curtiss W. '79
Sinklier, Scott R. '78

LAMONI
Keyser, John H. '87

RINGSTED
Peterson, James '61

SPIRIT LAKE
Kleene, Gerald J. '73
Olson, Kenneth L. '71

WATERLOO
Dodge, John W. '71

KANSAS

FAIRVIEW
Sawyer, Gerald '83

FAIRWAY
Vanderwal, Carol L. '79
Wegst, Andrew '90

GARDEN CITY
Turner, Terry '63

GREAT BEND
Riggs, Dale A. '75
Riggs, Sheldon '75

KANSAS CITY
BLOCK, ERNIE '76
Chisholm, William '73

LARNED
Scott, Michael C. '86

LAWRENCE
Davis, Julie K. '78
Everley, Robert '78
Young, R. Eric '80

LEAWOOD
Everley, Robert '78
Young, R. Eric '80

MANHATTAN
Watson, James W. '67

NEWTON
Harper, Steve '71

OVERLAND PARK
Braswell, Mark '68
Ferney, Connie Barnes '86
Nash, Gerald A. '77

PRAIRIE VILLAGE
Brookfield, Betty B. '76

ROELAND PARK
Shepard, G. Dean '85

SHAWNEE
Baltzley, Mark C. '90

SHAWNEE MISSION
Accardo, Nathan L. '57
Johnson, Linda '89
PERRYMAN, JOHN G. '63

TOPEKA
Frenn, Thomas '72

WICHITA
Bastian, Christine '83
Fahey, Clifford G. '81
Hazelwood, Jack L. '86
Hetler, Jeffrey D. '77
Monnat, Nanci A. '78
Mostowitz, Joshua '78
Williams, Dale '57

KENTUCKY

ASHLAND
Fosson, Connie L. '85

CATLETTSBURG
Mc Coy, H. Patrick '76

HARTFORD
Weedman, Blair '73

LEXINGTON
LEVY, DAVID R. '78
Thomas, Marguerite A. '86
Thompson, Elizabeth Bakhaus '81

LOUISVILLE
Call, Susan C. '80
Carlton, Charles B. (Chuck) '81
Lynch, Warren '69
Milam, Kay '87
Moseley, Sam '71
Smith, Harold E. "Bud" '71

MT. OLIVET
Engelman, John R. '80

LOUISIANA

BATON ROUGE
Guercio, Philip '77

LAFAYETTE
Beyt, Peter D. '84
Schafer, Suanne '83

LAKE CHARLES
Crosby, Edwin K. '75
Hyatt, David '82
Monsour Jr., Victor '77
Newlin, Julye G. '89
Quienalty, Michael C. '85

METAIRIE
Burger, Jeffery F. '86

MINDEN
Feltus, John '52

MONROE
Gibbs, Tommy '74
Mc Carty, George W. '73

NATCHITOCHES
Bailey, Nolan W. '70

Column 7

NEW ORLEANS
Chauvin, William '71

SHREVEPORT
Lewis, Brian L. '81

SLIDELL
Haskin, David A. '86

MAINE

BRIDGTON
Morrisseau, William '71

BRUNSWICK
Luce, Alvah C. '71

BRYANT POND
Mills, Nathan H '86

CARIBOU
Lavigne, John Paul '86

DAMARISCOTTA
Fox, Deborah

NORTHAMPTON
Boyer Jr., Wallace '63

ORONO
Nab, Adrie '74

PORTLAND
Gomez-Kucine, Barbara M. '85
Kucine, Cliff G. '85

MARYLAND

ABERDEEN
Kerr, Maurice '68

ACCIDENT
Beitzel, Terry D. '87

BALTIMORE
Green, Jeremy '76

BETHESDA
Mac Vicar, Norman '56

CHEVY CHASE
Winslow, Laura '55

CHURCHTON
Groo, Stephen W. '81

COLUMBIA
Logue, James Allen '68

EDGEWATER
KOZAK, RICHARD E. '80

ELLICOTT
Biondi, Honey '79
Himburg-Biondi, Honey '79

FT. WASHINGTON
Le Tourneeau, Jerrold '81

GAITHERSBURG
Staley, Thomas M. '74

GERMANTOWN
Peabody II, Richard R. '67

GLEN BURNIE
Brendle Sr., Robert Lester '49

HAGERSTOWN
Beckley, Richard Douglas '80
Cook, Barry S. '80

HYATTSVILLE
Kucharski, John '73

KENSINGTON
Conley, Mary V. '79

LA PLATA
Madatic, Ted '77

OLNEY
Chung, Won Young '73

POINT OF ROCKS
Whieldon, J. Charles '76

POTOMAC
Dorfmann, Pamela B. '83

ROCKVILLE
Wines, Craig J '86

SEVERNA PARK
Kem, Patrick T. '80
Parker, James R. '81

SILVER SPRINGS
Holtz, Ronald J. '83

SMITHBURG
Wolfe, Daryl '79

SUITLAND
Salisbury Jr., James '75

UNIVERSITY PARK
Lucas, Pamela A. '89

WASHINGTON GROVE
Throop, Enos T '72

MASSACHUSETTS

BALTIMORE
Mc Cracken, James A. '84

BOSTON
Dern-Wolfgram, Jane R. '88
Williams, Christopher S. '82
Wolfgram, Craig G. '89

BROOKLINE
Copeland, Cathy A. '81
Milani, Farimah '87

CENTERVILLE
Bednark, Walter '66

CHATHAM
Wiseman, Patrick L. '85

DORCHESTER
Grant, Kimberly '77

MASSACHUSETTS (continued)

FRAMINGHAM
Conrad, Douglas '71
Tomaccio, Ralph '74

GRANBY
Lussier, Michael J. '89

GREEN HARBOR
Dullea, Lawrence F. '79

HAVERHILL
GRASSI, THOMAS G. '81

KINGSTON
Ayotte, Don '72

LUDLOW
Sutter, Douglas D. '86

MARSHFIELD
Dow, George '62

MASHPEE
Colina, Jorge '79

MONTAGUE CITY
Elfrink-Wadman, Danette L. '82

N. ATTLEBORO
Moody, Alan F. '71

NEEDHAM HTS.
Yoder, Delvon K. '75

SCITUATE
Reilly, Thomas M. '75

SOMERVILLE
Forlivesi-Amaral, Lisa '83

SOUTH BOSTON
Helmar, Dennis '71

SPRINGFIELD
Bruce, Robert '62

STURBRIDGE
Geiger, Adam '80

TAUNTON
Giglio, Al '52

TURNER FALLS
Markowski, Leon Francis '68

UPTON
Norton, Paul '72

WORCESTER
Allen, Robert J. '73

MICHIGAN

ADA
Nisbett, Mark F. '76

ANN ARBOR
Brougher, Martha L. '86

ATLANTA
Joy IV, Henry Bourne '90

AVOCA
Zosnowski, James E. '87

BATTLE CREEK
Obrig, Timothy G. '81
Wyckoff, Julie A. '74
Wyckoff, Theodore '74

BIG RAPIDS
Sholl, Jerry '69
Voorhees, Steven '67

BIRMINGHAM
Johnson, Kevin P. '80
Parris, Michael O. '71
Walowicz, George '78

BLOOMFIELD HILL
Hammarlund, Vern '57

BRIGHTON
Ondusky, Nicholas '78
Travis, John '72

CADILLAC
Tschirhart, Philip '80

CARO
ASHMUN, ROBERT T. '75

CLARKSTON
Dickieson, Garry T. '79

CLAWSON
Fobar, James L. '81

COLDWATER
Yockey, Fred '78

DEARBORN
Schonhofen, Margaret S. '89

DETROIT
Atkinson, Monica D '90
HOWRANI, AMEEN
Kwiecien, Norman '70
Plasko, Walter G. '79

E. DETROIT
Strong, Ronald '77

EAU CLAIRE
Brooks, William '73

FARWELL
Zugay, Gary A. '76

FLINT
Kessler, Aran D. '80

FRANKENMUTH
Rummel, William G. '78

GRAND RAPIDS
Jacobs, George R. '80

HAZELWOOD
Valenti, Grace M. '84

HOLLAND
Essenberg, James '57
Mc Kinley, Richard S. '79
Owen, Clifford '63

MICHIGAN (cont.)

INTERLOCHEN
Gillner, Michael G. '82

KALAMAZOO
GILROY, JOHN '66
Smith, James '68

LAKE ORION
Niensted, Jerry '69

LIVONIA
Fedrigo, Thomas A. '82

MT. CLEMENS
Irwin, Robin E. '89

MT. PLEASANT
Barclay, Robert A. '76
Brisbane, Margaret '77

PAW PAW
Kaiser, Bill '75

PORTAGE
Rykert, Maurice A. '59

ROCHESTER
Bence, David L. '79
Warholak, Fred J. '84

ROMEO
Fettig, Carl '70

ROMULUS
Nelson, David Paul '83
Wasvary, Lawrence '64

SAGINAW
Barnes, Robert E. '86

SPRINGFIELD
Conway, Robert J. '68
Krum, Stephen C. '86

TRAVERSE CITY
Brauer, Richard D. '77
Forton, Peter S. '78
Frook, Curtis '64
RUTT, DONALD R. '75

TROY
Arthur, David Ray '64
Doucet III, Edward J. '80

UTICA
Arthur, Dianne '82

W. BLOOMFIELD
Harvey, Jesse R. '75
OSBURN, KEN '69

WARREN
Ali, Amina M. '86
Hortigan, John T.

WHITMORE LAKE
Auer, Michael J. '79

MINNESOTA

AUSTIN
Doe, Brian W. '87
Grove, Vern '72

BEMIDJI
Yingling, John '73

BLAINE
Look, Catherine J. '86

BLOOMINGTON
Hanson, Dale B. '82

BROOKLYN PARK
Rekow, James M. '81

BURNSVILLE
Paul, Roger A. '80

COKATO
Stellman, Beverly J. '84

CORCORAN
Erickson, James W. '80

DETROIT LAKES
Arnold, Robert W. '79

DULUTH
Berg, Lawrence '56
Link, Tina L. '78
Mac Innes, James '51

EAGAN
Hauser, Duane '74
Vasquez, James J '86

EDEN PRAIRIE
Sherwood, Hugh C. '84

EDINA
Caterina, Patricia A '87
Moore, William '73

FARIBAULT
Hansen, Mark G. '76

GRAND RAPIDS
Riehle, Jesse D. '53

GRANITE FALLS
Andresen, Clifford '71

GREENFIELD
Natrop, Jeffrey '79

HOLLANDALE
De Boer, David J. '77

HOPKINS
Grafius, Guy '85

LAKE ELMO
Buck, Warren '73

MARSHALL
Taylor, David '64

MEDICINE LAKE
Cook, Daniel L. '82

MINNEAPOLIS
Amos, David V. '81
Anzevino, Patrick M. '77
Behr, Charlotte S. '86
Belem-Walth, Alda Maria '87

MINNESOTA (cont.)

Belknap, Daniel C '87
Dublin, Richard '70
Forrest, Alan '82
Fox, Patrick '81
Gilmore, Susan '79
Gutzmer, Walter L. '81
Hossfeld-Tarnowski, Elizabeth '69
Johnson, Wayne R. '64
Kubat, Anthony J. '81
Larson, Carrie E '87
Lauenstein, John P. '78
Paris, Constantine N. '56
Perrin, Gregory A. '86
Sheperd, Edwin '70
Smith, Alice '85
Strand, Thomas L. '88
Talley, Keith E. '85
Voigt, Richard R. '75
Walth, Daniel M. '87
Zuehlke, William A. '80

MINNETONKA
Hess, Peter H. '88

PINE CITY
Gross, Del M. '78

PLYMOUTH
Luxmoore, Carolyn '85

ROCHESTER
Breutzman, Phil '56
Gould, William A. '82

ROCKFORD
Natrop, Jeffrey L. '79

ROSEVILLE
Laine, Curtis S. '76

RUSH CITY
Halek, Thomas '71

SHAKAPEE
Cox, James S. '65

SHELLY
Brohaugh, Keith '73

ST LOUIS PARK
Arnold, Gurdon C. '70
Brown, Graham '81
Gatzke, Scott K. '83

ST. PAUL
Bass, David J. '77
Bubb, Gregory E. '83
Liane, Kirk
Nguyen, Nghia '88
Revoir, Jack '66
Zaccardi, Michael J. '76

ST. PETER
Bomier, Robert '72

STILLWATER
Johnson, Eric A. '87

UNDERWOOD
NELSON, STEVEN R. '76

VIRGINIA
Skansgaard, Ronald '56

WALKER
HAWKINS, PETER D. '84

WEBSTER
Carmody, Richard J '86

WEST ST. PAUL
Ramsay, Thomas '70
Stanger, James R '87

WHITE BEAR LAKE
Lamotte, Mary Ellen
Donohue '74

MISSISSIPPI

AMORY
Stewart, Buddy '67

JACKSON
Holloway, H. Kay '84

OCEAN SPRINGS
Mitchell, Michael W. '80

PASS CHRISTIAN
Brown, Alexander P. '82

TUPELO
Johnson, William '73

MISSOURI

BALLWIN
Hitz, Brad '81

BELTON
Bahm, Dave '70

BLUE SPRINGS
MC LAUGHLIN, DOUG '72

BRENTWOOD
Epstein, Joseph J. '77

CHESTERFIELD
Salvatori, Allan J. '73

COLUMBIA
Petsel, Joseph C '86

EUREKA
O'Toole, Michael J. '86
Rieder, Robert J. '78

FERGUSON
Abernathy, James L. '79

HOLLISTER
Rawlings, Daniel '67

INDEPENDENCE
Harger, Neil '71

JEFFERSON CITY
Finley, Frank C. '82

MISSOURI (cont.)

JOPLIN
Chapman, Edwin '52

KALISPELL
Kasala, Vicky '85

KANSAS CITY
Bolt, William K '88
Clark, Henry A. '80
Manning, Roy F. '88
Melara, Joseph E. '84
Phipps Jr, Russell S. '63
Pyle, Helen

KENNETT
Madden-Wood, Lisa G. '86
Wood, Byrne '86

MANCHESTER
Goodyear, Richard '71
Royer, Ramon D. '65

MARYLAND HEIGHT
Gamble, Wesley B. '77

MT. VERNON
Chapin, Douglas S. '90

PACIFIC
Merryweather, John D. '85

ST LOUIS
FLOOD, KEVIN J. '75

ST. CHARLES
Plante Jr., Ronald O. (Jay) '90

ST. LOUIS
Borgman, Herbert '79
Bruton, John '73
Burjoski, David G. '82
Gianelle, Frank '75
Hollenbeck, Douglas '87
Leong, Victor '89
Morgan Jr., S. Shane '90
O'Brien, Steve '84
Ott, Thorsten '89
Pawelko, Greg '77

ST. PETERS
Bruns, Barry L. '79

STOCKTON
Mitchell, Joseph R. '76

WARRENSBURG
Johnson, Edward '72

WARSON WOODS
Miller, H. Brookings '81

MONTANA

BILLINGS
Buck, Richard '59
Gerbase, Kimberly E. '86

BROCKWAY
Gackle, Delton '72

COLUMBIA FALLS
Bartsch, Jerry Lee '70

CONRAD
Anderson, Gordon '58

EAST GLACIER P
Turvey, Joyce M. '53

HELENA
Sandmire-Munda, Cheryl B. '83
Vanvoast, Gregory S. '63

KALISPELL
Johnson, Paul M. '84
Schmautz, Alan '74

MISSOULA
Hilton, Ronald E. '86
Pettit, Robert L. '80
Woodworth, Roger '69

SCOBEY
Frederick, Jack '61

TROUT CREEK
Townsend, John '65

WILSALL
Wonders, Douglas Russel '69

NEBRASKA

BEATRICE
Johnson, Mark R. '76

BLOOMFIELD
Buttner, David M. '85

CRESTWOOD
Johnson, William M. '86

FLORHAM PARK
Natale, Carmen J. '85

LINCOLN
Armstrong, Joel '81
Delaney, Tim '84
Farrall, Donald R. '79

LIVINGSTON
Feiger, Beth '85

NEW ROCHELLE
Yaghoubzadeh, Babak '84

NEW YORK
Kazan, Michael R. '86
Maxtone-Graham, Ian '83

OMAHA
Conway, Curtis A. '75

PLAINVIEW
Grand, Michael '86

SCOTTSBLUFF
Christian, Paul '53

NEVADA

BEATTY
Walker, Leslie A. '86

NEVADA (cont.)

CARSON CITY
Hammack, Ben '83

HENDERSON
Fleshman, Roger G. '84
Strange, Roger '71

LAS VEGAS
Altenburg, Sue A. '83
Covey, Norman E. '60
De Lespinasse, Hank '65
Karner, Fred '49
Martinez, Adriana '86
Meagher, Michael E. '86
Pelan, Michael '64
Pomeroy, James '79
Radstone, Richard M. '85
Reynolds, Albert E. '73
Rhodes, James '72
Roesies, Robert '66
Smith, Rickey E. '79
Taylor, Christopher '85
Weckhorst, Peter '86
Wood, Cynthia L. '85

RENO
Costanza, Robert '86
Cross, Michael '70
DOW, JEFFREY S. '89
Hart, Douglas W. '70
Helsem, Randall J. '82
Hofmann, Bret '83
Poncia, Linda R. '80
Schnitter, Hans '45

SEARCHLIGHT
Hanius, Richard

SPARKS
Fujimoto, Kazuya '62
Leong, Janet M. '84

STATELINE
Reynolds, Susan A. '79

NEW HAMPSHIRE

CONCORD
Rixon, Michael L. '82

CONWAY
Ohlson, Brian '72

HAMPTON
Weller, Stephen D. '81

NEW JERSEY

ANNANDALE
Stucky, David A. '85

BARNEGAT LIGHT
Rossmeissl, Kirk J. '82

BEACH HAVEN
King, Kathryn M. '78

BERNARDSVILLE
Fulton, Robert '73

BOONTON
Roepe, Brian E. '81
Sangillo, Tom '67

BRICK
Moffat, Ronald '72

BRICKTOWN
Nicoles, Michael A. '85

CARLSTADT
Crouch, Newel '74

CHERRY HILL
Herskowitz, David S. '87
Kauffman, Haskell '56

CLIFFSIDE PARK
Goretsky, Nancy S. '86

COLONIA
Cook, Leland A. '48

CRANBURY
Schaffer, Amy Michal '89

CRAWFORD
WAGNER, WILLIAM '64

EATONTOWN
Corley, Michael D. '73

ESSEX FELLS
Lord, Suzanne '88

FAIR LAWN
Garfield, Philip '80

FAIRFIELD
Wildi, Ernst

GILLETTE
Reed, Geoffrey M. '84

GUTTENBERG
Steinhardt, Dan '79

HILLSDALE
Siegler, Gary G '86

HOBOKEN
Feaster, Mark S. '82
Mc Conn, David A. '88

INTERLAKEN
Galipo, Frank '78

ISLAND HEIGHTS
Applin, Susan '87

LANDING
Kuczera, Michael G. '79

LINCOLN PARK
Radford, Neal '80

LIVINGSTON
Marcus, Kimberly '87
Varney, Paul R. '76

LAKE HOPATCONG
Pardee, David P. '79

NEW JERSEY (cont.)

MADISON
Stevens Jr., William '68
Von Hoffman, Bernard '78

MAPLEWOOD
Naideau, Harold E. '78

MARLTON
Mattie, Gary C. '79

MEDFORD LAKES
Keys, Michael '69

MONROEVILLE
Wurst, James H. '72

MONTCLAIR
Buck, Bruce W. '77

N. PLAINFIELD
Kelly, Eton
Kelly, Thomas A. '75
Mooney, Gail A. '75

NEW LISBON
Thompson, T. Stephan '77

NORTH BRUNSWICK
Warner, Whitey '72

PENNSAUKEN
Culver, Robert '79

PENNSVILLE
Ulissi, John '71

PERTH AMBOY
Bell, Frank '74

PRINCETON
MCPHIE, JEFF '76

RATHWAY
Zeigler, Reid '72

RED BANK
BAITZ, OTTO '68

ROSELLE PARK
Schmidt, Ronald J. '90

SEWELL
Carnevale, John J. '75

UNION
CATENA, JAMES J. '82

WEST END
Hesseels, Lloyd '73

NEW MEXICO

ALBUQUERQUE
Appelman, Guy '79
Cox, Luther W. '68
Garduno, Rey '71
Hunsley, Wallace '63
Johnson, Al '63
Maes, Manuel '79
Marshall, Roger '66
Moyers, Eric
Nowak, Thomas '89
Nufer, David '87
Ripp, Ronald A. '80
Suderman, William J. '76
Tucker, John '87
Whitehill, Stephen '68

ALTO
Noel, Charles M. '89

CARLSBAD
Crouch, Newel '74

CERRILLOS
Kennedy, David '70

CLOUDEROFT
Sutherlin, Jerry '75
Sutherlin, Miriam S. '70

DEMING
Crosby, Ken '75

GALLUP
ERRAMOUSPE-WALLACE, LISA D. '81
Wallace, Lisa E. '81
Woodard, Suzanne '85

HIGH ROLLS
Piche, Karen B. '84

KIRKLAND AB
Talbott, Arnold L. '71

LAS CRUCES
Giard, Louis Scott '83

LOS ALAMOS
Anders, Peter D. '71
Des Georges, Joseph '90
Gordon, Robert '67

LOS LUNAS
Aguilar, W. Barry '75

RIO RANCHO
Burns, Steven T. '81

RUIDOSO DOWNS
Rigdon, Steve '90

SANDIA PARK
Clark, Blair R. '78

SANTA FE
Contreras, Sue '74
Lehman, Danny '76
Sharer-Porter, Holly '70
Swenson, John R. '77

NEW YORK

AMAGANSETT
Kane, Betsy A. '82

APO NEW YORK
Havner, Patricia A. '83
Rhoades, Stefanie '87

NEW YORK (cont.)

ASTORIA
Bies, William J. '83
Reed, Richard R. '84

BELL HARBOR
Livine, Cynthia

BINGHAMTON
Zell, Victor J. '76

BRIDGEHAMPTON
Pease-Acquino, Mary '72

BROOKLYN
Bastardo, Jimmy '89
Faulkner, William R. '87
Goldman, Marian B. '82
Johnson, Robert E. '86
Negrin, Ted '81
Rizzo, Maria Elena '86
Sarkissian, Katherine '86
Skinner, Robert B. '83
Stone, Kelly '84
Thompson, Michael P. '84
Weckler, Chad '76
Wright, Jeffrey B. '87

BUFFALO
Degrood, Timothy '75

CENTER POST
Keanzler, Paul

CHEEKTOWAGA
Rowan, Thomas '72

CLARENCE
Kepner, Steve C. '83

COLLEGE CORNER
Sweeden, Virgil '71

DOUGLASTON
Foti, Ann Erin '82

FAIRPORT
GARN, MYK '77

FLUSHING
Prochnow, Robert L. '82

FOREST HILL
Kohlhoff, Frederick '76
Majocchi, Nicola S. '87

FULTON
Gionfriddo, Robert '72
Giovannetti, Mark L. '83

GERMANTOWN
Golden, Bob '76

GILBERTSVILLE
Stillman, Joseph '74

GLENS FALLS
PLUMMER, JEFFREY K. '80

GREAT NECK
White, Jonathan R. '80

HAMBURG
Kramer, William R. '81

HAMPTON BAYS
Greene, Richard '73

HOPEWELL JCT.
Burington, Stephen H. '88

HOWARD BEACH
Galler, Eric M. '89

HUNTINGTON
Morett, Lauren J. '76
Schubauer, Gretchen '82

ILION
Tooney, Stephen '71

JACKSON HEIGHTS
Tilas, Nicholas J. '80

JERICHO
Rho, Hyo Woon '90

JOHNSON CITY
Collavo, Kim O. '90

JOHNSTOWN
Barney, Wayne '61

KEW GARDENS
Bell, James A. '78
Clouthier, Kimberly '88

LAKE PLACID
Prime, Jonathan S. '82

LEVITTOWN
Rogers, James A. '78

LONG ISLAND
Lynaugh, Kathy '88

LONG ISLAND CITY
Pannier, Fredrick P. '82

MANLIUS
Feiling, David A. '76

MERRICK
Altman, Michael '79

MONTAUK
Donahue, Thomas '78

NEW CITY
Fiat, Gideon '79

NEW ROCHELLE
Klayman, Kerry '86

NEW YORK
Ariav, Haim R. '85
Arslanian, Ovak '77
Avneri, Ronit M. '85
Barr, Neal '57
Bernstein, David M. '56
Boncorps, Christian M. '68
Bordnick, Barbara
Breckheimer, Gary '86
Buddee, John '64
Chong, Jeffrey '83
Christensen, Paul H. '75

NEW YORK (continued)

Collin, Francis '82
Cooke, Colin A. '76
Cooper, III, John Newton '90
Cornell, Anna R. '82
De Leon, Martin '83
Doubilet, David '67
Duchaine, Randall D. '78
Emerick, Laura L. '81
Ferri, Mark A. '81
Filary, Katrina M. '85
FOULKE, DOUGLAS B. '79
Garcia, Enrique '74
Goble, Brian P. '79
Griffin, Gregory A. '82
Guiler, Kevin '83
Hathon, Elizabeth '78
Heuberger, William '79
Higginbotham, James '79
Hitz, Brad '81
Hofmann, Rudy '80
Kim, Beom C. '83
Kiriluk, John D. '82
Klauke, Christoph '86
Klauss, Cheryl A. '81
Koning, Erika
Kornicker, Peter J. '78
Krogh, Jennifer '88
Lefler, David A. '79
Lonninge, Lars A. '79
Murphy, Dennis J. '78
Newlin-Englander, Maury A. '81
Nofziger, Christopher '85
Penny, Donald G. '79
Pierce, Richard '79
Powell, Gary R '88
Rasmussen, Eric J. '82
Ray, Christopher B. '90
Rosenthal, Marshal '79
Schochat, Kevin R. '82
Stewart, Cameron F. '76
Stokmo, Rune '89
Stratton, Ann E. '80
Studebaker, Daryl P. '75
Tannenbaum, Dennis I. '75
Thomas, Mark W. '83
Trovato, Luca E. '87
Tynan, Dana '83
VOGEL, PETER '88
Wachs, Ted '75
Waldron, William P. '81
Watermann, Gregory '84
Wills, Bret '82
Yamada, Masato '78
Zimmerman, David J. '81

NEWBURGH
Strano, Aldo '73

NORTHPORT
Barreto, Patrick W. '81

OLD BROOKVILLE
Woods, Kaelin '89

PORT CHESTER
DUGAW, SUSAN M. '77
SPERDUTO MOTO, STEVE '76

ROCHESTER
Barker, Dennis '79
Barker, Robert P. '79
Benjamin, Beth E. '82
Kimoto, Walter '72
Moore, Robert '80
Naud, Jean-guy '64

SCARSDALE
Laurino, Don '78

SCHENECTADY
Burke, John '73

SCOTTSVILLE
Cramer, David '86
Stambaugh, Debi '76

SPRING VALLEY
Taffuri, Richard '80

STATEN ISLAND
Anderson, Jon Bryant '86
Easop, Thomas A. '86

SYRACUSE
Gardner, Richard E. '75
Golden, Anthony R. '74
SCHERZI, JAMES '71

TAPPAN
Kalan, Mark '77

WESTHAMPTON BEACH
Horton, Peter D. '70

YOUNGSTOWN
Fairbank, Rodney G. '86

NORTH CAROLINA

ASHEVILLE
Davis, Terry C. '76

CHAPEL HILL
Quade, Jonathan D. '86

CHARLOTTE
Epley, Paul '71
ISGETT, H. NEIL '83
Lecate, Robert H. '76
Palmer, Douglas S. '90
Shedd, Charles F. '75
Taylor, John M '84

CONCORD
Mc Ginnis, Michael G. '81

GOLDSBORO
Reynolds, Richard A. '76

HICKORY
Hicks, Charles '56

HIGH POINT
Barnes, John '90

LEWISVILLE
Mc Knight, H. Morris '82

LUMBERTON
Amos, Thomas '74
Revels, Suzanne C. '87

RALEIGH
Kiesow, Paul '73
Larson, John Scott '86
Patterson, Grady S. '81
VAN DE ZANDE, DOUGLAS '79

ROCKWELL
Austin, Keith '60

ROCKY MOUNTAIN
Bragg, Will '49

SMITHFIELD
Williams, William T. '52

SOUTHPORT
Thompson, Stephen '85

TRYON
Georgia, Frederica '86

VALLE CRUCIS
Scarlata, John '74

WEDDINGTON
Alexander, Rick L. '70

WILSON
Anthony, Claude '61

WINSTON-SALEM
Graham, Ashton C '88

NORTH DAKOTA

BISMARCK
Joyce, Dennis '58
Joyce, Nancy A. '85

CANDO
Westlind, Gregory '71

GRAND FORKS
Olson, Gerald '68

JAMESTOWN
Bettenhausen, Robert '86
Petersen, Phred S. '85

KINDRED
Crane, Stephen C. '82

MANDAN
Weller, Lawrence '71

OHIO

AKRON
Turouske, Ronald E. '79

ASHTABULA
Hyppa, Carl John '66

ATHENS
Jeong, Woo Young '89

BATH
Hoffman, Thomas '74

CENTERVILLE
Ahern, William '69

CINCINNATI
Brookes, Donn D. '77
Eklow, Fred S.H. '75
Emery, Gregory R. '77
Glutz Jr, Robert '77
Heminway, Truman '64
Hunt, John J. '76
Kocherov, Sam '58

CLEVELAND
BERR, KEITH W. '77
Schneider, Robert '64
Tropiano, Frank V. '76
Weeks, William '53

COLUMBUS
Herbst, Gary B. '73
Joslin, Rodney P. '80

COPLEY
Rosenthal, Ian J. '64

DUBLIN
Silverman, Norman '73

EAST LIVERPOOL
Halliday, Steve '47

GROVE CITY
Holscher, David C. '82

HAMILTON
Kohring, Gene W. '58
Woods, Jack '56

HUDSON
Richardson, William R. '77

LOVELAND
Kiley, Ralph '70

MENTOR
Hange, Robert '69
Money, Catherine E. '83

N. CANTON
Krebs, Robert '66
Raudabaugh, Bruce '77

PORT CLINTON
Gordon, William E. '70
Kilmer, Richard H. '76

REYNOLDSBURG
Woods, Dennis G. '77

ROSSFORD
Linkous, Larry G. '73

SIDNEY
Echemann, Raphael A. '79

TIFFIN
Cahill, Donald '73

TORONTO
Straka, Robert '62

TROY
Mc Lain, Stephen T. '71

UNIONTOWN
Finley, Russell C. '80

UNIVERSITY HEIGHTS
Karlin, Alan P. '76

WEST CARROLLTO
Vada, Jay '76

YOUNGSTOWN
Werning, Paul G. '90

OKLAHOMA

ALTUS
Dixon, Michelle Ann '90

BROKEN ARROW
Barnes, Larry M. '75
Hartness, Tracy Sierakowski '82
Peterson, Jon '70

GLENPOOL
Motto, Katherine Umbaugh '71

NORMAN
Munn, Winston B. '75

OKLAHOMA CITY
Carter, Robert '68
Dale, Gary L. '88
Goldstein, Gene '70
Mills, Jack '73
Shepherd, Michael L. '83
Singer, Michael J '88
Truesdell, Helen Renee '77

PONCA CITY
Treat, Van H. '68

SHAWNEE
Fogerty, Barry '82

TAHLEQUAH
Tejada, Adelaida L. '85

TULSA
Baxter, Kevin C. '81
Billings, Robert C. '73
Elder, Phillip '68
La Fortune, John M. '86
Lee, Mel '74

YUKON
SHORT, ROGER '68

OREGON

ALBANY
Fulton, Douglas J. '84

ALOHA
Knight, Warren '66
Mc Nally, John '76

ASHLAND
Child, Douglas R. '83
Jaffe, Robert N. '77

ASTORIA
Lind, Bill '73

BEAVERTON
Borland, Charlie '80
Crawford, Ron '68
Henry, Eddie L. '78
Opp, Kathryn A. '83
RATTY, BRIAN '68

BEND
Alvis, Gary '74
Chandler, Ross C. '80
Malan, Julie A. '87
Morris, David M. '75
Swan, David L. '61

CANBY
Derry, Mark W. '76

CLACKAMAS
Aeby, James T. '80

CLATSKANIE
Hall, Debra '80

CORNELIUS
Kinch, Jason A. '77

CORVALLIS
Edblom, Jock J. '64
Graham, Jared M. '77
Krupp, Peter '65
Meador, Steve '82
TARLETON, JAMES G. (GARY) '80

COTTAGE GROVE
Bachtler-Cushman, Robin '75

DALLAS
Archer, Zale '71

DAYTON
Anderson, Kenneth H '88

ESTACADA
Dooley-Collins, Kit '74

EUGENE
Ortiz, John '79
Whisenant, Charles '69

FOREST GROVE
Ohlgren, Brent '70

GLENDALE
Fox, Grace '70

GLIDE
Monie, Allan '77

GRANTS PASS
Hooker, Ken C. '85

GRESHAM
Culver, James P. '74

HILLSBORO
Brubaker, Craig M. '77
Drafahl, Jack '73
FISH, STEVEN D. '76

HOOD RIVER
Terry, James David '79

KLAMATH FALLS
Mc Fadzen-Marks, Annette L. '80

LAKE OSWEGO
Ager, Sharon S. '76
Gomena, J. Peter '90
Hartigan, John '85
Hessemer, David E. '79

LINCOLN CITY
Burr, James Allyn '88

MADRAS
Hethorn, John '86
Steckley, Steven '77

MEDFORD
Knackstedt, Kenneth '57
Silvester, Keith '82

MILWAUKIE
Bergman, Bruce '74
Ferriss, James '72
Larkins, Thomas '71

MOUNT ANGEL
Cheney, Catherine A. '76

OREGON CITY
Gillson, Dennis '68

PENDLETON
Grant, Bob '54

PORTLAND
Amestoy, Sharon Gayler '74
Amonson, David '71
Arcuri, Joseph A. '78
Bahner, Robert '73
Bosler, Daniel Eric '82
Brown, Larry '60
Ebsen, Mark D '88
Ellison, Greg '81
Evans, Mark S. '77
Farris, Stephen G. '85
Felzman, Joseph D. '77
Fowler, Chris E. '83
Hallinan, Peter R. '77
Hart, Edmund '74
Helin, Art '51
Horner, Laura Jean '57
Huerta, Jack '79
Huget, Erik P. '88
Jones, Dale '71
Kaufman, Andrew L. '83
Keller, John '70
Laubacher, Kevin '79
Leno, Greg A. '86
Lopez, Julie A '88
Nolte, Stephanie '87
Oderman, Dawn R. '90
Osborn, Robert '59
PAPAZIAN, DAVID S. '81
PATTERSON, BRETT '88
Patterson, John G. '84
Peterson, Burt '73
Philps, Steven '73
Prechtel, Brian C. '90
Ray, Steven L. '79
Reed, Kellie L. '82
Schauer, Brent '69
Shirahama, Grant '79
Smith, Herman Lee '73
Stewart, Thomas H. '77
Stoddard, Ernest R. '75
Strausbaugh, Debbie J. '79
Turner, Robert '73
Vala, Scott F. '76
Van Sciver, Diane '86
Wallace, Patrick R. '78
Wheeler, Scott D. '85
Wong, Glenn '86
Zeller, Nick '72

SALEM
Arendt, Gilbert '58
Augustin, Philip V. '83
Gorby, Richard L. '71
Steward, Eric Bradley '86
Wagers, Ralph '53

SCIO
Hueberger, William '79

SISTERS
Rierson, Barton '86

SPRINGFIELD
Mellor, Kenneth W. '78
Simmons, Frederick B. '68

TIGARD
Johnston, Howard H. '75
Martin, Sherry Kay '89
Mc Cabe, Serge '83

TUALATIN
Illig, Russell '50

WILLIAMS
Karpinski, Michael '78

WOODBURN
Brumbaugh, Wilbur '48

PENNSYLVANIA

ABINGTON
Van Scott, David J. '83

ALLENTOWN
Rodale, Anthony A '87

ARDSLEY
Vassalluzzo, Italo A. '62

BENSALEM
Jones, Jon L. '82
Mc Grail, John A. '76
Talarico, Roberto S. '78

BERWYN
Bellas, Johanna D.(Yo) '82

BETHLEHEM
Johnson, Daniel W. '85

BRACKNEY
Van Zandbergen, Kirk '81
Van Zandbergen, Leslie '81

BROOKHAVEN
Peirce, David C. '73

BRYN MAWR
Taylor, Gail T. '80

BUTLER
De Coux, Peter '72
Dodge, Ellen '82

CHESTER
Jacobs, James R. '82

DOWNINGTON
Andreen, Susan '77

EDINBORO
Goldsmith, Howard C. '76

ELIZABETH
Gedekoh, Clifford '52

ERIE
Bell, David K. '82
Gebhardt, Richard H. '66

EXTON
Ahlbom, Steven B. '70

FINLEYVILLE
Mc Keeta, Regis J. '62

FOLSOM
Berken, C. Geoffrey '74

GREENCASTLE
Pensinger, Douglas A '85

HARRISBURG
Katz, Jocelyn '86
Motter, Leon E. '53

HOLLIDAYSBURG
Woods, Loren '69

JENKINTOWN
Fowler, Eve M. '87

LANSDOWNE
Lewis, Gerwyn '69

LATROBE
Parker, Lawrence L. '82

LIBRARY
Flaherty, John M. '77

MARS
Wuchenich, Robert J. '77

MARTINSBURG
Leidy, Gerald T. '72

MEADOWBROOK
Blumenthal, Len '56

NORRISTOWN
Filone, Nick '80

OHIOVIEW-INDUS
Nola, John A. '79

PALMYRA
Kresge, Dennis C. '76

PAOLI
Dowler, Lauren K. '79

PHILADELPHIA
Fuhr, Nicholas J. '82
Nible, Richard C. '79
Rosner, Eric H. '77

PITTSBURGH
Brody, James '74
Franke, Richard '72
Jeffress, Anthony '67
Minnock, Marion P. '77
Popovich, Peter '77
Raco, Rocky '80
Rentz, David E. '70
Rodgers, Michael S. '75
Rosen, Allen I. '76
Twardy, Joseph '69
Warnicki, Joseph W. '76

POTTSTOWN
Cruise, Barry '72

SCOTTDALE
Seaman, William M. '76

SEWICKLEY
Wardrop, James R. '72

TOPTON
Tinsman, R.B.

WEST WYOMING
Malloy, Robert M. '88

WILLOW GROVE
Saylor, Mark W. '80

WORMLEYSBURG
Horn, Albert '55

YEADON
Van Krieken, Donald '88

PUERTO RICO

TRUJILLO ALTO
Belville, Everett '68

RHODE ISLAND

CRANSTON
Whitney, Stephen '69

HOPE VALLEY
De La Port, Marc C. '79

MIDDLETOWN
O'Neil, Jay '86

PROVIDENCE
Beagen, Andrew J. '87
Young, Robert '69

TIVERTON
Gustafson, Mark '79

WARWICK
Hyink, Paul A. '71

SOUTH CAROLINA

ANDERSON
Kesler, Douglas B. '81
Kesler, Kevin Williams '80

BLUFFTON
Rhoad, Timothy P. '78

CHARLESTON
Nettles, Robert '49
Rhodes, Richard '90

CLEMSON
Wickliffe, Louis "Clark" '71

COLUMBIA
Eleazer, G.D. '52

EASLEY
Belknap, Robin C. '83

GREENVILLE
Hohmann, Alvin '73
Ramsaur, E.A. (Ted) '75

GREENWOOD
Adams, William '66

HILTON HEAD ISLAND
Hurst, John '74

HODGES
Breazeale, Ronald R. '77

MT. PLEASANT
Ruggles, Linda L. '86

MYRTLE BEACH
Delmage, Sherman H. '47

SENECA
Fleishman, Bryan E. W. '89

SOUTH DAKOTA

MITCHELL
Landwehr, Eric H. '89

RAPID CITY
Baumgartner, William (Hans) '76

SIOUX FALLS
Bowden, Ronald L. '79

TENNESSEE

ANTIOCH
Orenstein, Amy E. '90

BRENTWOOD
Marrs, Ira '49

BRISTOL
Blankenbeckler, Kenneth '66

CHATTANOOGA
COPELAND, ROBERT W. '78
Russell, Gary & Rhodonna '78

CLEVELAND
Mitchell, John B. '66
Swearingen, G. Van '57

GALLATIN
Kennedy, Paul E. '78

GERMANTOWN
Van Gieson, Paul '69

HARRISON
Woods, David O. '77

HENDERSONVILLE
Dippold, Sue '82
Schoon, Alvin '52
Weedman, Brent '73

KINGSPORT
Gentry, Robert '59

KNOXVILLE
Oskooie, Ardeeshir R. '82

MARYVILLE
Wilkinson, Lee '63

MEMPHIS
Baldridge, Michael '69
Kenner, Jack W. '80
Mims, Allen '79
Sanders, Michael '86
Woodliff, Charles E. '77

NASHVILLE
Dixon, Dean D. '75
Frazier, Jeff '84
Frazier, Ned '70
Kopels, Stephen '72
Mitchell, Michael P. '78
Sengel, Marc
Stengel, Marc K. '81
Williams, Ronald C. '79

NOLENSVILLE
Reifschneider, Roberta L. '89

OLD HICKORY
Flowers, James '66

SCOTTS HILL
Bernstein, Karl '63

TEXAS

ADDISON
Hendrickson, Mike '70

ALPINE
Rochester, Anna Lou '52
Rochester, Dr. Alfred '52

AMARILLO
Walsh, Joseph '71

ANGLETON
Hattaway, Michael E. '78

ARGYLE
Judd, Edward H '55

ARLINGTON
Axe, Christopher E. '77
Carter, Randie L. '82
Forcht, James D. '82
Matteson, Robert '53
Mayes, Terrence '71
Mc Elroy, Rod H. '77

AUSTIN
CAVANAUGH-GRIMES, ELIZABETH A. '87
Grimes, David '87
Guerrero, Charles E. '73
Johnson, Len '76
Kyle, Franklin Mark '77
Miller, Scott '80
Nolan, Kelly K '88
Richardson, Jim '72
Seeman, Leigh Ann '80

BEAUMONT
Maraist, Bryant D. '90
Oliver, David M. '75

BEDFORD
Lang, Arthur '67

BELLAIRE
Webb, Drayton W. '81

BOERNE
Gordon, Harry L. '67

BRADY
Burrus Jr., Wiley '76

BRIDGE CITY
Reed Jr., Randolph R. '55

BRYAN
Wadsworth, Larry '79

CARROLLTON
Coursolle, Thomas '71
Mart, Loren '72
Mc Kee, David E. '81
Rodriguez, Daniel '79
Welch, Tom '60

COLLEGE STATION
Henryson, Gary L. '79

CORPUS CHRISTI
Perron, Paul '88

DALLAS
Allen, Jimmie E. '75
Babbitt, Norma
Barber, James (Stan) '81
Brelsford, Mark G '88
Buffington, John David '76
Falke, Terry G. '79
Freeman, Kirk A. '82
Galloway, James '68
Gaudet, Joseph M. '81
Graham, James '80
Henderson, James '50
Ishee, James '60
Jablonski, Anthony J. '76
Johnson, Michael R. '79
Kern, Geoffrey W. '77
Maloney, John '80
Murphy, David Lee '78
Myers, James R. '78
Nay, Richard K. '75
Nugent, Michael B. '89
PERRY, JANICE S. '80
Pierce, David J. '77
Redd, True '73
Reisman, Yvonne Blumberg '67
Roddie, Challenge S '88
Rodriguez, Rodolfo '86
Springer, Tom '77
Threadgill, Tobin E. '80
Tilghman, Michael S. '79
Trotzuk, G. Patrick
Voges, Deborah C. '89
Willis, Gordon H. '80
Wright, Paul Douglas '80

DE SOTO
Craft, Bill '74

DUNCANVILLE
Emmons, Russell A. '86

EL PASO
Carrasco, R. Ted '86
Corkill, Albert '51
LAMA, STEVEN '90
Sequeiros, David

ELECTRA
Keating, Lisa '89

FORT WORTH
Anthony, Glen '73
Clifton, David A. '77
Mc Cormick, Bret A. '80
Ordones, Daniel '84
Rosen-Walstrom, Leslie '86
WILLECKE, BRIAN D. '86

FRITCH
West, David Z. '74

GAINESVILLE
Mathews, Mat '68

GARLAND
Rose, Kevin M. '86

GRAPEVINE
Countryman, Mike '77

HELOTES
Kopacka, Gregory '80

HOUSTON
Baker, Judson '90
Batt, Howard E. '74
Blankinship, John '71
Boatright, Allan '72
Brady, Stephen A. '79
Cancelmo, Jessie '72

TEXAS (continued)

Chae, Jay '88
Deering, E. Joseph '69
Donaho, Linda L. '86
Edwards, Glenn '77
Edwards, Glenn W. '77
Gammon, Bryan K. '88
GATZ, WILLIAM L. ("LARRY") '75
Gorman, Synca '89
Griffin-Villavecchia, Roberta '76
Hamilton, Chuck '75
Haney, Larry K. '80
Harris, Ron '71
Hayes, Jon '65
Jones, C. Bryan '66
Jones, Wendy R. '82
Kreipe, Francis H. '74
Kuhlman, Chris L. '76
Lemoine, Jim '75
Lorfing, Greg M. '83
Mc Gregor, Lauren E. '83
Meltzer, Andrea C. '82
Meredith, Diane '86
Metyko, James H. '83
Mosichuk, Joseph '69
Provada, Fred '73
Ray, Jace '71
Robbins Jr., Joe D. '74
Sanders, Key '85
Schwab, Thomas '65
Shumaker, Maria C. '81
Siegel, Donna R. '78
Summers, Christopher '78
Vincent, Jo Ann '78
Wells, Mark T. '79
WERRE, BOB '71
Westell, Lise Ann '86
Whipple, Barbara J. '69

HUNTSVILLE
Jackson, O. Emmette '69

IRVINE
Winslow, Kenelm H. '80

IRVING
Bracken, David S. '82
Ciancio, Michael J. '83
Germany, Robert R. '82
Hamblin, Steven P. '77
Harrell, King '86
Iverson, Helen M. '89
Kovach, Michael '76
Lacker, Peter W. '82
Marott, Frank '87
Nolte, Steve '83
Pakalka Germany, Barbara J. '82

KATY
STEVENS, JAMES R. '86

KEMAH
Diebold, Mark S. '77

LAS COLINAS
Preston, Michael '83

LEAGUE CITY
Carter, Stuart '53

LOUISVILLE
Eads, Sidney '63

LUBBOCK
Anderson, Hampton '77
CHILDRESS, JIM '82
Thompson, Jon Q. '76

MERCEDES
French, Lanny R. '77

MESQUITE
Gibbs, Terri L. '83
Horn, Shawn E. '83

MIDLOTHIAN
Beck, Michael Craig '77

MONTGOMERY
Hoke, Karl H. '80

OAKWOOD
Stuard, Robert '72

PLANO
Staniszewski, Ron M. '78
Tingdale, Thomas S. '77

RICHARDSON
Frank, Robert A. '73
Mc Alister, Steve G. '80
Shackelford, Robert '72
Smith, Richard H. '79
Stringfellow, Cecil '69

RICHMOND
Foss, Terrell D. '86

ROANOKE
Yrisarri, David W '88

ROBERT LEE
Bessent, Lisa A. '83

ROCKPORT
Berry, Richard K. '76

SAN ANTONIO
Buendia, Richard K. '78
Burkholder, F. Dan '80
Evans, D. Clarke '85
French, Robert C. '77
LANGFORD, MARK '80
Mc Guire, Shauna K. '80
Rowland, Katherine '87
Sykes, Drew G '88

SAN MARCOS
Wilson, Jim '65

SPEARMAN
Collier, Thomas '65

SPRING
Van Cleave-O'Donnell, Gretchen '80

TERRELL
Jones, Harry Lynn '60

THE WOODLANDS
Prossack-Seiffert, Kyle R. '83
Seifert, Thomas A. '83

UNIVERSAL CITY
Hernandez, Richard '81
Litherland, Jeffrey D. '90

WACO
Irwin, Joe B. '79

UTAH

BOUNTIFUL
Pascoe, Wayne '68

BRIGHAM CITY
Evans, Thomas W. '81
Freshwater, Jeremy E. '78
Stoffer, Douglas L. '80

HELPER
Fossat, William '54

KEARNS
Hansen, Dale '63

LAYTON
Oleson, J. Chris '79

OGDEN
Lapine, Robert E. '75

OREM
Hirst, Frank '55

PARK CITY
Nass, Nicholas '71

SALEM
Davidson, Bruce '79

SALT LAKE CITY
Fraughton, Paul H. '77
Hansen, David L. '55
Jensen, Ralph '52
Leavitt, Frank A. '75
QUINNEY JR., DAVID E. '81
Rice, Michael D. '70

TOOELE
Toensing, Fredrick '75

TOQUERVILLE
Chamberlain, Lynn Atkin '80

WEST VALLEY
Magee, Robert R. '54

VERMONT

JERICHO
Zyber, Thomas K. '84

RICHMOND
Lorenz, William J '73

RUTLAND
Casavant, Jayson P. '82

S. BURLINGTON
Corrada, Fernando B. '85

VIRGIN ISLANDS

ALEXANDRIA
Gordon, Eric '86

ROCKY GAP
Bowen, Thomas H. '84

VIRGINIA

ABINGDON
Hudson, Stephen M. '75

ALEXANDRIA
Ashe, Terry '76
Mack, Karyn S. '85
Mc Curley, Budd K. '52
Potera, Paul B. '81
Tuttle, Steven '69

ANNANDALE
Romeo, Joseph '88

ARLINGTON
Flynn, Timothy J. '78
Poucel, Guillermo '76

ASHBURN
Church, James N. '75

BLACKSBURG
Hincker, Lawrence G. '77

BROAD RUN
Beane, William '84

EAGLE ROCK
Almarez, Charles '79

FAIRFAX
Striplin, Patrick '79

FAIRFAX STATION
Roop, Robert G. '74

HERNDON
Myers, Lawrence J. '73

LEXINGTON
Bradshaw, Thomas '71

MADISON HEIGHTS
Dodd, H. Lee '87

MC LEAN
Andriot, John W. '76
Thomas, James (Trey) '87

MECHANICSVILLE
Snead, Eugene E. '78

NEWPORT NEWS
BOXER, WILLIAM M. '80

NORFOLK
Hughes, Patricia J. '78

PORTSMOUTH
Wolfe, William K. '87

RICHMOND
Hutchison, Ann M. '81
Rhodes, Eugene W. '78

ROANOKE
Minighan, David P. '82

VIENNA
Barbalace, Philip K. '77
Chryssanthis, Debra '80
Jensen, Lisa A. '90

VIRGINIA BEACH
Setzer, William T. '76
Twine Jr., Robert E. '79
Wright, Timothy H. '79

WOODBRIDGE
Jones, Paul B. '79

WASHINGTON

AUBURN
Austin, Jeffrey M. '78
De La Guardia, Maurice '76
O'NEIL (KELLY), CATHARINE FRATT '82
Phillips, John R. (Dick) '64

BAINBRIDGE ISLAND
Francescutti, Alan '68
Gregg, Barry C. '75

BELLEVUE
Bates, Russell B. '70
Berry, Michael A. '78
Griffith, Herbert '60
Holderman, Steve C. '85
Landreth, Douglas S. '79
Luckow, Fred '74
Zimmerman, John D. '88

BELLINGHAM
Aubert, Richard J. '90
Frankel, Georgina E. '86
Geddes, Brian L. '79
Haner, Dorothy '71
Haner, Malcolm '72
Hardan, Gary '75

BENTON CITY
Roberts, Mark A. '89

BOTHELL
Videll, Dennis '73
Weston, Matthew '81

BREMERTON
Balogh, Robert Dean '72

BRIER
Rossi-Walsh, Terri '82

BRUSH PRAIRIE
Gere, Earl Tibbetts '65

CASTLE ROCK
Aldrich, Larry R. '76

CHEHALISTY
Blomdahl, David A. '82

DESMOINES
Sandman, Clarice F '89

EASTSOUND
Palmer, James H. '50
Skott, Michael '73

EDMOND
Beck, Phillip D. '77
KIRKENDALL, THOMAS '80
Ralston, Rod S. '77
Spring, Vicky '81
Thompson, Michael J. '78

EVERETT
Arrabito, James R. '83
Barnes, Rex '72
Beardsley, Keith '74
Dixon, Lynn '72
Murray, Carl '74
Selvidge, Tom '78

FEDERAL WAY
Raymer, John F '72
ROPEL, JOSEPH T. '77

FREELAND
Gaggia, Mark '74

FRIDAY HARBOR
Baldwin, Lauren D '86
Fitzgerald, Sheelin S. '88

GIG HARBOR
Gallinger, Michele '85
Nauman, Marvin '74
Rhody, Kurt '87

HANSVILLE
Marler, Daniel '70

ISSAQUAH
Fischer, Joyce '89
Gallagher, Frank B. '75
Mc Bride III, Paul A. '89
Root, Ken W. '90

KELSO
Almos, Robert A. '74

KENNEWICK
Clark, Norris R. '74
Eads, Andrew C. '76

KENT
Fournier, Charles '68
Gordon-Broadway, Cheryl L. '84
Hutsell, David D. '79
Newton, Jennifer E. '88

KIRKLAND
Anderson, Paul G. '79
Bull, Margaret
Morris, Mark W. '86
Prazan, John J. '77
Robertson, Ken S. '81
Shannon, Russell P. '88

LA CONNER
Garvey, Richard G. '77

LAKE STEVENS
Schueler, Lawrence '64

LAKEBAY
Bauer, Keith '72

LONGVIEW
Lang-Pierson, Molli '79
Pierson, Marvin W. '79

LYNNWOOD
Switzer, Michael J. '79
Walsh, Allen R. '82

MAPLE VALLEY
Swett, Timothy '75

MEDICAL LAKE
Nuess, Joseph H. '82

MEDINA
King, H. Edmunds (Ted) '72

MERCER ISLAND
Michels, Robert J. '79
Portteus, Steve '83

MILL CREEK
Bond, James R. '76

MT. VERNON
Pearson, Charles J. '81

NEWPORT
Rowan, Robert '65

NORTH BEND
Goble, Jeffrey R. '76

OAK HARBOR
Allen, Frank L.
Berglund, Robert E. '83

OLYMPIA
Locy, Frank '74
Presley, Ted '48
Ramsaur, Jack '73

PORT ANGELES
Farquhar, George '65

PUYALLUP
Bogue, Bradley '75
Hogensen, Lee '74

REDMOND
Hattori, Gordon M. '79
Sterling-Brewer, Robin R. '88

RENTON
Banko, Phillip '79
Brewer, Jeffrey A. '72
Fulwider, Jay '75
Morris, Brian C. '87
Nelson, Barbara '69
Stewart, John '68

RICHLAND
Scott, William J. '77
Upson, Stephen S. '79
White, Gary W. '74

ROY
Killian, Danial '76

SEATTLE
Anderson, P. Kip '70
Backus, John '74
Barker, Kenneth D. '84
Barsby-Bulat, Lori '80
Barth, Christopher '85
Bertolin, Richard '48
Bolding, Kathryn M. '89
Brooks, David B. '57
Charter, Robert R. '83
Clise, Eric '77
Conrad, Christopher '81
De Giulio, Robert A. '75
Drummond, Kathi D. '85
Elken-Muld, Tina R. '83
Essad, Robert D. '78
Gay, Jerry '68
Gohrke, Timothy G. '77
Green Jr., Donald W. '80
Greengard, Ronald T. '83
Greer, Ronald R. '86
Gunderson, Craig E. '80
Hall, Timothy D. '86
Hastings, Ryan W '87
Holt, Thomas M. '83
Hughson, Walter L. '76
Huling, Rodney C. '75
Johnson, Carl '86
Johnson, David A. '78
Johnson, David Kent '85
Kendall-Hastings, Katherine L. '88
Ketter, Mark L. '81
La Tona Kevin D '76
Latona, Kevin '76
Lindsay, Kurt W. '79

Long, Roderick H. '79
Lowe, Edmund C. '80
Marra, Ben '72
Mc Culloch, William N. '86
Niedoptalski, David '76
Pawley, Roger '78
Pease, James R. '84
Peterson, Mary
Porter, David '72
Roberts, Patrick L. '75
Russell, Anita E. '76
Schultz, Zackary R. '81
Schulz, Henry T. '84
Seslar, R. Budd '60
Shimizu, Sam '61
Stake, Tim '82
Stanard-Barrington, Wendy '86
Taylor, Jeffrey J. '77
Tyrrash, Peter '73
Webb, Harry '52

SEAVIEW
Brous, Andrew '69

SELAH
Kasinger, John '73

SEQUIM
Rames, J. Douglas '73

SHELTON
Bennett, Robert E. '66

SILVERDALE
Smalley, James L. '77

SNOLOMISH
Scolman, James '69

SPOKANE
Durkin, Michael '57
Frost, Jack '56
La Turner, Douglas '82
Meyer, Barry J. '79
Singer, Richard J. '79

TACOMA
Baldwin, Dick '71
Gammell, Curtis W. '78
Martinez, Laura A. '90

TOLEDO
Marek, Vern '50

VANCOUVER
Bailey, Arthur '64
Dodd, Kathryn '88

VASHON
Garcia, William G. '83

W. RICHLAND
Gatherum, Ken

WALLA WALLA
Brown, Daniel '67

WENATCHEE
Doll, James '68

YAKIMA
Miraglia, Joseph J. '72
Pace, Robert '59
Stockman, Robert J. '85

WEST VIRGINIA

HUNTINGTON
Cook, Willis W. '50

WISCONSIN

APPLETON
Ballin, Richard A. '75
Hough, Chuck '62
Luke, John J. '82

ASHLAND
Parent, Howard '67

BEAVER DAM
Schmucki, Michael '87

BRISTOL
Wike, Marla D. '77

BROOKFIELD
Winkler, Ralph '63

DANBURY
Gersbach, Gregory S. '76

EAGLE RIVER
Allen, Donald '57

ELM GROVE
Carter, Peter C. '84

FOX POINT
Mc Callum, Bruce '76
Pinter, Mark W. '83

FRANKSVILLE
Klimowicz, Rick A. '88

FRIENDSHIP
Melby, Orville '49

JANESVILLE
Ryan, Shirley J. '77

KENOSHA
Kauffman, Edward '49

LA CROSSE
Gundersen, Rolf '76

LAKE MILLS
Heussner, Robert R. '80

MADISON
Gibbs, Craig '81
Mc Tavish, Fiona M. '85

MENOMONIE
Springer, Martin '73

MILWAUKEE
Elsner, Mary J. '88
Huebner, Glen M. '76
Miller, Bruce A. '83
Olsen, Paul D. '80
Wright, Jonathan F '69

MINERAL POINT
Sterba, William T. '75

MINOCQUA
Hillyer, Lisa '86

NEENAH
Lendrum, Jeff '83

OCONOMOWOC
Clifford, Richard M. '90
Rentmeester, Earl '76

RACINE
Turner, Richard E. '69

S. MILWAUKEE
Kozina, Daniel P. '77

SALEM
Gettig, Eugene J. '78

SOBIESKI
Strong, Russ '77

SUN PRAIRIE
Wingren, John H. '88

TWO RIVERS
Eggers, Joseph R. '75

WASHINGTON ISLAND
Gage, James P. '74

WAUKESHA
Birch, Michael L. '83
Florian, Thomas J. (TJ) '84
Holguin, Carl A. '78

WAUSAU
Torreano, David J. '84

WAUWATOSA
Malloy, Brian S. '81

WEST ALLIS
Campbell, Dennis '74
Plichta, Daniel '57
Zuback, William R. '88

WRIGHTSTOWN
Lewis, John R. '76

WYOMING

CASPER
Ball, Kenneth C. '76
Ptasynski, Lisa J. '86
Sherrill, Bryan

CHEYENNE
Engel, Thomas H. '81

JACKSON
Joy, Frederic C. '77
Schwarm, Arthur Brad '88

Printed in Hong Kong

Typography:	Tammy Baker Graphics, Santa Barbara, California
	The TypeStudio, Santa Barbara, California
Scitex:	Jones Colourworks, Chattanooga, Tennessee
Creative Director and Design:	Michael Verbois, Brooks Institute
Production Coordinator:	Monie de Wit, Serbin Communications, Inc.
Advertising Staff:	Bryan Dunn, John Jiménez, James Johnson, Holly Schwartz

Additional Photo Credits:	Ralph Clevenger 176, 177
	John Dark 4
	Henry Fechtman 176
	Matt Hammarlund 178, 179, 180, 181, 183
	Tim Mantoani 178, 179, 180, 181, 183
	Mark Mosrie 178, 179, 180, 181
	John Noonan 178, 179, 180, 181
	Erhard Pfeiffer 174, 175
	Marcel Siegle 178, 179, 180, 181
	Michael Verbois 177

Published by Serbin Communications, Inc., Santa Barbara, California